MASTER WORKS

Publisher
TAKASHI YAMAMORI

Editor in Chief
KAZUYA SAKAI

Editors
MIKA KANMURI
YUKARI TASAI

Writers
NAOYUKI KAYAMA
KIKAI
AKINORI SAO
CHISATO MIKAME

Map Creation
TAKASHI OKAZAWA

Photographer
SHOJI NAKAMICHI

Revisions
DAISAKU SATO

Editing Collaborators
KIMIKO KANMURI
HARUE KANMURI
MASATO FURUYA

Supervision and Collaboration
NINTENDO CO., LTD.

Design
YUUKI FUMOTO (Freeway Ltd.)
KATSUYUKI MURAMASTU (Freeway Ltd.)
SHOMA SAITO (Freeway Ltd.)
HAYAKI SAITO (Freeway Ltd.)
AYUMI HONDA (Freeway Ltd.)
TOMOMI YAE (Freeway Ltd.)

Art Director
SHION SAITOU (Freeway Ltd.)

CREATING A CHAMPION

Publisher
MIKE RICHARDSON

Editor
PATRICK THORPE

Fact Checking
IAN FLYNN
DAVID OXFORD

Designer & Digital Art Technician
CARY GRAZZINI

Cover Illustration
TAKUMI WADA

Cover Design
CARY GRAZZINI

The Legend of Zelda: Breath of the Wild–Master Works was published by Ambit Ltd. First edition: December 2017.

Special thanks to Eiji Aonuma, Hidemaro Fujibayashi, Satoru Takizawa, Takumi Wada,
Rich Amtower, Audrey Drake, Melena Jankanish, Dave Marshall, Nick McWhorter, Michael Gombos,
Vanessa Todd-Holmes, Sarah Terry, David Nestelle, and Annie Gullion.

President and Publisher Mike Richardson · *Executive Vice President* Neil Hankerson · *Chief Financial Officer* Tom Weddle · *Vice President of Publishing* Randy Stradley · *Chief Business Development Officer* Nick McWhorter
Vice President of Marketing Matt Parkinson · *Vice President of Information Technology* Dale LaFountain · *Vice President of Production and Scheduling* Cara Niece · *Vice President of Book Trade and Digital Sales* Mark Bernardi
General Counsel Ken Lizzi · *Editor in Chief* Dave Marshall · *Editorial Director* Davey Estrada · *Senior Books Editor* Chris Warner · *Director of Specialty Projects* Cary Grazzini · *Art Director* Lia Ribacchi
Director of Print Purchasing Vanessa Todd-Holmes · *Director of Digital Art and Prepress* Matt Dryer · *Director of International Publishing and Licensing* Michael Gombos · *Director of Custom Programs* Kari Yadro

The Legend of Zelda © 1986 Nintendo
The Legend of Zelda: Ocarina of Time © 1998 Nintendo
The Legend of Zelda: Skyward Sword © 2011 Nintendo
The Legend of Zelda: The Wind Waker HD © 2002–2013 Nintendo
The Legend of Zelda: Majora's Mask 3D © 2000–2015 Nintendo
The Legend of Zelda: Twilight Princess HD © 2006–2016 Nintendo
The Legend of Zelda: Breath of the Wild © 2017 Nintendo

THE LEGEND OF ZELDA: BREATH OF THE WILD–CREATING A CHAMPION

Published by Dark Horse Books
A division of Dark Horse Comics, Inc.
10956 SE Main Street
Milwaukie, OR 97222

DarkHorse.com

Library of Congress Cataloging-in-Publication data is available.

International Licensing: (503) 905-2377

First English edition: November 2018
ISBN 978-1-50671-010-5

Hero's edition: November 2018
ISBN 978-1-50671-011-2

Champions' edition: November 2018
ISBN 978-1-50671-114-0

1 3 5 7 9 10 8 6 4 2
Printed in China

THE LEGEND OF
ZELDA™
BREATH OF THE WILD
CREATING A CHAMPION

Translation Partner
ULATUS

Translator
KEATON C. WHITE

Reviewer
SHINICHIRO TANAKA

*All concept illustrations that originally
contained handwritten notes in Japanese have been
translated into English for this book.*

DARK HORSE BOOKS

CONTENTS

"Open Your Eyes..."

ILLUSTRATIONS

Immerse yourself in the beautiful world of The Legend of Zelda: Breath of the Wild with all of the official illustrations completed as of March 2018, including artwork published here for the first time.

Rough sketches and commentary from Breath of the Wild's primary illustrator, Takumi Wada, accompany selected illustrations, providing insight into the creative process behind some of Breath of the Wild's most recognizable images.

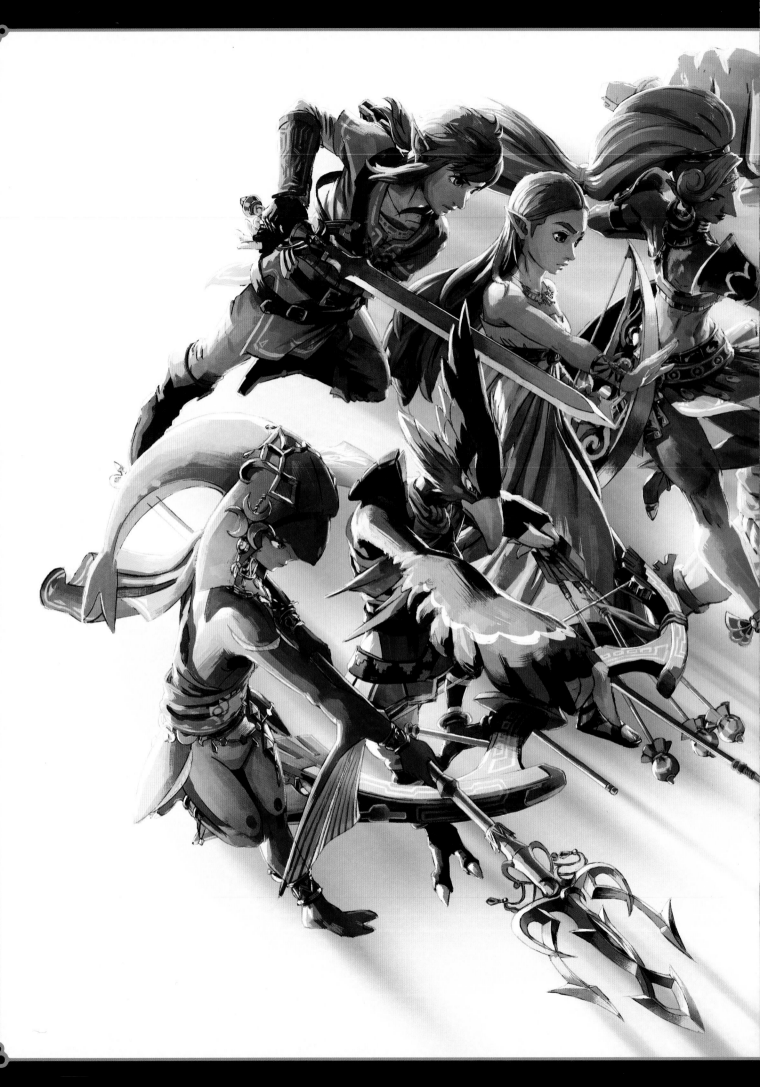

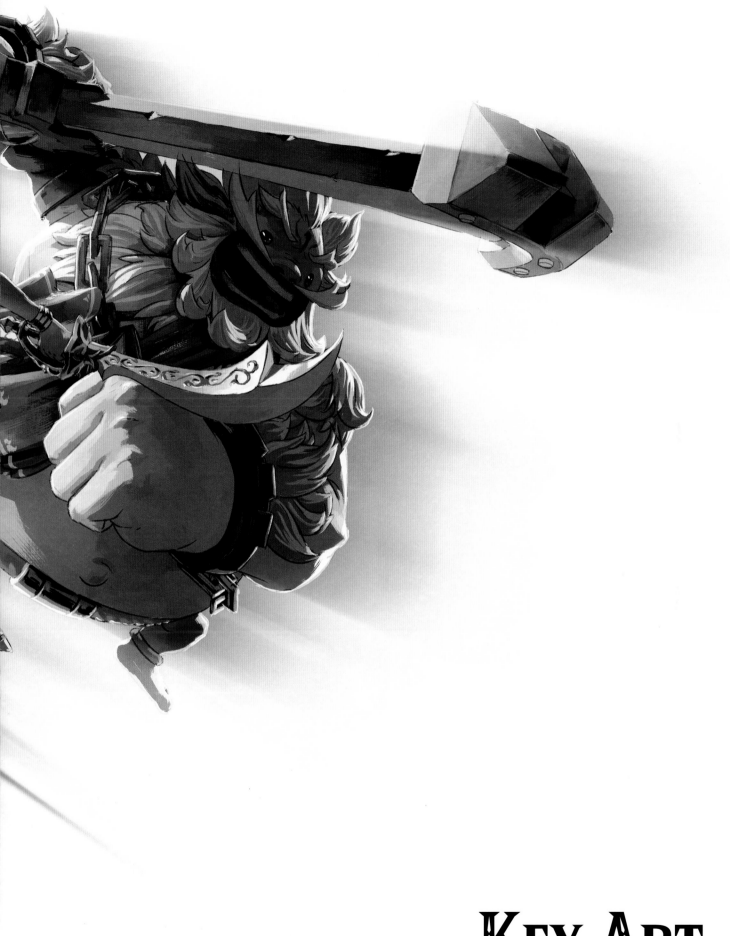

KEY ART

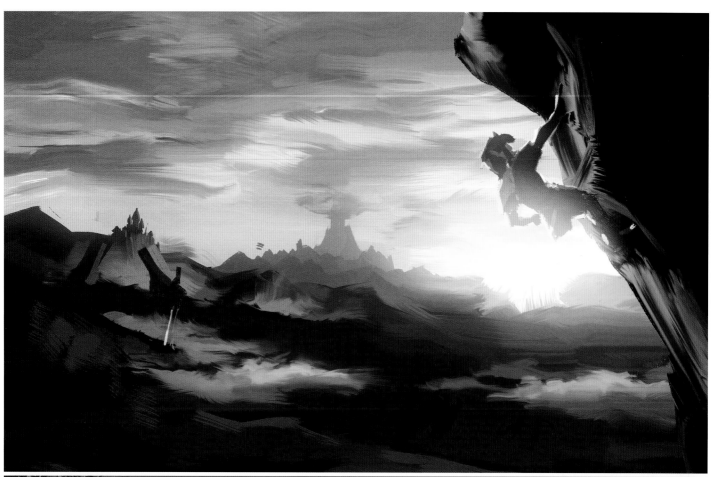

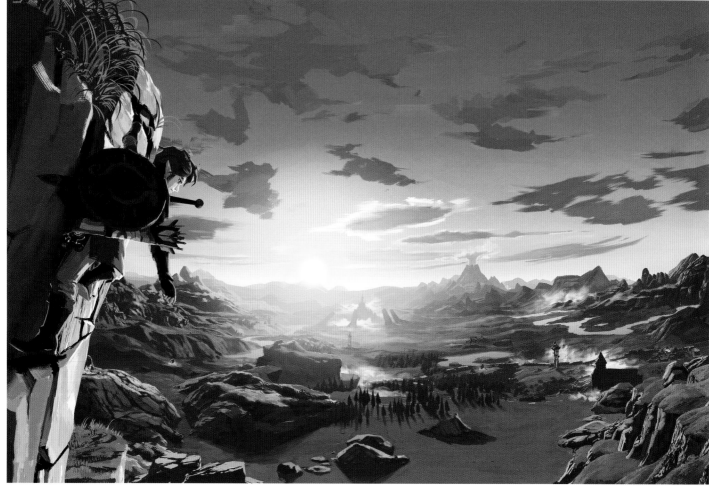

DEVELOPER'S NOTE

Initially, I was considering a composition that was inspired by the box art illustration for the original *Legend of Zelda* on the Famicom in addition to Link climbing a cliff, because, when I first played *Breath of the Wild*, it felt to me that it shared a similar essence with the original.

Ultimately, we decided to showcase how new and different this game was from what came before, and so we did not use the original *Legend of Zelda* composition for the E3 illustration. I ended up using the homage idea for an official Twitter illustration (page 35).

ILLUSTRATOR: TAKUMI WADA

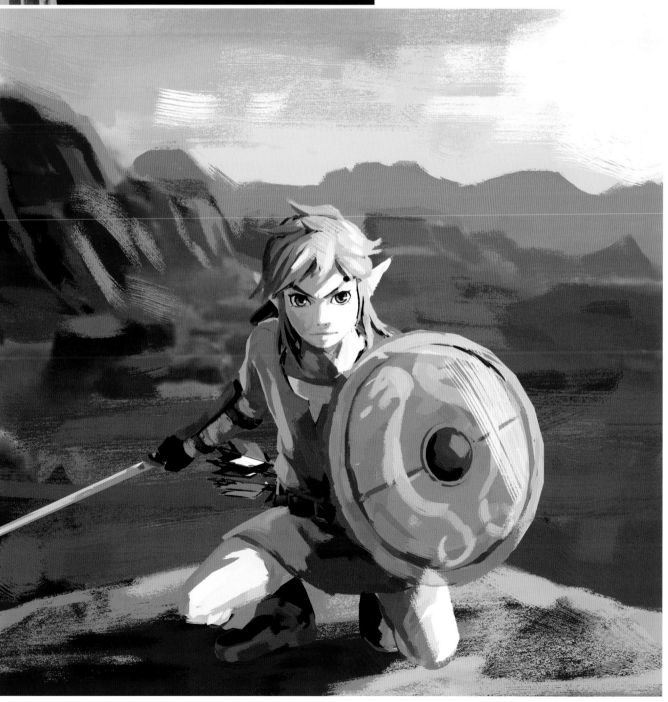

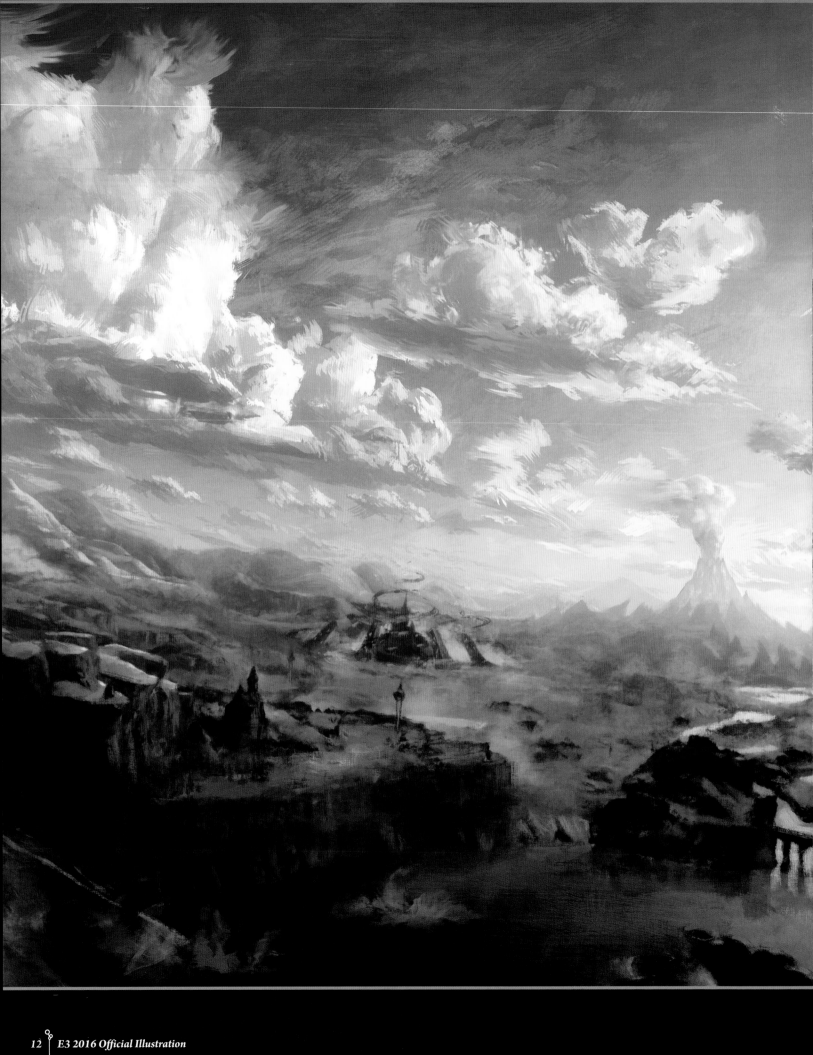

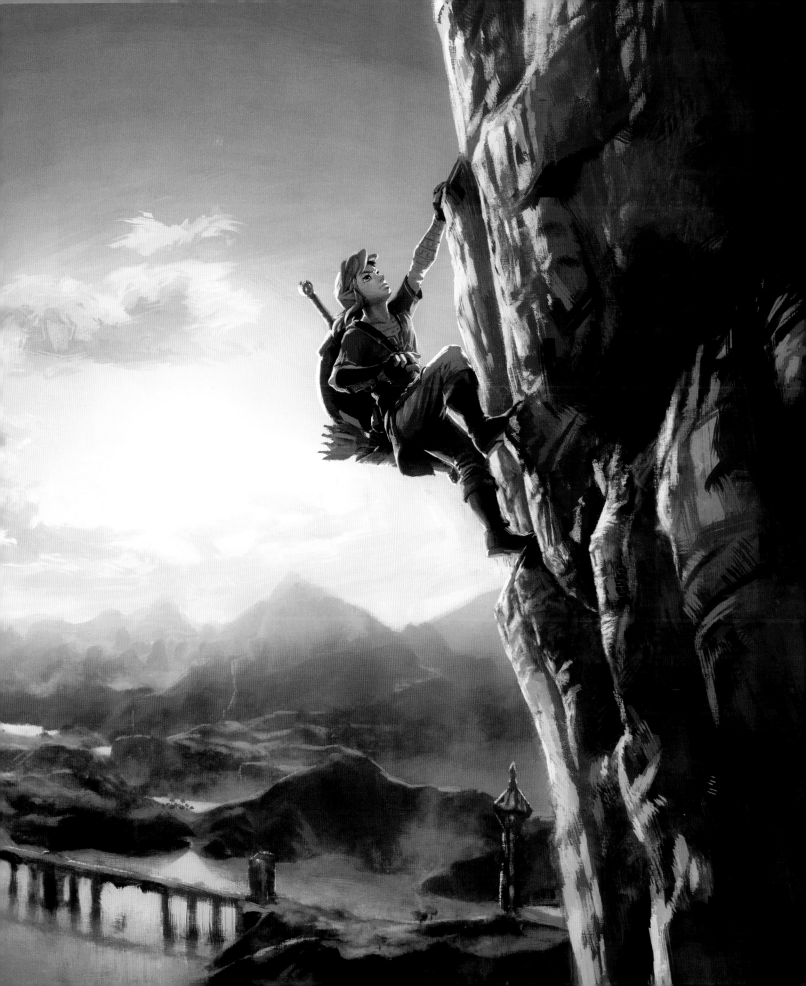

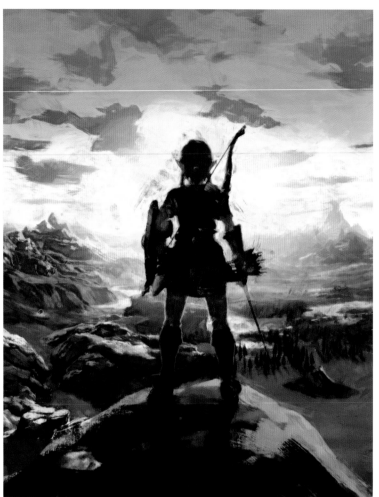

DEVELOPER'S NOTE

When I drew the official box art and E3 illustration, I wanted to give the sense that Link was confronting the world.

My first sketch portrayed Link looking out over Hyrule with his back to the viewer. I then experimented with several other compositions that more prominently featured Link, but eventually settled on the direction of my initial idea. I felt that the world itself, not just the characters, had a leading role in this game.

I also wanted to convey that this was the beginning of a new *Zelda*, so I drew the sky at daybreak.

ILLUSTRATOR: TAKUMI WADA

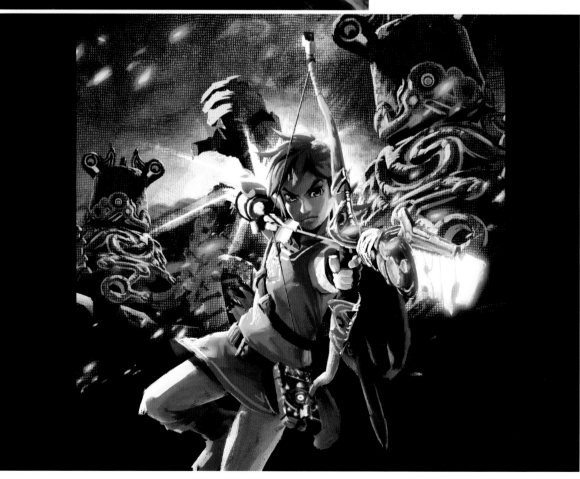

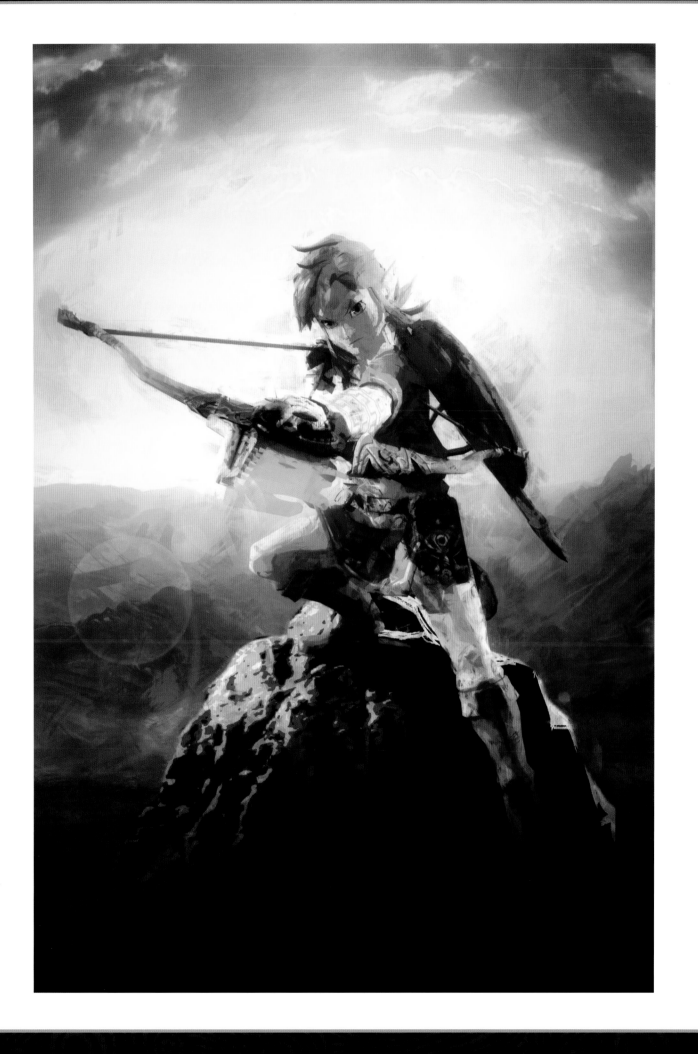

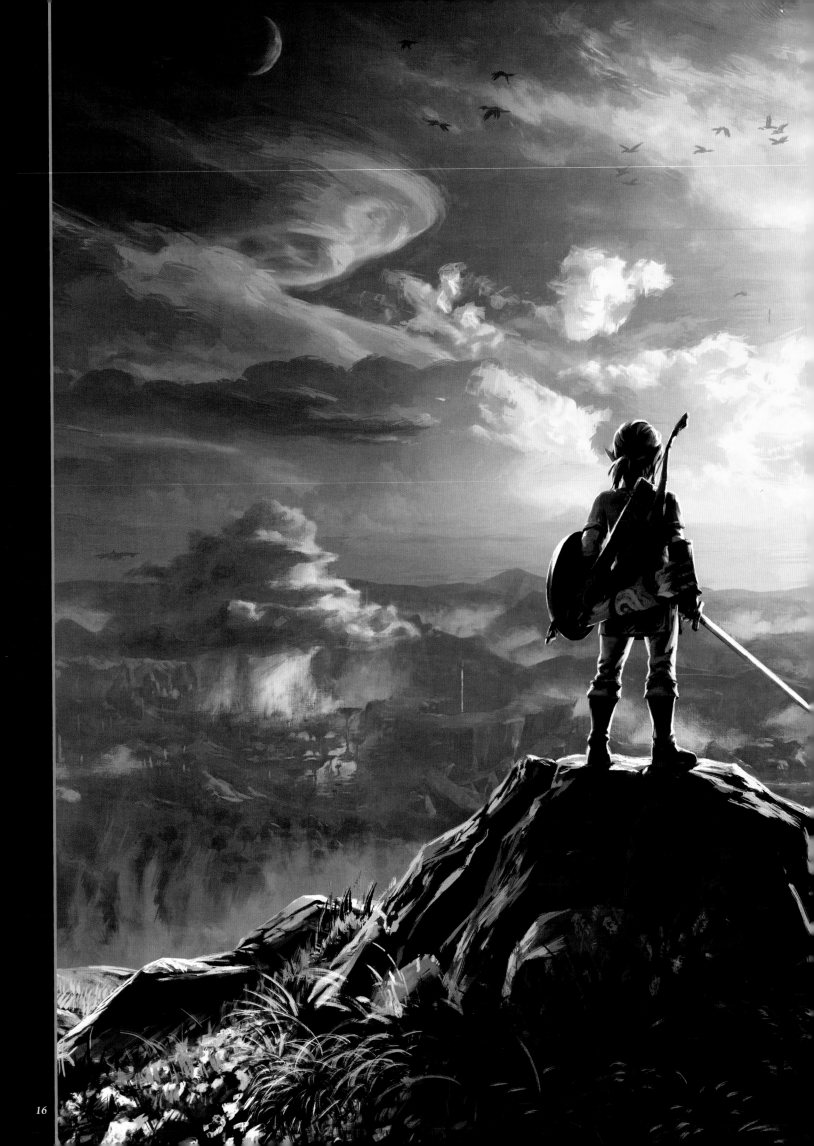

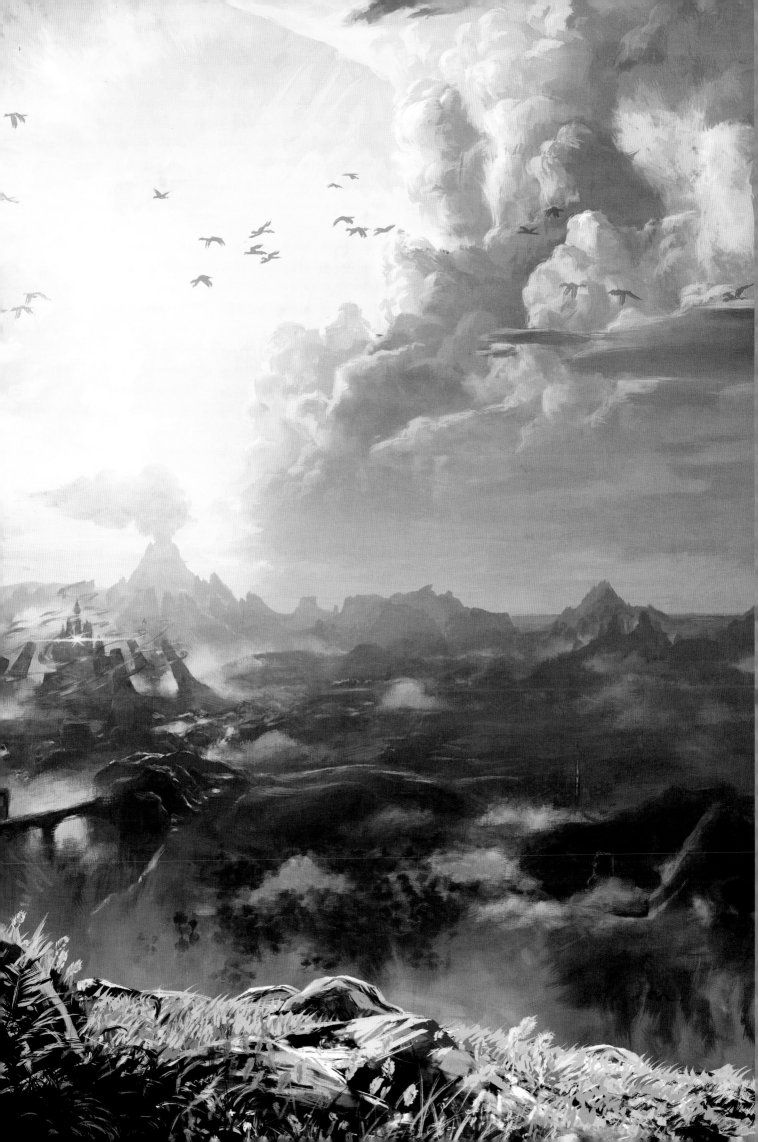

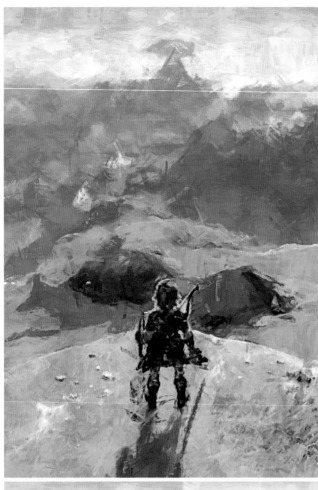

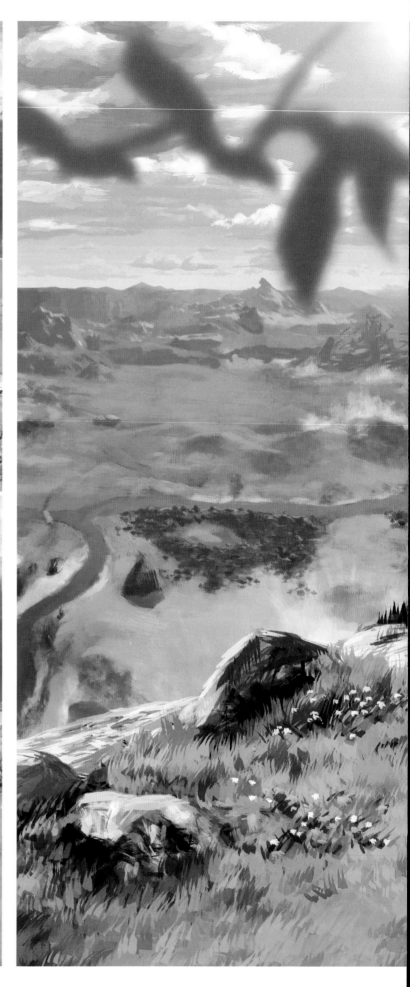

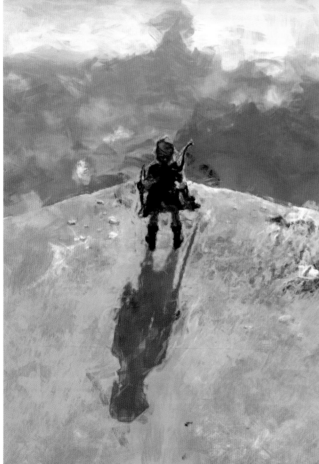

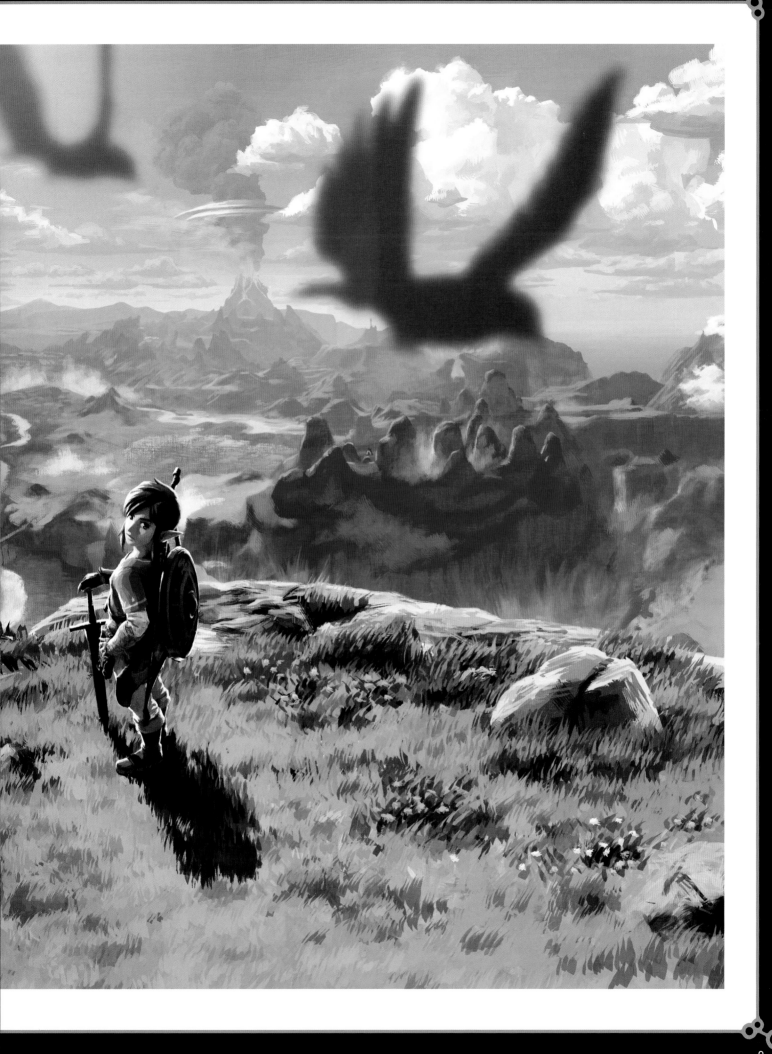

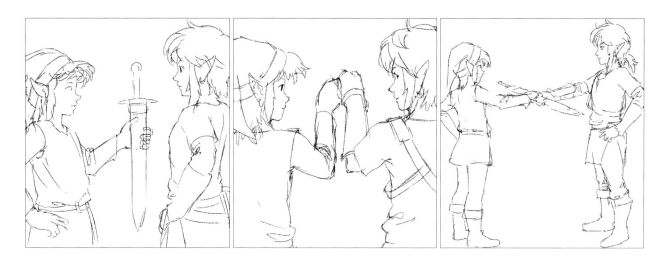

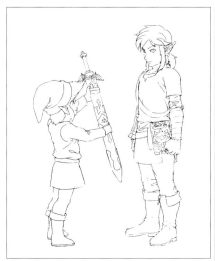

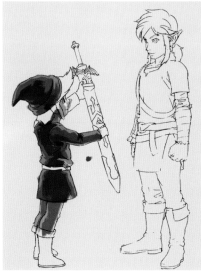

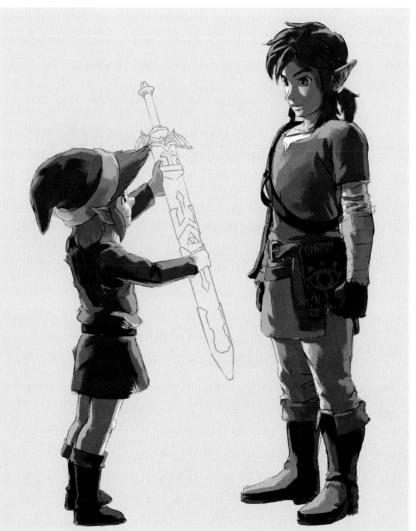

DEVELOPER'S NOTE

Since the *Weekly Famitsu* artwork would be seen in places like convenience stores and bookstores by people who might not be familiar with video games, I was concerned that an image of Link wearing a blue tunic wouldn't make it clear that this was *The Legend of Zelda*. I wanted to make sure that as many people as possible knew

that a new *Zelda* was coming out, so I paired him with the iconic original Link for reference.

To celebrate the launch of the title, I didn't want the focus to be on the size difference or the weapon but a sense of inheritance from past to present.

ILLUSTRATOR: TAKUMI WADA

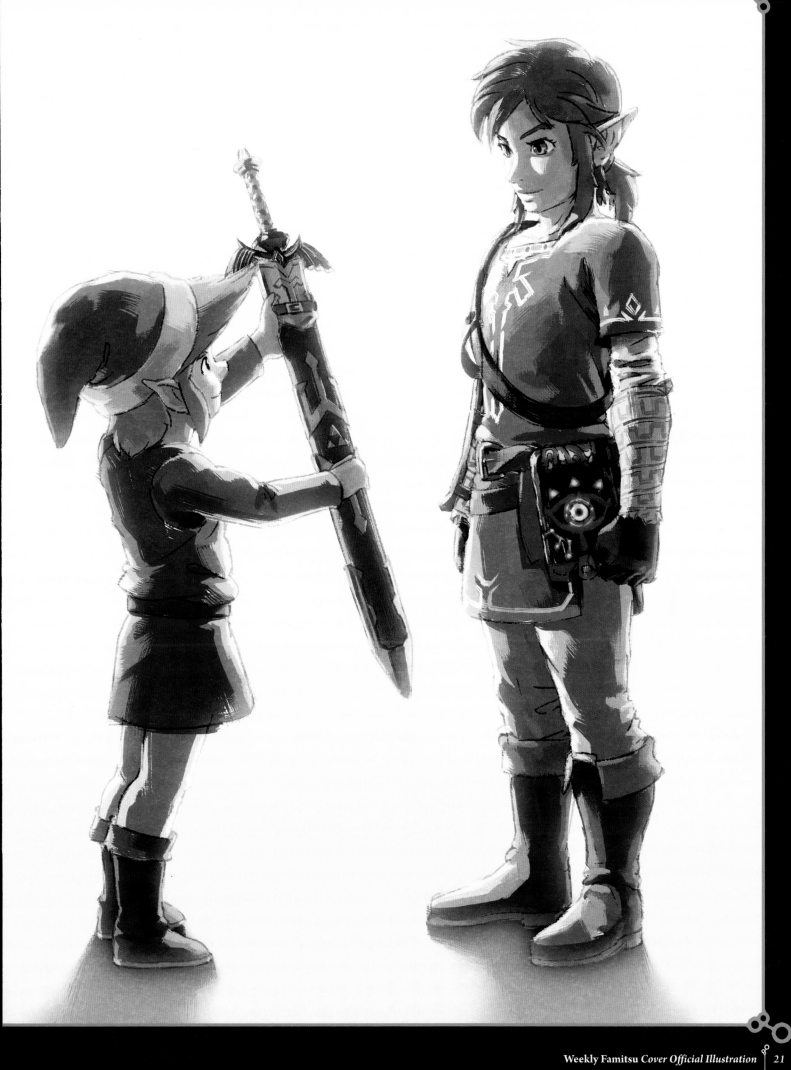

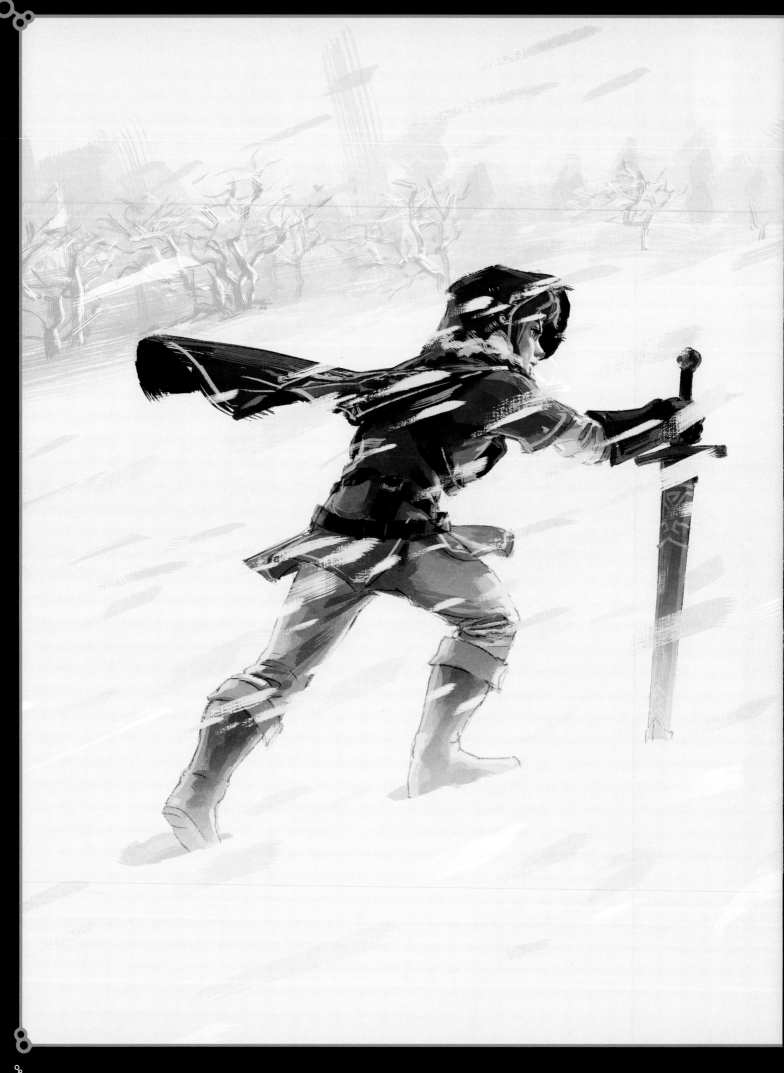

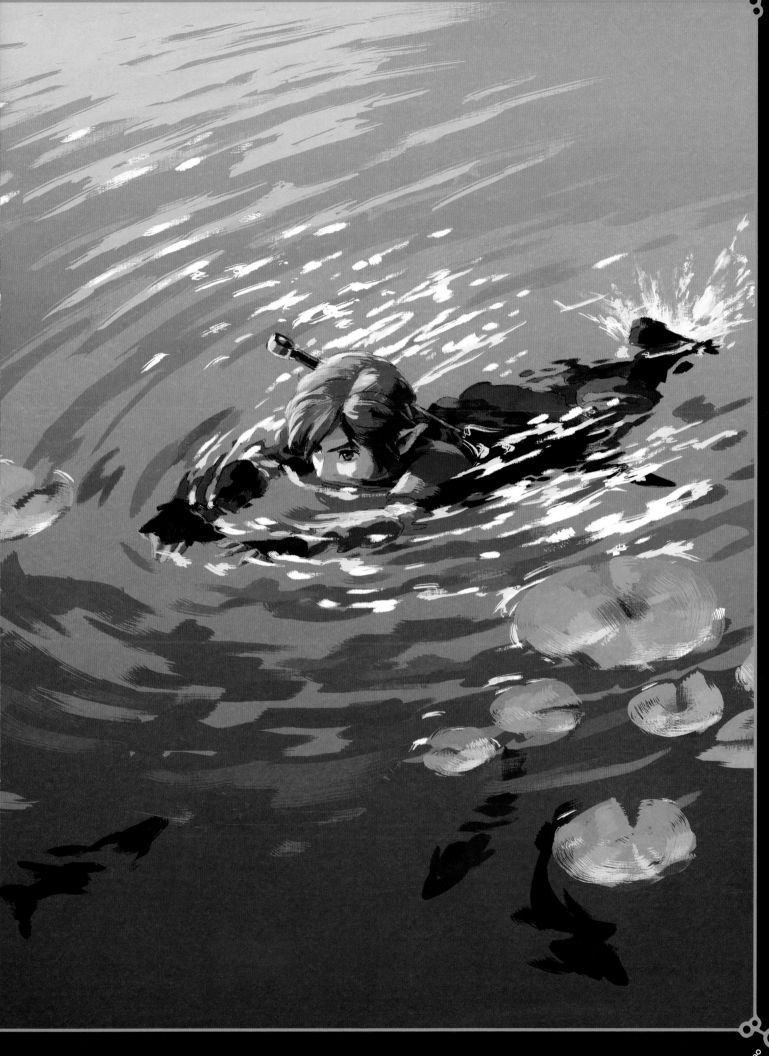

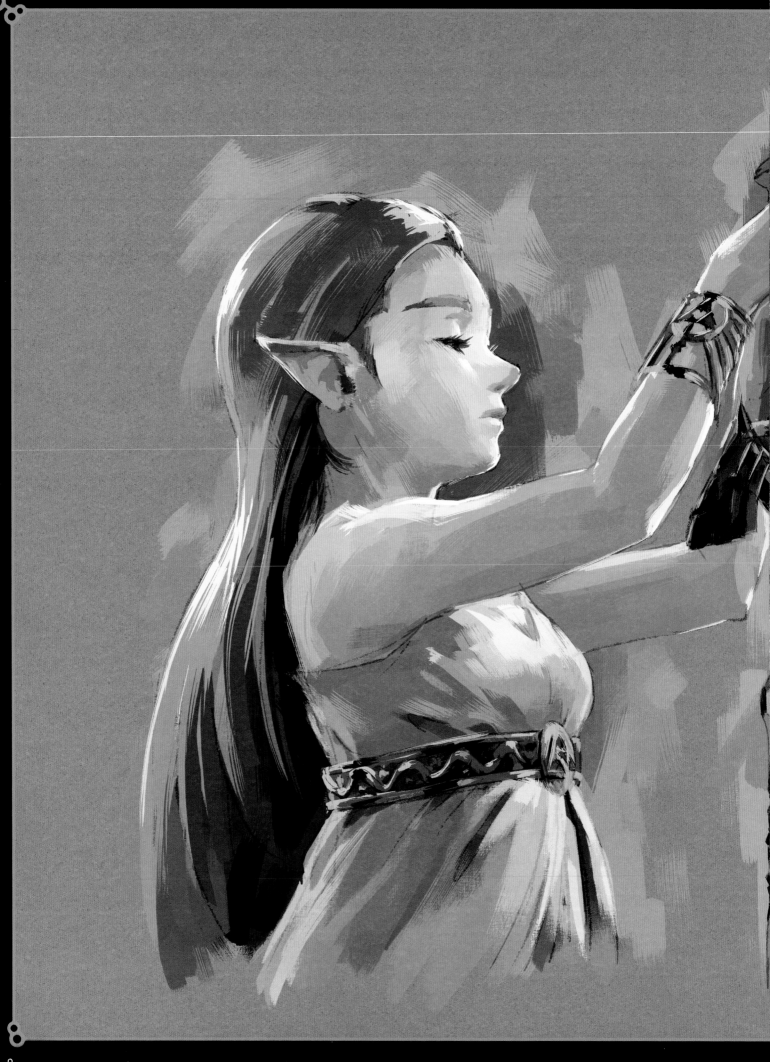

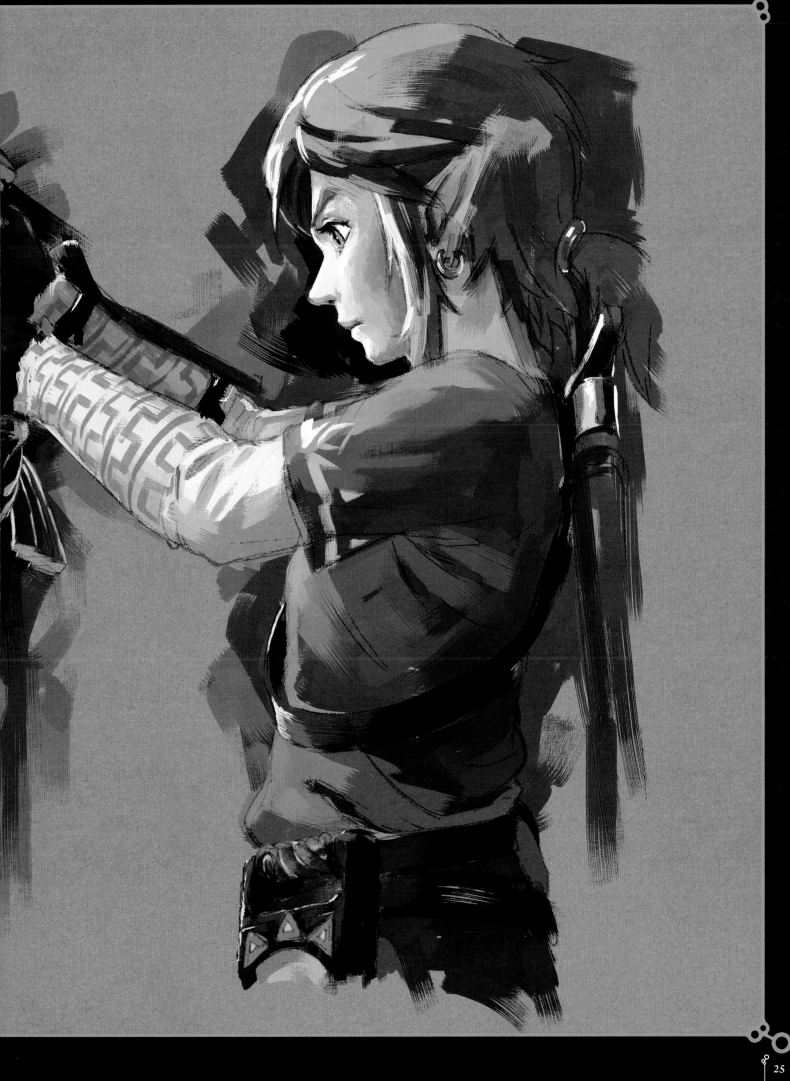

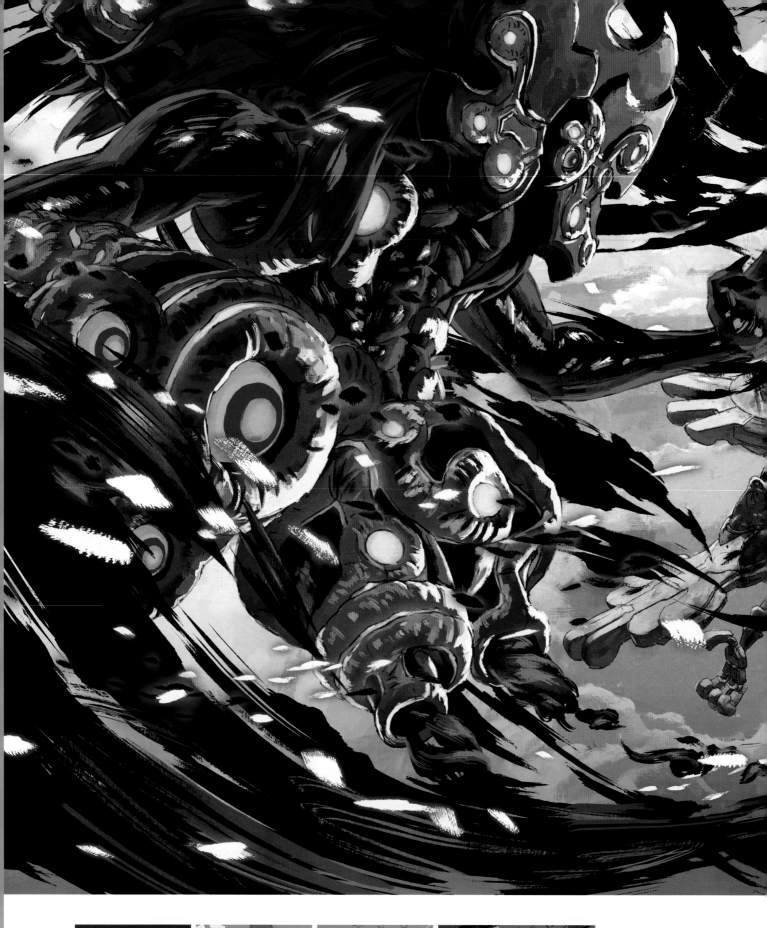

Explorer's Guide *Cover Official Illustration and Rough Designs*

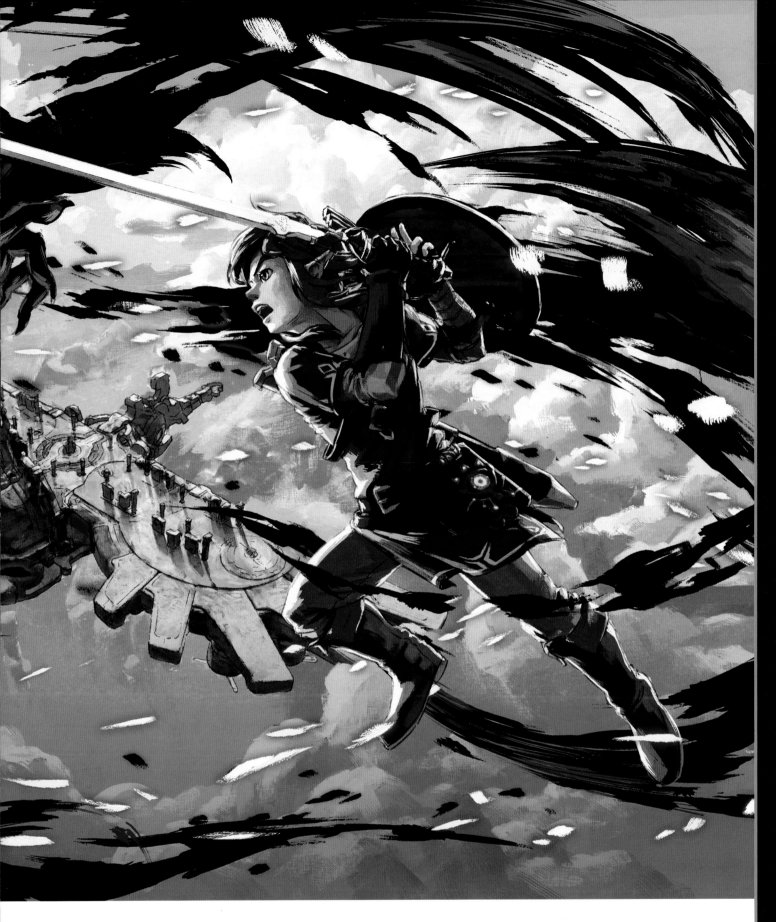
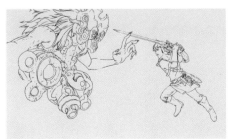

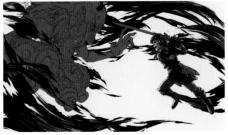

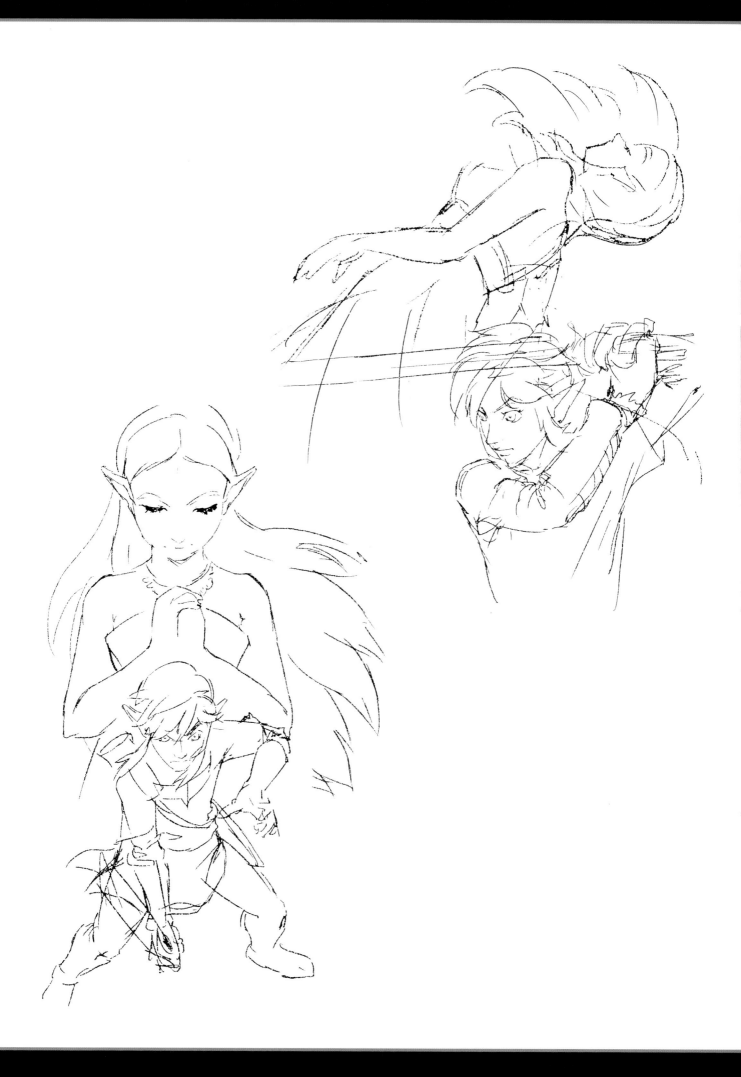

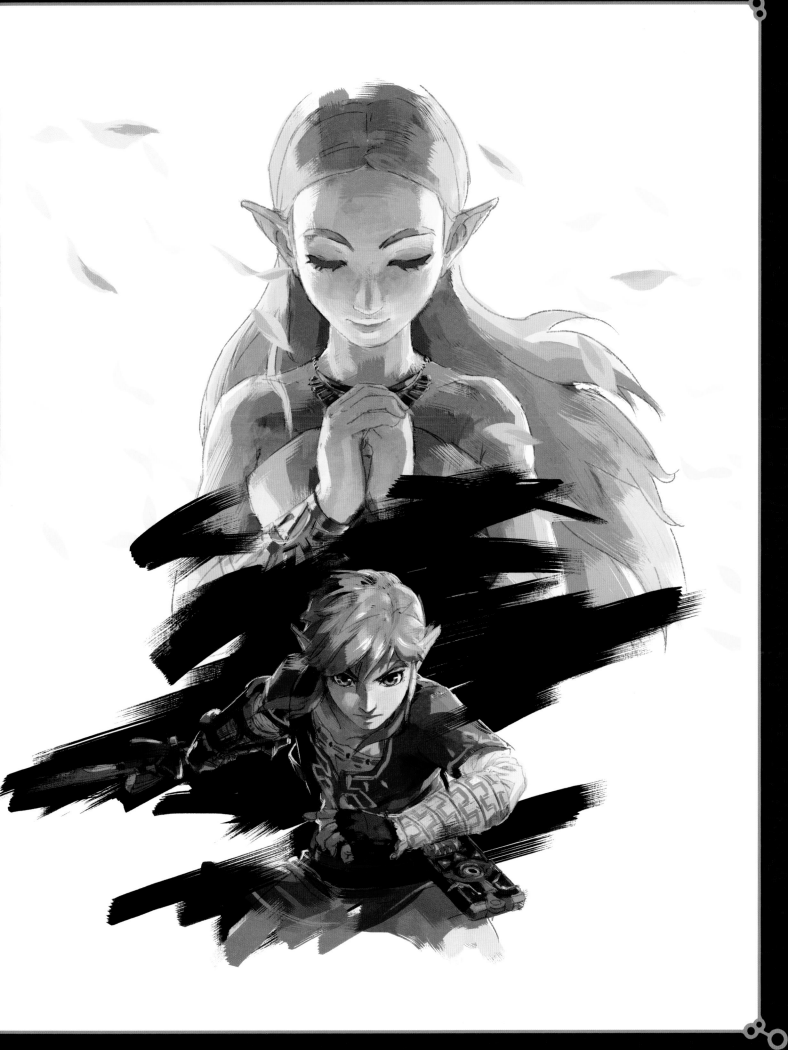

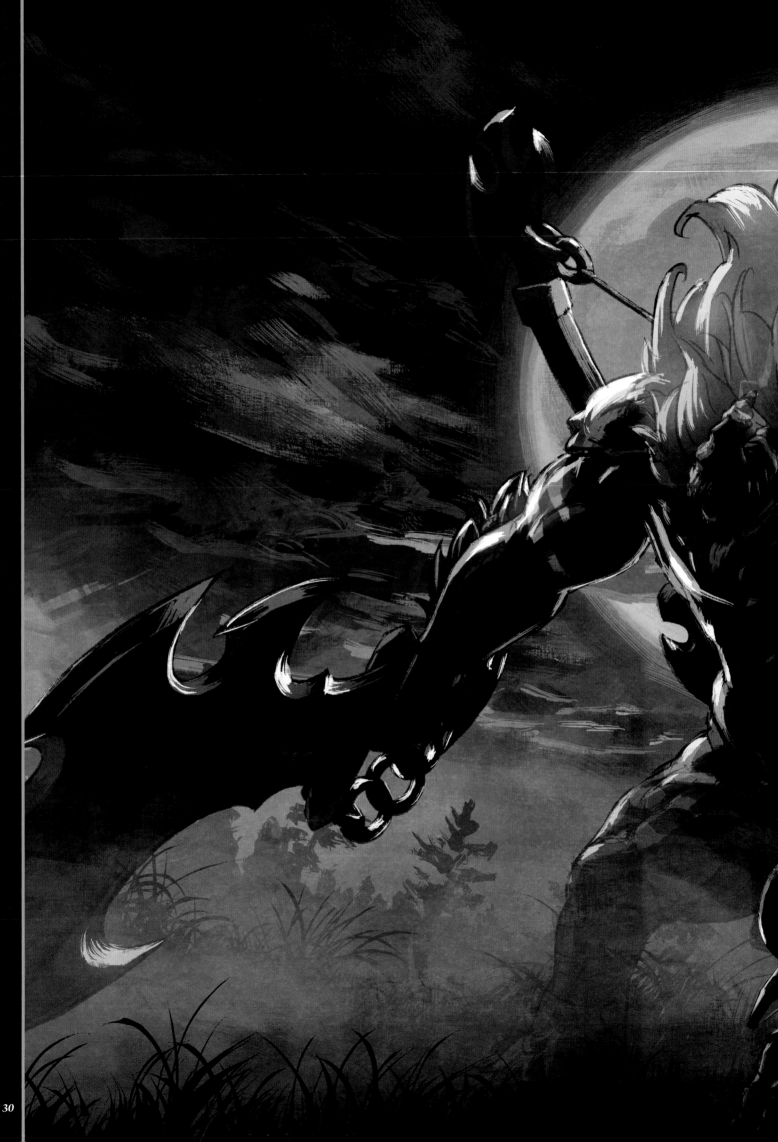

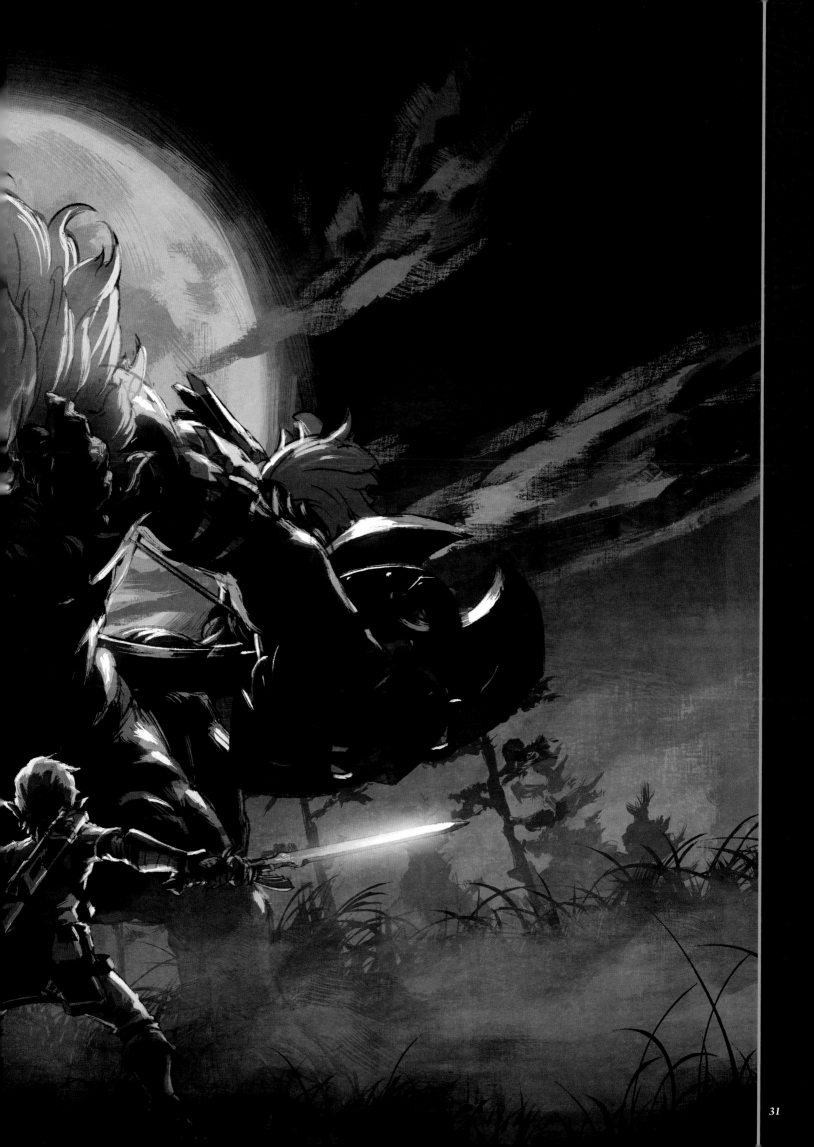

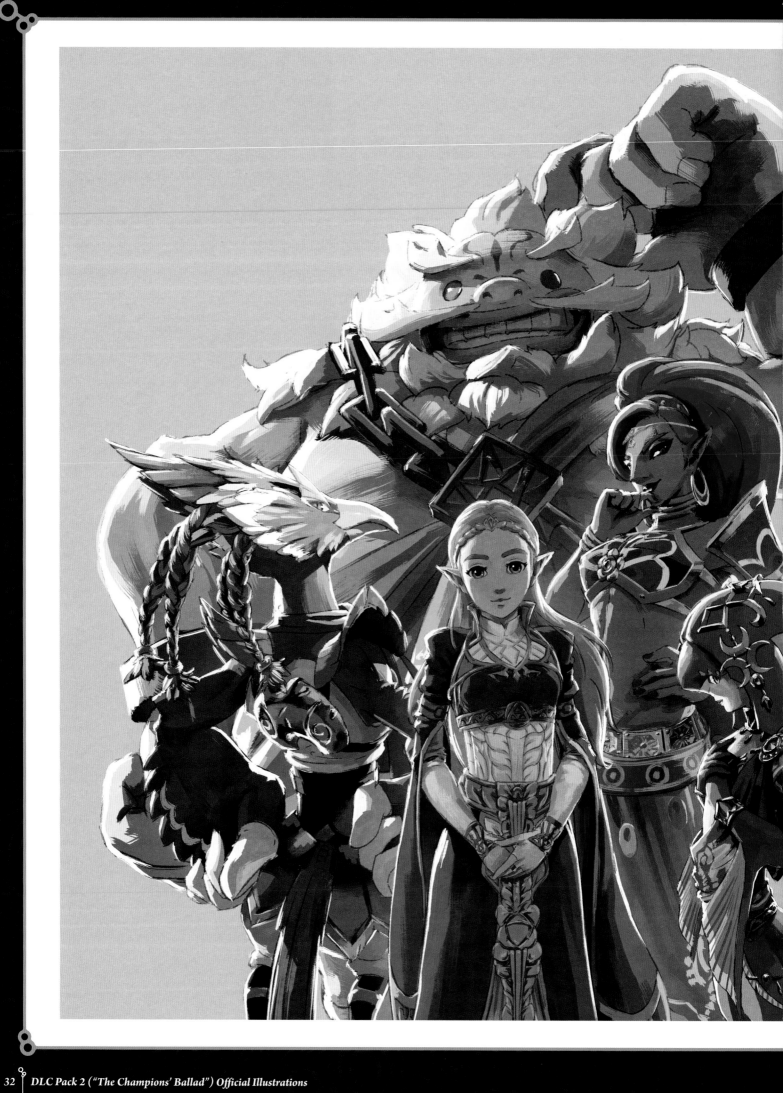

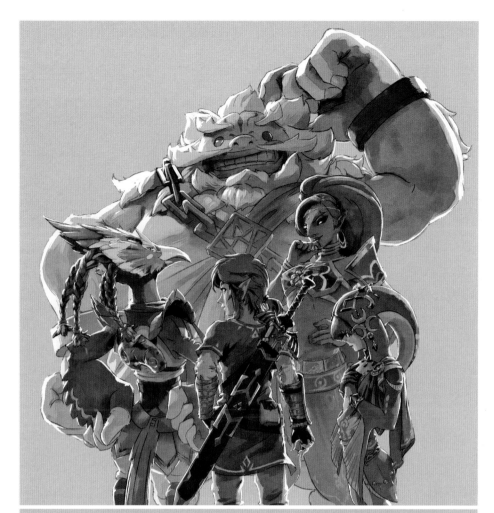

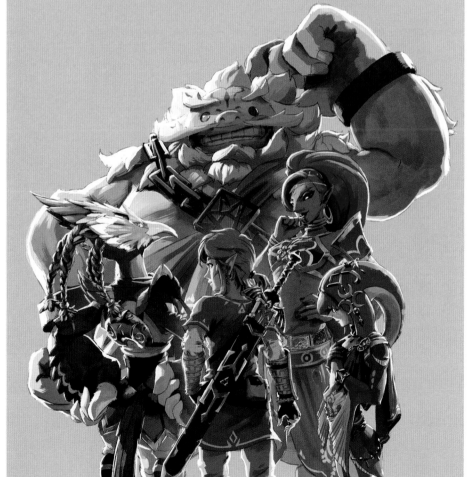

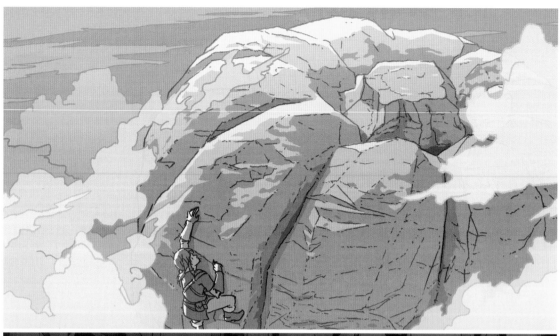

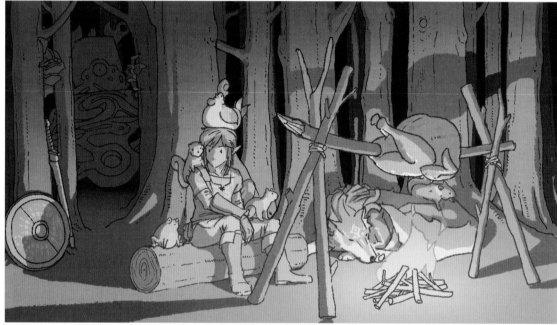

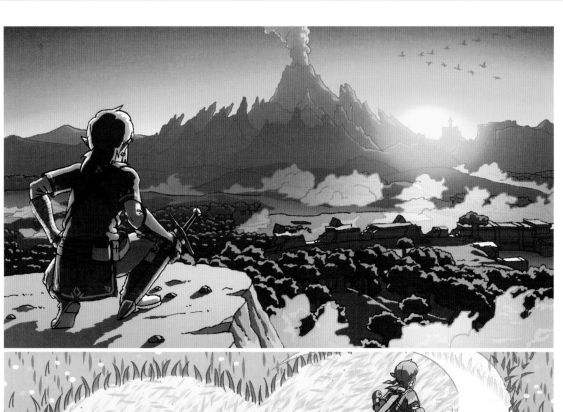

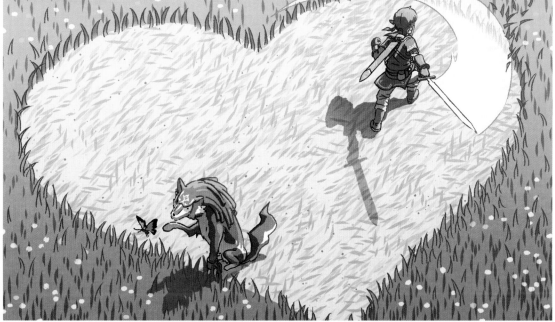

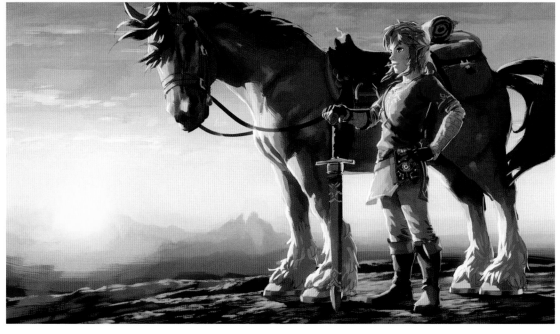

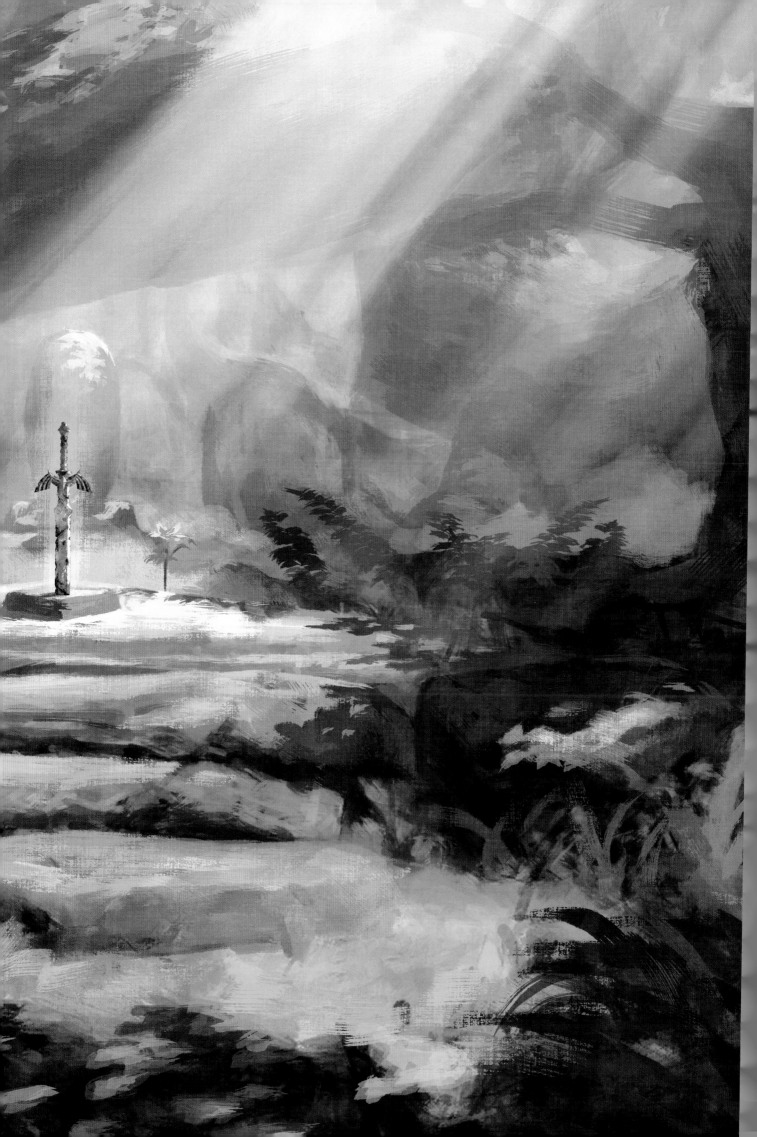

Twitter Official One-Year Anniversary Illustration

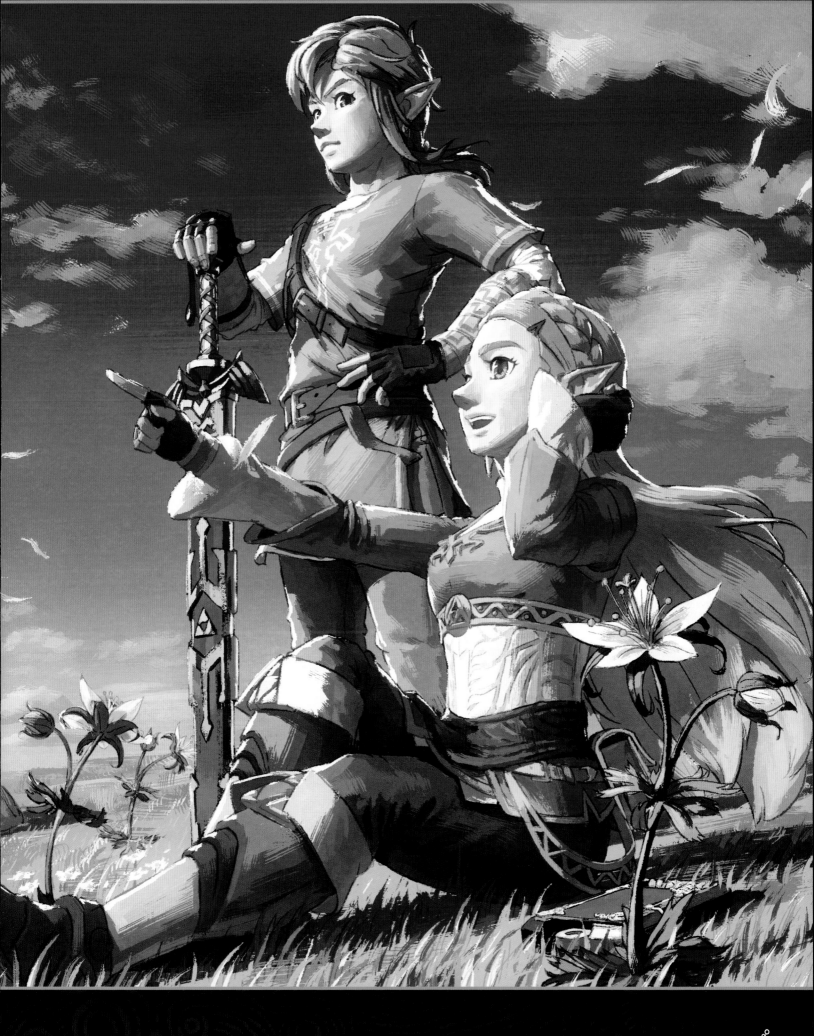

CHARACTER ART

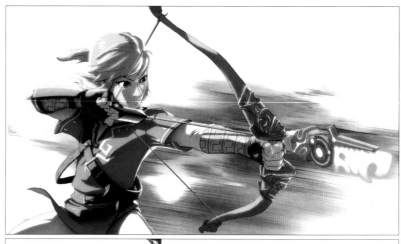

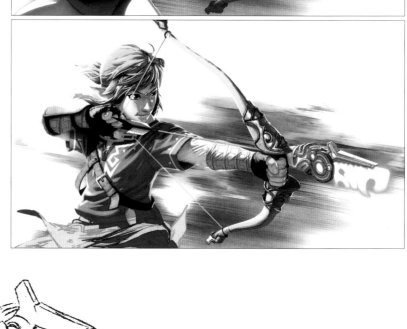

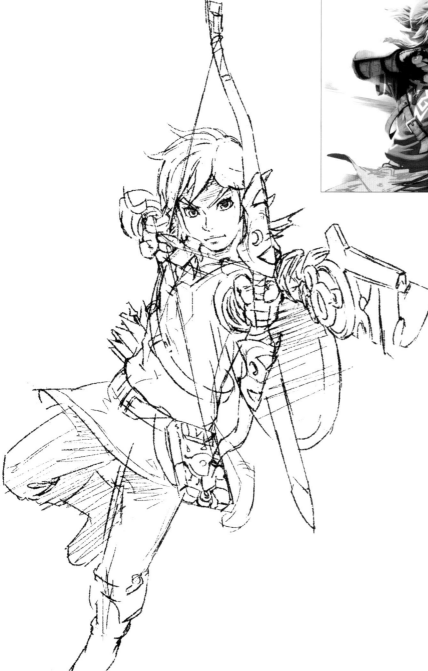

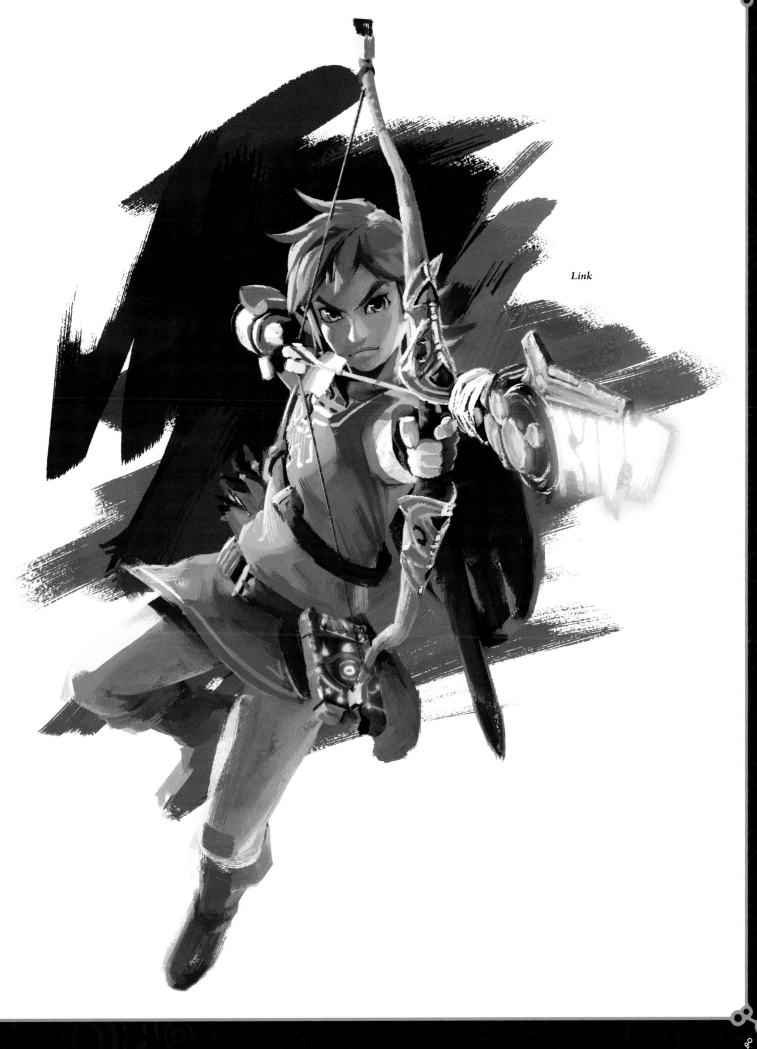

Link

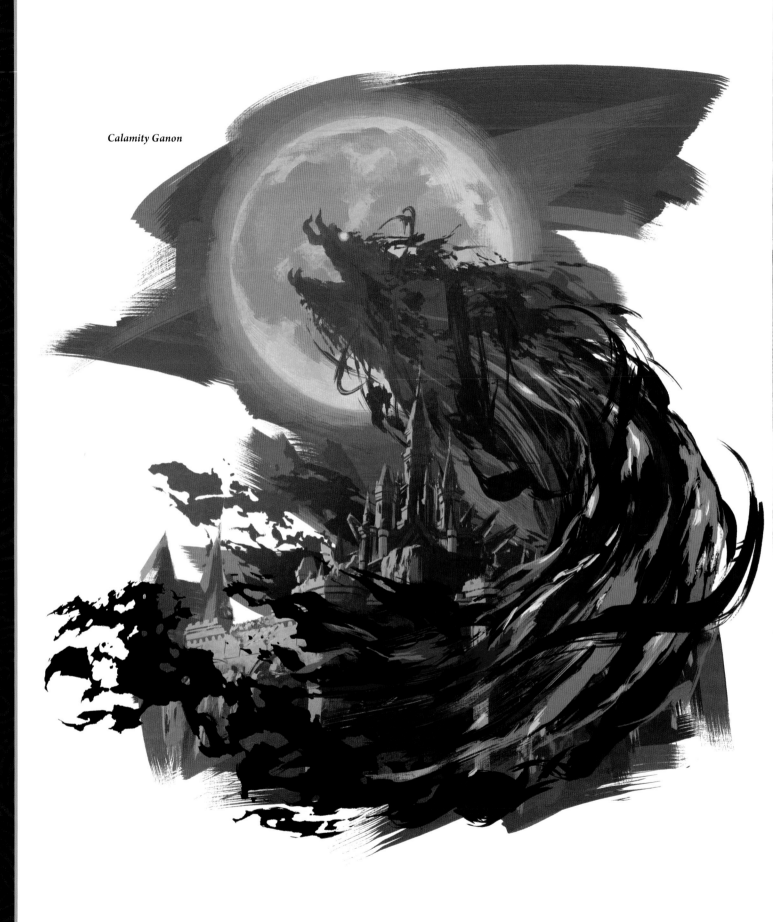

Calamity Ganon

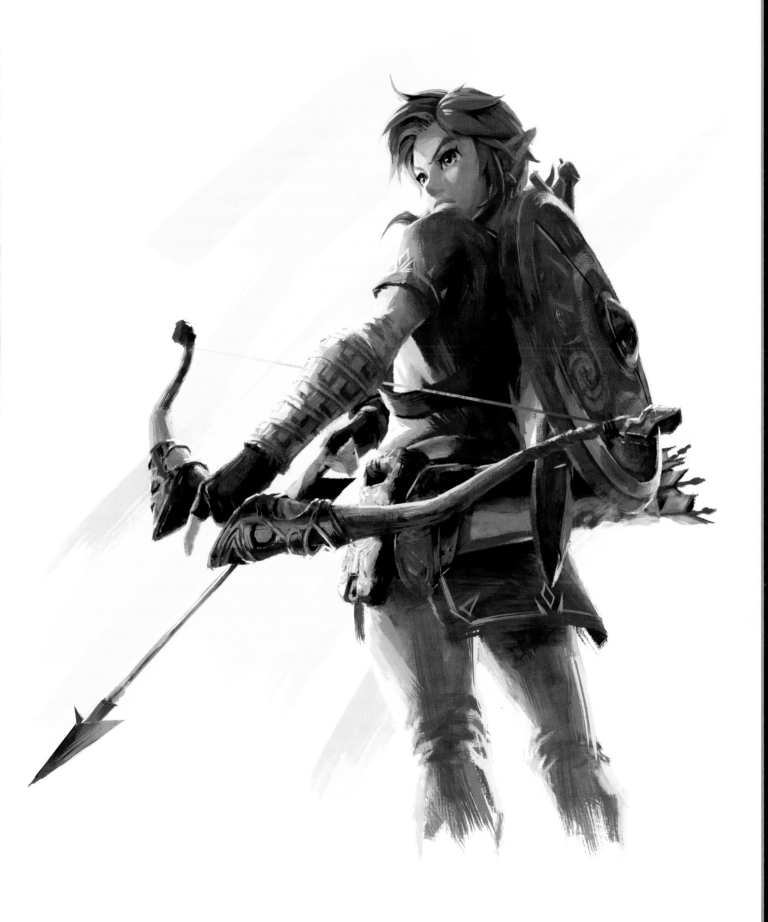

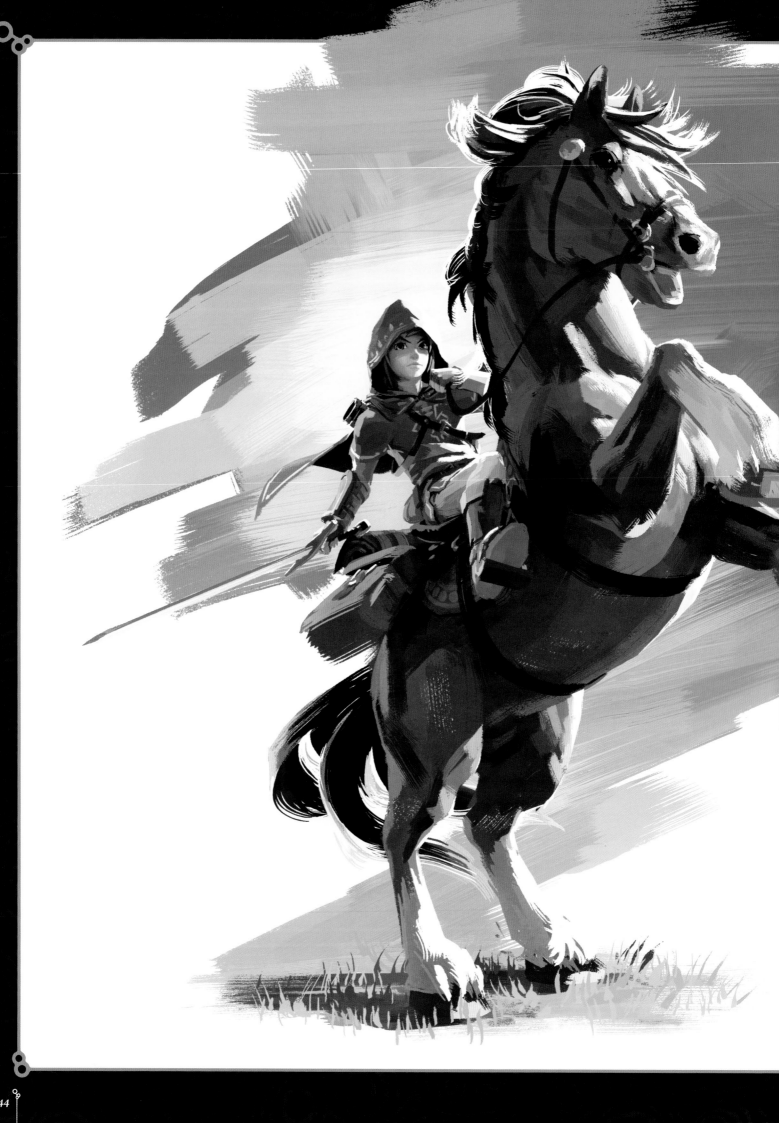

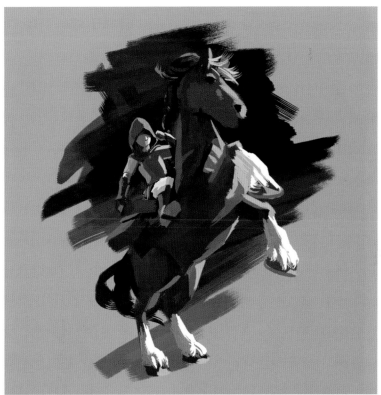

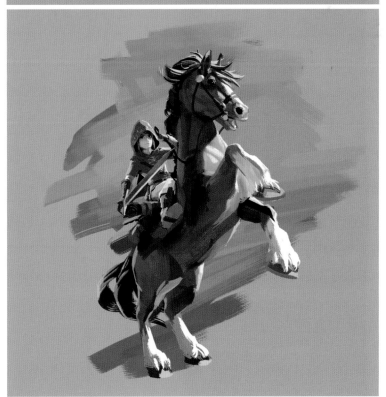

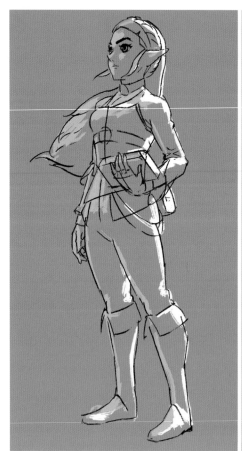

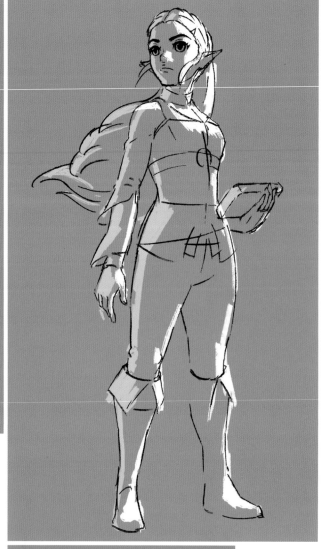

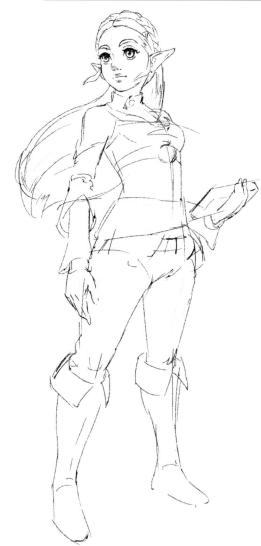

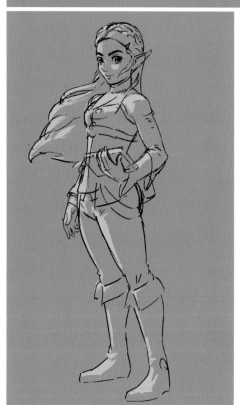

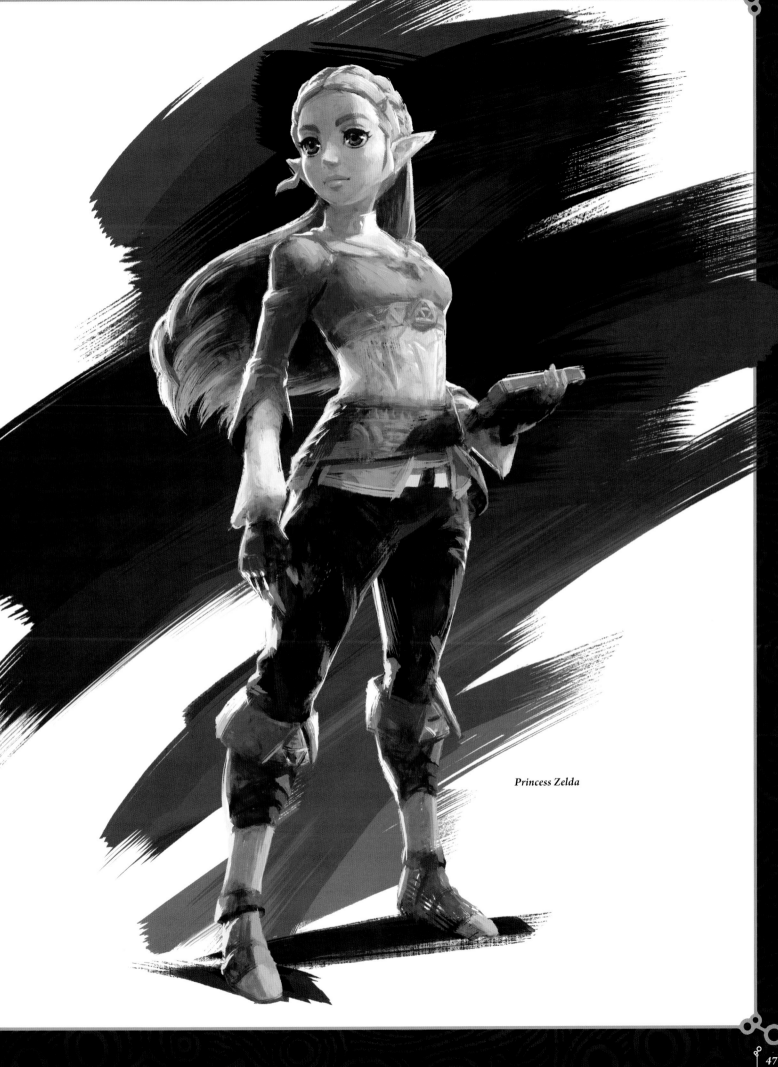

Princess Zelda

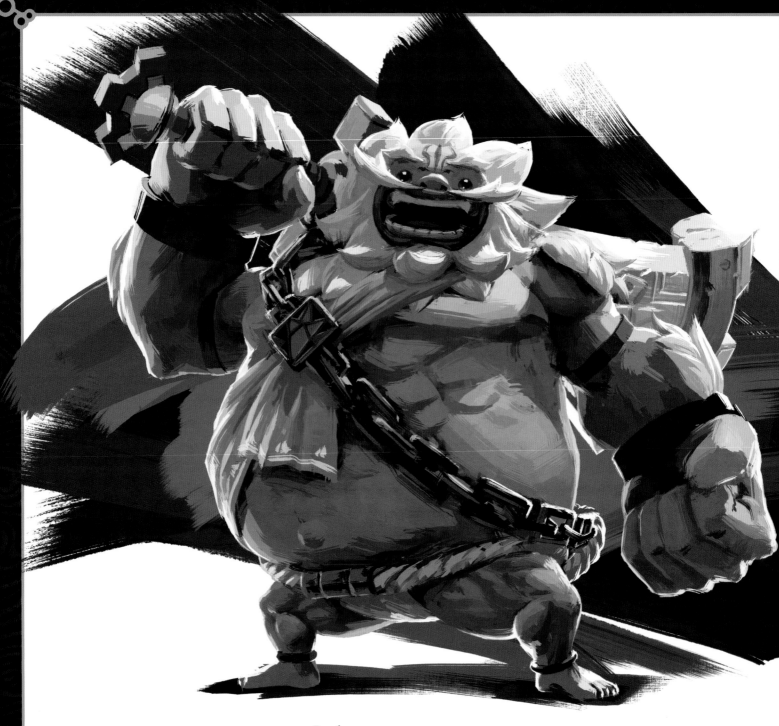

Daruk

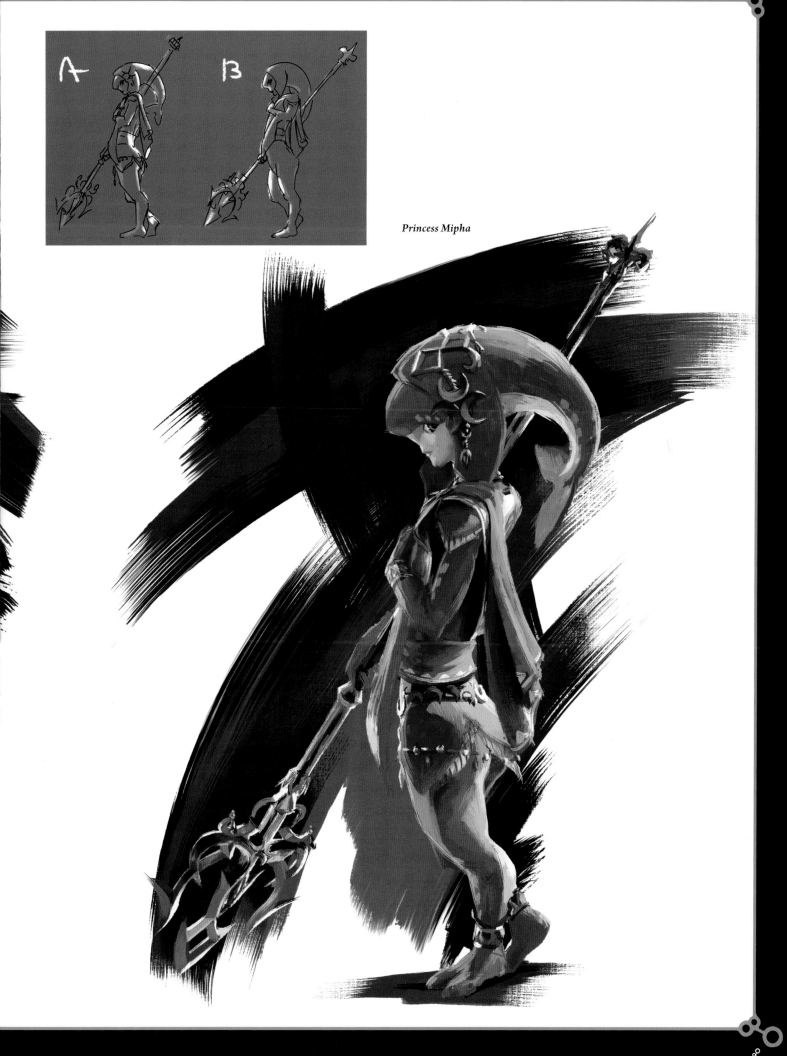

Princess Mipha

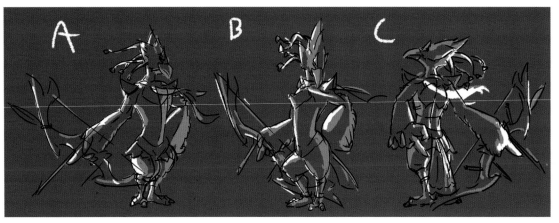

Revali

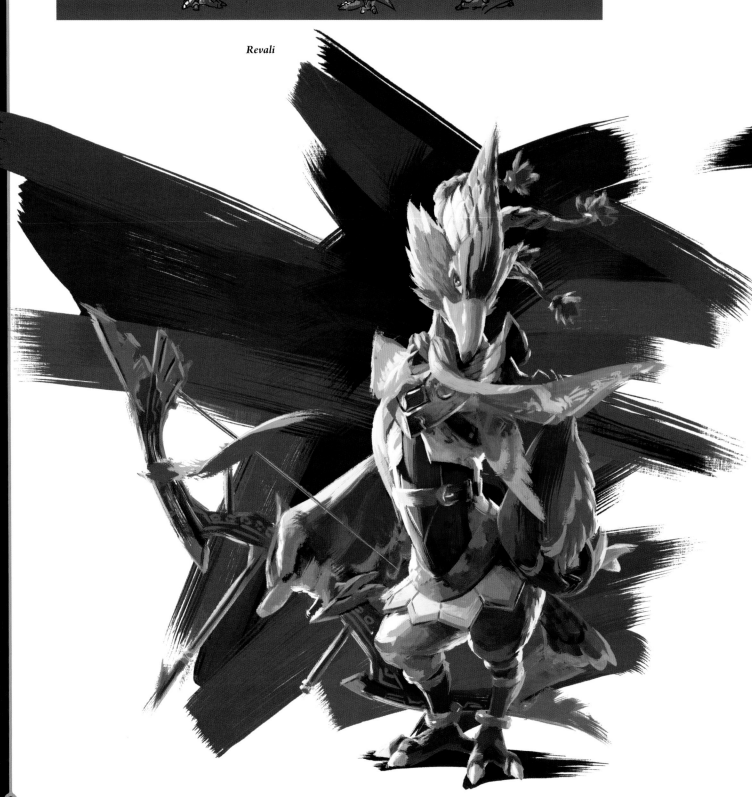

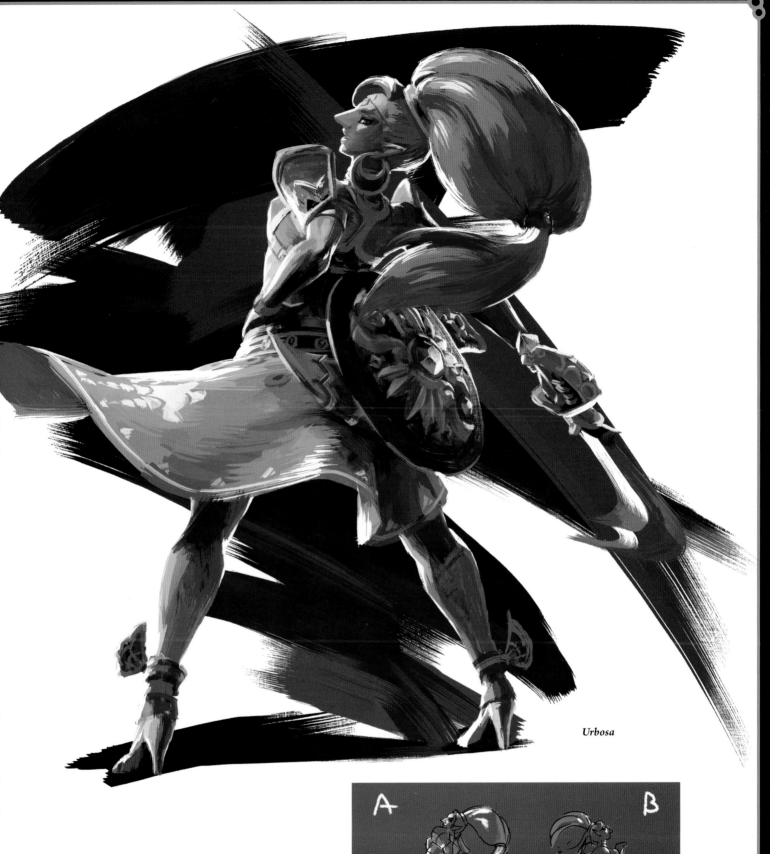

Urbosa

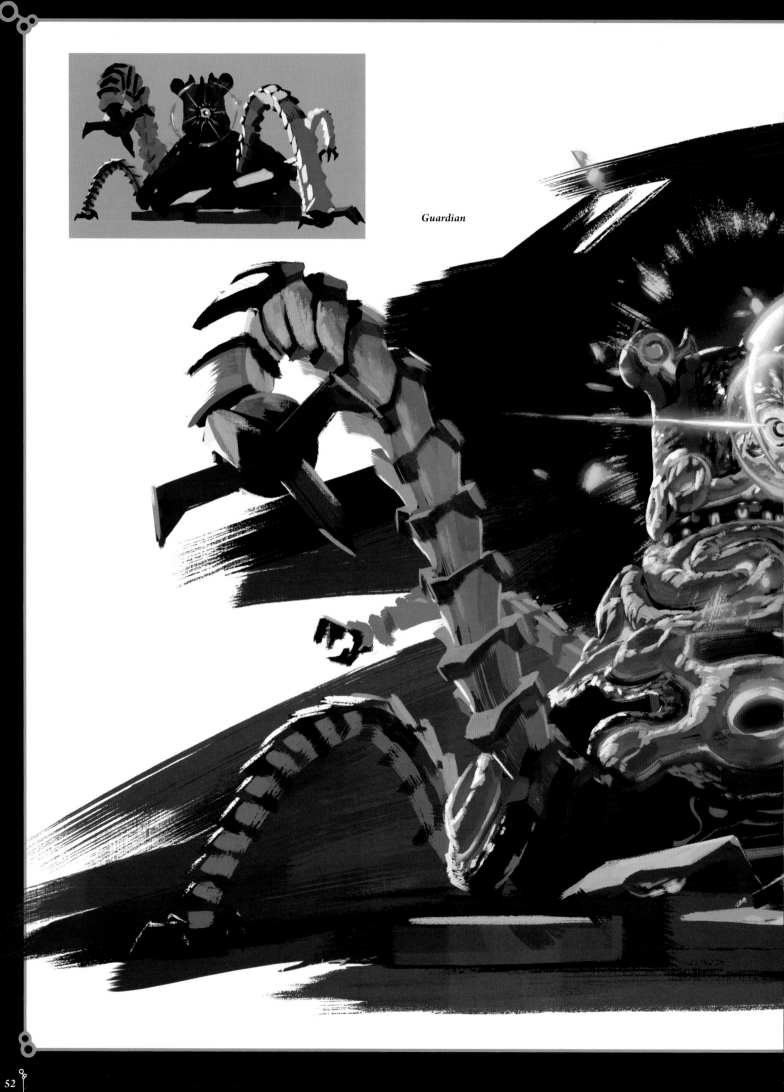

Guardian

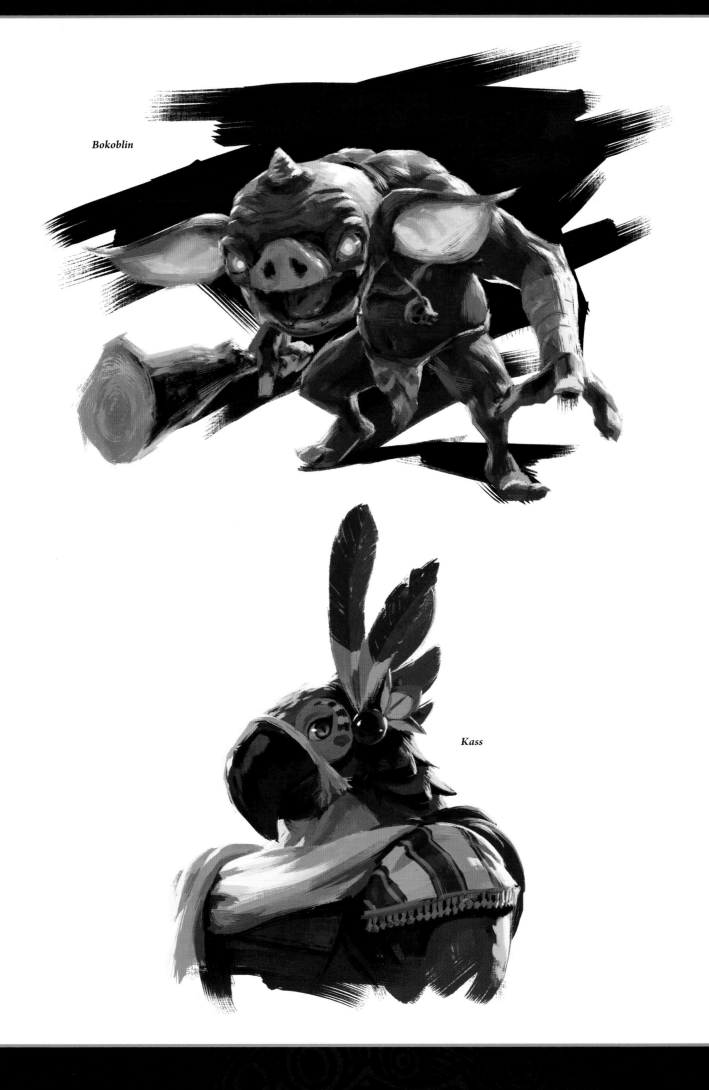

Bokoblin

Kass

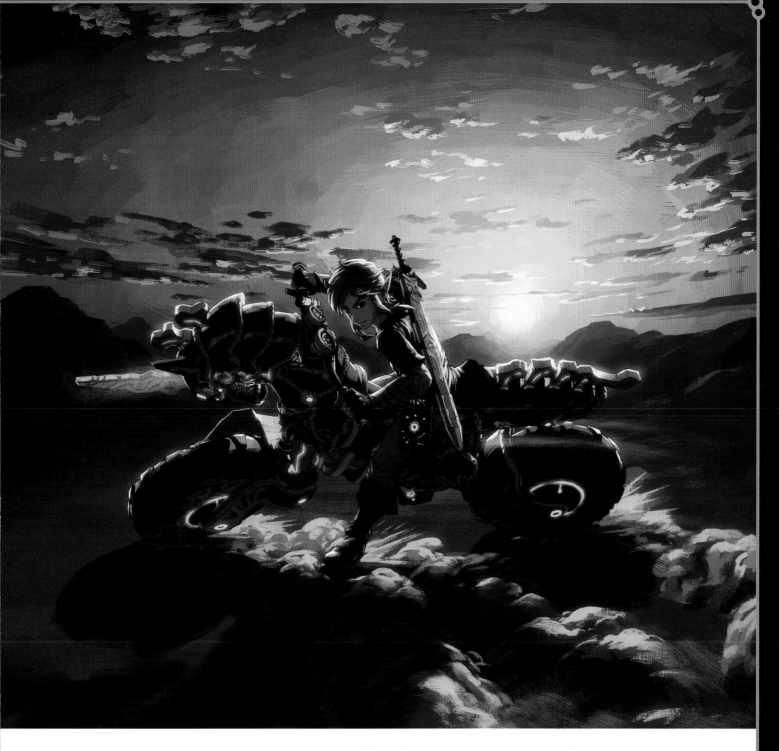

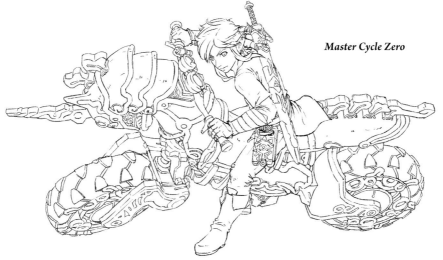

Master Cycle Zero

DEVELOPMENT

This section contains some of the many pieces of artwork created during the development process of The Legend of Zelda: Breath of the Wild. It provides a look behind the curtain at the overwhelming amount of material that was needed to build such a vast and well-realized world and gives a glimpse into the passion of its developers.

The artwork is organized by the category each piece falls under and is accompanied

LINK
THE HERO AWOKEN FROM A LONG SLUMBER

On the Great Plateau, a young man awakens from a one-hundred-year sleep having lost his memories.

Guided by a mysterious voice, he travels the vast lands of Hyrule on a mission to defeat Calamity Ganon and regain his memories.

One hundred years ago, Link served as a bodyguard for Hyrule's royal family and was the knight chosen by the sword that seals the darkness—the Master Sword. He possesses incredible athleticism and can scale cliffs with his bare hands. He's also a bit of a glutton who will eat nearly anything.

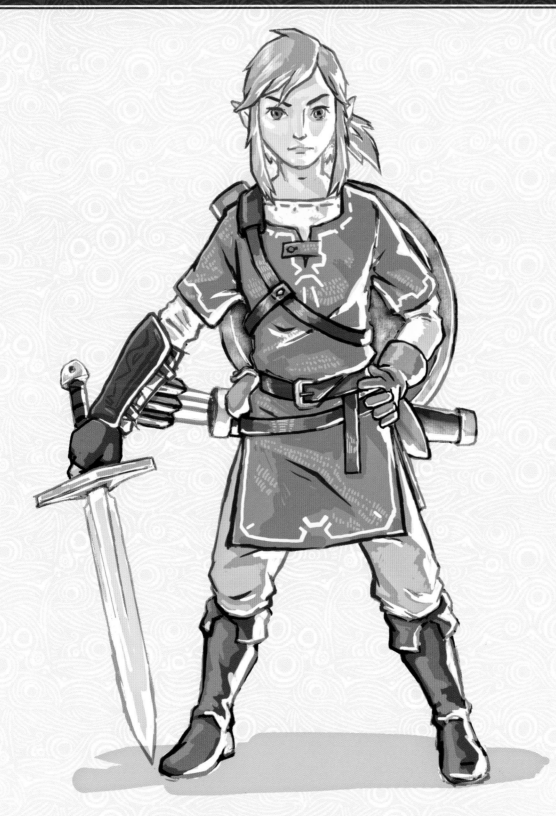

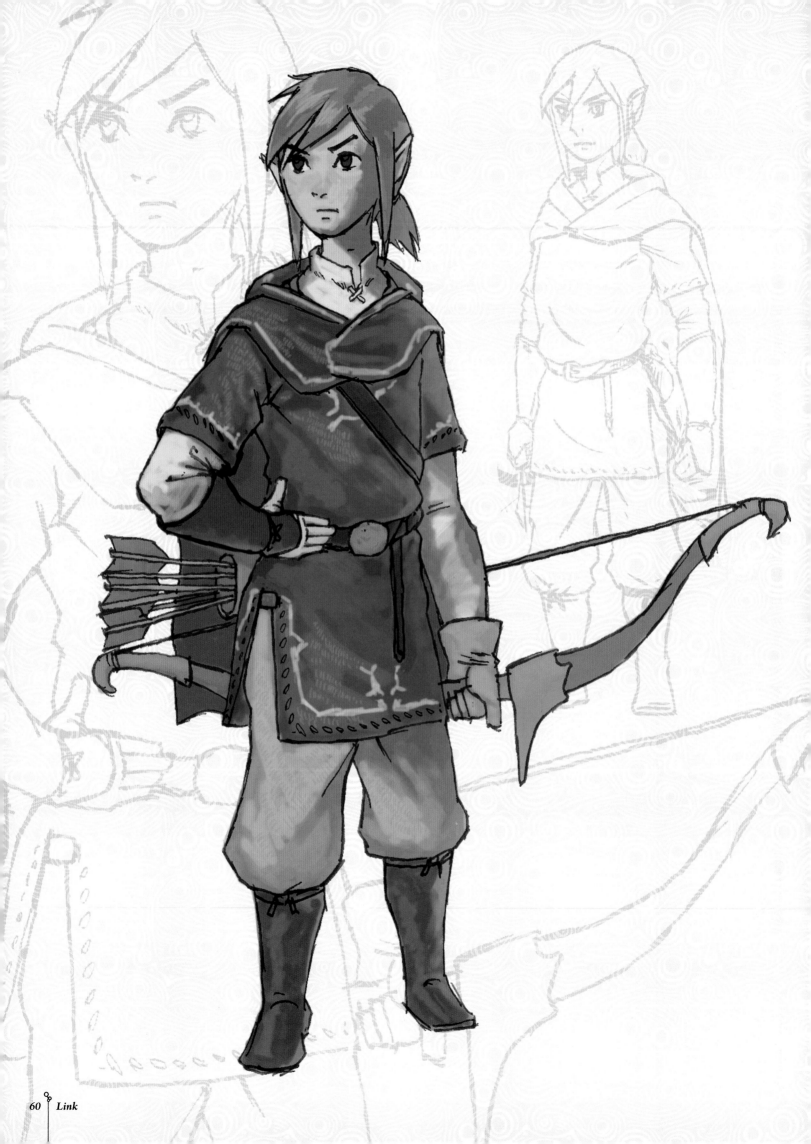

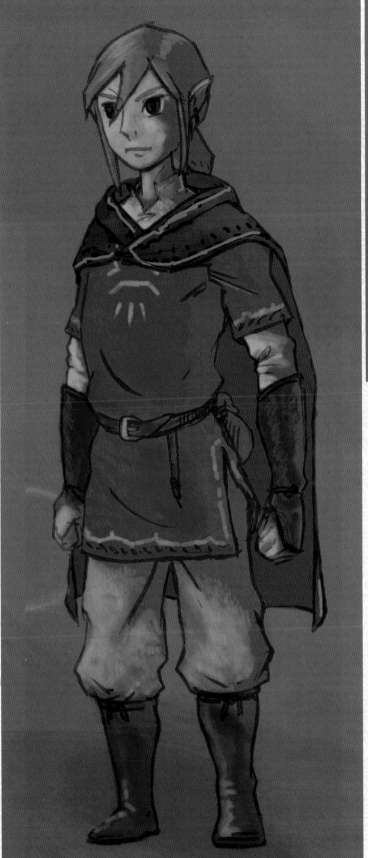

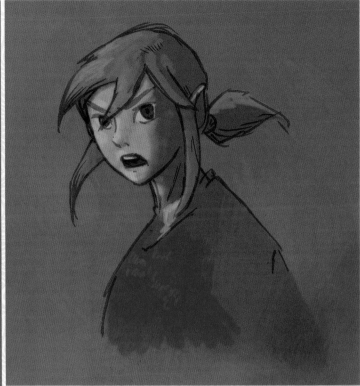

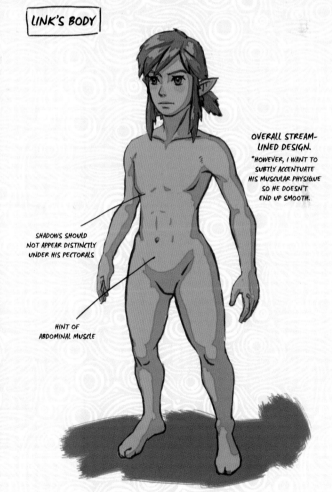

OVERALL STREAM-
LINED DESIGN.
"HOWEVER, I WANT TO
SUBTLY ACCENTUATE
HIS MUSCULAR PHYSIQUE
SO HE DOESN'T
END UP SMOOTH.

SHADOWS SHOULD
NOT APPEAR DISTINCTLY
UNDER HIS PECTORALS

HINT OF
ABDOMINAL MUSCLE

DEVELOPER'S NOTE

Link is the game's protagonist, so I've always thought we need him to look cool. Yet, if we overdo it, the people playing the game might feel like they're controlling an already accomplished hero, which I felt could get in the way of the players immersing themselves in the game. For that reason, this time I decided we should make Link a more neutral character in a variety of ways.

We thought that the iconic green tunic and hat had become expected, so we wanted to mix things up and update his look. Interestingly, though, nobody on the team said, "Let's make him blue!" It just organically ended up that way.

PRODUCER: EIJI AONUMA

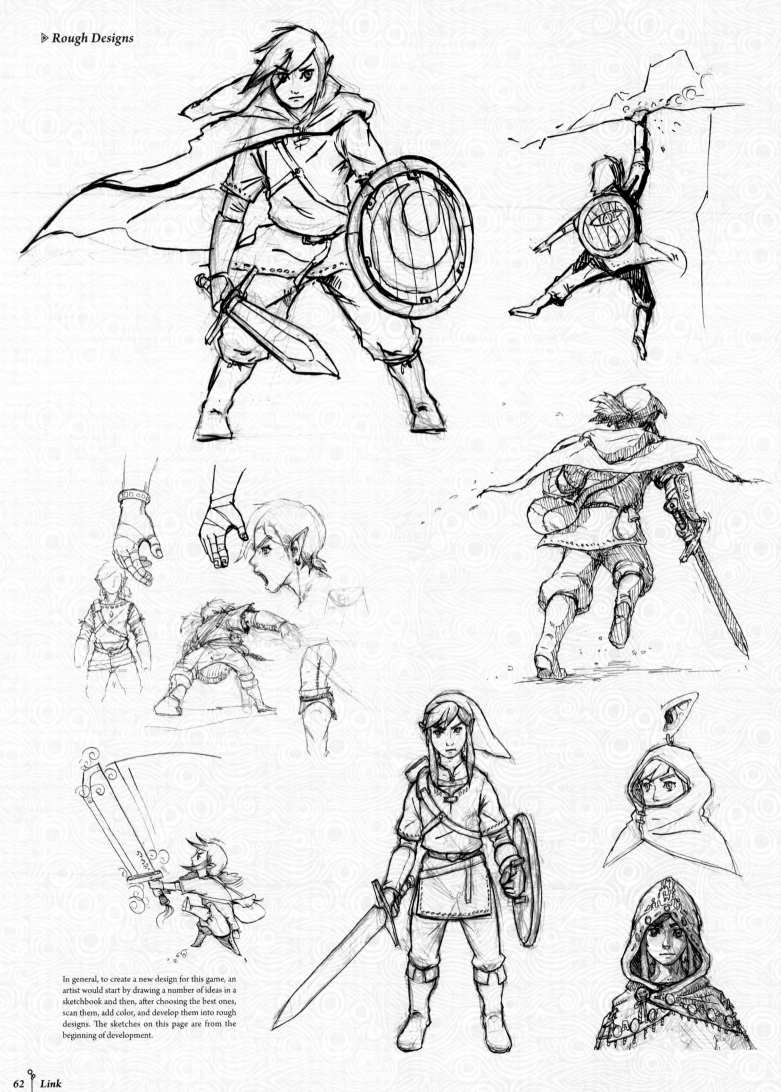

▷ Rough Designs

In general, to create a new design for this game, an artist would start by drawing a number of ideas in a sketchbook and then, after choosing the best ones, scan them, add color, and develop them into rough designs. The sketches on this page are from the beginning of development.

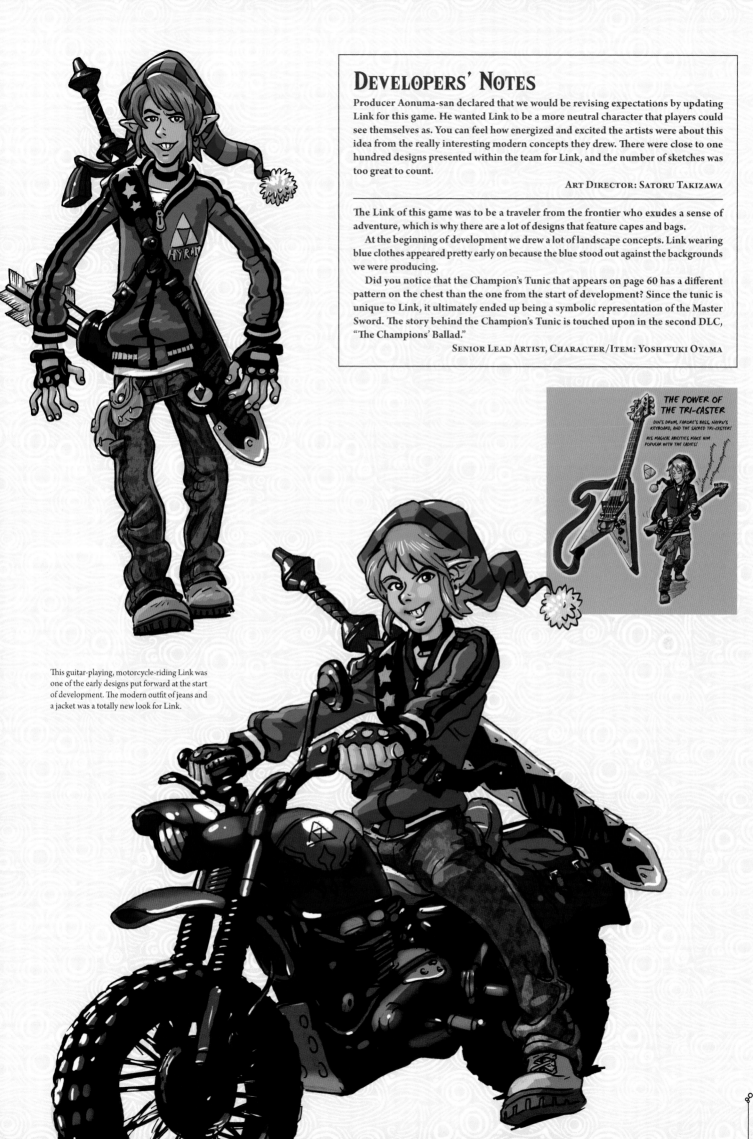

DEVELOPERS' NOTES

Producer Aonuma-san declared that we would be revising expectations by updating Link for this game. He wanted Link to be a more neutral character that players could see themselves as. You can feel how energized and excited the artists were about this idea from the really interesting modern concepts they drew. There were close to one hundred designs presented within the team for Link, and the number of sketches was too great to count.

ART DIRECTOR: SATORU TAKIZAWA

The Link of this game was to be a traveler from the frontier who exudes a sense of adventure, which is why there are a lot of designs that feature capes and bags.

At the beginning of development we drew a lot of landscape concepts. Link wearing blue clothes appeared pretty early on because the blue stood out against the backgrounds we were producing.

Did you notice that the Champion's Tunic that appears on page 60 has a different pattern on the chest than the one from the start of development? Since the tunic is unique to Link, it ultimately ended up being a symbolic representation of the Master Sword. The story behind the Champion's Tunic is touched upon in the second DLC, "The Champions' Ballad."

SENIOR LEAD ARTIST, CHARACTER/ITEM: YOSHIYUKI OYAMA

THE POWER OF THE TRI-CASTER

DIN'S DRUM, FARORE'S BASS, NAYRU'S KEYBOARD, AND THE SACRED TRI-CASTER!

HIS MAGICAL ABILITIES MAKE HIM POPULAR WITH THE LADIES!

This guitar-playing, motorcycle-riding Link was one of the early designs put forward at the start of development. The modern outfit of jeans and a jacket was a totally new look for Link.

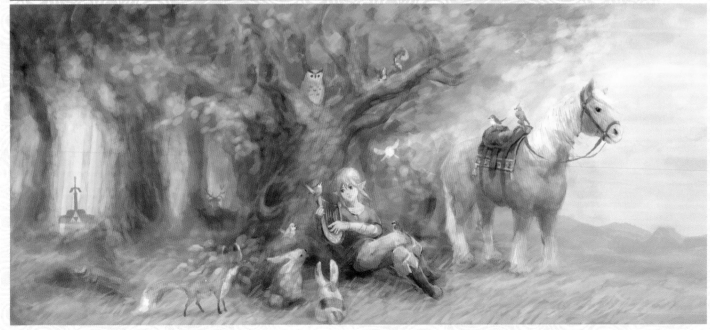

WOLF LINK (amiibo)

Wolf Link is the twilit beast form of Link from *The Legend of Zelda: Twilight Princess*. A Wolf Link amiibo was released alongside the HD rerelease of *Twilight Princess* in 2016, and if you tap the amiibo into *Breath of the Wild* he will accompany Link on his journey, search for shrines, hunt, and help fight enemies. He is invisible to ordinary folk since he is a visitor from another plane of existence.

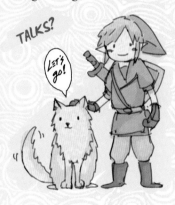

▷ *Rough Designs*

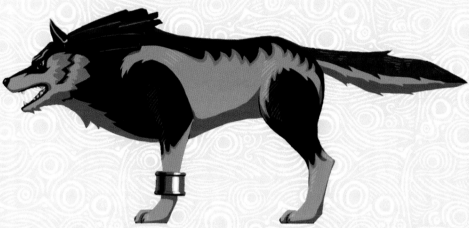

TALKS?

Let's go!

FOLLOWS

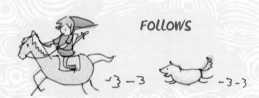

NAVIGATOR DOG
(WOLF SPIRIT?)

Grr

FIGHTS FOR YOU
BITES

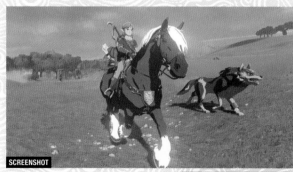

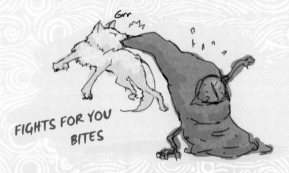

SCREENSHOT

These sketches illustrate an early idea to have a dog that would be Link's navigator companion. Wolf Link did not end up serving as a navigator, but the idea of a canine companion fighting monsters with Link came from these initial concepts.

SCREENSHOT

THE KNIGHT WHO SACRIFICED HIMSELF FOR THE PRINCESS

Born into a family of knights and chosen by the Master Sword, Link attracts the attention of others. Aware of how many people look up to him, Link understands that it is his responsibility to set a good example at all times. However, as a result, he has become unable to express himself openly, remaining silent and expressionless. He is honest, serious, and sometimes overly committed to his duties. After becoming Zelda's appointed knight, he accompanies her everywhere as she prepares herself for Calamity Ganon's return, even though she often asks him not to. Initially, she was wary of Link because he seemed inscrutable, but she came to trust him after he saved her from an attack by the Yiga Clan.

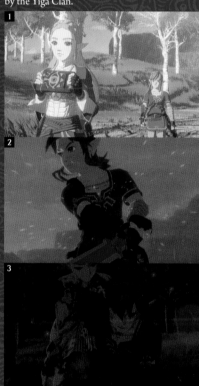

1 Link is always at Princess Zelda's side. The princess resents his presence because it is a reminder that she has not been able to unlock her own power. **2** Link, like his father before him, is a knight. On top of being capable, he is dedicated. He never skips out on training, even when it rains. **3** When Calamity strikes, Link drives back the Guardians while protecting Princess Zelda, but his strength gives out before they reach Fort Hateno.

LINK'S MEMORY LOSS AND CHANGE IN PERSONALITY

While the century-long Slumber of Restoration heals Link's wounds, it also robs him of his memories.

Link was pretty much emotionless as the chosen knight one hundred years ago, but he awakes to a time where he is relatively unknown. Only a few people who were around then are still alive. Freed from the attention and expectations of the people and without any memory of the past, this era's Link is more expressive and lighthearted than the stoic knight he was before.

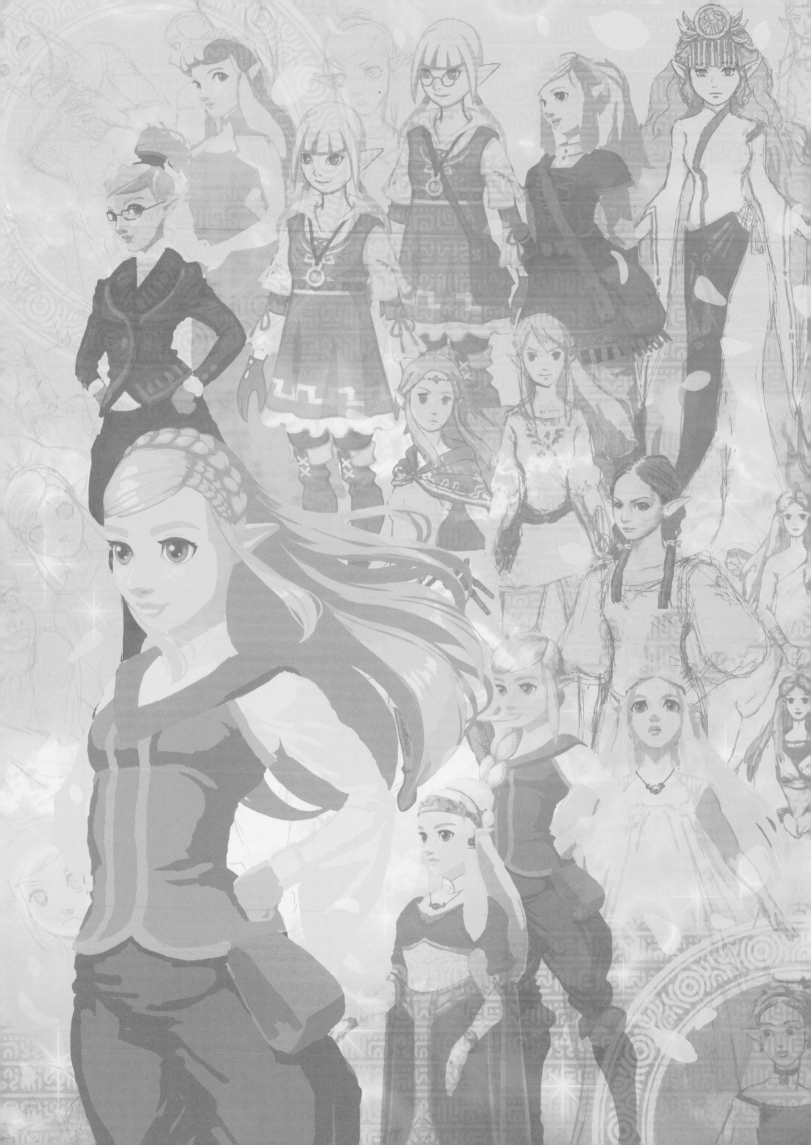

PRINCESS ZELDA
THE PRINCESS WHO SEALED CALAMITY GANON

Zelda was the princess of the kingdom of Hyrule one hundred years prior to the events of *Breath of the Wild* and inherited the blood of the Goddess Hylia from her ancestors. She is kindhearted but can be overly serious, to her own detriment.

Prior to Calamity Ganon's attack, she worried about her inability to access her sacred power. When Hyrule was destroyed in the event known as the Great Calamity, Princess Zelda's great power awoke, and she sealed Calamity Ganon in the center of the kingdom. For one hundred years, she has succeeded in containing his evil power within Hyrule Castle.

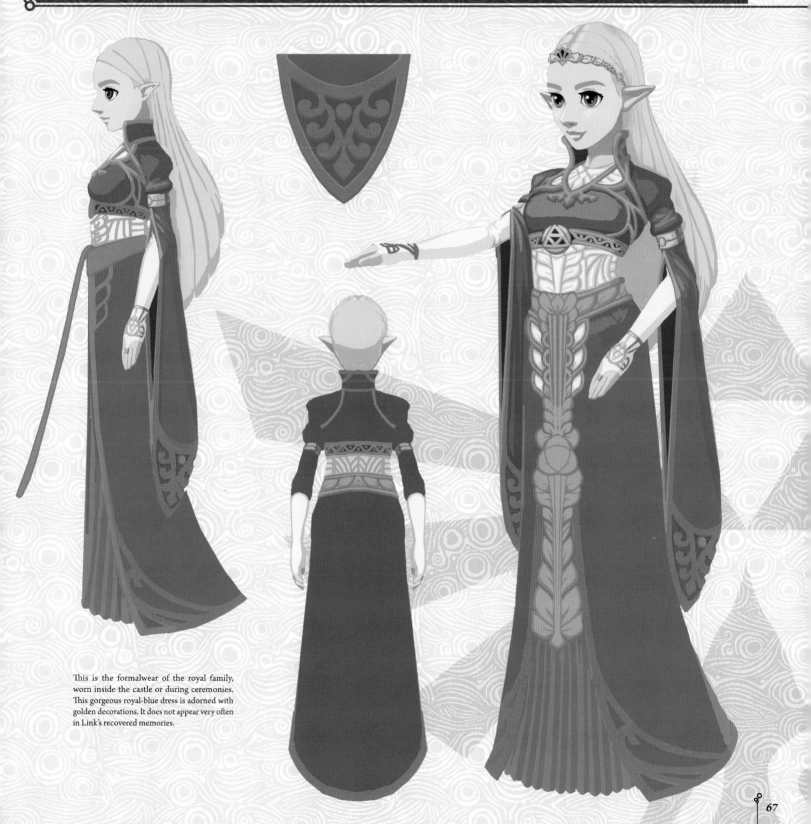

This is the formalwear of the royal family, worn inside the castle or during ceremonies. This gorgeous royal-blue dress is adorned with golden decorations. It does not appear very often in Link's recovered memories.

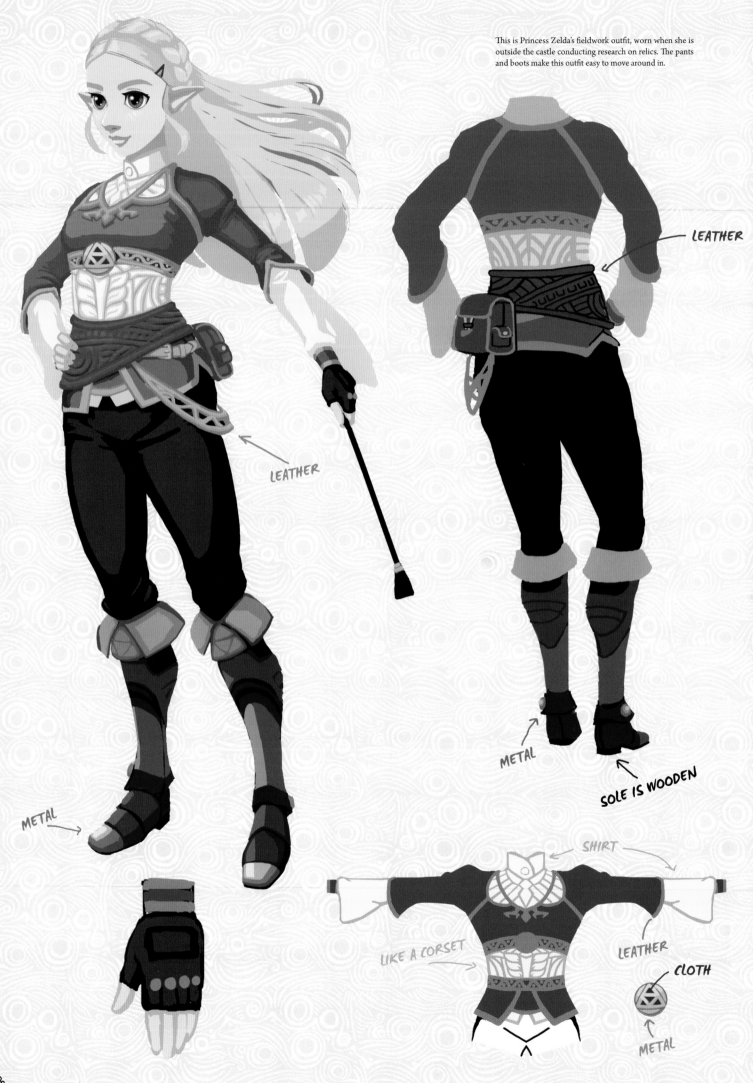

This is Princess Zelda's fieldwork outfit, worn when she is outside the castle conducting research on relics. The pants and boots make this outfit easy to move around in.

LEATHER

LEATHER

METAL

METAL

SOLE IS WOODEN

SHIRT

LIKE A CORSET

LEATHER

CLOTH

METAL

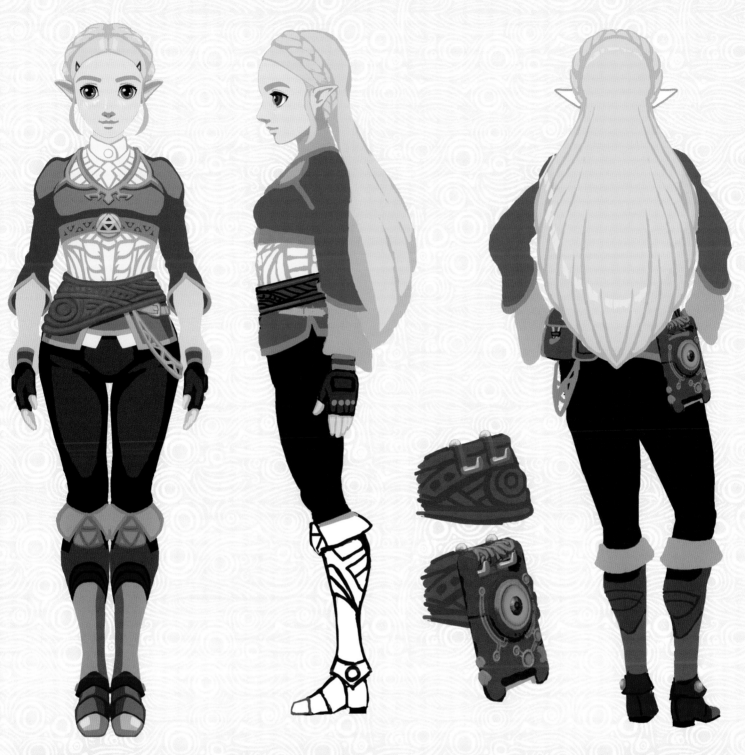

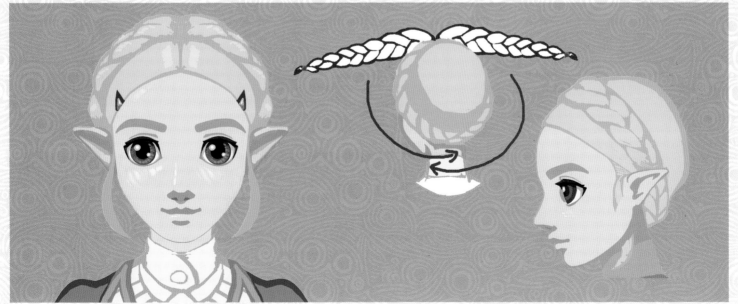

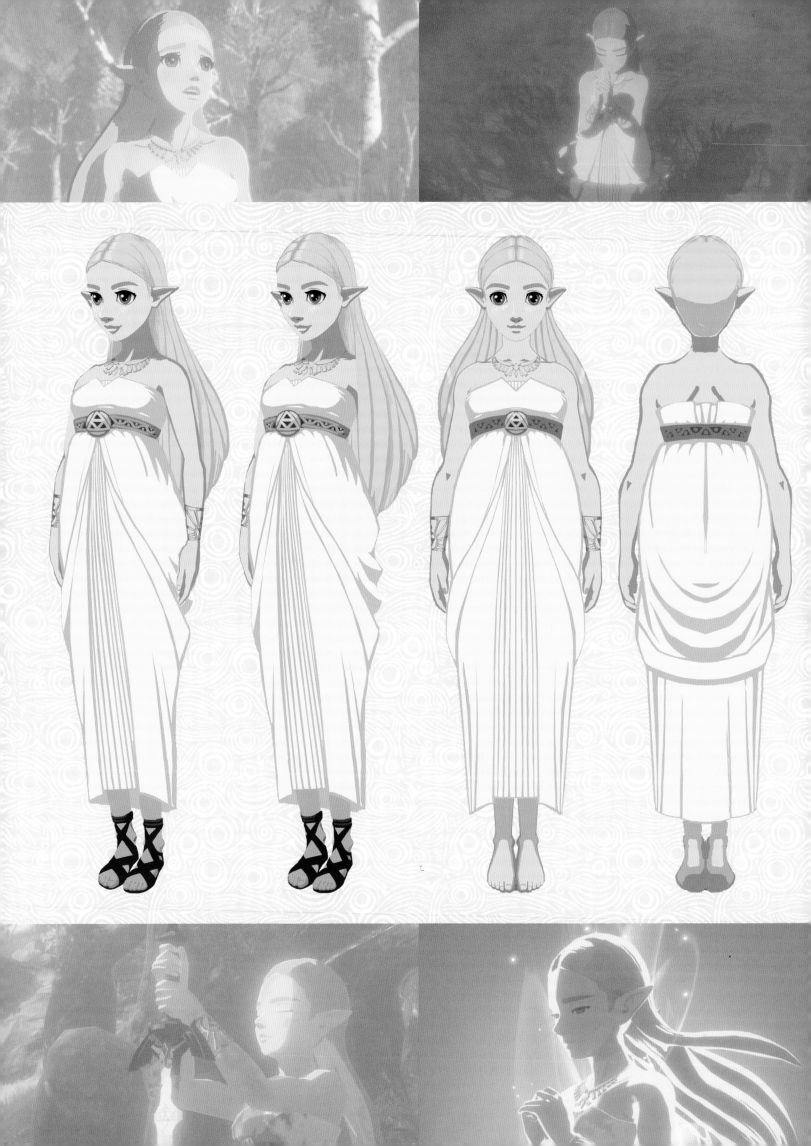

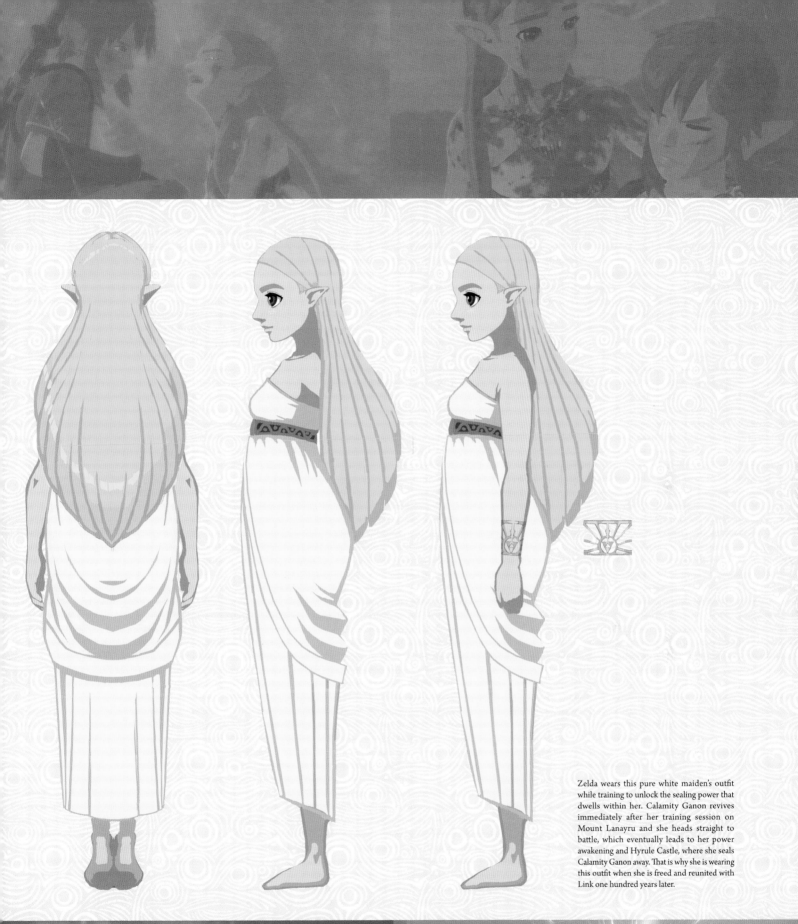

Zelda wears this pure white maiden's outfit while training to unlock the sealing power that dwells within her. Calamity Ganon revives immediately after her training session on Mount Lanayru and she heads straight to battle, which eventually leads to her power awakening and Hyrule Castle, where she seals Calamity Ganon away. That is why she is wearing this outfit when she is freed and reunited with Link one hundred years later.

DEVELOPERS' NOTES

The reason the memory fragments show Princess Zelda's thoughts and struggles is because I wanted players to be curious about her, be invested in her well-being, and want to save her. The story goes that she is a princess who cannot use the sacred sealing power within her, and that came from the idea that Zelda and the hero were defeated one hundred years prior. I think the reason this story carries so much weight is because the series has so many earlier titles that set the stage for this one.

CINEMATIC DESIGN: NAOKI MORI

I placed more emphasis on the fact that Zelda is a real girl who we can empathize with than the fact that she's a princess. I wanted to show that she is a sensitive person and at an age where she is struggling to find her place. I aimed for three outfit designs that Zelda would choose for herself based on the time, place, and occasion.

LEAD ARTIST, NPCs: HIROHITO SHINODA

▷ Rough Designs

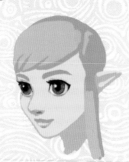

"I thought I made it clear that I am not in need of an escort. I, the person in question, am fine, regardless of the king's orders. Return to the castle."

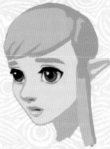

"If that was the only thing that you were ever told, I wonder then, would you have chosen a different path?"

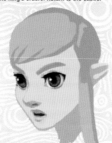

"And should Ganon ever show itself again, we'll be well positioned to defend ourselves."

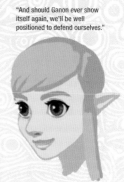

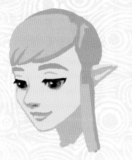

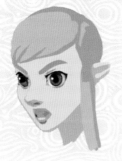

"But I don't hear . . . or feel anything!"

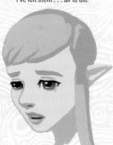

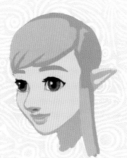

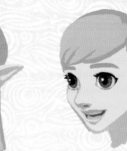

"So I really am just a failure!"

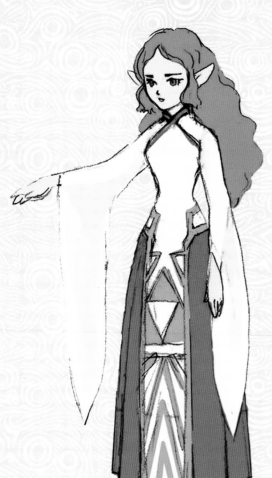

"I've left them . . . all to die."

Even though Zelda is a sacred princess, it was important that her expressions convey that she has human weaknesses and is a character with great emotional depth. There are many images of her facial expressions that were referenced when creating the cinematic cutscenes.

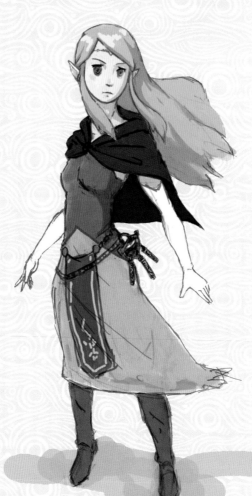

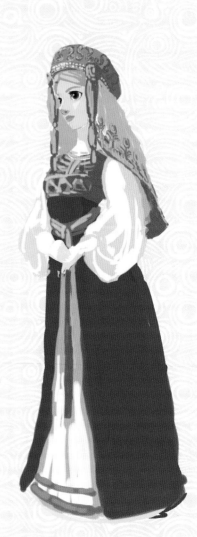

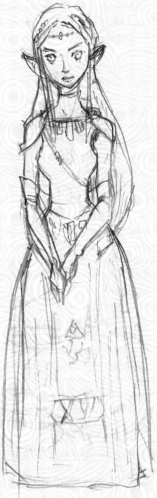

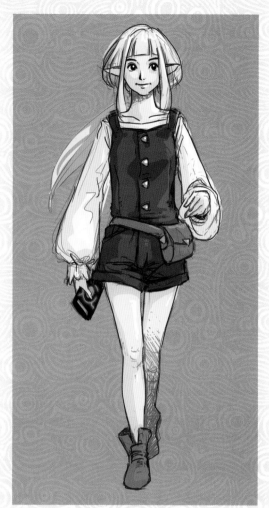

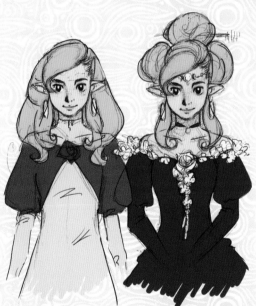

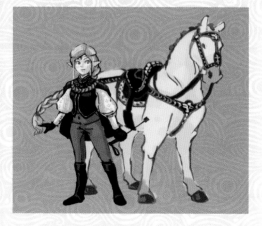

BACKGROUND
Princess Zelda

PRINCESS ZELDA'S ROYAL WHITE STALLION

Princess Zelda traveled all across Hyrule in her quest for knowledge, exploring relics and training for the inevitable return of Calamity Ganon, accompanied by her beloved horse whose white hair made it a rarity in Hyrule. Horses of a single color are exceptionally capable, but have poor temperaments, which makes bonding with the rider difficult. Princess Zelda struggled with her mount at first, but, with Link's coaching, she succeeded in forming an inseparable bond with her horse.

One of these rare stallions is seen one hundred years after the fall of the kingdom of Hyrule around the Sanidin Park Ruins in Central Hyrule. The owner of the nearby Outskirt Stable theorizes that the white horse is a descendant of Princess Zelda's stallion.

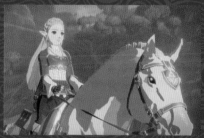

Princess Zelda's horse's saddle is adorned with the crest of the royal family. The Royal Saddle has been passed down among the owners of the Outskirt Stable.

A SACRED BUT HUMAN PRINCESS

Princess Zelda doesn't let royal propriety get in the way of her research. She is a determined young woman who is not afraid to voice her opinion and take action.

She agonizes over the fact that the sacred power that manifests in the women of the royal bloodline has not yet awakened in her, and she often takes out her frustration on Link. Though, according to Kass, a student of the court poet who was close to Princess Zelda, her initial standoffishness gave way to trust, which led to a feeling of affection, showing that underneath her royal image Zelda is also a young woman.

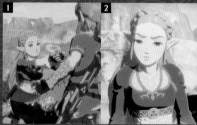

1 Zelda's curiosity makes her light on her feet. She captures an elusive hot-footed frog said to enhance certain abilities if eaten. Link is unsure about this experiment. **2** Zelda told Link not to accompany her, but he followed her anyway. Zelda voices her displeasure.

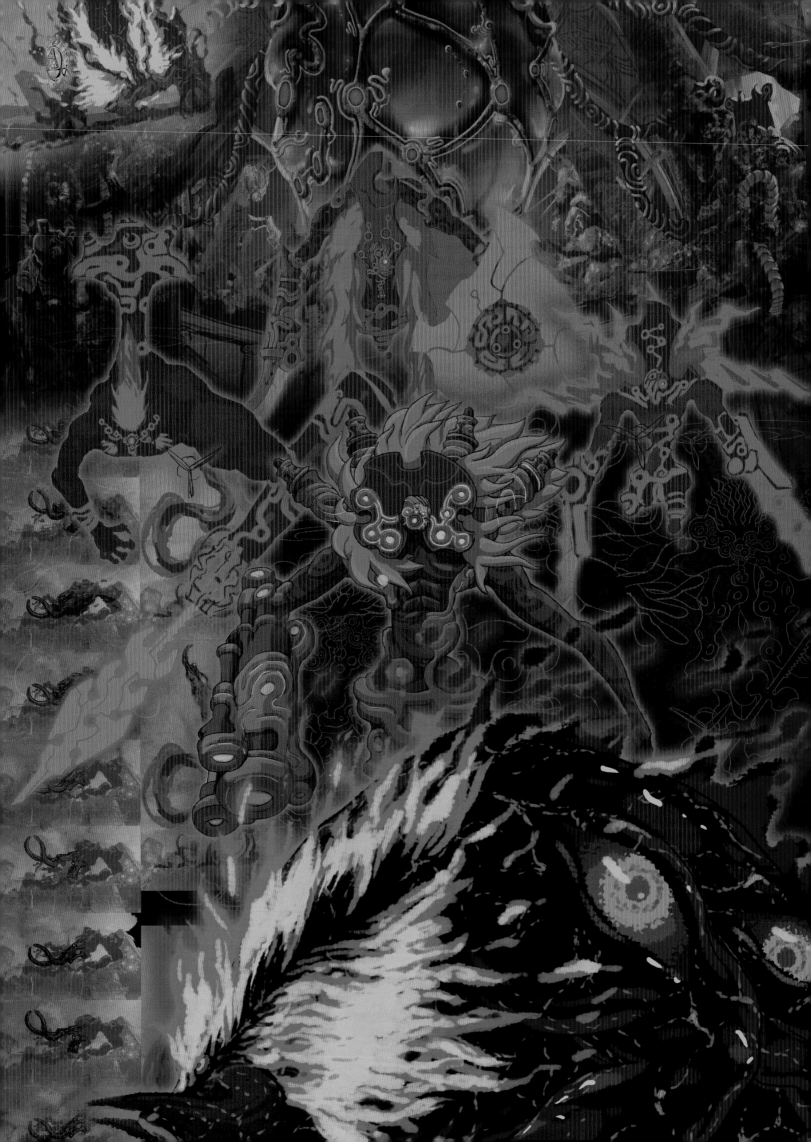

GANON
A CALAMITY ENVELOPED IN MALICE

Ganon is the incarnation of hatred and malice that has brought pain and suffering to Hyrule countless times. Ten thousand years in the past, the hero and the princess, with the help of the technological prowess of the Sheikah, sealed it away, but one hundred years ago it returned, as it always does, and brought the people of Hyrule to the brink of annihilation. Through strength of will, Princess Zelda has contained its evil power within Hyrule Castle for one hundred years.

CALAMITY GANON (MALICE)

This is the form Ganon has taken since Princess Zelda contained its power within Hyrule Castle. Calamity Ganon's corporeal form is sealed inside, but its evil is so strong that it has manifested a spirit body formed of coalesced malice and hatred that writhes around the castle. Though it has no physical presence, this awful sight reveals just how potent Ganon's evil really is.

▷ *Rough Designs*

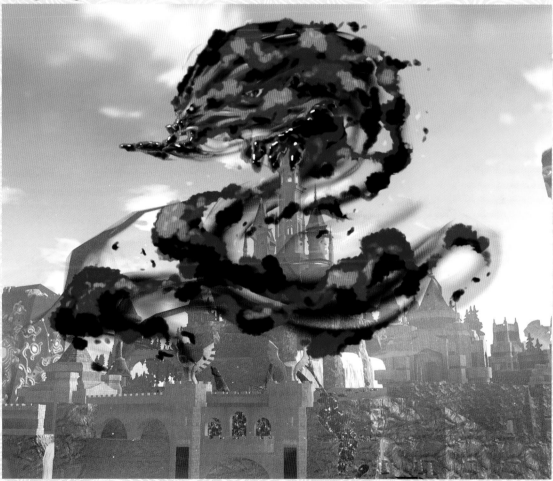

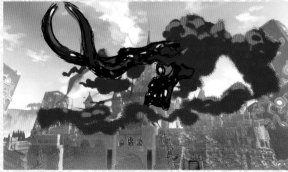
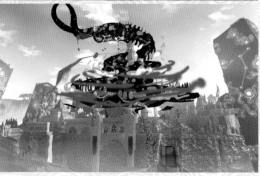

CALAMITY GANON

Calamity Ganon's physical body is sealed away inside of Hyrule Castle. Princess Zelda's weakening powers and the hero's awakening have served as a catalyst for Ganon's revival. When Calamity Ganon finally breaks Zelda's seal, its form is incomplete. It resembles an enormous spider equipped with a variety of weapons. It has absorbed the ancient Sheikah relics used to attack it one hundred years ago, and utilizes a beam attack that is not unlike a Guardian's laser.

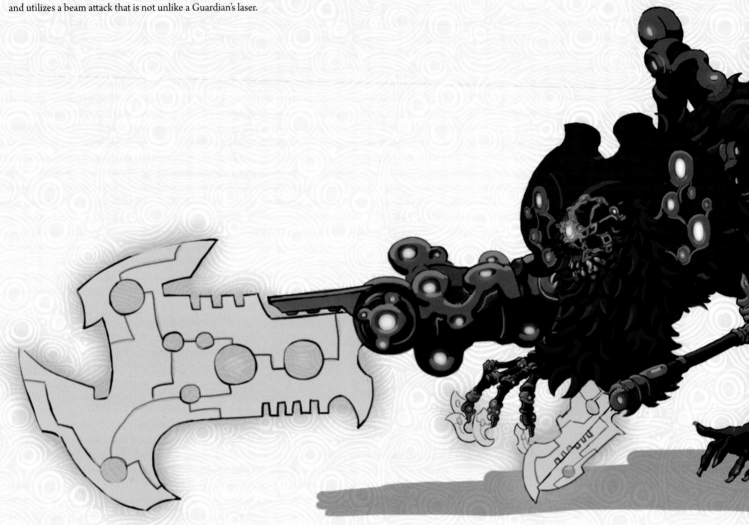

▷ *Rough Designs*

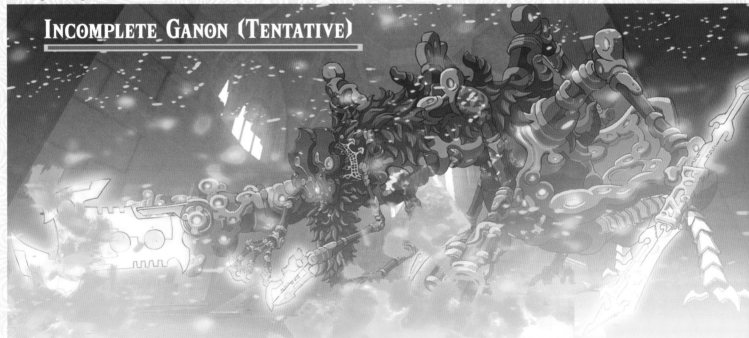

INCOMPLETE GANON (TENTATIVE)

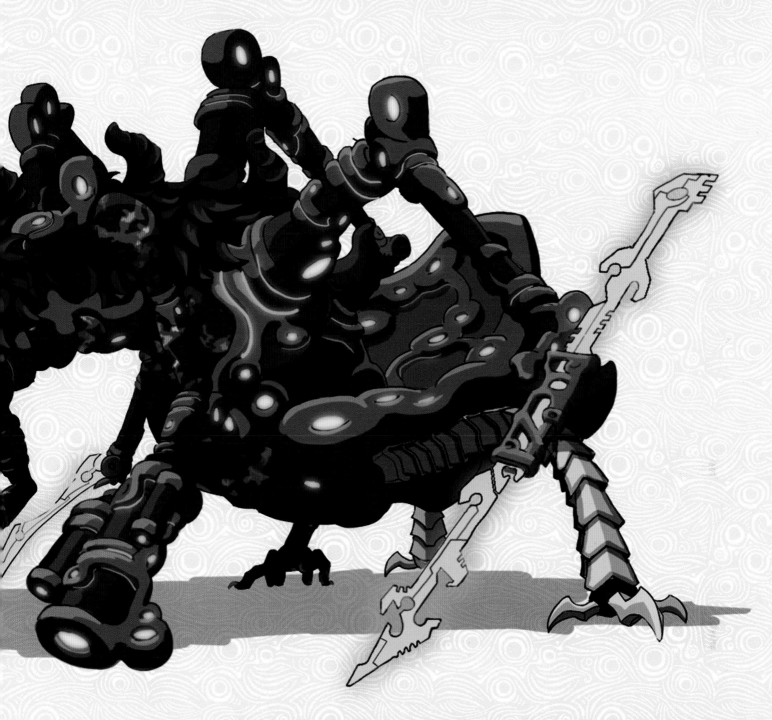

GANON'S COCOON

Princess Zelda sealed Calamity Ganon in this pupal state one hundred years ago, right before its revival. It has remained dormant ever since. Ganon's Cocoon rests in the audience chamber of the Sanctum of Hyrule Castle. It has waited on the cusp of revival for a century.

GANON'S COCOON

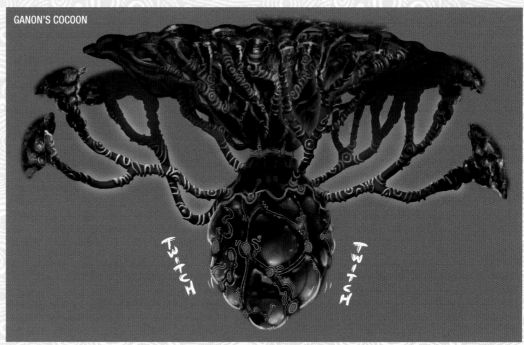

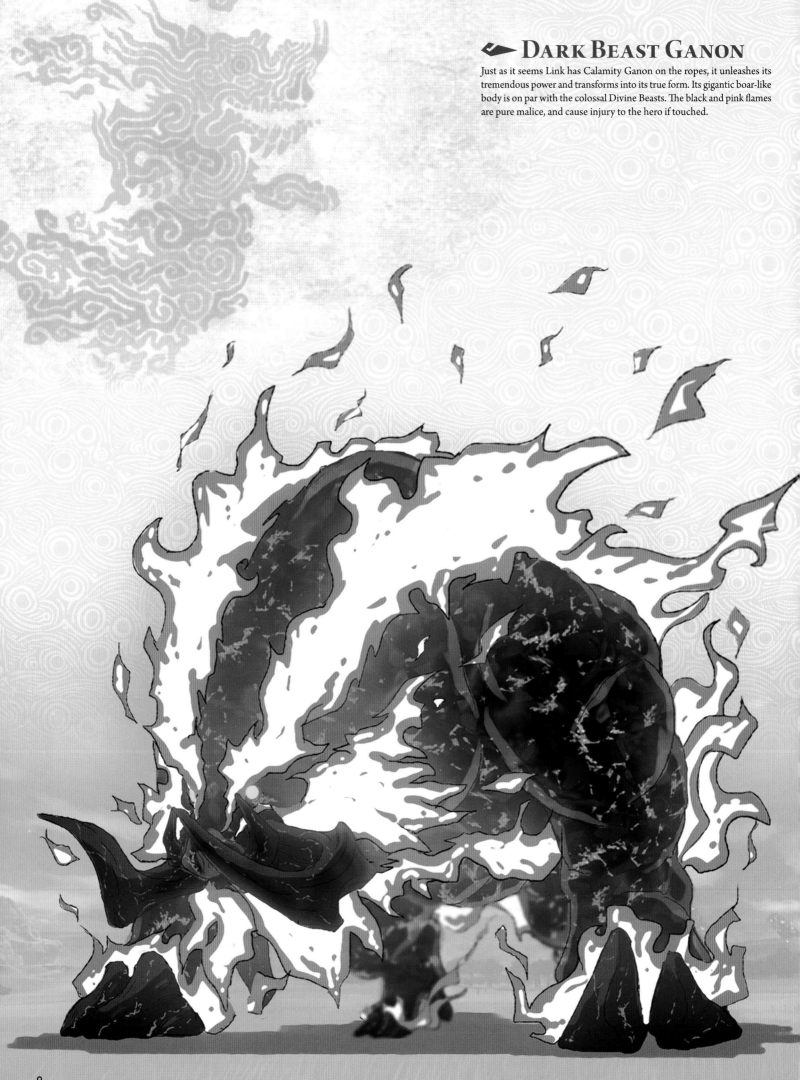

DARK BEAST GANON

Just as it seems Link has Calamity Ganon on the ropes, it unleashes its tremendous power and transforms into its true form. Its gigantic boar-like body is on par with the colossal Divine Beasts. The black and pink flames are pure malice, and cause injury to the hero if touched.

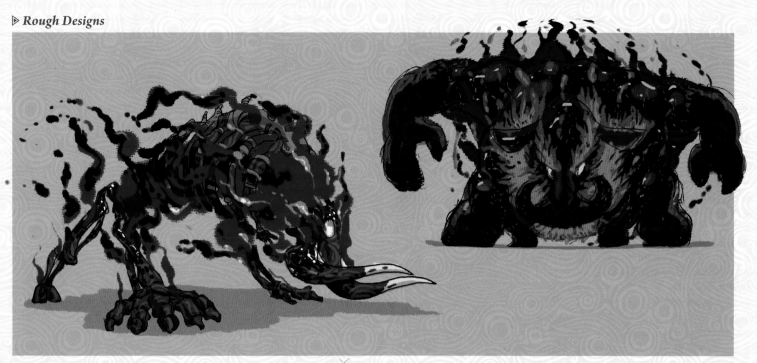

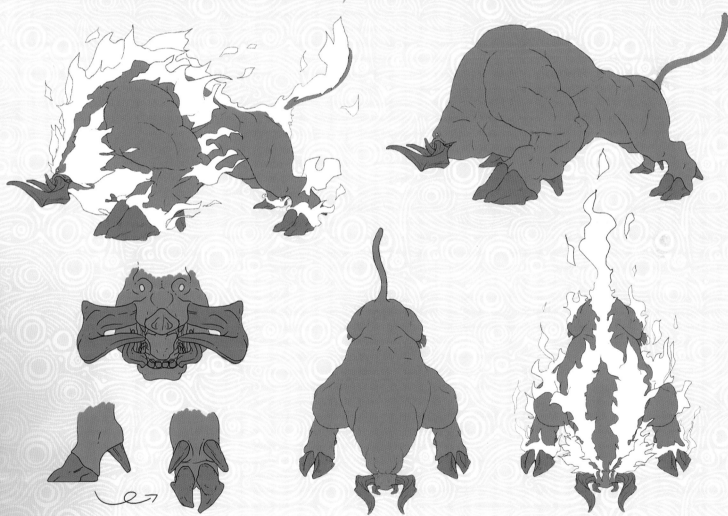

DEVELOPER'S NOTE

When Link first battles Calamity Ganon, it's in an incomplete state. It could not fully revive because Princess Zelda has been actively suppressing its power. However, when Link gains the upper hand in their battle, it loses its tenuous control of the pure malice within and transforms into a raging beast. The pink and purple tar-like malice that appears all over Hyrule was designed first, and, based on that idea, I decided to make Ganon's entire body into a monster made of hatred and malice incarnate. Dark Beast Ganon takes the shape of a boar like the Ganons of prior games but ended up being very large compared to Link since we wanted the game to end in the vast open plain of Hyrule Field. This might be the biggest Ganon in the history of the series.

ENEMY ARTIST: YUKI HAMADA

PHANTOM GANONS

Phantoms created by Ganon one hundred years in the past that entered the four Divine Beasts and killed their Champion pilots. They all have fiery red hair and have absorbed ancient weapons.

▷ *Fireblight Ganon*

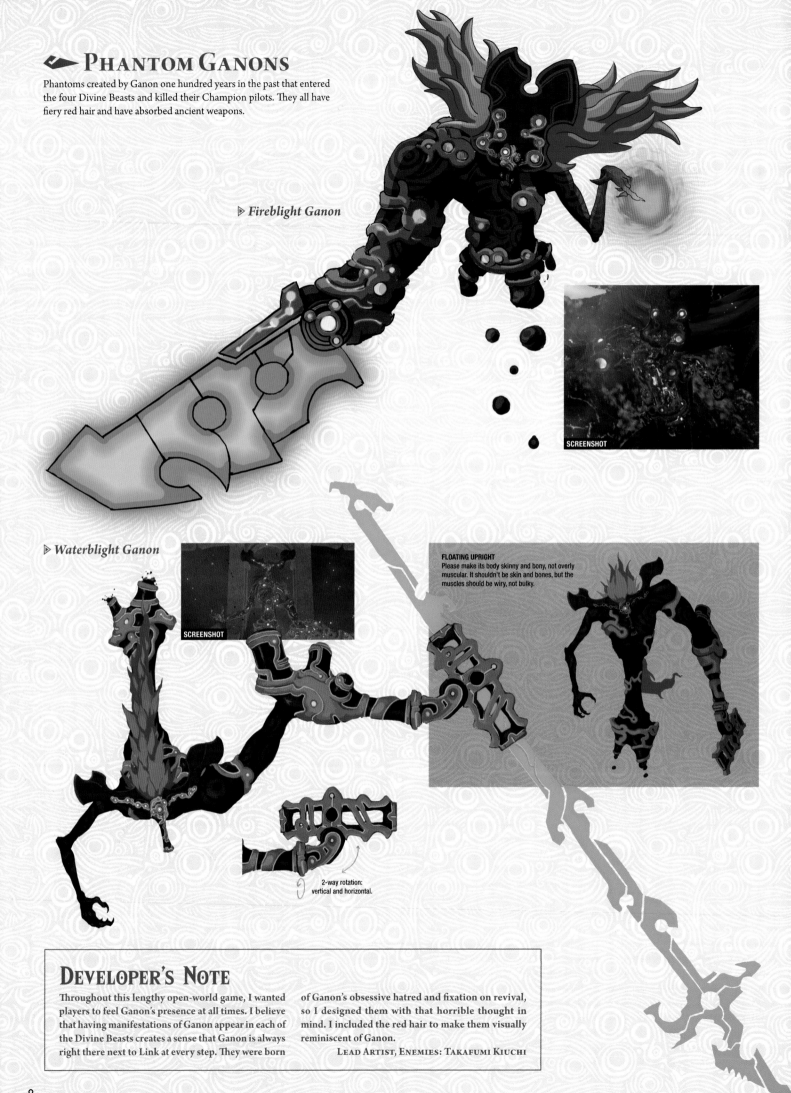

SCREENSHOT

▷ *Waterblight Ganon*

SCREENSHOT

FLOATING UPRIGHT
Please make its body skinny and bony, not overly muscular. It shouldn't be skin and bones, but the muscles should be wiry, not bulky.

2-way rotation:
vertical and horizontal.

DEVELOPER'S NOTE

Throughout this lengthy open-world game, I wanted players to feel Ganon's presence at all times. I believe that having manifestations of Ganon appear in each of the Divine Beasts creates a sense that Ganon is always right there next to Link at every step. They were born of Ganon's obsessive hatred and fixation on revival, so I designed them with that horrible thought in mind. I included the red hair to make them visually reminiscent of Ganon.

LEAD ARTIST, ENEMIES: TAKAFUMI KIUCHI

▷ *Windblight Ganon*

SCREENSHOT

OPENS

▷ *Thunderblight Ganon*

SCREENSHOT

The base of the shield is like a spherical joint and the wrist portion can move.

ABERRANT PHANTOMS BORN OF GANON'S OBSESSION

Legend has it that Ganon was once a Gerudo born in the distant past. Even if he was once a man, the only way to describe his current form is as a calamity.

Calamity Ganon takes on the twisted forms of beasts like spiders and boars, but the four manifestations of Ganon more closely resemble a distorted Hylian form. Both Calamity Ganon and his phantoms have fiery red hair similar to the Gerudo, which may hint to some truth to the legend.

GANON SUBVERTS ANCIENT TECHNOLOGY

The ancient Sheikah technology was meant to fight Calamity Ganon, but he has taken control of it and twisted it to his purpose instead.

The Phantom Ganons that entered the four Divine Beasts take on the abilities of those beasts. Waterblight Ganon takes in Ruta's power, firing chunks of ice at its foes, while Windblight Ganon uses Medoh to produce tornadoes. Calamity Ganon possesses all of the powers of the Phantom Ganons, but has also taken control of the Guardians. Its hind legs were even absorbed from one.

1 2 The manifestations of Ganon absorb the abilities of the Divine Beasts, and use them to attack Link. Each one uses a different weapon appropriated from ancient Sheikah technology. **3** Calamity Ganon can use the same attacks as the Phantom Ganons because they are extensions of it, and it absorbs the powers of the Divine Beasts through them.

THE CHAMPIONS
HYRULEAN COMPANIONS IN COMBAT

One hundred years ago, King Rhoam selected elite warriors from throughout Hyrule to stand against Calamity Ganon. In addition to the sacred princess and the Hylian chosen by the Master Sword, one fighter with unique abilities was chosen from each of the Hyrulean races.

In this section, we take a look at the development of the four Champions who were chosen to pilot the Divine Beasts.

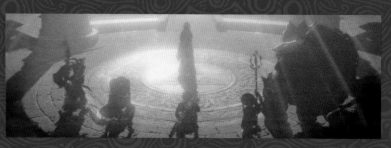

▷ **Rough Designs**

These are concept sketches of the Champions from the beginning of development. The rough character designs were created by imagining a common person from each of the races who would become the foundation of that race. As you can see at the bottom, in place of a Rito Champion, there is a character who resembles a Kokiri from *Ocarina of Time*.

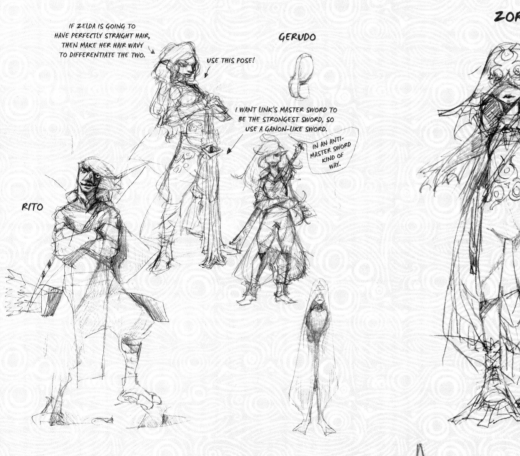

IF ZELDA IS GOING TO HAVE PERFECTLY STRAIGHT HAIR, THEN MAKE HER HAIR WAVY TO DIFFERENTIATE THE TWO.

USE THIS POSE!

GERUDO

I WANT LINK'S MASTER SWORD TO BE THE STRONGEST SWORD, SO USE A GANON-LIKE SWORD.

IN AN ANTI-MASTER SWORD KIND OF WAY.

RITO

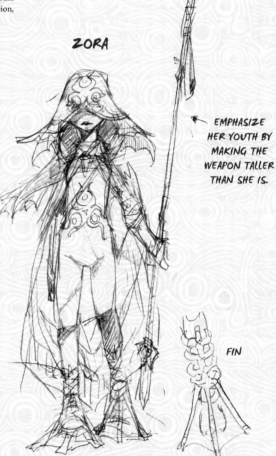

ZORA

EMPHASIZE HER YOUTH BY MAKING THE WEAPON TALLER THAN SHE IS.

FIN

SHORT SWORD

GREAT SWORD

SPEAR

WHIP

SOMETHING HOOKSHOT-LIKE

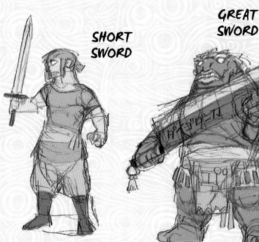

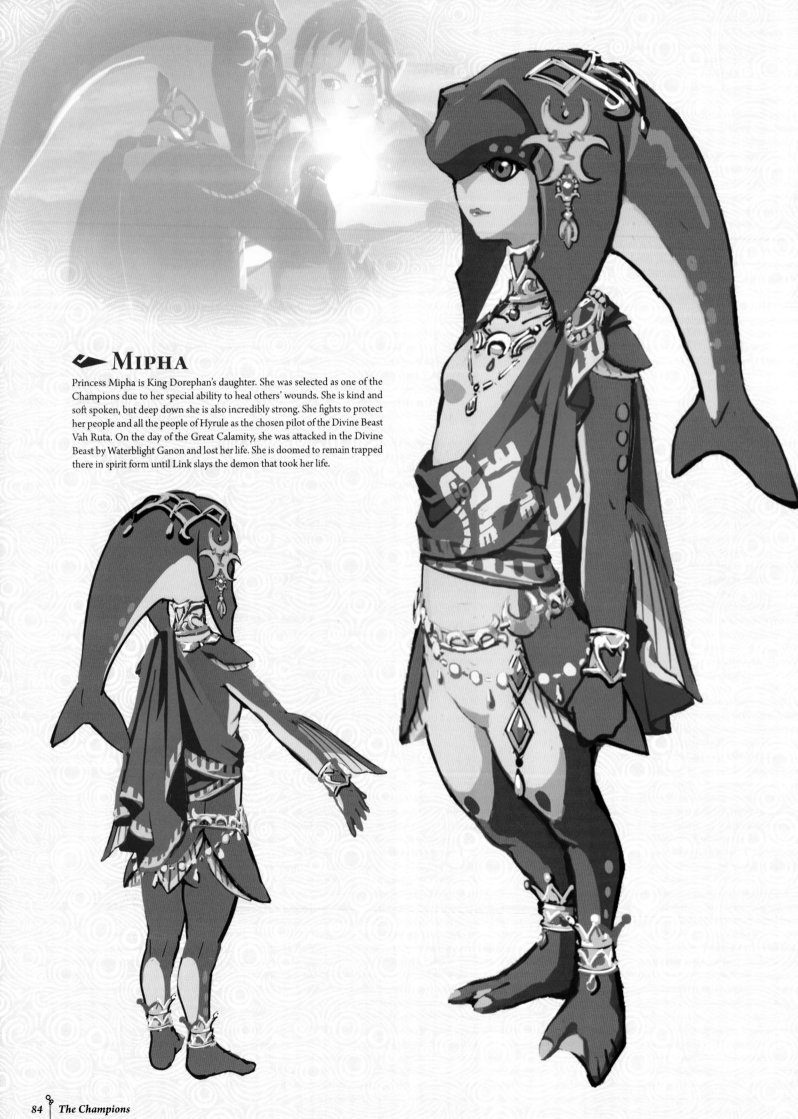

Mipha

Princess Mipha is King Dorephan's daughter. She was selected as one of the Champions due to her special ability to heal others' wounds. She is kind and soft spoken, but deep down she is also incredibly strong. She fights to protect her people and all the people of Hyrule as the chosen pilot of the Divine Beast Vah Ruta. On the day of the Great Calamity, she was attacked in the Divine Beast by Waterblight Ganon and lost her life. She is doomed to remain trapped there in spirit form until Link slays the demon that took her life.

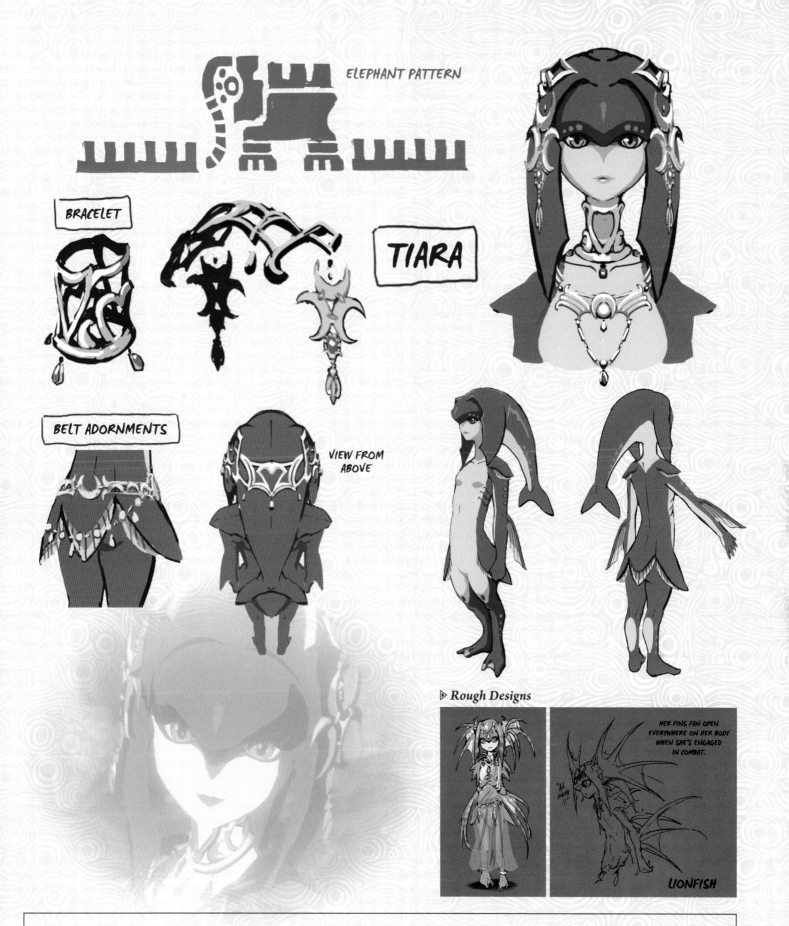

ELEPHANT PATTERN

BRACELET

TIARA

BELT ADORNMENTS

VIEW FROM ABOVE

▷ *Rough Designs*

HER FINS FAN OPEN EVERYWHERE ON HER BODY WHEN SHE'S ENGAGED IN COMBAT.

LIONFISH

DEVELOPERS' NOTES

I wanted Mipha to be a female character with a different relationship with Link than Princess Zelda. She is the complete opposite of the princess, who cannot use her sealing power. The fact that she and Link have a past informs her character. She's known him since childhood, and, as a result, their relationship ended up being almost too intense. I tried to balance things by making her into a quieter person. The Zora are longer-lived than the Hylians, so I intended the reversal of the perceived age gap between her and Link to feel very emotional.

CINEMATIC DESIGN: NAOKI MORI

I ended up using a dolphin as the inspiration for Mipha's design, but I also considered several other ideas, including using an oarfish or a rockfish as a motif. Her outfit incorporates the delicate design of the Zora in her accessories, as well as an ephemeral feeling that reflects Mipha's personality.

LEAD ARTIST, NPCs: HIROHITO SHINODA

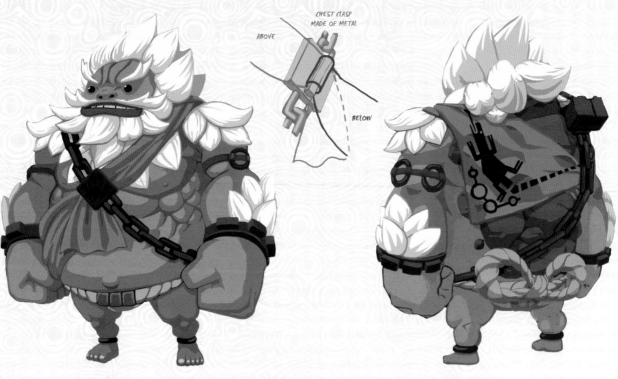

CHEST CLASP
MADE OF METAL

ABOVE

BELOW

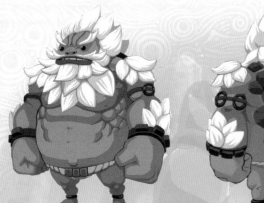

DARUK

Daruk has the special ability to create a force field around himself to defend against all manner of attacks. Because of this power, he was selected to be a Champion. Though he may appear gruff, he is tremendously kind. He fondly calls Link "little guy" while also acknowledging his unparalleled skills. Daruk was chosen to pilot the Divine Beast Vah Rudania, but, before he could bring the beast's power to bear on Calamity Ganon, he was attacked by Fireblight Ganon and killed—his spirit sealed within Vah Rudania.

▷ *Rough Designs*

A.

MAGMA FLOWS THROUGH HIM.

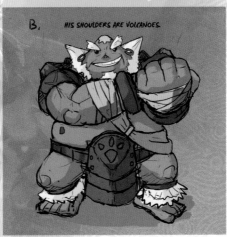

B. HIS SHOULDERS ARE VOLCANOES.

DEVELOPERS' NOTES

Daruk is reminiscent of Darunia from *Ocarina of Time*. Daruk calling Link "little guy" is an homage to Darunia calling the hero "brother." I designed him to have the straightforward nature of the Gorons while also being the elder spiritual leader of the Champions.

CINEMATIC DESIGN: NAOKI MORI

I wanted him to feel like an experienced leader you can count on. The hair growing all over his body looks like armor. I focused on his overall body shape to give him a powerful, muscular physique, since he's bulky but not out of shape.

LEAD ARTIST, NPCs: HIROHITO SHINODA

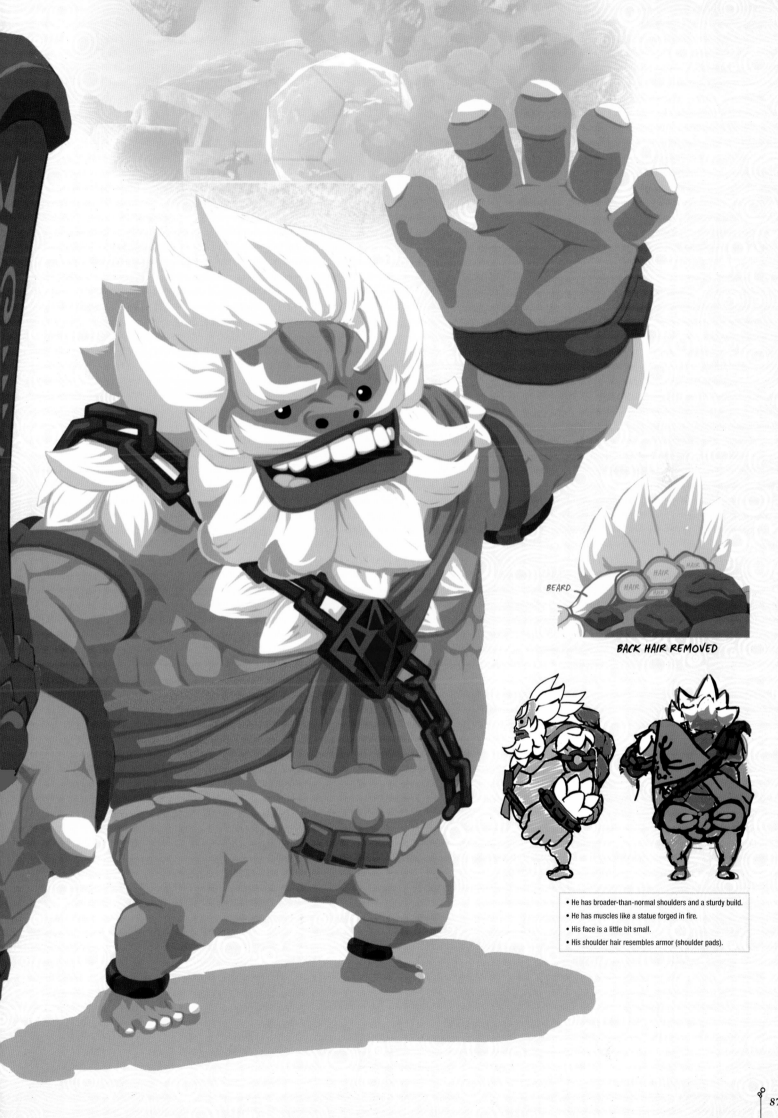

BEARD

HAIR
HAIR
HAIR
HAIR

BACK HAIR REMOVED

- He has broader-than-normal shoulders and a sturdy build.
- He has muscles like a statue forged in fire.
- His face is a little bit small.
- His shoulder hair resembles armor (shoulder pads).

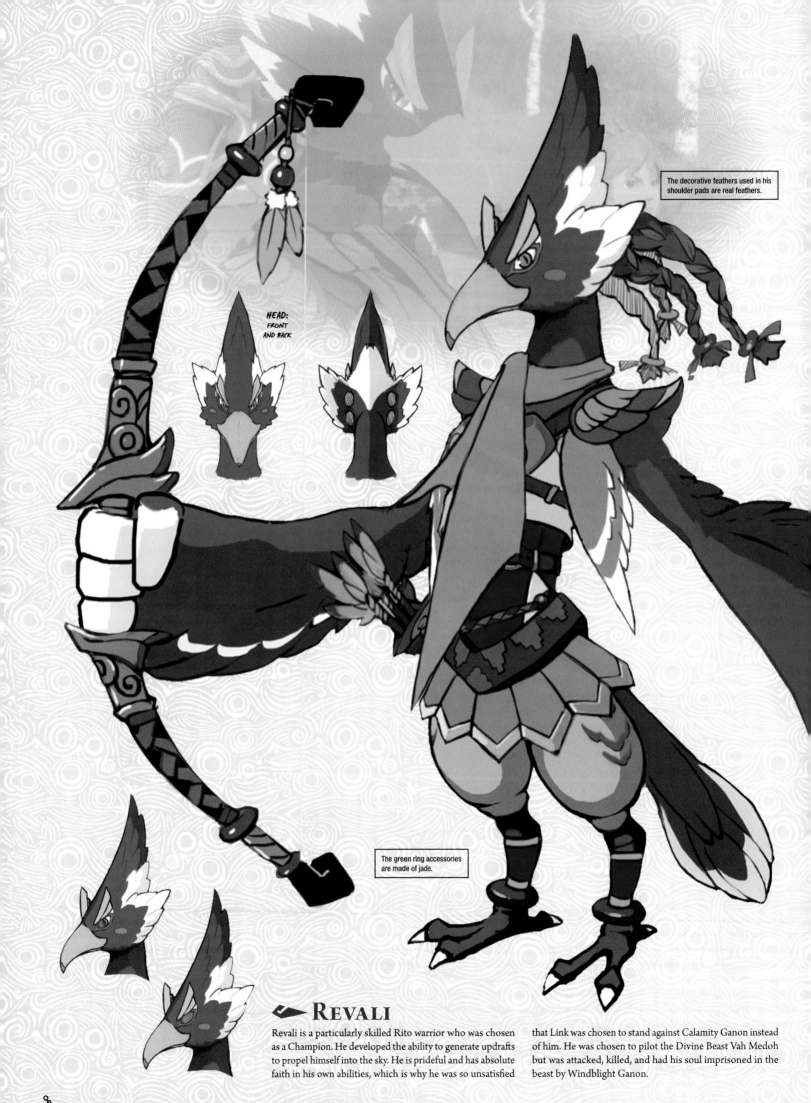

The decorative feathers used in his shoulder pads are real feathers.

HEAD: FRONT AND BACK

The green ring accessories are made of jade.

REVALI

Revali is a particularly skilled Rito warrior who was chosen as a Champion. He developed the ability to generate updrafts to propel himself into the sky. He is prideful and has absolute faith in his own abilities, which is why he was so unsatisfied that Link was chosen to stand against Calamity Ganon instead of him. He was chosen to pilot the Divine Beast Vah Medoh but was attacked, killed, and had his soul imprisoned in the beast by Windblight Ganon.

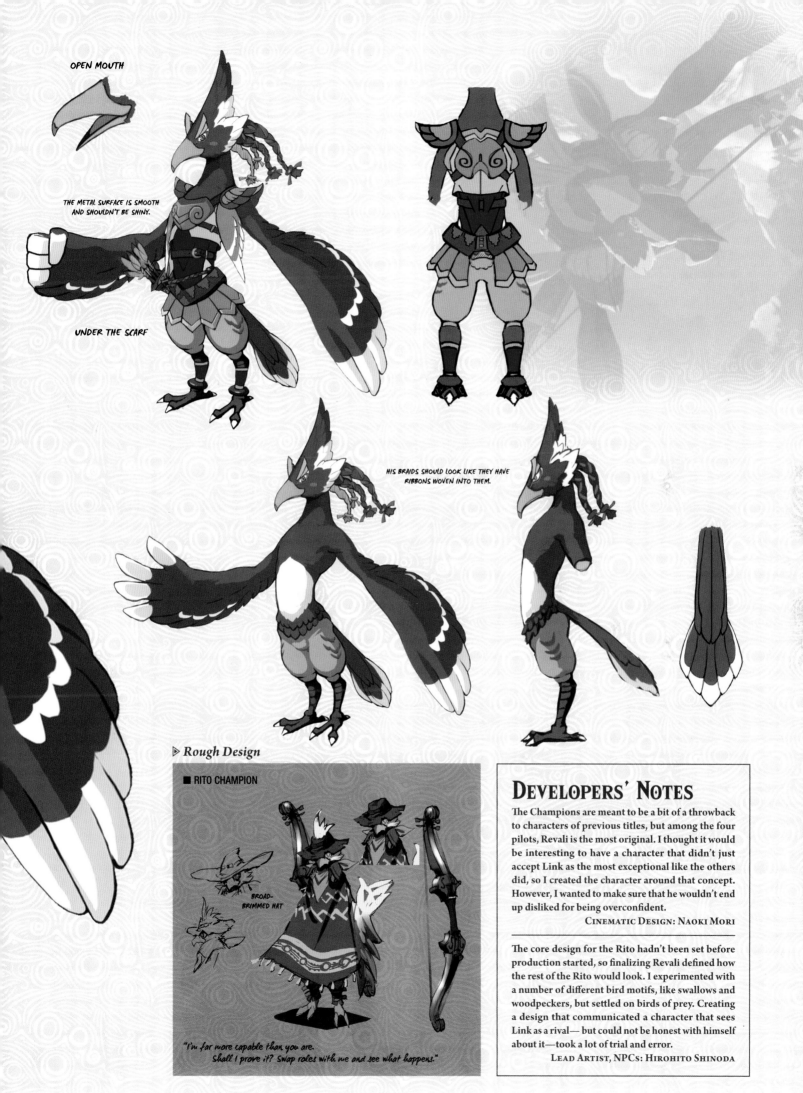

OPEN MOUTH

THE METAL SURFACE IS SMOOTH AND SHOULDN'T BE SHINY.

UNDER THE SCARF

HIS BRAIDS SHOULD LOOK LIKE THEY HAVE RIBBONS WOVEN INTO THEM.

▷ *Rough Design*

■ RITO CHAMPION

BROAD-BRIMMED HAT

"I'm far more capable than you are.
Shall I prove it? Swap roles with me and see what happens."

DEVELOPERS' NOTES

The Champions are meant to be a bit of a throwback to characters of previous titles, but among the four pilots, Revali is the most original. I thought it would be interesting to have a character that didn't just accept Link as the most exceptional like the others did, so I created the character around that concept. However, I wanted to make sure that he wouldn't end up disliked for being overconfident.

CINEMATIC DESIGN: NAOKI MORI

The core design for the Rito hadn't been set before production started, so finalizing Revali defined how the rest of the Rito would look. I experimented with a number of different bird motifs, like swallows and woodpeckers, but settled on birds of prey. Creating a design that communicated a character that sees Link as a rival— but could not be honest with himself about it—took a lot of trial and error.

LEAD ARTIST, NPCs: HIROHITO SHINODA

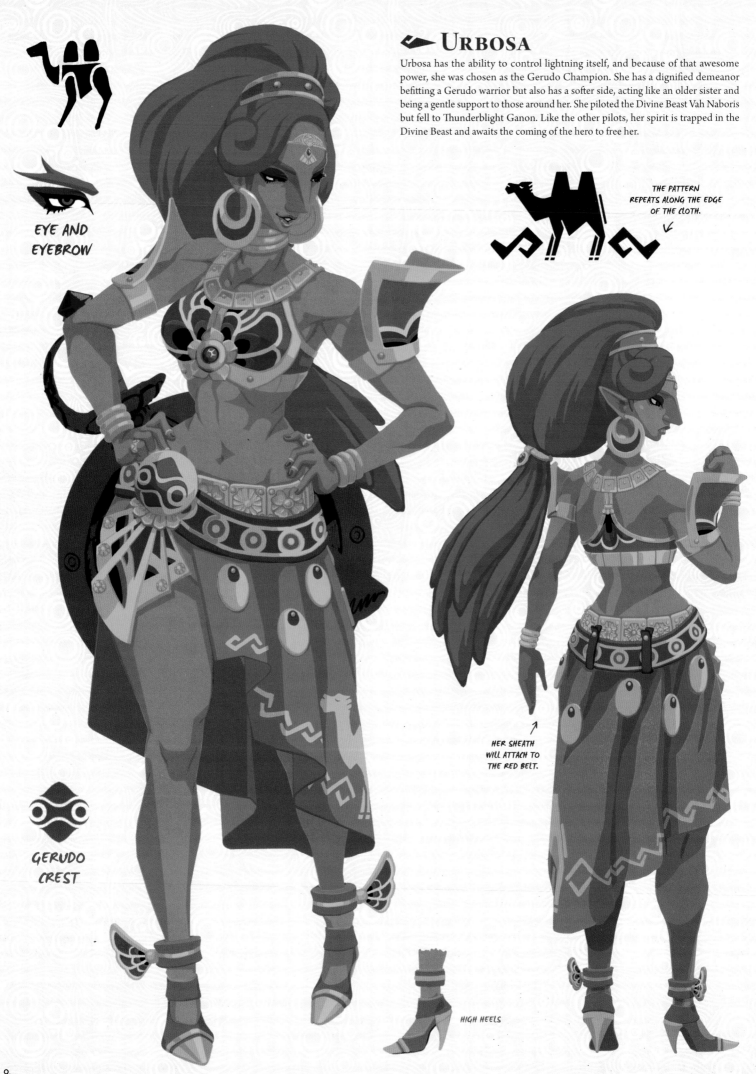

URBOSA

Urbosa has the ability to control lightning itself, and because of that awesome power, she was chosen as the Gerudo Champion. She has a dignified demeanor befitting a Gerudo warrior but also has a softer side, acting like an older sister and being a gentle support to those around her. She piloted the Divine Beast Vah Naboris but fell to Thunderblight Ganon. Like the other pilots, her spirit is trapped in the Divine Beast and awaits the coming of the hero to free her.

EYE AND EYEBROW

THE PATTERN REPEATS ALONG THE EDGE OF THE CLOTH.

GERUDO CREST

HER SHEATH WILL ATTACH TO THE RED BELT.

HIGH HEELS

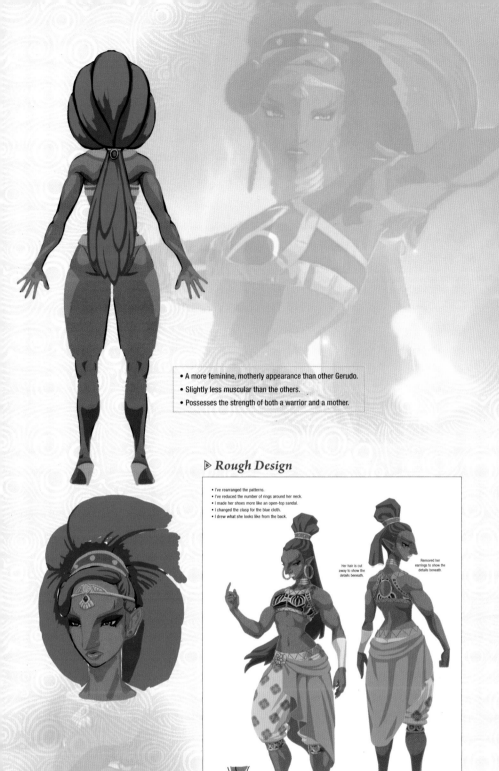

- A more feminine, motherly appearance than other Gerudo.
- Slightly less muscular than the others.
- Possesses the strength of both a warrior and a mother.

▷ *Rough Design*

- I've rearranged the patterns.
- I've reduced the number of rings around her neck.
- I made her shoes more like an open-top sandal.
- I changed the clasp for the blue cloth.
- I drew what she looks like from the back.

Her hair is cut away to show the details beneath.

Removed her earrings to show the details beneath.

DEVELOPERS' NOTES

In Princess Zelda's memories I showed Urbosa saving her from the Yiga and serving as a spiritual mother to her as Zelda becomes more and more overwhelmed with stress. Not only is Urbosa kind and relaxed, I gave her a little bit of sass as well. The Gerudo tribe birthed the central villain of the series, as seen in *Ocarina of Time*, so I drew on the expansive nature of this series and its rich history and made Urbosa, the Gerudo chief, feel responsible for their part in that. Similar to Daruk, we see a side of her in the DLC we weren't able to show in the main game.

CINEMATIC DESIGN: NAOKI MORI

She exudes the tough beauty of the Gerudo as well as being a mom with moxie. I took extra care exploring how to make her outfit look fitting for someone of her station—a person an ordinary Gerudo would look up to.

LEAD ARTIST, NPCS: HIROHITO SHINODA

BACKGROUND
The Champions

PROVIDING SUPPORT

One by one, Link enters the corrupted Divine Beasts, defeats the Phantom Ganon within, and frees the imprisoned spirits of the Champions, thus enabling them to again control the Divine Beasts. They are able to briefly speak with Link again, entrusting him with their special abilities and supporting him as best they can.

1 The healing power of Mipha's Grace can restore Link's health after he suffers a fatal injury. **2** Daruk's Protection forms a shield around the hero that will deflect any attack. **3** Revali's Gale will temporarily generate an updraft under Link. **4** Urbosa's Fury summons lightning in the area surrounding Link and damages all nearby enemies.

THE CHAMPIONS'
FAVORITE WEAPONS

Each of the Champions is remembered by their people, and their favorite weapons have been passed on through the ages, guarded carefully as treasures.

Each of the weapons has a story behind it, but they also possess properties that make them superior to other weapons of the same type.

1 The Lightscale Trident skillfully wielded by Mipha was a present given to her on the day she was born. **2** The Boulder Breaker boasts the strength to smash stone but is extremely heavy. It is said that Daruk used this in place of a fan. **3** Out of all the Rito, only Revali was able to wield the powerful Great Eagle Bow. **4** It is said that Urbosa's movements resembled a beautiful dance when she wielded her beloved Scimitar of the Seven.

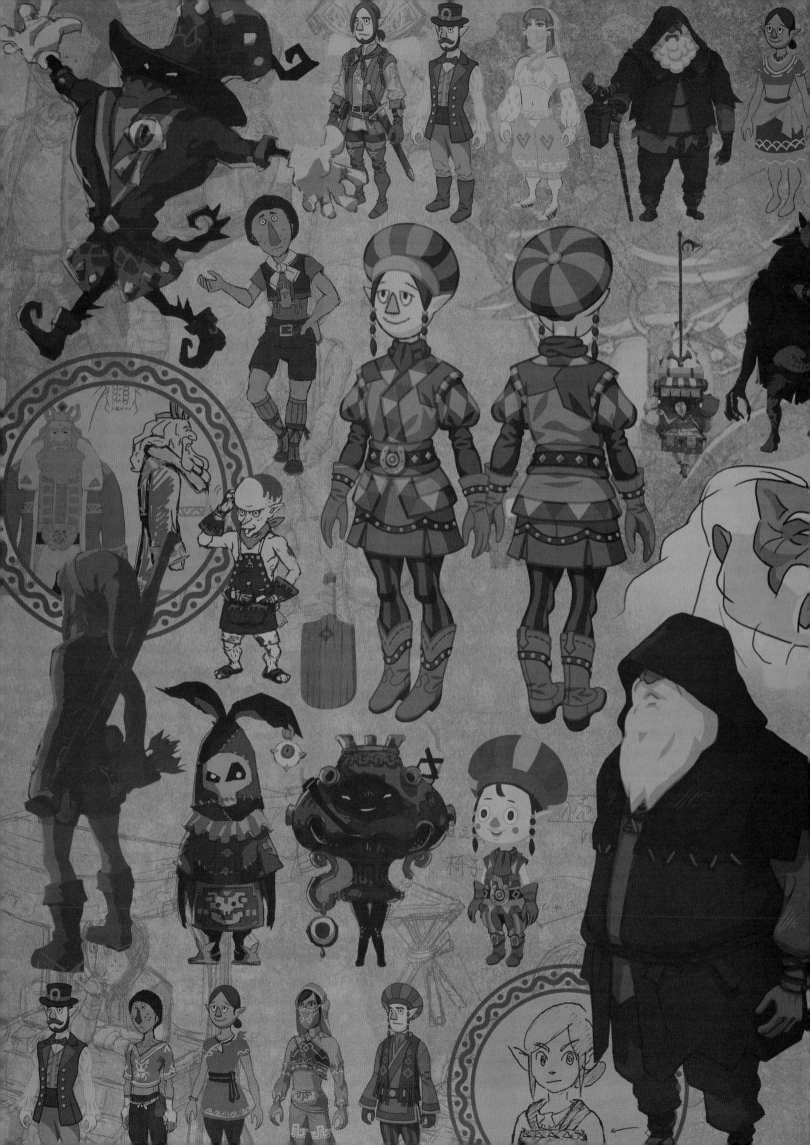

THE HYLIANS
HEARTY AND PROSPEROUS

The Hylians are easily identified by their distinct pointed ears; both Link and Princess Zelda are among their ranks. The Hylians once flourished in Hyrule, with villages throughout Central Hyrule and the lands beyond. Legend has it that the Hylian royal family carries the blood of the namesake of their race, the goddess Hylia. Though they were perhaps the most prosperous race in Hyrule a century ago, the Great Calamity drove them nearly to extinction as their capital and towns in Central Hyrule were destroyed. The efforts of Princess Zelda and others allowed a few survivors to escape, and their descendants live on throughout the land.

THE OLD MAN

He is the first person Link encounters upon waking from his restorative slumber and the only person that lives on the Great Plateau. He asks the amnesiac Link to investigate the ancient shrines and provides him with crucial knowledge on how to survive in this ruined world.

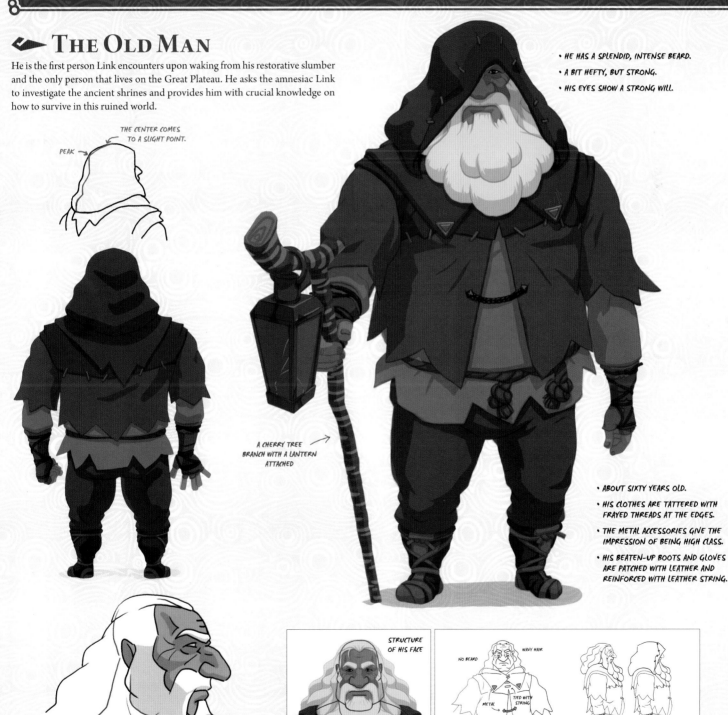

THE CENTER COMES TO A SLIGHT POINT.

PEAK

A CHERRY TREE BRANCH WITH A LANTERN ATTACHED

- HE HAS A SPLENDID, INTENSE BEARD.
- A BIT HEFTY, BUT STRONG.
- HIS EYES SHOW A STRONG WILL.

- ABOUT SIXTY YEARS OLD.
- HIS CLOTHES ARE TATTERED WITH FRAYED THREADS AT THE EDGES.
- THE METAL ACCESSORIES GIVE THE IMPRESSION OF BEING HIGH CLASS.
- HIS BEATEN-UP BOOTS AND GLOVES ARE PATCHED WITH LEATHER AND REINFORCED WITH LEATHER STRING.

STRUCTURE OF HIS FACE

NO BEARD

WAVY HAIR

METAL

TIED WITH STRING

ROPE

HEMP SACK-LIKE CLOTHING

KING RHOAM

King Rhoam Bosphoramus Hyrule was the last king of the kingdom of Hyrule and Princess Zelda's father. His spirit remained in the plain of the living after his death, and he disguises himself as a common old man to pass on the truth of the destruction of the kingdom to Link when he awakens.

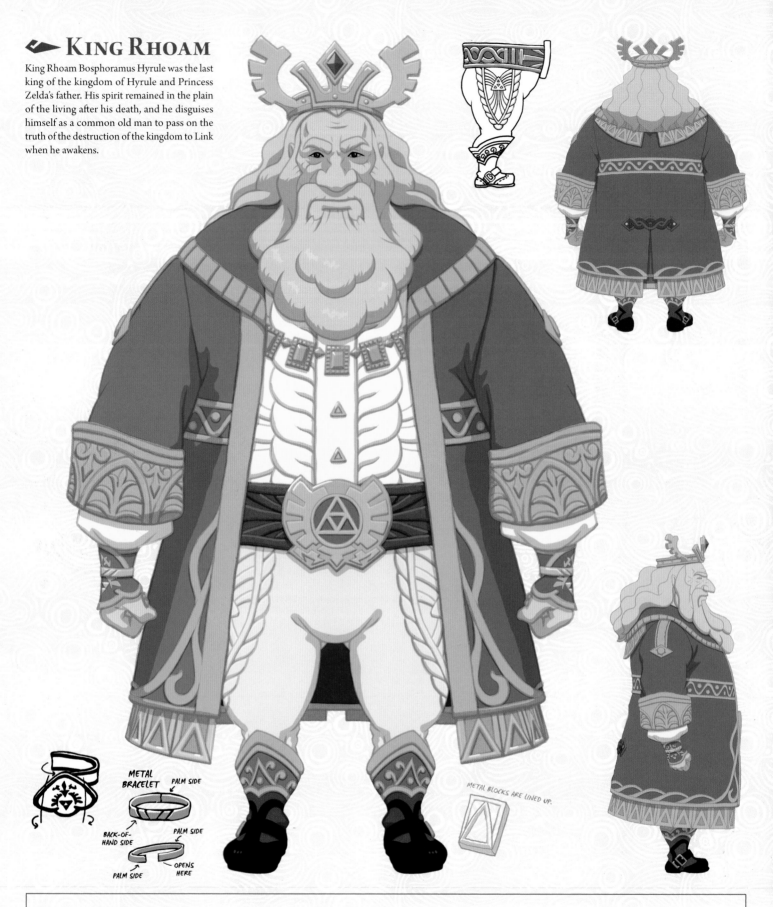

METAL BRACELET

PALM SIDE

BACK-OF-HAND SIDE

PALM SIDE

PALM SIDE

OPENS HERE

METAL BLOCKS ARE LINED UP.

DEVELOPERS' NOTES

The Hylians are good, common folk, so I gave their clothes a calming, relaxed look. The Hylians' and Sheikah's faces were individualized via a special tool, and they were changed almost daily during development. There are characters whose faces changed so much from where they began that you could say that they ended up being entirely different characters at the end of development. Personally, my favorite is Branli, who studies the "bird-men." I made him at the end of development.

NPC ART: MANABU HIRAOKA

From the beginning of development, King Rhoam was going to be located in the Great Plateau and act as a guide for Link and the player, neither of which have any knowledge of Hyrule at this point. Conceptually, he was the wise king of a fallen kingdom who was hiding himself from the world. I designed his look when he is in disguise and when he is operating as king to be polar opposites. Bolson (page 96) also originally had a larger physique, but we kept slimming him down and eventually settled on his design.

LEAD ARTIST, NPCs: HIROHITO SHINODA

BEEDLE

This traveling merchant wanders Hyrule with an enormous pack full of merchandise on his back, stopping at stables to set up shop. He may never change his outfit, whether he's in scorching heat or frigid tundra, but the wares he sells change based on what is necessary in the area he is in. He loves beetles, as is evidenced by his beetle-shaped backpack.

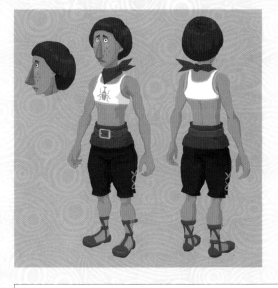

• **CHANGE PLATE**

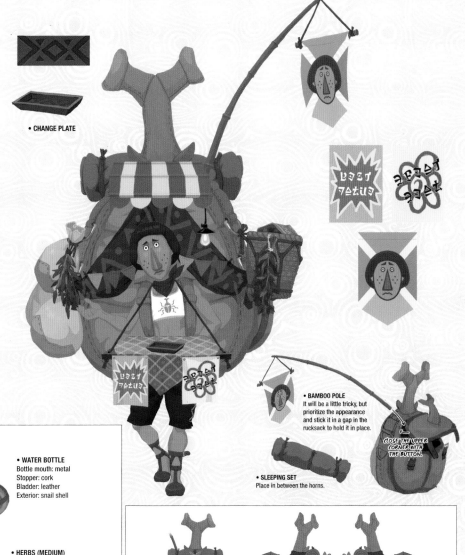

• **BAMBOO POLE**
It will be a little tricky, but prioritize the appearance and stick it in a gap in the rucksack to hold it in place.

CLOSE THE UPPER CORNER WITH THE BUTTON.

• **SLEEPING SET**
Place in between the horns.

• **SIMPLE PARASOL**
Folds up. Like the bamboo pole that holds his sign, it is fixed with rods to the interior of the backpack.

• **WATER BOTTLE**
Bottle mouth: metal
Stopper: cork
Bladder: leather
Exterior: snail shell

• **HERBS (MEDIUM)**
Bundled together with a string.

• **LIGHT BULB**
The light bulb hangs from a leather band on one of the parasol's arms.

• **FRUIT BASKET**

Basket tie close-up

• **HERBS (LARGE)**
Bundled together with a string.

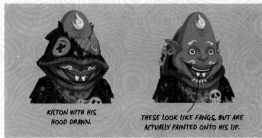

KILTON

Kilton operates a shop called the Fang and Bone. He moves the shop just outside major towns by using a hot-air balloon and only operates at night. He's an odd fellow who loves monsters so much that he even dresses in monstrous garb. In exchange for monster parts, he offers Link a special currency called mon that can be exchanged for the monster-themed items he sells.

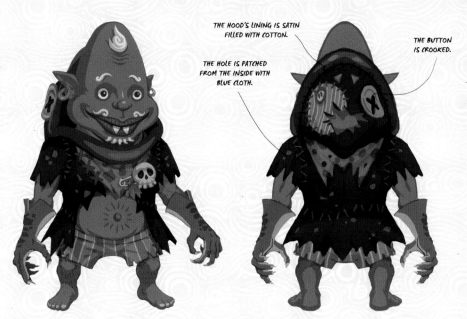

THE HOOD'S LINING IS SATIN FILLED WITH COTTON.

THE HOLE IS PATCHED FROM THE INSIDE WITH BLUE CLOTH.

THE BUTTON IS CROOKED.

KILTON WITH HIS HOOD DRAWN.

THESE LOOK LIKE FANGS, BUT ARE ACTUALLY PAINTED ONTO HIS LIP.

▷ *Rough Design*

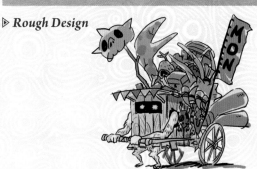

BOLSON CONSTRUCTION

These three are the carpenters who run Bolson Construction out of Hateno Village. In order to be an employee of the company, you must have a name that ends in "son." Bolson is the president, boss, and designer for Bolson Construction, and he and his newest hire, Karson, offer to improve the house Link buys from them for a reasonable price. Longtime employee Hudson sets off for Akkala by himself to found a new town.

• HAMMER
DECORATIVE VERSION

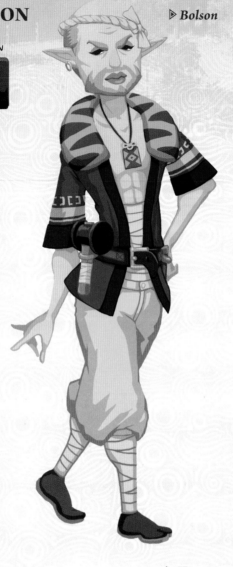

▷ *Bolson*

FROM BEHIND

▷ *Rough Design*

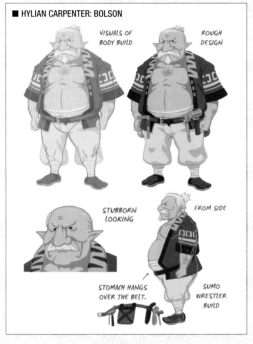

■ HYLIAN CARPENTER: BOLSON

VISUALS OF BODY BUILD

ROUGH DESIGN

STUBBORN LOOKING

FROM SIDE

STOMACH HANGS OVER THE BELT.

SUMO WRESTLER BUILD

▷ *Hudson*

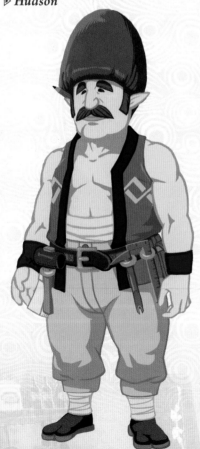

▷ *Karson*

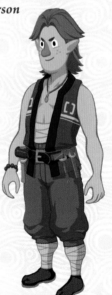

SCREENSHOT

Karson had long hair in his final design, like something a trendy young person might have, but it was changed to a buzzcut when he was put into the game.

KOCHI DYE SHOP

Located in Hateno Village, the Kochi Dye Shop specializes in using various materials to dye customers' clothing their desired color. The shop's owner is named Sayge, though some call him Mr. Toothy. It is his personal mission to stop young people from losing interest in dyeing.

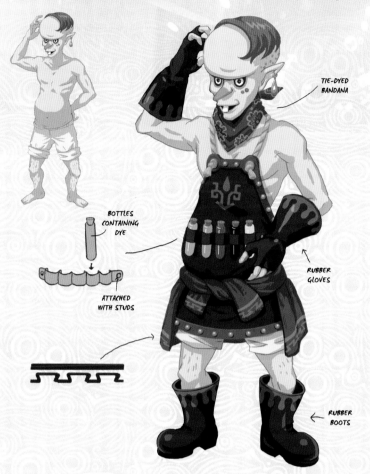

BOTTLES CONTAINING DYE

ATTACHED WITH STUDS

RUBBER GLOVES

RUBBER BOOTS

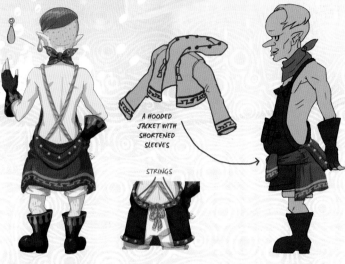

TIE-DYED BANDANA

A HOODED JACKET WITH SHORTENED SLEEVES

STRINGS

▷ *Rough Designs*

THERE IS MUCH TO THE WORLD OF DYEING...

ECCENTRIC MAN WITH AN EYE FOR BEAUTIFUL AESTHETICS.

OPINIONATED ABOUT FASHION?

SKINTIGHT

"THERE IS AN EXCELLENT BLACK IN STOCK."

GERUDO OUTFIT MERCHANT

This Hylian merchant can be found in the Kara Kara Bazaar. He wears a Gerudo outfit and has been rumored to have slipped into Gerudo Town, even though men are forbidden there. He will sell Link a similarly designed Gerudo outfit. His name is Vilia, but it is unclear if that is his birth name or not.

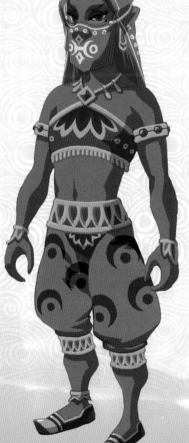
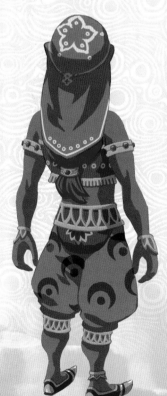
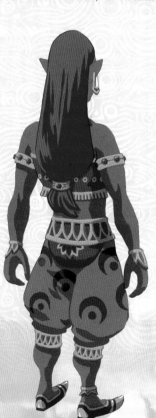
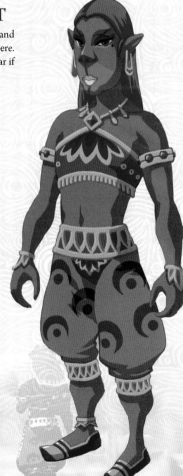

TYPICAL HYLIANS

▷ Hateno Village

These are some of the outfits that the residents of Hateno Village wear. Their clothing is colorful and has a Nordic aesthetic. Since the village is located in the eastern-most part of Necluda at the base of Mount Lanayru, the area is chilly. Most villagers wear long sleeves as a result.

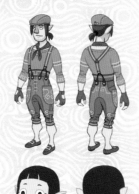
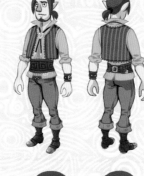
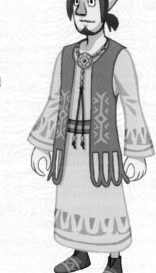
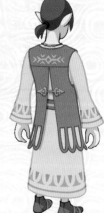

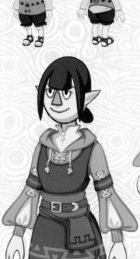

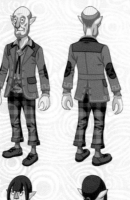
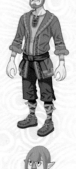
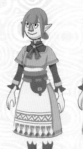

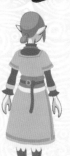

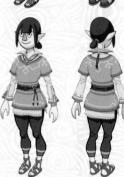

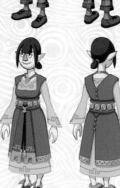
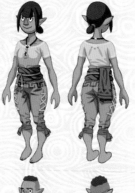

▷ Lurelin Village

The residents of Lurelin Village reside in the farthest reaches of Faron. Unlike Hateno Village, the climate near the sea is warm, so they wear light, breezy outfits. They wear accessories made out of shells.

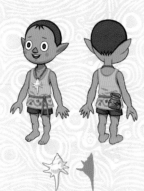

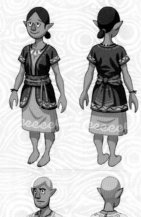
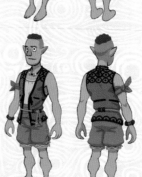
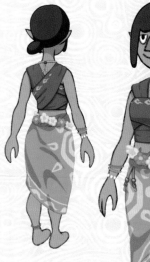
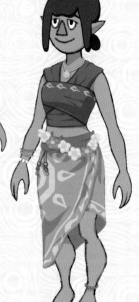

A SEA-SNAIL SHELL WITH A SMOOTH INTERIOR

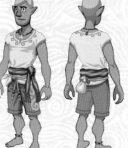

THE PATTERN IS ONLY ON ONE SIDE.

▷ Stables

The employees of the stables that connect all parts of Hyrule can be distinguished by their uniquely shaped hats and garb suited to their nomadic lifestyle. Stables are a place to register and board horses, but they are also inns where a traveler can get a good night's sleep. They are great places to find out information about the local area.

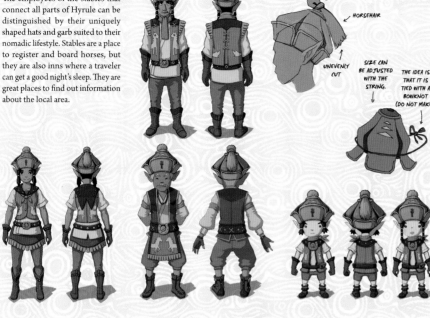

PONYTAIL-REVERSED VERSION

HORSEHAIR

UNEVENLY CUT

SIZE CAN BE ADJUSTED WITH THE STRING.

THE IDEA IS THAT IT IS TIED WITH A BOWKNOT (DO NOT MAKE).

▷ Travelers & Merchants

These hearty Hylians can be found traveling throughout Hyrule. Their outfits are dictated by the climate of their current location or by the climate of where they are headed. Some are dressed for fast and light travel, while others carry weapons or armor.

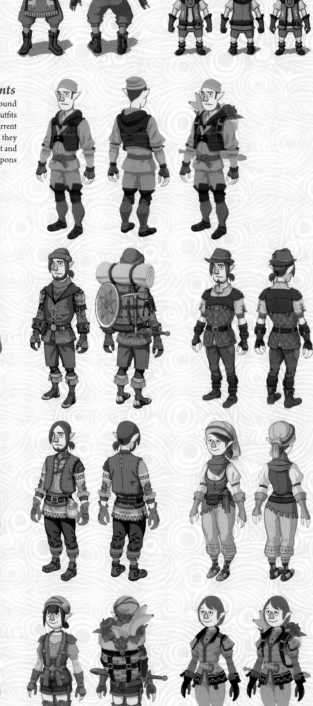

LIVING OFF THE LAND

The Hylians lost a great many settlements to the Great Calamity and were forced to flee Central Hyrule to villages on the outskirts of Hyrule. Even a century later, the threat posed by monsters has not subsided. What few villages survived have adapted to be self-sufficient—developing trades suitable for their environments.

Hateno Village is located in the far east portion of Necluda. Its cool, gentle climate makes it perfect for farming and raising livestock for dairy products. Most houses have some type of field behind them cultivating a variety of crops, and some raise cuccos. There are even ranches that raise water buffalo. One of Hateno Village's traditional crafts is "Hateno dyeing," a technique for dyeing clothes.

On the other end of the spectrum is Lurelin Village in Faron. Its warm climate and nearness to the sea have led to a fishing-based society. Most of the residents there make a living off the sea.

Hateno Pasture is located part of the way up the hill from Hateno Village on the way to Hateno Ancient Tech Lab. They collect milk from a few cows and sheep, using a sheepdog to help tend the herd. However, there was an incident where some of the sheep were stolen by monsters.

ADVENTUROUS TRAVELERS

There are many Hylian travelers who use the stables of Hyrule as bases for their travels. Some are treasure hunters, while others are roaming merchants who have decided not to set up permanent shops in a village. These travelers can be found in all parts of Hyrule.

These bold, curious Hylians visit the homes of other races to sightsee or sell goods, thriving even in a land infested with monsters. There are those among them who are brave enough to take up arms against any monsters who might attack them on the roads.

Travelers who do not reside in villages will generally sleep in village inns or stables, but some choose to spend the night under the stars—pitching tents along the road to wait out the night.

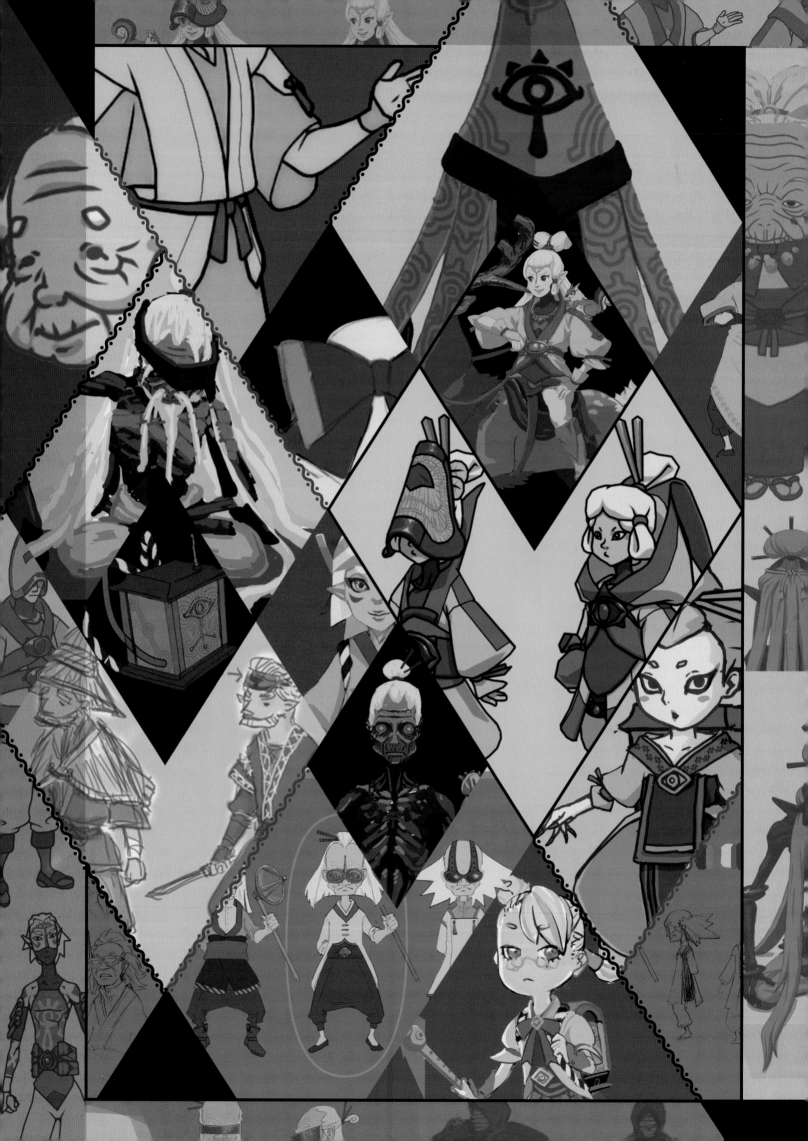

THE SHEIKAH
THE WISE CLAN THAT SUPPORTS THE ROYAL FAMILY

Ten thousand years ago, the Sheikah were a prosperous people who created and wielded advanced technology in the service of the kingdom of Hyrule's royal family. They used their technological prowess to create weapons that helped defeat Calamity Ganon but were later banned from using that technology and oppressed by the king of Hyrule.

They have a unique and deeply ingrained culture that can readily be observed in their distinctive clothing and practices. They look very similar to your average Hylian, but on the whole they are more physically gifted—with many learning martial arts. They are also characterized by their white hair.

TYPICAL MALE

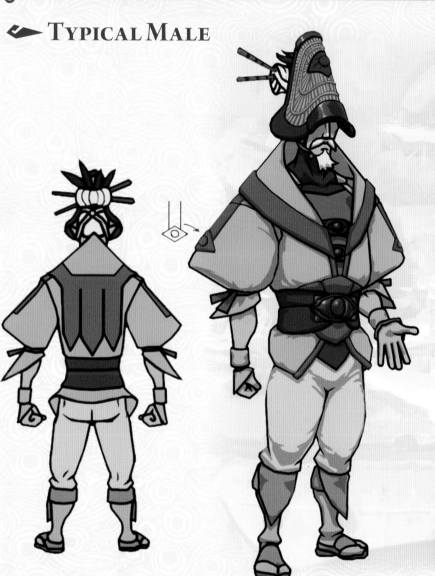

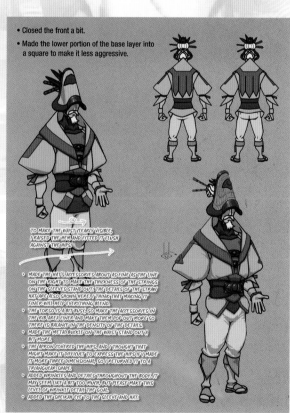

- Closed the front a bit.
- Made the lower portion of the base layer into a square to make it less aggressive.

TO MAKE THE WAIST CLEARLY VISIBLE, I RAISED THE HEM AND FITTED IT FLUSH AGAINST THE HIPS.

- MADE THE HAT'S ACCESSORIES ABOUT AS FINE AS THE LINE ON THE RIGHT TO MAKE THE THICKNESS OF THE STRINGS ON THE SLEEVES STAND OUT. THE DETAILS OF THE STRAW HAT ARE ALSO SHOWN HERE. I THINK THAT MAKING IT FINER WILL HELP EVERYTHING BLEND.
- THE TORSO IS A BIT BUSY, SO MAKE THE ACCESSORIES IN THE RIB AREA FINER AND MAKE THEM POP OUT MORE SO THERE IS BALANCE IN THE DENSITY OF THE DETAILS.
- MADE THE METAL BUCKLE ON THE WAIST STAND OUT A BIT MORE.
- THE APRON COVERED THE HIPS, AND I THOUGHT THAT MIGHT MAKE IT DIFFICULT TO EXPRESS THE HIPS IF I MADE IT MORE THREE DIMENSIONAL, SO I RETURNED IT TO A TRIANGULAR SHAPE.
- ADDED WRINKLES AND DETAILS THROUGHOUT THE BODY. IT MAY SEEM LIKE A BIT TOO MUCH, BUT PLEASE MAKE THIS LEVEL OF WRINKLE DETAIL THE GOAL.
- ADDED THE SHEIKAH EYE TO THE SLEEVE AND HAT.

▷ *Rough Designs*

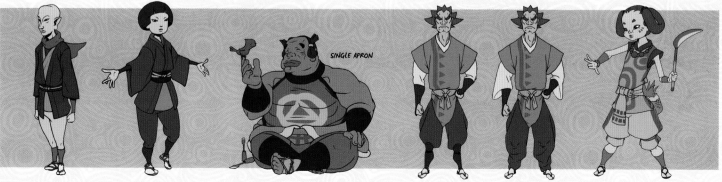

SINGLE APRON

❧ TYPICAL FEMALE

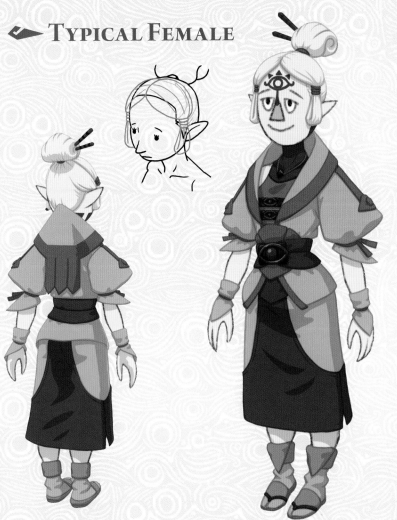

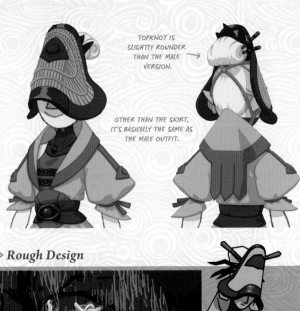

TOPKNOT IS SLIGHTLY ROUNDER THAN THE MALE VERSION. →

OTHER THAN THE SKIRT, IT'S BASICALLY THE SAME AS THE MALE OUTFIT.

▷ Rough Design

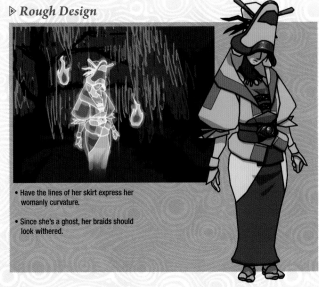

- Have the lines of her skirt express her womanly curvature.

- Since she's a ghost, her braids should look withered.

❧ THE ELDERLY

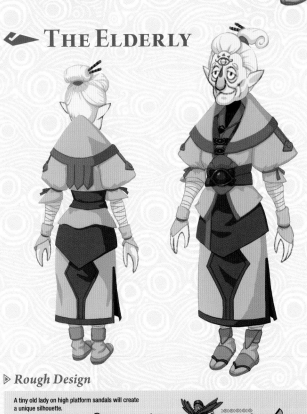

▷ Rough Design

A tiny old lady on high platform sandals will create a unique silhouette.

❧ CHILDREN

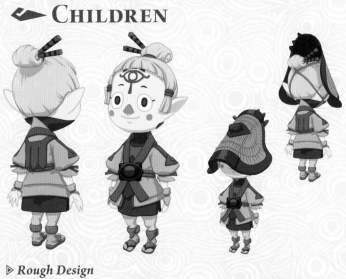

▷ Rough Design

Kept the neck area simple. This outfit is based on the typical Sheikah design. Made the undergarments similar to tights.

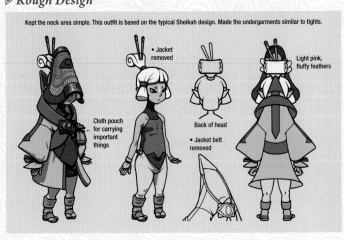

- Jacket removed

Cloth pouch for carrying important things

Back of head

- Jacket belt removed

Light pink, fluffy feathers

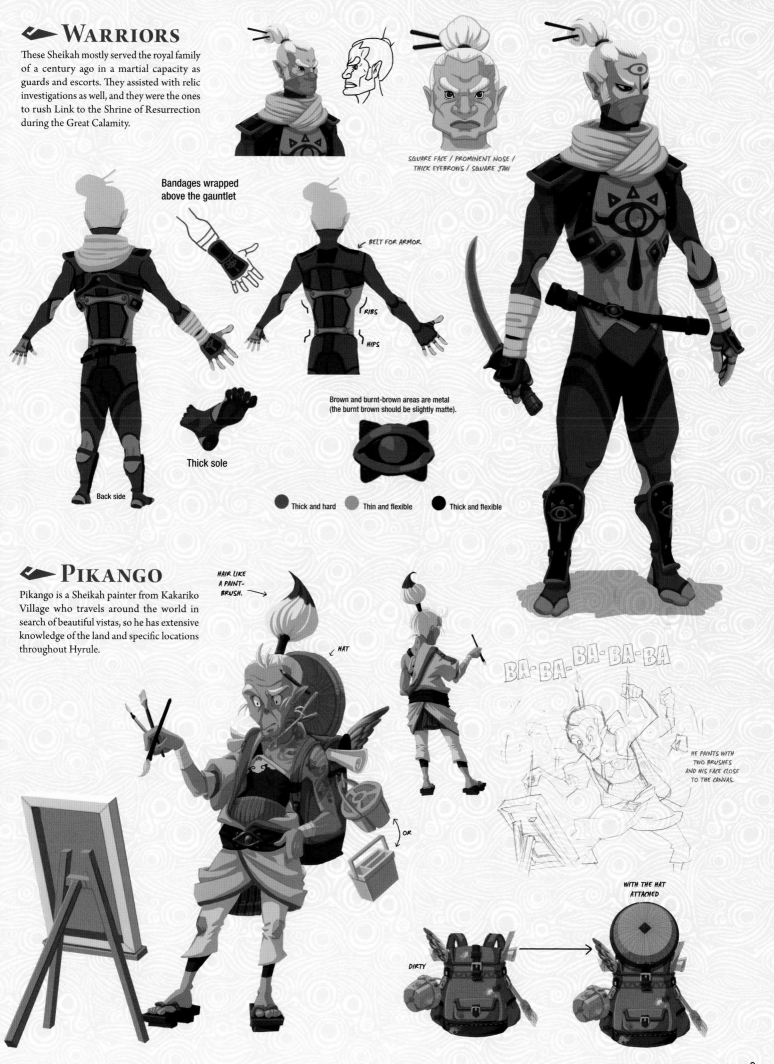

WARRIORS

These Sheikah mostly served the royal family of a century ago in a martial capacity as guards and escorts. They assisted with relic investigations as well, and they were the ones to rush Link to the Shrine of Resurrection during the Great Calamity.

SQUARE FACE / PROMINENT NOSE / THICK EYEBROWS / SQUARE JAW

Bandages wrapped above the gauntlet

BELT FOR ARMOR.

RIBS

HIPS

Brown and burnt-brown areas are metal (the burnt brown should be slightly matte).

Thick sole

Back side

Thick and hard Thin and flexible Thick and flexible

PIKANGO

Pikango is a Sheikah painter from Kakariko Village who travels around the world in search of beautiful vistas, so he has extensive knowledge of the land and specific locations throughout Hyrule.

HAIR LIKE A PAINT-BRUSH.

HAT

BA-BA-BA-BA-BA

HE PAINTS WITH TWO BRUSHES AND HIS FACE CLOSE TO THE CANVAS.

OR

DIRTY

WITH THE HAT ATTACHED

IMPA

Impa is the chief of Kakariko Village, and one of the few people still living who experienced the Great Calamity.

She was originally an official adviser to the royal family of the kingdom of Hyrule, but after the castle was destroyed by Calamity Ganon, she became the leader of Kakariko Village. Purah, who runs the Hateno Ancient Tech Lab, is her sister.

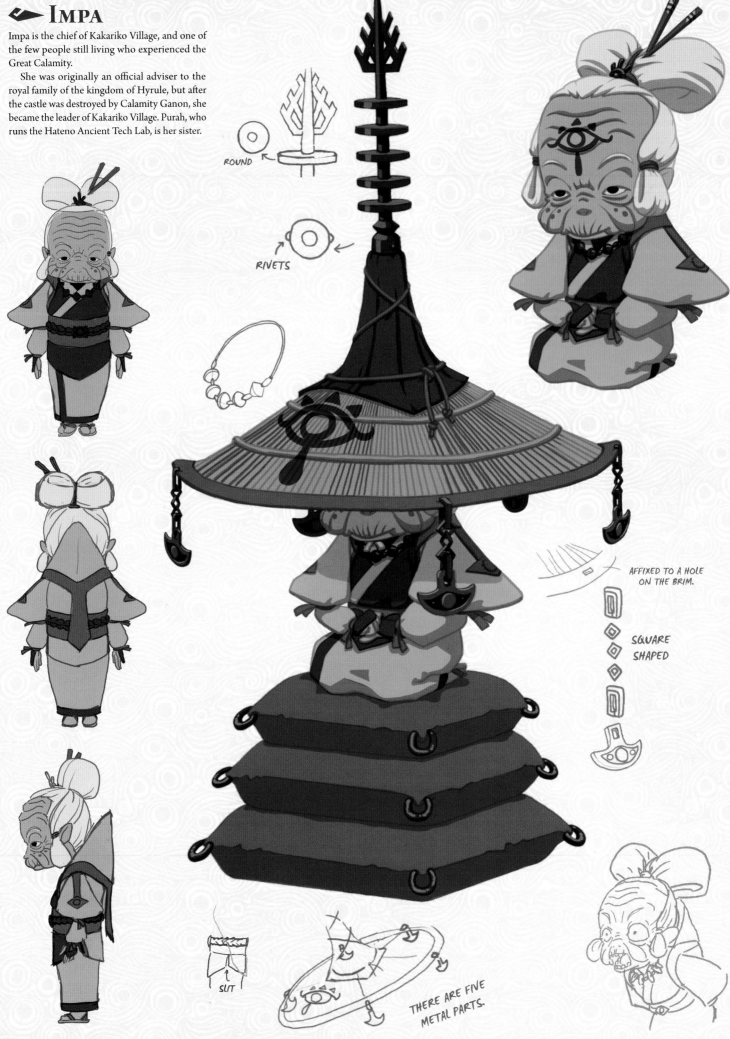

ROUND

RIVETS

AFFIXED TO A HOLE ON THE BRIM.

SQUARE SHAPED

SLIT

THERE ARE FIVE METAL PARTS.

PAYA

Paya is Impa's granddaughter. She is earnest and kind. She gives her all every day no matter what the job and loves the village more than anyone but has a tendency to get flustered in front of boys. Her name comes from the papaya-seed-shaped birthmark on her backside which causes her some embarrassment.

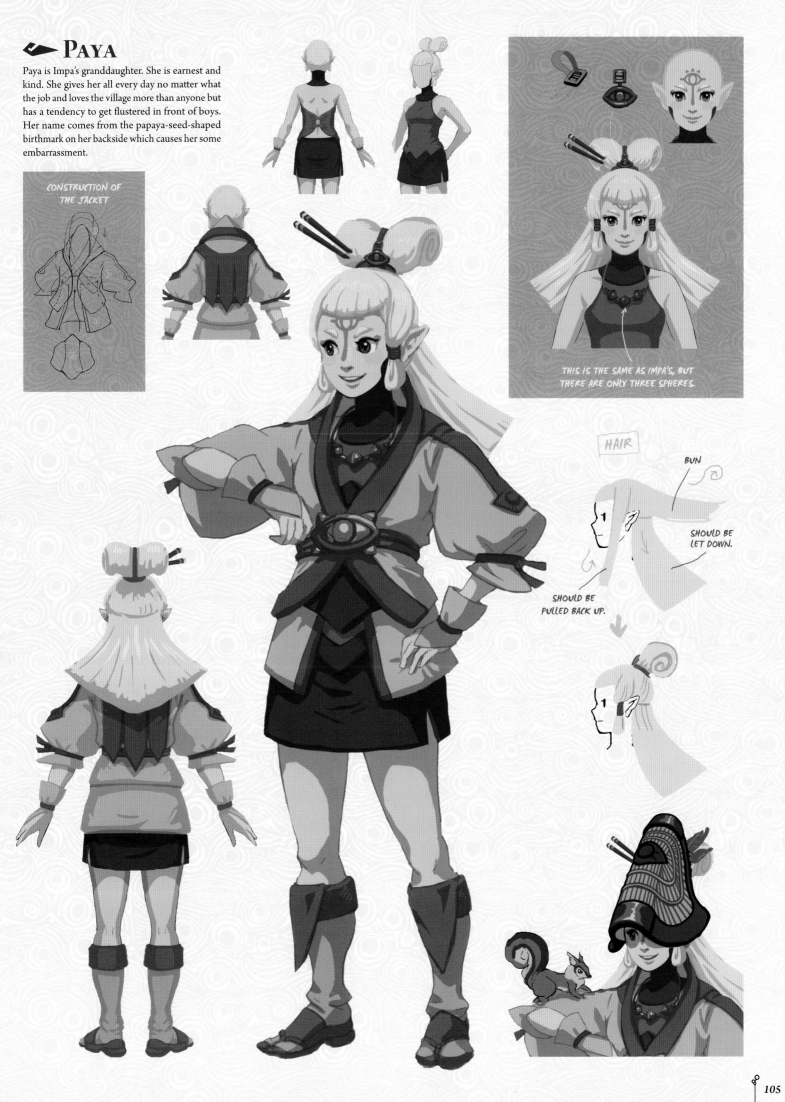

CONSTRUCTION OF THE JACKET

THIS IS THE SAME AS IMPA'S, BUT THERE ARE ONLY THREE SPHERES.

HAIR

BUN

SHOULD BE LET DOWN.

SHOULD BE PULLED BACK UP.

PURAH

Purah is the foremost authority in the field of ancient relic research and the head of the Hateno Ancient Tech Lab. She is the oldest living Sheikah and Impa's older sister, but due to a botched experiment to reverse the aging process, she currently looks and feels like a six-year-old. She's enjoying her second childhood and has developed poses and catch phrases to match her appearance—check it!

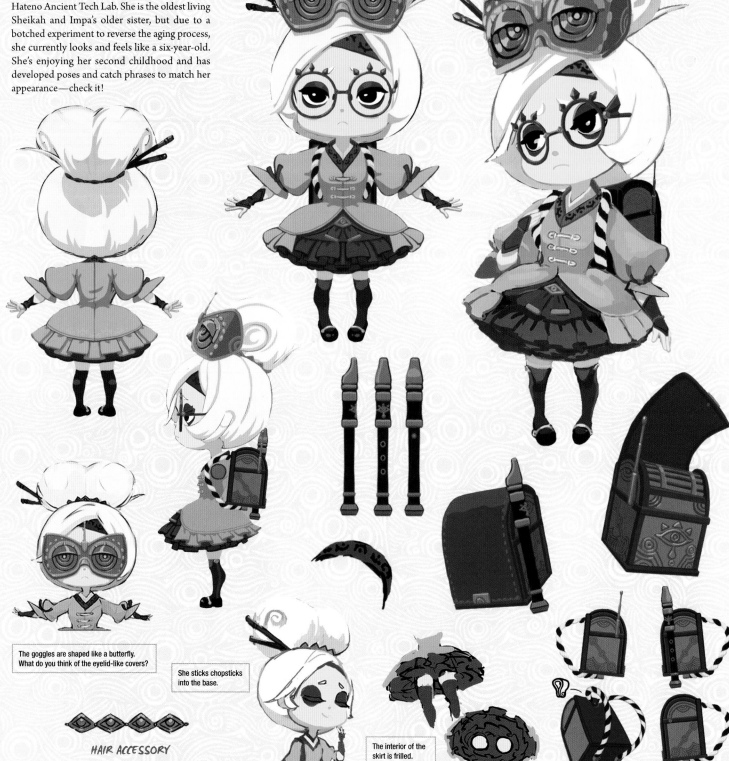

The goggles are shaped like a butterfly. What do you think of the eyelid-like covers?

She sticks chopsticks into the base.

HAIR ACCESSORY

The interior of the skirt is frilled.

▷ Rough Designs

Robbie's design was completed first, and from there a number of designs were tried out for Purah based on the "magical girl" archetype. She ended up being a very cheerful, strong character, but her initial design could be described as languid and unenergetic. She was the opposite of the character she became.

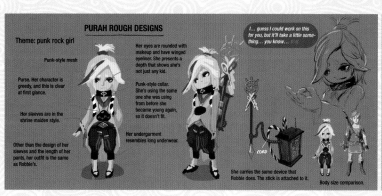

PURAH ROUGH DESIGNS

Theme: punk rock girl

Punk-style mesh

Purse. Her character is greedy, and this is clear at first glance.

Her sleeves are in the shrine maiden style.

Other than the design of her sleeves and the length of her pants, her outfit is the same as Robbie's.

Her eyes are rounded with makeup and have winged eyeliner. She presents a depth that shows she's not just any kid.

Punk-style collar. She's using the same one she was using from before she became young again, so it doesn't fit.

Her undergarment resembles long underwear.

I... guess I could work on this for you, but it'll take a little something... you know...

She carries the same device that Robbie does. The stick is attached to it.

Body size comparison.

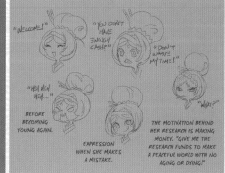

"WELCOME!"

"YOU DON'T HAVE ENOUGH CASH?"

"DON'T WASTE MY TIME!"

"HEH HEH HEH..."

BEFORE BECOMING YOUNG AGAIN.

EXPRESSION WHEN SHE MAKES A MISTAKE.

"WHAT?!"

THE MOTIVATION BEHIND HER RESEARCH IS MAKING MONEY. "GIVE ME THE RESEARCH FUNDS TO MAKE A PEACEFUL WORLD WITH NO AGING OR DYING!"

ROBBIE

Robbie is the elderly gentleman who is the head of Akkala Ancient Tech Lab and researches both the Guardians and ancient weapons. He has side conversations with himself while speaking and quite often punctuates his points by yelling for emphasis and posing. He is very skilled with technology and supports Link's fight by providing him with Ancient Soldier Gear.

↑ Mysterious device on back.

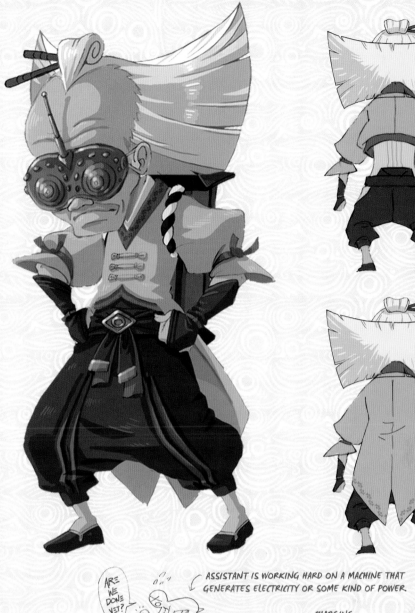

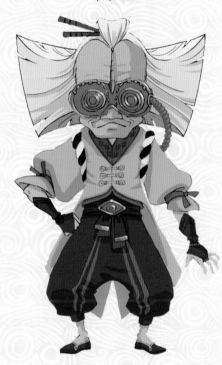

ARE WE DONE YET?

ASSISTANT IS WORKING HARD ON A MACHINE THAT GENERATES ELECTRICITY OR SOME KIND OF POWER

CHARGING.

HE TREATS LINK BADLY AT FIRST. HE'LL TELL YOU TO "COME BACK LATER" OR SOMETHING.

▷ *Rough Designs*

DEVELOPERS' NOTES

The Sheikah were built around the concept of a group who live in a hidden village away from the eyes of the world. I gave their outfits a very Japanese aesthetic so you could distinguish them from the other characters in the game at a glance. Initially, we were going to make Paya (page 105) a very young girl, but since there were very few girls around Link's age in the world, we decided to change her design and make her somewhere between eighteen and twenty years old. I also tried to give each of the ten-thousand-year-old monks (page 108) in the shrines distinct looks, which meant I had to find ways to differentiate all one hundred and twenty of them using their hats, accessories, and poses. The Yiga Clan (page 108) is also made up of Sheikah. We were trying to figure out how to work assassins who would attack Link on sight into the game and trying to work out why they would attack Link. We thought it would be interesting to have Sheikah who hated and were betrayed by the royal family of the kingdom of Hyrule and wanted to exact some kind of revenge. The idea expanded from there.

LEAD ARTIST, NPCs: HIROHITO SHINODA

The idea for Robbie's character was that he was a strange and stubborn mad scientist who embodied the spirit of rock and roll and left a traditional village in order to conduct research that is really out there. He originally had a Western design, but that didn't look quite right against the final designs for the Sheikah, so we ended up with the current design, which is a combination of a Japanese aesthetic and ancient relics.

NPC ART: YUKO MIYAKAWA

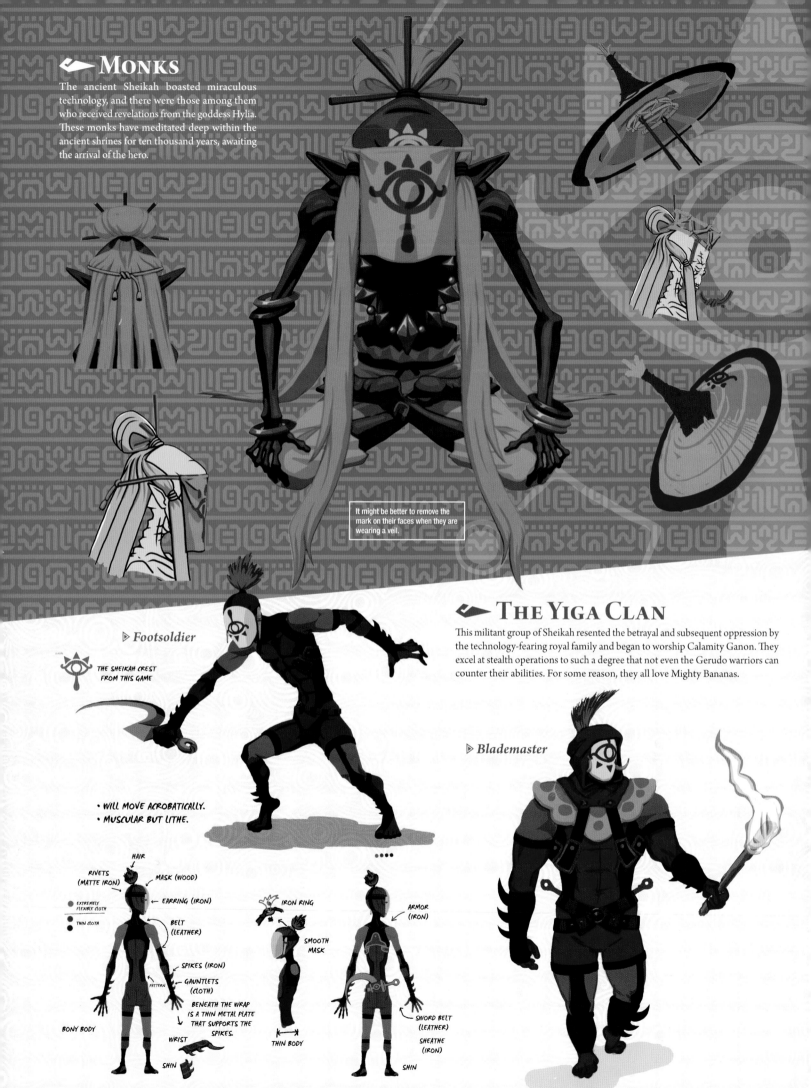

MONKS

The ancient Sheikah boasted miraculous technology, and there were those among them who received revelations from the goddess Hylia. These monks have meditated deep within the ancient shrines for ten thousand years, awaiting the arrival of the hero.

It might be better to remove the mark on their faces when they are wearing a veil.

THE YIGA CLAN

This militant group of Sheikah resented the betrayal and subsequent oppression by the technology-fearing royal family and began to worship Calamity Ganon. They excel at stealth operations to such a degree that not even the Gerudo warriors can counter their abilities. For some reason, they all love Mighty Bananas.

▷ *Footsoldier*

THE SHEIKAH CREST FROM THIS GAME

- WILL MOVE ACROBATICALLY.
- MUSCULAR BUT LITHE.

▷ *Blademaster*

HAIR

RIVETS (MATTE IRON)

MASK (WOOD)

EARRING (IRON)

● ─ EXTREMELY FLEXIBLE CLOTH

● ─ THIN CLOTH

BELT (LEATHER)

IRON RING

SMOOTH MASK

ARMOR (IRON)

SPIKES (IRON)

GAUNTLETS (CLOTH)

PATTERN

BENEATH THE WRAP IS A THIN METAL PLATE THAT SUPPORTS THE SPIKES.

BONY BODY

WRIST

SHIN

THIN BODY

SWORD BELT (LEATHER)

SHEATHE (IRON)

SHIN

▷ *Rough Designs*

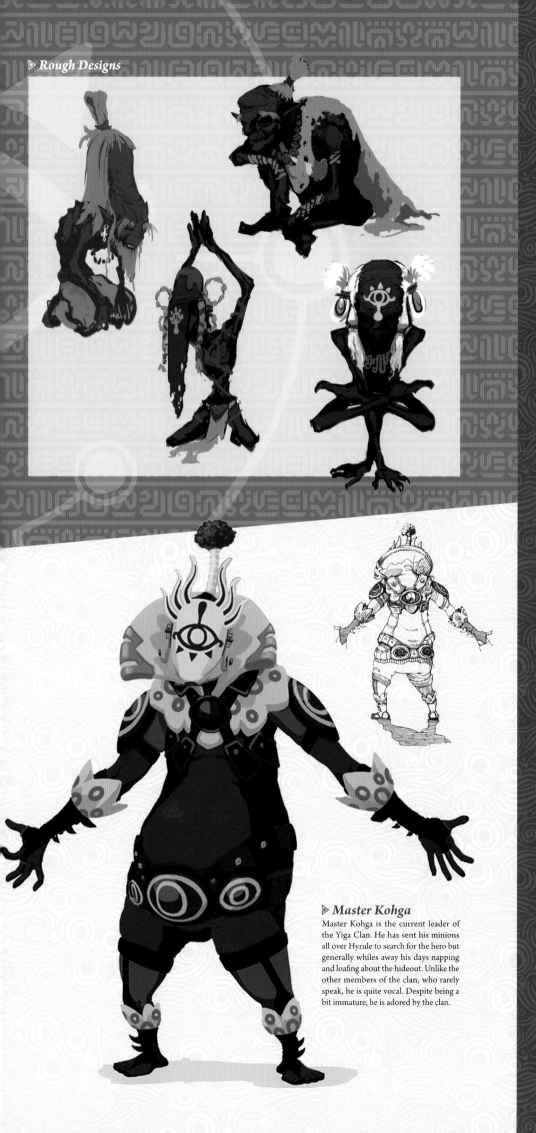

▷ **Master Kohga**

Master Kohga is the current leader of the Yiga Clan. He has sent his minions all over Hyrule to search for the hero but generally whiles away his days napping and loafing about the hideout. Unlike the other members of the clan, who rarely speak, he is quite vocal. Despite being a bit immature, he is adored by the clan.

BACKGROUND
The Sheikah

TECHNOLOGICAL EXPERTS & KEEPERS OF LEGENDS

Ten thousand years ago, the Sheikah were forced by the royal family to abandon their advanced technology, but they did not lose it entirely.

Aside from the ancient relics being studied, the clothing that the residents of Kakariko Village wear contains Sheikah technology and is particularly effective at negating the effects of rain and lightning. That is why there are villagers who go about their days normally even in a heavy downpour.

The legend of the hero is passed down among the clan as well. The orb in Impa's house has been passed down as a family treasure for generations along with the saying "The hero, as chosen by the Sheikah heirloom, will be gifted the blessing of antiquity." The orb is the key to unlocking an ancient shrine and shows just how deeply the roots between the Sheikah and the chosen hero run.

1 According to the gatekeeper Dorian, Sheikah outfits keep rain off, ward off lightning, and are still comfortable even when wet. **2** Paya watches over the family heirloom. She researches the orb and discovers that it is the key to opening a shrine.

THE COURT POET WHO LOVED PRINCESS ZELDA

A century ago, there was a Sheikah that served the Hyrulean royal family but was not part of the ancient research effort. He was the court poet and is thought to have been a young man of similar age to Princess Zelda. During the Great Calamity, the poet fled for Kakariko Village and along the way saw Princess Zelda and her collapsed knight-attendant, Link. After Zelda suppressed the calamity, the poet traveled to all corners of Hyrule researching ancient songs of the hero. When he was approaching death, he entrusted his disciple, a Rito named Kass, with passing them on to the hero when he awakened. Kass tells of how his master accompanied the princess on her investigations of relics and through his interactions with her developed a love that would go unrequited.

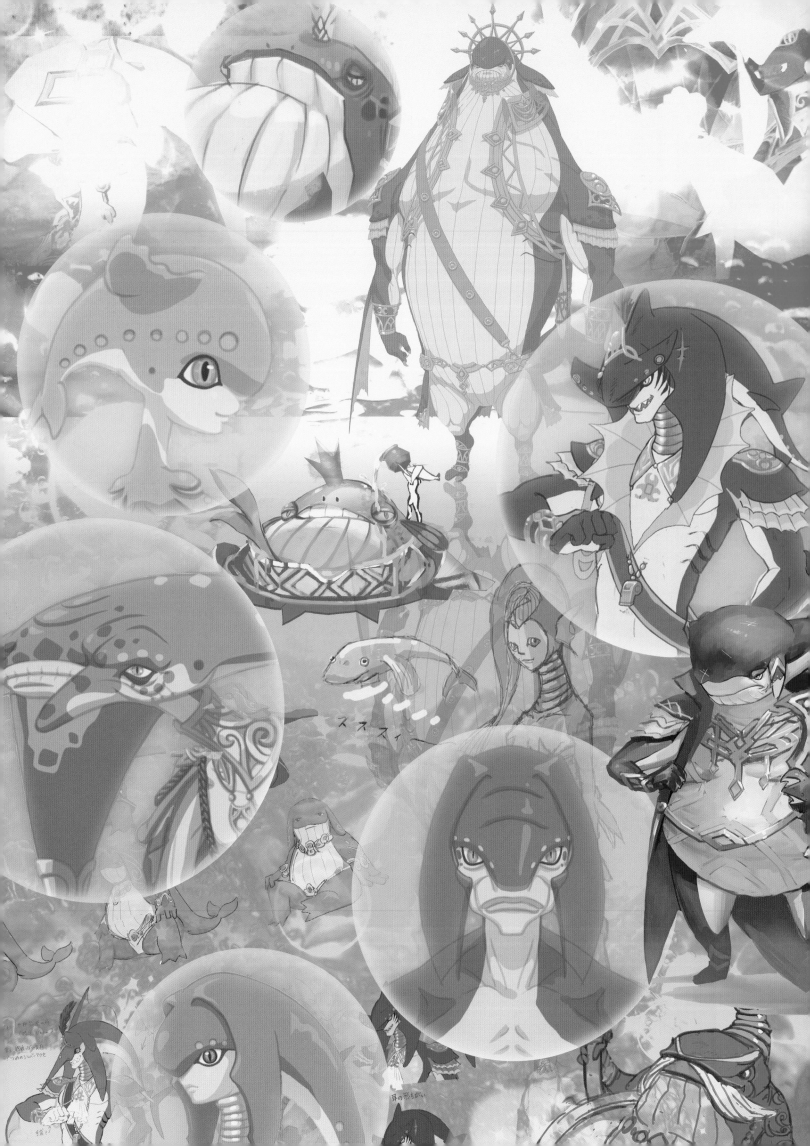

ススィー

THE ZORA
THOSE WHO GUARD THE WATER

The Zora are an aquatic race who live in the pure, bountiful waters of Lanayru. They have fish-like fins and uniquely colored scales. They excel at swimming and water-based activities, but that also makes them vulnerable to electricity. They have their own royal family which goes back countless generations and unifies the people. Compared to other Hyrulean races, the Zora age slowly and are extremely long lived. That is why there are so many Zora still alive who experienced the Great Calamity firsthand.

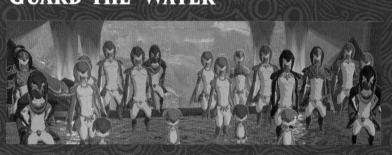

TYPICAL MALE

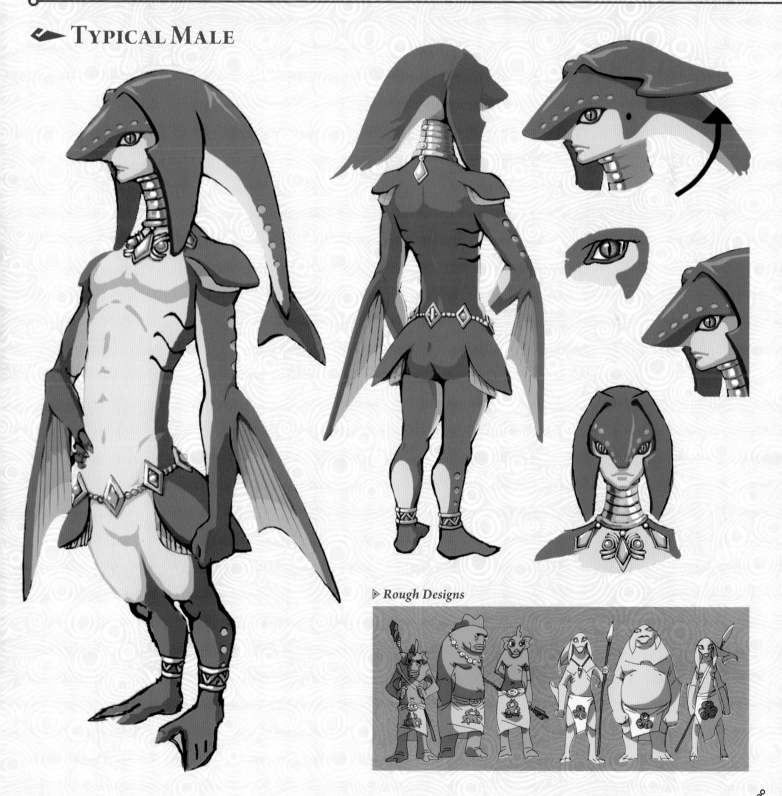

▷ *Rough Designs*

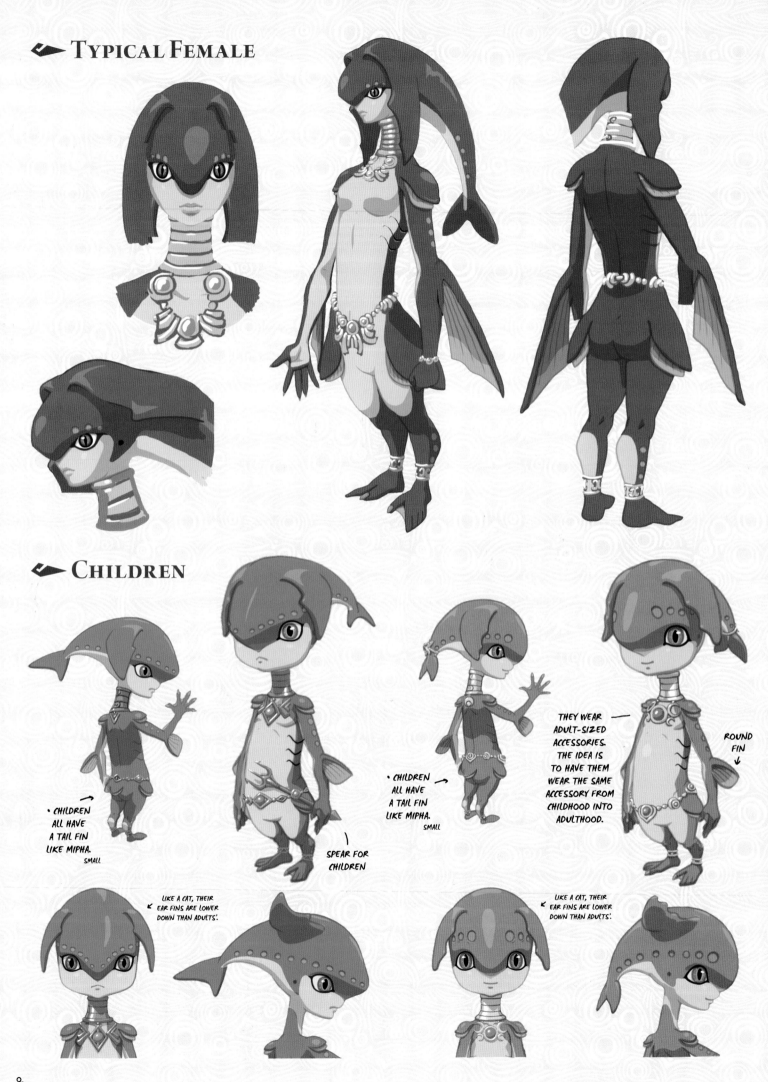

⬥ TYPICAL FEMALE

⬥ CHILDREN

- CHILDREN ALL HAVE A TAIL FIN LIKE MIPHA. SMALL

SPEAR FOR CHILDREN

- CHILDREN ALL HAVE A TAIL FIN LIKE MIPHA. SMALL

THEY WEAR ADULT-SIZED ACCESSORIES. THE IDEA IS TO HAVE THEM WEAR THE SAME ACCESSORY FROM CHILDHOOD INTO ADULTHOOD.

ROUND FIN ↓

LIKE A CAT, THEIR EAR FINS ARE LOWER DOWN THAN ADULTS'.

LIKE A CAT, THEIR EAR FINS ARE LOWER DOWN THAN ADULTS'.

ELDERLY MALE

CUTAWAY NOSE TO SHOW DETAILS BENEATH.

HAS BEEN SWIMMING FOR A LONG TIME, SO THE TIP IS WORN DOWN.

SINEWY DUE TO AGE. LOTS OF WRINKLES. BODY PATTERN LOOKS LIKE AGE SPOTS.

SILVER AND CLOTH ACCESSORY

STREAKED ARMS AND LEGS

FINS HAVE DAMAGE

STIFF HANDS

WITH NOSE ↑

CURVED CLAWS

COUNCILMAN MUZU

Muzu has served as a member of the council for over a century and was in charge of educating Mipha. He came to resent Hylians after losing Mipha in the Great Calamity.

FRONT FIN IS ROUNDED (DEFORM THE ROUNDED SHAPE).

MANTA RAY: FLAT FACE

SHOULDER FINS ARE LIKE A COAT THAT COVERS HIS SHOULDERS.

METAL ON TIPS

METAL CLASP IN THE BACK

LONG-LIVED, SO HIS TAIL FIN IS LONG.

FINS ON HIS THIGHS LOOK LIKE A COAT.

FRONT

BACK

▷ *Typical Zora Rough Designs*

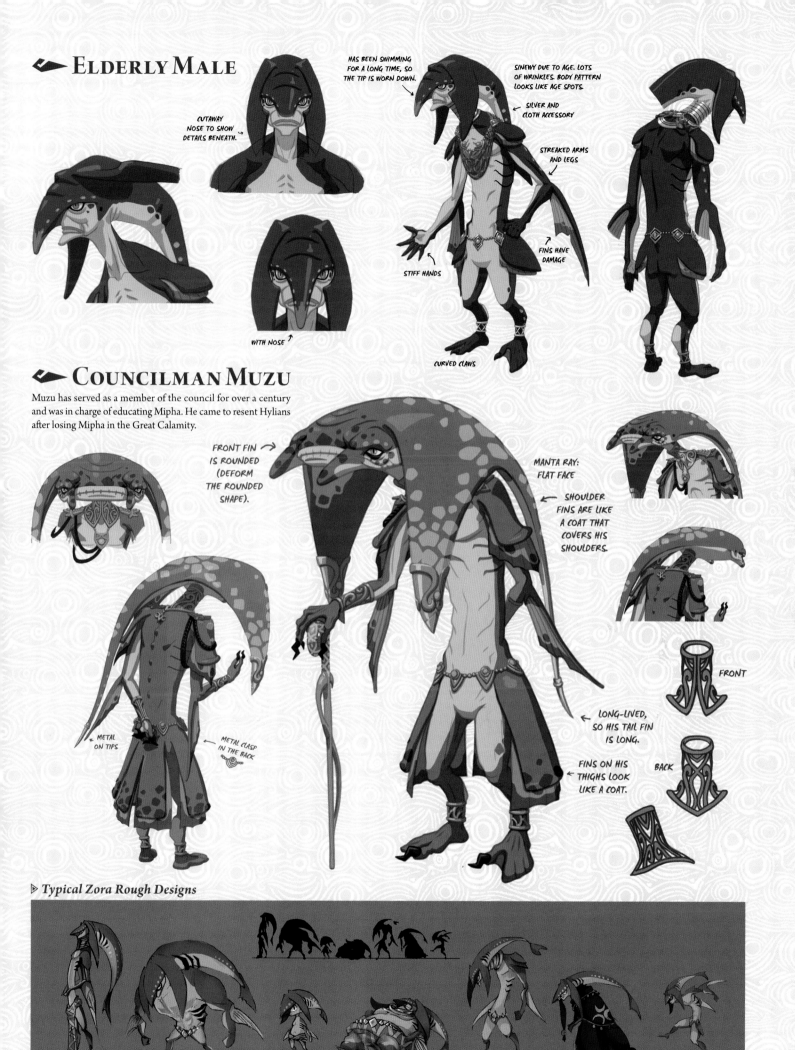

SIDON

Sidon is the son of the Zora king, Dorephan, and the younger brother of the Champion princess, Mipha. Even though he is royalty, he doesn't let his station get in the way of his openhearted personality. He treats everyone with respect regardless of their race, and because of this, he is adored by his people. He is cheerful and positive, and he always expresses his faith in others. Sidon puts his people first and takes the necessary actions to save them.

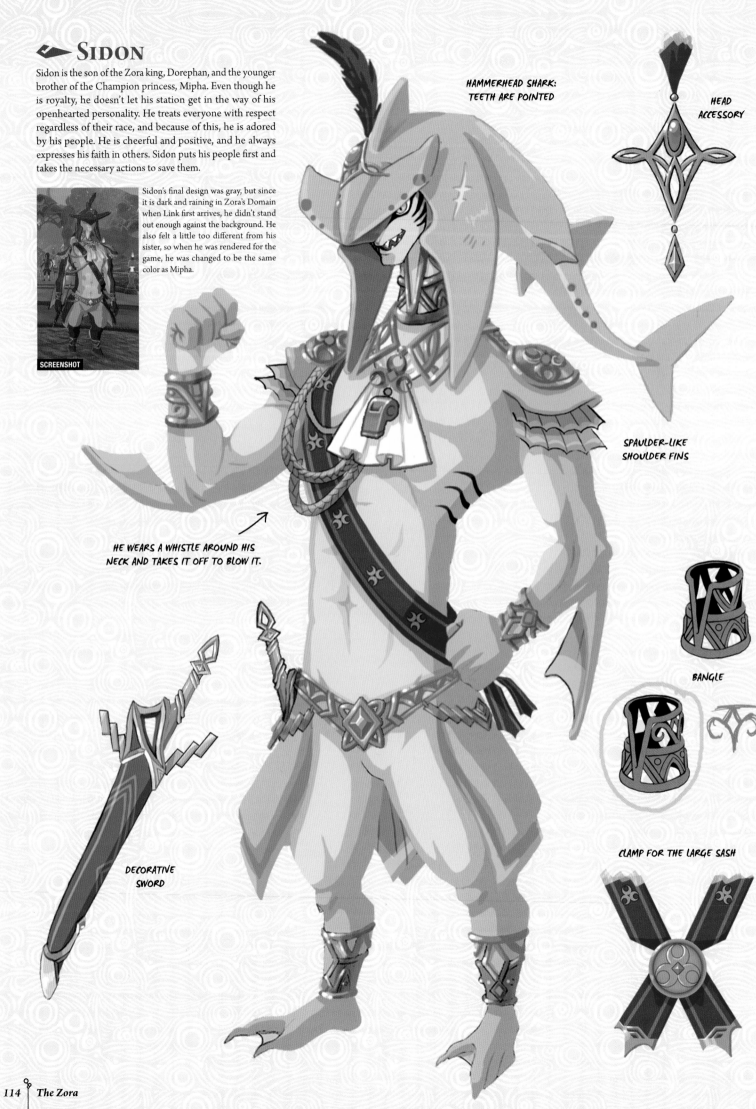

SCREENSHOT

Sidon's final design was gray, but since it is dark and raining in Zora's Domain when Link first arrives, he didn't stand out enough against the background. He also felt a little too different from his sister, so when he was rendered for the game, he was changed to be the same color as Mipha.

HAMMERHEAD SHARK:
TEETH ARE POINTED

HEAD
ACCESSORY

SPAULDER-LIKE
SHOULDER FINS

HE WEARS A WHISTLE AROUND HIS
NECK AND TAKES IT OFF TO BLOW IT.

BANGLE

DECORATIVE
SWORD

CLAMP FOR THE LARGE SASH

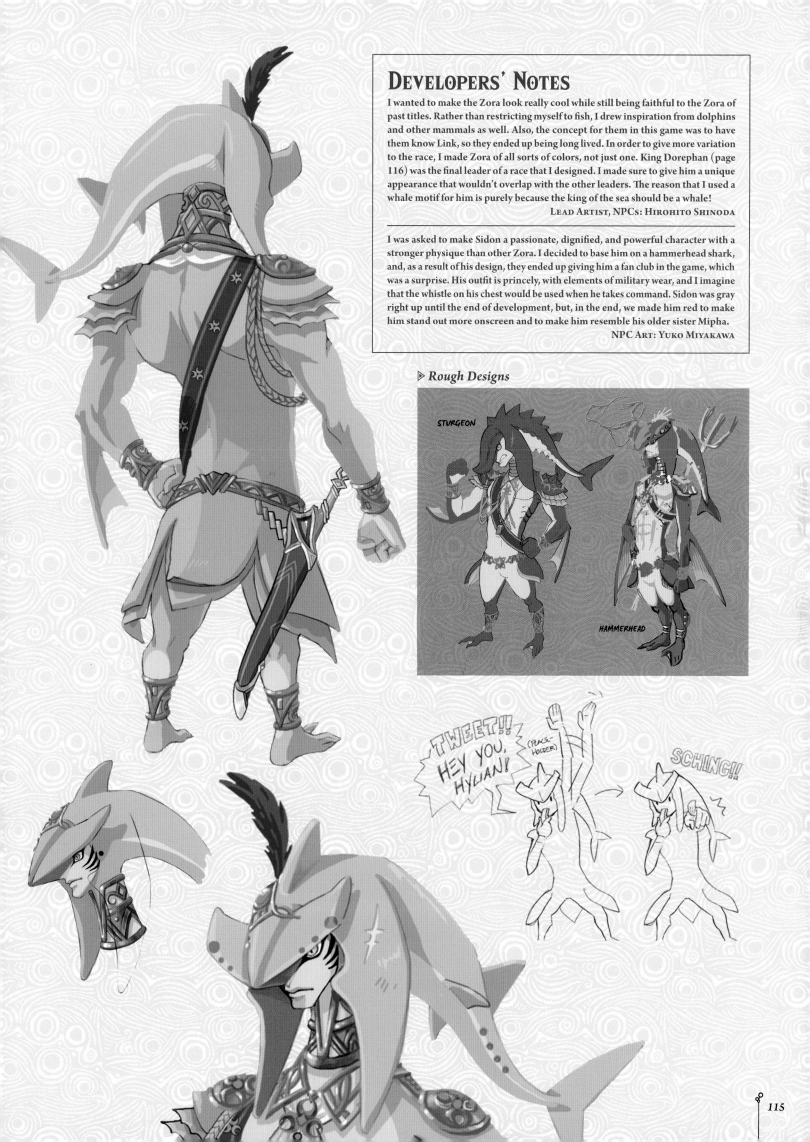

DEVELOPERS' NOTES

I wanted to make the Zora look really cool while still being faithful to the Zora of past titles. Rather than restricting myself to fish, I drew inspiration from dolphins and other mammals as well. Also, the concept for them in this game was to have them know Link, so they ended up being long lived. In order to give more variation to the race, I made Zora of all sorts of colors, not just one. King Dorephan (page 116) was the final leader of a race that I designed. I made sure to give him a unique appearance that wouldn't overlap with the other leaders. The reason that I used a whale motif for him is purely because the king of the sea should be a whale!

LEAD ARTIST, NPCs: HIROHITO SHINODA

I was asked to make Sidon a passionate, dignified, and powerful character with a stronger physique than other Zora. I decided to base him on a hammerhead shark, and, as a result of his design, they ended up giving him a fan club in the game, which was a surprise. His outfit is princely, with elements of military wear, and I imagine that the whistle on his chest would be used when he takes command. Sidon was gray right up until the end of development, but, in the end, we made him red to make him stand out more onscreen and to make him resemble his older sister Mipha.

NPC ART: YUKO MIYAKAWA

▷ *Rough Designs*

STURGEON

HAMMERHEAD

TWEET!! HEY YOU, HYLIAN! (PLACE-HOLDER)

SCHING!!

KING DOREPHAN

Dorephan is the king of the Zora as well as Mipha's father. While getting on in years, he is still sharp and thoughtful. He treats Link warmly upon seeing him again after a century. He is a historian who tells the stories of Zora's Domain passed down through the royal family—as well as tales of his daughter Mipha—to a stonemason to record on stone monuments, ensuring that they will persist long after he's gone.

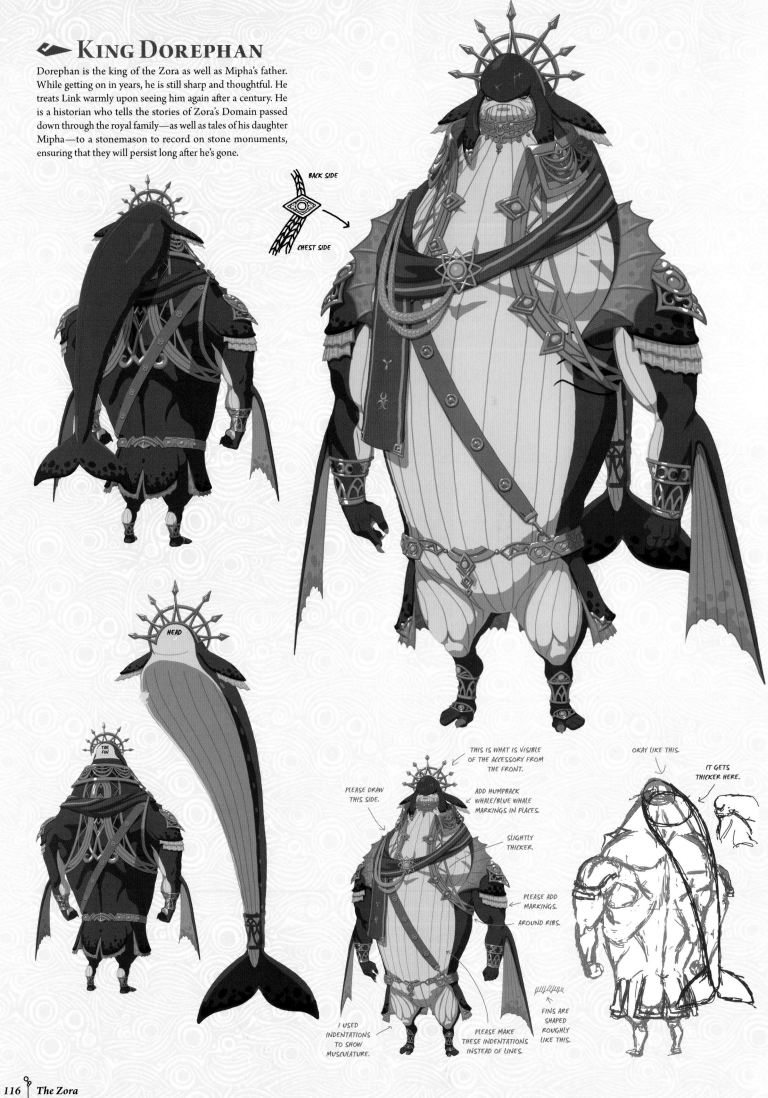

BACK SIDE

CHEST SIDE

HEAD

TAIL FIN

THIS IS WHAT IS VISIBLE OF THE ACCESSORY FROM THE FRONT.

PLEASE DRAW THIS SIDE.

ADD HUMPBACK WHALE/BLUE WHALE MARKINGS IN PLACES.

SLIGHTLY THICKER

PLEASE ADD MARKINGS.

AROUND RIBS.

I USED INDENTATIONS TO SHOW MUSCULATURE.

PLEASE MAKE THESE INDENTATIONS INSTEAD OF LINES.

FINS ARE SHAPED ROUGHLY LIKE THIS.

OKAY LIKE THIS.

IT GETS THICKER HERE.

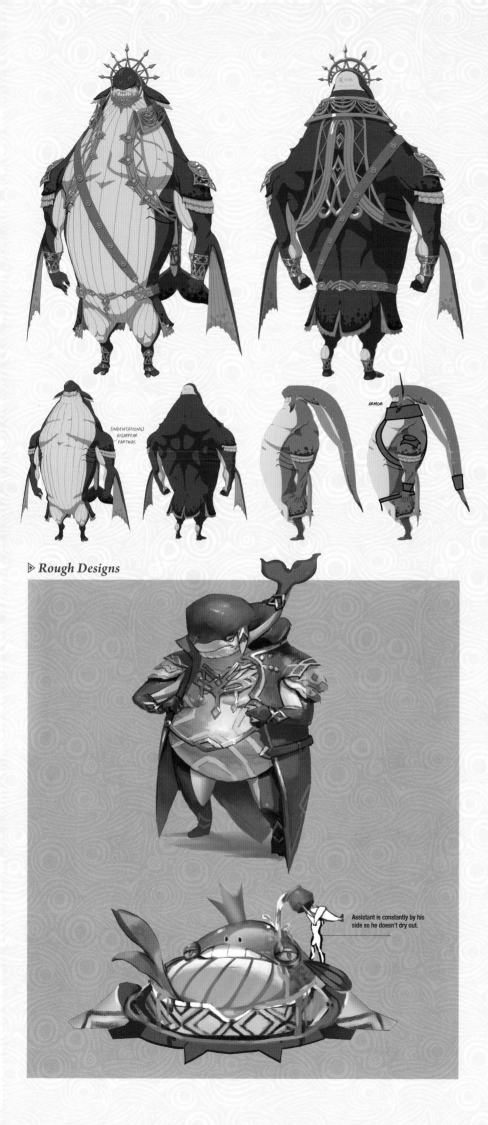

▷ *Rough Designs*

Assistant is constantly by his side so he doesn't dry out.

(INDENTATIONS) DISAPPEAR PARTWAY.

ARMOR

The Zora are specifically suited to water-based activities, and particularly athletic members of the race can even carry Hylians on their backs while they swim. However, they are vulnerable to electricity, which makes it difficult for them to wield shock arrows. When they sleep, they soak in large, deep pools inside Zora's Domain. The pools are communal—they do not have individual homes.

REUNION & RECONCILIATION

The Zora live exceptionally long lives compared to other Hyruleans, so most of those considered adults in Zora's Domain are over one-hundred years old. Link visited often when he was young, and the Zora he was friends with are now middle aged in Hylian terms. Although Sidon was alive a century ago and would have seen Link and Mipha together, he was too young to remember Link's face. He does not recognize the hero when he encounters him in the present.

Since the Great Calamity, the elders resent Link as one of the causes for Mipha's death, but they reconsider their long-held grudge after he saves Zora's Domain from disaster.

A VILLAGE BUILT
WITH CRAFTSMANSHIP

The Lanayru Great Spring contains a wealth of ore, which led the Zora to develop exceptional stonemasonry techniques which can be seen in their buildings. They also developed exquisite metalsmithing skills and make beautiful accessories as well as equipment. Those tasked with protecting the area around Zora's Domain wear helmets and chest plates, while nonmilitary Zora including the royal family wear decorative ornamentation like necklaces and bangles. The Lightscale Trident that Mipha wielded was created by the Zora smith Dento.

THE GORONS
GOOD FOLKS WITH BIG, BOULDER-LIKE BODIES

Gorons possess massive, powerful, stone-like bodies and call the side of Death Mountain home. They boast superior strength and can withstand the blazing heat of piping-hot magma, but most are fairly laid-back individuals. They can curl into a ball and roll in order to get around, protecting their faces with their large arms and hands.

◄ TYPICAL GORON

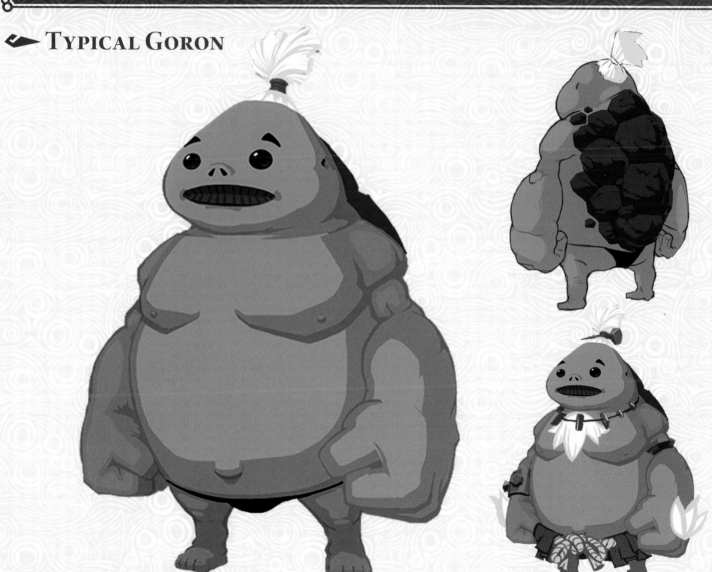

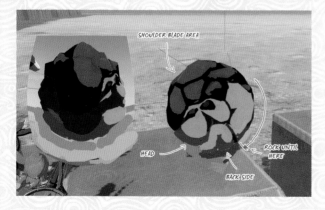

SHOULDER BLADE AREA

HEAD

ROCK UNTIL HERE

BACK SIDE

▷ Rough Designs

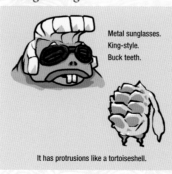

Metal sunglasses.
King-style.
Buck teeth.

It has protrusions like a tortoiseshell.

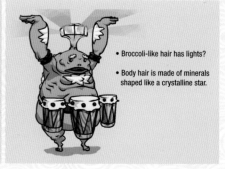

• Broccoli-like hair has lights?

• Body hair is made of minerals shaped like a crystalline star.

☜ ELDERLY GORON

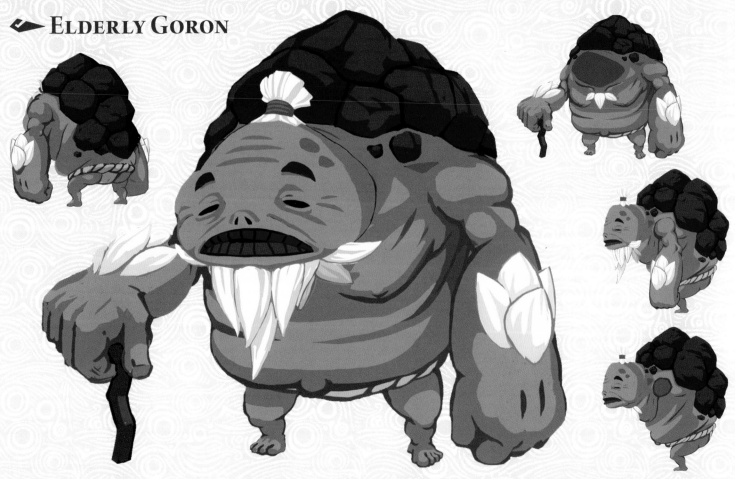

☜ CHILD

▷ **Traveling Pack**

They set out on a journey with a single iron cage frame and find cloth sacks to store things in along the way.

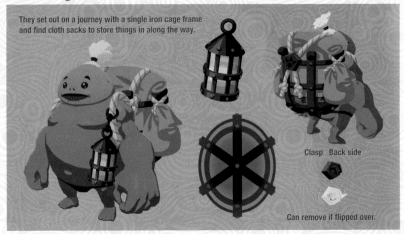

Clasp Back side

Can remove if flipped over.

☜ MINING EQUIPMENT

▷ *Mallet*

▷ *Pickaxe*

SHOULD BE ABOUT THIS SIZE.

▷ *Pincers*

▷ *Helmet*

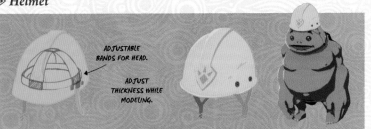

ADJUSTABLE BANDS FOR HEAD.

ADJUST THICKNESS WHILE MODELING.

▷ *Forehead Protector*

▷ *Headband*

BLUDO

Bludo is the Goron chief and the boss of the Goron Group Mining Company, which supports the development of Goron City. He has a rough way about him and is impatient, but he also has a strong sense of duty and real compassion. He is strong enough to swat Magma Bombs out of the air with his bare hands, but he also suffers from chronic back pain.

Back of head

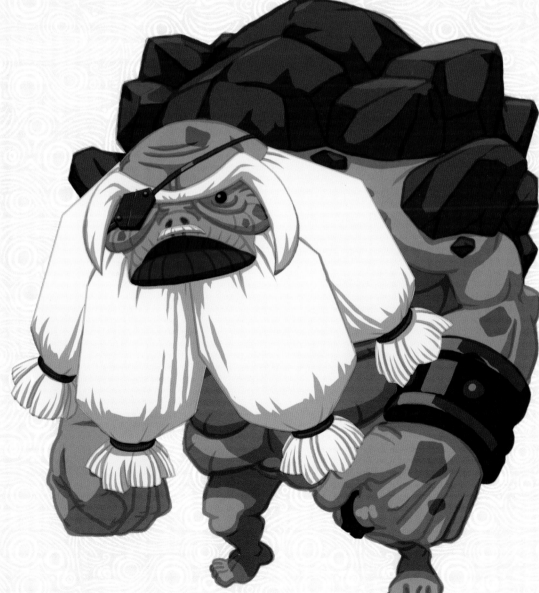

RING

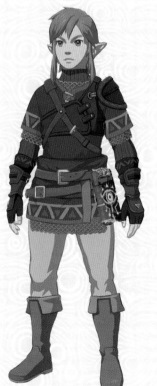

YUNOBO

Yunobo is the grandchild of the Champion Daruk. He has an adult body but still has some growing up to do. He is easily frightened by monsters and isn't exactly what one might call brave, but, driven by thoughts of protecting his people, he gathers enough courage to aid Link in quelling the Divine Beast Vah Rudania. He is earnest and naive, readily believing nearly anything anyone tells him.

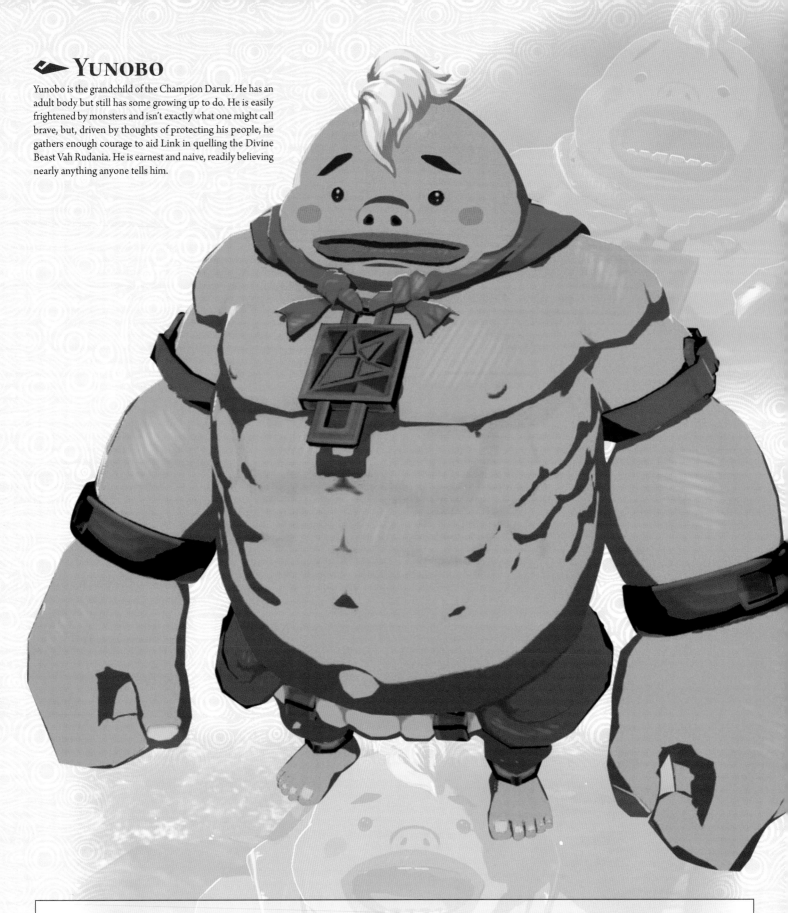

DEVELOPER'S NOTE

At the beginning of development, we tried to dramatically change the Gorons' appearance compared to past titles. I made their heads bigger, made them more human-like, and explored a lot of different ideas, but none of them really fit. So I returned to their roots and decided to lean into their original design from *Ocarina of Time*. In recent titles the Gorons have had tattoos, but I thought that due to the anime-like styling of this title, we should aim to make use of empty space rather than trying to fill it, so I went with a very clean design. Rather than just making them round, I paid close attention to the 3D model to ensure they felt like a sumo wrestler, someone with body fat and muscles, and that they looked powerful. At first, to make Yunobo look related to his grandfather Daruk, I made Yunobo very similar—from his hairstyle to his muscles. A lot of people said that it made him look like an old man, so I made some major changes to his design to make him feel younger and sweeter. The character was spawned from the idea of a character who is cowardly but paradoxically physically powerful. The gap between being very strong with high physical potential while being a bit fragile led to a very charming character.

LEAD ARTIST, NPCS: HIROHITO SHINODA

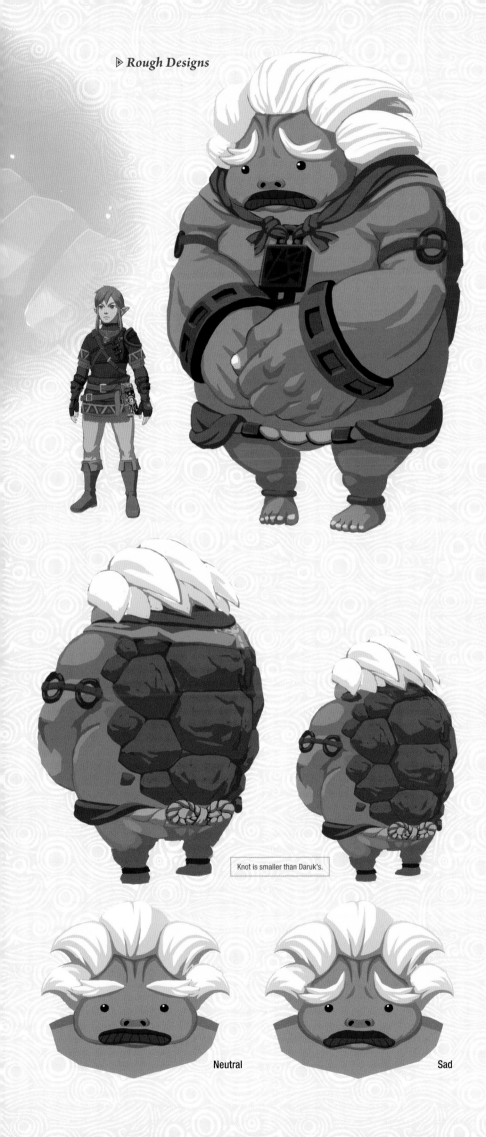

▷ *Rough Designs*

Knot is smaller than Daruk's.

Neutral

Sad

Gorons consume the stone excavated from around Death Mountain and have powerful jaws with strong teeth for breaking down the hard rock. It is said that rock roasts, a delicacy to the Gorons, can only be obtained in a limited number of areas. However, not all stones are palatable. Gorons don't think that gemstones taste particularly good and once treated them as worthless.

AN EXPORT-DRIVEN ECONOMY

Many of the Gorons living in Goron City are employees of the Goron Group Mining Company and make a living excavating and selling ore. Bludo, boss and founder of the company, noticed that the gemstones found around the volcano that they thought were worthless traded for a high price to other races. He started a thriving business selling these gemstones, and it developed into the largest enterprise among the Gorons. The profits from mining gemstones drive Goron City's economy, leading it to develop into the thriving city it is today.

TRAVELING GORONS

The Gorons are able to adapt to some of the harshest environments in Hyrule due to their sturdy bodies. That is why Gorons can be found on roads or in villages all over the realm. There are even those who visit Zora's Domain, which requires traversing its slippery mountain path, and Gerudo Town, which only permits women to enter. Gorons are about as widespread as Hylians are throughout the world.

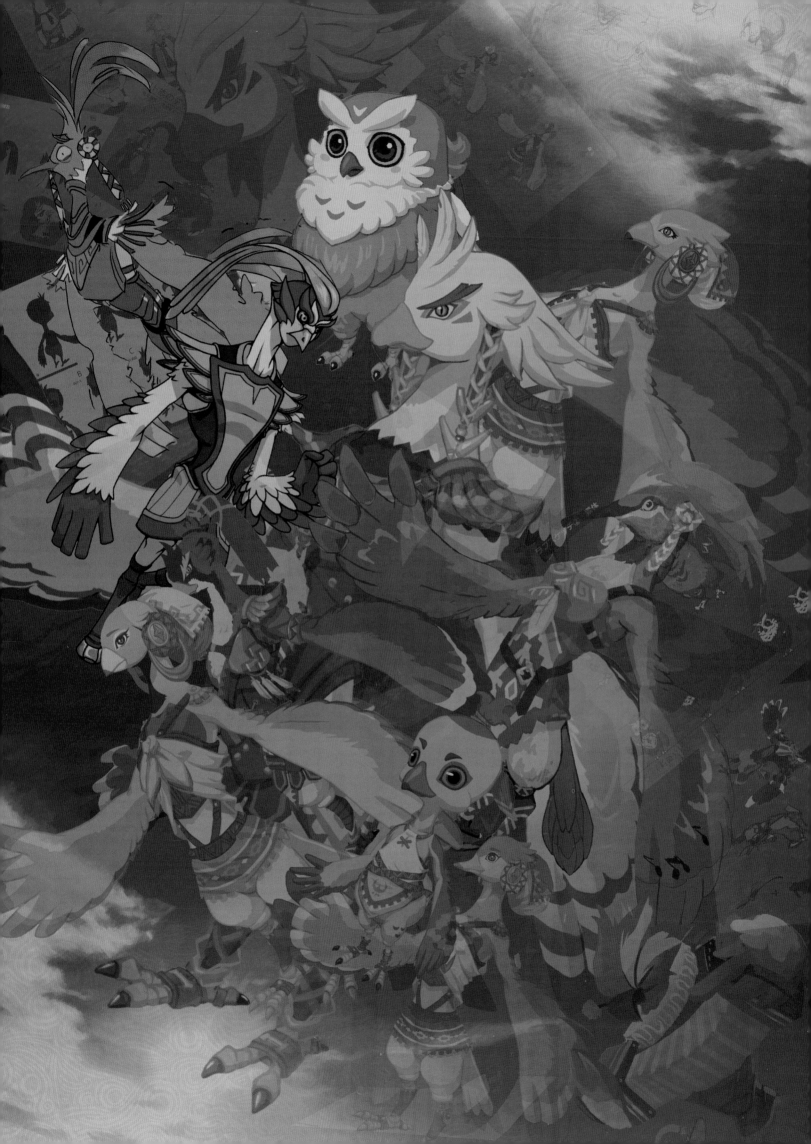

THE RITO
WIND-DANCING RULERS OF THE SKY

The Rito have established a village in the Tabantha Frontier near the snowy peaks of Hebra. They are easily identifiable by their bird-like features—colorful feathers, beaks, and taloned feet. Using their powerful winged arms, they move through the sky freely. They are a people with a tradition of developing expert archers and skilled songsters. Rito warriors are so adept at aerial maneuvers that they are nearly invincible in the air, earning them the reputation of being rulers of the sky.

◤ TYPICAL MALE

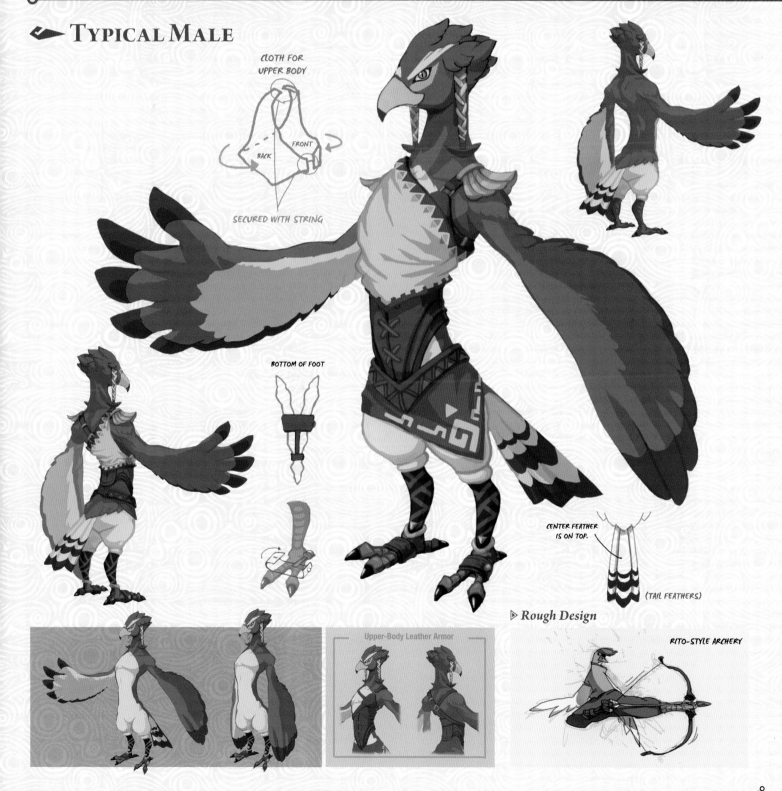

CLOTH FOR UPPER BODY

BACK

FRONT

SECURED WITH STRING

BOTTOM OF FOOT

CENTER FEATHER IS ON TOP.

(TAIL FEATHERS)

▷ Rough Design

Upper-Body Leather Armor

RITO-STYLE ARCHERY

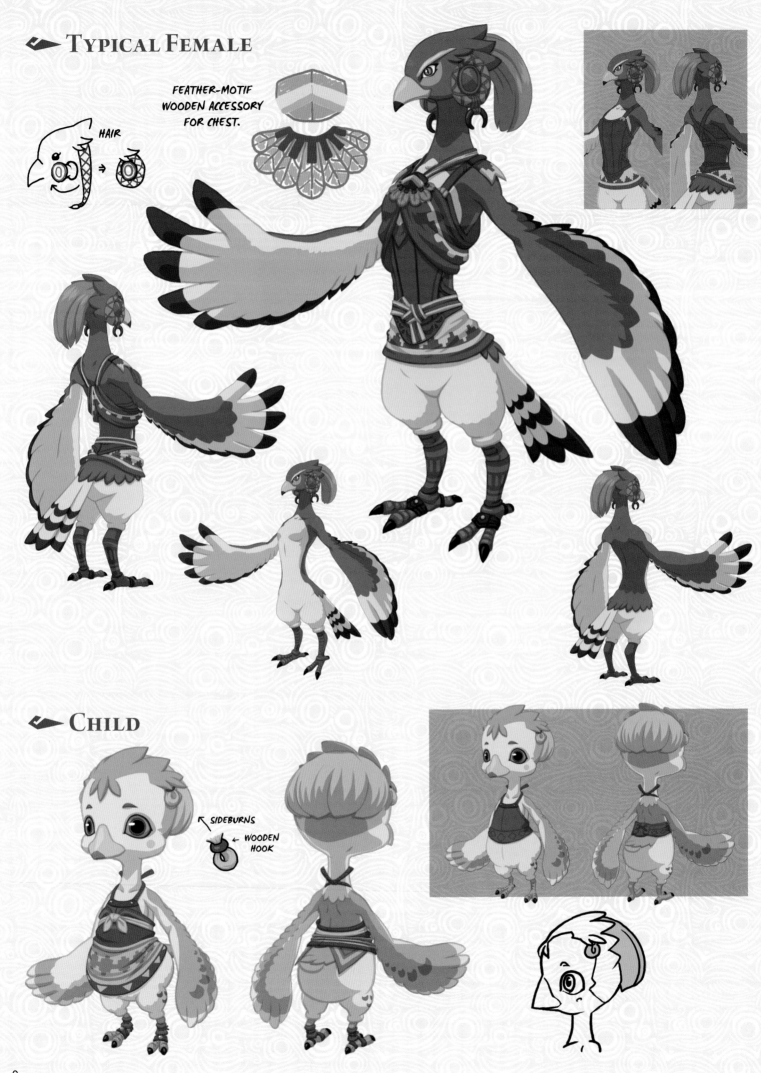

⬤ TYPICAL FEMALE

FEATHER-MOTIF
WOODEN ACCESSORY
FOR CHEST.

HAIR

⬤ CHILD

SIDEBURNS

WOODEN HOOK

HARTH

Harth is a young man who has taken over the family business of bow craftsmanship and inherited the technical know-how for repairing the late Champion Revali's beloved Great Eagle Bow. He is a Rito warrior whose friend Teba is a bad influence on him.

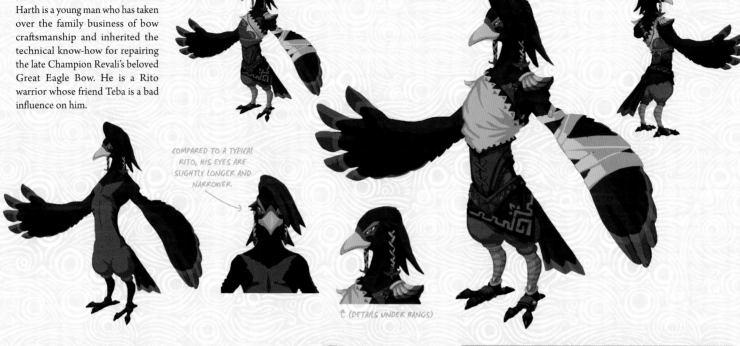

COMPARED TO A TYPICAL RITO, HIS EYES ARE SLIGHTLY LONGER AND NARROWER.

↑ (DETAILS UNDER BANGS)

KANELI

Kaneli is the chief of the Rito. He is well versed in stories of the Champions passed down through the ages and thinks Link must be a descendant of the Hylian Champion due to the Sheikah Slate on his hip. Kaneli asks him to stop Teba from confronting the rampaging Vah Medoh alone and to stop the Divine Beast from causing harm to his people.

DETAIL OF WHAT HIS HAIR LOOKS LIKE UNDER HIS BEARD

POSTURE CONCEPT

His cane is carved from wood. The carving is detailed and the wood rough, but the handle is starting to look smooth and gentle to the touch due to years of use.

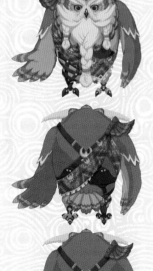

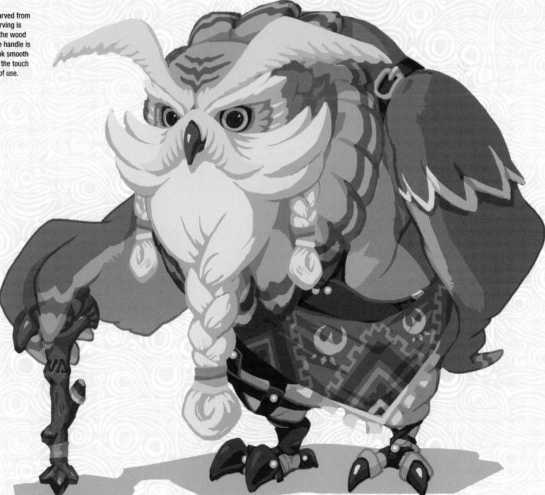

TEBA

Teba is the most skilled Rito warrior of his generation. No one can hope to compare. However, his pride makes him reckless. He is preparing to take on Vah Medoh by himself after his friend Harth was injured in an attempt to investigate the beast. He is secure enough to recognize and appreciate skill in others. He is also training his son Tulin to be a proud warrior, but his wife, Saki, is opposed.

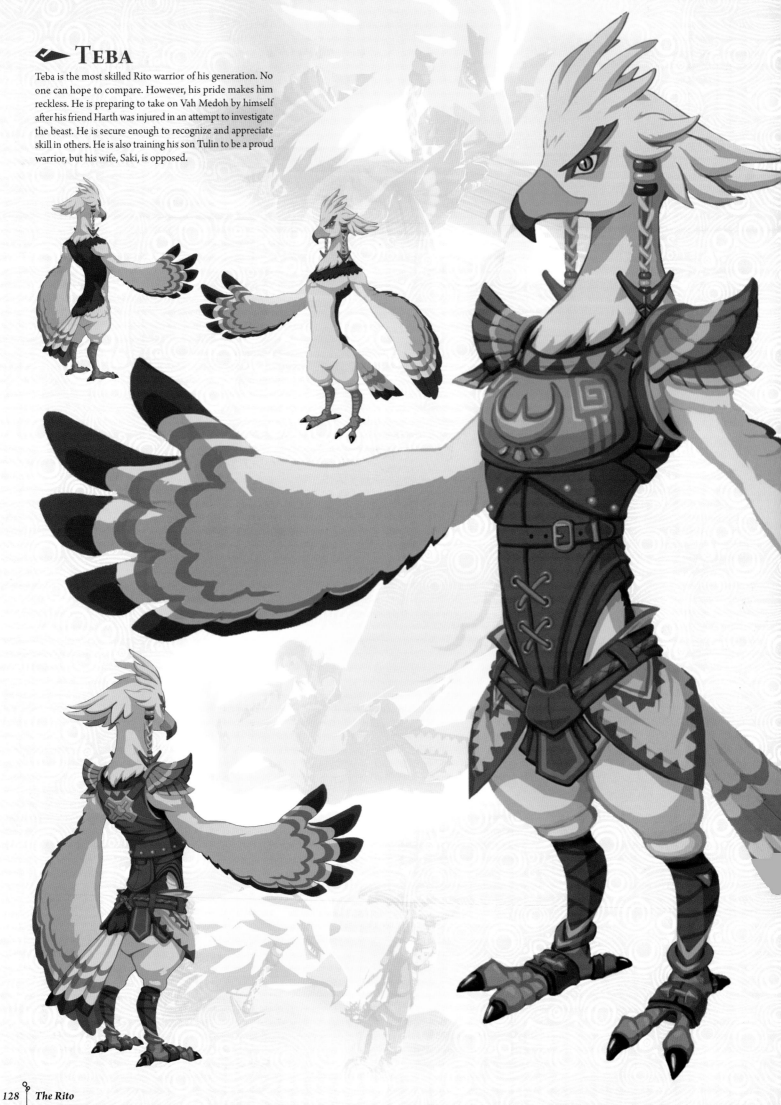

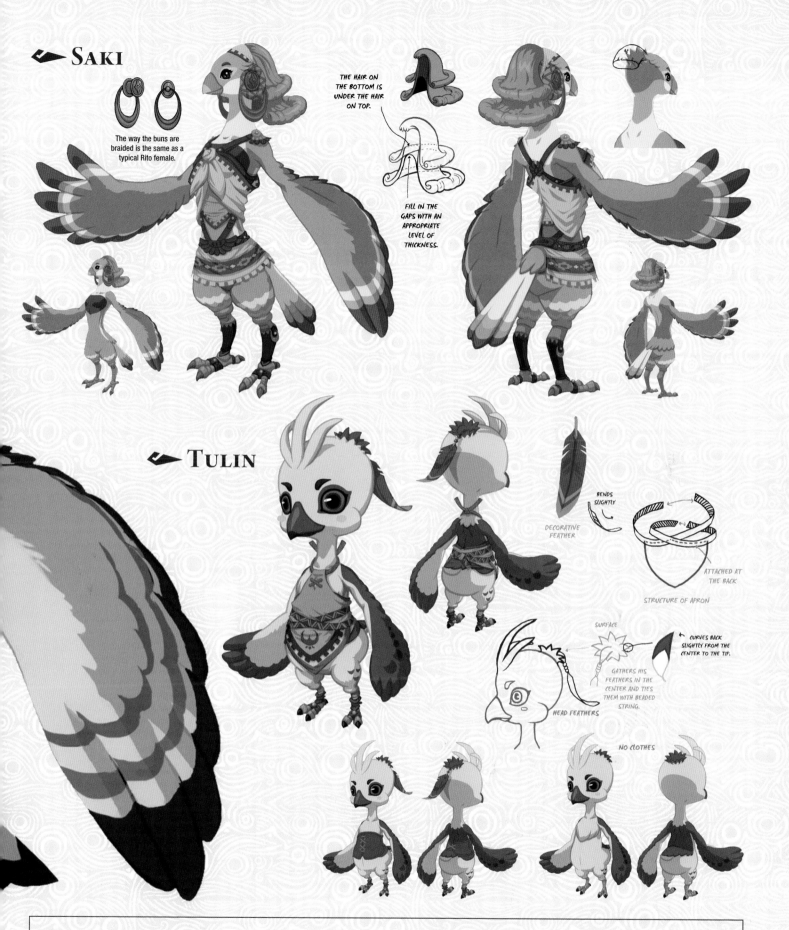

SAKI

The way the buns are braided is the same as a typical Rito female.

THE HAIR ON THE BOTTOM IS UNDER THE HAIR ON TOP.

FILL IN THE GAPS WITH AN APPROPRIATE LEVEL OF THICKNESS.

TULIN

DECORATIVE FEATHER

BENDS SLIGHTLY

ATTACHED AT THE BACK

STRUCTURE OF APRON

SURFACE

CURVES BACK SLIGHTLY FROM THE CENTER TO THE TIP.

GATHERS HIS FEATHERS IN THE CENTER AND TIES THEM WITH BEADED STRING.

HEAD FEATHERS

NO CLOTHES

DEVELOPER'S NOTE

The Rito first appeared in *The Wind Waker*, but their appearance has changed dramatically since then. The biggest reason for that is that I wanted to emphasize their bird-like silhouette and have their unique characteristics stand out more as a race. As they are based mainly on birds of prey, I tried to present them as dignified and stout. Teba was originally a brown color, since he is based on a hawk, but in order to differentiate him as the village's number-one warrior, I made him white, which is unique among the rest of the Rito. Kass (page 130) is based on a blue-and-yellow macaw. I referenced the outfits of European nobility from the Middle Ages and made him a genteel bird. I had decided that he would carry either an accordion or bandoneon, but his hands are large wings, so I was very nervous that he wouldn't be able to hold an instrument properly until I saw the final model. His chest is exaggerated, so I imagine that his animator struggled with him quite a bit.

LEAD ARTIST, NPCs: HIROHITO SHINODA

KASS

Kass is a bard who wanders Hyrule in search of ancient hero songs. He was the student of the Sheikah court poet in service to the royal family a century ago and the keeper of the song of the two brave souls who battled the Calamity ten thousand years ago. He vowed that he would share his teacher's song with the chosen hero, so he left Rito Village, his home, and travels the world, aiding Link with poetry from the past. He is a father of five daughters.

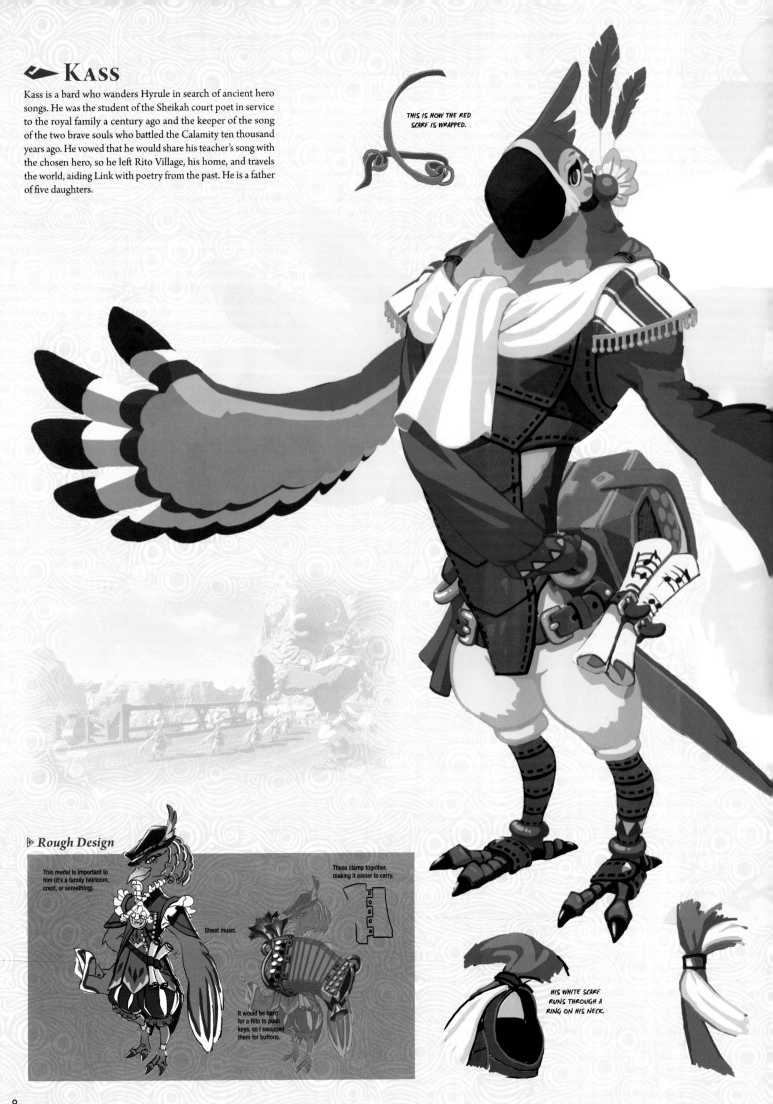

THIS IS HOW THE RED SCARF IS WRAPPED.

▷ *Rough Design*

This medal is important to him (it's a family heirloom, crest, or something).

These clamp together, making it easier to carry.

Sheet music.

It would be hard for a Rito to push keys, so I swapped them for buttons.

HIS WHITE SCARF RUNS THROUGH A RING ON HIS NECK.

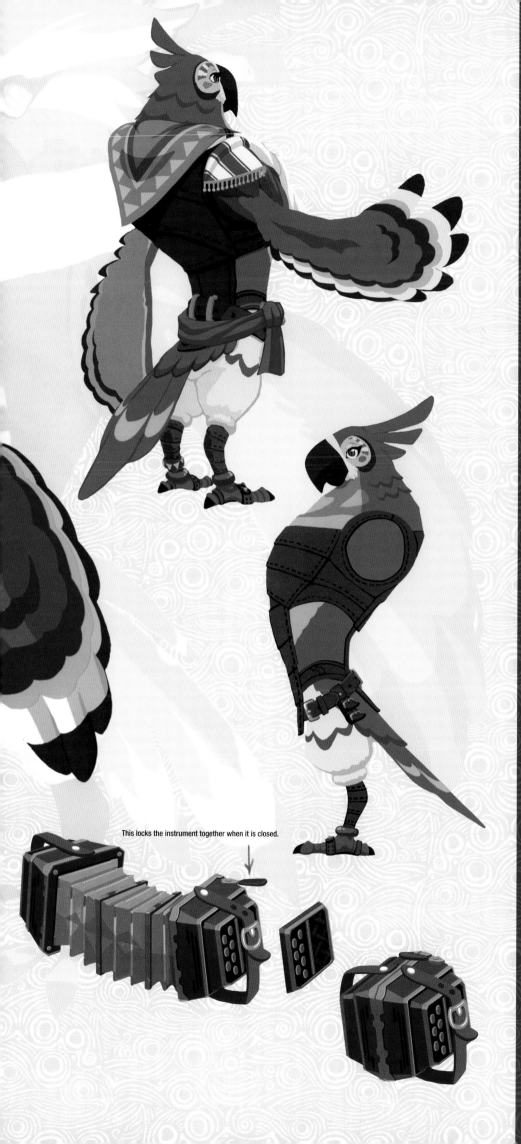

This locks the instrument together when it is closed.

The Rito are a combination of the traits of birds and Hylians. For example, they have poor night vision and struggle to see in dimly lit places like some types of birds. They also prefer to eat meat or fish like birds of prey, but their store sells butter and grains as well. Some of their recipes are similar to what a Hylian might eat.

INSULATING FEATHERS

One of the Rito's most useful qualities is that their bodies are completely covered in soft feathers which retain heat. That is particularly helpful since they dwell in a chilly climate, and it also enables them to fly high into altitudes where the cold is extreme. Baby Rito's feathers will molt once per year with the seasons, and their shed feathers can be used to make warm doublets for Hylians. They can also be used for feather beds in places like inns. The Rito have developed a thriving industry based on their feathers.

Each individual's feathers have unique coloration, and the Rito aesthetic draws on a wide palette as well. Their furniture and clothing are eye catching because of their bright, colorful patterns.

The Rito only get slightly chilled in places where Hylians without warm clothing or a special elixir would be sapped of their strength.

SONGS PASSED
DOWN BY THE RITO

The Rito are known for their musical abilities and have passed down many legends through the ages in the form of songs or poems. The songs taught to Link by Laissa and Bedoli and the one sung by the five young sisters at the Warbler's Nest are prime examples.

Many of the Rito's songs convey the locations of ancient shrines and are meant for the hero chosen by the Master Sword.

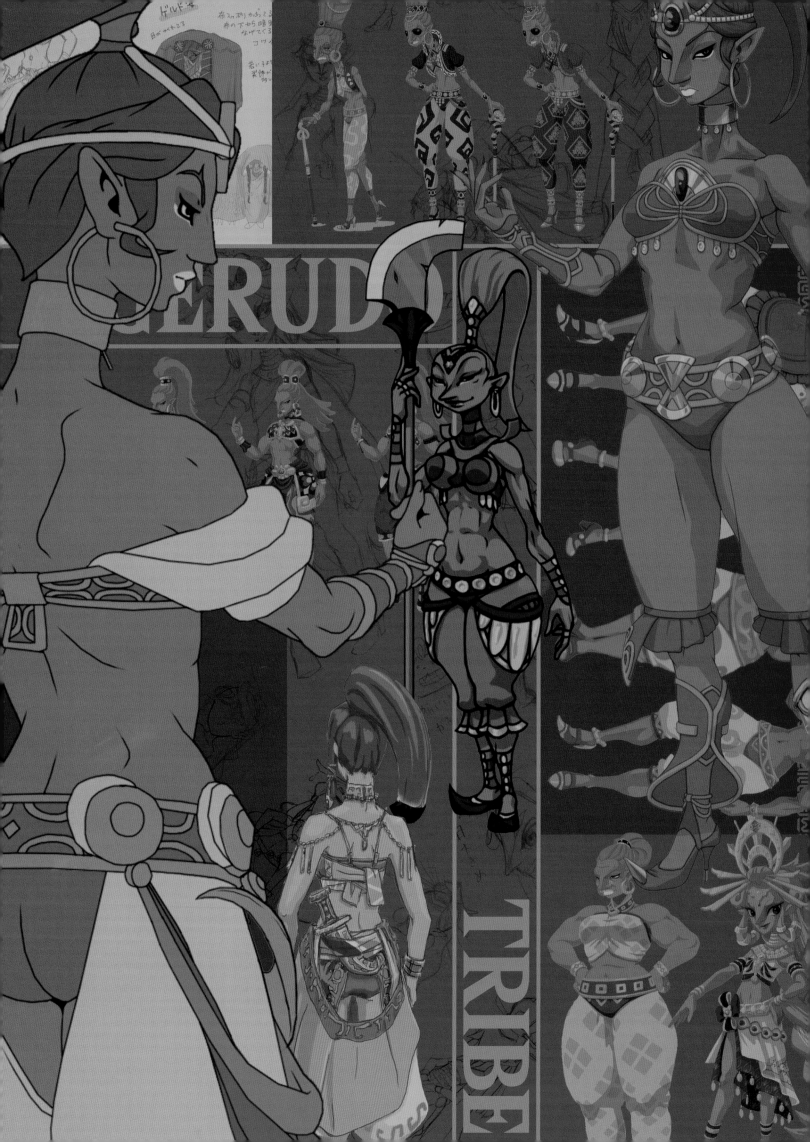

GERUDO TRIBE

THE GERUDO
PROUD WOMEN OF THE DESERT

The Gerudo are a tribe composed exclusively of women who have built a prosperous settlement in the Gerudo Desert. The Gerudo have brilliant red hair and brown skin. They are taller than Hylian women and have a more muscular build. With training, they are easily some of the fiercest warriors in Hyrule. They have their own unique language and, because they are a society isolated by a vast desert, their own deeply rooted culture and customs.

TYPICAL GERUDO

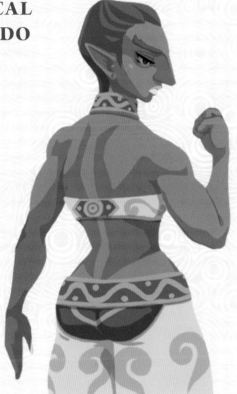

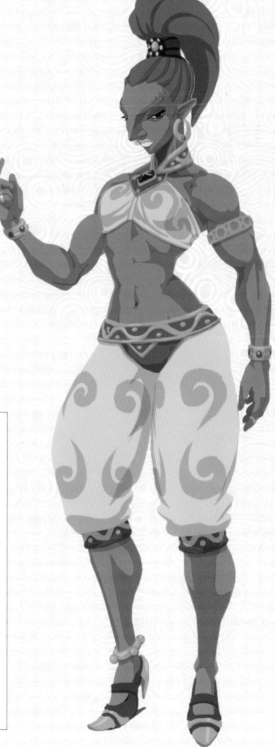

▷ *Rough Designs*

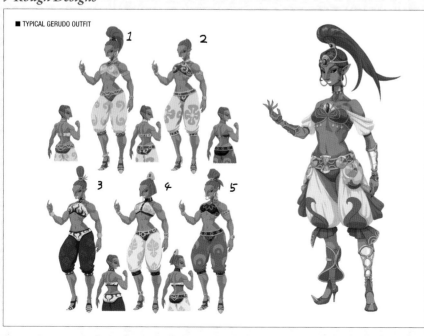

■ TYPICAL GERUDO OUTFIT

1　2　3　4　5

133

MIDDLE-AGED GERUDO

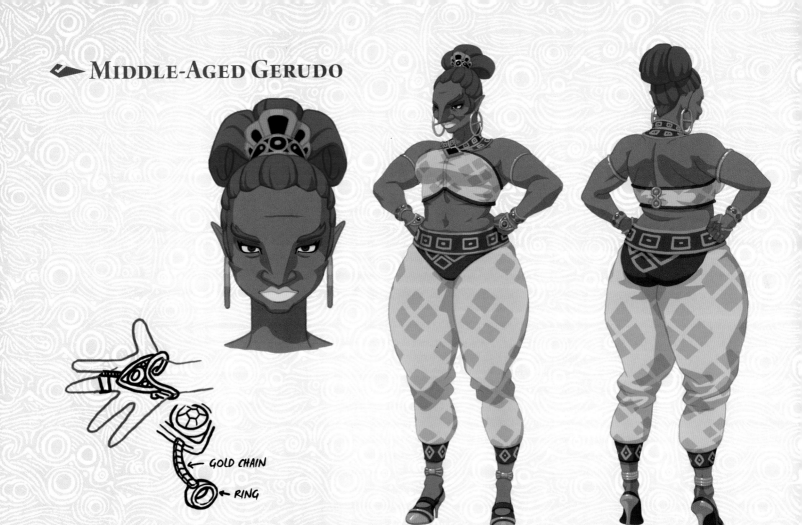

GOLD CHAIN ◄ ──

RING ◄ ──

ELDERLY GERUDO

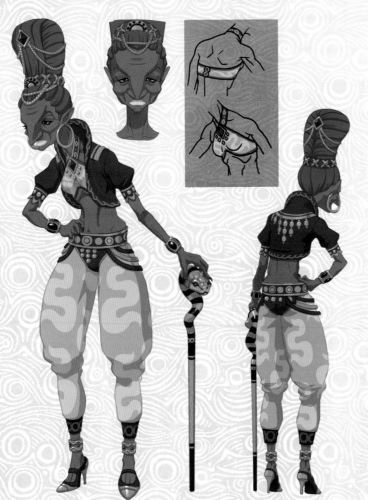

CHILD GERUDO

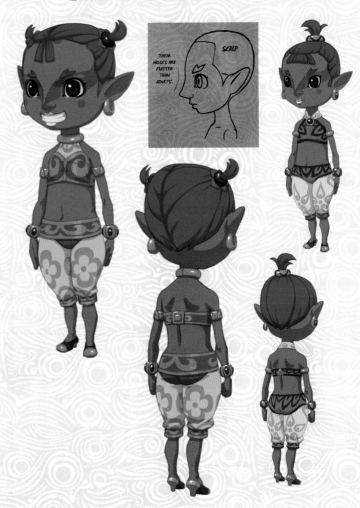

THEIR NOSES ARE FLATTER THAN ADULTS'.

SCALP

SAND-SEAL RENTAL SHOP

Kohm and her daughter Frelly own the Sand-Seal Rental Shop and rent out domesticated sand seals as a means of traversing the desert. They will also explain how to ride a sand seal. Kohm manages the west entrance booth, and Frelly works the east entrance booth, covering both sides of town.

▷ *Kohm*

▷ *Frelly*

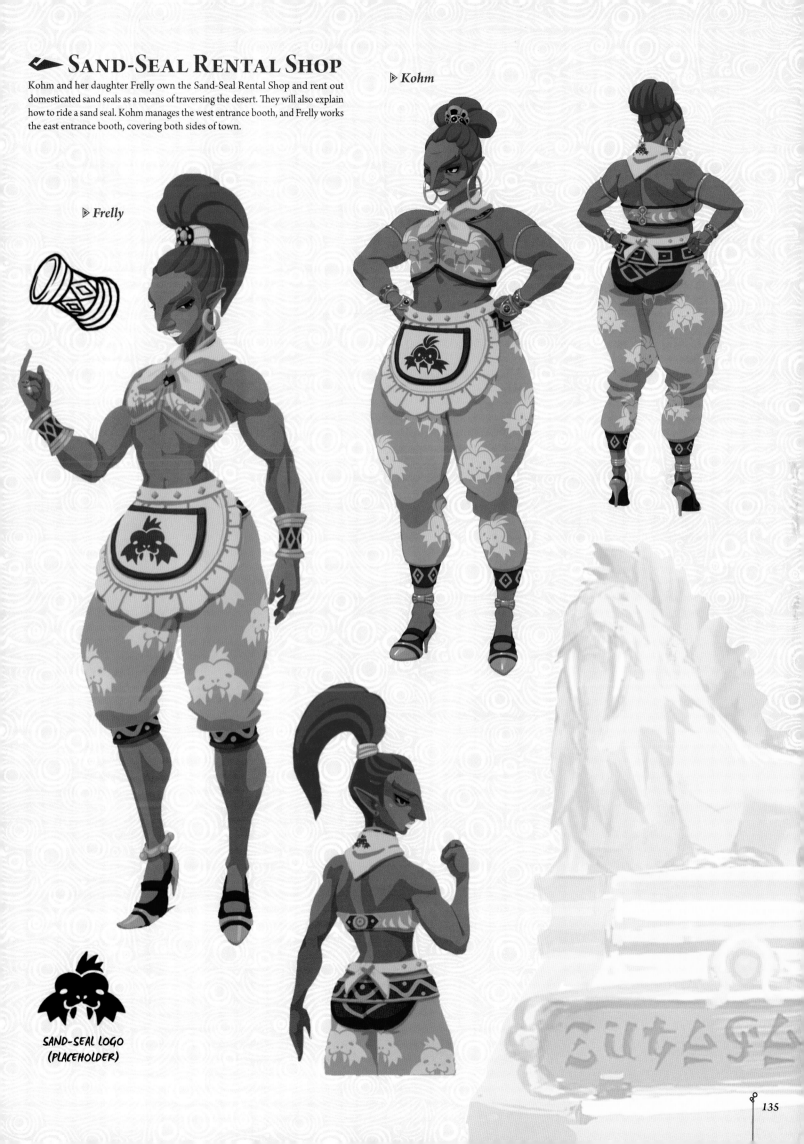

SAND-SEAL LOGO
(PLACEHOLDER)

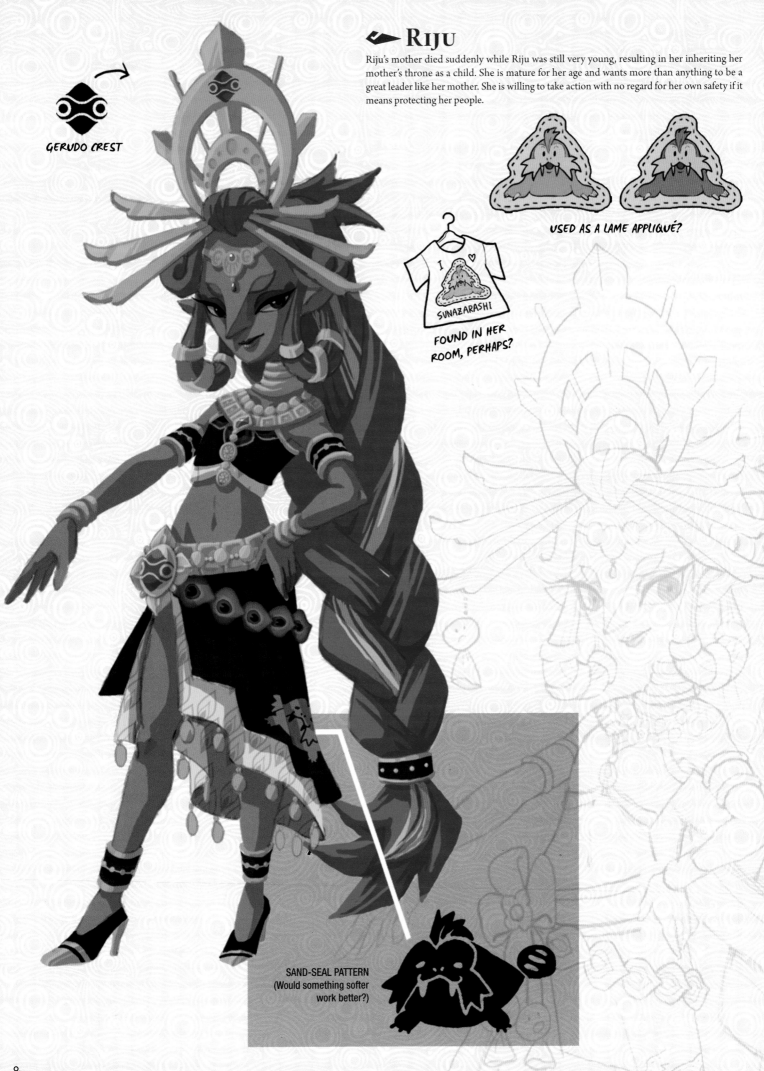

GERUDO CREST

Riju

Riju's mother died suddenly while Riju was still very young, resulting in her inheriting her mother's throne as a child. She is mature for her age and wants more than anything to be a great leader like her mother. She is willing to take action with no regard for her own safety if it means protecting her people.

USED AS A LAME APPLIQUÉ?

I ♥ SUNAZARASHI

FOUND IN HER ROOM, PERHAPS?

SAND-SEAL PATTERN
(Would something softer work better?)

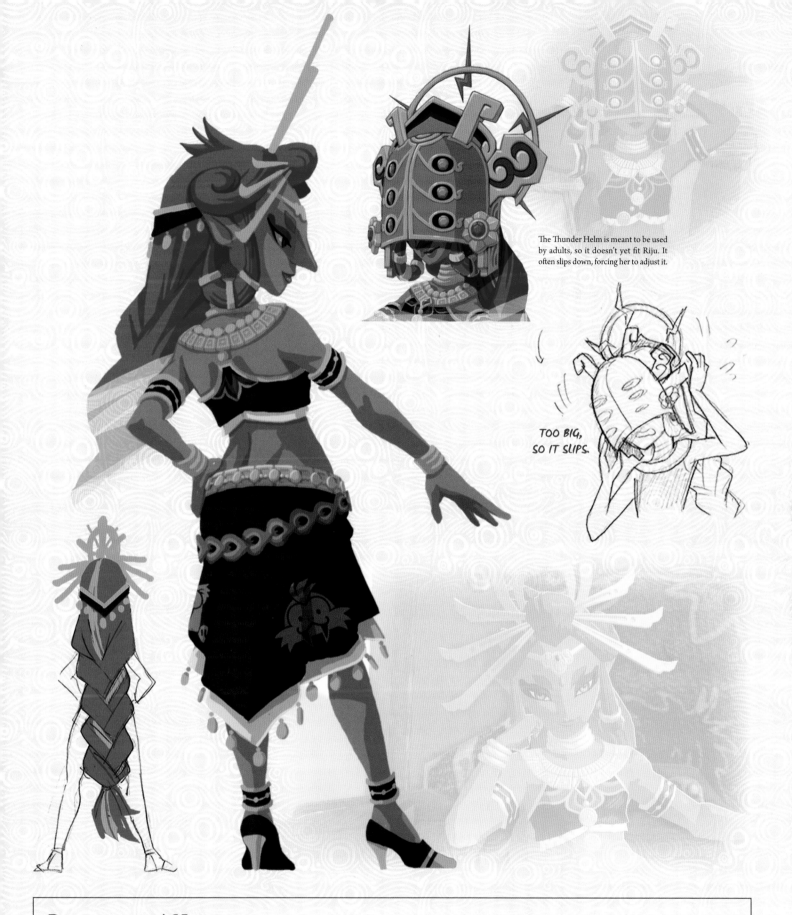

The Thunder Helm is meant to be used by adults, so it doesn't yet fit Riju. It often slips down, forcing her to adjust it.

TOO BIG, SO IT SLIPS.

DEVELOPERS' NOTES

While retaining key elements of previous Gerudo iterations, I designed them to cut striking figures while standing—making their torsos shorter and their legs longer. I also included design elements from Buddhist statues that haven't been present in the series until now, so they are influenced by both Indian and Chinese culture as a result, making their appearance in this game unique.

LEAD ARTIST, NPCs: HIROHITO SHINODA

I thought about how to balance Riju with the leaders of the other Hyrulean races, and so, to create more variation and impact on the plot, I made her a child. She respects her ancestor Urbosa and possesses some of her accessories. She is about twelve years old, but because the Gerudo grow up faster than Hylians, she has a more mature air to her. She presents herself with dignity as the chief, but I also wanted to give her some girlishness appropriate to her age, so she loves sand seals. She has a ton of sand-seal merchandise in her room, and even her skirt has a sand seal on it.

NPC ART: YUKO MIYAKAWA

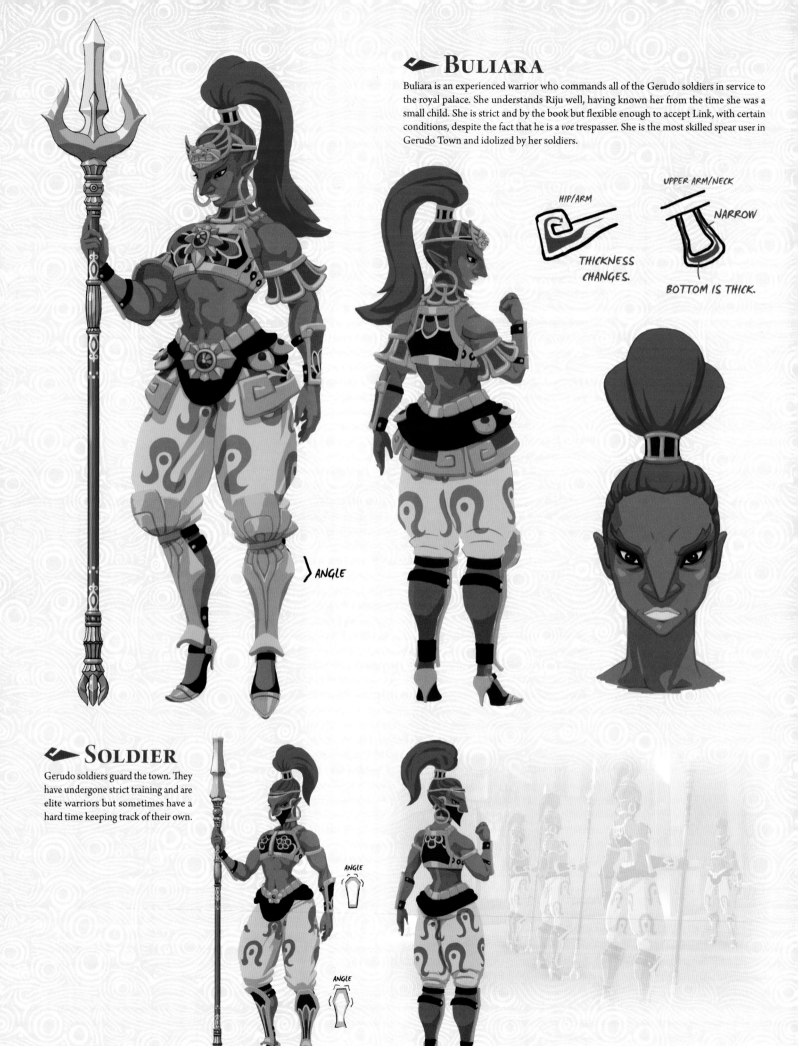

BULIARA

Buliara is an experienced warrior who commands all of the Gerudo soldiers in service to the royal palace. She understands Riju well, having known her from the time she was a small child. She is strict and by the book but flexible enough to accept Link, with certain conditions, despite the fact that he is a *voe* trespasser. She is the most skilled spear user in Gerudo Town and idolized by her soldiers.

HIP/ARM

THICKNESS CHANGES.

UPPER ARM/NECK

NARROW

BOTTOM IS THICK.

ANGLE

SOLDIER

Gerudo soldiers guard the town. They have undergone strict training and are elite warriors but sometimes have a hard time keeping track of their own.

ANGLE

ANGLE

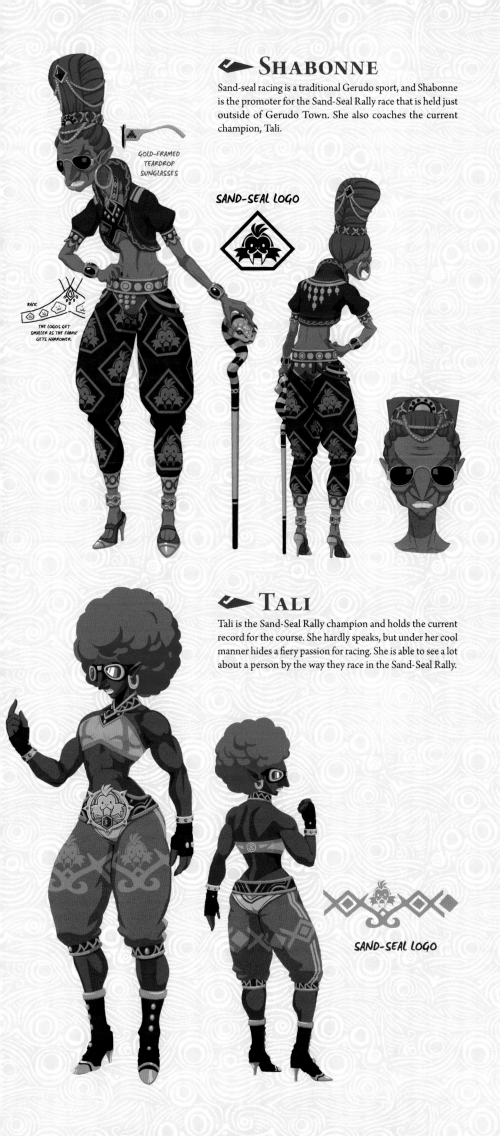

SHABONNE

Sand-seal racing is a traditional Gerudo sport, and Shabonne is the promoter for the Sand-Seal Rally race that is held just outside of Gerudo Town. She also coaches the current champion, Tali.

GOLD-FRAMED TEARDROP SUNGLASSES

SAND-SEAL LOGO

BACK
THE LOGOS GET SMALLER AS THE FABRIC GETS NARROWER

TALI

Tali is the Sand-Seal Rally champion and holds the current record for the course. She hardly speaks, but under her cool manner hides a fiery passion for racing. She is able to see a lot about a person by the way they race in the Sand-Seal Rally.

SAND-SEAL LOGO

BACKGROUND
The Gerudo

A UNIQUE CULTURE

The Gerudo's religious beliefs are a departure from those of the other races of Hyrule. They worship the Seven Heroines, seeing them as divine protectors. There are seven gigantic statues of the heroines in the East Gerudo Ruins (page 325), and according to the Gerudo archaeologist Rotana each one possessed a different power: skill, spirit, endurance, knowledge, flight, motion, and gentleness. They are now the patron deities of those attributes.

Meanwhile, the goddess Hylia, worshiped throughout the rest of Hyrule, is lesser known. Gerudo Town's goddess statue can be found, forgotten, in a back alley.

GERUDO COURTSHIP & THE TRADITION BEHIND BANNING MEN

Since ancient times the Gerudo have held onto a belief that if young Gerudo women interact with men it will bring disaster. That is why entrance to Gerudo Town is forbidden to men. When a Gerudo reaches the age of marriage, she sets out from the town in search of a mate. One can encounter Gerudo all over Hyrule who are traveling on their courtship journey. Most of the Gerudo running the shops within Gerudo Town are married and have returned in order to make money.

1 There are guards posted at all of the entrances to Gerudo Town at all times to prevent men from entering. 2 In order to educate women about courting a man in the outside world, the Gerudo have schools that teach skills that will hopefully lead to a relationship.

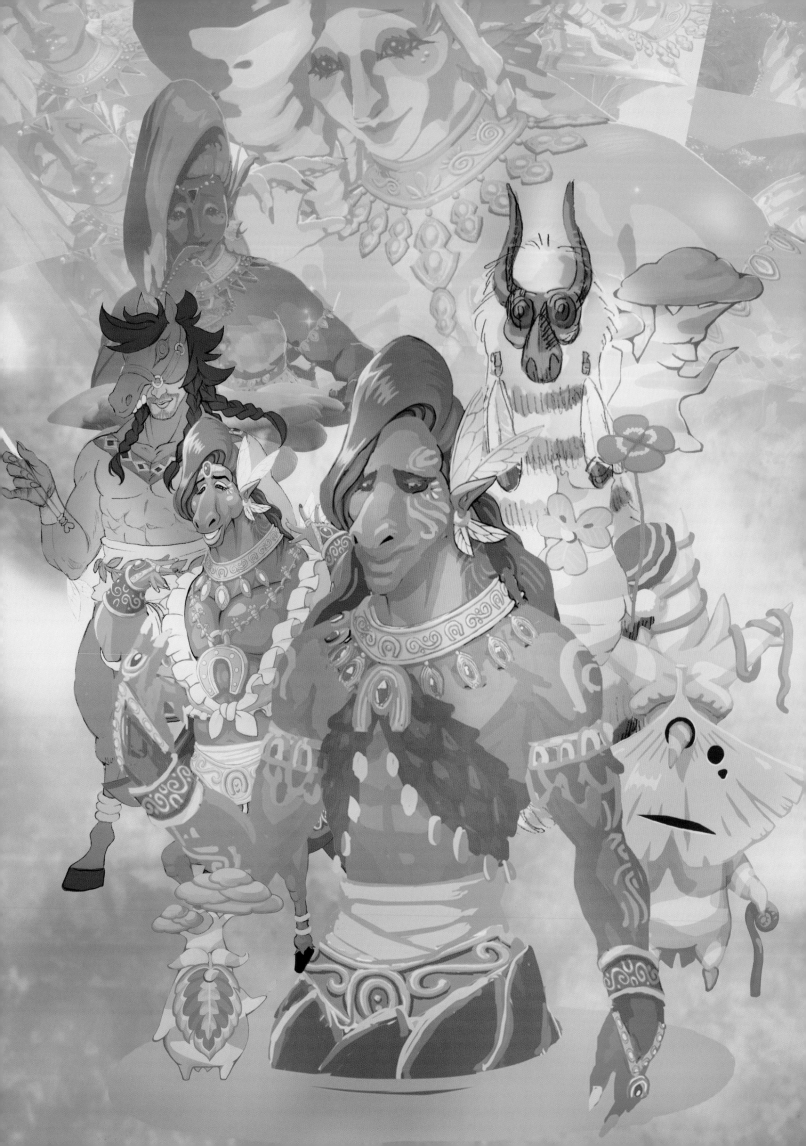

SPIRITS OF THE LAND
HIDDEN HYRULE

Beyond the mortal races living in Hyrule, there are supernatural spirits who call the land home. In this section, we take a look at those spirits who occasionally interact directly with Hyruleans.

These beings possess a variety of incredible powers and support the chosen hero on his journey. Ordinary folk are unable to see these entities, but stories and rumors are told about them. Some people even worship them.

MALANYA

The horse god Malanya resides in a spring in Faron. His appearance may be startling, but he will not harm anyone who cares for horses, though he has a strange sense of humor on the subject. Like the Great Fairies, Malanya has been dormant and without power inside a large flower bud for some time. He will revive any of Link's horses who have lost their lives in return for the hero restoring his power.

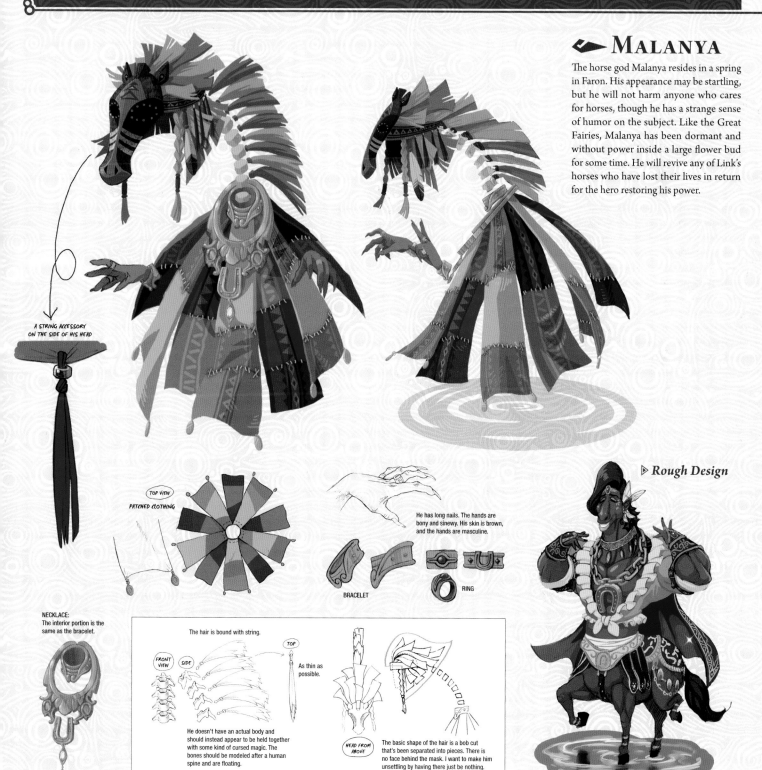

A STRING ACCESSORY ON THE SIDE OF HIS HEAD

TOP VIEW

PATCHED CLOTHING

He has long nails. The hands are bony and sinewy. His skin is brown, and the hands are masculine.

BRACELET

RING

NECKLACE:
The interior portion is the same as the bracelet.

The hair is bound with string.

FRONT VIEW SIDE TOP

As thin as possible.

He doesn't have an actual body and should instead appear to be held together with some kind of cursed magic. The bones should be modeled after a human spine and are floating.

HEAD FROM ABOVE

The basic shape of the hair is a bob cut that's been separated into pieces. There is no face behind the mask. I want to make him unsettling by having there just be nothing.

▷ *Rough Design*

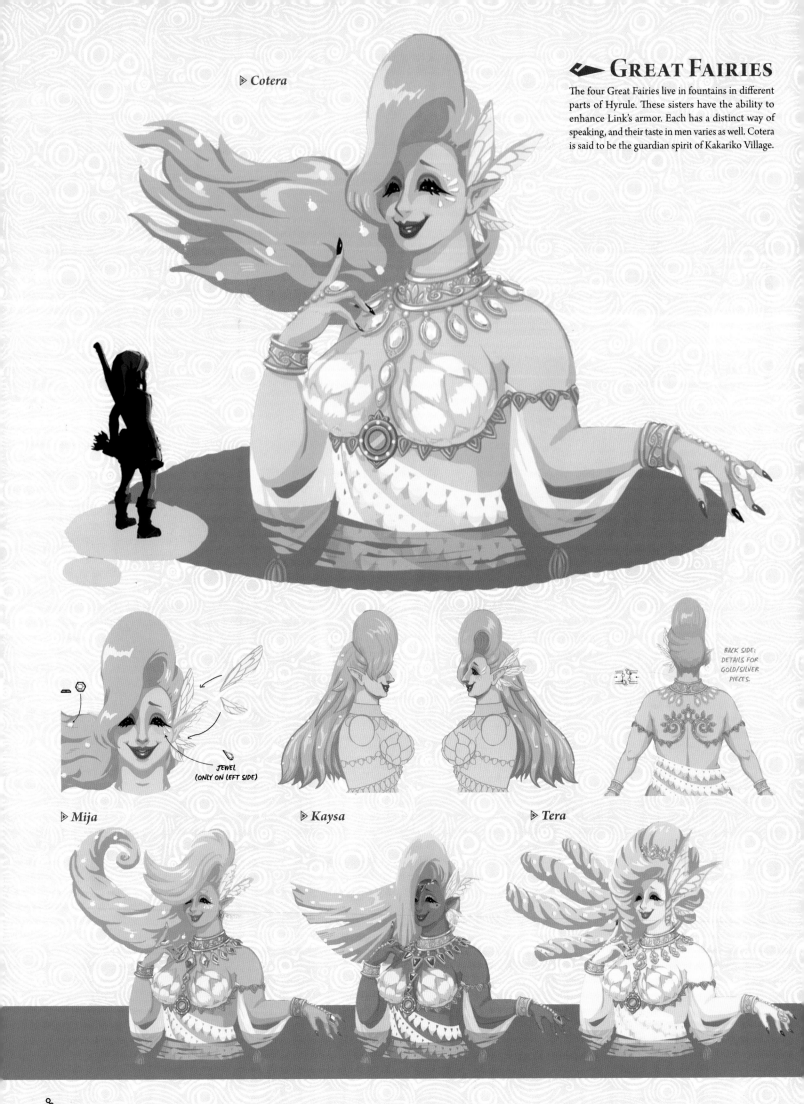

▷ *Cotera*

GREAT FAIRIES

The four Great Fairies live in fountains in different parts of Hyrule. These sisters have the ability to enhance Link's armor. Each has a distinct way of speaking, and their taste in men varies as well. Cotera is said to be the guardian spirit of Kakariko Village.

JEWEL (ONLY ON LEFT SIDE)

BACK SIDE; DETAILS FOR GOLD/SILVER PIECES.

▷ *Mija*

▷ *Kaysa*

▷ *Tera*

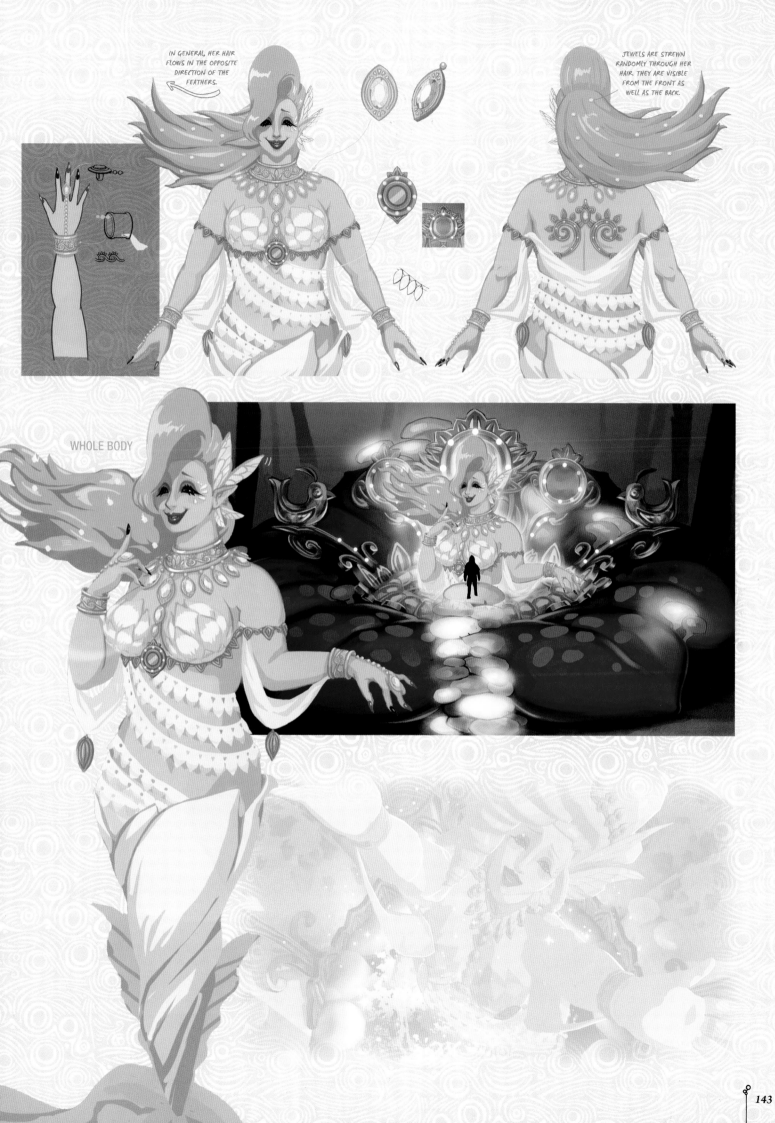

IN GENERAL, HER HAIR FLOWS IN THE OPPOSITE DIRECTION OF THE FEATHERS.

JEWELS ARE STREWN RANDOMLY THROUGH HER HAIR. THEY ARE VISIBLE FROM THE FRONT AS WELL AS THE BACK.

WHOLE BODY

IN GENERAL, HER HAIR FLOWS IN THE OPPOSITE DIRECTION OF THE FEATHERS.

JEWELS ARE STREWN RANDOMLY THROUGH HER HAIR. THEY ARE VISIBLE FROM THE FRONT AS WELL AS THE BACK.

THE KOROKS

The spirits of the forest have tiny, wood-like bodies with mask faces made of leaves. Koroks are innocent and childlike. They love pranks and have stolen the seeds from inside Hestu's maracas, hiding with them throughout the realm. Their village is deep within the Great Hyrule Forest, where they live with the Great Deku Tree (page 228).

▷ Hestu

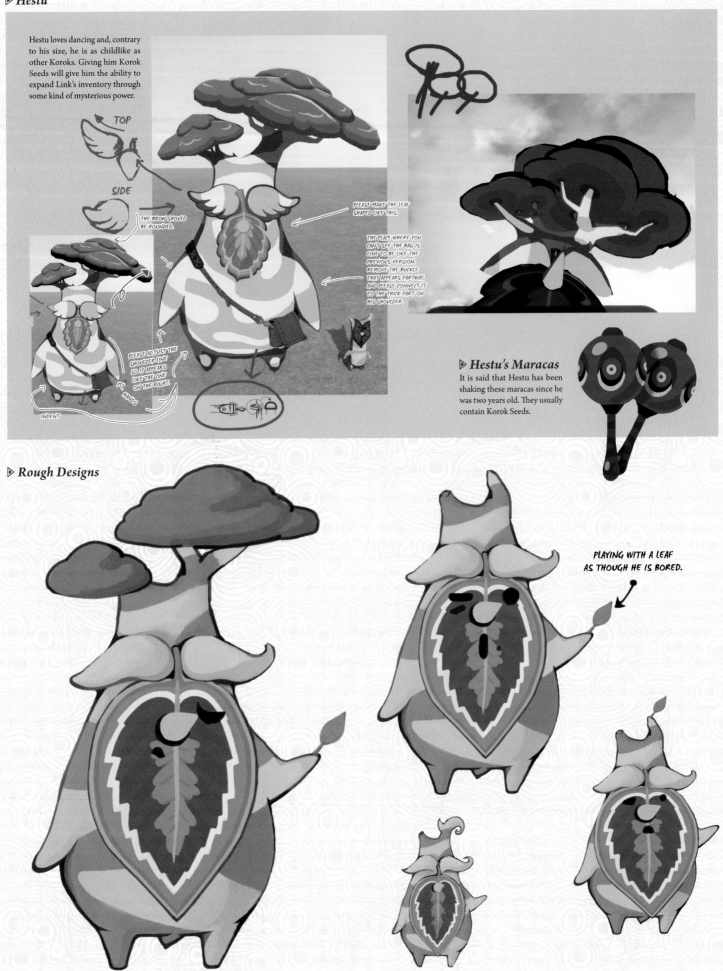

Hestu loves dancing and, contrary to his size, he is as childlike as other Koroks. Giving him Korok Seeds will give him the ability to expand Link's inventory through some kind of mysterious power.

TOP

SIDE

THE BROW SHOULD BE ROUNDED.

PLEASE ADJUST THE SHOULDER LINE SO IT APPEARS LIKE THE ONE ON THE RIGHT.

HANDS

INDENT

PLEASE MAKE THE LEAF SHAPED LIKE THIS.

THE PLACE WHERE YOU CAN'T SEE THE BAG IS FINE TO BE LIKE THE PREVIOUS VERSION. REMOVE THE BUCKLE THAT APPEARS PARTWAY, AND PLEASE CONNECT IT TO THE THICK PART ON HIS SHOULDER.

▷ Hestu's Maracas

It is said that Hestu has been shaking these maracas since he was two years old. They usually contain Korok Seeds.

▷ Rough Designs

PLAYING WITH A LEAF AS THOUGH HE IS BORED.

▷ *Elder Korok* The elder of Korok Forest is the leader of the village. He possesses knowledge about the Great Hyrule Forest and imposes the Korok Trials that they have prepared for Link, who he calls Mr. Hero.

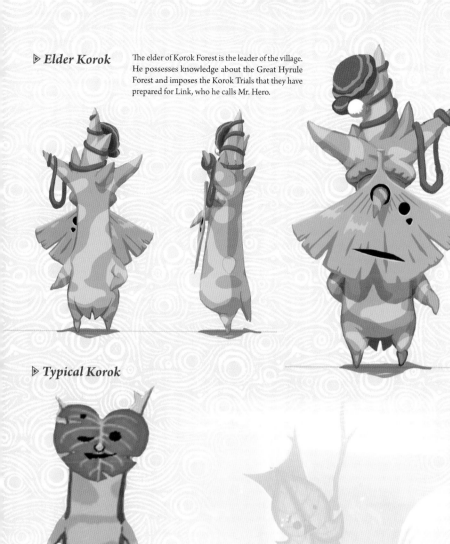

▷ *Typical Korok*

▷ *Typical Korok Rough Designs* The Koroks' final designs were nearly identical to their appearance in *The Wind Waker*, but an original design was proposed for this title. These early and ultimately rejected designs show the Koroks covered in different kinds of leaves.

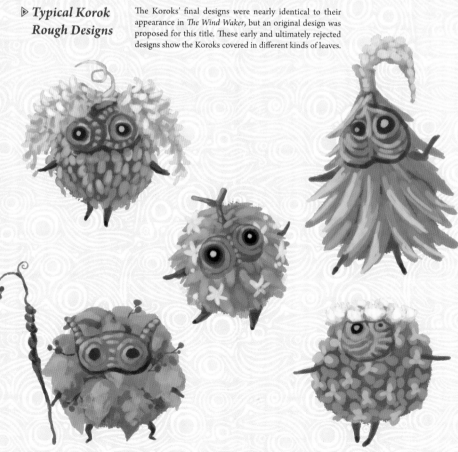

RESTORING THE GREAT FAIRIES' POWER

When Link awakens from his restorative slumber, the Great Fairies are dormant within large flower buds and have lost their powers. Rupees are needed to restore them. Just as Cotera is considered the guardian spirit of Kakariko Village, all of the Great Fairies operate similarly to gods. The source of their powers is faith, and proof of that faith comes in the form of offerings—in this case, Hyrule's currency, rupees. It is said that long ago it was customary to give tribute to the Great Fairies, but, in the years following the Great Calamity, the number of pilgrims to the Fairy Fountains dwindled and the fairies lost their powers.

THE KOROKS AWAIT THE HERO'S RETURN

The hero's weapon, the Master Sword, is resting in Korok Forest. The Great Deku Tree, spirit of the forest who is like a father to the Koroks, has been guarding it. So, unlike most other Hyruleans, the Koroks know that the hero will someday return and reclaim his sword.

Since no one other than the Koroks can enter the forest, the Hylian-sized bedding and store carrying provisions were made exclusively for the hero. They also created the Korok Trials, designed to make Link even stronger than he is now.

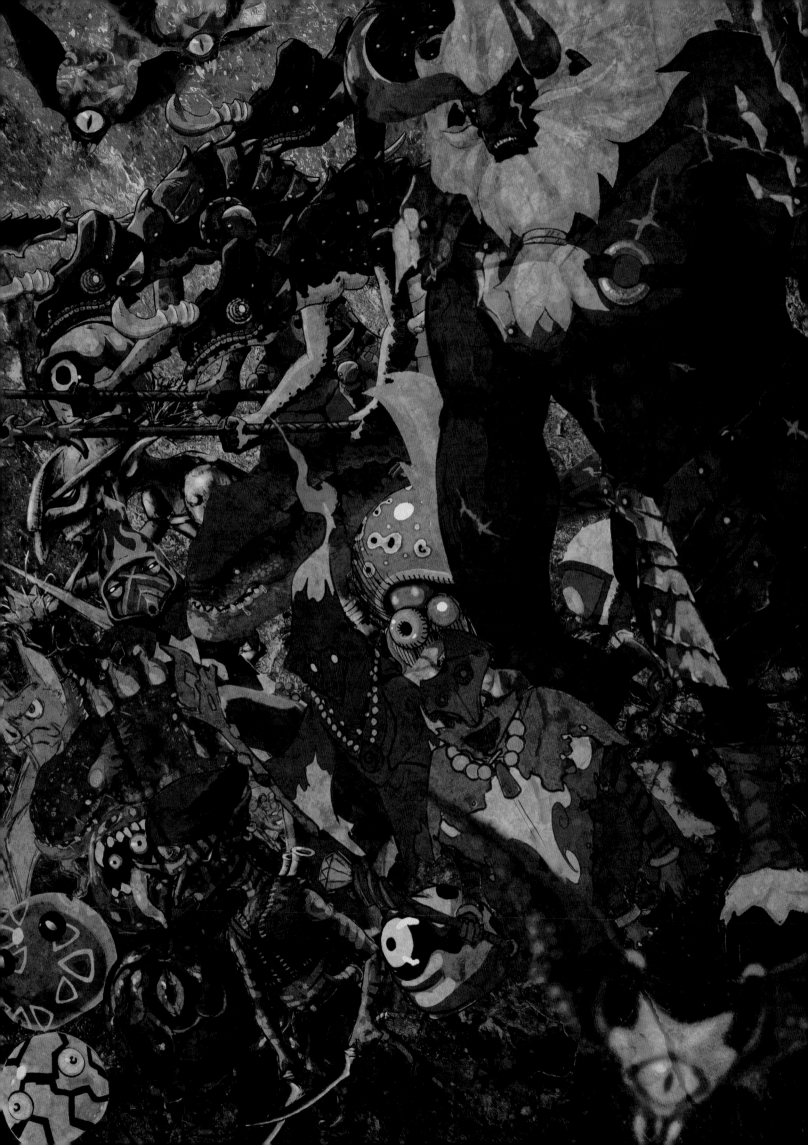

MONSTERS
SCOURGE OF THE CITIZENS OF HYRULE

After the Great Calamity, monsters became more prevalent and bold. They spread to all corners of Hyrule—the mountains, the plains, and even the sea. It used to be that roads were safe for travelers, but that is no longer the case. Monsters frequently attack travelers brave enough to use the roads, and it's getting worse every day.

There are a wide variety of monsters that populate Hyrule. Each of them differs in appearance, shape, size, and culture, but the one thing they all share is malevolence toward Hyruleans.

BOKOBLINS

The Bokoblins are the most common monster found in Hyrule and could be found all throughout the land even before the Great Calamity. They live in loosely organized groups and build forts to ward off enemies. They are violent omnivores who prefer meat but will happily eat fruit in addition to the game they hunt.

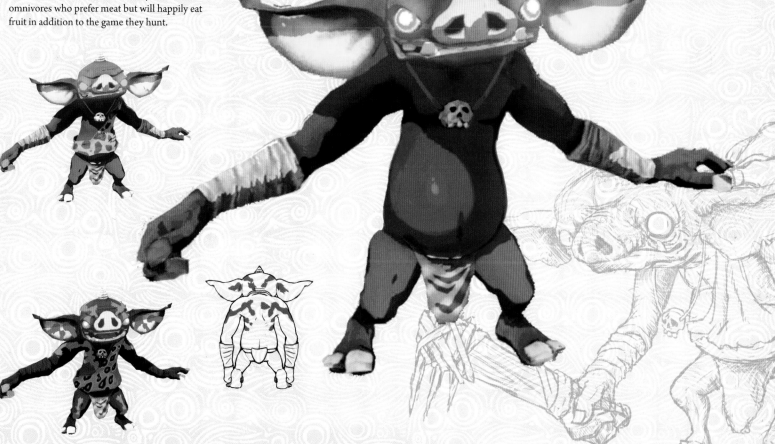

▷ *Stalkoblin*

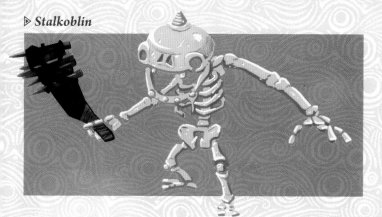

DEVELOPER'S NOTE

I designed the Bokoblins first and worked hard to design each of the monsters to be kind of charming. Rather than making them eerie and off-putting, I wanted them to have an element of cuteness and humor. I thought building in this kind of charm would make people want to play the game more. I applied this way of thinking to their behavior and reactions as well. They snore while they sleep. They devour meat. They look up at the sky when it rains. I tried really hard to create details that would keep players engaged.

LEAD ARTIST, ENEMIES: TAKAFUMI KIUCHI

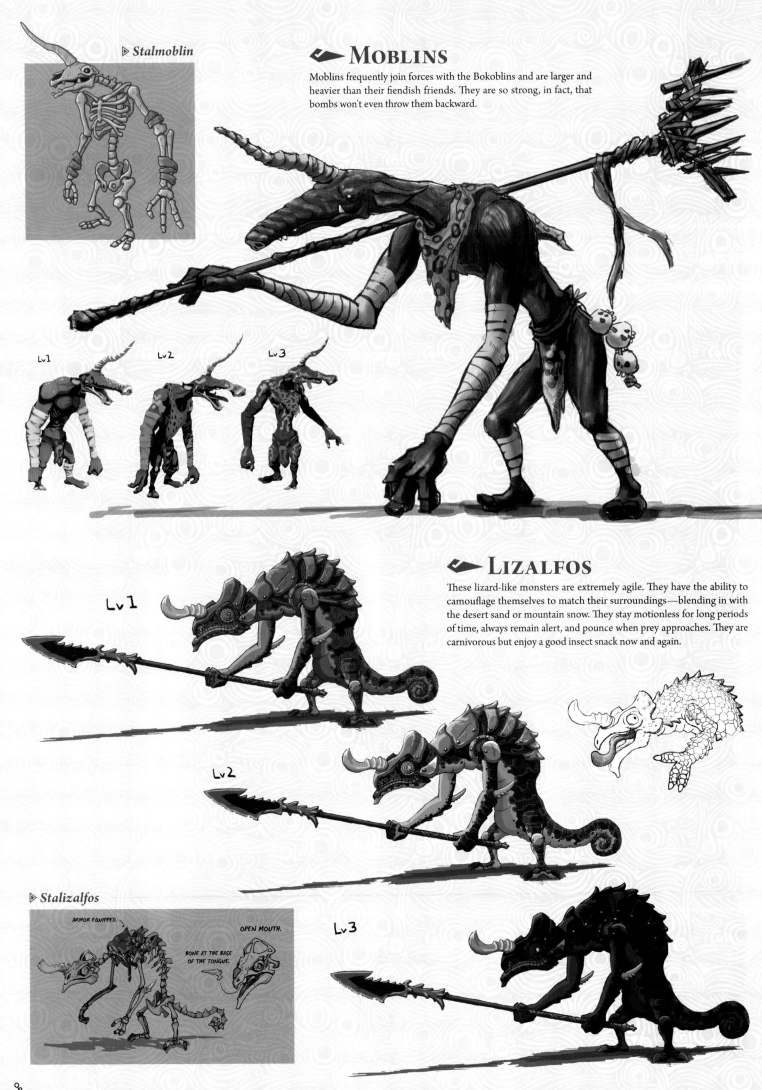

▷ *Stalmoblin*

MOBLINS

Moblins frequently join forces with the Bokoblins and are larger and heavier than their fiendish friends. They are so strong, in fact, that bombs won't even throw them backward.

Lv1 Lv2 Lv3

LIZALFOS

These lizard-like monsters are extremely agile. They have the ability to camouflage themselves to match their surroundings—blending in with the desert sand or mountain snow. They stay motionless for long periods of time, always remain alert, and pounce when prey approaches. They are carnivorous but enjoy a good insect snack now and again.

Lv1

Lv2

▷ *Stalizalfos*

ARMOR EQUIPPED.

OPEN MOUTH.

BONE AT THE BASE OF THE TONGUE.

Lv3

WIZZROBES

These robed monsters skip through the sky impishly. They have the ability to disappear and wield magical rods with the power to control ice, lightning, or fire. They can even alter the weather.

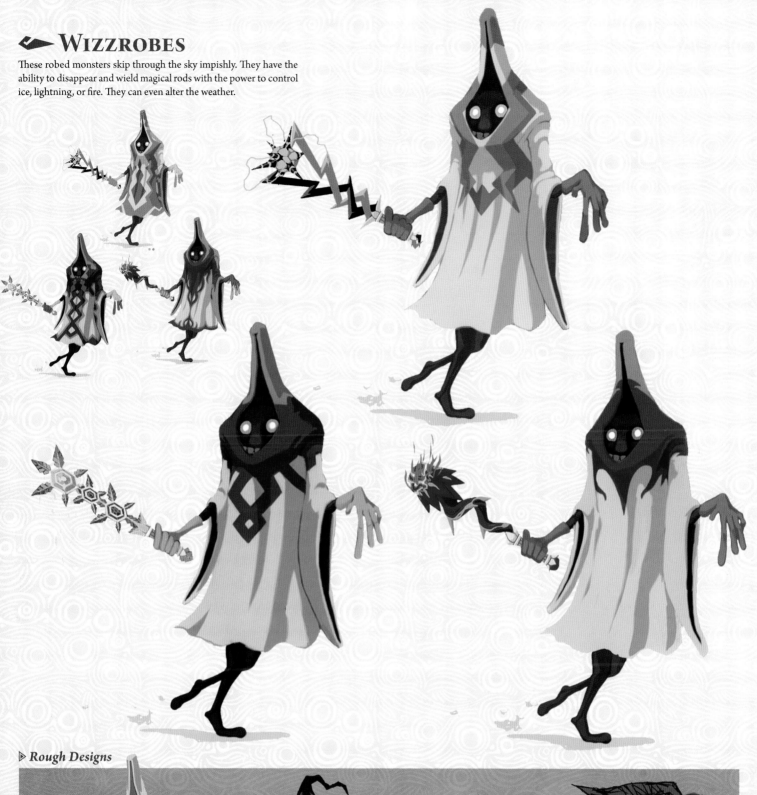

▷ *Rough Designs*

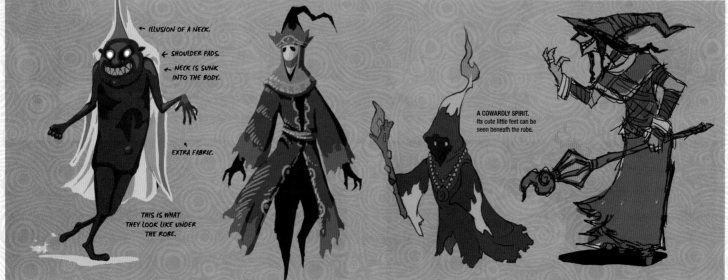

← ILLUSION OF A NECK.

← SHOULDER PADS.

← NECK IS SUNK INTO THE BODY.

EXTRA FABRIC.

THIS IS WHAT THEY LOOK LIKE UNDER THE ROBE.

A COWARDLY SPIRIT. Its cute little feet can be seen beneath the robe.

OCTOROKS

Octoroks are lower-level monsters that look similar to octopuses. Originally, these creatures lived exclusively in the water but evolved to inhabit other environments, like forests and volcanoes, as well. Octoroks all have something on their head that is common to the surrounding area, like grass or treasure chests. They use these to lure unsuspecting prey closer while they remain hidden underground. When their target is close enough, they strike!

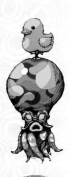
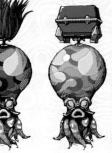
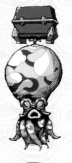

PLAINS • FORESTS
They hide in the ground in forests or plains. They may carry branches or mushrooms on their head.

RIVERS • OCEANS
This type of Octorok lives in the rivers and oceans. It could carry reeds or seaweed on its head for camouflage.

DESERTS
A desert Octorok swims through the sand, pretending to be a treasure chest. They attack the player when they draw near.

SNOW
This Octorok appears on snow-topped mountains. It spits snowballs, which could roll around. I'm planning to have it mimic a treasure chest.

They pick up items lying on the ground and place them on top of their heads for camouflage. What they are carrying changes based on the area they are in.

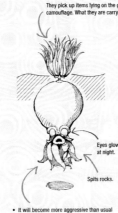
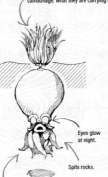

Eyes glow at night.

Spits rocks.

- It will become more aggressive than usual when it rains.
- If the player sees through its disguise and attacks first, it will be stunned.
- They are not very bright and will quickly forget about the player if they lose sight of them.

NOT TOO STEALTHY

While they can very effectively mimic rocks or grass, they are easy to spot when their guard is down. If they notice the player, they will bury themselves entirely and are difficult to see until they start spitting rocks.

Only one patch of seaweed is moving.

The treasure chest is rattling around.

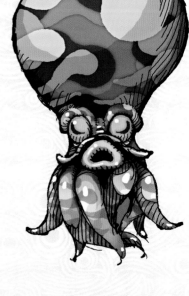

▷ *Rough Designs*

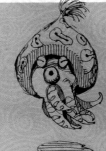

FOUR MIGHT BE GOOD.

GRABS CAMOUFLAGE WITH THESE.

HEAD

THIS MIGHT BE GOOD.

WATER / GROUND

CHUCHUS

These weak monsters appear suddenly from the ground or the tops of trees. There are various types adapted for the climate in which they live—some are very large, some explode, and some will freeze Link upon defeat if he's not careful.

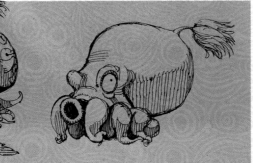

▷ *Rough Designs*

Candy-like appearance.

It opens and closes. It has a shell on the outside and a gooey interior like an egg. The eye in the center does not rotate.

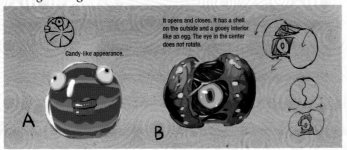

A

B

KEESE

These bat-like monsters prefer the dark, so they are often found hanging from the ceilings of caves. At night, they come out in small groups or large clusters to attack unlucky prey.

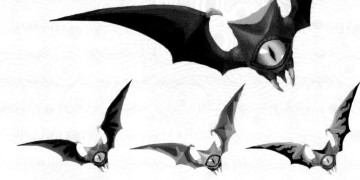

▷ *Rough Designs*

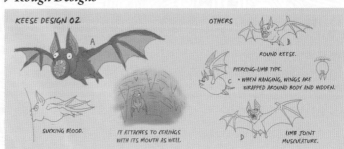

KEESE DESIGN 02

A

OTHERS

ROUND KEESE.

PIERCING-LIMB TYPE.
• WHEN HANGING, WINGS ARE WRAPPED AROUND BODY AND HIDDEN.

SUCKING BLOOD.

IT ATTACHES TO CEILINGS WITH ITS MOUTH AS WELL.

LIMB JOINT MUSCULATURE.

LYNELS

These fearsome monsters have existed in Hyrule since before recorded history. They are incredibly strong, and their attacks formidable. Their durable bodies are resistant to fire, ice, and lightning. Lynels are skilled, intelligent, and equipped with forged metal weapons and armor.

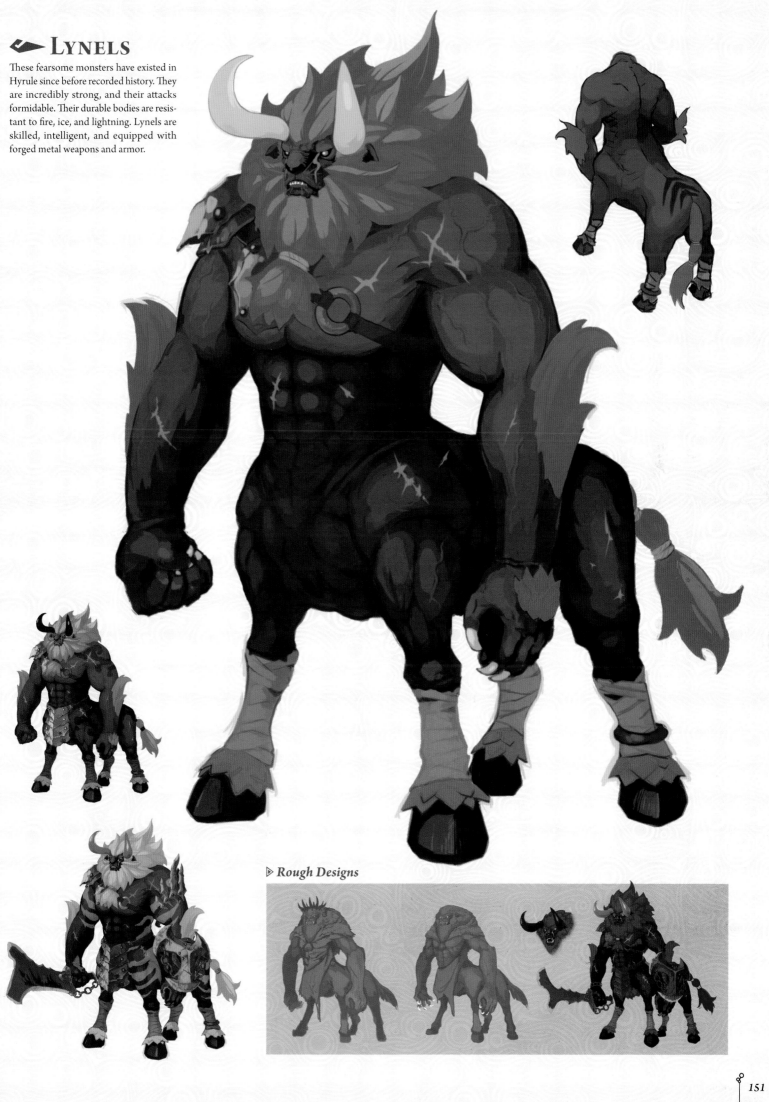

▷ *Rough Designs*

STONE TALUS

This monster's body is made entirely of stone. They camouflage themselves as boulders or piles of rocks and will strike if a foe draws near. No weapon is capable of inflicting damage on their dense bodies, but a cunning adventurer will know where to strike to bring it down.

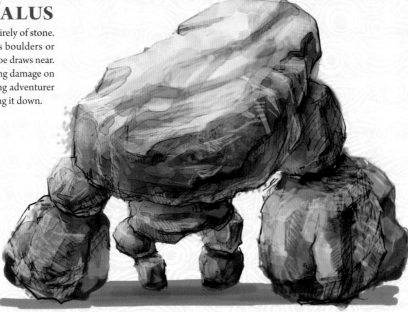

HINOX

The Hinox are one of the largest monsters living in Hyrule. They sleep both day and night, but if something disturbs them, watch out! They are extremely violent and known for uprooting entire trees and using them as weapons. Some are even smart enough to protect their weak, tiny legs with armor.

▷ **Stalnox**

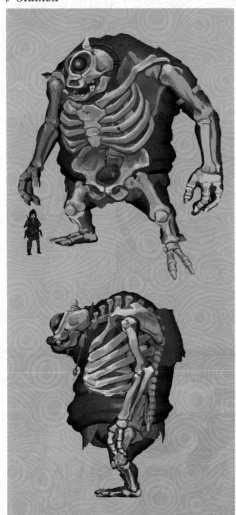

▷ **Rough Designs**

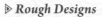

ATTACKING A CART.

SWALLOWING A COW WHOLE.

SHAKES TREES FOR FRUIT.

BATHING IN WATER.

SOMERSAULT.

CHASES ANIMALS.

BLOCKING A BRIDGE.

A CLEAN HIT TO THE BACK OF THE KNEE WILL BRING IT DOWN.

BARE LEG

WOOD

IRON — SHIELD, SECURED WITH STRING

IRON — SHIELD, BELT

VARIOUS SITUATIONS (SCREENSHOTS FOR REFERENCE)

AT NIGHT, THE UNDEAD RISE.

IS THIS A GRAVE?

A CLIFF FACE FULL OF BONES.

TINY COMPARED TO THE FOSSILIZED WHALE.

SMALL COMPARED TO A 💀 SKULL ROCK.

STALNOX LINK.

IT THROWS ITS RIBS, JAW, AND ARMS UNTIL THERE IS NOTHING LEFT TO THROW.

IS IT EMERGING FROM LAVA?

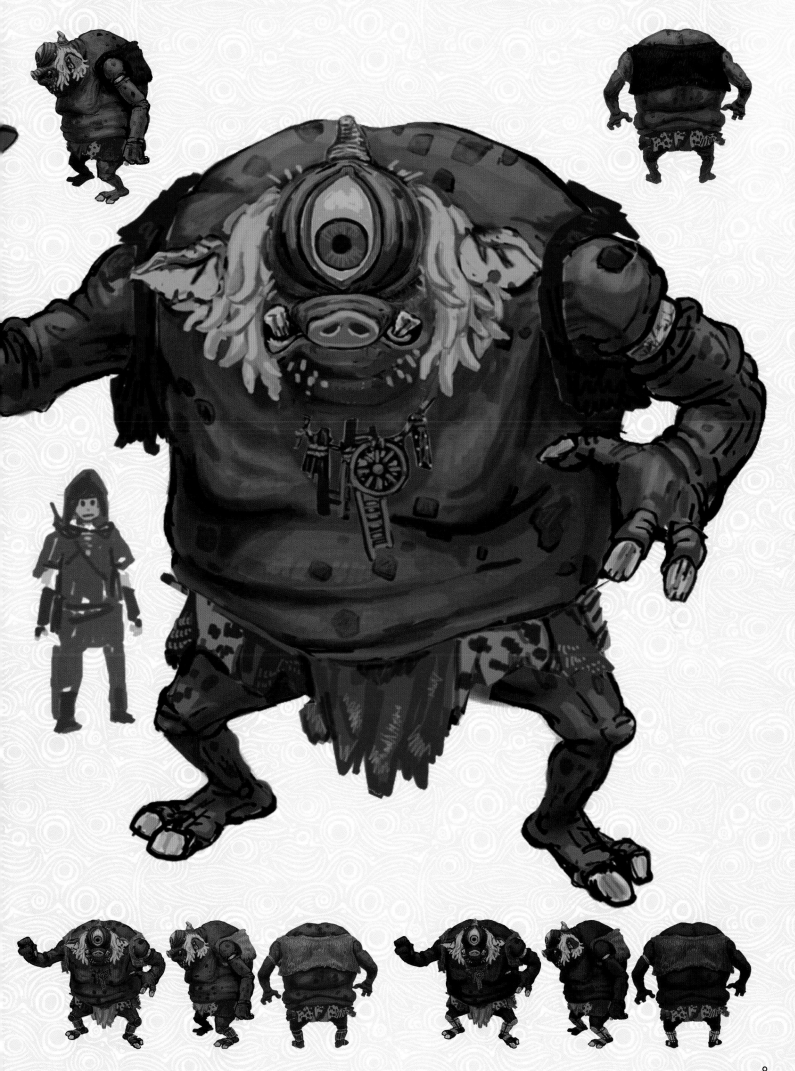

MOLDUGAS

These giant sand monsters live in the Gerudo Desert and are very rare, with only four existing in all of Hyrule. Despite their massive size, they can swim through sand with surprising speed. Their hearing is excellent, and if they hear so much as a footfall on a grain of desert sand, they will leap toward their intended prey, mouth wide, hoping to take a bite out of whatever has strayed into their territory.

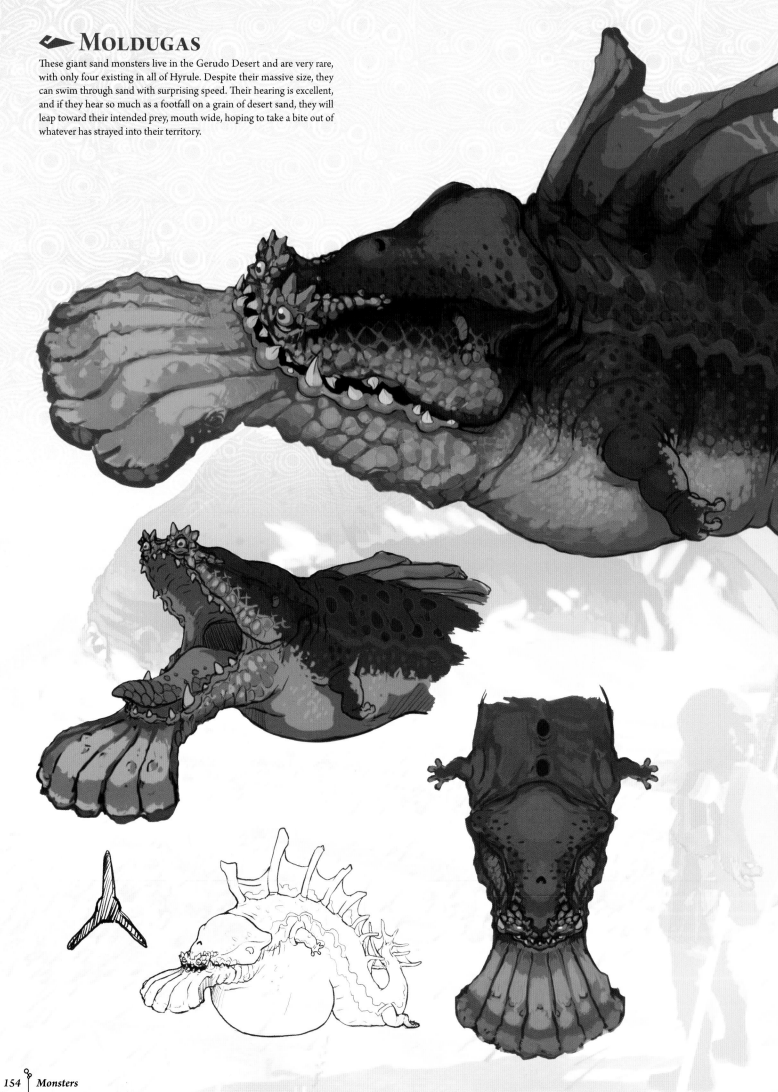

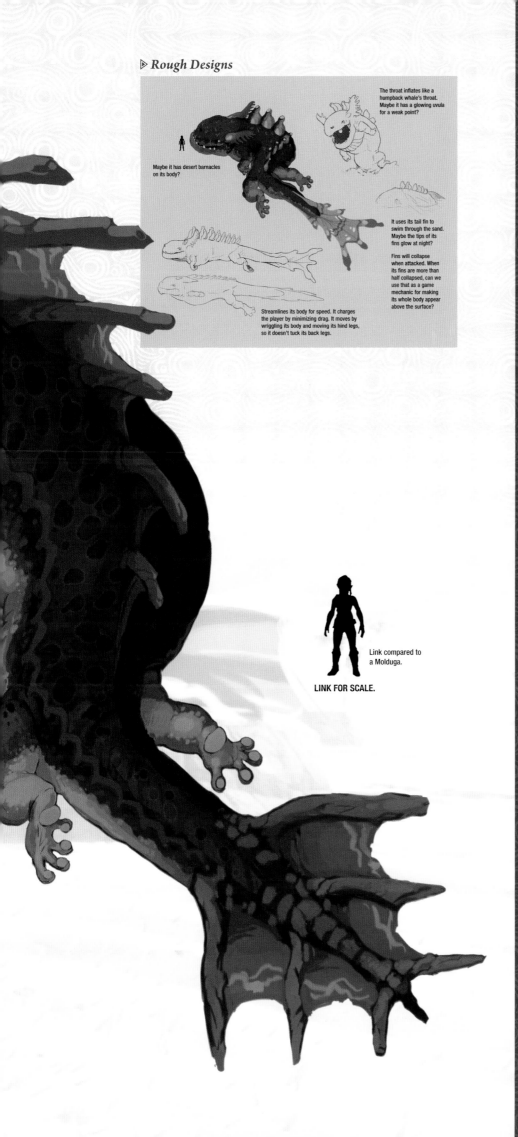

The throat inflates like a humpback whale's throat. Maybe it has a glowing uvula for a weak point?

Maybe it has desert barnacles on its body?

It uses its tail fin to swim through the sand. Maybe the tips of its fins glow at night?

Fins will collapse when attacked. When its fins are more than half collapsed, can we use that as a game mechanic for making its whole body appear above the surface?

Streamlines its body for speed. It charges the player by minimizing drag. It moves by wriggling its body and moving its hind legs, so it doesn't tuck its back legs.

Link compared to a Molduga.

LINK FOR SCALE.

BACKGROUND
Monsters

Monsters threaten the lives and livelihoods of the people of Hyrule, but when they aren't on the prowl, they all have their own culture and way of life. For example, Bokoblins use fire as a part of their daily routine to roast fish and meat and sleep around at night. Bokoblins are also known to boogie every once in a while, dancing when they're in the mood. Hinox sleep all day and all night, while the ever-vigilant Lynels are ceaselessly searching for prey to hunt. Monsters also adapt their way of life to their surroundings as well.

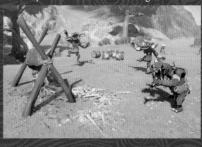

MONSTERS & WATER

Bokoblins and Moblins are some of the most adaptable monsters in Hyrule, appearing in all habitats. However, water is the one environment that they do not thrive in. If their prey crosses a body of water, they cannot or will not pursue them. On the other hand, the water-loving Lizalfos are happy to use their excellent swimming skills to chase an enemy.

MONSTERS & HORNS

If a monster spots a trespasser near their fort, they will blow into a horn to alert their allies. The construction of the horn varies by type of monster.

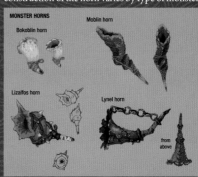

MONSTER HORNS

Moblin horn

Bokoblin horn

Lizalfos horn

Lynel horn

from above

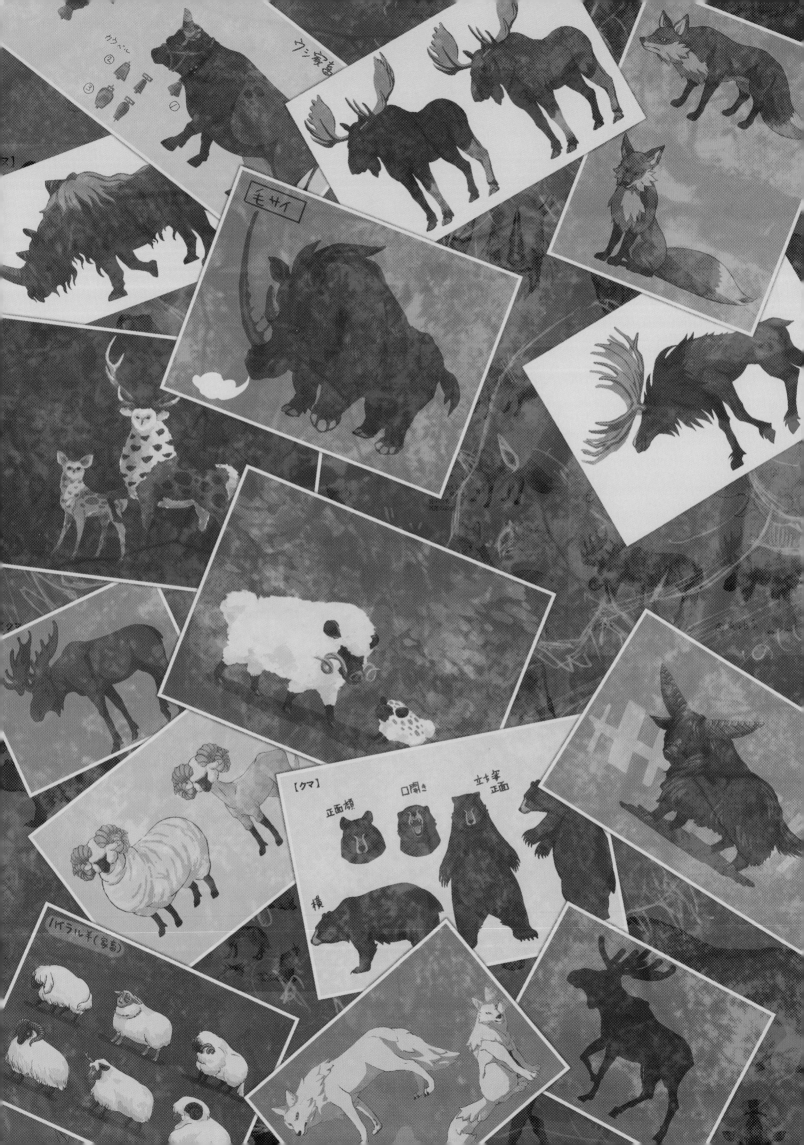

CREATURES
THE DIVERSITY OF HYRULE'S LIVING THINGS

There are a variety of creatures living in the vast expanses of Hyrule other than Hyruleans and the monsters that threaten them. There are a number of animals, insects, fish, and more exotic living things that thrive in every one of Hyrule's environments that are not polluted by Calamity Ganon's Malice. In addition to the more common organisms, there are sacred creatures that grace the land, like spirits and fairies.

LORD OF THE MOUNTAIN

The Lord of the Mountain is a spirit that only reveals itself on certain nights and can be found on Satori Mountain, west of Central Hyrule. It is incredibly skittish and will flee if it spots a person. It is spoken of reverently as a guardian spirit.

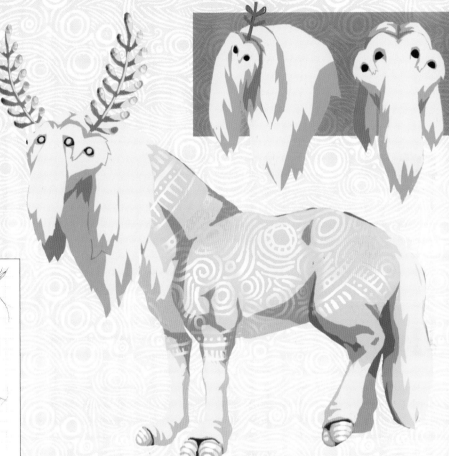

▷ *Rough Designs*

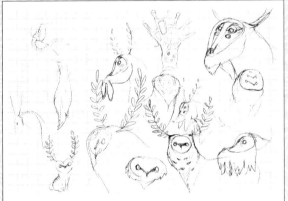

BLUPEES

This adorable spirit resembles a rabbit. It is tiny, only about the size of the Lord of the Mountain's foot, and glows a soft blue. Blupees are very shy, so they tend to reside in places that receive very little traffic from people. These peculiar animals have a penchant for collecting rupees, or so people say.

FAIRIES

Fairies can be found in special locations like fairy fountains or hiding in tall grass, away from prying eyes.

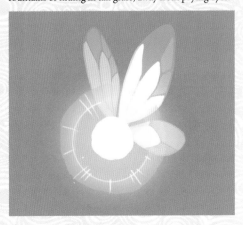

SERVANTS OF THE SPRINGS

No one has seen these dragon spirits in the current age, but their existence is still spread through legends and old sayings, like "The dragon ascends to the heavens as the sun begins to set." It is said that Dinraal served the Spring of Power; Naydra, the Spring of Wisdom; and Farosh, the Spring of Courage. Further, there are legends that those who obtain an extremely rare scale or horn fragment from one of these spirits will be blessed. Link can find both Dinraal and Farosh roaming the land, but Naydra must be freed of the Malice that has infected it before it once again serves its fountain.

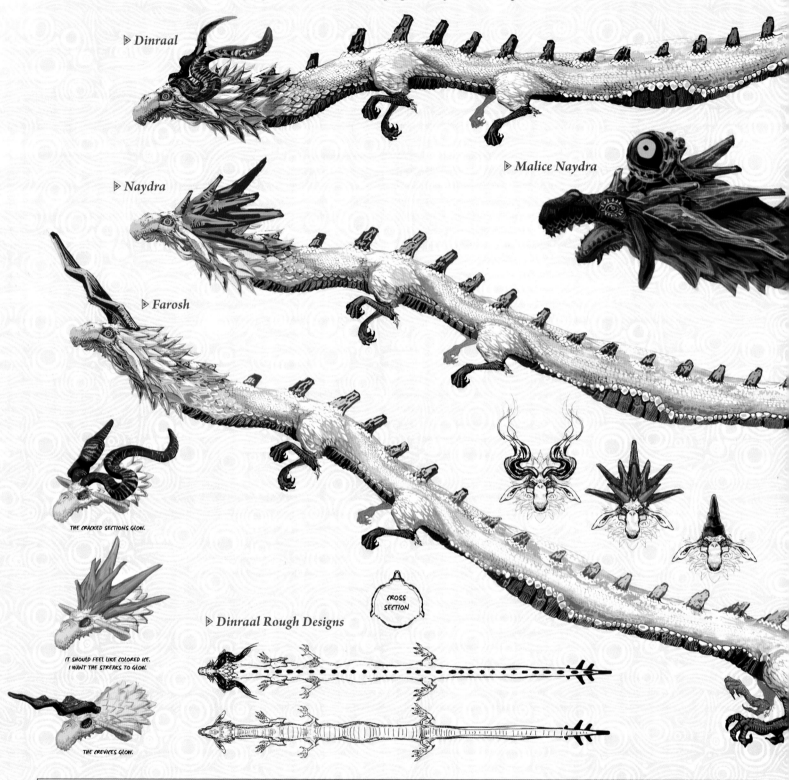

▷ Dinraal

▷ Naydra

▷ Malice Naydra

▷ Farosh

THE CRACKED SECTIONS GLOW.

IT SHOULD FEEL LIKE COLORED ICE.
I WANT THE STREAKS TO GLOW.

THE CREVICES GLOW.

CROSS SECTION

▷ Dinraal Rough Designs

DEVELOPERS' NOTES

The spring servants were designed to be ancient dragons who have lived in Hyrule since the distant past. They were to fly through the sky and possess a mysterious yet calm aura, so I gave them a design that would feel a little strange. I played around with a number of ideas that would be recognizable as a dragon but also different from what you would expect. So I made the face and body mammalian, like a dog or a goat, and their arms contain elements of both birds and human hands. I very much hope that these dragons evoke a romantic feeling as they soar through the sky.

ENEMY ART: SATOMI USUI

The creatures that inhabit Hyrule play a critical role in making the land feel rich and alive. I aimed for a neutral design that, depending on when you encountered it, could look lovable, menacing, or occasionally tasty. It was also a conscious decision to choose colors that would stand out against the stunning plains that are a key feature of the game.

WILDLIFE ART: AYA SHIDA

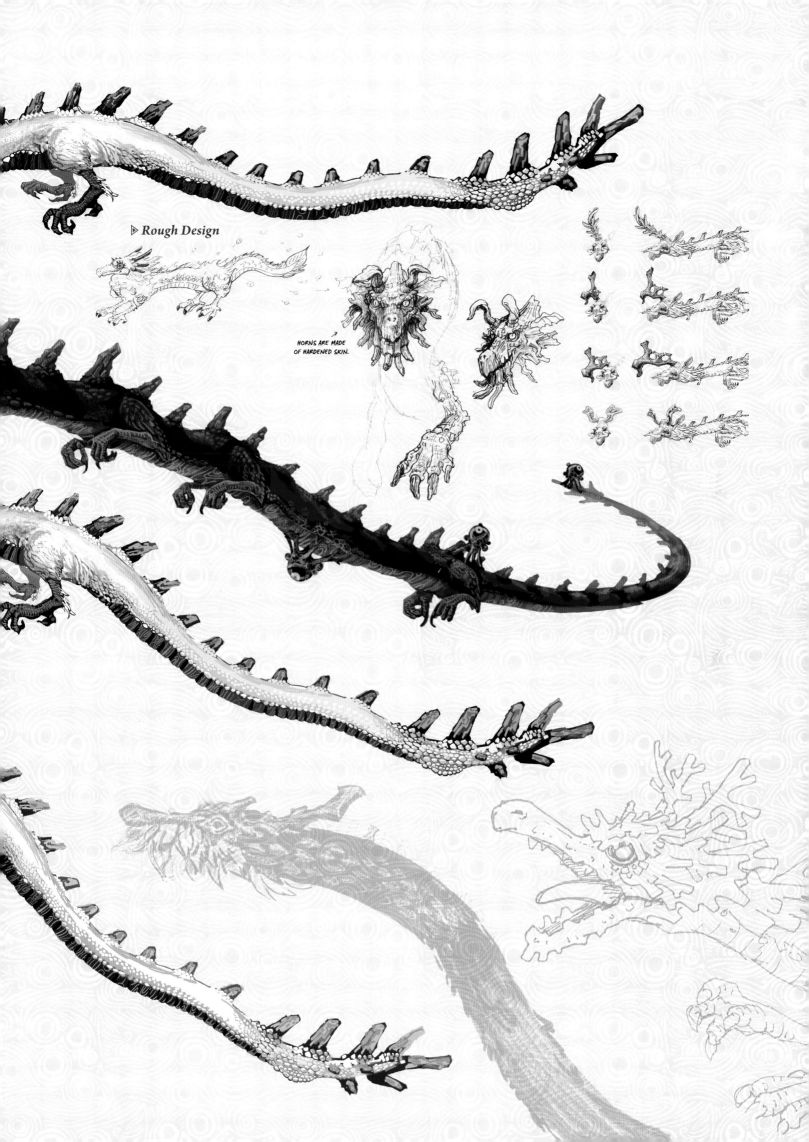

▷ **Rough Design**

HORNS ARE MADE
OF HARDENED SKIN.

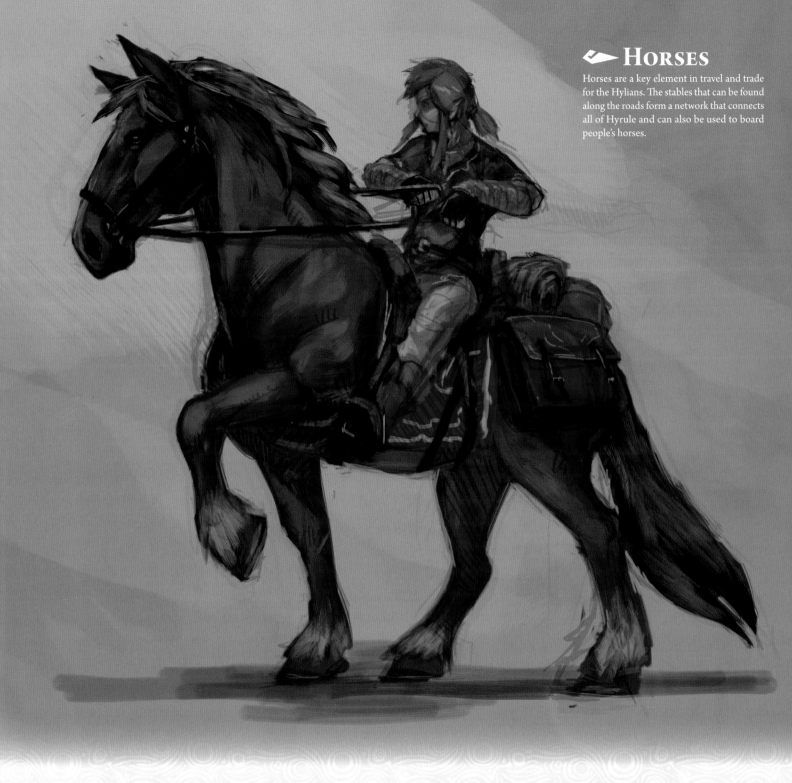

HORSES

Horses are a key element in travel and trade for the Hylians. The stables that can be found along the roads form a network that connects all of Hyrule and can also be used to board people's horses.

▷ **Rough Concepts**

POINTLESS STUFF I WANT THE HORSES TO DO.

1 CHEEK NUZZLING.
I DON'T KNOW HOW WE'RE GOING TO DO THIS.

2 EATS ITEMS.
I WANT TO BE ABLE TO GIVE IT WATER TOO.

3 SHAKES WHEN IT GETS OUT OF THE WATER.
THIS SHOULD BE DOABLE.

4 POPS ITS HEAD THROUGH THE WINDOW IF LINK IS INSIDE.
"HEY, WHATCHA DOIN'?"

5 SWAYS IN TIME WITH MUSIC.
INDIVIDUAL PARAMETERS FOR FAVORITE MUSIC COULD BE A THING.

5 EATS TREE BRANCHES.
"YUM YUM"
IF WE HAVE AN ANIMATION FOR FEEDING A BRANCH INTO A FIRE, WE WILL USE THAT AS IS.

6 RUNS WITH LINK AND WHINNIES.
"PLAY WITH ME!"
• THERE ARE NO ENEMIES AROUND AND LINK IS NEARBY.
• MAYBE WE COULD MAKE A UNIQUE "FUN RUN"?
MATCH RUNNING SPEED TO LINK'S WHEN ANIMATING

▷ **Stalhorse**

BACKBONE NEAR THE TAIL.

PELVIS

NECK BONE

HORSE GEAR

A complete set of horse gear consists of both a bridle and a saddle. If a horse is equipped with horse gear, that means that the horse has been tamed and registered at a stable. Depending on the bond between rider and horse, a horse can be equipped with a variety of saddles and bridles.

▷ *Epona Gear* (amiibo)

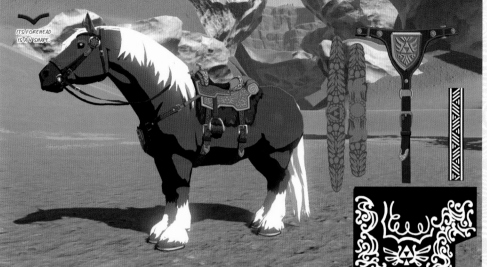

ITS FOREHEAD IS A V SHAPE.

▷ *Monster Horse Gear*

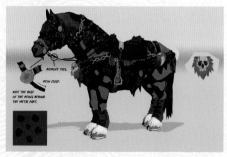

REMOVE THIS.

REIN CLASP.

HIDE THE BASE OF THE REINS BEHIND THE METAL PART.

▷ *Stable Gear*

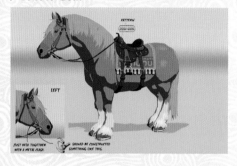

PATTERN

LEFT

JUST HELD TOGETHER WITH A METAL CLASP.

SHOULD BE CONSTRUCTED SOMETHING LIKE THIS.

▷ *Giant Horse Gear*

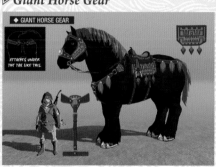

◆ GIANT HORSE GEAR

ATTACHES UNDER THE TAIL LIKE THIS.

▷ *Royal Horse Gear*

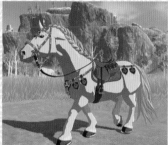

▷ *Extravagant Gear*

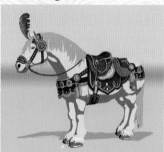

▷ *Knight's Gear*

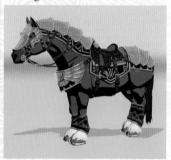

▷ *Ancient Horse Gear* (DLC Pack 2)

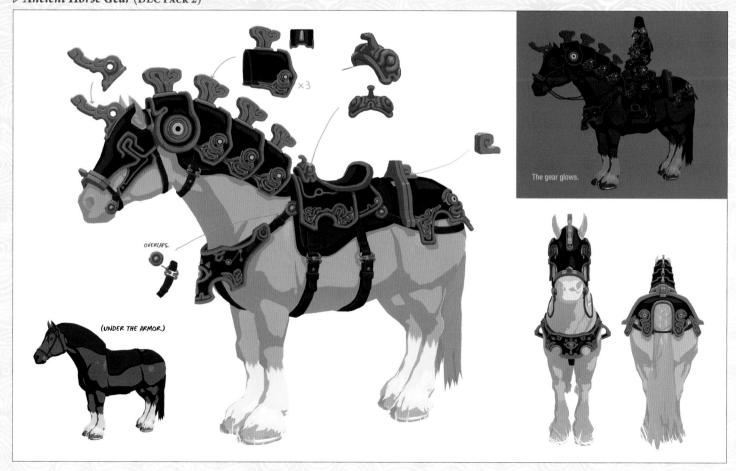

×3

OVERLAPS.

(UNDER THE ARMOR.)

The gear glows.

SAND SEALS

These gentle giants live in the Gerudo Desert. They are more docile than they appear, and the Gerudo have taken to domesticating them for the purpose of transportation.

Patricia is Gerudo Chief Riju's personal Sand Seal, and it is said that she is willing to deliver divine messages in exchange for fruit.

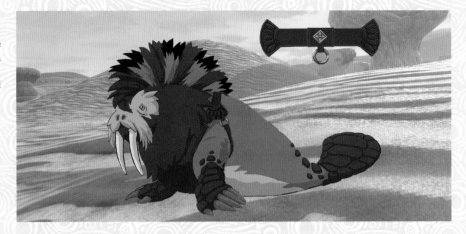

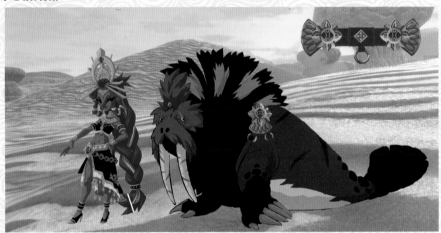

▷ *Rough Designs*

▷ *Patricia*

DONKEYS

Donkeys can often be seen accompanying travelers and wandering merchants. Unlike horses, they are not ridden but used to pack provisions.

▷ *Rough Designs*

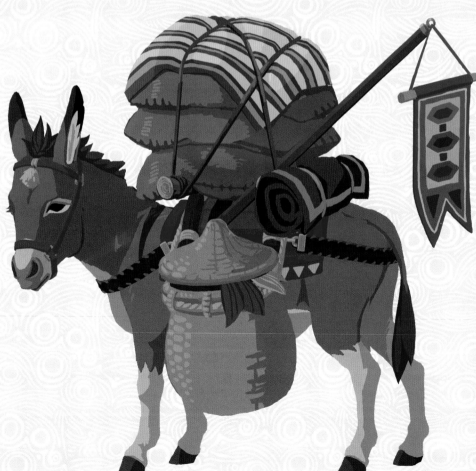

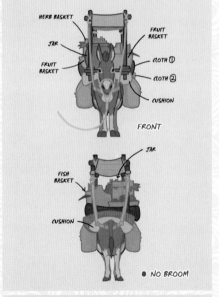

HERB BASKET
FRUIT BASKET
JAR
FRUIT BASKET
CLOTH ①
CLOTH ②
CUSHION
FRONT

JAR
FISH BASKET
CUSHION
● NO BROOM

WITH BANGS
NO BANGS
MANE ①

MANE ②
AND PALETTE SWAP

⚔ ANIMALS

Wherever life can exist in Hyrule, it does. Animals roam all parts of the land, though some can only be encountered where they are best adapted to live. Dogs have been domesticated and can be found wherever people have settled. Hylian Retrievers are very grateful when given attention and fed, but be careful: not all animals are friendly to Hylians. For every animal that will take off at the sight of a person, there is an animal like a bear or a boar that is unafraid of people and will stand its ground.

▷ **Hateno Cow**

▷ **Water Buffalo**

▷ **Hylian Retriever**

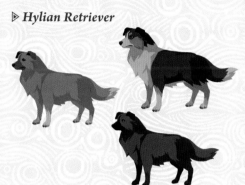

▷ **Maraudo Wolf**

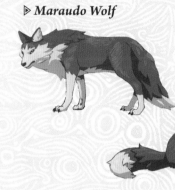

▷ **Bushy-Tailed Squirrel**

▷ **Honeyvore Bear**

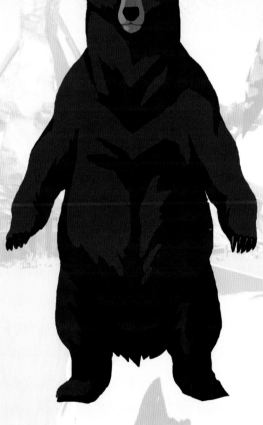

▷ **Mountain Buck**

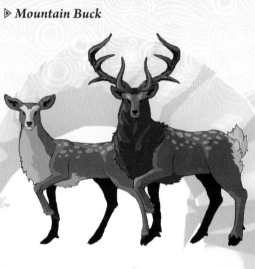

▷ **Mountain Goat**

▷ **Tabantha Moose**

▷ **Highland Sheep**

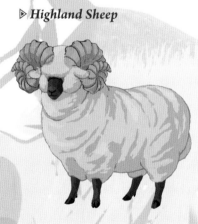

▷ **Red-Tusked Boar**

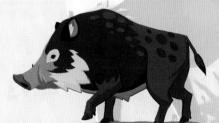

▷ **Great-Horned Rhinoceros**

▷ **Grassland Fox**

BIRDS

Herons, pigeons, and sparrows can be found all over the realm, though the climate of the region determines which kind you might see. Ducks can be found in all bodies of water, while seagulls are specific to the ocean.

▷ *Islander Hawk*

▷ *Sparrow*

▷ *Pigeon*

▷ *Heron*

▷ *Bright-Chested Duck*

▷ *Seagull*

▷ **Cucco Rough Designs**

CUCCO HD

ITS COMB IS ROUND AND HUGE.

IT WOBBLES NOTICEABLY.

LONG TAIL

REPTILIAN FACE? IT SHOULD FEEL LIKE IT'S A FANTASY CREATURE, DISTINCT FROM A REAL CHICKEN.

IT COULD BE SHORT AND SQUAT— AS LONG AS IT IS WIDE.

WING

THICK, STURDY LEGS. THEY SHOULD BE EASY TO SEE. LINK GRABS ONTO THEM, AFTER ALL.

I WANT IT TO SPREAD ITS WINGS LIKE THIS. THEY ARE SHAPED FOR GLIDING.

SCREENSHOT

"MORNING" FIGHT!

ANGRY

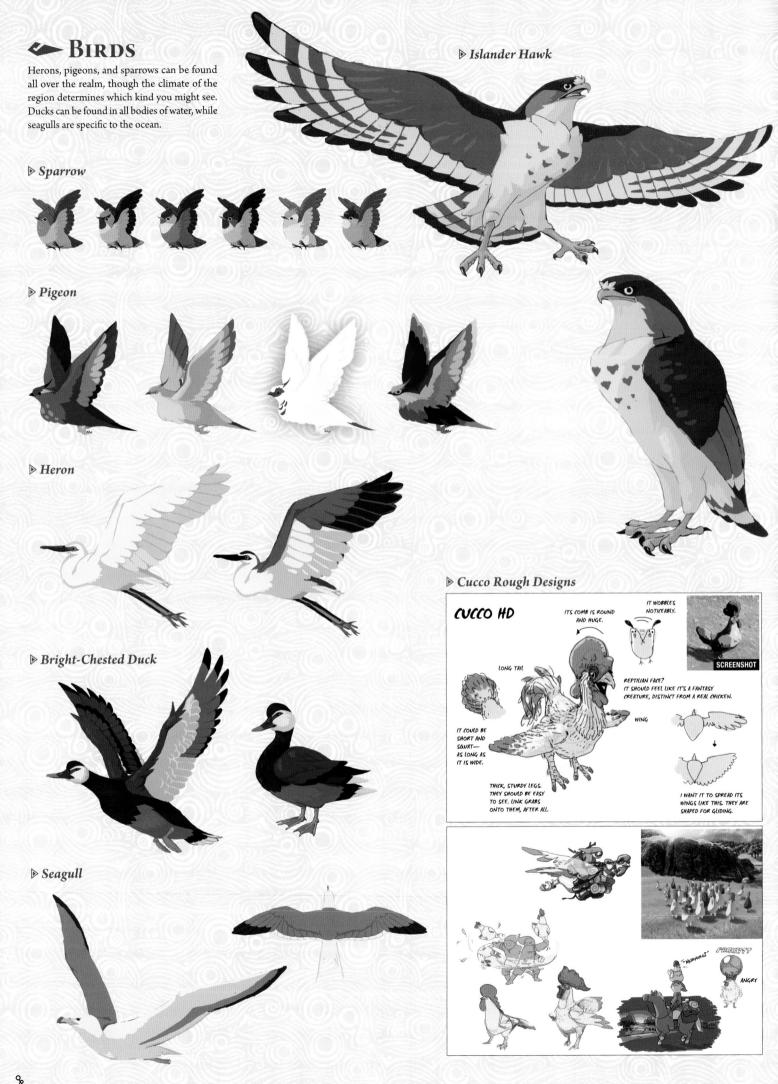

AQUATIC CREATURES

Aquatic animals live in the bodies of water of Hyrule—lakes, rivers, and the sea. Because the waters of Hyrule are so clear, it is easy to see these vividly colored creatures. If you are trying to catch a fish, it is good to keep in mind that each type of fish prefers a different kind of bait.

▷ *Ironshell Crab*

▷ *Snails*

▷ *Hearty Bass*

▷ *Hearty Salmon*
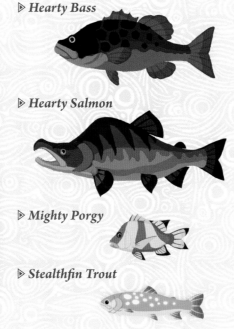

▷ *Mighty Porgy*

▷ *Stealthfin Trout*

INSECTS & SMALL ANIMALS

Tiny creatures can be found in all kinds of places, whether climbing trees, scuttling across the ground, or flitting across the sky. These creatures adapt to their climates, and their appearances and properties change dramatically based on the location where they are found.

▷ *Hightail Lizard*
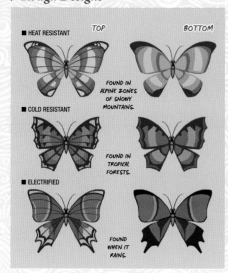

▷ *Energetic Rhino Beetle*

▷ *Hot-Footed Frog*

▷ *Courser Bee*

▷ *Bladed Rhino Beetle*

▷ *Rough Designs*
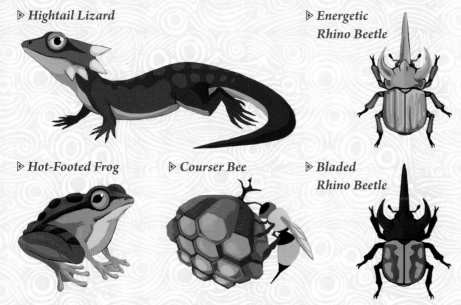

■ HEAT RESISTANT
TOP BOTTOM
FOUND IN ALPINE ZONES OF SNOWY MOUNTAINS.

■ COLD RESISTANT
FOUND IN TROPICAL FORESTS.

■ ELECTRIFIED
FOUND WHEN IT RAINS.

DRAGONFLY
FACE
FRONT
WINGS
• ELECTRIFIED FOUND WHEN IT RAINS.
SIDE

• COLD RESISTANT FOUND IN WARM ENVIRONMENTS.

• HEAT RESISTANT FOUND IN COOL PLACES.

BACKGROUND
Creatures

The relationships between people and the creatures of Hyrule vary considerably. Sometimes animals and people form symbiotic relationships to help each other survive, while other times creatures are aggressive toward people. Some animals are hunted or bred for food.

Though animal behavior is very different to that of people, the observant will be able to see that every animal in Hyrule has particular reasons for doing what it does, with some relying on the strength of a community to help them survive. Wolves will howl to call in their pack to defeat possible prey, while mountain bucks avoid danger by being constantly vigilant and alerting the herd to threats. These animals have evolved means of communication that have helped them endure in the wild lands of Hyrule.

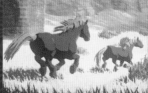

SYMBIOTIC RELATIONSHIPS

Horses are critical to life in Hyrule as a means of getting safely from one place to another, and donkeys are crucial for carrying goods from one part of the land to the other. Horses are also ridden by crafty Bokoblins, making these mounted monsters particularly difficult to get away from. In spite of Hyrule's fine network of stables and the wide availability of horses, some adventurous souls choose to ride wild animals like deer and bears!

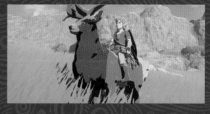

ADAPTATIONS

Creatures of the same species often have coloring specific to the region they inhabit. Hyrule contains a vast number of different climates within it's relatively small borders, from volcanoes to snowy mountains, deserts to oceans, and more. In addition to the more common animals that live in all environments, there are some unique specimens that can only be found in specific places. Ecological surveys of these rare creatures are being conducted.

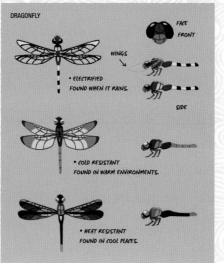

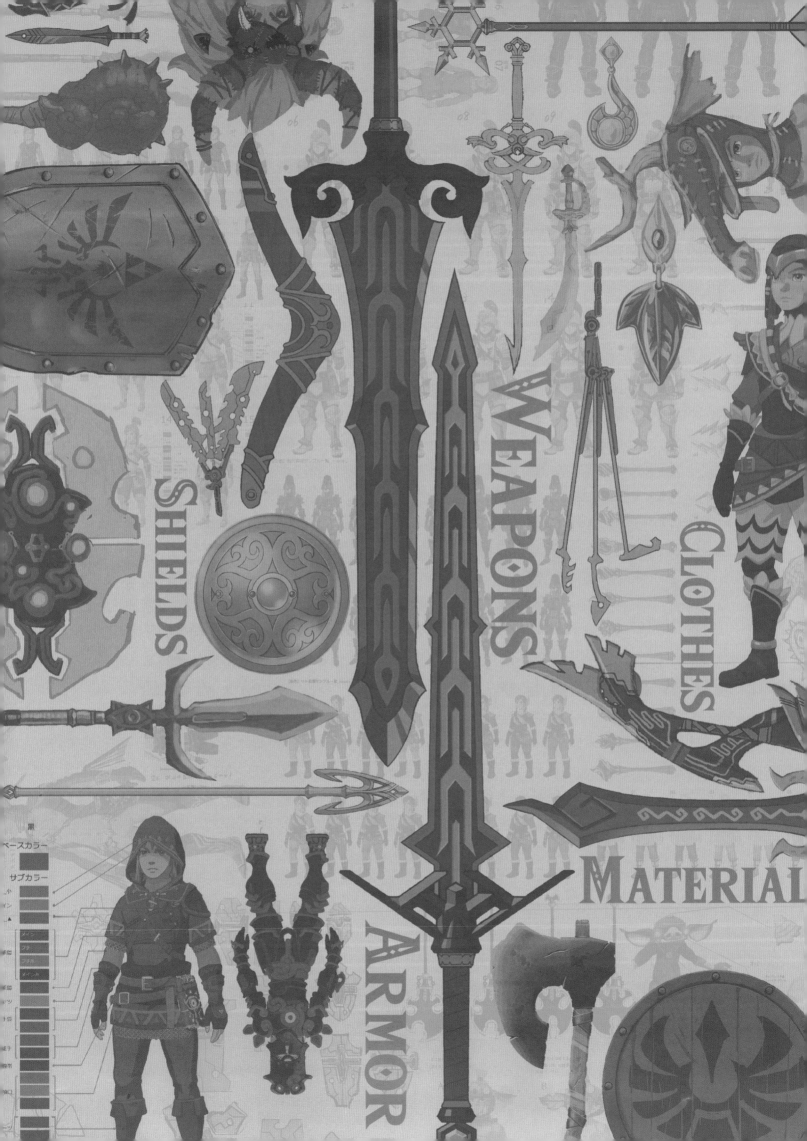

SHIELDS

WEAPONS

CLOTHES

ARMOR

MATERIAL

WEAPONS & SHIELDS
LINK'S ARMORY

After the Great Calamity, Hyrule became more dangerous with the rise of more aggressive monsters and the absence of trained Hylian soldiers. Weapons became commonplace tools of survival.

Over the course of Link's adventure, he will need to utilize a variety of weapons to save Hyrule. Weapons can be loosely broken into the following types: one-handed, two-handed, and bows. Link may also be forced to get creative, wielding daily implements like mops, hammers, or soup ladles against the hordes. If Link is not wielding a two-handed weapon, he is able to utilize a shield for defense in his off hand.

MASTER SWORD

The Master Sword is the only blade of its kind in this world. It was damaged during the Guardians' assault during the Great Calamity as Link fled with Princess Zelda. After Link fell in battle, Zelda delivered the sword to its pedestal in the Korok Forest so that it might recover. She knew that when Link woke from the Slumber of Restoration, it would find its way into his hand once again.

▷ *Rough Concepts*

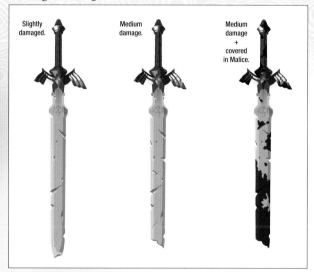

Slightly damaged.

Medium damage.

Medium damage + covered in Malice.

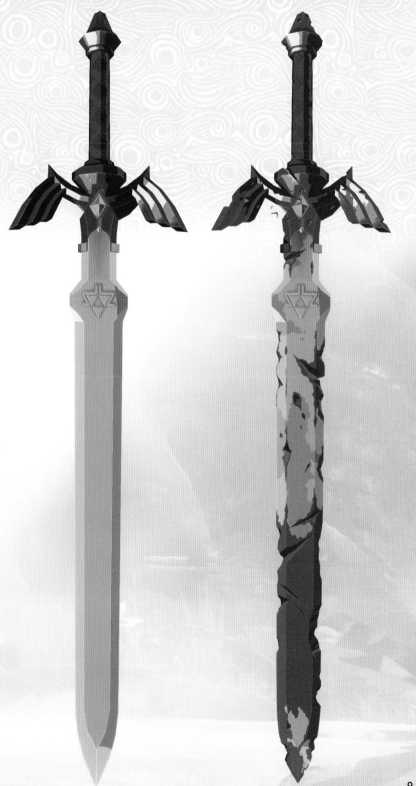

HYLIAN WEAPONS & SHIELDS

The types of weapons used by the soldiers of the kingdom of Hyrule differ by the rank of the soldier. The Royal Gear is of the highest quality, is extremely durable, and boasts decorative details, but the Royal Guard's Gear has a higher attack power.

▷ *Royal Gear*

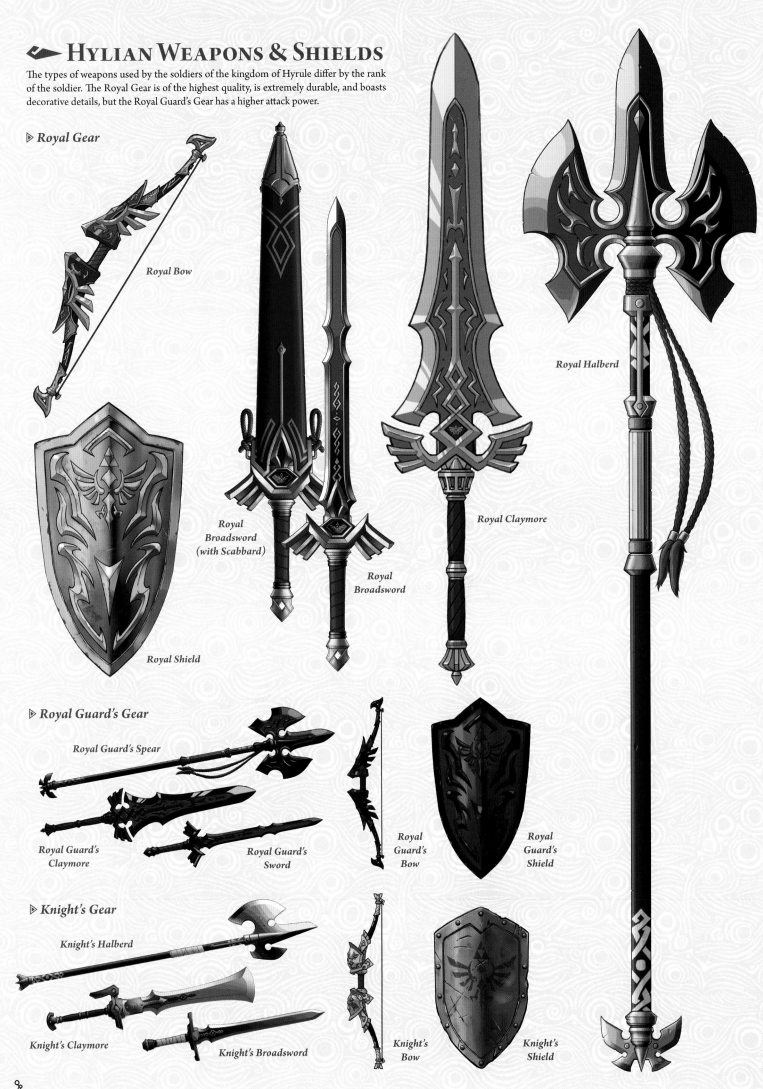

Royal Bow

Royal Halberd

Royal Broadsword (with Scabbard)

Royal Broadsword

Royal Claymore

Royal Shield

▷ *Royal Guard's Gear*

Royal Guard's Spear

Royal Guard's Claymore

Royal Guard's Sword

Royal Guard's Bow

Royal Guard's Shield

▷ *Knight's Gear*

Knight's Halberd

Knight's Claymore

Knight's Broadsword

Knight's Bow

Knight's Shield

▷ Soldier's Gear

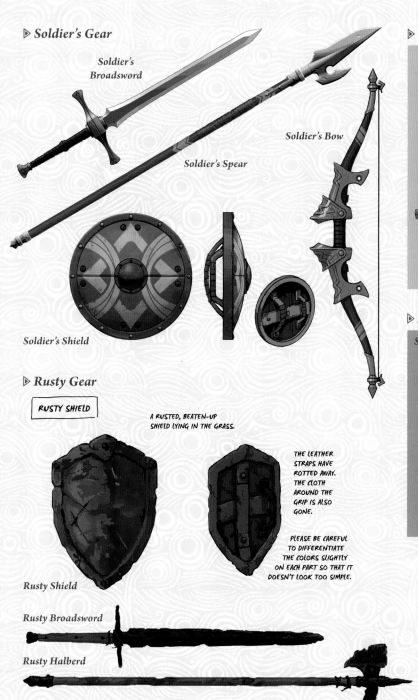

Soldier's Broadsword

Soldier's Spear

Soldier's Bow

Soldier's Shield

▷ Rusty Gear

RUSTY SHIELD

A RUSTED, BEATEN-UP SHIELD LYING IN THE GRASS.

THE LEATHER STRAPS HAVE ROTTED AWAY. THE CLOTH AROUND THE GRIP IS ALSO GONE.

PLEASE BE CAREFUL TO DIFFERENTIATE THE COLORS SLIGHTLY ON EACH PART SO THAT IT DOESN'T LOOK TOO SIMPLE.

Rusty Shield

Rusty Broadsword

Rusty Halberd

▷ Rusty Gear Rough Concepts

A number of ideas for how to repair Rusty Gear were considered during development. The one that was implemented was to have the player throw their weapon at a Rock Octorok as it is inhaling. They will swallow it and spit it out restored to its former glory.

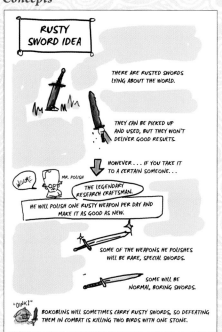

RUSTY SWORD IDEA

THERE ARE RUSTED SWORDS LYING ABOUT THE WORLD.

THEY CAN BE PICKED UP AND USED, BUT THEY WON'T DELIVER GOOD RESULTS.

HOWEVER . . . IF YOU TAKE IT TO A CERTAIN SOMEONE . . .

MR. POLISH

THE LEGENDARY RESEARCH CRAFTSMAN.

HE WILL POLISH ONE RUSTY WEAPON PER DAY AND MAKE IT AS GOOD AS NEW.

SOME OF THE WEAPONS HE POLISHES WILL BE RARE, SPECIAL SWORDS.

SOME WILL BE NORMAL, BORING SWORDS.

"OINK!" BOKOBLINS WILL SOMETIMES CARRY RUSTY SWORDS, SO DEFEATING THEM IN COMBAT IS KILLING TWO BIRDS WITH ONE STONE.

▷ Traveler's Gear

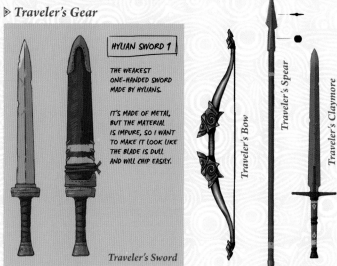

HYLIAN SWORD 1

THE WEAKEST ONE-HANDED SWORD MADE BY HYLIANS.

IT'S MADE OF METAL, BUT THE MATERIAL IS IMPURE, SO I WANT TO MAKE IT LOOK LIKE THE BLADE IS DULL AND WILL CHIP EASILY.

Traveler's Bow

Traveler's Spear

Traveler's Claymore

Traveler's Sword

▷ Hammer

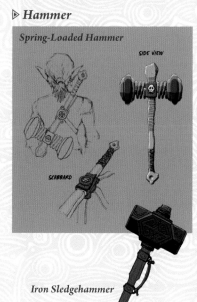

Spring-Loaded Hammer

SIDE VIEW

SCABBARD

Iron Sledgehammer

▷ Boomerang

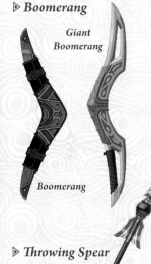

Giant Boomerang

Boomerang

▷ Throwing Spear

▷ Daily Use Goods

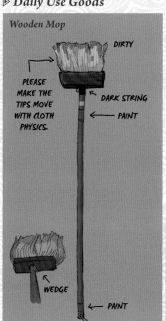

Wooden Mop

DIRTY

PLEASE MAKE THE TIPS MOVE WITH CLOTH PHYSICS.

DARK STRING

PAINT

WEDGE

PAINT

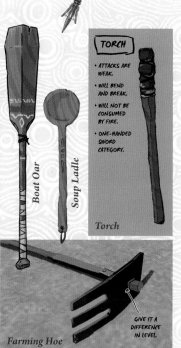

Boat Oar

Soup Ladle

TORCH

- ATTACKS ARE WEAK.
- WILL BEND AND BREAK.
- WILL NOT BE CONSUMED BY FIRE.
- ONE-HANDED SWORD CATEGORY.

Torch

Farming Hoe

GIVE IT A DIFFERENCE IN LEVEL.

HYRULEAN WEAPONS & SHIELDS

All of the Hyrulean races have created their own unique equipment specifically suited to their physique that also reflects their culture.

▷ *Sheikah Gear*

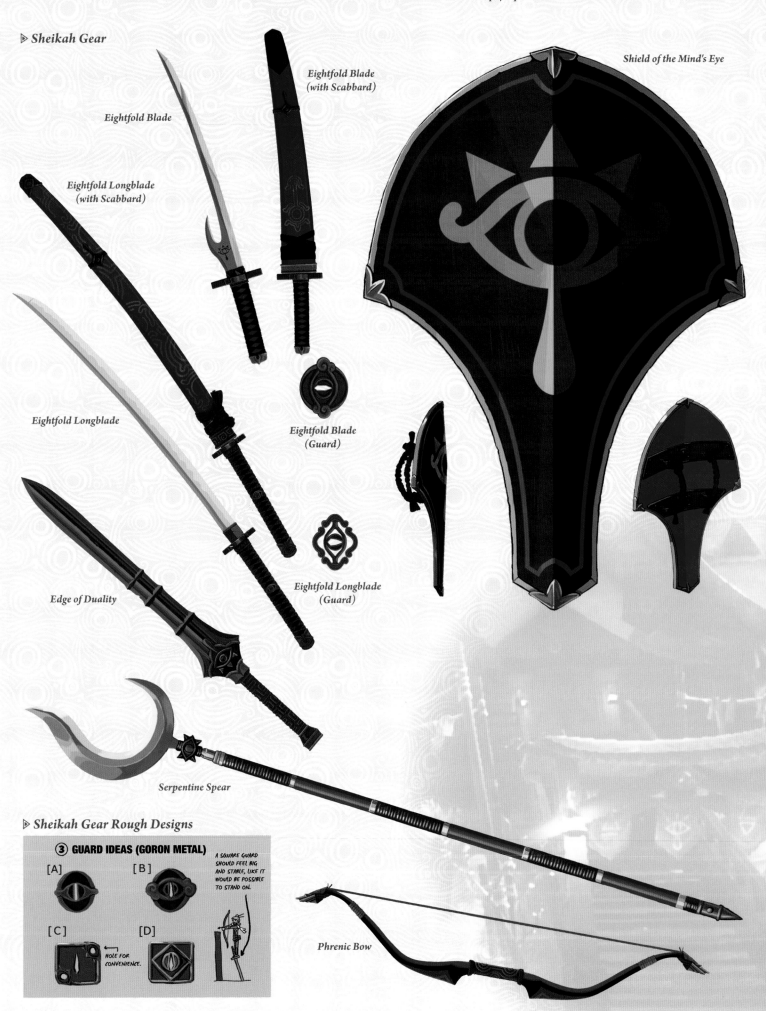

Eightfold Blade

Eightfold Blade (with Scabbard)

Shield of the Mind's Eye

Eightfold Longblade (with Scabbard)

Eightfold Longblade

Eightfold Blade (Guard)

Eightfold Longblade (Guard)

Edge of Duality

Serpentine Spear

▷ *Sheikah Gear Rough Designs*

③ GUARD IDEAS (GORON METAL)

[A] [B]

A SQUARE GUARD SHOULD FEEL BIG AND STABLE, LIKE IT WOULD BE POSSIBLE TO STAND ON.

[C] [D]

HOLE FOR CONVENIENCE.

Phrenic Bow

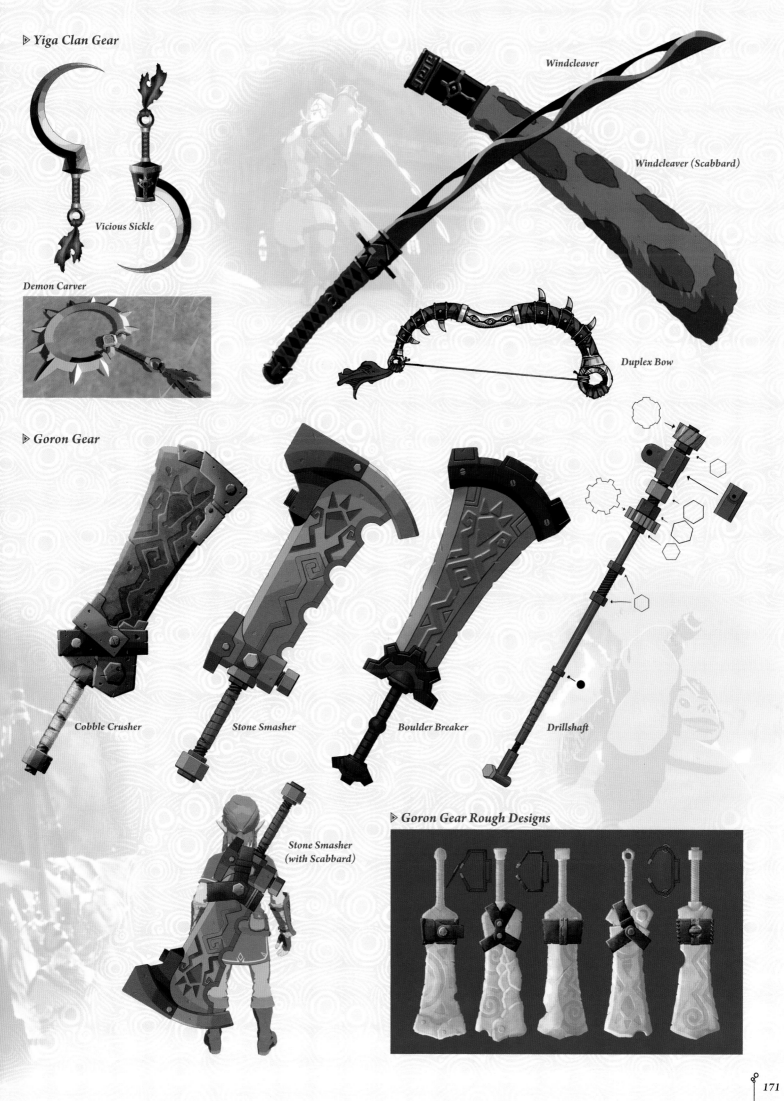

▷ *Yiga Clan Gear*

Vicious Sickle

Demon Carver

Windcleaver

Windcleaver (Scabbard)

Duplex Bow

▷ *Goron Gear*

Cobble Crusher

Stone Smasher

Boulder Breaker

Drillshaft

Stone Smasher (with Scabbard)

▷ *Goron Gear Rough Designs*

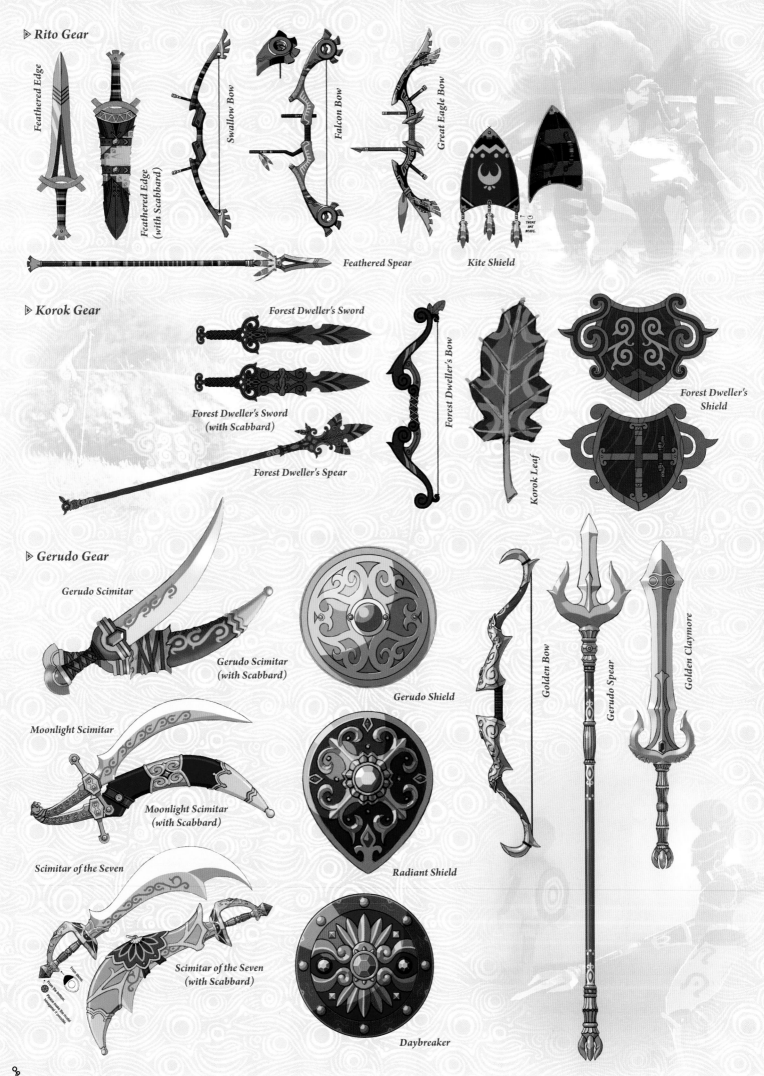

▷ *Rito Gear*

Feathered Edge

Feathered Edge (with Scabbard)

Swallow Bow

Falcon Bow

Great Eagle Bow

Feathered Spear

Kite Shield

▷ *Korok Gear*

Forest Dweller's Sword

Forest Dweller's Sword (with Scabbard)

Forest Dweller's Spear

Forest Dweller's Bow

Korok Leaf

Forest Dweller's Shield

▷ *Gerudo Gear*

Gerudo Scimitar

Gerudo Scimitar (with Scabbard)

Gerudo Shield

Moonlight Scimitar

Moonlight Scimitar (with Scabbard)

Radiant Shield

Scimitar of the Seven

Scimitar of the Seven (with Scabbard)

Daybreaker

Golden Bow

Gerudo Spear

Golden Claymore

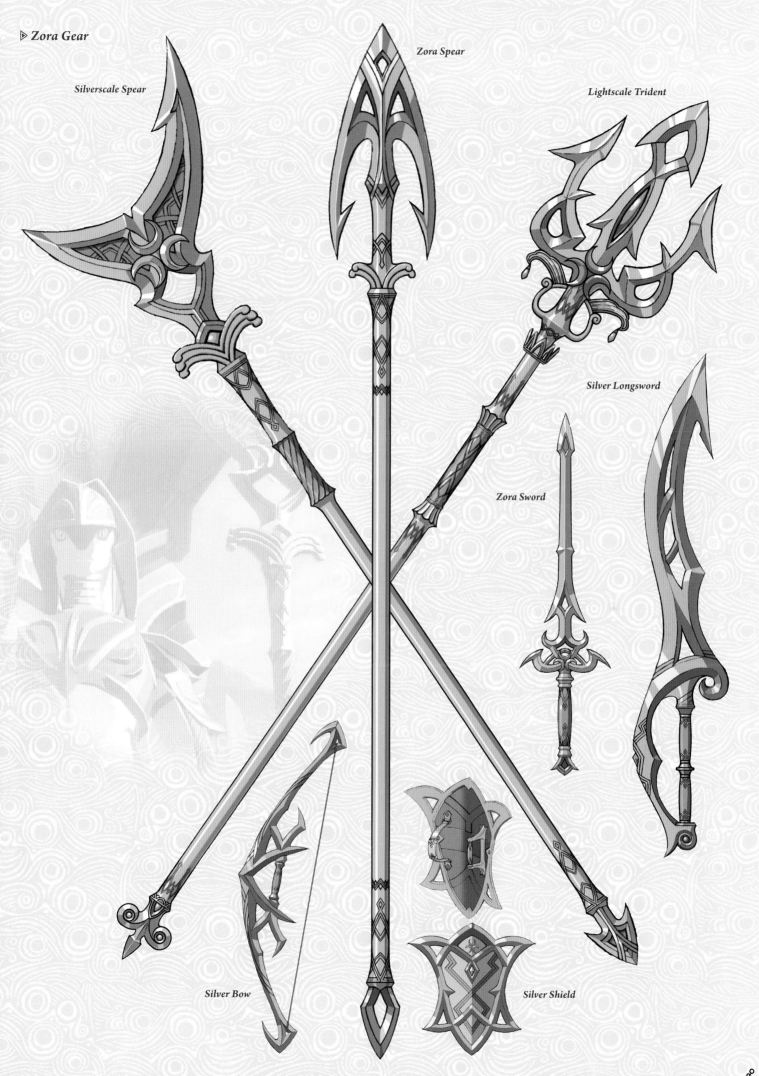

▷ *Zora Gear*

Silverscale Spear

Zora Spear

Lightscale Trident

Silver Longsword

Zora Sword

Silver Bow

Silver Shield

MONSTER WEAPONS & SHIELDS

The equipment used by monsters varies by type of monster based on differences in lifestyle, abilities, and technical aptitude. Bokoblins attach bones to clubs while Lizalfos utilize forged metal in their gear, revealing the difference in tool-making skills between the two sets of monsters.

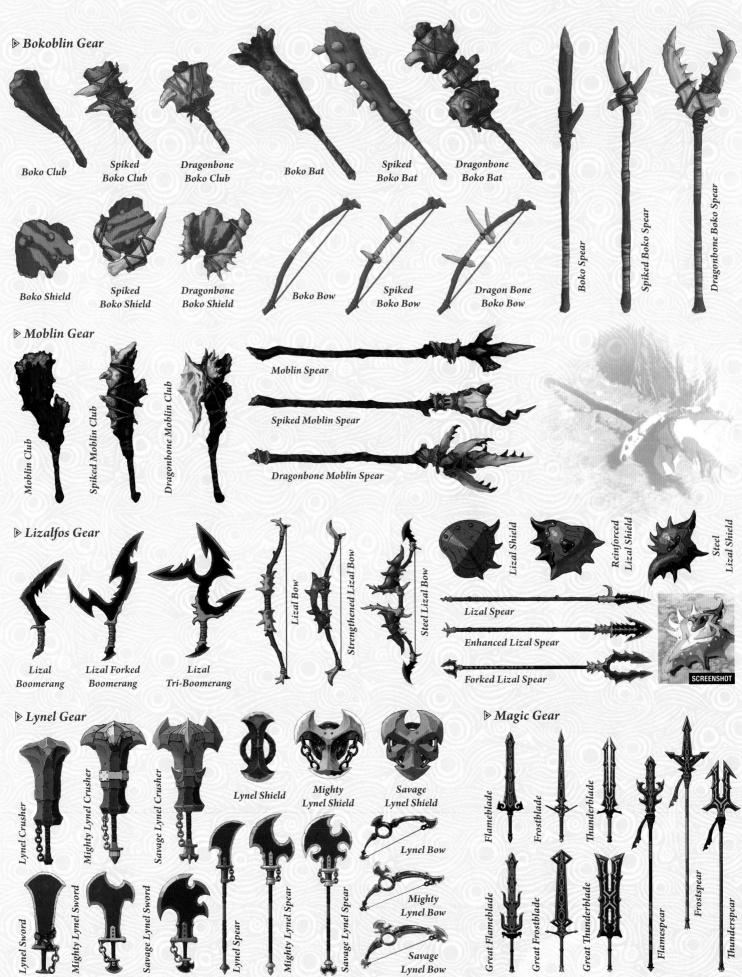

▷ Bokoblin Gear

Boko Club

Spiked Boko Club

Dragonbone Boko Club

Boko Bat

Spiked Boko Bat

Dragonbone Boko Bat

Boko Shield

Spiked Boko Shield

Dragonbone Boko Shield

Boko Bow

Spiked Boko Bow

Dragon Bone Boko Bow

Boko Spear

Spiked Boko Spear

Dragonbone Boko Spear

▷ Moblin Gear

Moblin Club

Spiked Moblin Club

Dragonbone Moblin Club

Moblin Spear

Spiked Moblin Spear

Dragonbone Moblin Spear

▷ Lizalfos Gear

Lizal Boomerang

Lizal Forked Boomerang

Lizal Tri-Boomerang

Lizal Bow

Strengthened Lizal Bow

Steel Lizal Bow

Lizal Shield

Reinforced Lizal Shield

Steel Lizal Shield

Lizal Spear

Enhanced Lizal Spear

Forked Lizal Spear

SCREENSHOT

▷ Lynel Gear

Lynel Crusher

Mighty Lynel Crusher

Savage Lynel Crusher

Lynel Shield

Mighty Lynel Shield

Savage Lynel Shield

Lynel Sword

Mighty Lynel Sword

Savage Lynel Sword

Lynel Spear

Mighty Lynel Spear

Savage Lynel Spear

Lynel Bow

Mighty Lynel Bow

Savage Lynel Bow

▷ Magic Gear

Flameblade

Frostblade

Thunderblade

Great Flameblade

Great Frostblade

Great Thunderblade

Flamespear

Frostspear

Thunderspear

▷ Guardian Gear

Guardian Shield

Guardian Shield+

Guardian Shield++

▷ Guardian Gear Rough Designs

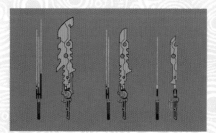
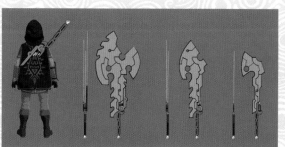
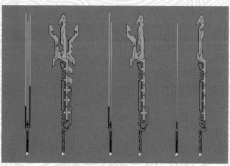

Guardian Swords

Ancient Battle Axes

Guardian Spears

▷ Ancient Soldier Gear

Ancient Short Sword

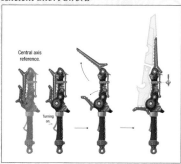

Ancient Bladesaw

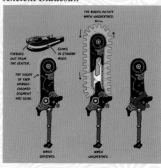
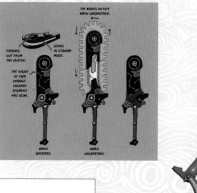

Ancient Shield

■ ANCIENT SHIELD DESIGN PROPOSAL
■ Front

Two arms extend from inside when opened.

Ancient Arrow

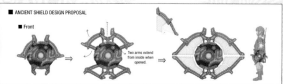
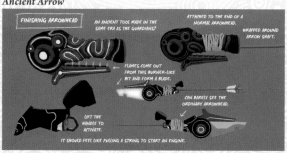

FINISHING ARROWHEAD

AN ANCIENT TOOL MADE IN THE SAME ERA AS THE GUARDIANS?

ATTACHED TO THE END OF A NORMAL ARROWHEAD.

WRAPPED AROUND ARROW SHAFT.

FLAMES COME OUT FROM THIS BURNER-LIKE BIT AND FORM A BLADE.

CAN RARELY SEE THE ORDINARY ARROWHEAD.

LIFT THE HANDLE TO ACTIVATE.

IT SHOULD FEEL LIKE PULLING A STRING TO START AN ENGINE.

Ancient Bow

Ancient Spear

▷ Ancient Soldier Gear Rough Designs

Ancient Bladesaw

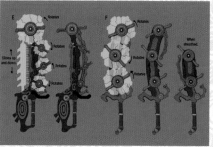

E Rotates
F Rotates

Ancient Arrow

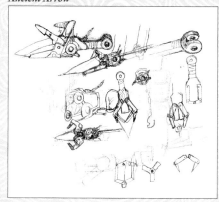

▷ Bow of Light • Arrows • Quiver

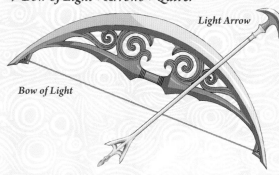

Light Arrow

Bow of Light

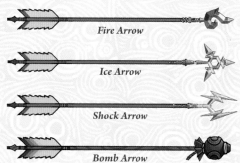

Fire Arrow

Ice Arrow

Shock Arrow

Bomb Arrow

Quiver

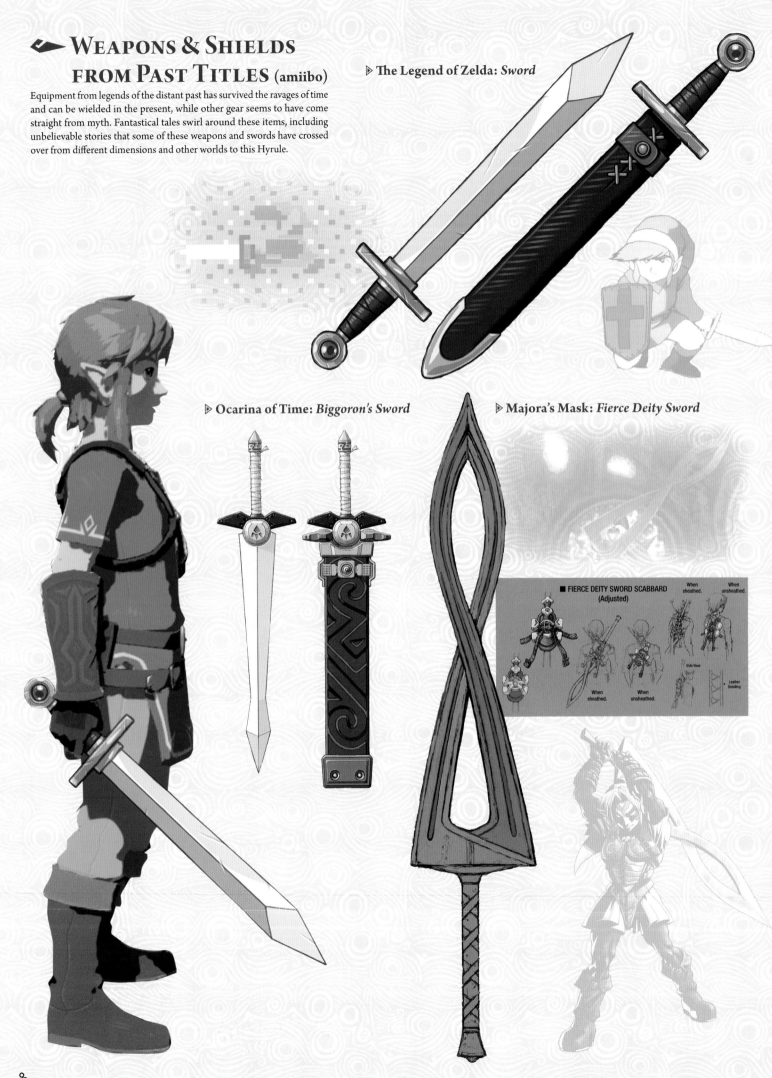

WEAPONS & SHIELDS FROM PAST TITLES (amiibo)

Equipment from legends of the distant past has survived the ravages of time and can be wielded in the present, while other gear seems to have come straight from myth. Fantastical tales swirl around these items, including unbelievable stories that some of these weapons and swords have crossed over from different dimensions and other worlds to this Hyrule.

▷ **The Legend of Zelda:** *Sword*

▷ **Ocarina of Time:** *Biggoron's Sword*

▷ **Majora's Mask:** *Fierce Deity Sword*

■ FIERCE DEITY SWORD SCABBARD (Adjusted)

When sheathed.

When unsheathed.

When sheathed.

When unsheathed.

Side View

Leather Detailing

▷ **Skyward Sword:** *Goddess Sword*

▷ **The Wind Waker:** *Sea-Breeze Boomerang*

▷ **Twilight Princess:**
Sword of the Six Sages

▷ **The Wind Waker:** *Hero's Shield*

▷ **Twilight Princess:** *Twilight Bow*

■ BOW OF LIGHT (Adjusted)
(TWILIGHT PRINCESS)

Side View

Only This Part: Top View

FOUR-FOLD
ARROWHEAD

THREE-FEATHER BASE

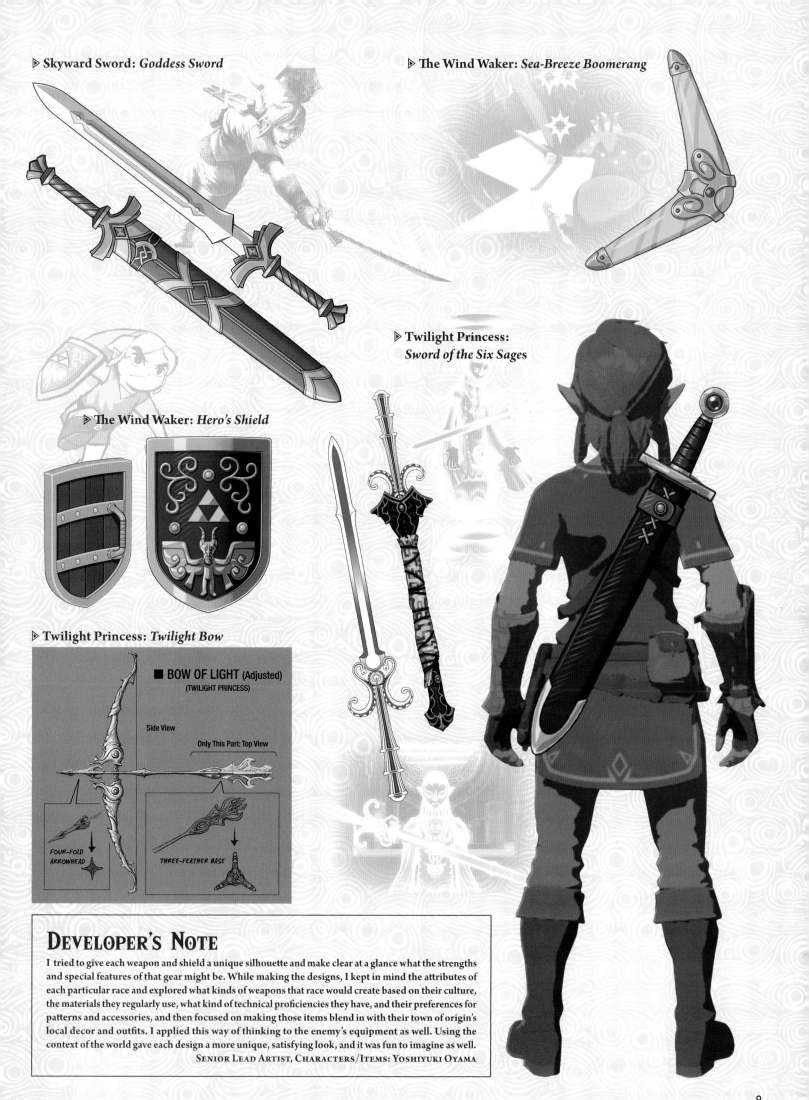

DEVELOPER'S NOTE

I tried to give each weapon and shield a unique silhouette and make clear at a glance what the strengths and special features of that gear might be. While making the designs, I kept in mind the attributes of each particular race and explored what kinds of weapons that race would create based on their culture, the materials they regularly use, what kind of technical proficiencies they have, and their preferences for patterns and accessories, and then focused on making those items blend in with their town of origin's local decor and outfits. I applied this way of thinking to the enemy's equipment as well. Using the context of the world gave each design a more unique, satisfying look, and it was fun to imagine as well.

SENIOR LEAD ARTIST, CHARACTERS/ITEMS: YOSHIYUKI OYAMA

Armor & Clothing
An Array of Accessories

The people of Hyrule generally wear practical attire adapted to their occupation and regional climate. Link travels to all corners of Hyrule, so it makes sense that he would utilize a variety of outfits appropriate to the activities he's engaging in and his environment. There is a wealth of clothing and armor options available to him, with some allowing him to endure extreme cold or heat, move more efficiently on difficult terrain, and be protected from the brunt of an enemy attack.

CHAMPION'S TUNIC

This garment can only be worn by one who has earned the respect of the royal family and will defend Hyrule against Calamity Ganon. Link was wearing this outfit on the day of the Great Calamity when he was gravely injured fighting the Guardians. He retrieves it from Impa in Kakariko Village when he awakens from the Slumber of Restoration.

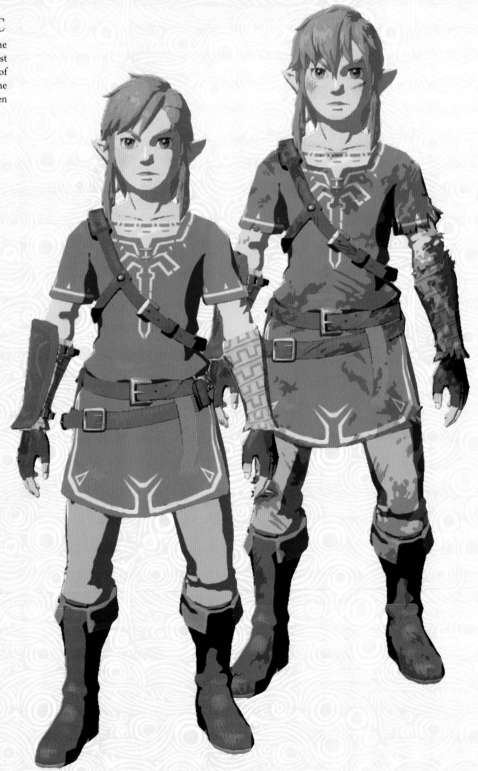

DEVELOPER'S NOTE

When we first started, I was under orders to provide players with a variety of outfits they could equip based on their preference rather than just relying on the most powerful equipment. So I created designs for outfit sets that could be mixed and matched without the whole design falling apart while maintaining a clear silhouette that was recognizable at a glance. I think it added to the adventure that players were free to decide whether they would wear a full, matching outfit, pick and choose based on stats, or simply wear the combination they thought looked best. We also included the dyeing mechanic so that players could incorporate their own unique styles into the game.

The stripped-down version of Link didn't appear until after production started. When it made its way into the game, the development team got really excited. Ultimately, it meant that the player starts the game with nothing equipped, but now that I think about it, maybe that was inevitable.

The Gerudo Top (page 182) was challenging, because I had to create a garment that would deceive the Gerudo guards but also fit Link. I was surprised to find that when we created the outfit it didn't feel out of place at all, but Riju still sees right through you.

SENIOR LEAD ARTIST, CHARACTER/ITEM:
YOSHIYUKI OYAMA

UNEQUIPPED

This is the outfit that Link is wearing upon waking from his one-hundred-year slumber.

SCREENSHOT

A WELL-WORN OUTFIT

These old clothes were left in the Shrine of Resurrection for Link by those who placed him there a century ago. They have become a bit tattered after so much time.

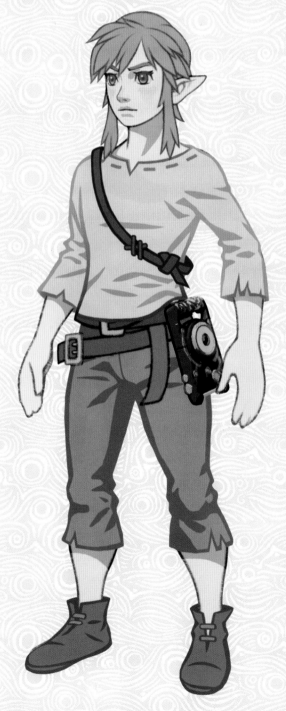

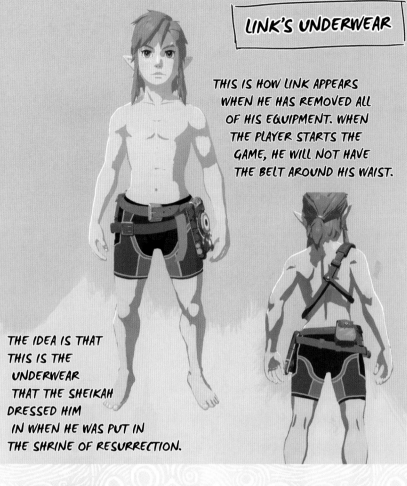

LINK'S UNDERWEAR

THIS IS HOW LINK APPEARS WHEN HE HAS REMOVED ALL OF HIS EQUIPMENT. WHEN THE PLAYER STARTS THE GAME, HE WILL NOT HAVE THE BELT AROUND HIS WAIST.

THE IDEA IS THAT THIS IS THE UNDERWEAR THAT THE SHEIKAH DRESSED HIM IN WHEN HE WAS PUT IN THE SHRINE OF RESURRECTION.

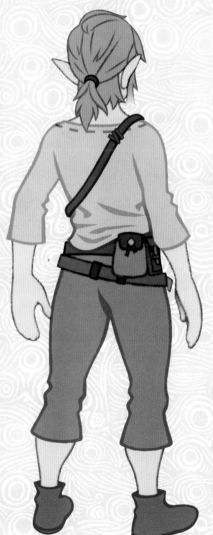

▷ *Color Variations*

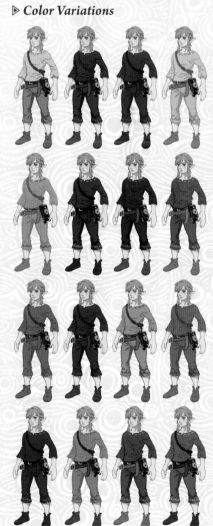

STEALTH SET

The Stealth Set is made of noise-suppressing cloth, which is an ancient Sheikah technology that has survived through the ages. This outfit is excellent for covert operations.

FLAME-BREAKER SET

This armor is made by Goron craftsmen to protect Hylian tourists from the heat of Goron City. It is made primarily of stone.

ZORA SET

Each generation's Zora princess painstakingly crafts custom armor for her future husband. It's been said it's crafted using dragon scales.

SNOWQUILL SET

Lined with the molted feathers of the Rito, this outfit is insulated against the cold. The headset is adorned with rubies which contain the power of fire.

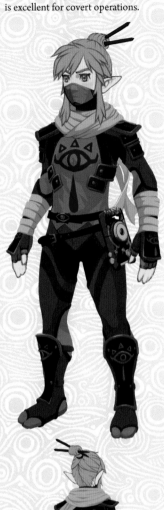

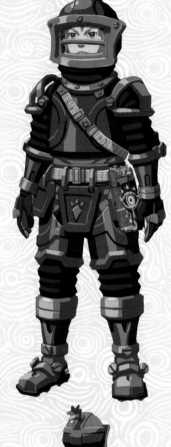

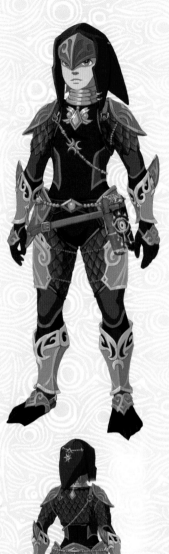

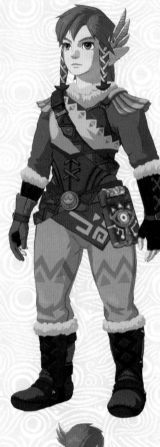

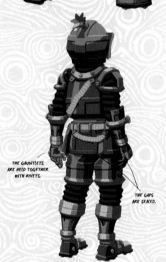

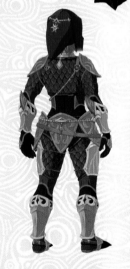

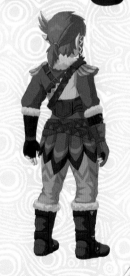

THE GAUNTLETS ARE HELD TOGETHER WITH RIVETS.

THE GAPS ARE SEALED.

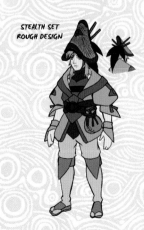

STEALTH SET ROUGH DESIGN

TOPKNOT

CENTER BENDS INWARD.

HIP PARTS DETAILS

SOLE DETAILS

BUTTERFLY-LIKE CONSTRUCTION

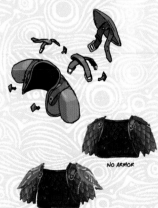

NO ARMOR

SCALED OUTFIT

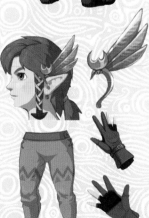

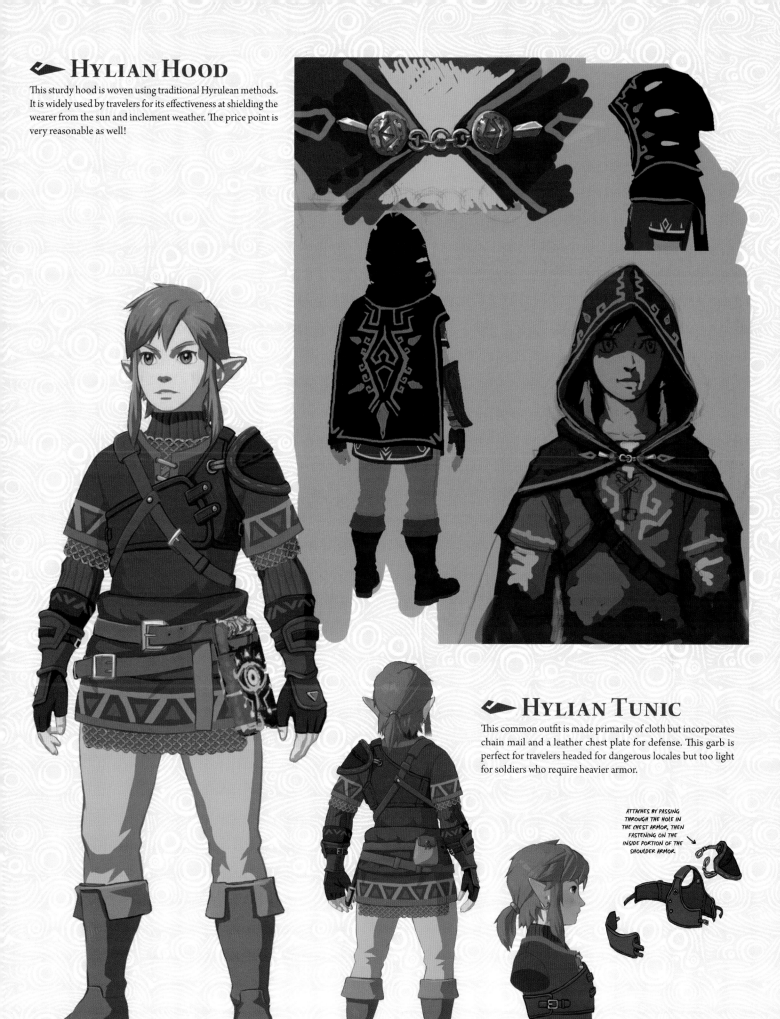

HYLIAN HOOD

This sturdy hood is woven using traditional Hyrulean methods. It is widely used by travelers for its effectiveness at shielding the wearer from the sun and inclement weather. The price point is very reasonable as well!

HYLIAN TUNIC

This common outfit is made primarily of cloth but incorporates chain mail and a leather chest plate for defense. This garb is perfect for travelers headed for dangerous locales but too light for soldiers who require heavier armor.

ATTACHES BY PASSING THROUGH THE HOLE IN THE CHEST ARMOR, THEN FASTENING ON THE INSIDE PORTION OF THE SHOULDER ARMOR

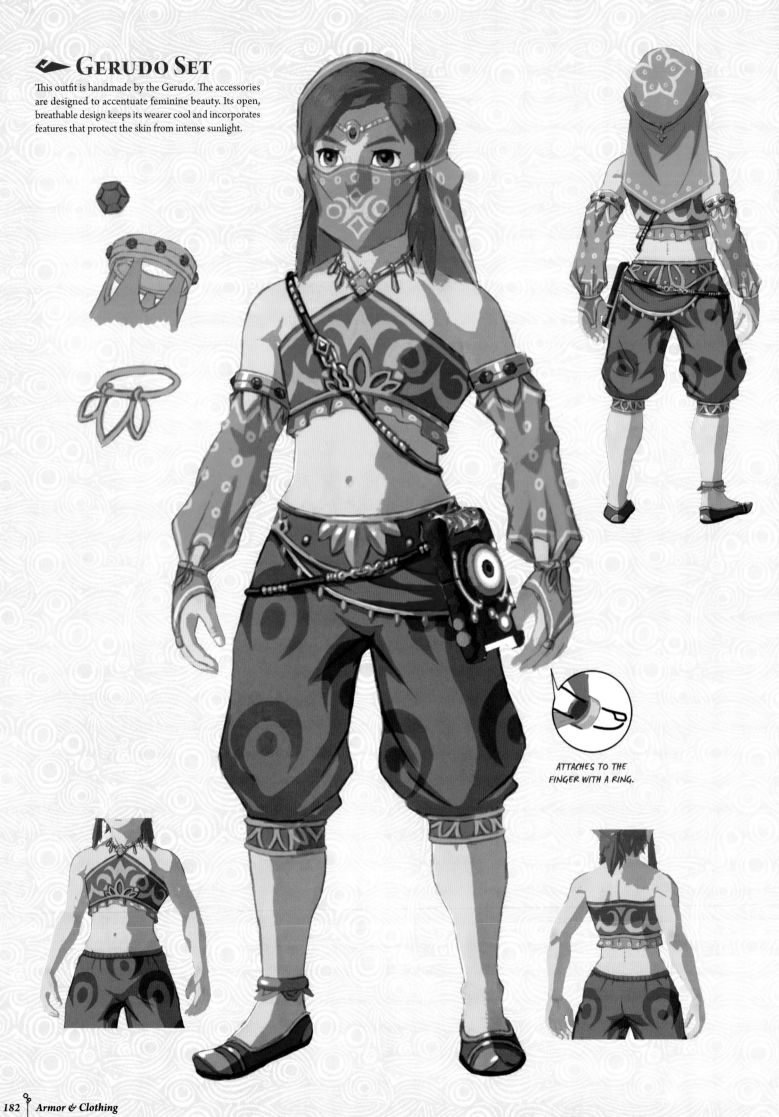

GERUDO SET

This outfit is handmade by the Gerudo. The accessories are designed to accentuate feminine beauty. Its open, breathable design keeps its wearer cool and incorporates features that protect the skin from intense sunlight.

ATTACHES TO THE FINGER WITH A RING.

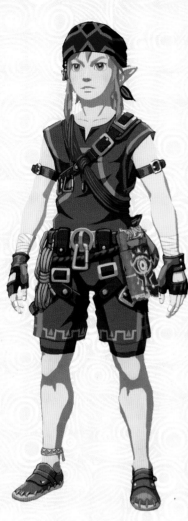

CLIMBING SET

This outfit is infused with ancient technology that enhances core strength. Coupled with the no-slip gloves and climbing boots, this gear will up your climbing game.

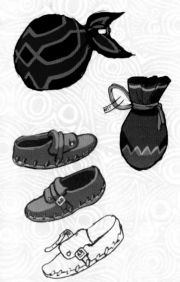

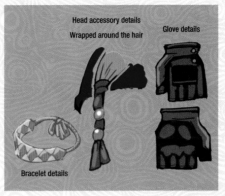

Head accessory details

Wrapped around the hair

Glove details

Bracelet details

WARM DOUBLET

This jacket will keep the wearer warm with its thick gloves and sturdy fabric. It is not as effective at retaining body heat as the Snowquill Set, with its Rito-feather lining, but works well enough for the mountain people who typically wear it.

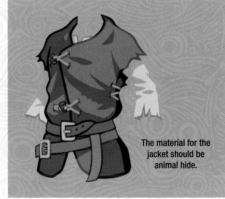

The material for the jacket should be animal hide.

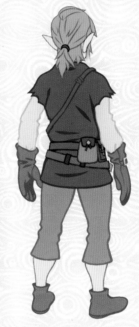

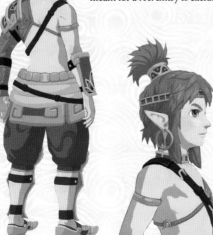

DESERT VOE SET

The male version of the Gerudo Set contains sapphires which harness the power of ice to keep the wearer cool in the heat of the desert. It is sold at the Gerudo Secret Club, which is the only shop in Gerudo Town where someone can buy clothes meant for a *voe*. Entry is exclusive.

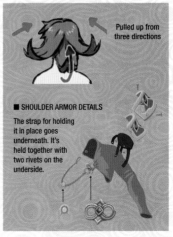

Pulled up from three directions

■ SHOULDER ARMOR DETAILS

The strap for holding it in place goes underneath. It's held together with two rivets on the underside.

▷ *Desert Voe Set Rough Designs*

SOLDIER'S SET

This heavy armor was made by skilled craftsmen to protect frontline soldiers. Being made of metal plates, it weighs a lot and restricts movement but makes up for those drawbacks with its superior defense.

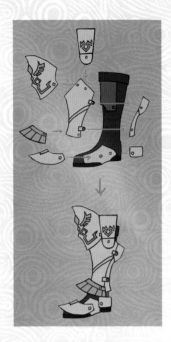

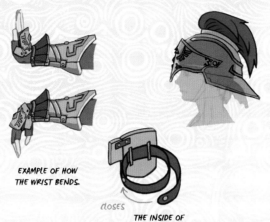

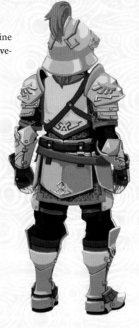

EXAMPLE OF HOW THE WRIST BENDS.

closes

THE INSIDE OF THE GAUNTLET.

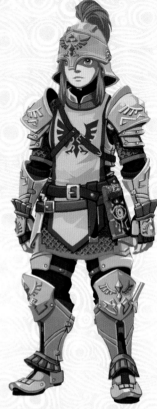

BARBARIAN SET

This outfit was worn by the warriors of an ancient warlike tribe from the Faron region. The war paint brings out your inner strength and increases attack power.

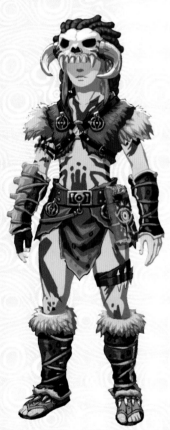

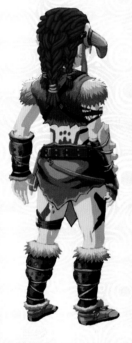

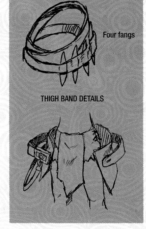

Four fangs

THIGH BAND DETAILS

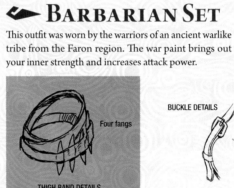

BUCKLE DETAILS

Four talons

Details for chest harness

SANDAL DETAILS

RUBBER ARMOR

This armor is made from something called "rubber," a material that can no longer be found in Hyrule. It is an incredibly valuable substance made with ancient technology. Covering one's entire body in rubber makes it nonconductive and resistant to electricity.

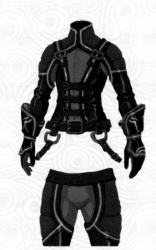

THE CHIN STRAP CAN BE ADJUSTED WITH A D-RING BUCKLE. IT IS HELD IN PLACE IN TWO PLACES ON THE INTERIOR NEAR THE LOWER PARTS OF THE EYELIDS.

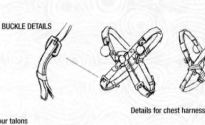
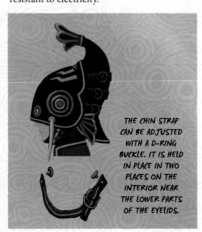

RADIANT SET

Wearing this outfit in the dark will reveal a strange glow-in-the-dark pattern that is made using a dye made from crushed luminous stones.

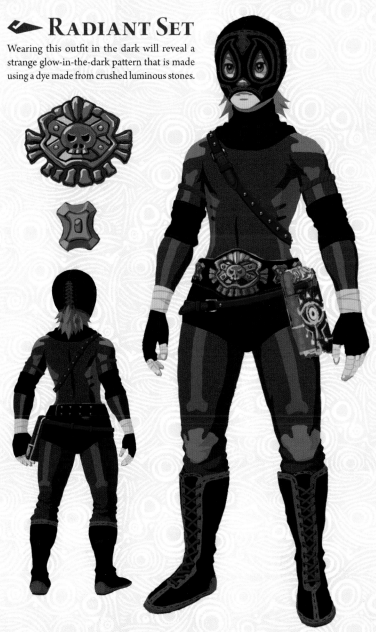

ANCIENT SET

This armor was developed by Robbie at the Akkala Ancient Tech Lab using Guardian parts. It requires a large quantity of ancient materials to create.

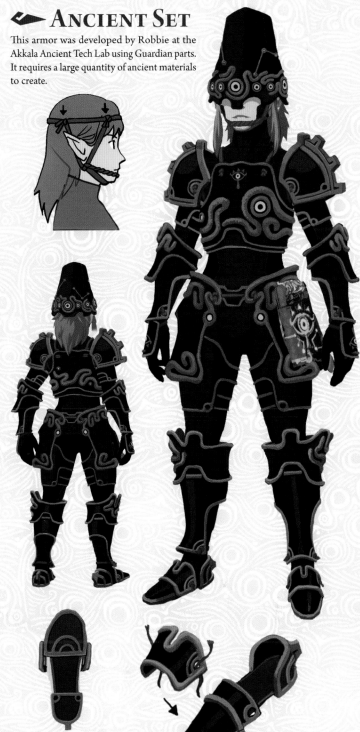

▷ *Radiant Set* (IN THE DARK)

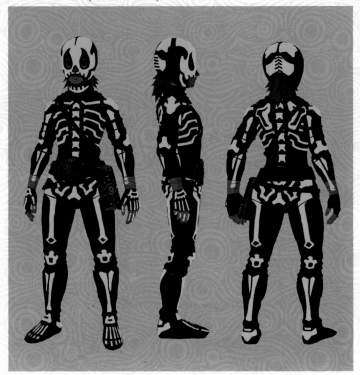

▷ *Ancient Set Rough Designs*

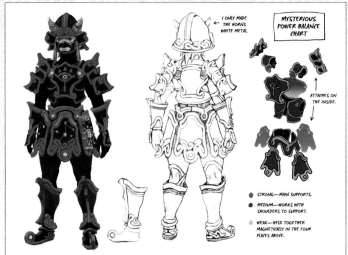

I ONLY MADE THE HORNS WHITE METAL.

MYSTERIOUS POWER BALANCE CHART

ATTACHES ON THE INSIDE.

• STRONG—MAIN SUPPORTS.

• MEDIUM—WORKS WITH SHOULDERS TO SUPPORT.

○ WEAK—HELD TOGETHER MAGNETICALLY IN THE FOUR PLACES ABOVE.

HERO OF THE WILD SET

This equipment is meant for a hero who travels the wild lands and can be acquired by conquering all of the ancient shrines. The design has been passed down from the distant past based on a hero who is said to have worn an outfit like this.

THUNDER HELM

This heirloom has been passed down among the Gerudo royal family. While anyone who wears it will be impervious to lightning strikes, only the Gerudo chief is said to have the ability to use its powers properly.

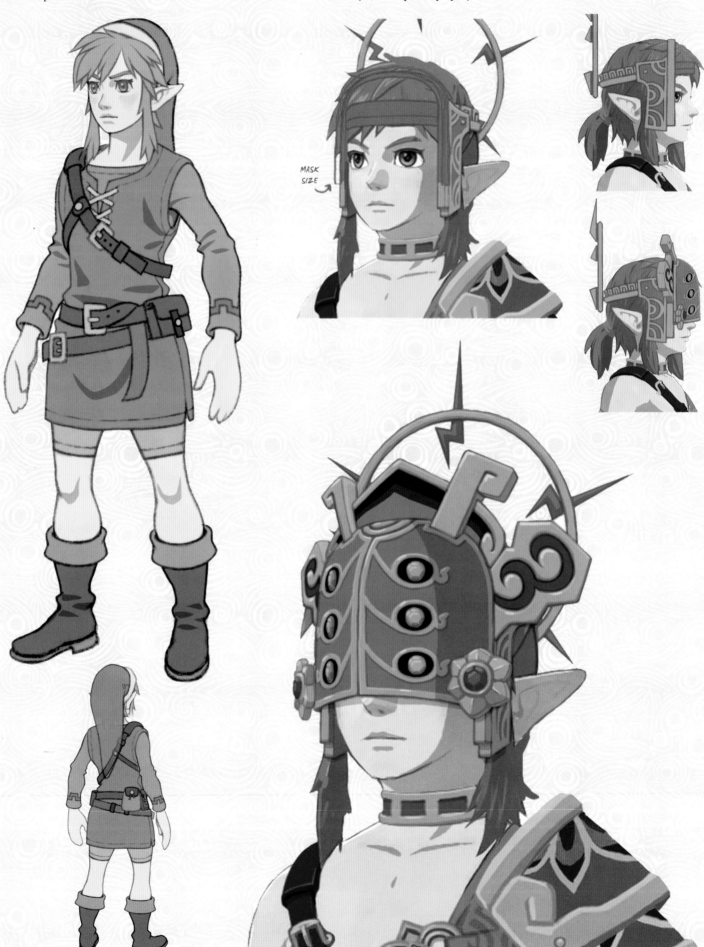

MASK SIZE

SAND BOOTS

The special soles on these boots distribute your body weight evenly so the wearer can move freely across sand. It is said that the ancient Gerudo used them.

The folded tips of the bandana slip into the inside so they don't stand out.

Sole's tread pattern

The strap's toe portion is connected to the sole.

SNOW BOOTS

These boots allow the wearer to tread across snowy terrain as though it were solid ground. They have built-in crampons that dig into snow and ice.

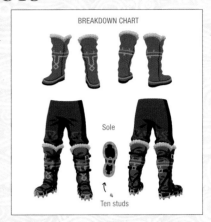

BREAKDOWN CHART

Sole

Ten studs

BOKOBLIN MASK

This headgear was created to disguise the wearer as a Bokoblin. Anyone who puts it on and adopts the Bokoblin's bad posture may even fool the monsters themselves. Kilton makes them and sells them at the Fang and Bone.

MOBLIN MASK

This is another of Kilton's handmade monster disguises. It is made to resemble the Moblin's long nose and large horn. Moblins are less likely to notice someone wearing this mask, especially if they adopt the Moblin's lumbering gait.

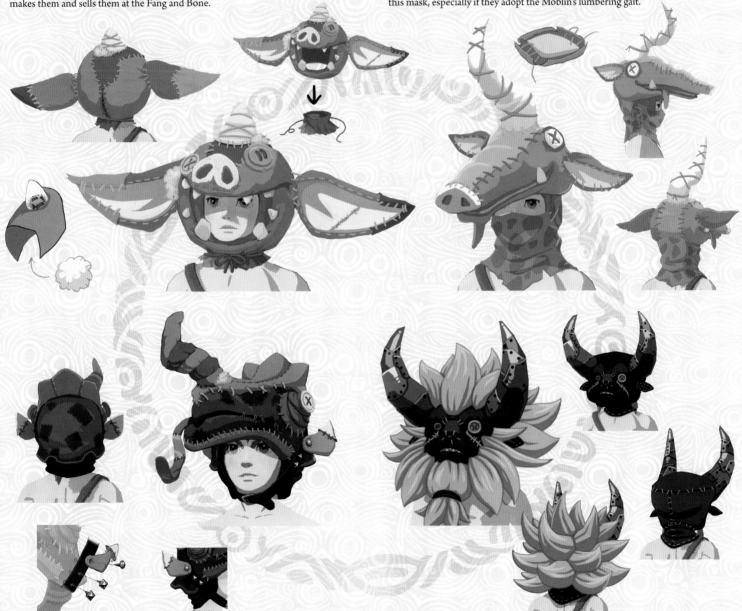

LIZALFOS MASK

This headpiece simulates the Lizalfos's bulging eyes and colorful tongue. Kilton makes each one himself, and the construction quality is good enough that a Lizalfos will think the disguised person is one of their own.

LYNEL MASK

The Lynel Mask re-creates their characteristic mane and horns. Wearing this and puffing out your chest may buy you a few seconds before you are attacked by a Lynel. This too is handmade by Kilton.

PHANTOM SET (DLC PACK 1)

Myths abound about armored phantoms that terrorized brave heroes. The crest of the Hyrule royal family is visible on the back, perhaps lending credibility to the ancient legend that tells of a princess of the royal family who once possessed these armored behemoths.

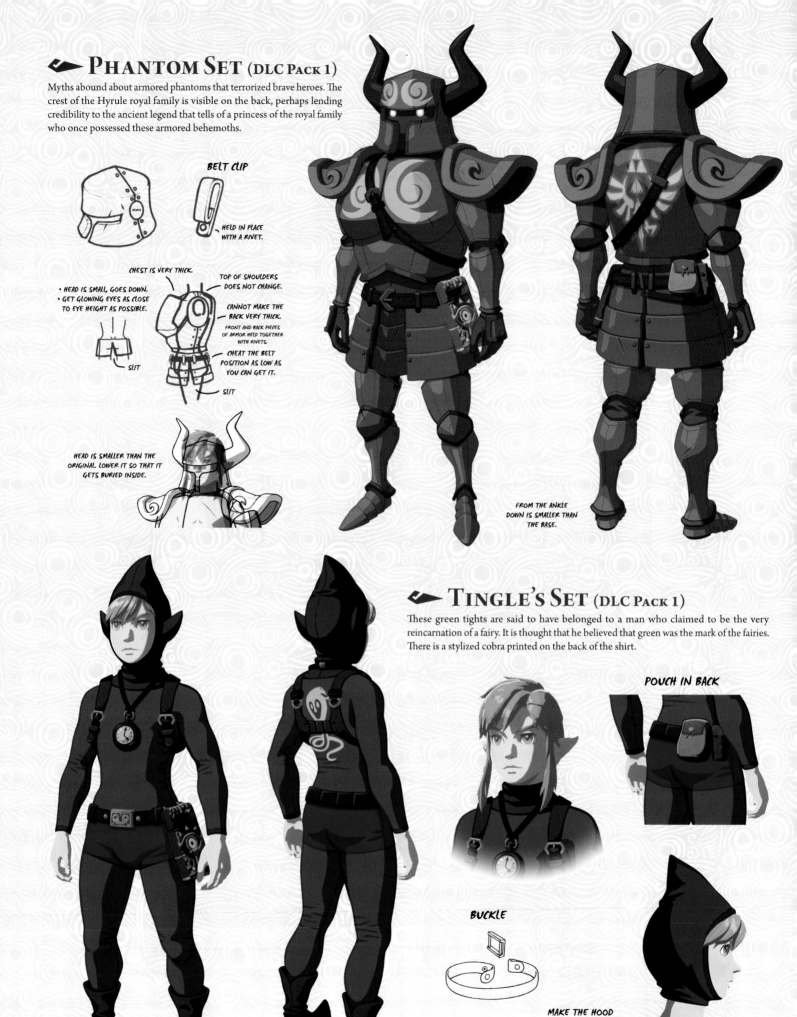

BELT CLIP

HELD IN PLACE WITH A RIVET.

CHEST IS VERY THICK.

TOP OF SHOULDERS DOES NOT CHANGE.

- HEAD IS SMALL, GOES DOWN.
- GET GLOWING EYES AS CLOSE TO EYE HEIGHT AS POSSIBLE.

CANNOT MAKE THE BACK VERY THICK.

FRONT AND BACK PIECES OF ARMOR HELD TOGETHER WITH RIVETS.

CHEAT THE BELT POSITION AS LOW AS YOU CAN GET IT.

SLIT

SLIT

HEAD IS SMALLER THAN THE ORIGINAL. LOWER IT SO THAT IT GETS BURIED INSIDE.

FROM THE ANKLE DOWN IS SMALLER THAN THE BASE.

TINGLE'S SET (DLC PACK 1)

These green tights are said to have belonged to a man who claimed to be the very reincarnation of a fairy. It is thought that he believed that green was the mark of the fairies. There is a stylized cobra printed on the back of the shirt.

POUCH IN BACK

BUCKLE

MAKE THE HOOD PART OF THE BODY SO THAT THE STRAPS AND STRING DON'T CLIP.

KOROK MASK (DLC PACK 1)

This mask is inspired by the fun-loving Koroks. It even comes with a decorative pinwheel. The mask will shake when the wearer passes close to a Korok in hiding.

NO PINWHEEL

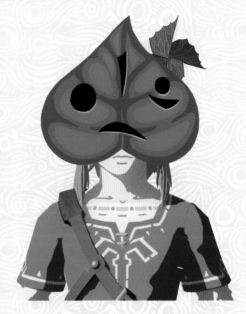

MIDNA'S HELMET (DLC PACK 1)

Rumor has it that this is the helmet worn by the Twilight Princess when she fought alongside the Hero of Twilight. It contains powerful magic and also has an accessory that resembles Midna's hair.

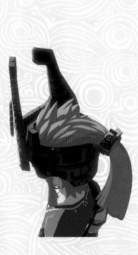
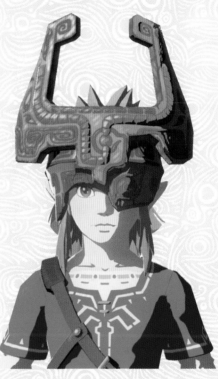

MAJORA'S MASK (DLC PACK 1)

Majora's Mask has been passed down since ancient times. Legends say that this eerie mask once plunged a parallel world into crisis. Wearing it will make most monsters overlook the wearer entirely.

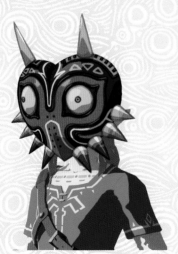
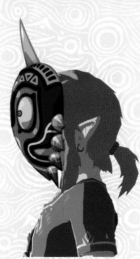
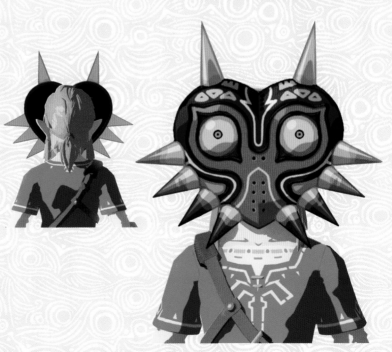

ROYAL GUARD SET (DLC Pack 2)

The official uniform of the royal guards who protected the royal family of Hyrule. Accompanying the king meant attending formal functions, so it blends both style and function. It is light and easy to move around in.

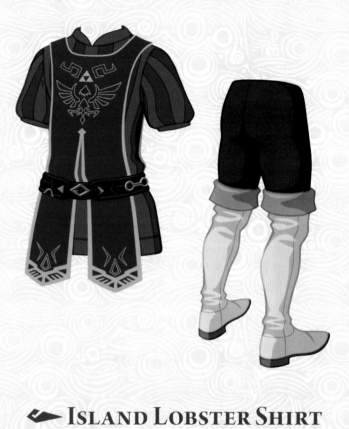

RAVIO'S HOOD (DLC Pack 2)

This hood belonged to a traveling merchant who was said to have a bracelet that could turn the wearer into a painting that was able to move along walls. It comes with a long scarf.

ISLAND LOBSTER SHIRT (DLC Pack 2)

The Hero of Winds wore this shirt on his island home. They say he controlled the winds and used them to travel the ocean. The shirt is blue like the sea and has a pattern resembling waves on it, as well as a lobster.

BRACELETS MADE OF LEAVES ADORN HIS WRISTS.

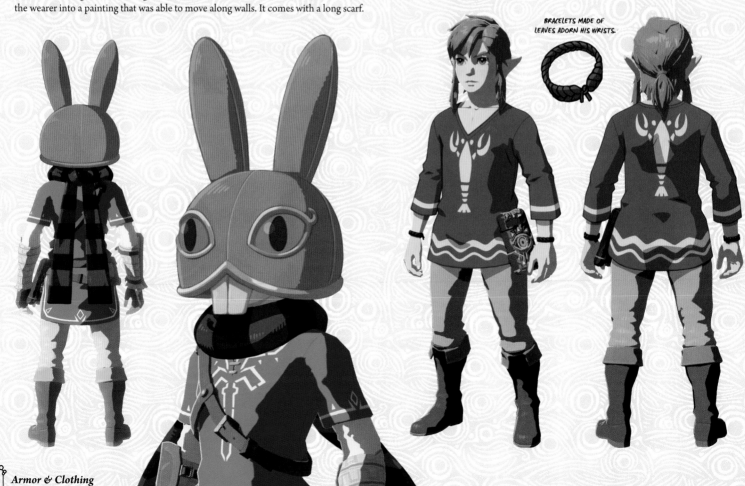

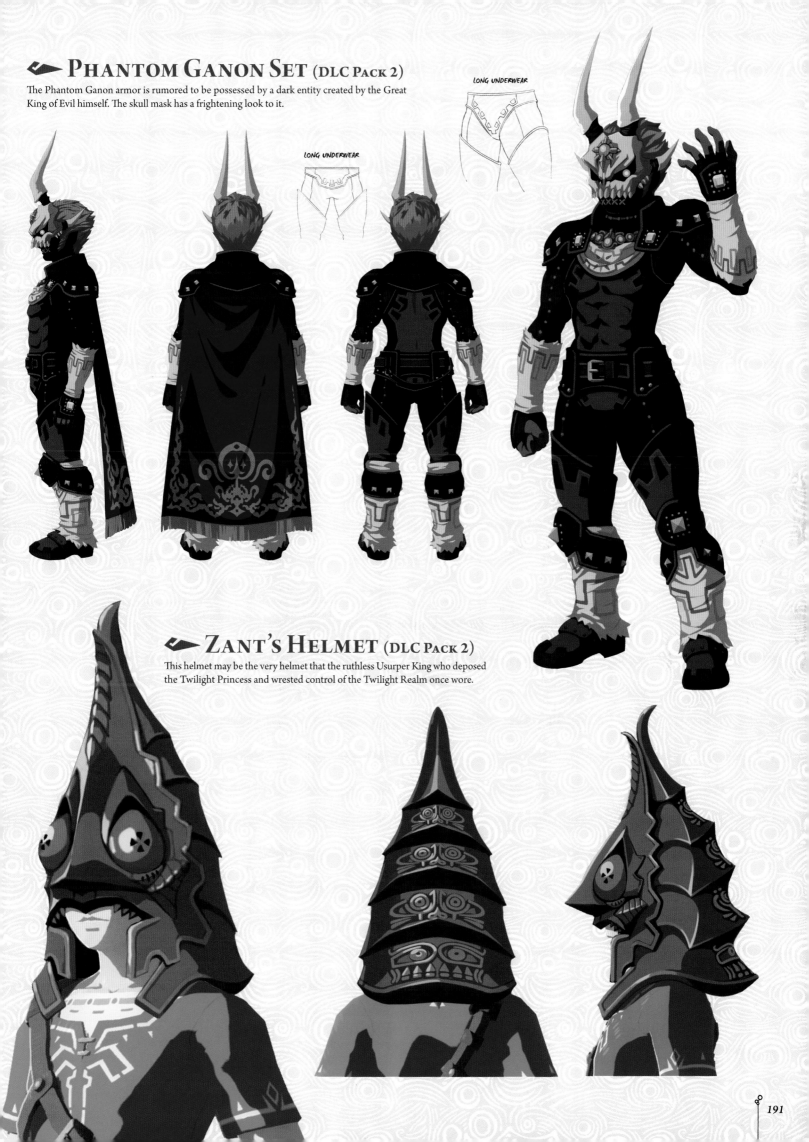

PHANTOM GANON SET (DLC PACK 2)

The Phantom Ganon armor is rumored to be possessed by a dark entity created by the Great King of Evil himself. The skull mask has a frightening look to it.

LONG UNDERWEAR

LONG UNDERWEAR

ZANT'S HELMET (DLC PACK 2)

This helmet may be the very helmet that the ruthless Usurper King who deposed the Twilight Princess and wrested control of the Twilight Realm once wore.

⬗ HERO SET (amiibo)

Legend has it that this outfit was the favorite of an ancient hero. The design is simple, but it has a charm about it. Wearing the cap gives Link a side part and makes his sideburns longer.

HE WEARS HIS HAT A LITTLE MORE FORWARD THAN THE KOROK'S HAT.

HIS HAIR IS PARTED TO THE SIDE WITH THE SIDE WITH LESS HAIR HAVING LESS VOLUME.

■ ORIGINAL LINK COSTUME
(From the 8-Bit Link amiibo)

GIVE THE TIPS OF HIS SIDEBURNS A BIT MORE VOLUME.

CHANGE THE UNDERSHIRT FROM A CREW NECK TO A CIRCULAR NECK.

CHANGE THE TUNIC INTO A V-NECK DESIGN.

CHANGE THE ARM-HOLE'S MATERIAL TO MATCH THE IMAGE.

CHANGE THE UNDERSHIRT'S COLOR TO HAVE MORE CONTRAST THAN THE KOROK VERSION.

THE CHEST STRAP IS SIMPLE, SO PLEASE START WITH THE DIRECTION HE WEARS IT IN.

MAKE THE CUFFS THICK AND STIFF.

LEAVE OUT THE CHEST STRAP. LOOK INTO MATCHING THE QUIVER STRAP ON HIS BACK WITH THE OCARINA OUTFIT.

LEAVE OUT THE CUFF PATTERN.

CHANGE FROM SPATS TO TIGHTS.

CHANGE THE FOLD OF THE BOOTS AND THE WIDTH OF THEIR SILHOUETTE TO BE SLIGHTLY NARROWER THAN THE KOROK OUTFIT.

BRING THE TOES OF THE BOOTS IN JUST A TINY BIT.

⬗ HERO OF TIME SET (amiibo)

According to legend, a hero who traveled through time once wore this clothing. The garb was said to have been made by a people who lived in a mystical forest and is easily identifiable by the size of the collar on the tunic. Equipping the cap causes Link's hair to part in the middle and his sideburns to shorten.

⬗ SHEIK'S MASK (amiibo)

This mask is said to have been worn by a Sheikah who saved a time-traveling hero. Wearing it with the Sheikah Set will really make Link resemble this fabled Sheikah.

HERO OF WINDS SET (amiibo)

These clothes were treasured by a hero who traveled a vast ocean. They are naturally water resistant, have a whirlpool belt buckle, and are said to have been a gift from his grandmother.

HERO OF TWILIGHT SET (amiibo)

This outfit was worn by the hero who battled the beasts of twilight. There seems to be some hair clinging to it that looks like it may be from a wolf. Chain mail lines the tunic.

HERO OF THE SKY SET (amiibo)

It is said a hero who appeared from the sky riding a mighty bird once wore these clothes. They were apparently presented at a ceremony and were the official garb of a certain order of knights.

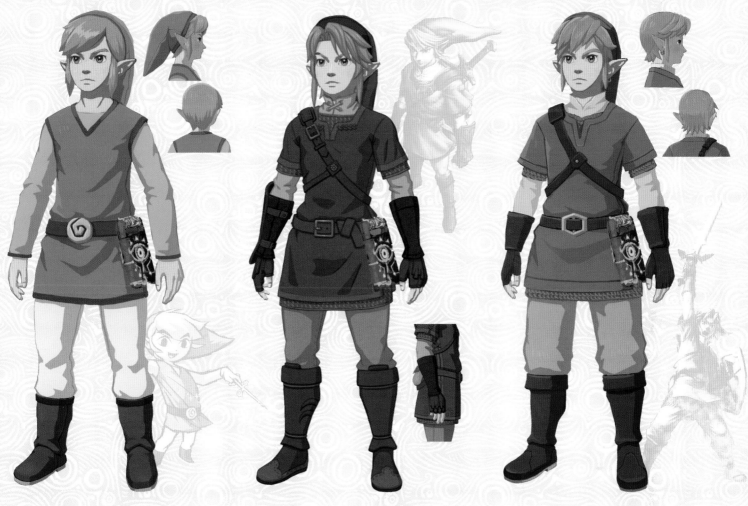

FIERCE DEITY SET (amiibo)

This armor is rumored to have been worn by the hero of a world in which the moon threatened to fall. The tales say that when he wore it, he felt fierce, godlike power flowing through him.

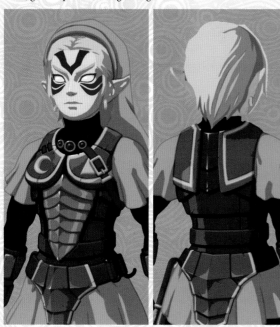

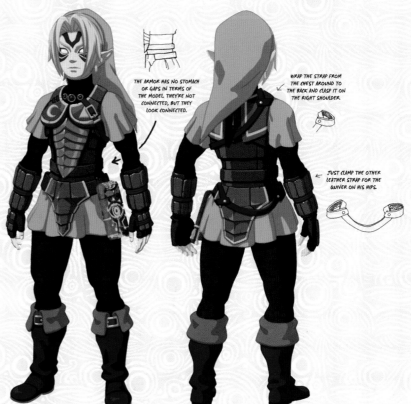

THE ARMOR HAS NO STOMACH OR GAPS IN TERMS OF THE MODEL. THEY'RE NOT CONNECTED, BUT THEY LOOK CONNECTED.

WRAP THE STRAP FROM THE CHEST AROUND TO THE BACK AND CLASP IT ON THE RIGHT SHOULDER.

JUST CLAMP THE OTHER LEATHER STRAP FOR THE QUIVER ON HIS HIPS.

VAH RUTA DIVINE HELM (amiibo)

This helmet resembles the Divine Beast Vah Ruta. Its defining characteristic is its long trunk.

EARS/TUSKS OFF

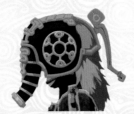

EARS/TUSKS OFF

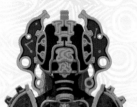

TUSKS OFF

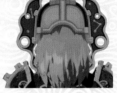

TAIL OFF

▷ *Front*

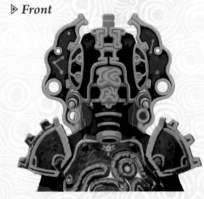

▷ *Back*

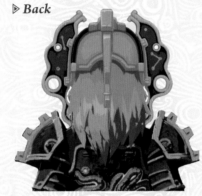

VAH RUDANIA DIVINE HELM (amiibo)

This helmet resembles the Divine Beast Vah Rudania. The face is made of six different plates to replicate the complex machinery of Vah Rudania's head.

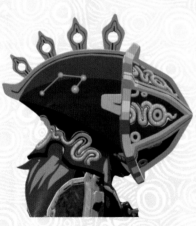

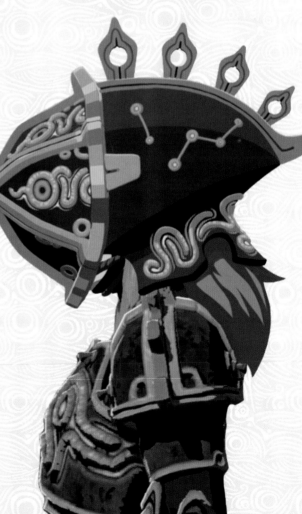

▷ *Front*

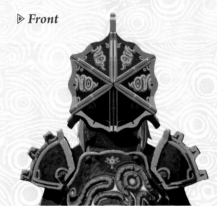

▷ *Back*

VAH NABORIS DIVINE HELM (amiibo)

This helmet resembles the Divine Beast Vah Naboris. The armor that runs down the spine is meant to replicate the beast's long neck.

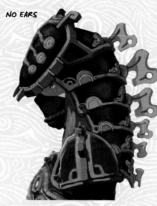

NO EARS

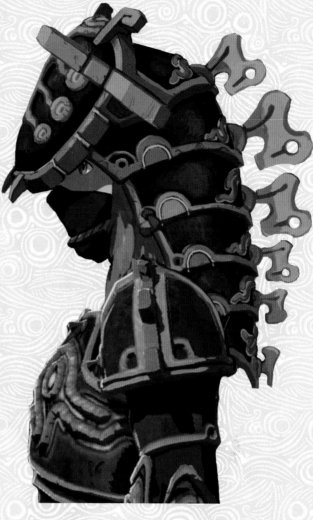

▷ *Front*

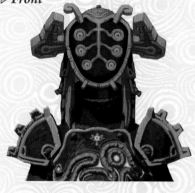

▷ *Back*

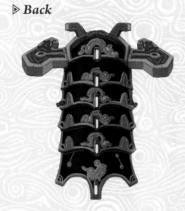

VAH MEDOH DIVINE HELM (amiibo)

This helmet resembles the Divine Beast Vah Medoh. It replicates Vah Medoh's beak and comb.

EYES ARE INDENTED.

EYES ARE INDENTED.

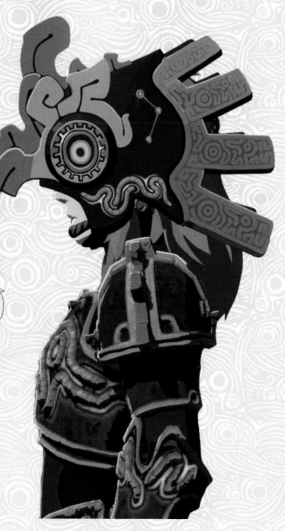

▷ *Front*

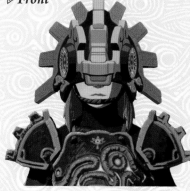

▷ *Back*

✒ CIRCLETS

These headpieces are crafted by Gerudo artisans and set with gems that bestow them with different attributes. Rubies harness the power of fire, sapphires the power of ice, and diamonds the power of light.

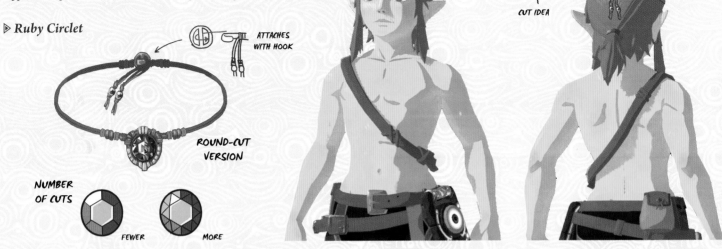

LIKE THIS

CUT IDEA

▷ Ruby Circlet

ATTACHES WITH HOOK

ROUND-CUT VERSION

NUMBER OF CUTS

FEWER

MORE

▷ Sapphire Circlet

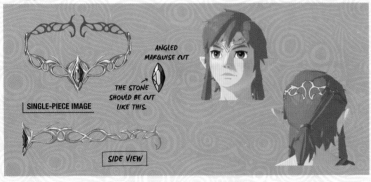

SINGLE-PIECE IMAGE

ANGLED MARQUISE CUT

THE STONE SHOULD BE CUT LIKE THIS.

SIDE VIEW

▷ Diamond Circlet

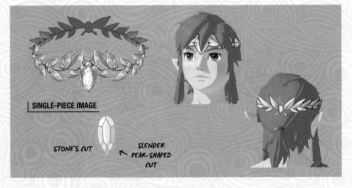

SINGLE-PIECE IMAGE

STONE'S CUT

SLENDER PEAR-SHAPED CUT

✒ EARRINGS

These accessories clamp around Link's earlobes. The stones lend the wearer their innate attributes. Opals contain the power of water, topaz contains the power of lightning, and amber contains the power of earth.

▷ Opal Earrings

SIDE

THE CLASP IS IN THE EXACT CENTER, AND PIECES WITH THE SAME DESIGN ARE ON EITHER SIDE.

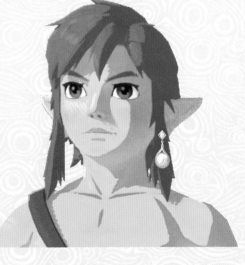

▷ Topaz Earrings

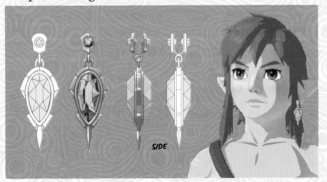

SIDE

▷ Amber Earrings

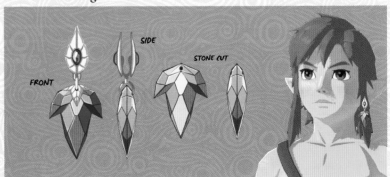

FRONT

SIDE

STONE CUT

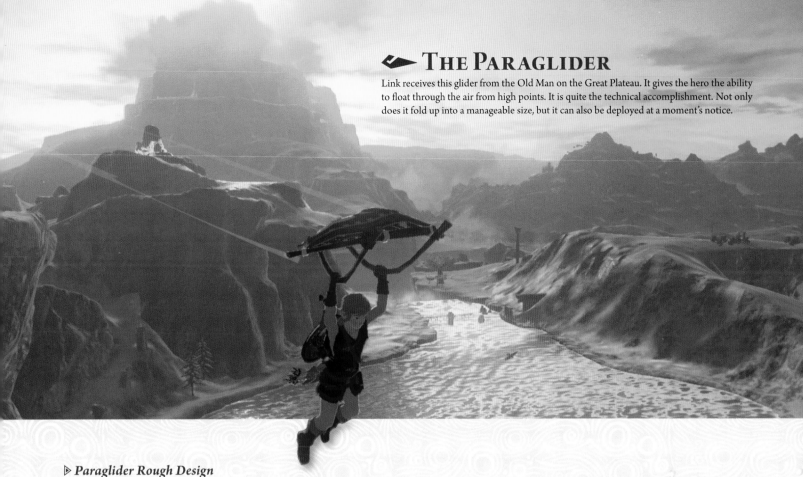

THE PARAGLIDER

Link receives this glider from the Old Man on the Great Plateau. It gives the hero the ability to float through the air from high points. It is quite the technical accomplishment. Not only does it fold up into a manageable size, but it can also be deployed at a moment's notice.

▷ *Paraglider Rough Design*

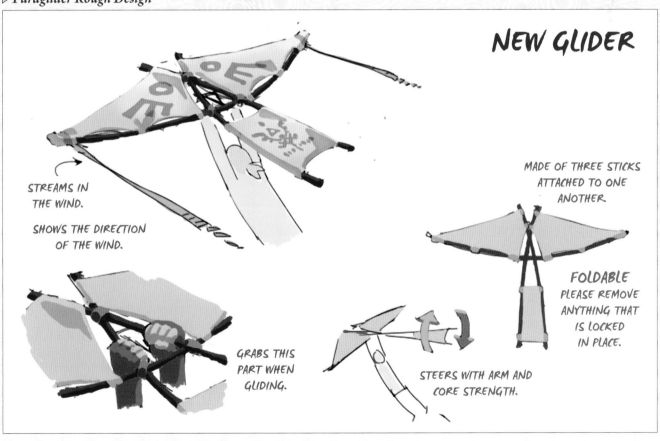

NEW GLIDER

STREAMS IN THE WIND.

SHOWS THE DIRECTION OF THE WIND.

MADE OF THREE STICKS ATTACHED TO ONE ANOTHER

FOLDABLE
PLEASE REMOVE ANYTHING THAT IS LOCKED IN PLACE.

GRABS THIS PART WHEN GLIDING.

STEERS WITH ARM AND CORE STRENGTH.

Parts, Ingredients & Ore
Creating Elixirs, Cooking Meals & Enhancing Equipment

There are all sorts of parts and materials spread throughout Hyrule. Separately they have little to no value, but combining them can bring out all sorts of beneficial effects and make them critical for survival. Edible ingredients gained from hunting or foraging become tasty and helpful meals, while other unexpected items like monster parts can be used to create beneficial elixirs or enhance equipment. Nothing is wasted in Hyrule.

MONSTER PARTS

Monsters' body parts are a valuable resource that can be used as ingredients for elixirs or for enhancing equipment. The stronger the monster, the higher the value of the part. Lynel and dragon parts are particularly prized.

▷ Chuchu Parts

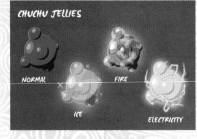

CHUCHU JELLIES

NORMAL · FIRE · ICE · ELECTRICITY

▷ Keese Parts

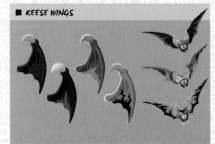

■ KEESE WINGS

■ KEESE WINGS & EYEBALLS

BASE OF THE ARM

A
B

THE ARM AND MEMBRANE ARE NOT CLEARLY DISTINGUISHED.

▷ Bokoblin Parts

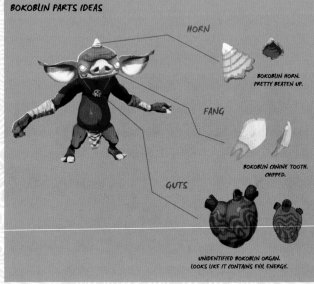

BOKOBLIN PARTS IDEAS

HORN

BOKOBLIN HORN. PRETTY BEATEN UP.

FANG

BOKOBLIN CANINE TOOTH. CHIPPED.

GUTS

UNIDENTIFIED BOKOBLIN ORGAN. LOOKS LIKE IT CONTAINS EVIL ENERGY.

▷ Hinox Parts

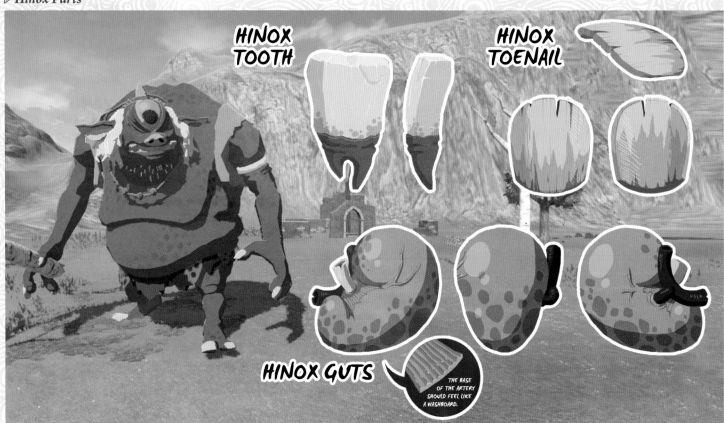

HINOX TOOTH

HINOX TOENAIL

HINOX GUTS

THE BASE OF THE ARTERY SHOULD FEEL LIKE A WASHBOARD.

▷ Moblin Parts

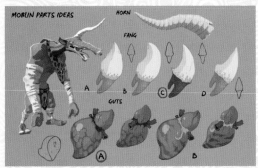

MOBLIN PARTS IDEAS
HORN
FANG
A B (C) D
GUTS
(A) B

▷ Servants of the Springs Parts

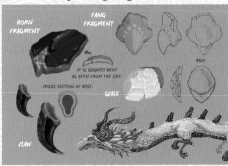

HORN FRAGMENT
FANG FRAGMENT
IT IS SLIGHTLY BENT AS SEEN FROM THE SIDE.
CROSS SECTION OF BASE.
SCALE
BACK
CLAW

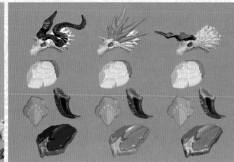

▷ Lynel Parts

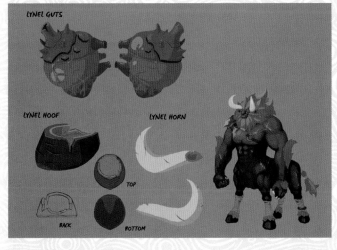

LYNEL GUTS
LYNEL HOOF
LYNEL HORN
TOP
BACK
BOTTOM

▷ Molduga Parts

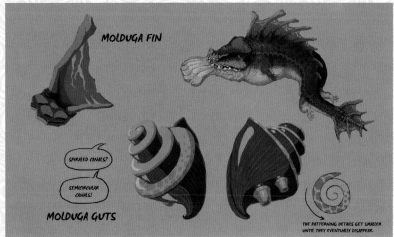

MOLDUGA FIN
SPIRALED CANALS?
SEMICIRCULAR CANALS!
MOLDUGA GUTS
THE PATTERNING DETAILS GET SMALLER UNTIL THEY EVENTUALLY DISAPPEAR.

▷ Lizalfos Parts

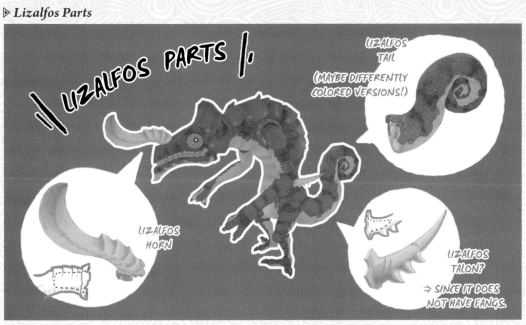

LIZALFOS PARTS
LIZALFOS TAIL (MAYBE DIFFERENTLY COLORED VERSIONS!)
LIZALFOS HORN
LIZALFOS TALON?
→ SINCE IT DOES NOT HAVE FANGS.

▷ Octorok Parts

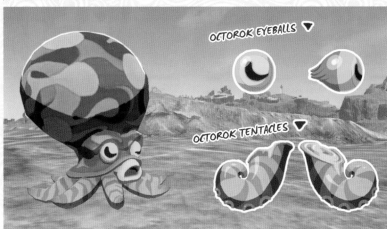

OCTOROK EYEBALLS ▼
OCTOROK TENTACLES ▼

▷ Octo Balloon

OCTO BALLOON
WHEN INFLATED
WHEN A PART

COOKING INGREDIENTS

You can create all kinds of delicious and beneficial dishes by throwing meat, mushrooms, grains, milk, butter, seasonings, and other edibles into a pot. Additionally, the cooking pot can be used to brew elixirs by cooking monster parts.

ANIMAL MEAT | PRIME MEAT | GOURMET MEAT

FLAT

BACON

MAY NOT FEEL LIKE ANIMAL MEAT. FEELS CHEAP. MAY BE TOO PROCESSED.

DEFROSTED BLOCK MEAT

SKIN ATTACHED.
↕
NO SKIN.
(SEEING THE RED FLESH WITH NO SKIN MAY MAKE IT LOOK HIGH QUALITY.)

BONE-IN MEAT. EASY TO VISUALLY UNDERSTAND.

TIED UP WITH MEAT JUICES. THIS MIGHT BE TOO MUCH. I WANT IT TO FEEL JUICY.

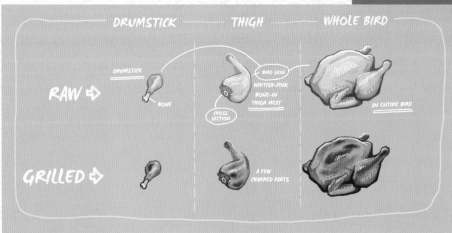

DRUMSTICK | THIGH | WHOLE BIRD

RAW ⇨

DRUMSTICK

BONE

CROSS SECTION

BIRD SKIN
WHITISH-PINK
BONE-IN THIGH MEAT

AN ENTIRE BIRD

GRILLED ⇨

A FEW CHARRED PARTS

▷ Ingredients Rough Designs

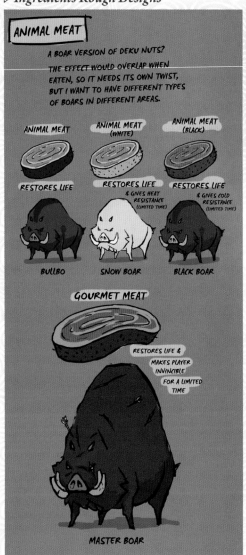

ANIMAL MEAT

A BOAR VERSION OF DEKU NUTS?

THE EFFECT WOULD OVERLAP WHEN EATEN, SO IT NEEDS ITS OWN TWIST, BUT I WANT TO HAVE DIFFERENT TYPES OF BOARS IN DIFFERENT AREAS.

ANIMAL MEAT | ANIMAL MEAT (WHITE) | ANIMAL MEAT (BLACK)

RESTORES LIFE | RESTORES LIFE & GIVES HEAT RESISTANCE (LIMITED TIME) | RESTORES LIFE & GIVES COLD RESISTANCE (LIMITED TIME)

BULLBO | SNOW BOAR | BLACK BOAR

GOURMET MEAT

RESTORES LIFE & MAKES PLAYER INVINCIBLE FOR A LIMITED TIME

MASTER BOAR

SALT | SUGAR | CURRY POWDER | RICE

EGGS | MILK | BUTTER

WHEAT | MONSTER EXTRACT | ADDITIONAL INGREDIENT IDEAS!

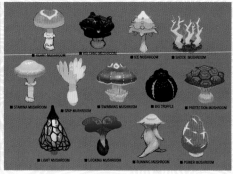

HEART MUSHROOM | VOLCANO MUSHROOM | ICE MUSHROOM | SHOCK MUSHROOM

STAMINA MUSHROOM | GRIP MUSHROOM | SWIMMING MUSHROOM | BIG TRUFFLE | PROTECTION MUSHROOM

LIGHT MUSHROOM | LOOKING MUSHROOM | RUNNING MUSHROOM | POWER MUSHROOM

▷ Cooking Pot Rough Concepts

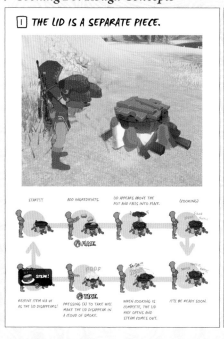

1️⃣ THE LID IS A SEPARATE PIECE.

START!!! | ADD INGREDIENTS. | LID APPEARS ABOVE THE POT AND FALLS INTO PLACE. | (COOKING)

PLACE.

STEAK!

RECEIVE ITEM VIA UI AS THE LID DISAPPEARS! | PRESSING (A) TO TAKE WILL MAKE THE LID DISAPPEAR IN A CLOUD OF SMOKE. | WHEN COOKING IS COMPLETE, THE LID HALF OPENS AND STEAM COMES OUT. | IT'LL BE READY SOON.

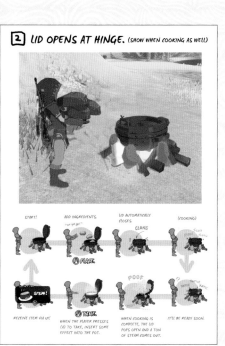

2️⃣ LID OPENS AT HINGE. (SHOW WHEN COOKING AS WELL)

START! | ADD INGREDIENTS. | LID AUTOMATICALLY CLOSES. CLANG | (COOKING)

PLACE.

STEAK!

RECEIVE ITEM VIA UI! | WHEN THE PLAYER PRESSES (A) TO TAKE, INSERT SOME EFFECT INTO THE POT. | WHEN COOKING IS COMPLETE, THE LID POPS OPEN AND A TON OF STEAM COMES OUT. | IT'LL BE READY SOON.

~ ORE

Link can find a wide variety of useful minerals by excavating ore, from practical items like flint, which can be used to start fires, to gemstones like diamonds, which can fetch a healthy price on the market.

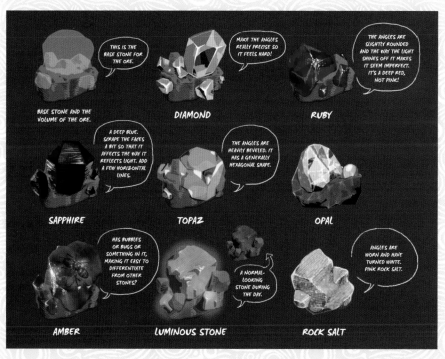

BASE STONE AND THE VOLUME OF THE ORE.
THIS IS THE BASE STONE FOR THE ORE.

DIAMOND
MAKE THE ANGLES REALLY PRECISE SO IT FEELS HARD!

RUBY
THE ANGLES ARE SLIGHTLY ROUNDED AND THE WAY THE LIGHT SHINES OFF IT MAKES IT SEEM IMPERFECT. IT'S A DEEP RED, NOT PINK!

SAPPHIRE
A DEEP BLUE. SCRAPE THE FACES A BIT SO THAT IT AFFECTS THE WAY IT REFLECTS LIGHT. ADD A FEW HORIZONTAL LINES.

TOPAZ
THE ANGLES ARE HEAVILY BEVELED. IT HAS A GENERALLY HEXAGONAL SHAPE.

OPAL

AMBER
HAS BUBBLES OR BUGS OR SOMETHING IN IT, MAKING IT EASY TO DIFFERENTIATE FROM OTHER STONES?

LUMINOUS STONE
A NORMAL-LOOKING STONE DURING THE DAY.

ROCK SALT
ANGLES ARE WORN AND HAVE TURNED WHITE. PINK ROCK SALT.

~ ANCIENT PARTS

You cannot buy these ancient items from shops, but if you obtain them through battle or scavenging, they can be used at the Akkala Ancient Tech Lab and turned into useful items. The surest way to obtain ancient parts is to defeat a Guardian. As a result, they are difficult to come by.

▷ Ancient Shaft

CROSS SECTION

BACK SIDE

▷ Ancient Screw

(A) SCREW HOLE

(B) SCREW HOLE

▷ Ancient Core

☐ ANCIENT CORE
FRONT BACK

☐ GIANT ANCIENT CORE

▷ Ancient Spring

BACKGROUND

Weapons & Shields
Armor & Clothing
Parts, Ingredients & Ore

DIFFERENT FORMS & FUNCTIONS

Equipment varies in appearance based on who made it, and it is easy to categorize by looking at the materials and techniques used to create it. As seen in the chart below, it is possible to identify which race made which sword based on silhouette alone. The artisans of one race may prefer straight construction, while others prefer angular or curved forms.

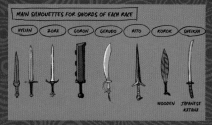

MAIN SILHOUETTES FOR SWORDS OF EACH RACE
HYLIAN ZORA GORON GERUDO RITO KOROK SHEIKAH
WOODEN JAPANESE KATANA

THE MANY MANNEQUINS

In most major villages there are shops that sell clothing and armor. They display their wares separately for headgear, body gear, and leg gear. The material that the gear is made from and the mannequins of each region are slightly different based on the inhabitants of that area.

WORLD'S BEST!

Each region is known for a unique item of food. In Kakariko Village, they grow Fortified Pumpkins. The fish sold in Zora's Domain can't be beat. The people of each region have particular diets based on their location and races, and their local fare can be sampled in their village's shops.

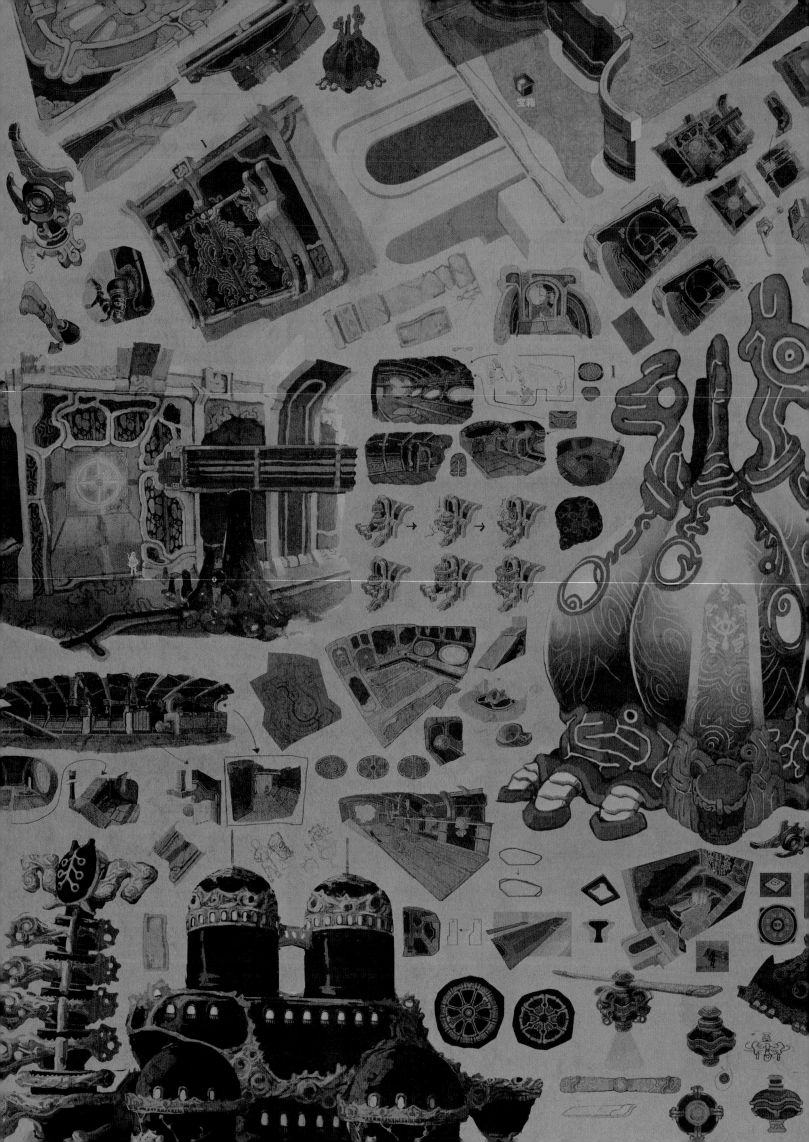

宝箱

SHEIKAH RELICS
ANCIENT ADVANCED TECHNOLOGY

In ancient times, the Sheikah were at the forefront of Hyrule's contemporary culture and leaders in technology. They used their knowledge in service of the hero, creating training grounds and mechanical soldiers to aid him in defeating Calamity Ganon. The shrines and Guardians that they created were so well constructed that many are still in perfect working condition today. However, Sheikah technology was banned long, long ago, so these relics have just recently been rediscovered. The way they work is still a mystery that researchers work on daily.

SHEIKAH SLATE

This small tablet contains a number of functions to support the hero on his adventure. It can display maps, take pictures, activate other ancient relics, and grant access to control terminals. Additionally, it can manifest powers based on the runes it possesses, like Remote Bombs and Magnesis.

▷ *Sheikah Slate Rough Concepts*

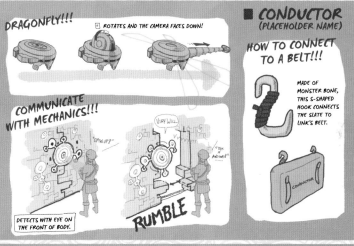

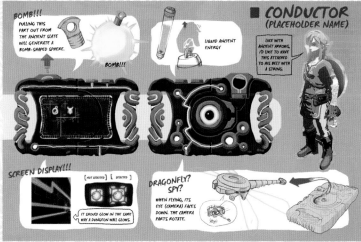

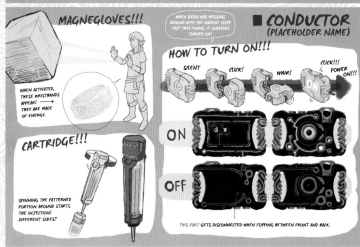

THE GUARDIANS

These ancient mechanical defenders were discovered one hundred years ago. They were built by the ancient Sheikah to protect Hyrule from Calamity Ganon, but Ganon corrupted them and turned them against the people they were meant to save.

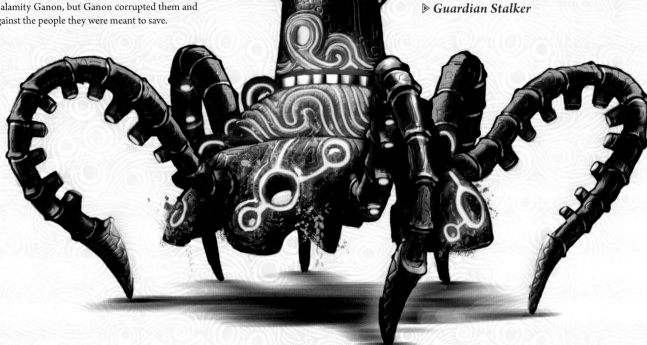

▷ *Guardian Stalker*

▷ *Guardian Stalker Rough Designs*

The developers ultimately gave the Guardians a mechanical look that seemed advanced and also ancient, but they also explored organic designs as seen here.

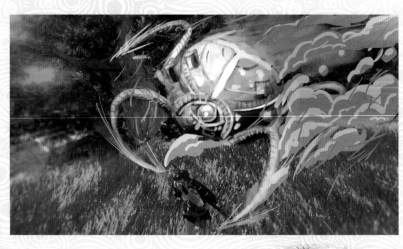

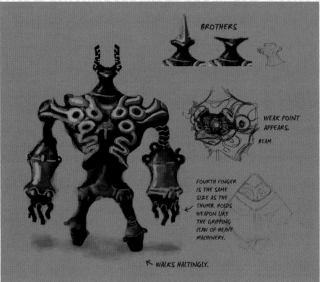

BROTHERS

WEAK POINT APPEARS.

BEAM

FOURTH FINGER IS THE SAME SIZE AS THE THUMB. HOLDS WEAPON LIKE THE GRIPPING CLAW OF HEAVY MACHINERY.

← WALKS HALTINGLY.

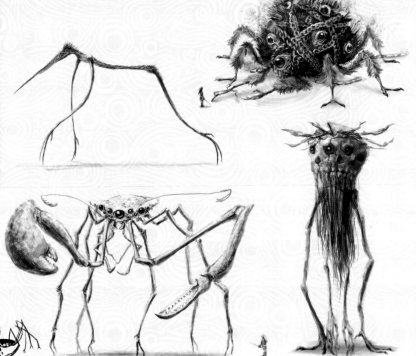

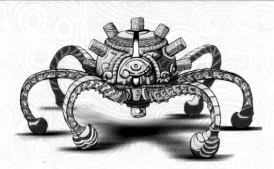

▷ Guardian Turret

This Guardian is stationary but can move its neck up and down, and it can also rotate. When it senses an enemy, it will lock onto them and fire the same powerful laser as the Stalker unless the enemy breaks the line of sight.

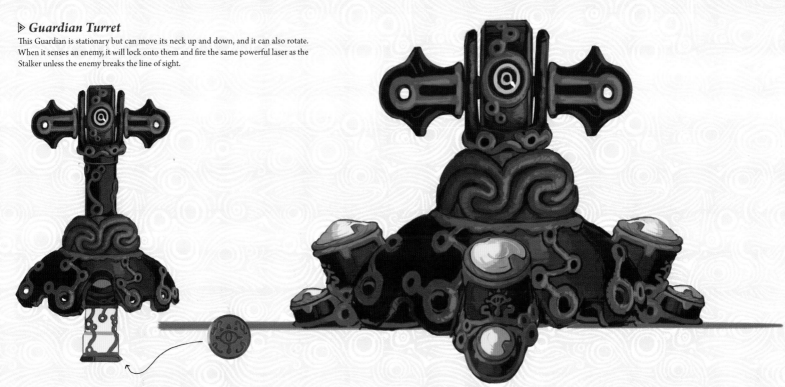

▷ Guardian Skywatcher

The Skywatcher is an inverted version of the Turret variety. The bolts in the half dome have been removed and replaced with propeller units capable of flight.

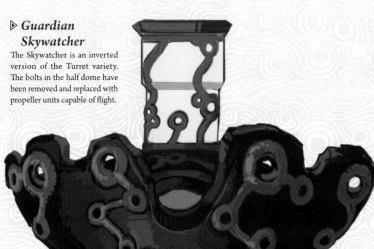

▷ Guardian Skywatcher Rough Design

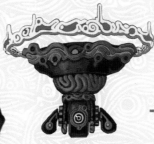

▷ Guardian Turret Rough Design

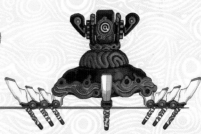

Many different designs for mechanisms to get the Guardian Skywatcher to fly were considered, including propellers and a levitating ring. Also, different designs for the bolts that would fix the Guardian Turret to the ground were also considered.

DEVELOPER'S NOTE

The art director gave me two directives in regard to the design of the Guardians. The first was that they should have many legs that move fluidly, and the second was that they are from an ancient culture. From there, I started sketching. At the beginning of development, it wasn't yet decided whether the Guardians would be your allies or enemies, so I tried to design them to look neutral. That way, later, they could be used either way. As far as the legs moving fluidly, I designed legs that could bend freely like an accordion and would allow them to move quickly over variable natural terrain. I used Jōmon-era flame-shaped pottery as inspiration for its body. If you look at a Guardian upside down, you should be able to see the form of that pottery. In addition to the Guardians that ended up in the game, there was a design for a giant, fortress-like Guardian that was equipped with multiple beam cannons, but we were ultimately unable to implement it.

LEAD ARTIST, ENEMIES: TAKAFUMI KIUCHI

Concept Image

The Four Divine Beasts

The Divine Beasts were created by the ancient Sheikah to assist the hero and the princess with sealing power to defeat Calamity Ganon and were piloted by four chosen Champions. They are like large, mechanical buildings with a number of moving parts. By using the Sheikah Slate and activating the terminals within them, the pilot can access the main control unit and use the Divine Beast for its intended purpose—weakening Calamity Ganon with a well-aimed laser blast!

▷ *Rough Designs*

These Divine Beast designs from the beginning of development could be said to have been the origin of all the ancient Sheikah relics.

CONCEPT IMAGE

Many of the initial designs were inspired by animals.

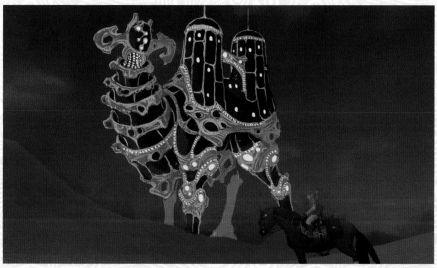

Among the early design proposals, the camel made a big impression. The direction of the design of all the Divine Beasts was dictated by the polished version of the initial camel.

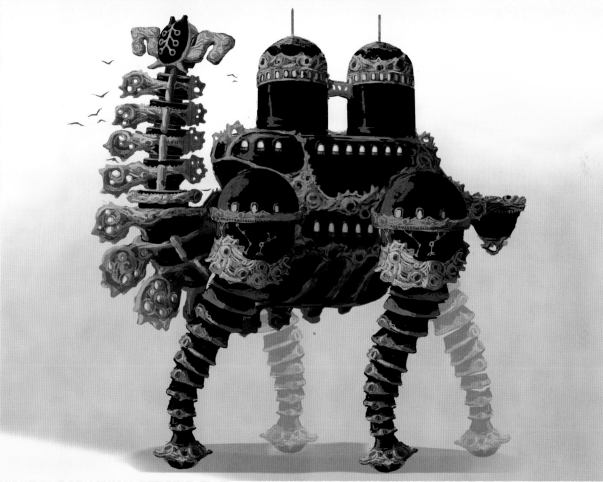

DEVELOPERS' NOTES

The Divine Beasts are these strange things that draw you to them the instant you lay eyes on them. During development we were seeking to create a giant dungeon, and the Divine Beasts, then called the Four Great Relics, were what came from that. They were very challenging to design. I vividly remember all of the sketches on page 206; it was a mountain of effort that finally yielded a path forward. Despite their strong resemblance to animals in silhouette, they also contain elements of palaces, factories, and bridges. They were designed to look like living machines and possess traits that make them both cute and unsettling. It's not exactly clear whether they are on your side or not, so I made them strange enough that the player would be curious enough about them to want to explore them right away.

When we implemented the walking animation for Vah Naboris, we modeled it as though the camel was a costume with people in the front and back like a lion dance! I am convinced we pulled it off.

ART DIRECTOR: SATORU TAKIZAWA

We used Jōmon pottery and the look of the already established Guardians (page 204) as a base but also referenced ceremonial masks from Southeast Asia, children's drawings, and other things. I wanted to explore a different aesthetic than that found in Western art. In order to make their silhouettes easy to recognize at a distance, I used well-known animals as a motif, but that alone wouldn't have been interesting. Molding it into something like a camel but drawn by someone who has never actually seen a camel made it feel like some kind of mythological creature. I think that leaving in those undeveloped elements helped us capture the essence of something ancient while also being both unsettling and lovable.

WILDLIFE ART: AYA SHIDA

Divine Beast Vah Ruta

Vah Ruta was once piloted by the Zora Champion Mipha. It goes berserk after Calamity Ganon's Malice corrupts it and sprays enormous quantities of water from its trunk, drenches Zora's Domain, and threatens the integrity of Rutala Dam and Hyrule with it!

▷ Rough Design

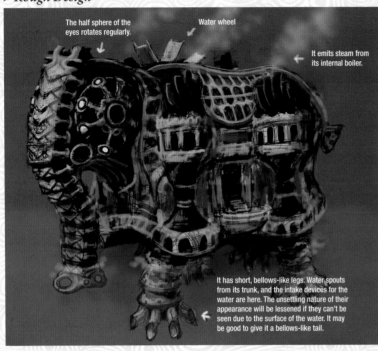

The half sphere of the eyes rotates regularly.

Water wheel

It emits steam from its internal boiler.

It has short, bellows-like legs. Water spouts from its trunk, and the intake devices for the water are here. The unsettling nature of their appearance will be lessened if they can't be seen due to the surface of the water. It may be good to give it a bellows-like tail.

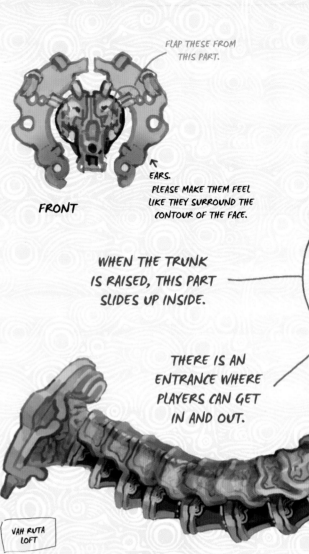

FLAP THESE FROM THIS PART.

FRONT

EARS.
PLEASE MAKE THEM FEEL LIKE THEY SURROUND THE CONTOUR OF THE FACE.

WHEN THE TRUNK IS RAISED, THIS PART SLIDES UP INSIDE.

THERE IS AN ENTRANCE WHERE PLAYERS CAN GET IN AND OUT.

TUSK

SLOT EXTENDS

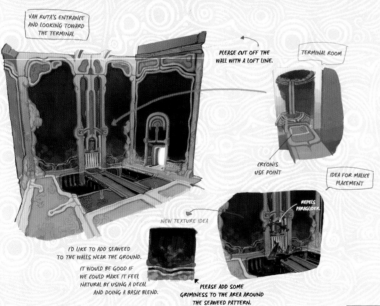

VAH RUTA'S ENTRANCE AND LOOKING TOWARD THE TERMINAL

PLEASE CUT OFF THE WALL WITH A LOFT LINE.

TERMINAL ROOM

CRYONIS USE POINT

IDEA FOR MALICE PLACEMENT

NEW TEXTURE IDEA

REPELS PARAGLIDER.

I'D LIKE TO ADD SEAWEED TO THE WALLS NEAR THE GROUND.

IT WOULD BE GOOD IF WE COULD MAKE IT FEEL NATURAL BY USING A DECAL AND DOING A BASIC BLEND.

PLEASE ADD SOME GRIMINESS TO THE AREA AROUND THE SEAWEED PATTERN.

VAH RUTA LOFT

PLEASE BREAK UP PLACES WITH LONG, STRAIGHT LINES BY WARPING THEM.

C Dungeon Chain

Standing area protrudes a bit.

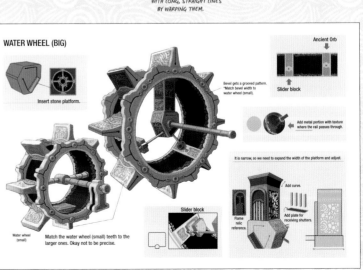

WATER WHEEL (BIG)

Insert stone platform.

Bevel gets a grooved pattern. *Match bevel width to water wheel (small).

Ancient Orb

Slider block

Add metal portion with texture where the rail passes through.

It is narrow, so we need to expand the width of the platform and adjust.

Add curve.

Slider block

Flame relic reference.

Add plate for receiving shutters.

Water wheel (small)

Match the water wheel (small) teeth to the larger ones. Okay not to be precise.

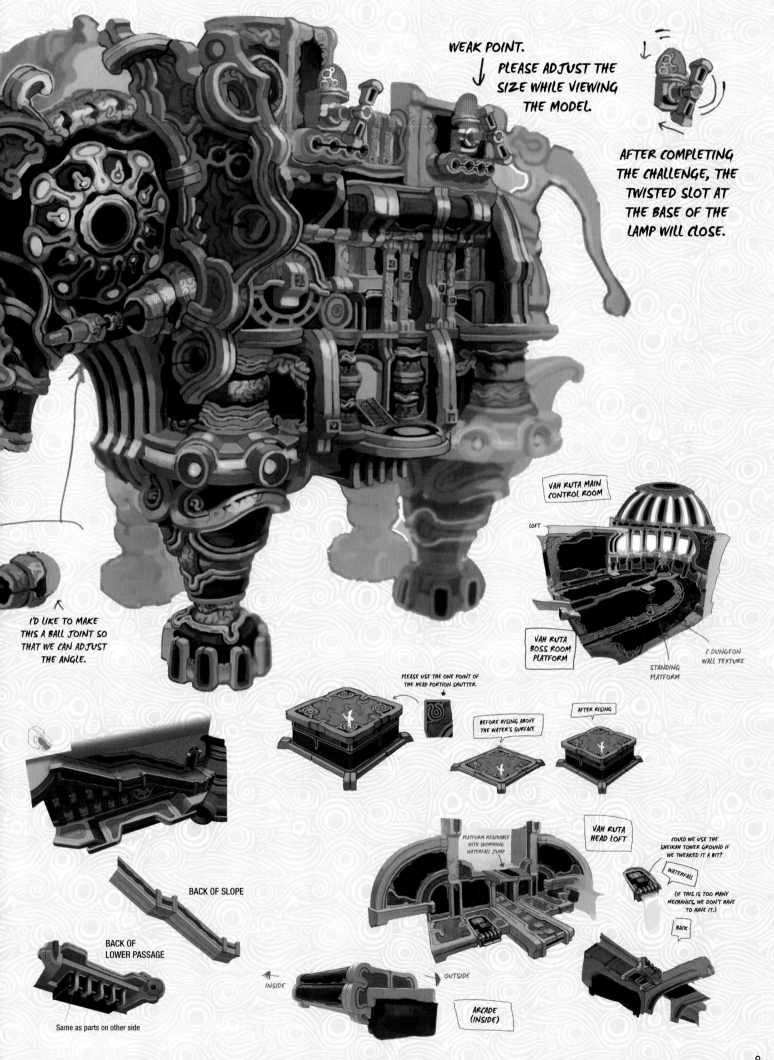

WEAK POINT.

PLEASE ADJUST THE SIZE WHILE VIEWING THE MODEL.

AFTER COMPLETING THE CHALLENGE, THE TWISTED SLOT AT THE BASE OF THE LAMP WILL CLOSE.

I'D LIKE TO MAKE THIS A BALL JOINT SO THAT WE CAN ADJUST THE ANGLE.

VAH RUTA MAIN CONTROL ROOM

LOFT

VAH RUTA BOSS ROOM PLATFORM

C DUNGEON WALL TEXTURE

STANDING PLATFORM

PLEASE USE THE ONE POINT OF THE HEAD PORTION SHUTTER

BEFORE RISING ABOVE THE WATER'S SURFACE

AFTER RISING

BACK OF SLOPE

PLATFORM REACHABLE WITH SWIMMING WATERFALL JUMP

VAH RUTA HEAD LOFT

COULD WE USE THE SHEIKAH TOWER GROUND IF WE TWEAKED IT A BIT?

WATERFALL

(IF THIS IS TOO MANY MECHANICS, WE DON'T HAVE TO HAVE IT.)

BACK

BACK OF LOWER PASSAGE

Same as parts on other side

INSIDE

OUTSIDE

ARCADE (INSIDE)

DIVINE BEAST VAH RUDANIA

Vah Rudania was once piloted by the Goron Champion Daruk. In spite of its massive size, it is able to nimbly navigate Death Mountain's steep slopes with its lizard-like legs.

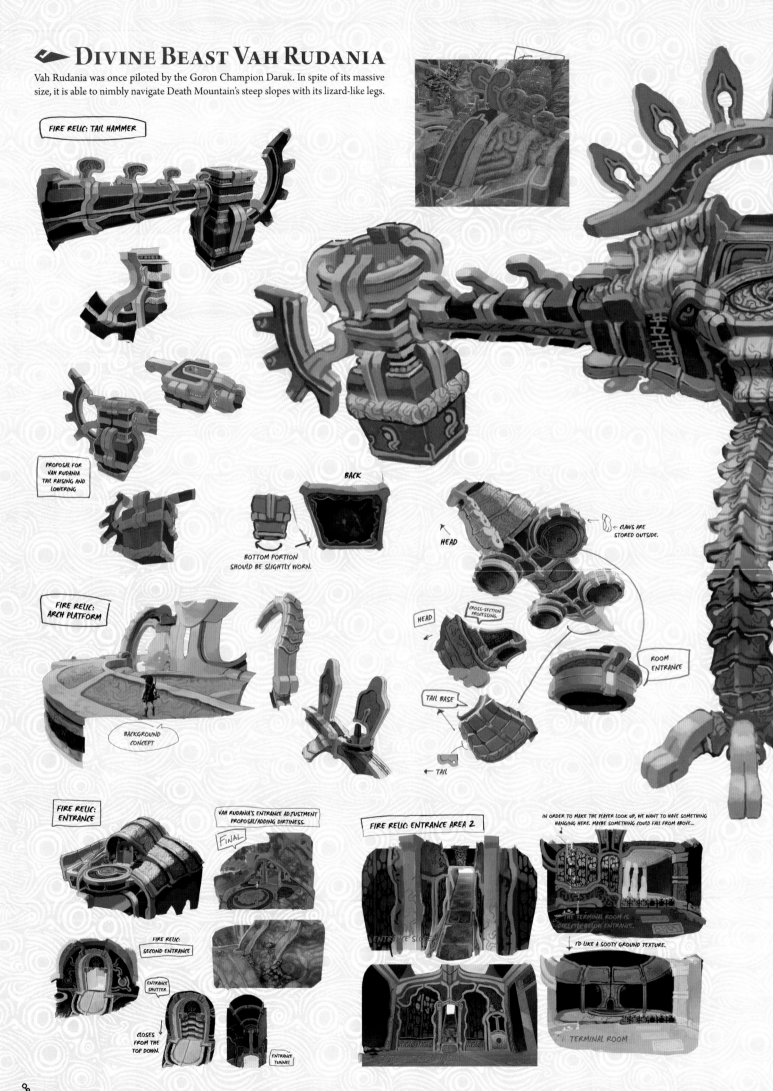

FIRE RELIC: TAIL HAMMER

PROPOSAL FOR VAH RUDANIA TAIL RAISING AND LOWERING

BACK

BOTTOM PORTION SHOULD BE SLIGHTLY WORN.

HEAD

CLAWS ARE STORED OUTSIDE.

HEAD

CROSS-SECTION PROCESSING.

ROOM ENTRANCE

TAIL BASE

TAIL

FIRE RELIC: ARCH PLATFORM

BACKGROUND CONCEPT

FIRE RELIC: ENTRANCE

VAH RUDANIA'S ENTRANCE ADJUSTMENT PROPOSAL/ADDING DIRTINESS.

FINAL

FIRE RELIC: ENTRANCE AREA 2

IN ORDER TO MAKE THE PLAYER LOOK UP, WE WANT TO HAVE SOMETHING HANGING HERE. MAYBE SOMETHING COULD FALL FROM ABOVE...

FIRE RELIC: SECOND ENTRANCE

ENTRANCE SHUTTER

CLOSES FROM THE TOP DOWN.

ENTRANCE TUNNEL

ENTRANCE SLOPE

THE TERMINAL ROOM IS DIRECTLY BELOW ENTRANCE.

I'D LIKE A SOOTY GROUND TEXTURE.

TERMINAL ROOM

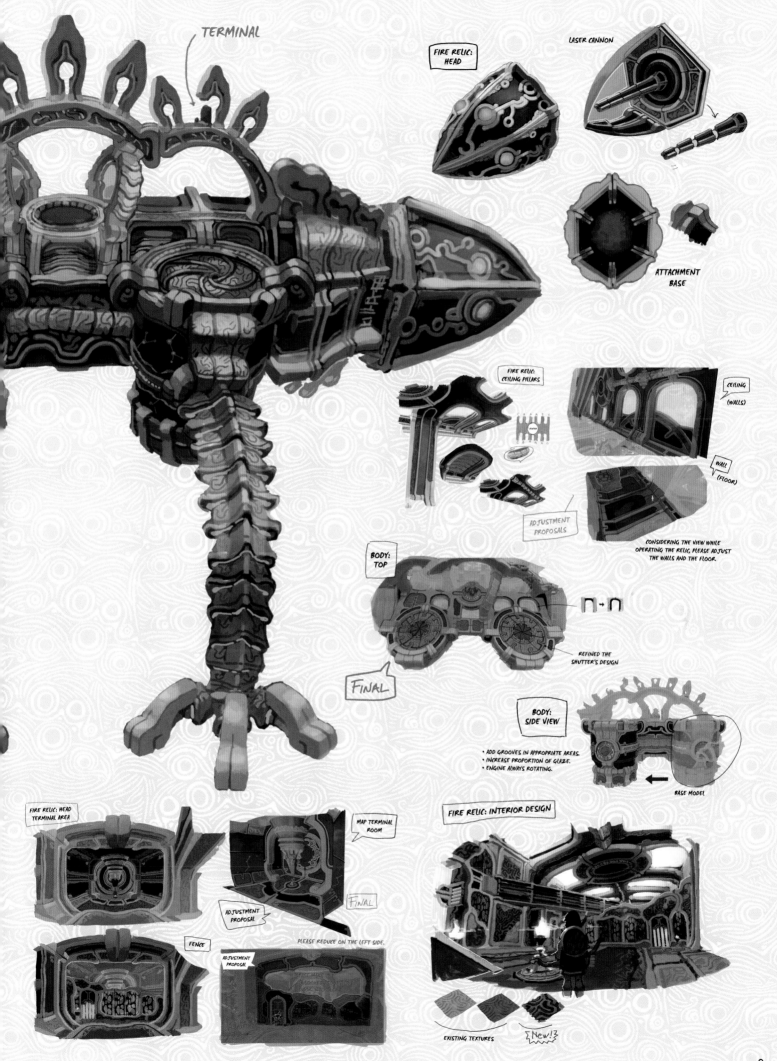

TERMINAL

FIRE RELIC: HEAD

LASER CANNON

ATTACHMENT BASE

FIRE RELIC: CEILING PILLARS

CEILING (WALLS)

WALL (FLOOR)

ADJUSTMENT PROPOSALS

CONSIDERING THE VIEW WHILE OPERATING THE RELIC, PLEASE ADJUST THE WALLS AND THE FLOOR.

BODY: TOP

Π → Π

REFINED THE SHUTTER'S DESIGN

FINAL

BODY: SIDE VIEW

• ADD GROOVES IN APPROPRIATE AREAS.
• INCREASE PROPORTION OF GLAZE.
• ENGINE ALWAYS ROTATING.

BASE MODEL

FIRE RELIC: HEAD TERMINAL AREA

MAP TERMINAL ROOM

ADJUSTMENT PROPOSAL

FINAL

FENCE

ADJUSTMENT PROPOSAL

PLEASE REDUCE ON THE LEFT SIDE.

FIRE RELIC: INTERIOR DESIGN

EXISTING TEXTURES

{New!?

211

DIVINE BEAST VAH NABORIS

Vah Naboris was once piloted by the Gerudo Champion Urbosa. It was corrupted by Calamity Ganon's Malice and went berserk, targeting anyone who approached it with well-aimed lightning bolts fired from the two humps on its back.

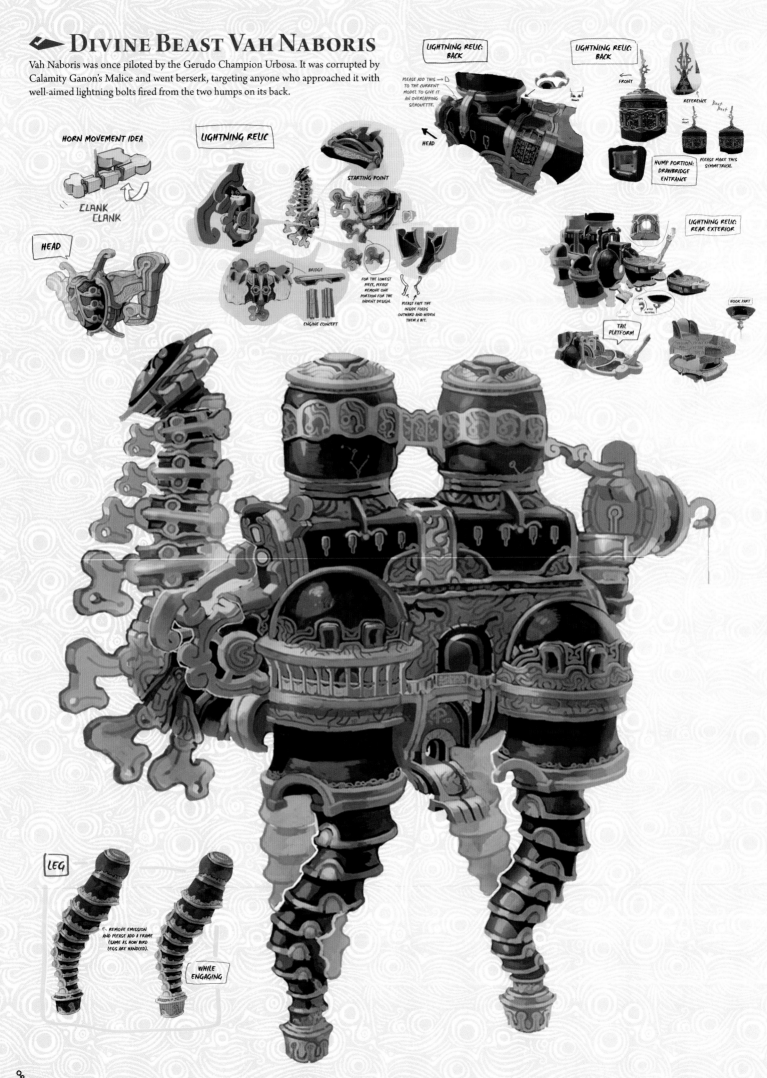

HORN MOVEMENT IDEA

CLANK CLANK

HEAD

LIGHTNING RELIC

STARTING POINT

BRIDGE

ENGINE CONCEPT

FOR THE LOWEST PIECE, PLEASE REMOVE ONE PORTION FOR THE INDENT DESIGN.

PLEASE FACE THE INSIDE FOLDS OUTWARD AND WIDEN THEM A BIT.

LIGHTNING RELIC: BACK

PLEASE ADD THIS TO THE CURRENT MODEL TO GIVE IT AN OVERLAPPING SILHOUETTE.

HEAD

FRONT

LIGHTNING RELIC: BACK

FRONT

REFERENCE

HUMP PORTION: DRAWBRIDGE ENTRANCE

PLEASE MAKE THIS SYMMETRICAL.

LIGHTNING RELIC: REAR EXTERIOR

HOOK PART

TAIL PLATFORM

LEG

REMOVE EMISSION AND PLEASE ADD A FRAME (SAME AS HOW BIRD LEGS ARE HANDLED).

WHILE ENGAGING

▷ Vah Naboris Interior

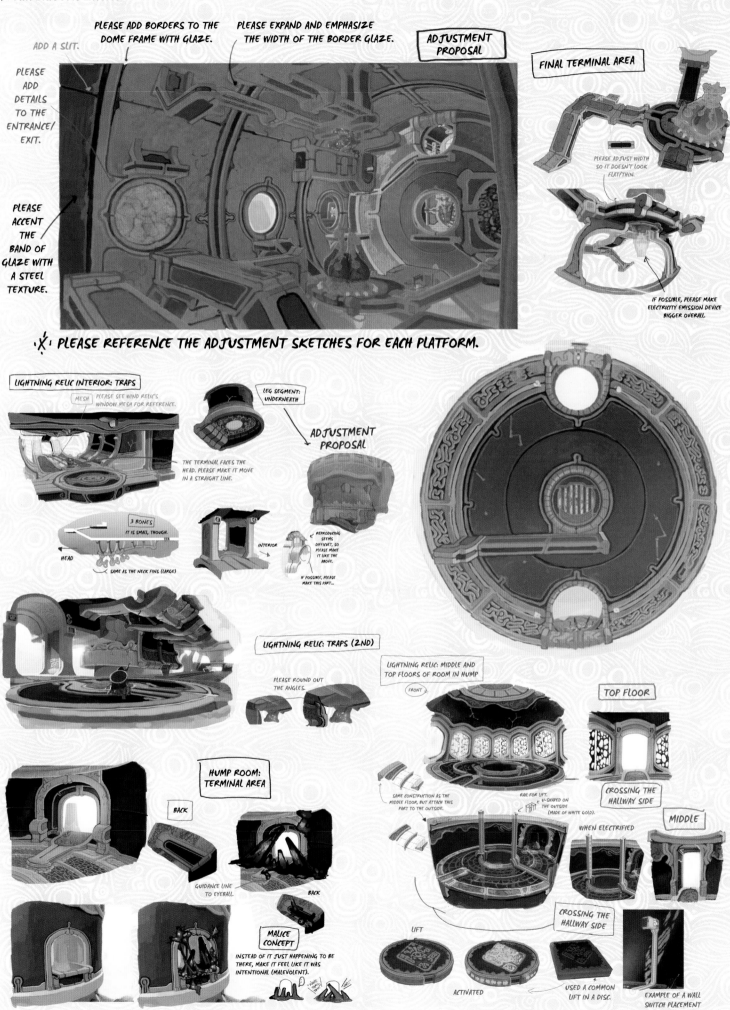

ADD A SLIT.

PLEASE ADD BORDERS TO THE DOME FRAME WITH GLAZE.

PLEASE EXPAND AND EMPHASIZE THE WIDTH OF THE BORDER GLAZE.

ADJUSTMENT PROPOSAL

PLEASE ADD DETAILS TO THE ENTRANCE/ EXIT.

FINAL TERMINAL AREA

PLEASE ADJUST WIDTH SO IT DOESN'T LOOK FLAT/THIN.

PLEASE ACCENT THE BAND OF GLAZE WITH A STEEL TEXTURE.

IF POSSIBLE, PLEASE MAKE ELECTRICITY EMISSION DEVICE BIGGER OVERALL.

⋮X⋮ PLEASE REFERENCE THE ADJUSTMENT SKETCHES FOR EACH PLATFORM.

LIGHTNING RELIC INTERIOR: TRAPS

MESH PLEASE SEE WIND RELIC'S WINDOW MESH FOR REFERENCE.

LEG SEGMENT: UNDERNEATH

ADJUSTMENT PROPOSAL

THE TERMINAL FACES THE HEAD. PLEASE MAKE IT MOVE IN A STRAIGHT LINE.

3 BONES
IT IS SMALL, THOUGH.

HEAD

INTERIOR

REPRODUCING SEEMS DIFFICULT, SO PLEASE MAKE IT LIKE THE ABOVE.

IF POSSIBLE, PLEASE MAKE THIS PART...

SAME AS THE NECK FINS (LARGE)

LIGHTNING RELIC: TRAPS (2ND)

PLEASE ROUND OUT THE ANGLES.

LIGHTNING RELIC: MIDDLE AND TOP FLOORS OF ROOM IN HUMP

FRONT

TOP FLOOR

SAME CONSTRUCTION AS THE MIDDLE FLOOR, BUT ATTACH THIS PART TO THE OUTSIDE.

RAIL FOR LIFT. U-SHAPED ON THE OUTSIDE (MADE OF WHITE GOLD).

CROSSING THE HALLWAY SIDE

HUMP ROOM: TERMINAL AREA

BACK

WHEN ELECTRIFIED

MIDDLE

GUIDANCE LINE TO EYEBALL.

BACK

MALICE CONCEPT

INSTEAD OF IT JUST HAPPENING TO BE THERE, MAKE IT FEEL LIKE IT WAS INTENTIONAL (MALEVOLENT).

LIFT

ACTIVATED

CROSSING THE HALLWAY SIDE

USED A COMMON LIFT IN A DISC.

EXAMPLE OF A WALL SWITCH PLACEMENT

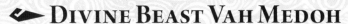

DIVINE BEAST VAH MEDOH

Vah Medoh was once piloted by the Rito Champion Revali. It soars high over Rito Village, and because it is capable of flight, only Rito can approach it. It is out of control and will fire powerful cannons at anyone who approaches.

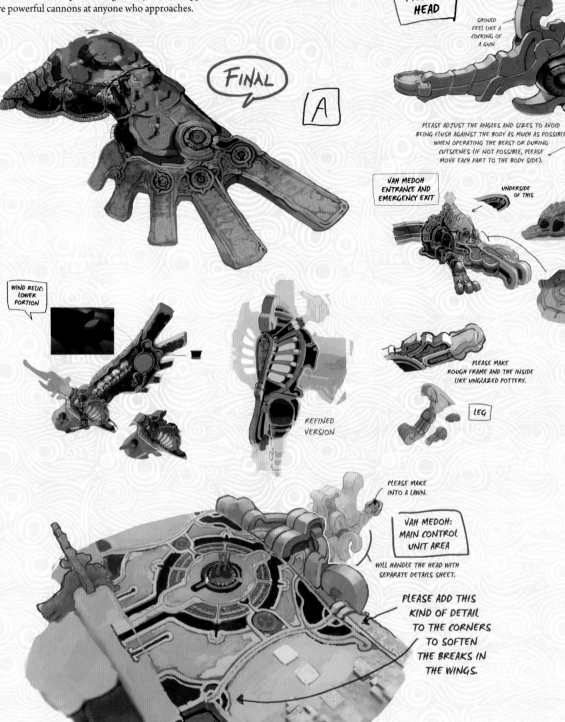

FINAL

A

WIND RELIC: LOWER PORTION

REFINED VERSION

TOP OF CREST

THE CHAMPION WILL ROLL OVER WHILE NAPPING HERE IN A CUTSCENE.

VAH MEDOH: HEAD

SHOULD FEEL LIKE A COCKING OF A GUN

PLEASE ADJUST THE ANGLES AND SIZES TO AVOID BEING FLUSH AGAINST THE BODY AS MUCH AS POSSIBLE WHEN OPERATING THE BEAST OR DURING CUTSCENES (IF NOT POSSIBLE, PLEASE MOVE EACH PART TO THE BODY SIDE).

VAH MEDOH ENTRANCE AND EMERGENCY EXIT

UNDERSIDE OF THIS

EMERGENCY EXIT

PLEASE MAKE ROUGH FRAME AND THE INSIDE LIKE UNGLAZED POTTERY.

▷ *Rough Design*

LEG

PLEASE MAKE INTO A LAWN.

VAH MEDOH: MAIN CONTROL UNIT AREA

WILL HANDLE THE HEAD WITH SEPARATE DETAILS SHEET.

PLEASE ADD THIS KIND OF DETAIL TO THE CORNERS TO SOFTEN THE BREAKS IN THE WINGS.

DEVELOPER'S NOTE

The starting point for designing the Divine Beast dungeons was questioning if we could use in-game physics mechanics to make dungeons. We wanted to move entire floors to affect a variety of objects, for example. Then, we decided on the elemental themes of water, fire, lightning, and wind and created designs that combined those with movement.

For the designs themselves, while keeping in mind that these are highly advanced weapons, we instilled a sense that these were tin toys rather than pursuing a cool, futuristic sci-fi look. I tried to make them into something attractive—off-putting, but also somehow nostalgic. I tried to make each dungeon into its own character using its appearance, animal motif, and movement. I feel like we were able to achieve something new with the dungeons that is unique to this game, since the player can see the dungeons moving around in the distance while they are exploring and even fight the dungeon itself.

LEAD ARTIST, DUNGEONS: YASUTOMO NISHIBE

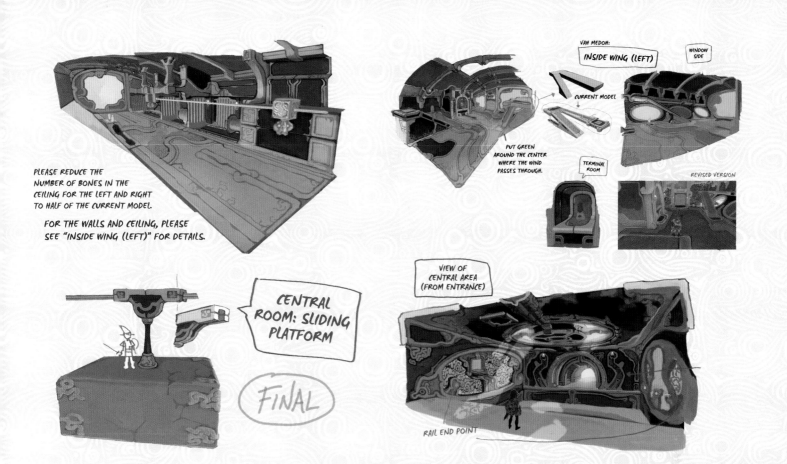

PLEASE REDUCE THE NUMBER OF BONES IN THE CEILING FOR THE LEFT AND RIGHT TO HALF OF THE CURRENT MODEL.

FOR THE WALLS AND CEILING, PLEASE SEE "INSIDE WING (LEFT)" FOR DETAILS.

VAH MEDOH:

INSIDE WING (LEFT)

WINDOW SIDE

CURRENT MODEL

PUT GREEN AROUND THE CENTER WHERE THE WIND PASSES THROUGH.

TERMINAL ROOM

REVISED VERSION

CENTRAL ROOM: SLIDING PLATFORM

FINAL

VIEW OF CENTRAL AREA (FROM ENTRANCE)

RAIL END POINT

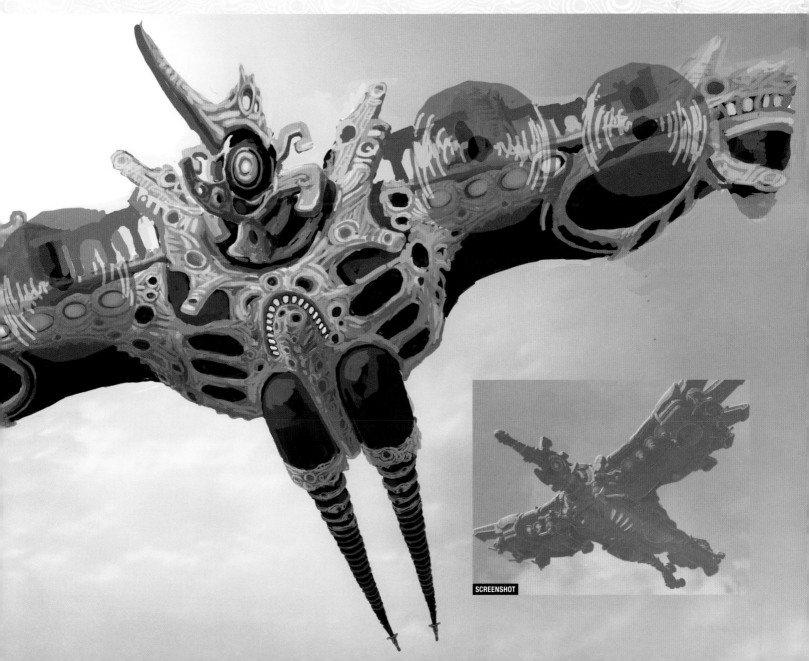

SCREENSHOT

SHEIKAH TOWER

These relics have long remained buried deep within the earth all throughout Hyrule, but when Link activates the Great Plateau's tower, it activates all of the Sheikah Towers, causing them to burst forth from the ground. Map data for the region is contained within their Guidance Stones and can be transferred to the Sheikah Slate.

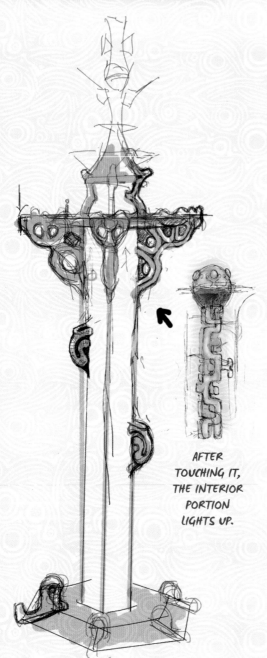

AFTER TOUCHING IT, THE INTERIOR PORTION LIGHTS UP.

▷ Rough Concepts

■ SHEIKAH TOWER (MAP TOWER)

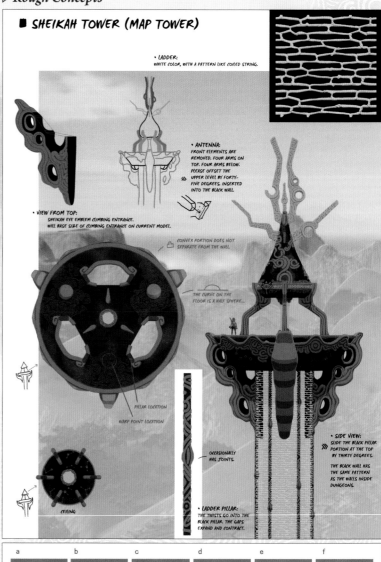

• LADDER:
WHITE COLOR, WITH A PATTERN LIKE COILED STRING.

• ANTENNA:
FRONT ELEMENTS ARE REMOVED. FOUR ARMS ON TOP. FOUR ARMS BELOW. PLEASE OFFSET THE UPPER LEVEL BY FORTY-FIVE DEGREES, INSERTED INTO THE BLACK WALL.

• VIEW FROM TOP:
SHEIKAH EYE EMBLEM CLIMBING ENTRANCE. WILL BASE SIZE OF CLIMBING ENTRANCE ON CURRENT MODEL.

CONVEX PORTION DOES NOT SEPARATE FROM THE WALL.

THE CURVE ON THE FLOOR IS A HALF SPHERE...

PILLAR LOCATION

WARP POINT LOCATION

OCCASIONALLY HAS JOINTS.

CEILING

• SIDE VIEW:
SLIDE THE BLACK PILLAR PORTION AT THE TOP BY THIRTY DEGREES.

THE BLACK WALL HAS THE SAME PATTERN AS THE WALLS INSIDE DUNGEONS.

• LADDER PILLAR:
THE TWISTS GO INTO THE BLACK PILLAR. THE GAPS EXPAND AND CONTRACT.

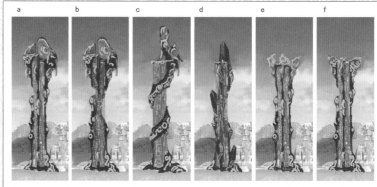

a b c d e f

▷ Guidance Stone & Terminal

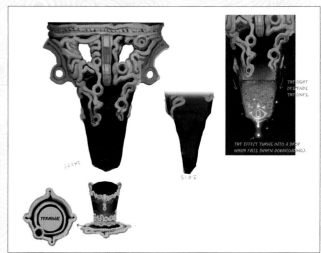

FRONT

SIDE

THE LIGHT DESCENDS THE LINES.

THE EFFECT TURNS INTO A DROP WHICH FALLS (WHEN DOWNLOADING).

TERMINAL

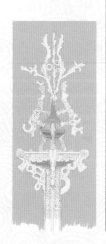

ANCIENT SHRINES (EXTERIOR)

Shrines in standby mode are locked tight awaiting the chosen hero to activate them with the Sheikah Slate. There are well over a hundred shrines throughout Hyrule—some out in the open and others that will only reveal themselves after a riddle has been solved.

▷ **Rough Concepts**

▷ **Sheikah Slate Terminal**

▷ **Elevator Platform**

■ **ENTRANCE ELEVATOR TO SHRINE INTERIOR (FB readjustment)**

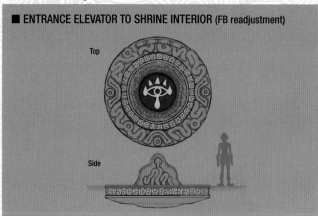

Top

Side

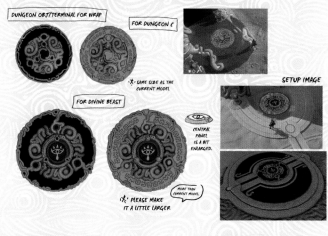

DUNGEON OBJ/TERMINAL FOR WRAP

FOR DUNGEON C

* SAME SIZE AS THE CURRENT MODEL

FOR DIVINE BEAST

SETUP IMAGE

CENTRAL PANEL IS A BIT ENLARGED.

* PLEASE MAKE IT A LITTLE LARGER

MORE THAN CURRENT MODEL

ANCIENT SHRINES (INTERIOR)

The interiors of the shrines are designed to test specific aspects of the hero's strength and skill. Link must overcome their unique trials to reach the Sheikah monk and be rewarded with a Spirit Orb.

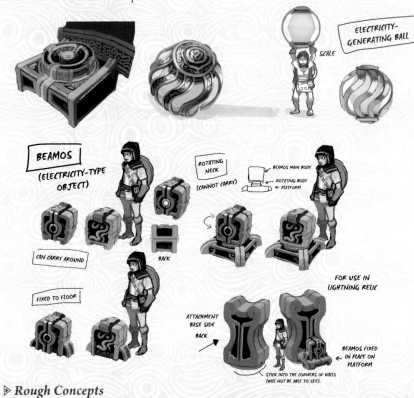

SCALE

ELECTRICITY-GENERATING BALL

BEAMOS
(ELECTRICITY-TYPE OBJECT)

ROTATING NECK
(CANNOT CARRY)

BEAMOS MAIN BODY
ROTATING BODY
PLATFORM

CAN CARRY AROUND

BACK

FIXED TO FLOOR

FOR USE IN LIGHTNING RELIC

ATTACHMENT BASE SIDE
BACK

STICK INTO THE CORNERS OF WALLS
(WILL NOT BE ABLE TO SEE).

BEAMOS FIXED IN PLACE ON PLATFORM

▷ **Rough Concepts**

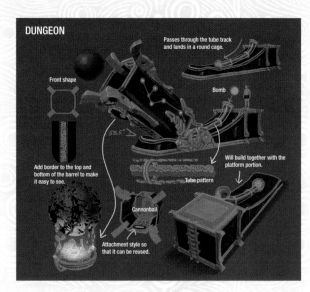

DUNGEON

Passes through the tube track and lands in a round cage.

Front shape

Bomb

Add border to the top and bottom of the barrel to make it easy to see.

58.5°

Will build together with the platform portion.

Tube pattern

Cannonball

Attachment style so that it can be reused.

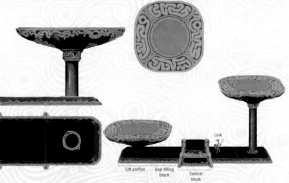

Link

Lift portion Gap-filling block Central block

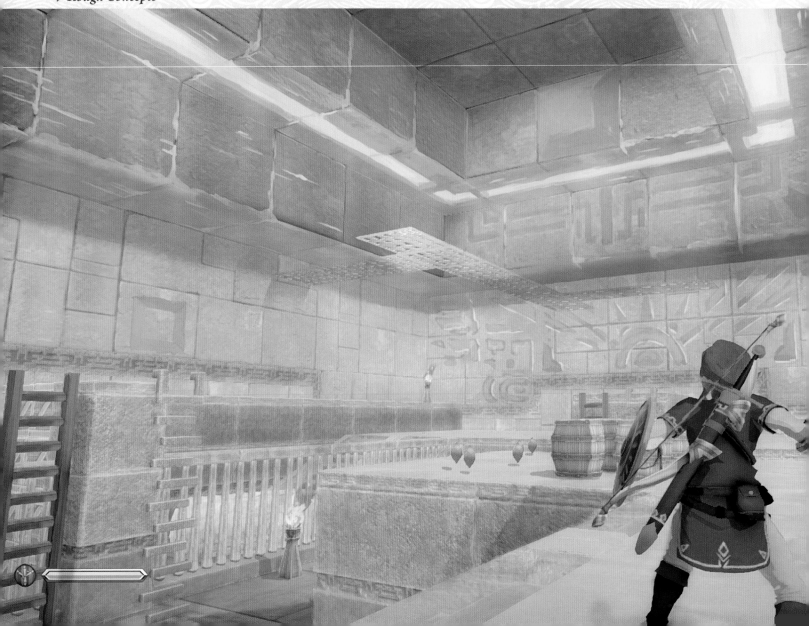

▷ Monk's Pedestal

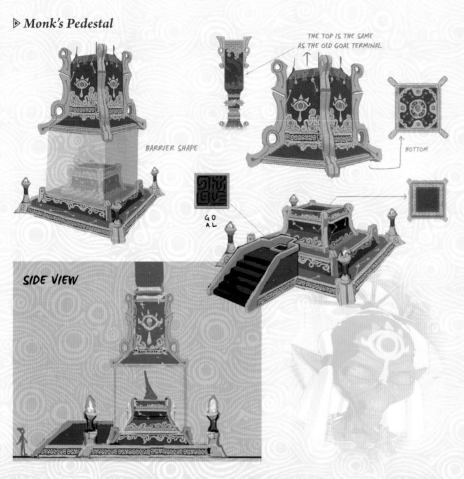

THE TOP IS THE SAME
AS THE OLD GOAL TERMINAL

BARRIER SHAPE

BOTTOM

GOAL

SIDE VIEW

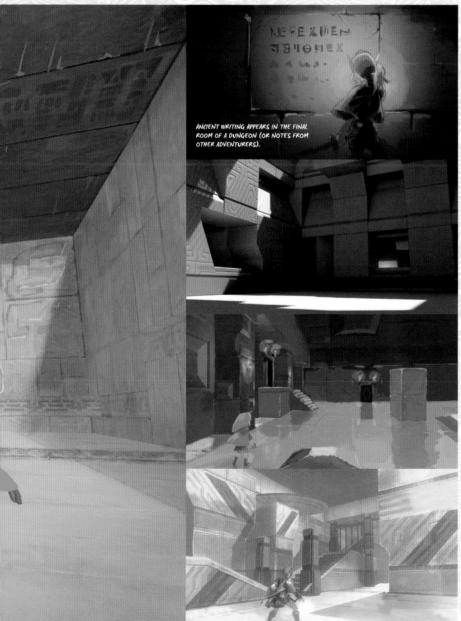

ANCIENT WRITING APPEARS IN THE FINAL
ROOM OF A DUNGEON (OR NOTES FROM
OTHER ADVENTURERS).

REMOTE BOMB ACTIVATION

Link can use Remote Bombs once that rune is downloaded onto the Sheikah Slate. Link can make a Remote Bomb appear by pulling the pin on the Sheikah Slate that has the round ring attached to it. The round protrusion at the top of the bomb is the pin.

AN ANCIENT ALPHABET

The ancient Sheikah relics are adorned with the symbol of the Sheikah, swirling whirlpool designs, and often the letters of an ancient alphabet. Notes can be found in the flowing light energy that appears when the Sheikah Slate is connected to a download terminal or in the walls and doors of shrines. It is possible to decipher these ancient characters.

ANCIENT ASTRONOMERS?

There are patterns within some ancient Sheikah relics that connect points of light with lines. A few of these patterns are used as hints for solving puzzles in the ancient shrines, and similar patterns can be glimpsed on a Guardian's body where its legs connect. One theory is that these shapes depict stars and constellations from the night sky over Hyrule. It is probable that the ancient Sheikah were stargazers researching the heavens.

CENTRAL HYRULE
LAND OF BEGINNINGS & ENDINGS

Central Hyrule is made up of a broad plain whose eastern border roughly follows the Hylia River from north to south. Hyrule Castle and its castle town occupy its northern border. It stretches as far west as Satori Mountain, where the land drops into a precipitous gorge. The Great Plateau, home of the Shrine of Resurrection, where Link slept for one hundred years, is in the southern reaches.

Hyrule Castle and the ruins of Hyrule Castle Town are patrolled by numerous Guardians to this day, making them extremely dangerous and keeping adventurous travelers at bay.

Beyond Hyrule Castle to the north is the Great Hyrule Forest, where beautiful cherry trees blossom, but travelers should be wary: within the forest are the Lost Woods, where people tend to lose their way . . .

◀ THE GREAT PLATEAU

The Great Plateau is perched high above the rest of Central Hyrule, making it a land island with sheer cliffs on all sides. When Link's famed strength finally gave out during the Guardians' assault and he succumbed to his injuries, he was transported to the Great Plateau's Shrine of Resurrection to sleep and be healed.

▷ *Shrine of Resurrection* (RESTORATION ROOM)

CUTSCENES

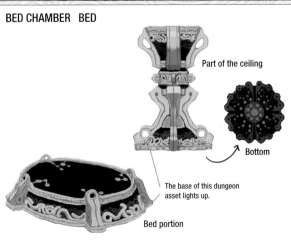

BED CHAMBER BED

Part of the ceiling

Bottom

The base of this dungeon asset lights up.

Bed portion

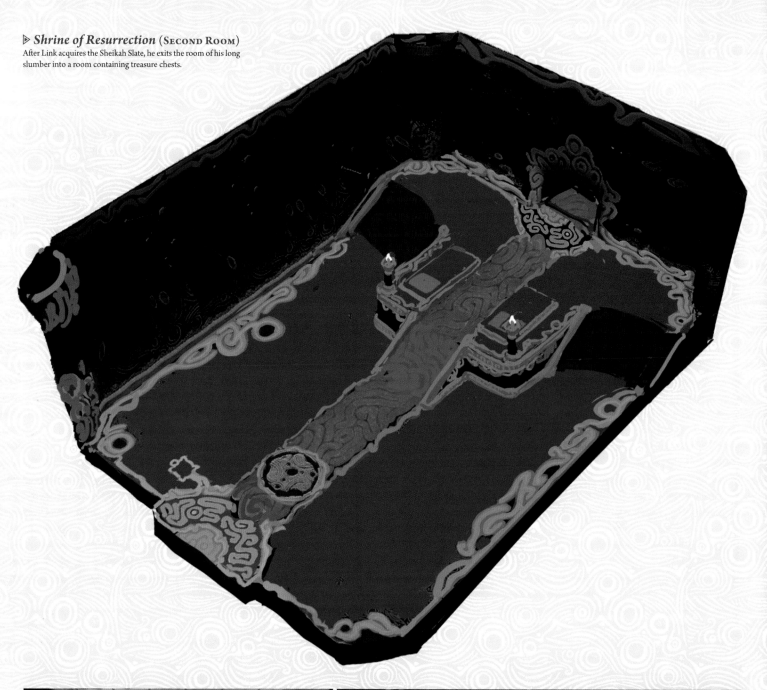

▷ *Shrine of Resurrection* (Second Room)

After Link acquires the Sheikah Slate, he exits the room of his long slumber into a room containing treasure chests.

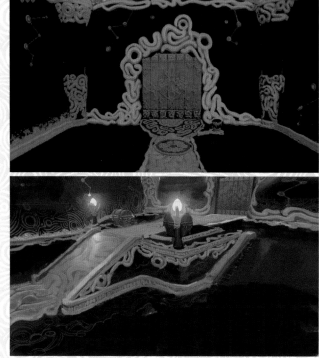

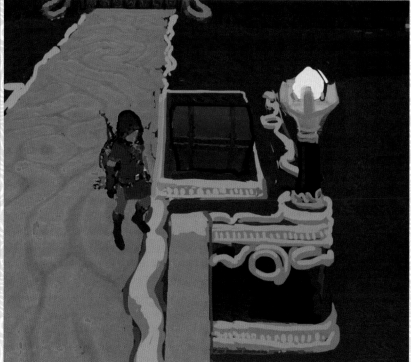

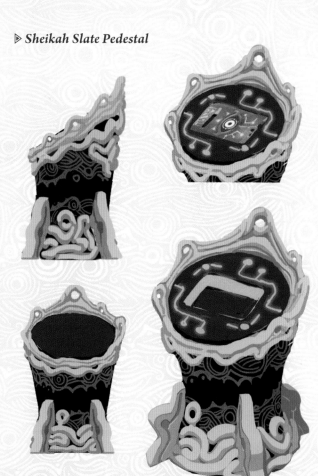

▷ **Rough Designs**

CONDUCTOR (PLACEHOLDER) PEDESTAL

Initially, the face surrounding the Conductor does not glow.

Link approaches the front of the pedestal and an "Examine" prompt appears.

If one follows the prompt, the area around the Conductor lights up and an activation icon appears at the center of the Conductor and the Game Pad. When the user touches the icon on the Game Pad . . .

. . . the struts supporting the Conductor glow slightly and open in a clockwise pattern.

The entire disc around the Conductor will extend outward. I want smoke to come up from the lower portion when this happens.

Link takes the Conductor (removes it).

The pedestal will descend around the time that Link attaches the Conductor to his hip.

Before it descends completely, boards made of the same material as the floor will extend from four slots and cover the hole.

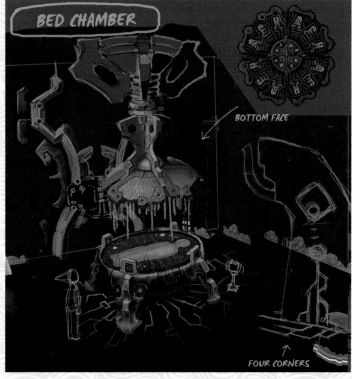

BED CHAMBER

BOTTOM FACE

FOUR CORNERS

DEVELOPER'S NOTE

To ensure that the players wouldn't lose track of the goals laid out in the start of the game, we had to restrict their movement somewhat with the topography of the initial area. We decided to make it a plateau because we thought it would be a shame to lose the ability to see the world's expansive environments if we made it a canyon or valley. I was originally planning to match the map in this game to how things have been laid out throughout the *Zelda* series, and so I placed the Temple of Time (page 225) on this geographically important plateau. From there, the idea of transcending time led to the idea of the Shrine of Resurrection.

By the way, the Shrine of Resurrection shares its layout with the Throne Room (page 253) in Hyrule Castle where Ganon's cocoon is, and they were both designed around the concept of revival.

SENIOR LEAD ARTIST, LANDSCAPE: MAKOTO YONEZU

▷ Old Man's Cabin

This cabin is found to the southeast of the Shrine of Resurrection. The Old Man that Link meets right outside the shrine lives here. It's a bit rundown but has recently used tools and a cooking pot, so it is clearly still occupied.

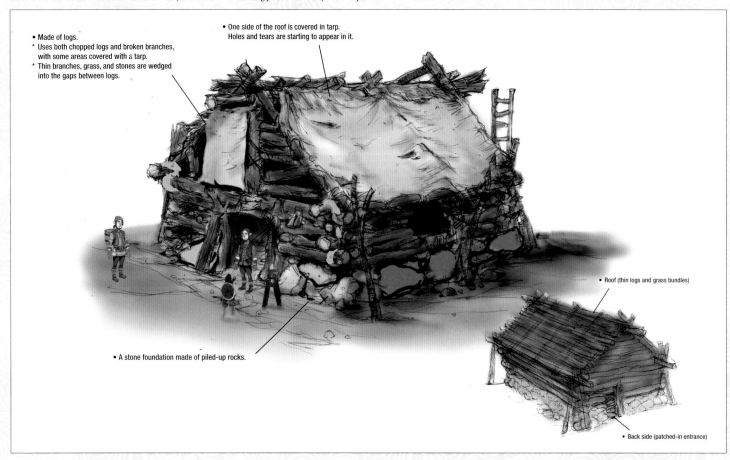

- Made of logs.
* Uses both chopped logs and broken branches, with some areas covered with a tarp.
* Thin branches, grass, and stones are wedged into the gaps between logs.

- One side of the roof is covered in tarp. Holes and tears are starting to appear in it.

- Roof (thin logs and grass bundles)

- A stone foundation made of piled-up rocks.

- Back side (patched-in entrance)

▷ Great Plateau Tower (Before Activation) Rough Designs

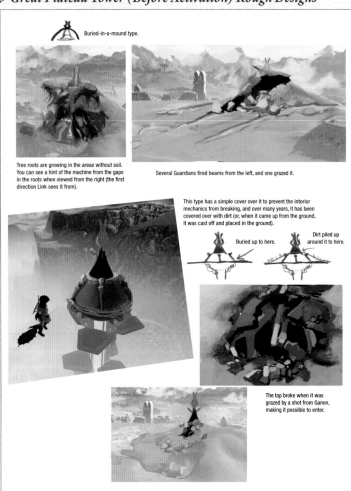

Buried-in-a-mound type.

Tree roots are growing in the areas without soil. You can see a hint of the machine from the gaps in the roots when viewed from the right (the first direction Link sees it from).

Several Guardians fired beams from the left, and one grazed it.

This type has a simple cover over it to prevent the interior mechanics from breaking, and over many years, it has been covered over with dirt (or, when it came up from the ground, it was cast off and placed in the ground).

Buried up to here.

Dirt piled up around it to here.

The top broke when it was grazed by a shot from Ganon, making it possible to enter.

▷ Old Man's Cabin Interior

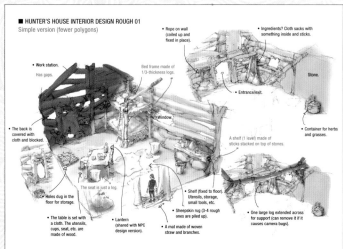

■ HUNTER'S HOUSE INTERIOR DESIGN ROUGH 01
Simple version (fewer polygons)

- Work station.
Has gaps.

- Rope on wall (coiled up and fixed in place).

- Ingredients? Cloth sacks with something inside and sticks.

Bed frame made of 1/3-thickness logs.

Stone.

- The back is covered with cloth and blocked.

- Entrance/exit.

Window.

- Container for herbs and grasses.

A shelf (1 level) made of sticks stacked on top of stones.

- Holes dug in the floor for storage.

The seat is just a log.

- Shelf (fixed to floor). Utensils, storage, small tools, etc.

- One large log extended across for support (can remove it if it causes camera bugs).

- The table is set with a cloth. The utensils, cups, seat, etc. are made of wood.

- Lantern (shared with NPC design version).

- A mat made of woven straw and branches.

- Sheepskin rug (3-4 rough ones are piled up).

▷ Old Man's Cabin Rough Design

▷ Temple of Time Rough Design

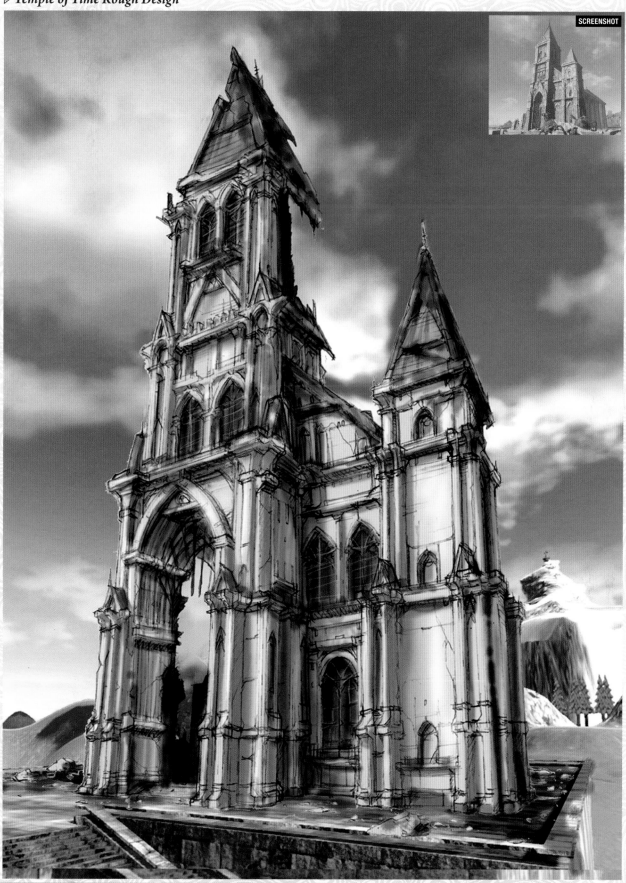

SCREENSHOT

TEMPLE OF TIME SURROUNDINGS CONCEPT

The Temple of Time is in a particularly bad state, and King Rhoam's grave is here as well, so it should feel like there was a huge battle with Ganon here. The ground burned by beams should still be barren one hundred years later, etc. It would be nice to have Sheikah who know what happened visit sometimes to offer flowers, perhaps. (In that case, I would want flowers at the king's grave too . . .)

It would be interesting if the grounds were complex—detailed objects such as buildings or pillars are covered in grime and buried. Like the Guardian in the image on the left.

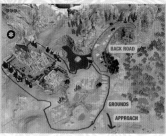

Facilities around the temple.

Try having trees growing in the gaps of the temple grounds and increase the amount of exposed stone. Also, try to increase the number of rocks on the back path to make it distinct.

I thought it was easy to imagine what sort of temple it was one hundred years ago.

It might be nice to have simple things such as a broken gate at the area where the back path and grounds meet.

HYRULE RIDGE

Hyrule Ridge is located in the western portion of Hyrule Field and has several locations of interest: Thundra Plateau is a place of violent thunderstorms and frequent lightning bolts, the Breach of Demise is an area where the land looks as though it has been thrust upward by some great force, and the bard Kass sings of a legend related to the stone rings on Nima Plain.

▷ *Thundra Plateau Rough Design*

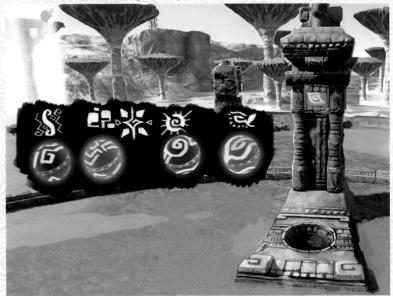

SCREENSHOT

▷ *Nima Plain Stone Rings Rough Designs*

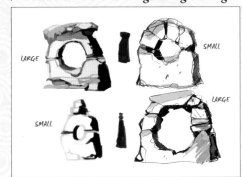

LARGE
SMALL
SMALL
LARGE

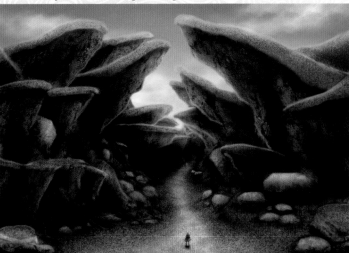

SCREENSHOT

▷ *Breach of Demise Rough Design*

SCREENSHOT

SCREENSHOT

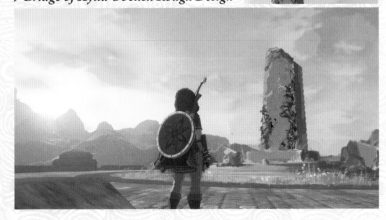

LAKE HYLIA

This enormous lake extends out from the southeast of Hyrule Field. The Bridge of Hylia spans the lake from north to south and is perhaps the grandest bridge in all of Hyrule.

SCREENSHOT

THE TOP IS SHAPED LIKE THE TRIFORCE.

▷ *Bridge of Hylia Fountain Rough Design*

LOWER THAN THE GROUND.

▷ *Bridge of Hylia Obelisk Rough Design*

KOROK FOREST

The Korok Forest is located in the center of the Great Hyrule Forest to the north of Hyrule Castle. The Lost Woods that surround it prevent all but those chosen from finding their way to the home of the Koroks. This allows the spirits of the forest to live in peace. Within the forest is the pedestal where the damaged Master Sword is kept.

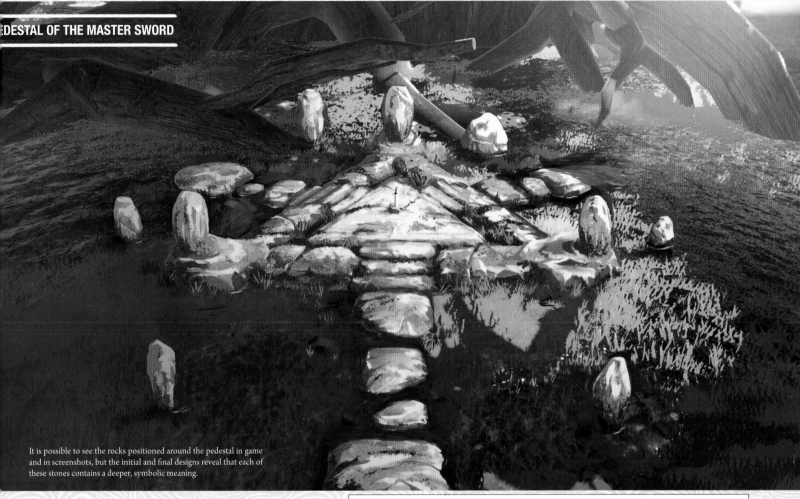

DESTAL OF THE MASTER SWORD

It is possible to see the rocks positioned around the pedestal in game and in screenshots, but the initial and final designs reveal that each of these stones contains a deeper, symbolic meaning.

▷ *Pedestal of the Master Sword Rough Designs*

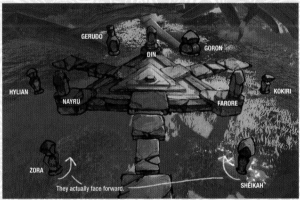

GERUDO
DIN
GORON
HYLIAN
NAYRU
KOKIRI
FARORE
ZORA
They actually face forward.
SHEIKAH

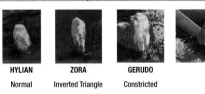					
HYLIAN	**ZORA**	**GERUDO**	**GORON**	**KOKIRI**	**SHEIKAH**
Normal	Inverted Triangle	Constricted	Rice Ball	Small	Water Chestnut

PEDESTAL OF THE MASTER SWORD CONCEPT

The crest on the ground surrounding the Master Sword is a Triforce with designs inspired by the symbols of Nayru, Din, and Farore.

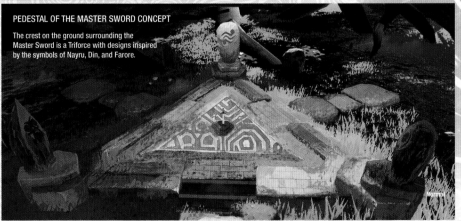

Normal

227

▷ Great Deku Tree

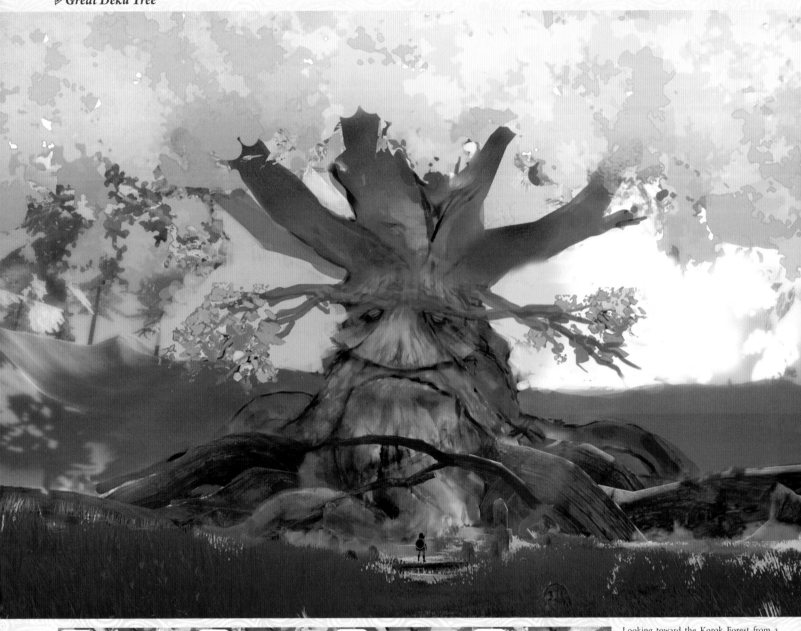

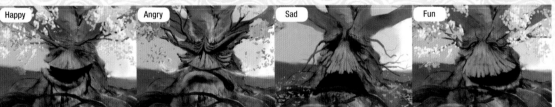

Happy	Angry	Sad	Fun

Looking toward the Korok Forest from a distant mountain, one can see cherry blossoms covering a large area in the center. These are the branches of a very large tree, which may seem like any other tree until it starts speaking . . .

▷ Great Deku Tree Rough Designs

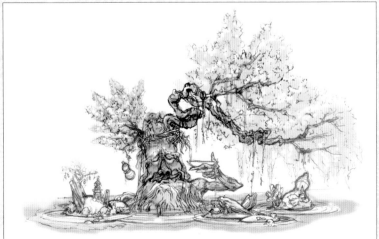

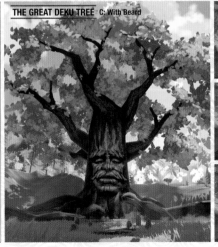

THE GREAT DEKU TREE · C: With Beard

▷ *The Great Deku Tree's Navel Rough Concepts*

Ultimately, the developers went with a design of the Great Deku Tree's Navel where the three rooms were lined up symmetrically on the left, right, and center, but other ideas were considered as well. The structure and furniture were designed to give the player an idea of what kind of lives the Koroks lead.

SCREENSHOT

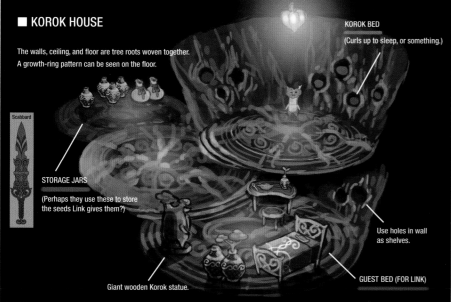

■ KOROK HOUSE

The walls, ceiling, and floor are tree roots woven together. A growth-ring pattern can be seen on the floor.

Scabbard

STORAGE JARS
(Perhaps they use these to store the seeds Link gives them?)

Giant wooden Korok statue.

KOROK BED
(Curls up to sleep, or something.)

Use holes in wall as shelves.

GUEST BED (FOR LINK)

DEVELOPERS' NOTES

I wanted to put a cherry blossom tree somewhere in the Hyrule of this game. I think that giving the Great Deku Tree a slightly Japanese aesthetic allows the player to imagine a different view of this world.
SENIOR LEAD ARTIST, LANDSCAPE: MAKOTO YONEZU

The Master Sword has averted many calamities alongside the hero, and the pedestal that restores the sword from the damage it incurs in those battles is located in Korok Forest, which brims with the energy of the land. Perhaps by design of the Goddess, beside the pedestal a single young cherry tree grew. The young tree bathed in the energy flowing through the land and, after an eternity had passed, became the guardian of the blade. How many sacred maidens and heroes opposing countless calamities has this ancient tree witnessed?

This backstory gave birth to the Great Deku Tree's design. This old tree has lived for countless generations and is the largest Great Deku Tree of the series.
LEAD ARTIST, STRUCTURAL: MANABU TAKEHARA

KOROK HOUSE INTERIOR CONCEPT

Design with hanging leaves and decorative panels.

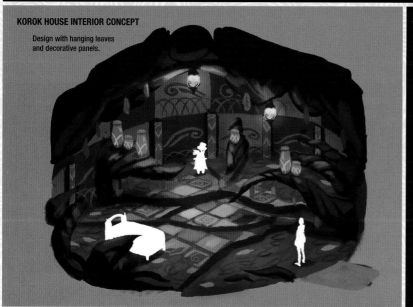

KOROK RESIDENCE CONCEPT

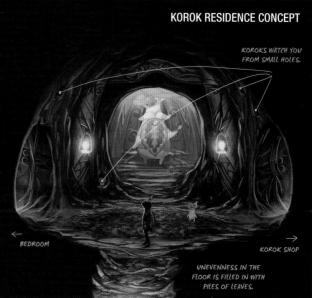

KOROKS WATCH YOU FROM SMALL HOLES.

← BEDROOM

KOROK SHOP →

UNEVENNESS IN THE FLOOR IS FILLED IN WITH PILES OF LEAVES.

KOROK RESIDENCE CONCEPT

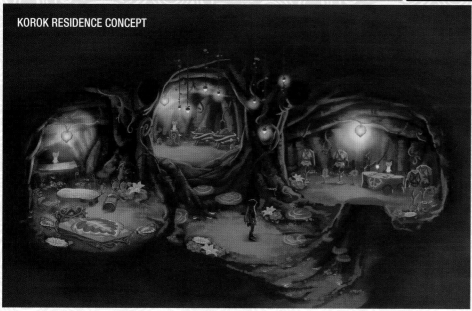

KOROK FURNITURE COLLECTION

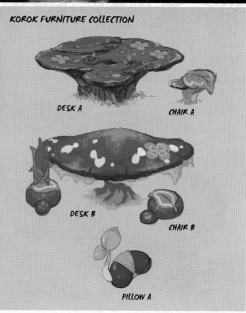

DESK A

CHAIR A

DESK B

CHAIR B

PILLOW A

HYRULE FIELD

Hyrule Field expands outward from the north side of the Great Plateau. It is bordered by the Hylia River to the east and the Regencia River to the west and is connected to the rest of Hyrule by a significant number of bridges. The ruins of homes, garrisons, and ranches beyond Hyrule Castle Town indicate just how lively this area must have been just one hundred years ago.

▷ Proxim Bridge

Level ground damage can just use flat collision.

Missing guardrail

Broken pillar

Moss

BRIDGE DAMAGE

▷ Hyrule Field Rough Concepts

The buildings in the Hyrule Field area were demolished during the Great Calamity, and only ruins remain. The only things left are the cornerstones of houses and other materials that survived in various states of disrepair. You can see here how much detail went into the design of the vestiges of a once-thriving area.

FIELD IDEAS (1)

BROKEN LAND BRIDGE

MIGHT BE CONVINCING IF LOCATED IN RAVINES, ETC.

A PILLAR WITH A TREE GROWING AGAINST IT.

REFERENCE: BRIDGE NEAR DUNGEON 07.

FORTRESS

WHILE SCALES VARY, THEY COULD BE ON SMALL/TALL HILLS, ETC. LOCATED IN AREAS WITH GOOD VIEWS OF THE LAND.

BROKEN MILITARY FLAGS, ETC.

PEOPLE CANNOT APPROACH BECAUSE OF TONS OF ENEMIES.

FORTRESS VARIATION

• RELIC DESIGN.
• SHOWS JUST HOW POWERFUL THE CALAMITY IS.

FOUNTAIN RUINS

FEELS LIKE A PLACE FROM A MEMORY.

I WANT HIM TO BE ABLE TO SIT DOWN.

KOROK INSIDE THE BARREL.
↓
IF THE PLAYER FINDS IT, THE CAMERA FOCUSES ON THE INTERIOR OF THE BARREL.

SEAT FOR TWO.

Assassin-clan tags with their symbol: "Go Ganon!"

RUINS OF A SMALL VILLAGE.
May be used as a base by monsters.
Use small, broken house assets from the snow mountain and castle town ruins.
Make each unit into a unique actor and change their placement to create variation.

Simple, weathered gravestones quietly hidden in the forest.

▷ Hyrule Castle Town Gate

This is its original appearance. It was constructed near the center of Hyrule Field. Passing through this gate led to Hyrule Castle Town and all it had to offer. Large walls take the form of a ring moving out from the sides of the gate, guarding the castle town.

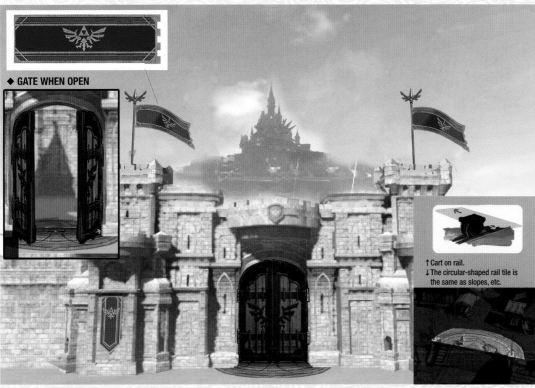

◆ GATE WHEN OPEN

↑ Cart on rail.
↓ The circular-shaped rail tile is the same as slopes, etc.

GATE RAIL

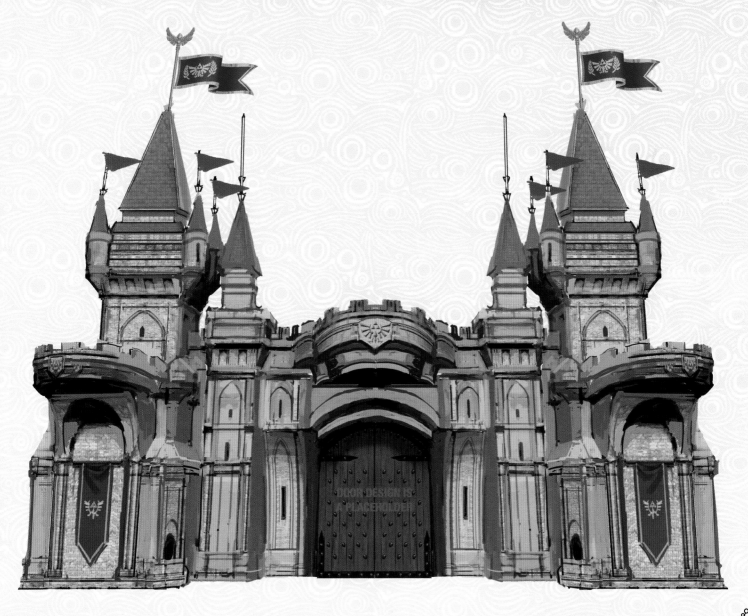

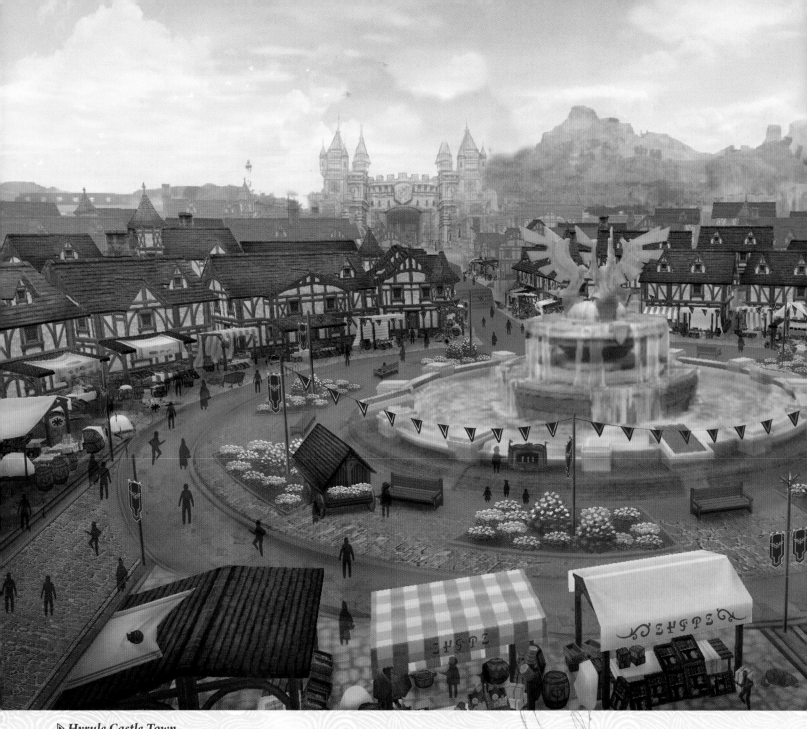

▷ Hyrule Castle Town

This is how Hyrule Castle Town looked before the Great Calamity struck. It was the largest city in all of Hyrule and the hub for travel and the exchange of goods.

*People in the square are placeholders.

BIG 2 23
MEDIUM 2 6
SMALL 1 18
2 11

A BIG PLAZA

EXTRA BIG

④

Window and door are a single object.

This way.

Roof part.

HOUSE REVISED VERSION

I added an arch.

Planning to adjust tile on model to reduce a sense of randomness.

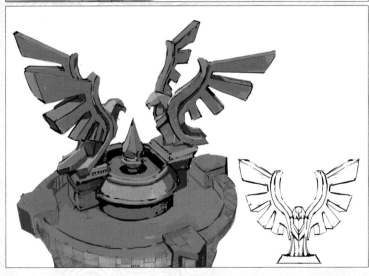

HYRULE CASTLE

Looking north from Hyrule Castle Town reveals the ruins of Hyrule Castle. It is protected by layers of high walls and gatehouses, fortified further by a deep moat. The castle's complex interior construction includes underground caverns and passageways, most likely built to defend the castle should the exterior defense be compromised. At the castle's heart lies the Sanctum.

▷ Hyrule Castle Gate Rough Designs

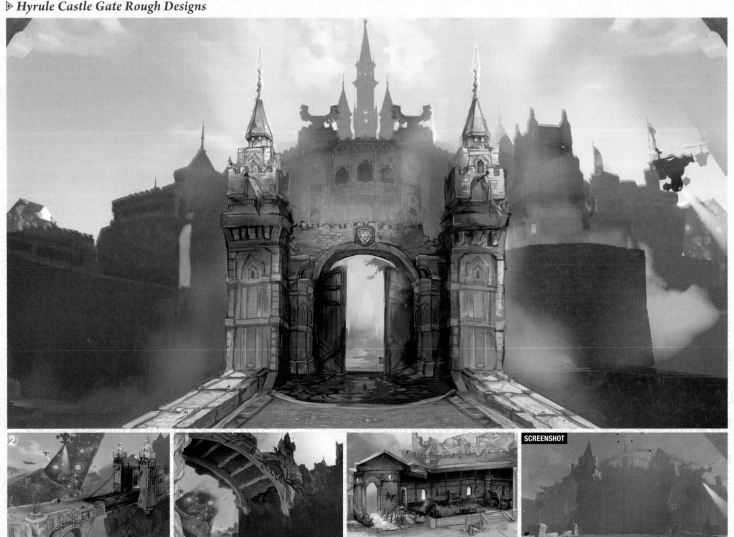

② SCREENSHOT

▷ Bridge & Castle Walls

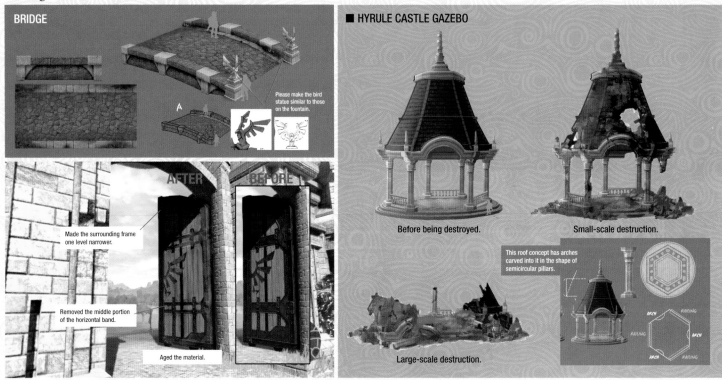

BRIDGE

Please make the bird statue similar to those on the fountain.

A

AFTER **BEFORE**

Made the surrounding frame one level narrower.

Removed the middle portion of the horizontal band.

Aged the material.

■ HYRULE CASTLE GAZEBO

Before being destroyed.

Small-scale destruction.

Large-scale destruction.

This roof concept has arches carved into it in the shape of semicircular pillars.

ARCH RAILING
ARCH
RAILING
ARCH RAILING

▷ Giant Columns

The columns that protrude from the ground around Hyrule Castle are exceptionally large. They are covered in Sheikah patterns, making it clear that they are ancient Sheikah technology, but they glow an ominous pink, signifying their corruption by Calamity Ganon's Malice.

They appear to have stored the Guardians and were designed to unleash them on Calamity Ganon through an opening in the center of the circular patterns.

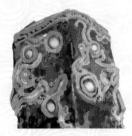

LARGE TWIST SMALL TWIST SINUOUS PATTERN

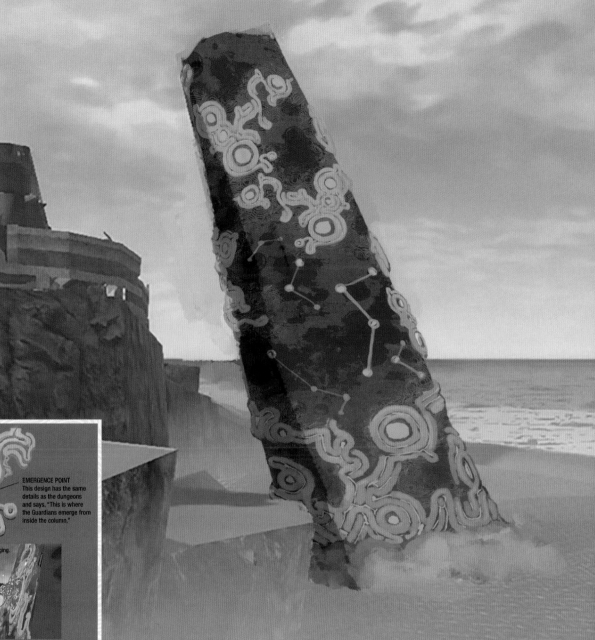

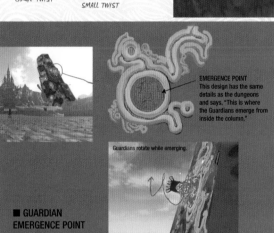

EMERGENCE POINT
This design has the same details as the dungeons and says, "This is where the Guardians emerge from inside the column."

Guardians rotate while emerging.

■ **GUARDIAN EMERGENCE POINT**

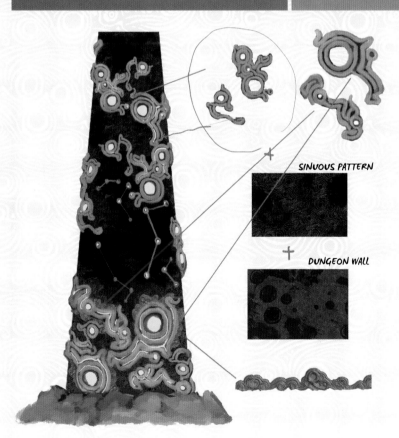

SINUOUS PATTERN

DUNGEON WALL

▷ Giant Columns Rough Designs

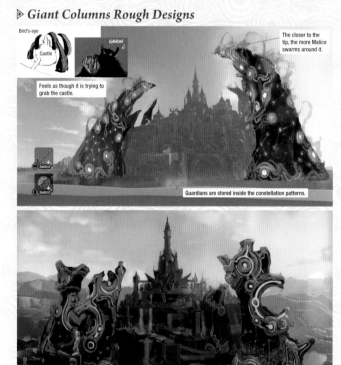

Bird's-eye
Castle
GANON

The closer to the tip, the more Malice swarms around it.

Feels as though it is trying to grab the castle.

Switch
Switch

Guardians are stored inside the constellation patterns.

Guardian

▷ Gatehouses

These two medium-sized buildings resemble castles themselves and are built along the road that runs up to the Sanctum. These sturdy structures survived the Great Calamity, but their interiors are now filled with Malice, and Lynels have taken up residence within them.

• SECOND GATEHOUSE/FIRST GATEHOUSE

◆ REVISED THE EMBLEM ENGRAVING.

◆ FLOOR

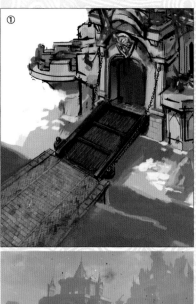

①

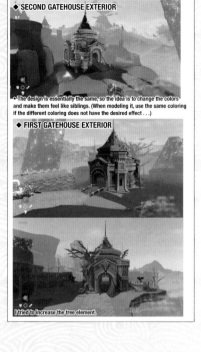

SCREENSHOT

▷ Gatehouses Rough Designs

◆ SECOND GATEHOUSE EXTERIOR

◆The design is essentially the same, so the idea is to change the colors and make them feel like siblings. (When modeling it, use the same coloring if the different coloring does not have the desired effect . . .)

◆ FIRST GATEHOUSE EXTERIOR

I tried to increase the tree element.

▷ Hyrule Castle Courtyard

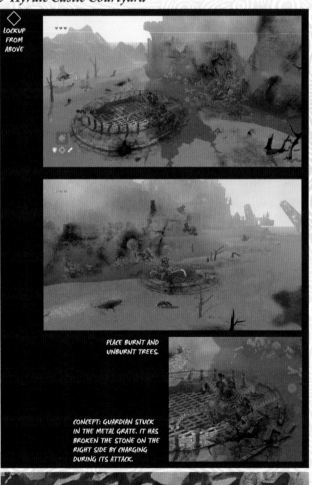

◇ LOCKUP FROM ABOVE

PLACE BURNT AND UNBURNT TREES.

CONCEPT: GUARDIAN STUCK IN THE METAL GRATE. IT HAS BROKEN THE STONE ON THE RIGHT SIDE BY CHARGING DURING ITS ATTACK.

FIXED STRETCHED

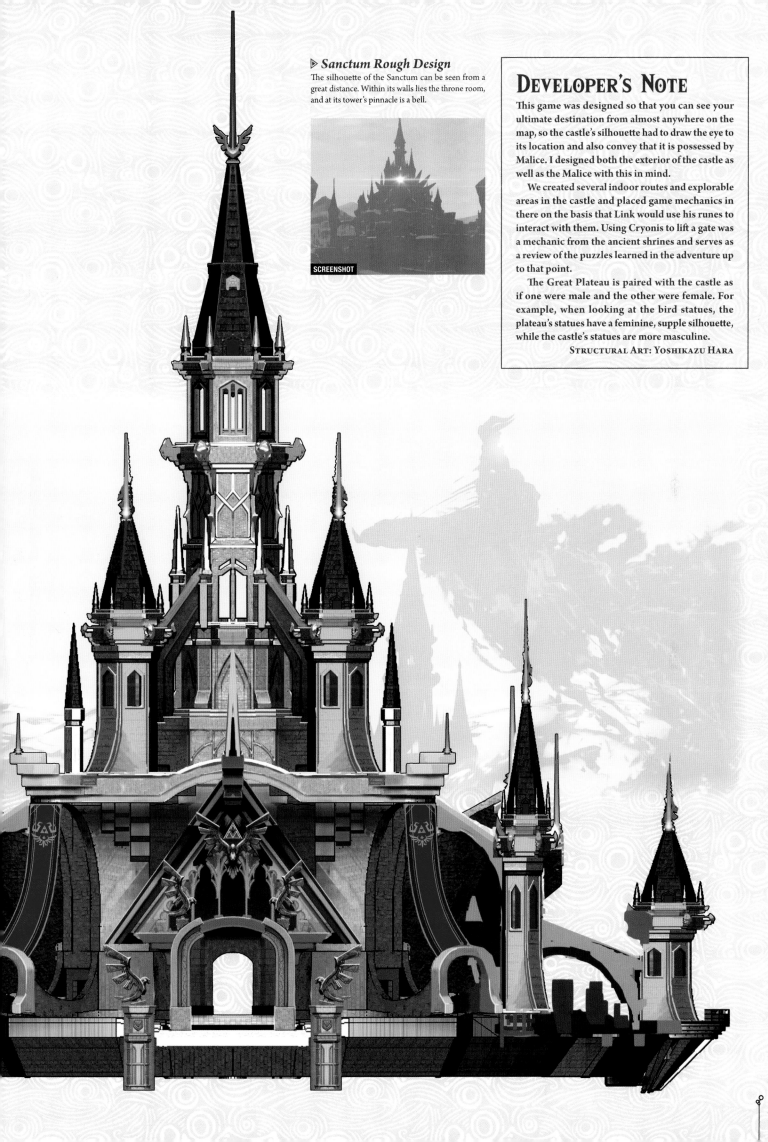

▷ Sanctum Rough Design

The silhouette of the Sanctum can be seen from a great distance. Within its walls lies the throne room, and at its tower's pinnacle is a bell.

SCREENSHOT

DEVELOPER'S NOTE

This game was designed so that you can see your ultimate destination from almost anywhere on the map, so the castle's silhouette had to draw the eye to its location and also convey that it is possessed by Malice. I designed both the exterior of the castle as well as the Malice with this in mind.

We created several indoor routes and explorable areas in the castle and placed game mechanics in there on the basis that Link would use his runes to interact with them. Using Cryonis to lift a gate was a mechanic from the ancient shrines and serves as a review of the puzzles learned in the adventure up to that point.

The Great Plateau is paired with the castle as if one were male and the other were female. For example, when looking at the bird statues, the plateau's statues have a feminine, supple silhouette, while the castle's statues are more masculine.

STRUCTURAL ART: YOSHIKAZU HARA

▷ Hyrule Castle Corridors

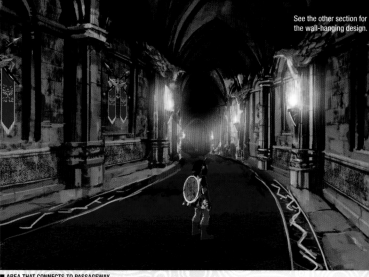

See the other section for the wall-hanging design.

Soldier Weapons Decoration

Royal Weapons Decoration

■ AREA THAT CONNECTS TO PASSAGEWAY

Passageway: Soldier's Side

Passageway: Royal Family's Side

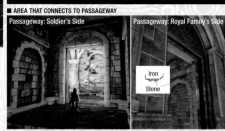

Iron
Stone

WOOL RUG CONCEPT

The end of the wool rug.

Inside the massive castle are areas used primarily by soldiers and others used by the royal family. The construction materials and decorations make it apparent which areas are intended for use by which party.

■ HYRULE CASTLE SOLDIER PASSAGEWAY GATE

■ HYRULE CASTLE INTERIOR PASSAGEWAY (CAVERN) It's supported in places with wooden beams.

Simple handrails and torches.

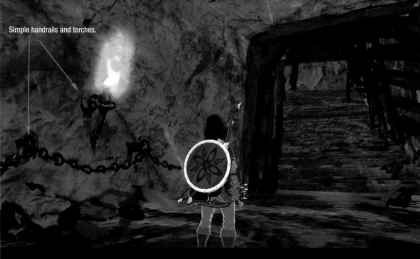

◆ **PASSAGEWAY AREA** ②

▷ Lockup

◆ ENTRANCES TO SMALL CELLS

▷ Lockup Back Room

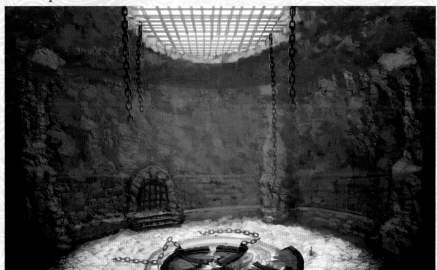

PILLAR
1

ENTRANCE

PILLAR
2

PILLAR
4

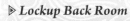

PILLAR
3

LIFT

FLOOR PATTERN INDENT

SIDE

▷ *Water Pump Room*

It is possible to enter here from the lower part of the tower connected to Princess Zelda's room. This facility used to send water to the rest of the castle but has fallen into disrepair in the last century. The room is tall and vertical and there is a grate on the floor that, after activating a switch in the center of the room, creates strong upward gusts.

▷ *Docks*

At the rear of Hyrule Castle is a room that Link can enter from the moat by paragliding, swimming, or using a raft, and it contains the only ancient shrine within Hyrule Castle. The path from the docks leads to the castle's library.

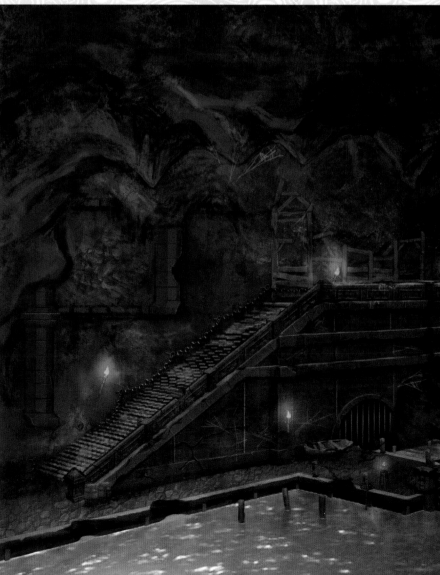

RIGHT SIDE
The manmade wall joins the cavern stone partway across.

WALL WITH LEVELS
From the front (bridge and walkways removed).

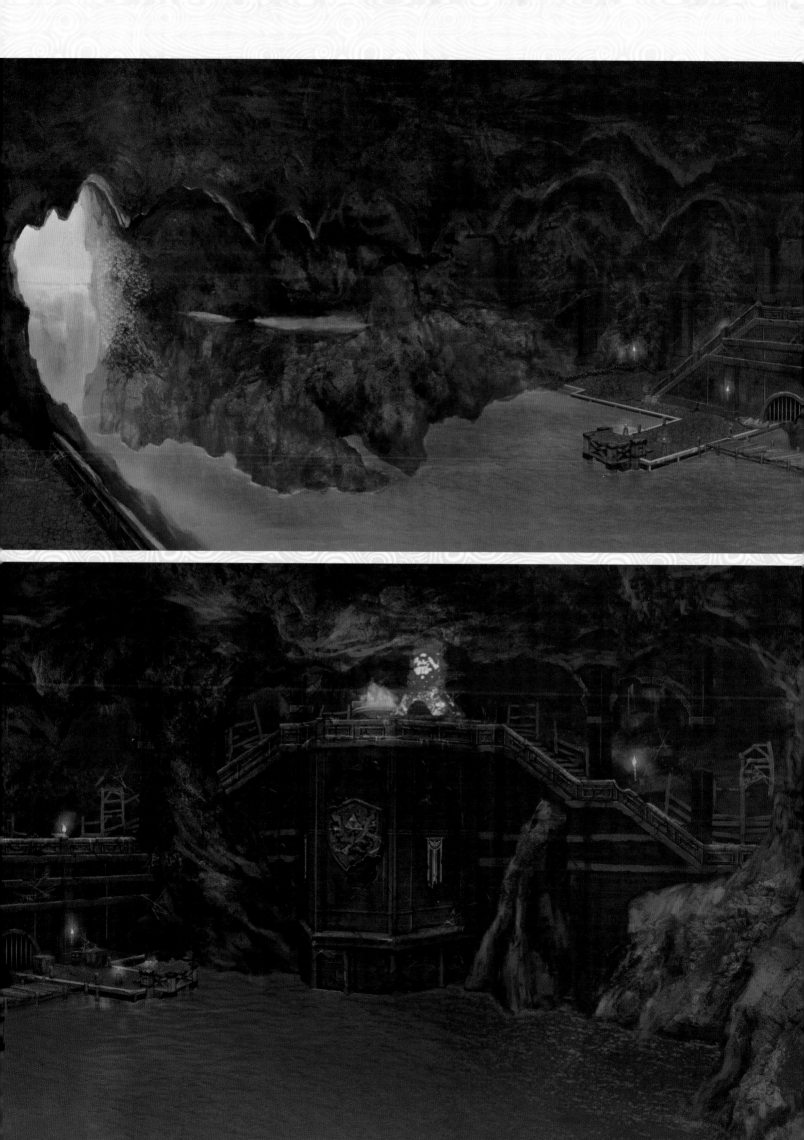

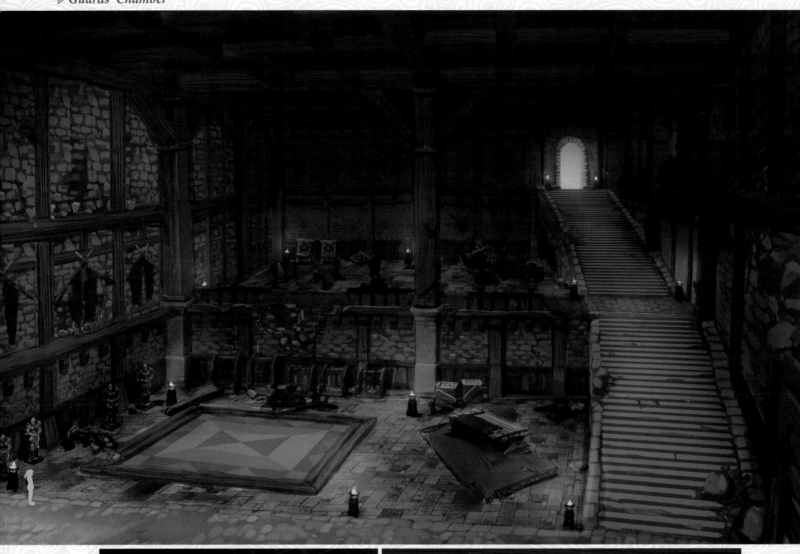

When making the model,
please make this into stairs instead of a ramp.

■ HYRULE CASTLE GUARDS' ROOM STEP-ON SWITCH
①

■ HYRULE CASTLE GUARDS' ROOM OBJECTS

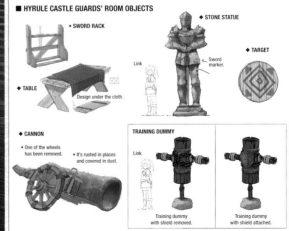

◆ STONE STATUE

• SWORD RACK

Link

Sword
marker.

◆ TABLE

Design under the cloth.

◆ TARGET

◆ CANNON

• One of the wheels
has been removed.

• It's rusted in places
and covered in dust.

TRAINING DUMMY

Link

Training dummy
with shield removed.

Training dummy
with shield attached.

▷ Round Spiral Staircase & Garden

From the top of the water pump room, a path leads toward the interior of the castle and reveals a broken spiral staircase. If you destroy the Malice eyeball and climb the stairs, it takes you to a lush garden surrounded by beautiful arches.

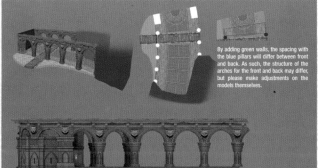

By adding green walls, the spacing with the blue pillars will differ between front and back. As such, the structure of the arches for the front and back may differ, but please make adjustments on the models themselves.

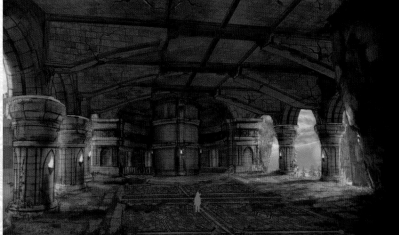

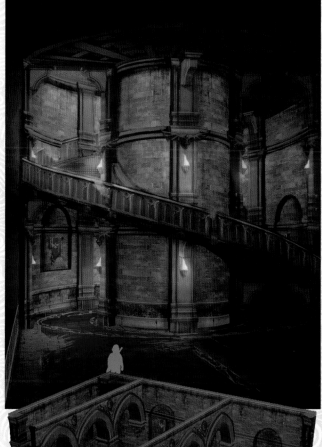

▷ Square Spiral Staircase

The staircase collapsed partway up following the Great Calamity, making it difficult to climb. It connects the library on the bottom level to the dining hall on the upper level. There are several weapons at the bottom of the stairs, which were most likely for use by the guards in case of a fight.

※ This is a ramp and goes up one level.

243

▷ Library

This large two-story room has an open floor plan and bookshelves lining the walls. There is a large hole in the ceiling from the Great Calamity.

◆EXTERIOR

AM 07:00
+18.0℃

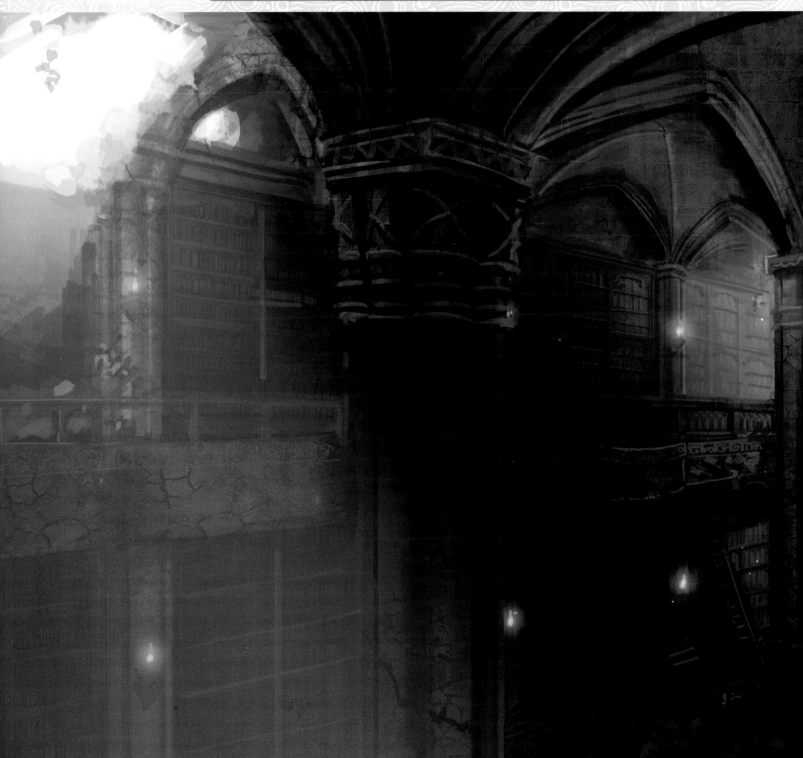

◆ BOOKSHELF

If there are numbers in Hylian script…

◆ Shelf variation concepts:
① Shelf with scrolls mixed in.
② Shelf with books lying flat.
③ Shelf with books crammed in to capacity.
④ Shelf with some books leaning over.
⑤ Shelf with books and pieces of paper sticking out.
⑥ Shelf with gaps.

⑤ Oversized books.

The sense of repetition was very strong with limited variations, so I have created placement ideas that change colors and arrangements.

COMES OUT.

• Metal shelf

TOP

● Large frame
● Shelf

• The shelves are placed into the frame.

𝘢

▷ *King's Study*

☐ LIBRARY: HIDDEN ROOM

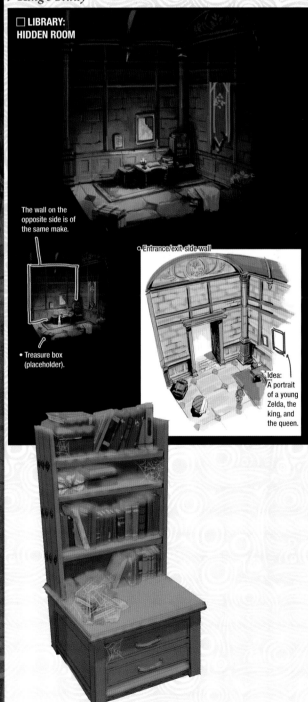

The wall on the opposite side is of the same make.

• Treasure box (placeholder).

Entrance/exit-side wall

Idea: A portrait of a young Zelda, the king, and the queen.

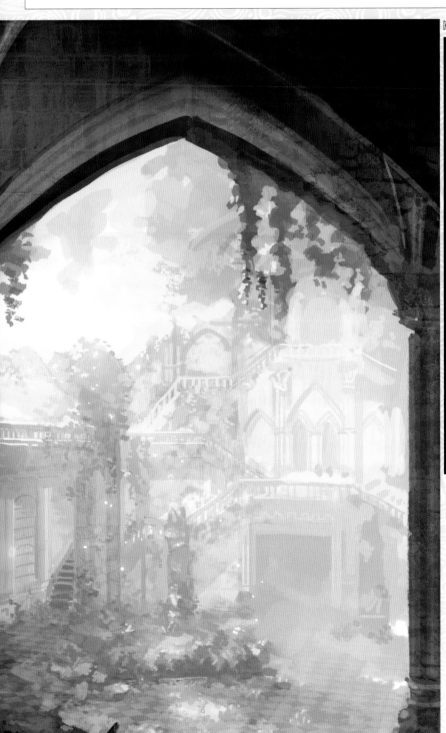

▷ Dining Hall

The spacious dining hall can comfortably seat a large number of people and, during times of peace, must have hosted countless guests. The ceiling has a slight arch, and a large door leads to the outer corridor. Its current dinner guests have less than ideal manners. Monsters infest the hall and have left partially eaten fruit everywhere.

▷ Dining Hall Decorations

Couch
Added giant eagle.

◆ **SHELF**

Ⓐ • An ornate shelf.

SIDE
OVERLAPS
DEPRESSION
STICKS OUT

SIDE

ARRANGED AS MUCH AS POSSIBLE LIKE THIS.

◆ **ON THE TABLE:**
Ideas for small articles.

① Make objects look like they can't be picked up by covering them with spiderwebs and dust.

• WITH A SPIDERWEB AND DUST

• WITHOUT A SPIDERWEB AND DUST

ONE OF OBJECT

• TABLEWARE

SIZE REFERENCE

LARGE

TABLE

• FRUIT CONTAINER:
Monsters use it like a garbage can (fruit peels, etc.).

▷ *Dining Hall Exterior*

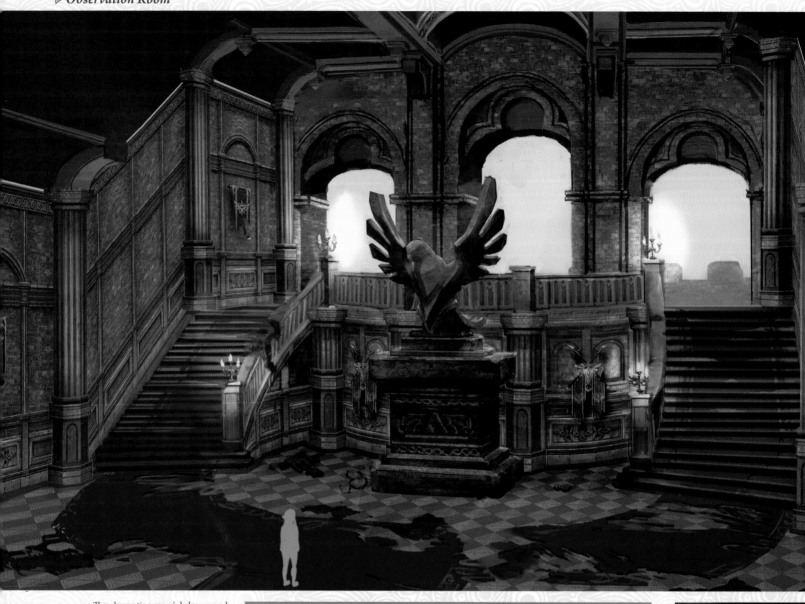

The observation room's balcony can be seen after passing through the castle's front gates. King Rhoam must have addressed his subjects from here. Following the Great Calamity, the windows were entirely covered in Malice.

OBSERVATION ROOM (Exterior Wall)

▷ *Observation Room*
Exterior Rough Design

▷ Great Hall

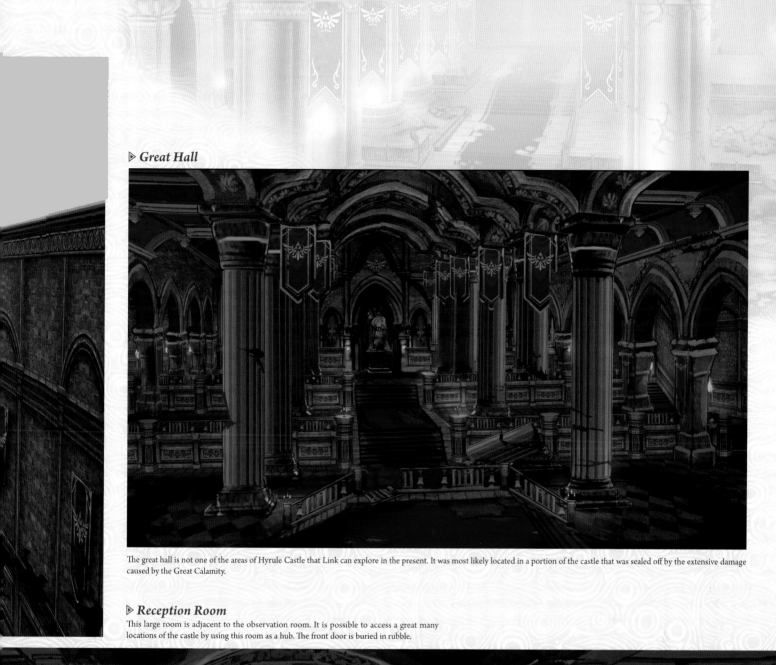

The great hall is not one of the areas of Hyrule Castle that Link can explore in the present. It was most likely located in a portion of the castle that was sealed off by the extensive damage caused by the Great Calamity.

▷ Reception Room

This large room is adjacent to the observation room. It is possible to access a great many locations of the castle by using this room as a hub. The front door is buried in rubble.

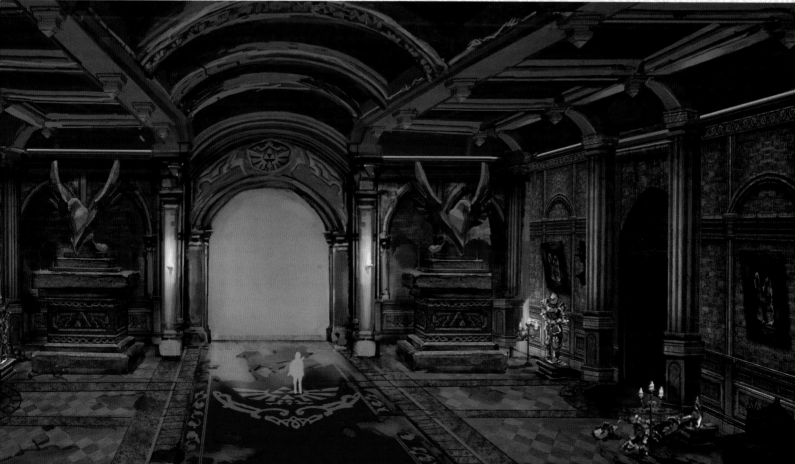

▷ Princess Zelda's Room

The princess's room is located one level lower and to the west of the Sanctum. It is currently in disarray, but it is still possible to imagine how it looked a century ago with its ornate mirror stand, canopy bed, and other pieces of furniture befitting a princess. It is clear from the extensive notes found here that she took her research with her everywhere, even to her private chambers.

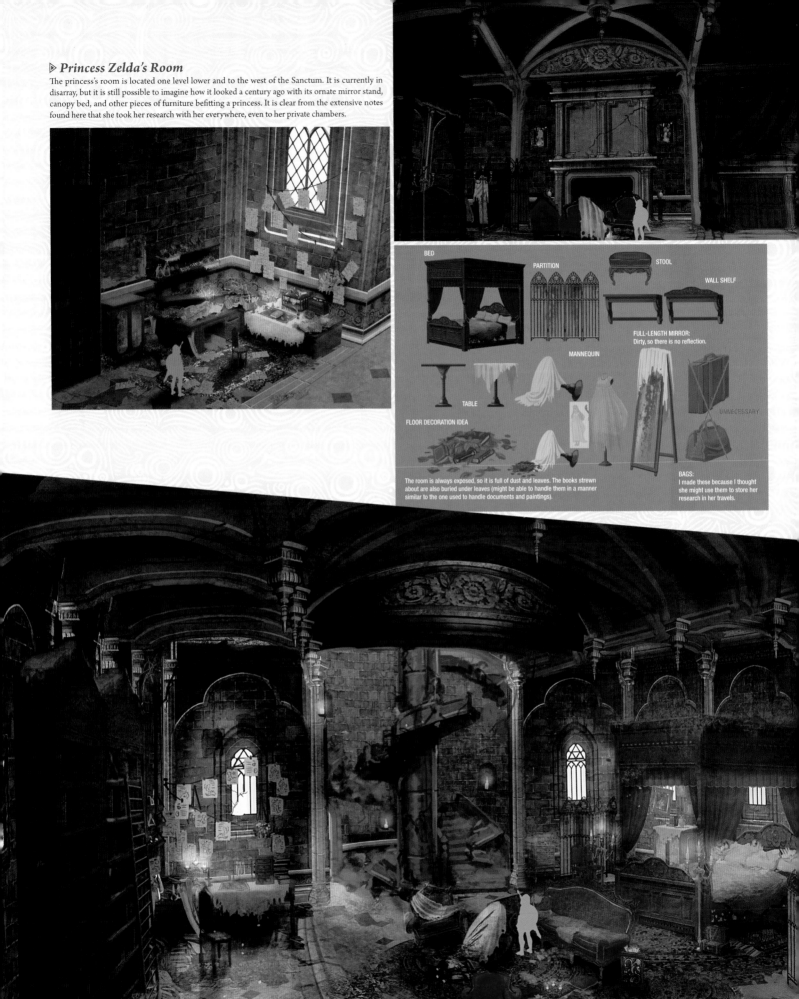

BED

PARTITION

STOOL

WALL SHELF

MANNEQUIN

FULL-LENGTH MIRROR:
Dirty, so there is no reflection.

TABLE

UNNECESSARY

FLOOR DECORATION IDEA

The room is always exposed, so it is full of dust and leaves. The books strewn about are also buried under leaves (might be able to handle them in a manner similar to the one used to handle documents and paintings).

BAGS:
I made these because I thought she might use them to store her research in her travels.

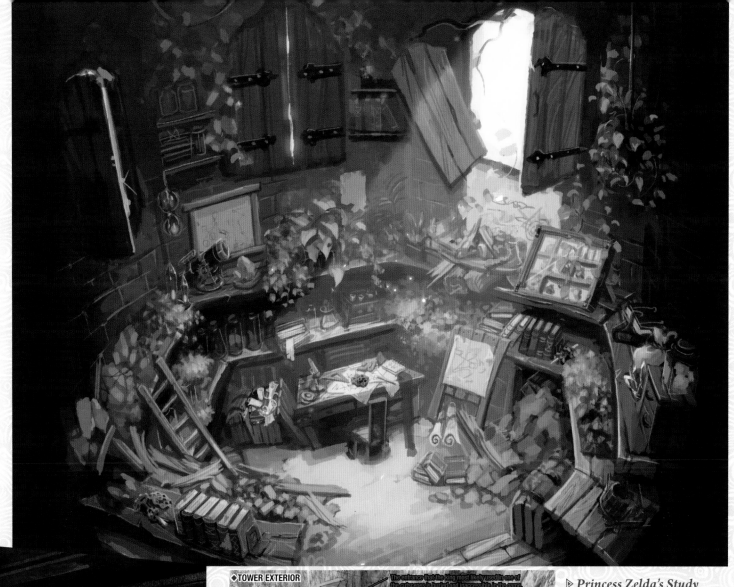

◆TOWER EXTERIOR
The entrance that the king most likely used in one of the cutscenes is buried and inaccessible in the game.
•Route

▷ *Princess Zelda's Study*

Zelda's study can be accessed via the spiral staircase leading out of her room. Numerous samples of ancient technology and plants are scattered about the room, and it is easy to picture Princess Zelda frantically conducting her research here. Plants that she was studying one hundred years ago continue to grow unchecked, spreading all the way to the exterior of the tower.

Having been neglected for a century, it is covered in dust and grime. The dried leaves that have drifted in from the outside give a sense of the passage of time.

DEVELOPER'S NOTE

I created the study out of the concept that, since it is in a separate tower, it was originally intended to be used as a lookout station but was not in use at the time. Also, since it was far from her father's watchful eye, Princess Zelda used this room for her research. She struggled to produce results on her own, so I expressed her isolation within the castle through this lone tower. However, I think that it will be apparent to players from the remains of the room that she was prolific in her research and continued to fight, looking for ways to help and not giving in to the circumstances. In the game, you can see a single Silent Princess blooming here—an object of her research. The flower represents Princess Zelda and her solitary fight within the embattled castle.

In the sketches of Princess Zelda's room there is an intact bed, but it got in the way of fighting enemies, so we destroyed it to make it easier to move around—a little tale from development.

The passageway that extends out from this room to the interior is blocked by rubble, so you can't see it in game, but the layout is such that she could have accessed the Sanctum without ever having to go outside.

STRUCTURAL ART: YOSHIKAZU HARA

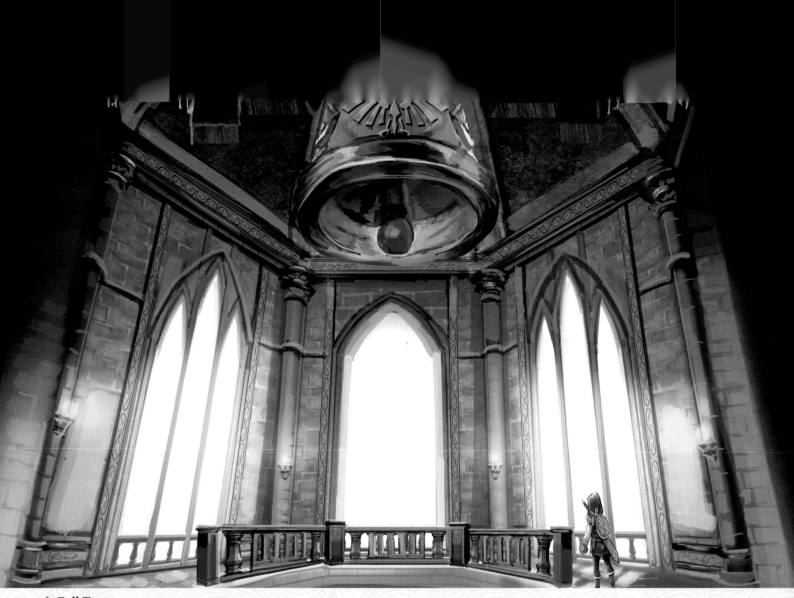

▷ Bell Tower

High above the observation room hangs a giant bell. It was designed to ring when the chain below it was pulled.

▷ Champions' Hall

The Champions' Hall is the upper portion of the throne room. It is open in the center, making it possible to see what is happening in the throne room. This beautiful arrangement is now a dim reflection of its former self, with Calamity Ganon's cocoon fixed to it and Malice spreading everywhere.

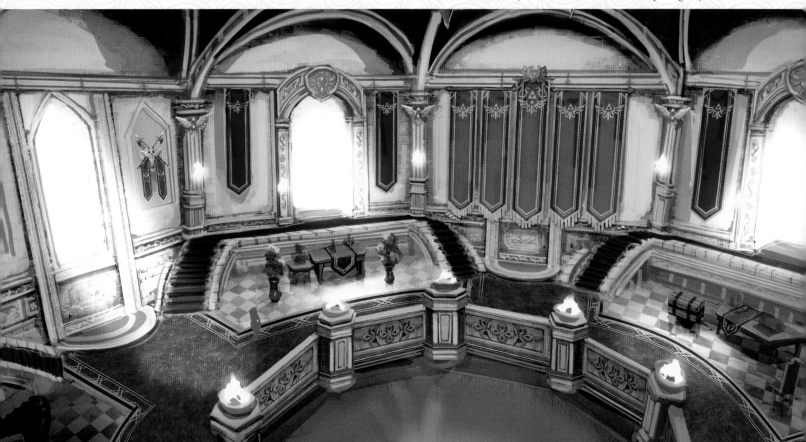

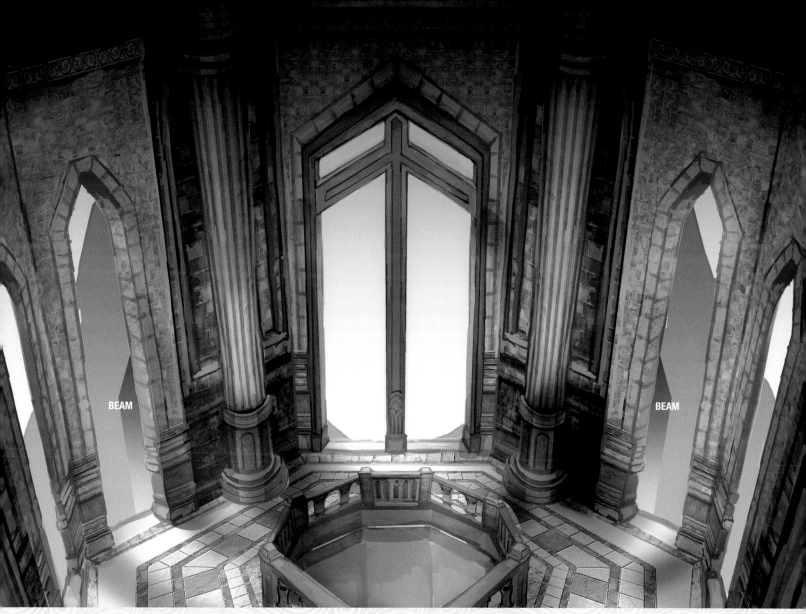

BEAM

BEAM

▷ Sanctum Observation Room

Heading farther up from the Sanctum beyond the Champions' Hall, one comes upon the observation room. It escaped the Calamity relatively undamaged, and it is possible to keep an eye over Central Hyrule and the surrounding areas from here.

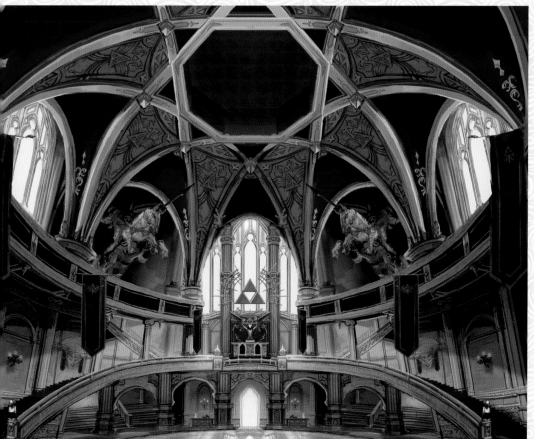

▷ Throne Room

The throne room is accessible from the front of the Sanctum and from an entrance in the back. Climbing the stairs leads to King Rhoam's throne. Calamity Ganon's cocoon clings to the ceiling here.

▷ Rough Design

Center of the floor.

▷ Astral Observatory

This underground room is located directly beneath the throne room. It is said that the ancient Sheikah researched celestial bodies here. The half-dome walls are covered in constellations, with the lower portion painted with silhouettes of locations from across Hyrule.

▷ Astral Observatory Floor

OTHER LOCATIONS
Central Hyrule

▷ Satori Mountain

This midsized mountain is located near the Gerudo region in the western part of Central Hyrule. Despite having a beautiful, blooming cherry tree and a spring halfway to its summit, it is rarely visited.

On specific days, at specific times, this spring is enveloped in mystical light and the Lord of the Mountain (page 157) comes to rest there accompanied by a host of Blupees. However, this magical moment can be ruined in an instant if the Lord of the Mountain detects the presence of an intruder. It will immediately flee, the light will fade, and Satori Mountain will return to normal.

▷ Lost Woods

This densely forested area surrounds Korok Forest. It is filled with eerie trees whose knots and hollowed bark resemble frightening faces. A mysterious, ever-present fog blankets the area, obstructing views, which creates a safe haven for many animals. There is only one correct path through the woods to Korok Forest, and anyone who strays from that path will be enveloped by that fog and transported back to the entrance to the woods.

The three Korok trials are undertaken in the Lost Woods. The hero must set out from Korok Forest and venture deep into the Lost Woods in order to find three ancient shrines.

▷ Ancient Tree Stump

This giant stump is located directly to the southwest of Hyrule Castle Town. In the past, this was a massive tree with resplendent branches. The stump that remains demonstrates just how big it was. Now it is surrounded by a lake, and a simple bridge spans the water to the top of the stump.

DEVELOPER'S NOTE

The final showdown with Calamity Ganon emphasizes dynamic movement, so as far as fighting goes, this room is essentially the location of the final battle. In order to make the fight on the bright, open Hyrule Field all the more attractive as you move across it, I designed this room to be narrow and dark in comparison, basing it on Hyrule at night.

The lower portion of the walls shows Hyrule extending out in all directions, with Hyrule Castle at its center. The room is supposed to be a guide for observing the movements of the stars, but I designed it with the intent that players would remember their adventure up to this point and feel as though this final battle at the center of the world is what everything has built toward.

STRUCTURAL ART: YOSHIKAZU HARA

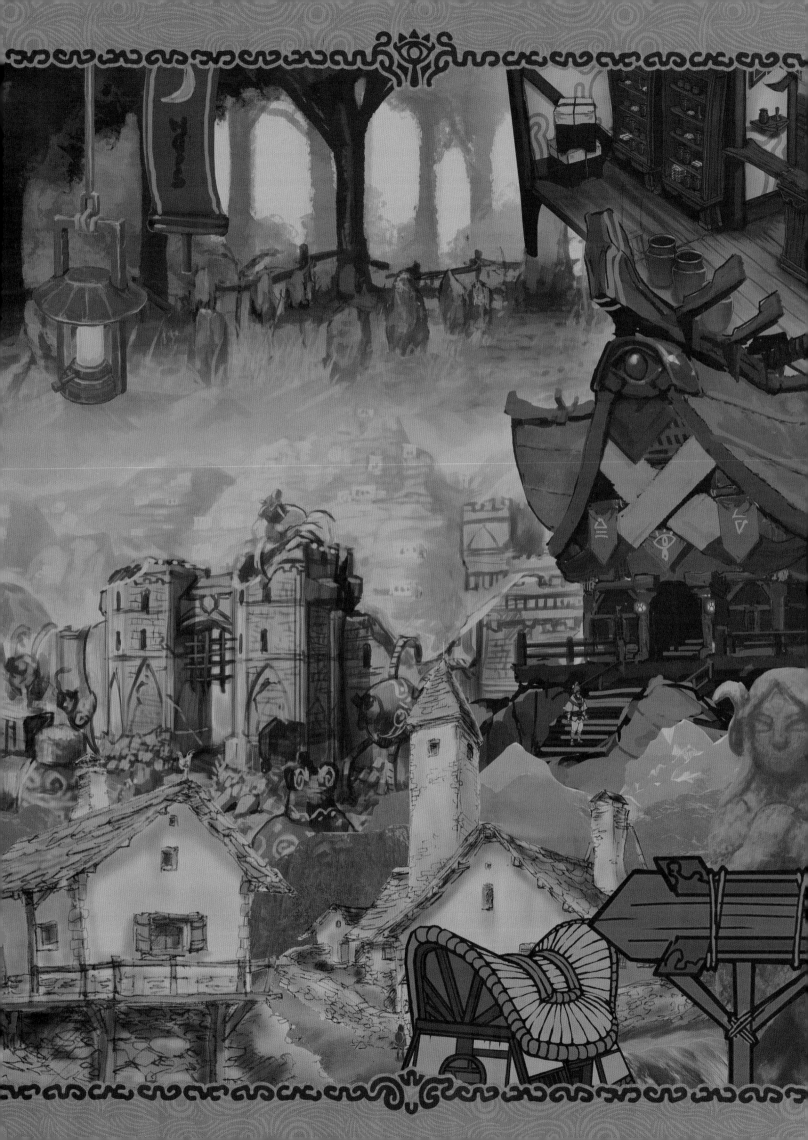

NECLUDA
AN IDYLLIC PLAIN AT THE FOOT OF THE DUELING PEAKS

Necluda covers the southeastern portion of Hyrule. It is surrounded by tall mountains and is characterized by its sheer cliffs and varied topography. Due to its temperate climate, there are two settlements here: Kakariko Village, where the Sheikah reside, and Hateno Village, home of the Hylians.

The area around the Dueling Peaks was ravaged during the Great Calamity, and though it has largely recovered, it is still common to see monsters or the remains of Guardians on Blatchery Plain.

KAKARIKO VILLAGE

This Sheikah Village is nestled between mountains and is said to be under the protection of the Great Fairy Cotera. The villagers make their living through agriculture, and the Fortified Pumpkin is one of their celebrated products. The plum trees that dot the village symbolize endurance and prosperity, reflecting the character and current circumstances of these hearty people, so they treat them as protectors of the village.

▷ Village Overview Rough Design

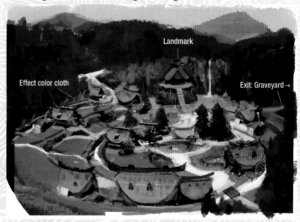

Landmark

Effect color cloth

Exit: Graveyard →

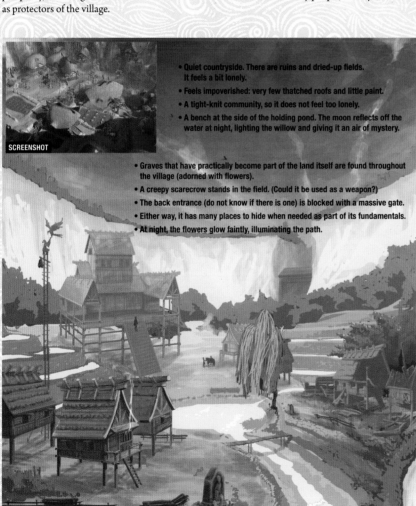

SCREENSHOT

- Quiet countryside. There are ruins and dried-up fields. It feels a bit lonely.
- Feels impoverished: very few thatched roofs and little paint.
- A tight-knit community, so it does not feel too lonely.
- A bench at the side of the holding pond. The moon reflects off the water at night, lighting the willow and giving it an air of mystery.
- Graves that have practically become part of the land itself are found throughout the village (adorned with flowers).
- A creepy scarecrow stands in the field. (Could it be used as a weapon?)
- The back entrance (do not know if there is one) is blocked with a massive gate.
- Either way, it has many places to hide when needed as part of its fundamentals.
- At night, the flowers glow faintly, illuminating the path.

DEVELOPER'S NOTE

Necluda is the base area of this title—a ruined world, grass blowing in the wind, and the survivors living a rustic life. The elements that embody life after the destruction of their world are contained in this area. These images show the struggle that we undertook to make simply walking through the terrain of this memorable region interesting.

At the beginning of the project, I had thought about how I wanted to create some element of ancient Japanese culture somewhere in this *Zelda* game. From there, the connection between ancient Japan and *shinobi* was folded into a Sheikah village, which led to the concept behind Kakariko Village. It was built around the motifs of Japanese mountain villages with terraced rice fields, as well as other elements such as stone statues of frogs (page 258) to capture the ninja essence.

SENIOR LEAD ARTIST, LANDSCAPE: MAKOTO YONEZU

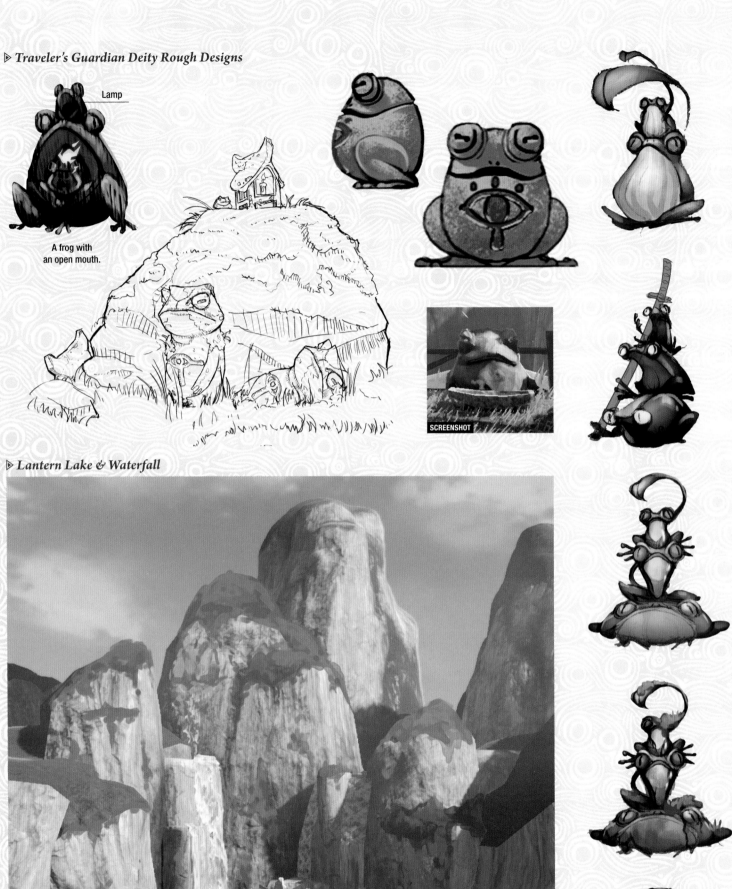

▷ Traveler's Guardian Deity Rough Designs

Lamp

A frog with
an open mouth.

SCREENSHOT

▷ Lantern Lake & Waterfall

▷ *Private Home Interior Rough Design*

▷ *Private Home Exterior*

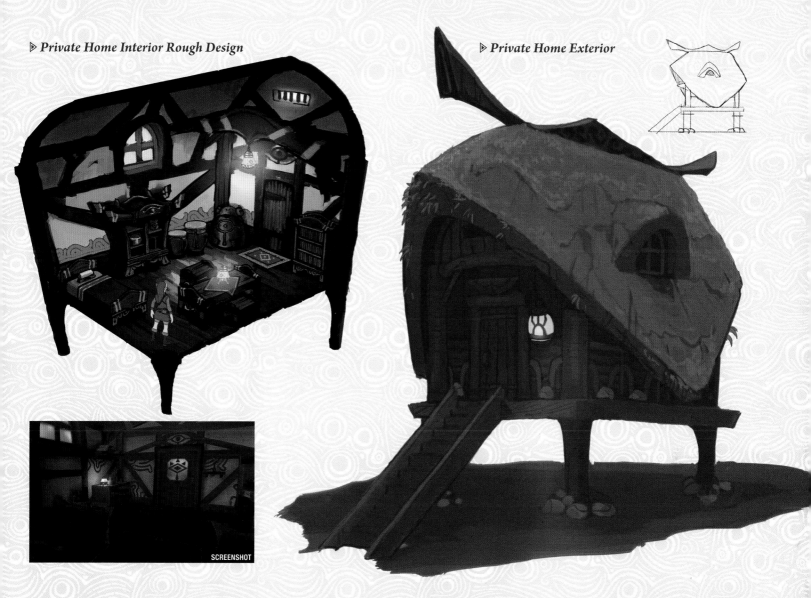

SCREENSHOT

▷ *Inn Rough Design*

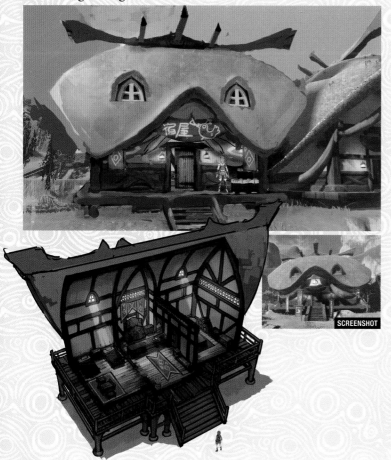

SCREENSHOT

▷ *Cucco Coop Rough Design*

▷ *Common Cooking Area Rough Design*

◆ SHEIKAH COOKING AREA

SCREENSHOT

SCREENSHOT

▷ Impa's House Interior Rough Design

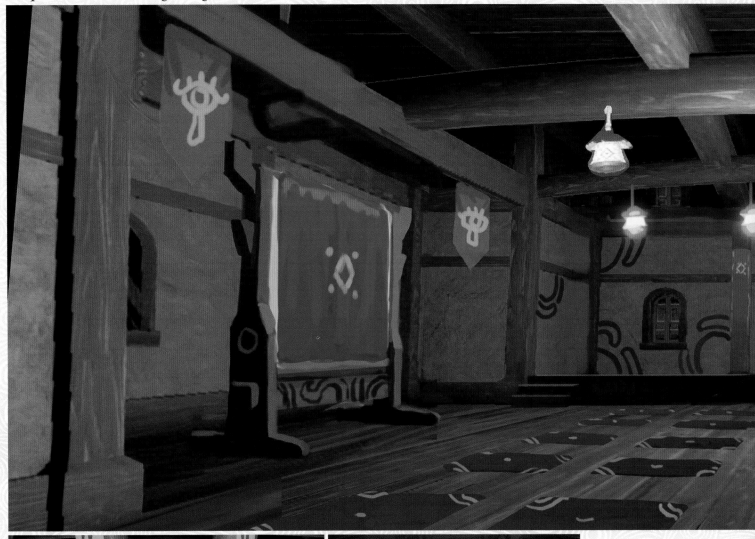

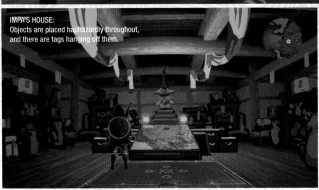

IMPA'S HOUSE:
Objects are placed haphazardly throughout,
and there are tags hanging off them.

SCREENSHOT

▷ Paya's Room Rough Design

■ IMPA'S SUCCESSOR'S ATTIC ROOM

She is a scholar, so there are many books (piled).
The books are filled with bookmarks.
Has quite a few pillows for gatherings.

Adjusted exterior window to match interior window design.

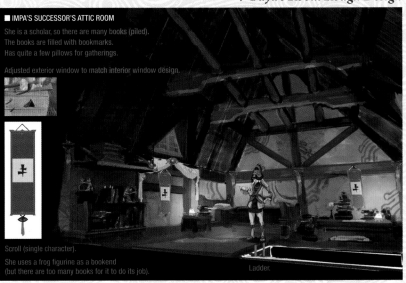

Scroll (single character).

She uses a frog figurine as a bookend
(but there are too many books for it to do its job).

SCREENSHOT

Ladder.

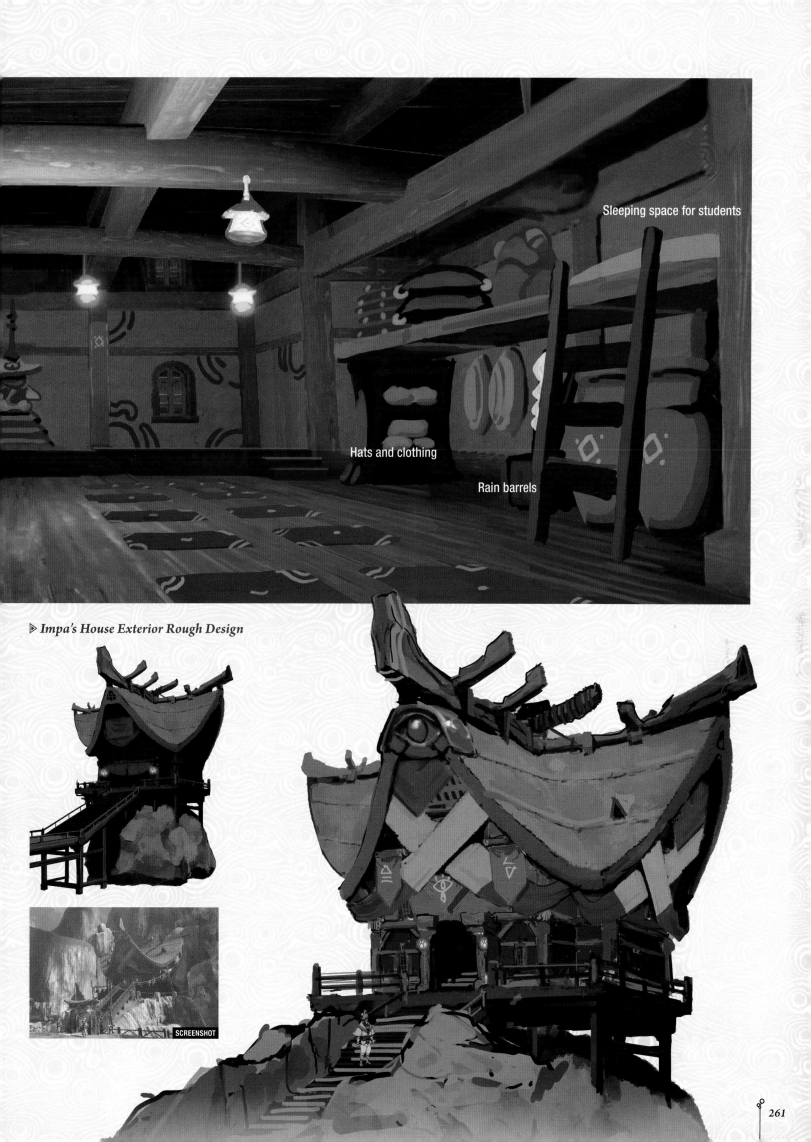

Sleeping space for students

Hats and clothing

Rain barrels

▷ *Impa's House Exterior Rough Design*

SCREENSHOT

WEST NECLUDA

▷ *Fort Hateno*

At the foot of the Dueling Peaks, a large mountain split down the middle, is a plain filled with ponds large and small, as well as bogs. Fort Hateno, which protected Hateno Village from the Great Calamity, stands proudly to the east. The ruined husks of many Guardians lie rusting around its wall, and the evidence of a desperate defensive stand can still be seen.

■ CHECKPOINT: AFTER ITS DESTRUCTION

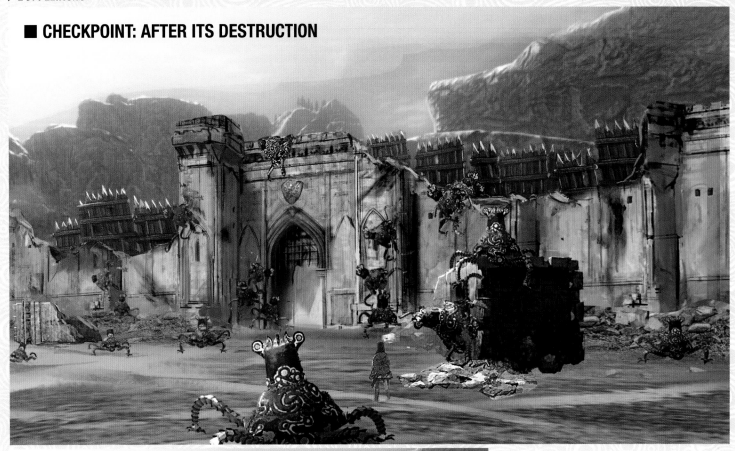

■ CHECKPOINT: BEFORE ITS DESTRUCTION

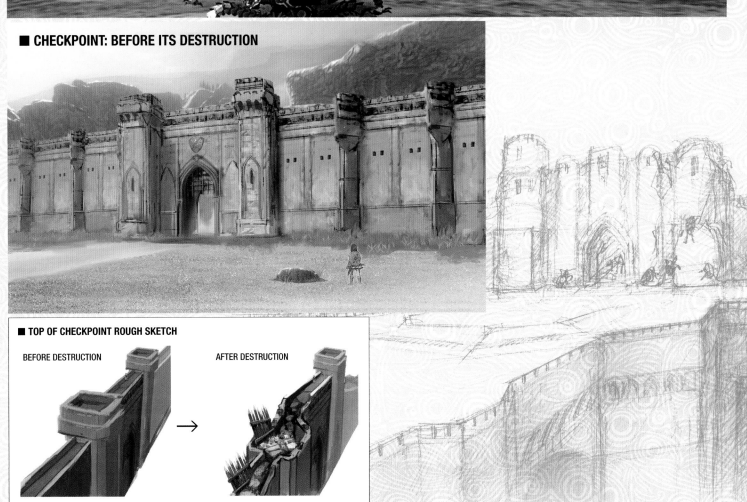

■ TOP OF CHECKPOINT ROUGH SKETCH

BEFORE DESTRUCTION

AFTER DESTRUCTION

The top of the wall is filled in with rubble and just flattened enough to be even.
One hundred years have passed, so there is some dirt and grass growing between the cracks.

▷ *Kakariko Bridge*

WALL:

The blocks are piled up and not aligned very well—the wall is made from sand and whatnot being plastered into the cracks and over the blocks.

Weathering has caused the sand at the top to wear off. There are places where the cracks in the blocks are apparent.

The wall is covered in moss.

FLOOR:

It has been filled in with nearly square shaped blocks. It is very mossy.

Grass is piled up.

Portions sticking out on the left and right of the center.

SCREENSHOT

▷ *Dueling Peaks Rough Design*

■ **THE DUELING PEAKS IDEA SKETCH 1**
• Fractured terrain driven upward, making layers of earth visible.

↓ The terrain was connected before splitting, so you can see where it was connected on either side.

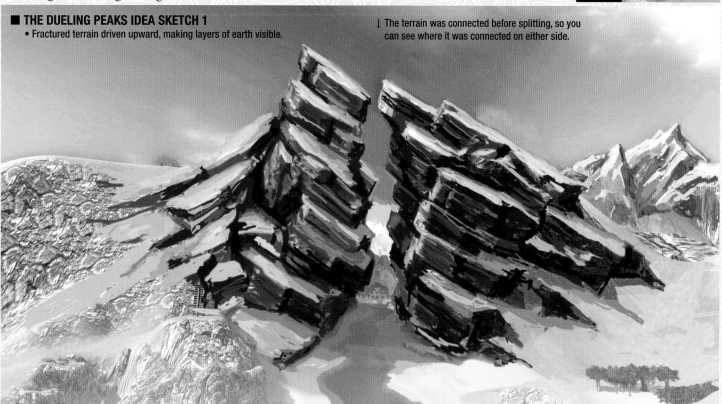

HATENO VILLAGE

This quaint village lies in the easternmost portion of Necluda. It is located far from Central Hyrule and was spared the destruction of the Great Calamity thanks to the successful defense at Fort Hateno. The villagers primarily make their living through agriculture. Link can use several facilities here, including the dye shop, where he can dye his clothes, and he can even purchase a house from Bolson Construction.

▷ *Village Overview*
 Rough Design

↓ Eating under a sun tent on a high outcropping with a spectacular view is part of their lifestyle.
↓ The crane is used to bring up bags and livestock from below.

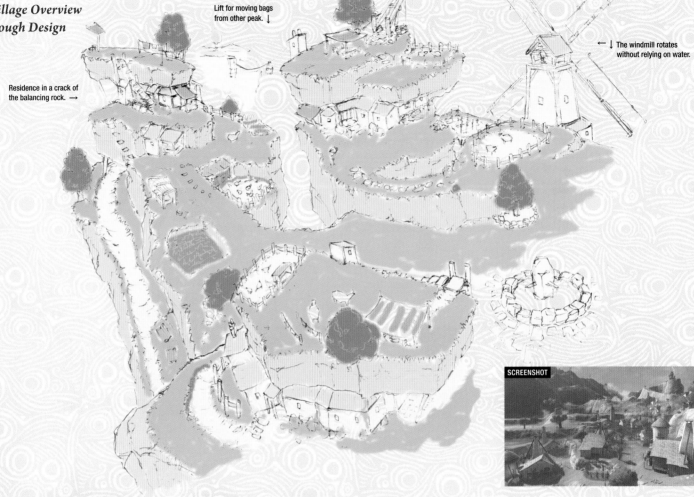

Lift for moving bags from other peak. ↓

Residence in a crack of the balancing rock. →

← ↓ The windmill rotates without relying on water.

SCREENSHOT

• SELF-SUSTAINING VILLAGE WITH FARM AND FIELDS

↓ A misshapen chimney that is very tall due to large amounts of snowfall.

↓ Hotel built into an old silo.

↓ Scenery with silo.

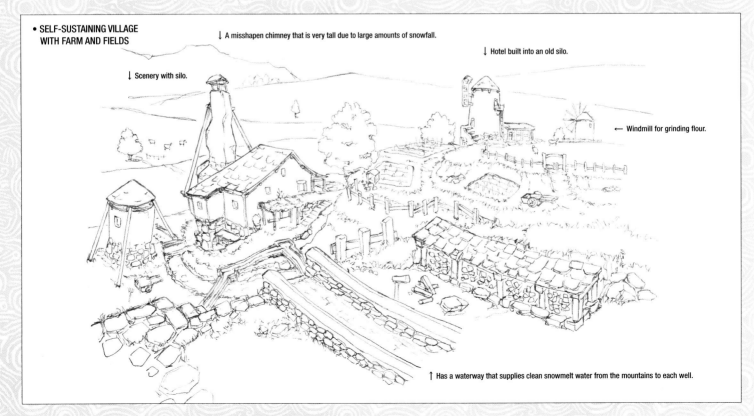

← Windmill for grinding flour.

↑ Has a waterway that supplies clean snowmelt water from the mountains to each well.

▷ Front Gate

▷ Shared Cooking Space

▷ Kochi Dye Shop

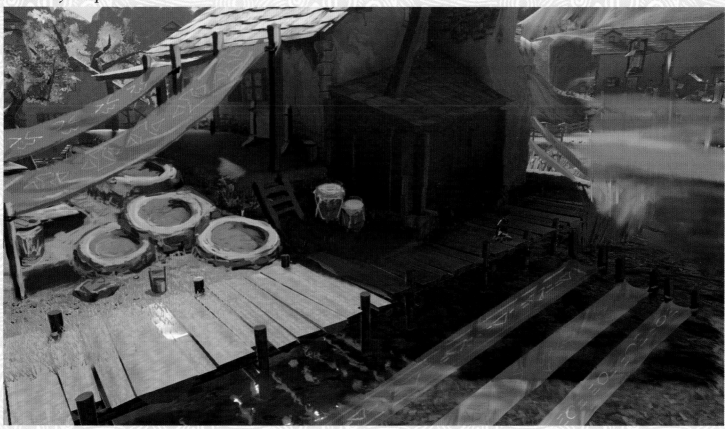

▷ Silo Rough Designs

SCREENSHOT

▷ Private Home Exterior

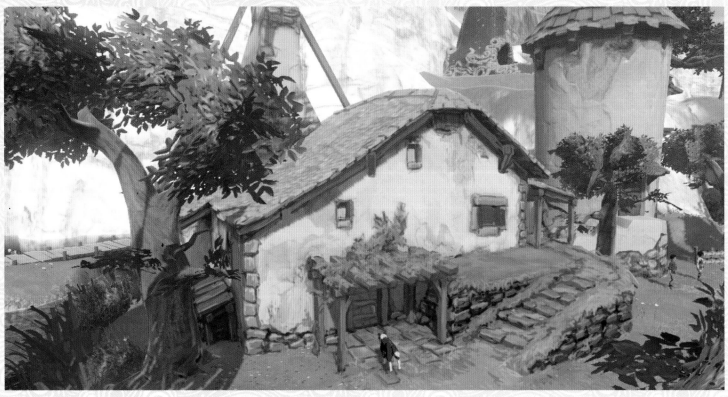

▷ Private Home Interior Rough Design

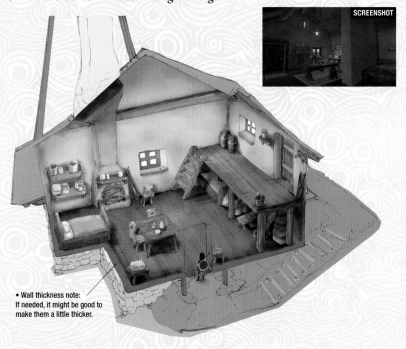

SCREENSHOT

• Wall thickness note:
If needed, it might be good to
make them a little thicker.

▷ Furniture

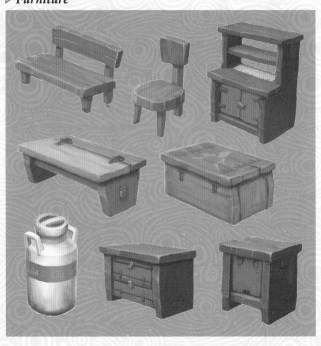

▷ Ton Pu Inn Exterior

▷ Ton Pu Inn Interior

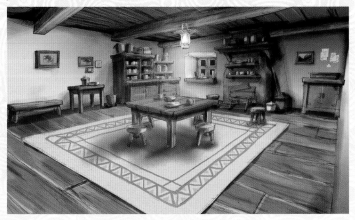

▷ *Village Chief's House Exterior Rough Design*

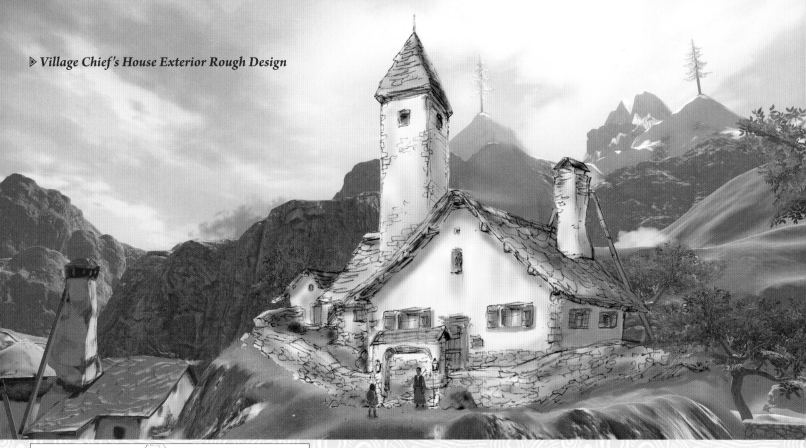

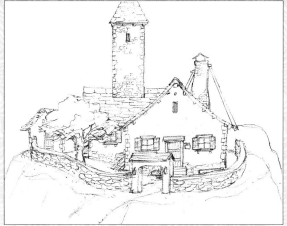

▷ *Village Chief's House Interior Rough Design*

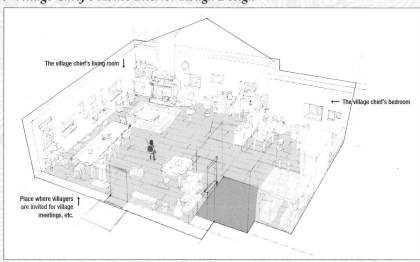

The village chief's living room ↓

← The village chief's bedroom

Place where villagers are invited for village meetings, etc. ↑

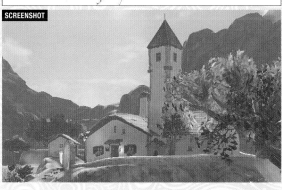

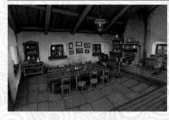

▷ *Horned Statue Rough Designs*

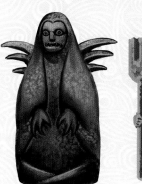

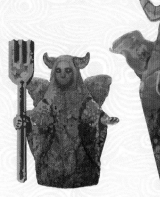

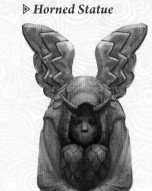

▷ *Horned Statue*

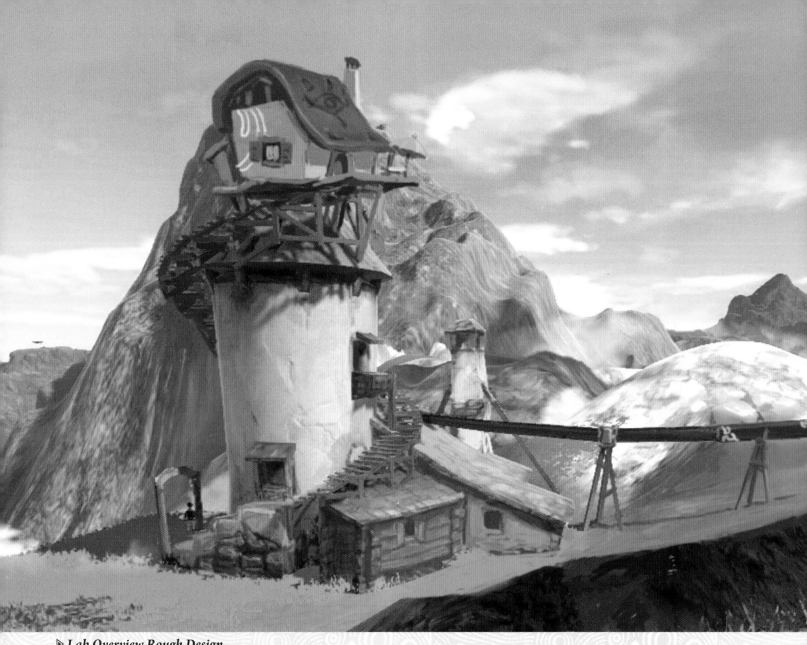

▷ *Lab Overview Rough Design*

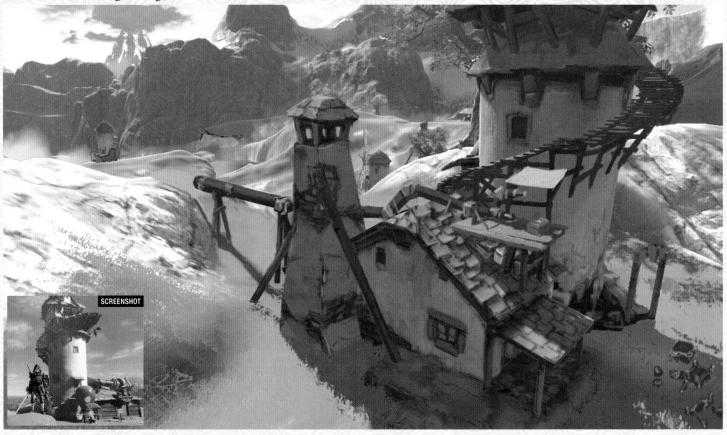

SCREENSHOT

HATENO ANCIENT TECH LAB

This research laboratory was built at the top of a high hill just past Hateno Village. Purah and her assistant Symin conduct their research within. Purah's room is built onto the top of the research lab. A blackboard and desk occupy the interior, which makes the space feel a little bit like a school.

▷ *Front Entrance*

▷ *Telescope*

▷ *Purah's Room Exterior*

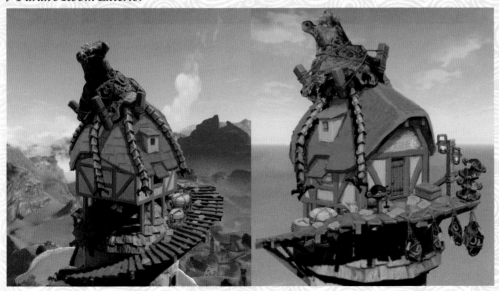

▷ *Arch Leading to Stairs*

▷ *Hateno Village Ancient Tech Lab Interior*

▷ *Purah's Room*

DEVELOPER'S NOTE

Hateno Village was designed to be the baseline village concept that we were aiming for in this game. The architecture of its many homes resembles the homes of the Hylians living in Hyrule Castle Town (page 232), but we gave it a regional flavor by using stone very sparingly.

I started by placing the Kochi Dye Shop (page 265) in the center of the village, and from there I worked the fundamental essence of traditional Japanese crafts into it, making adjustments to differentiate it from Western styles while also adding more colors, which resulted in something that looks like it could be real, but is actually made up!

The Bolson Construction carpenters that wish for Hyrule's recovery, an off-putting Horned Statue (page 267)... There is a lot in this village, but it is defined by the Hateno Ancient Tech Lab. I designed it to reflect Purah's personality as the foremost fan of ancient relics and showed that through the number of documents and ancient relics scattered throughout the house as well as the Guardian on the roof—which is probably its most striking characteristic. Did you notice the white lines on the floor of the main room of the ground floor? There are also relics hanging from ropes. In contrast to the scattered genius of Purah, Symin is very organized. "This is my space!" You can almost hear the pair's everyday interactions. In this game, when designing an interior, I would focus on showing the characteristics and personalities of the people who lived in that space.

LEAD ARTIST, STRUCTURAL: MANABU TAKEHARA

OTHER LOCATIONS
Necluda

▷ *Eventide Island*

Out where the sun sets on the horizon sits a small, remote island. It is inhabited by monsters, so even the fishermen of Lurelin Village won't go near it. If Link finds his way out to the island, a trial where he must steal orbs from fierce monsters without the aid of any of his equipment will begin.

▷ *Cliffs of Quince*

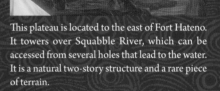

This plateau is located to the east of Fort Hateno. It towers over Squabble River, which can be accessed from several holes that lead to the water. It is a natural two-story structure and a rare piece of terrain.

▷ *Kitano Bay*

This reef lies at the very end of the road leading out from Hateno Village. The rock pillars out in the water appear in an ancient song, and it is said that a treasure cached by an ancient hero for use against the Calamity is stored here. The large number of seagulls that circle overhead make Kitano Bay quite the spectacle.

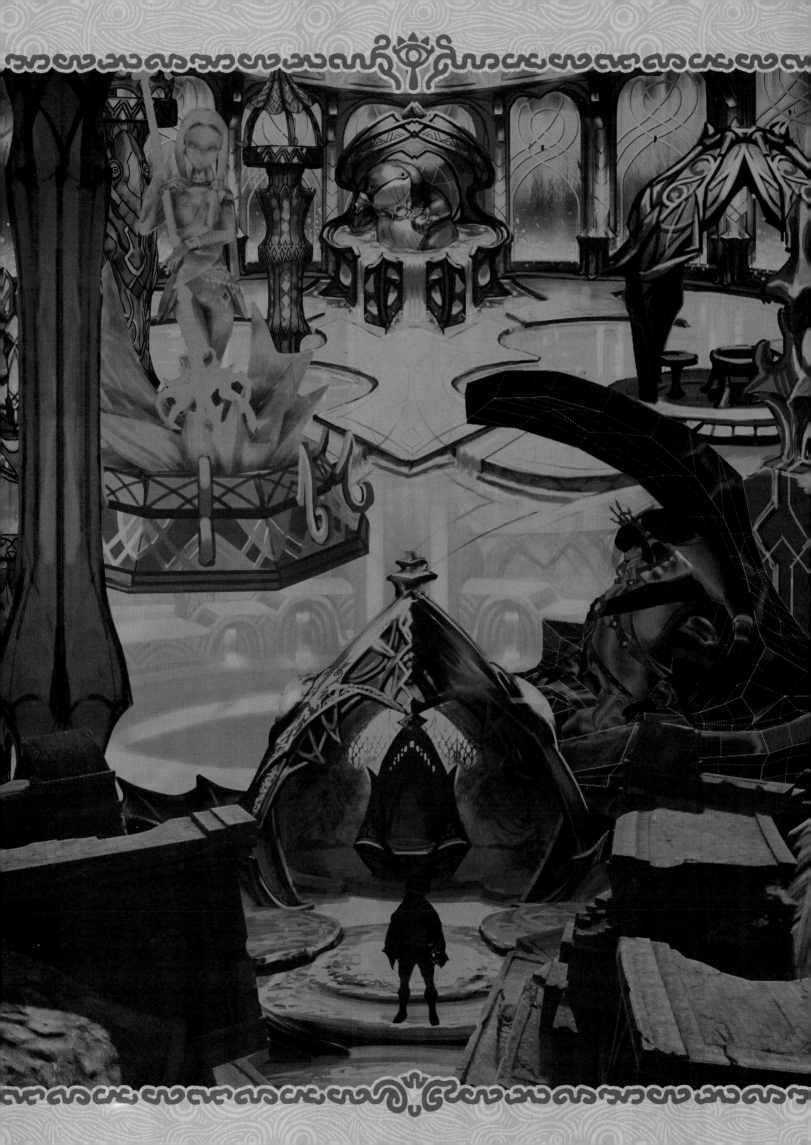

LANAYRU
HOME TO THE ZORA & SOURCE OF HYRULE'S WATER

Lanayru is located in the eastern part of Hyrule. The region is blessed with ample rainfall and sources of water. Both the Rutala River, which flows from East Reservoir Lake, and the Zora River, which runs from Zora's Domain, feed into the Lanayru Wetlands. The Lanayru Great Spring area contains the source of all of Hyrule's fresh water as well as Lanayru Bay, which extends from the southern portion of Zora's Domain. The Zora came to this land seeking pure, abundant water and have made their home here.

⬅ ZORA'S DOMAIN

This Zora settlement was established over ten thousand years ago when the Zora went in search of a fresh water source. The land is rife with other natural resources as well, including mineral deposits. Zora's Domain features a massive fish-shaped monument at its heart. Water bubbles up below it and runs through the village via beautifully crafted waterways. The settlement is a sight to behold, appearing to have been carved from a single stone.

▷ *Zora's Domain Overview Rough Design*

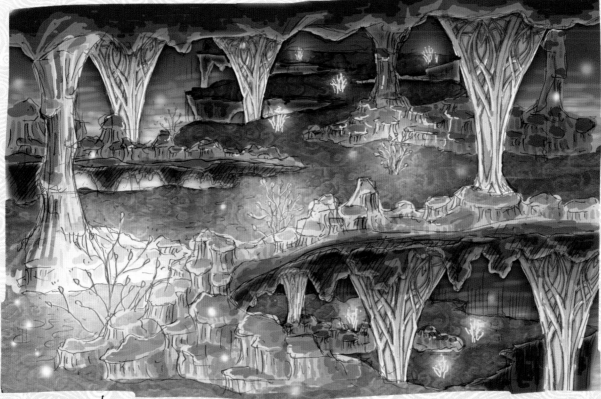

ZORA CAVERN

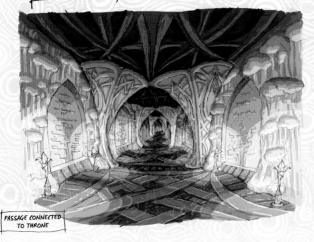

PASSAGE CONNECTED TO THRONE

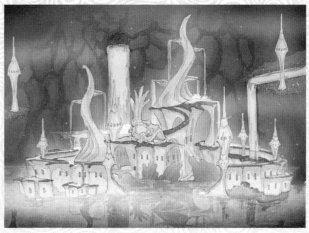

DEVELOPER'S NOTE

I decided on the direction for Zora's Domain based on the Zora's faith in Lord Jabu-Jabu from past games. The concept is that their faith has persisted into the present and manifests itself through their architecture. That led to the giant fish statue and the temple-like appearance of Zora's Domain. There wasn't as much water flowing through the village in the initial designs, but we realized that the Zora would most likely be happiest in the water, so we filled the village with it. From there, the Zora's traits and lifestyle fell into place. They are merpeople who live in a village, and the design of Zora's Domain needed to express that, which led to the current appearance and facilities found there.

The reason that the Zora record their history on stone monuments is that paper books would get wet and fall apart right away. It's a simple idea, but I took great care to ensure that props placed there would not seem out of place, not only in Zora's Domain but also for the players visiting it.

LEAD ARTIST, STRUCTURAL: MANABU TAKEHARA

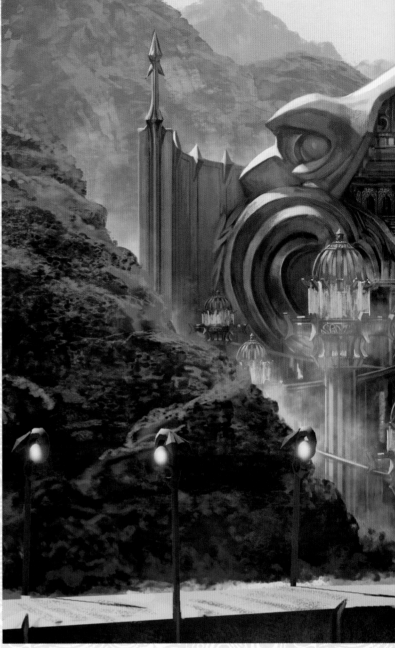

SCREENSHOT

▷ *Zora's Domain Overview Rough Design*

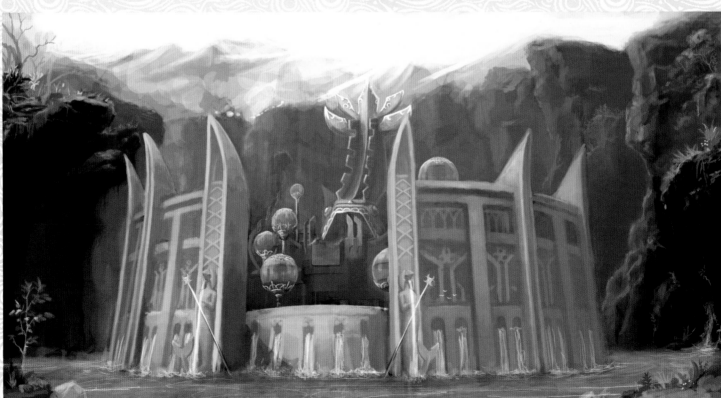

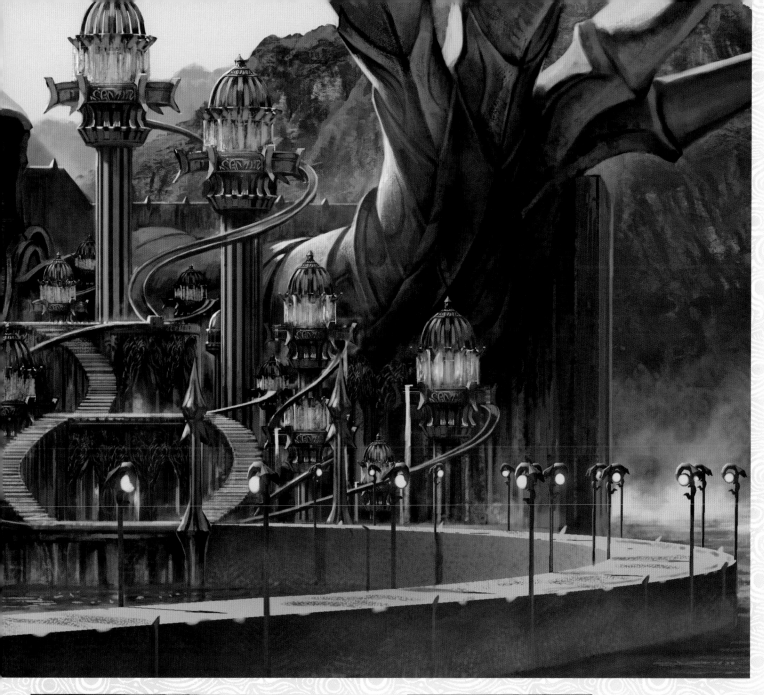

At the top of the king's residence is the main landmark of the area, which features goldfish-like fins. The eyes and mouth have been eliminated in order to create a geometric design. The chief loves the view from the top window (terrace).

A light that uses a massive glowing stone like a crystal. Light comes out from the cracks.

Rooftop garden at the top of the building.

Lights and windows with crest (stained glass).

Emphasis on geometrical construction: the building is completely symmetrical.

They live in the communal residence area at the center. Lights are inserted into the walls.

Waterfall at the center (if we do this, the waterfall will stop flowing to reveal the entrance to a dungeon).

Not only are the castle walls surrounded in mist and high stone cliffs, waterfalls and these curved objects also prevent enemy intrusion.

There are doors hidden in the walls that can close when an enemy attacks.

The stone bridge is made of a smooth material with a marble-like pattern. The roofs of the building are made of the same material. There are lights built into it, and at night, they shine fantastically.

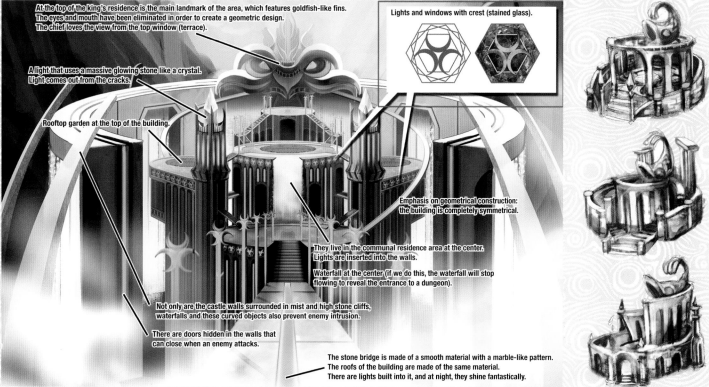

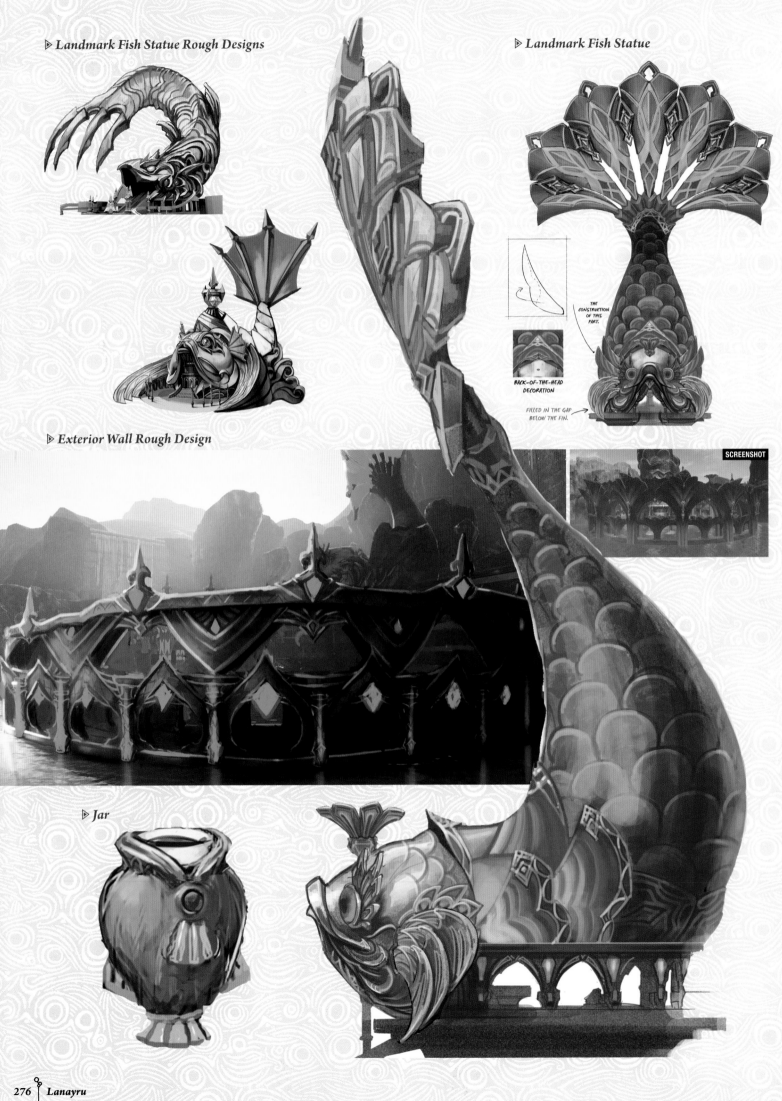

▷ *Landmark Fish Statue Rough Designs*

▷ *Landmark Fish Statue*

THE CONSTRUCTION OF THIS PART.

BACK-OF-THE-HEAD DECORATION

FILLED IN THE GAP BELOW THE FIN.

SCREENSHOT

▷ *Exterior Wall Rough Design*

▷ *Jar*

▷ Central Plaza Rough Design

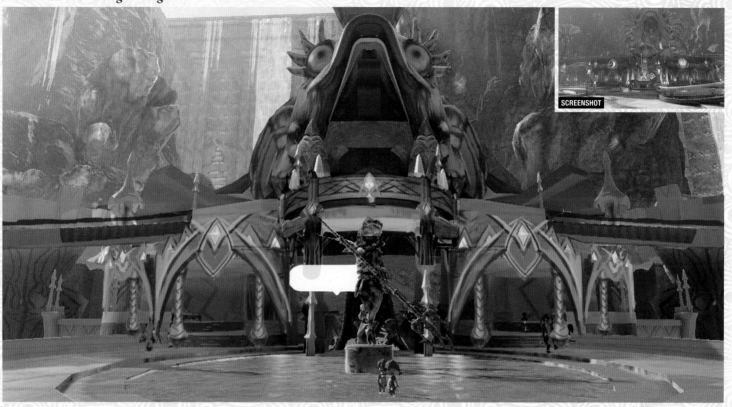

SCREENSHOT

▷ Great Hall Pools Rough Design

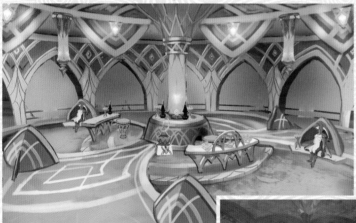

SCREENSHOT

▷ Large Zora Pillar Rough Design

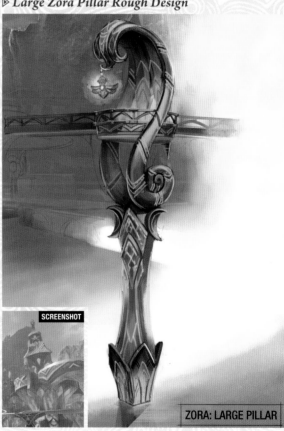

SCREENSHOT

ZORA: LARGE PILLAR

▷ Great Zora Bridge Rough Design

SCREENSHOT

▷ Workshop Rough Design

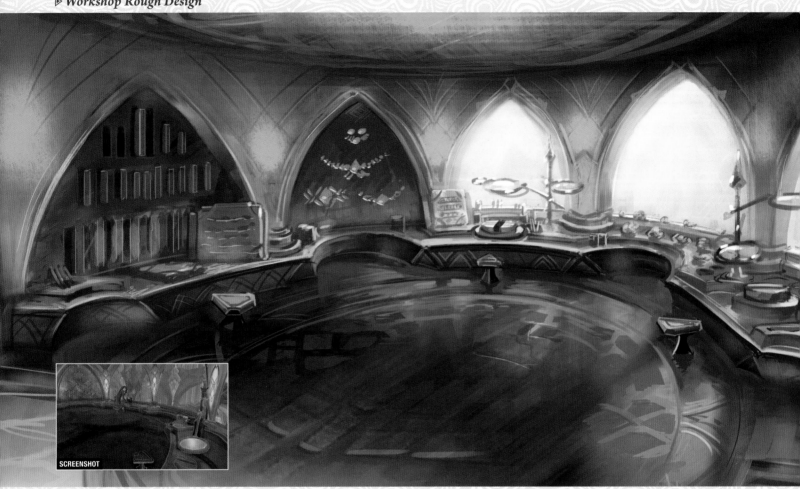

SCREENSHOT

▷ Workshop Tools Rough Designs

PLIERS

MAGNIFYING LENS PLATFORM

HAMMER

CHISEL A CHISEL B

HAND-OPERATED GRINDER

SCREENSHOT SCREENSHOT

▷ Inn Rough Design

SCREENSHOT

▷ Bed Rough Design

SCREENSHOT

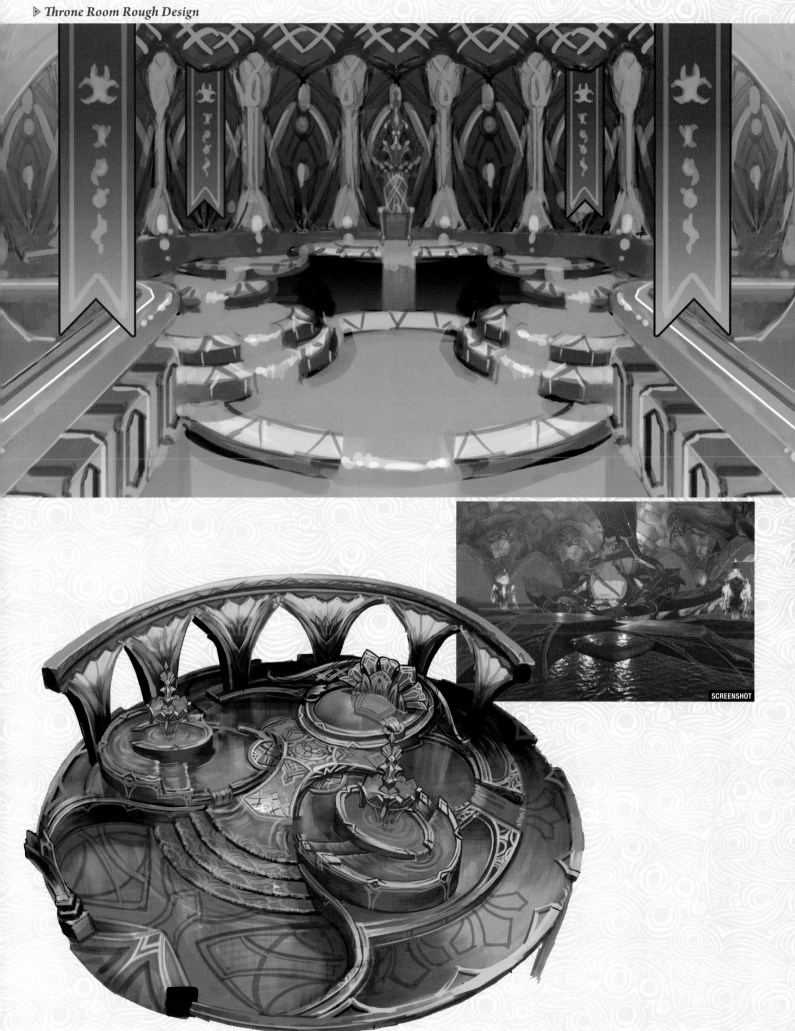

SCREENSHOT

LANAYRU GREAT SPRING

The Lanayru Great Spring is the primary source of water for all of Hyrule. The area around Zora's Domain is a high plateau that forms a semicircle around the Domain, and small lakes dot the landscape around the East Reservoir Lake. To the south are Lanayru Bay and Horon Lagoon. The latter is featured in an ancient song.

▷ East Reservoir Lake Rough Design

The East Reservoir Lake, where the Divine Beast has been running amok, was created in a joint effort by the Hyrule and Zora royal families over ten thousand years ago. There are five artificial platforms that extend into the lake, but the one featured here is the one closest to Zora's Domain. At the top of a flight of stairs is a bedroom where visitors can rest.

SCREENSHOT

SCREENSHOT

▷ Stairs Rough Design

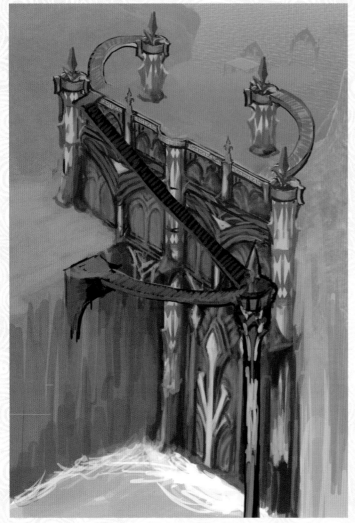

▷ Bedroom Rough Design

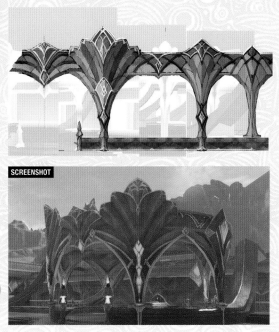

SCREENSHOT

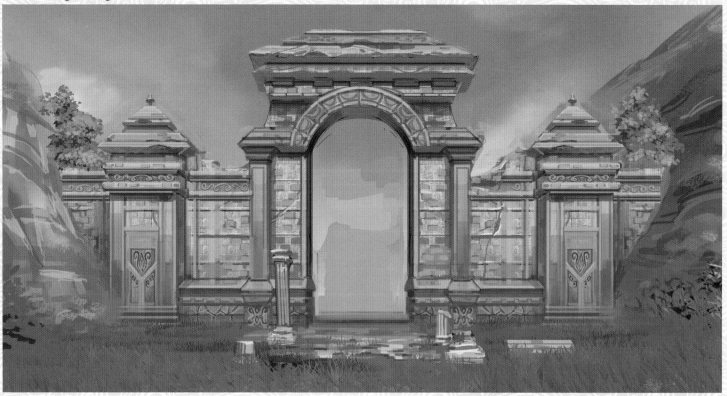

LANAYRU ROAD

This road runs from the east of Kakariko Village to the foot of Mount Lanayru. It runs through a narrow valley above the flooded floor. It was destroyed in the Calamity, but the ruins demonstrate exquisite stonework. In some of the initial designs, it was known as Spider's Nest Mountain.

SCREENSHOT

▷ *Road Overview*

SPIDER'S NEST MOUNTAIN CONCEPT

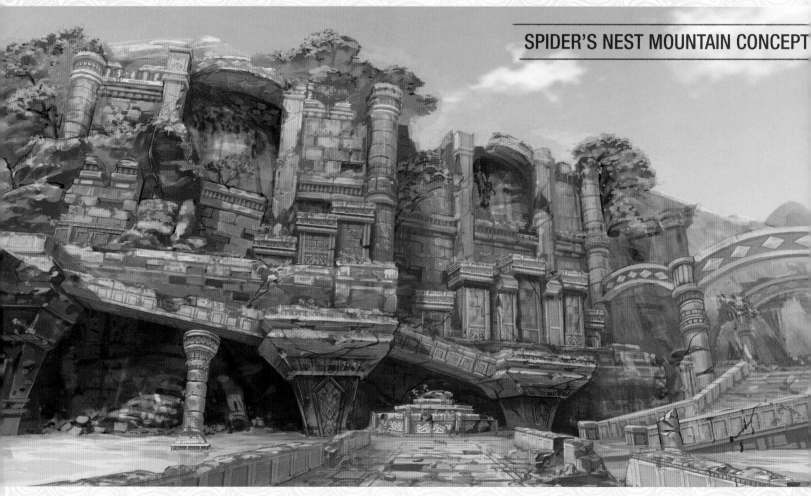

▷ Road Overview Rough Designs

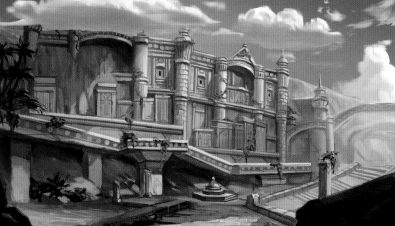

SPIDER'S NEST MOUNTAIN CONCEPT

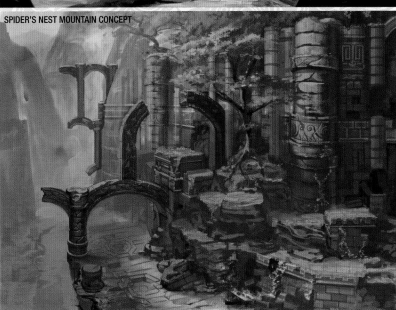

OTHER LOCATIONS
Lanayru

▷ Lanayru Wetlands

These extensive wetlands cover a broad plain to the southwest of Zora's Domain. There are several islands throughout the shallow lake that are connected with crude bridges. There are the remains of a ruined village on the large island in the middle of the wetlands.

▷ Shatterback Point

Shatterback Point is a high cliff at the summit of Ploymus Mountain. Zora warriors prove their bravery by diving from here into the reservoir far below. At present, a Lynel has taken up residence on Ploymus Mountain, making the area a prime place to test one's courage.

▷ Mount Lanayru

Mount Lanayru is an extraordinarily cold mountain to the south of Zora's Domain. This sacred place, named for the Goddess of Wisdom, Nayru, is off limits to anyone under the age of seventeen since they lack the requisite wisdom to be there. The Spring of Wisdom sits at the top.

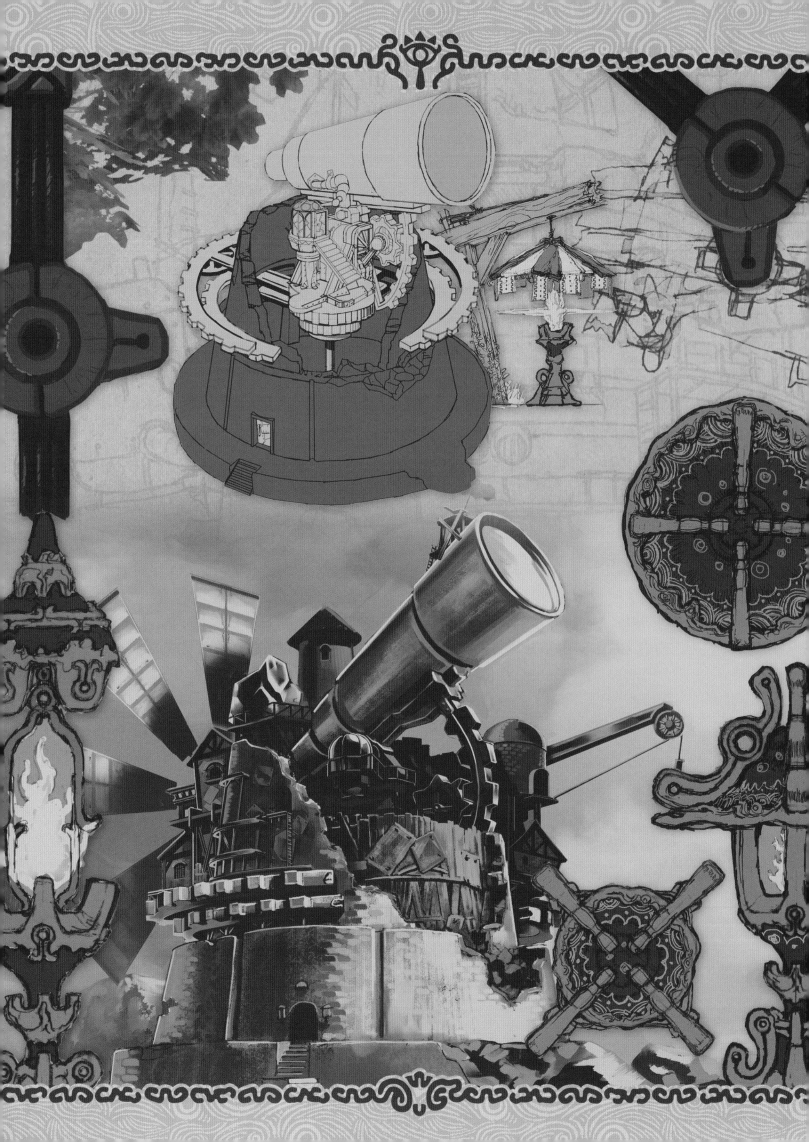

AKKALA
A PLATEAU OF BEAUTIFUL RED LEAVES

Akkala is located in the northeast corner of Hyrule. It is home to Akkala Citadel, where the soldiers of the kingdom of Hyrule made their final stand during the Great Calamity. It is said that when the citadel fell, so too did the kingdom. With the citadel gone, the Guardians destroyed the villages located here. Only Robbie and his wife have lived in a permanent residence in the area since the Calamity. They can be found in the Akkala Ancient Tech Lab on top of a high plateau. The region is distinguished by the stunning crimson leaves on its trees and its pristine nature. With Link's help, Hudson of Bolson Construction has recently established Tarrey Town, which has attracted residents of all races from across Hyrule.

AKKALA ANCIENT TECH LAB

Robbie, the foremost researcher of the Guardians, lives here with Jerrin, his wife and assistant. Robbie has transformed parts of a Guidance Stone into an Ancient Oven, which can produce Ancient Soldier Gear.

▷ Exterior Rough Designs

■ ANCIENT CIVILIZATION RESEARCH LAB CONCEPT SKETCH 1
- Built in the ruins of a lighthouse, this lab is used to research the ancient civilization via relics.

Giant telescope. →

← The professor's favorite spot is the top of the telescope.

↓ The relics that look like panels that are propped up around the building are safety devices to prevent ancient energy experiments from going out of control (stabilizers) or are energy panels that generate ancient energy from the air.

↓ Inside the egg-shaped relic are various ancient technologies listed in the language of the time, and he is trying to decipher it.

SCREENSHOT

TELESCOPE:
Extends, rotates, and moves up and down.

A Guardian (mobile type) welcomes you at the door with a smile (its head spins).

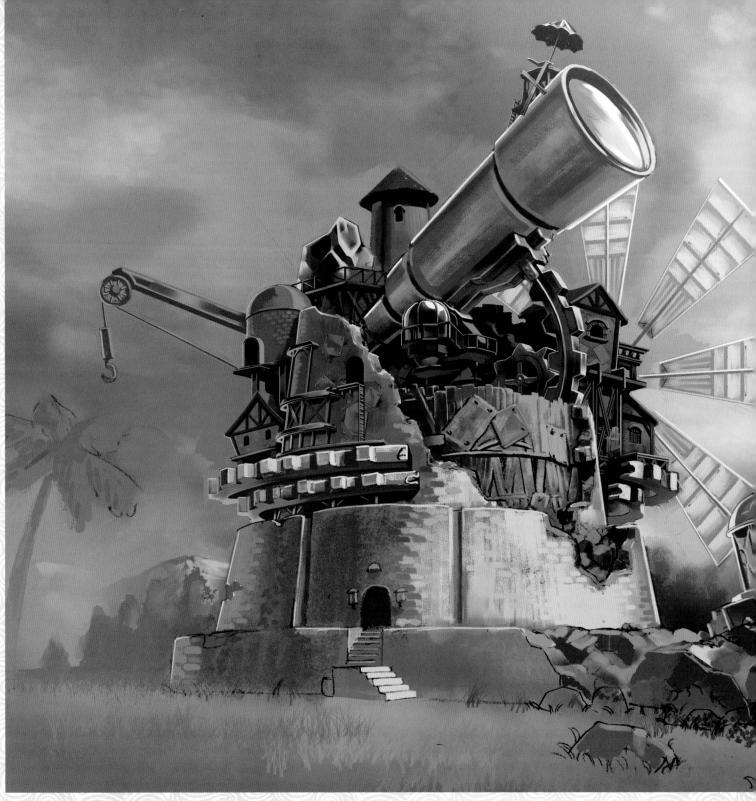

▷ Exterior Rough Designs

SCREENSHOT

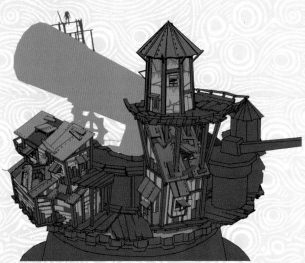

Windmill connects here.

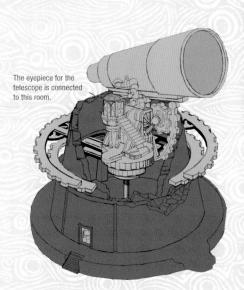

The eyepiece for the telescope is connected to this room.

Workbench

Desk is in the recessed part of the wall.

SLEEPING BAG

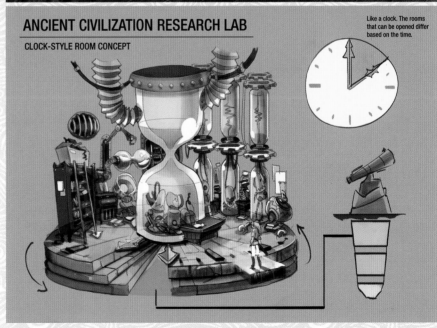

ANCIENT CIVILIZATION RESEARCH LAB

CLOCK-STYLE ROOM CONCEPT

Like a clock. The rooms that can be opened differ based on the time.

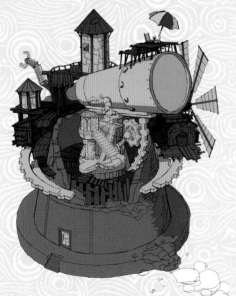

SCREENSHOT

SCREENSHOT

▷ Crane Rough Design

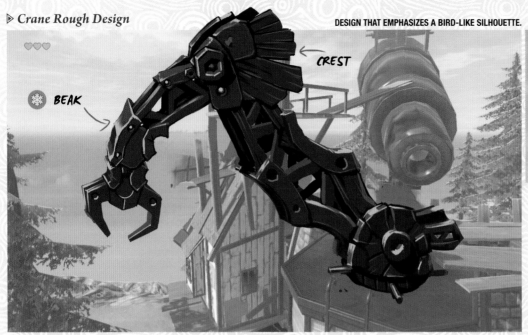

DESIGN THAT EMPHASIZES A BIRD-LIKE SILHOUETTE.

CREST

❄ BEAK

▷ Scope Rough Design

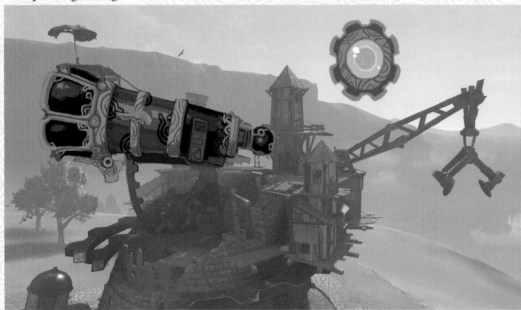

Front view

A B

C D

▷ Scope Base Rough Design

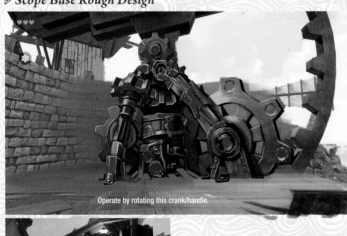

Operate by rotating this crank/handle.

▷ Viewing Platform Rough Design

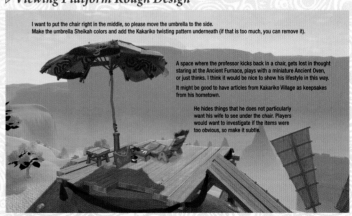

I want to put the chair right in the middle, so please move the umbrella to the side.
Make the umbrella Sheikah colors and add the Kakariko twisting pattern underneath (if that is too much, you can remove it).

A space where the professor kicks back in a chair, gets lost in thought staring at the Ancient Furnace, plays with a miniature Ancient Oven, or just thinks. I think it would be nice to show his lifestyle in this way.

It might be good to have articles from Kakariko Village as keepsakes from his hometown.

He hides things that he does not particularly want his wife to see under the chair. Players would want to investigate if the items were too obvious, so make it subtle.

▷ Ancient Oven (CHERRY)

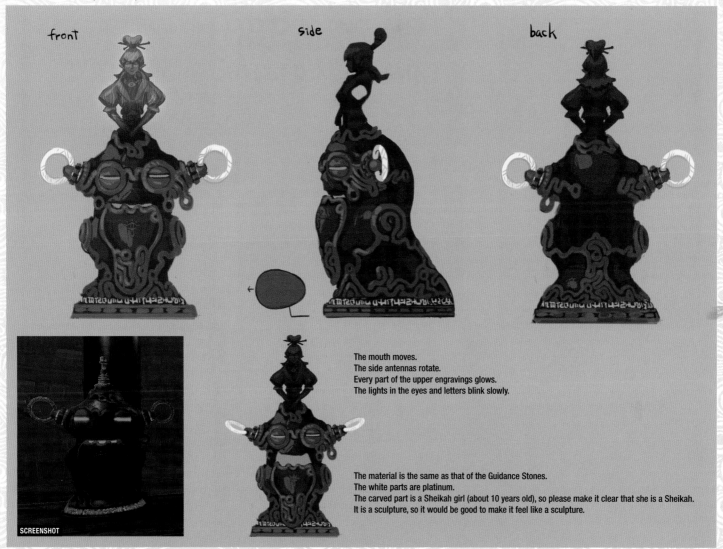

front

side

back

The mouth moves.
The side antennas rotate.
Every part of the upper engravings glows.
The lights in the eyes and letters blink slowly.

The material is the same as that of the Guidance Stones.
The white parts are platinum.
The carved part is a Sheikah girl (about 10 years old), so please make it clear that she is a Sheikah.
It is a sculpture, so it would be good to make it feel like a sculpture.

SCREENSHOT

▷ Ancient Furnace Rough Designs

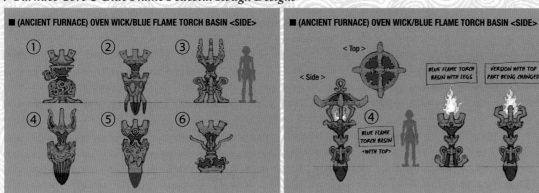

■ ANCIENT FURNACE ①

< Front >

< Side >

(INFLUENCE OF UPHEAVAL?)
SLIGHTLY BURIED.

FEELS LIKE IT ROSE
FROM THE GROUND.

IT'S STILL PARTIALLY
BURIED, SO IT'S HARD
TO SEE FROM THE
SURROUNDING AREA.

GROUND

< Top >

GRASS

■ ANCIENT FURNACE ②

< Top >

< Front >

< Side >

Half underground

SCREENSHOT

▷ Furnace Core & Blue Flame Pedestal Rough Designs

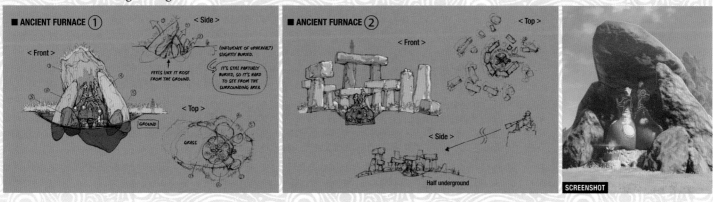

■ (ANCIENT FURNACE) OVEN WICK/BLUE FLAME TORCH BASIN <SIDE>

① ② ③
④ ⑤ ⑥

■ (ANCIENT FURNACE) OVEN WICK/BLUE FLAME TORCH BASIN <SIDE>

< Top >

< Side >

④

BLUE FLAME
TORCH BASIN
<WITH TOP>

BLUE FLAME TORCH
BASIN WITH LEGS

VERSION WITH TOP
PART BEING CHANGED

SCREENSHOT

TARREY TOWN

Tarrey Town is a recently established village located on Lake Akkala. It was built from the ground up by Hudson of the Bolson Construction carpenters, who was dispatched by Bolson from Hateno Village. Link aids the process by providing raw materials and finding helpful new residents with names ending in "son" to gradually bring life to the village. It is characterized by the colorful exteriors of its homes, which are similar to those found in Hateno Village.

SCREENSHOT

▷ Gate Rough Designs

▷ Fountain Rough Designs

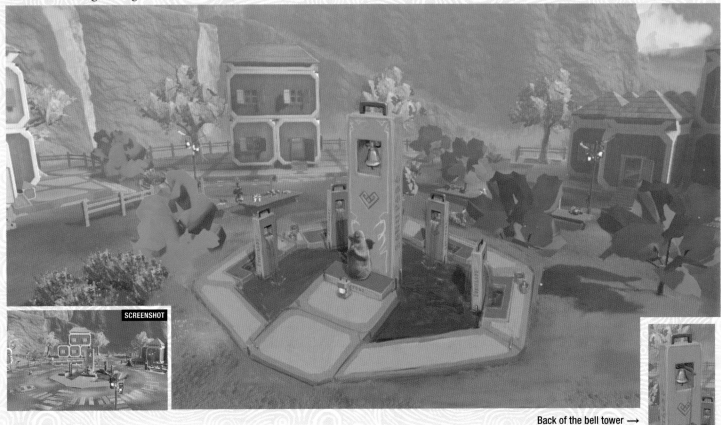

SCREENSHOT

Back of the bell tower →

▷ Lamp Rough Designs

SCREENSHOT

▷ Home Rough Designs

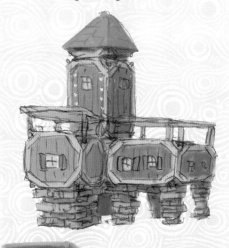
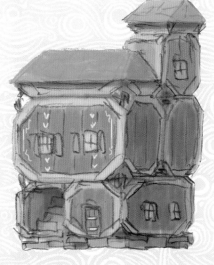

SCREENSHOT

▷ Home Interior

DEVELOPERS' NOTES

Bolson Construction builds their structures using the contemporary construction method of stacking containers, which does not exactly fit with a fantasy setting. This is a design that Bolson came up with when trying to revitalize the town in the wake of Hyrule losing its craftsmen and lumber resources to the Calamity.

SENIOR LEAD ARTIST, LANDSCAPE: MAKOTO YONEZU

Bolson's stacking method is a way of building that was dreamed up by Bolson himself. It has no precedent in the history of Hyrule. It is extremely simple—these square rooms are simply stacked together and locked into place. Then you can add a wooden deck or flower bed in whatever way you choose. They ship the town lights directly from Hateno Village, which is the home of Bolson Construction. With a single adult Goron, anyone can easily create a stacked building. They can be freely and easily arranged as well. Of course, they are easy to break down and can be transported later as you see fit. Will Bolson be able to rebuild Hyrule with his innovative stacked construction?

LEAD ARTIST, STRUCTURAL: MANABU TAKEHARA

OTHER LOCATIONS
Akkala

▷ Tumlea Heights

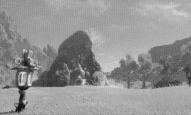

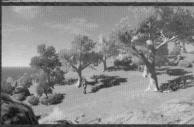

This plateau is lined with colorful trees as well as the Ancient Furnace, which is critical for research in the Akkala Ancient Tech Lab. The crimson trees run from Akkala Falls to the Akkala Wilds and create a landscape unique to Akkala.

▷ Rist Peninsula

This sandy beach spirals out into the Akkala Sea. It makes for a splendid view but is inhabited by monsters, so if you are going to go on a stroll down by the beach, caution is recommended. There is a legend passed down since ancient times that carrying an ancient orb to the center of the swirl will cause a shrine to appear.

▷ Skull Lake

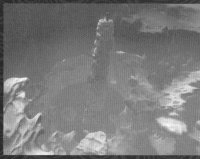

This small lake is in a valley in northwestern Akkala. It resembles a skull when viewed from above. The rock that forms the left eye is actually a very tall spire with a shrine at the top. It requires a great deal of stamina and effort to get to. The first time Link visits Skull Lake at night, Kilton will be preparing to open the Fang and Bone (page 339) on top of the lower right eye. Once Link meets him, it will become possible to visit the Fang and Bone near all of the major villages across Hyrule.

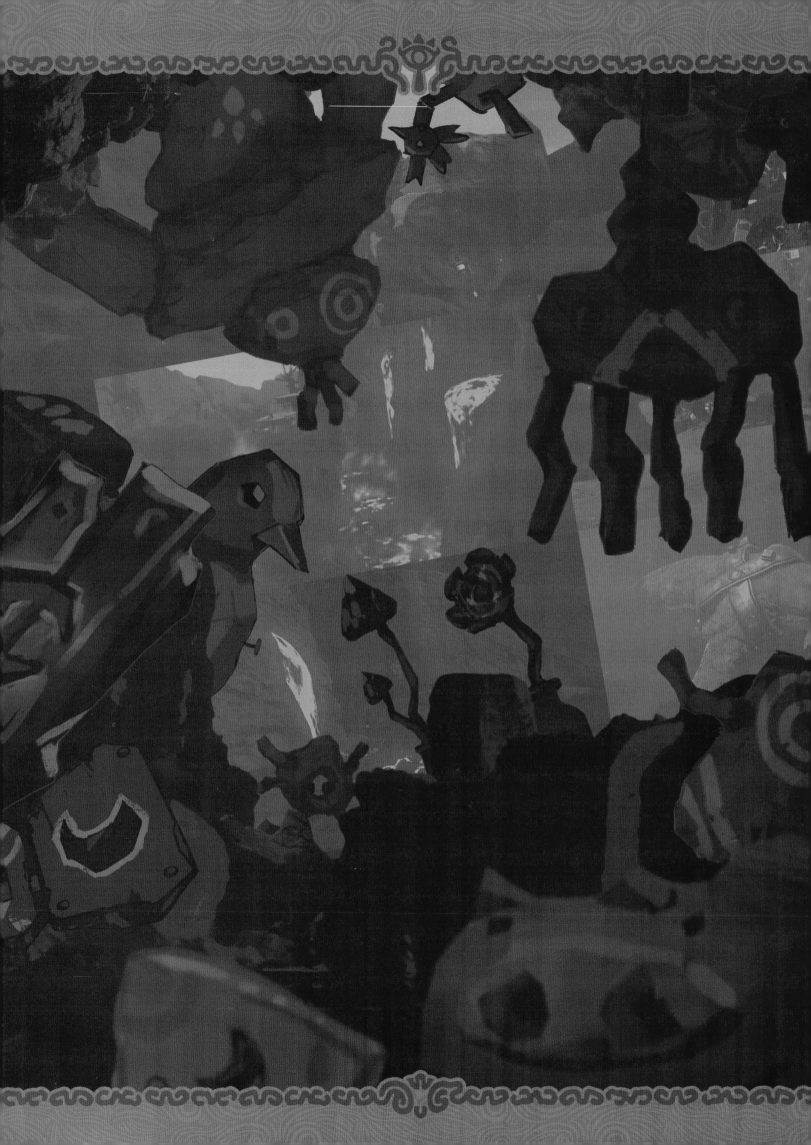

ELDIN
PIPING-HOT PEAKS
INHABITED BY THE GORONS

Eldin is located in the northeast of Hyrule. This scorched terrain extends out from its Death Mountain volcano center. It is so hot that simply placing objects on the ground is enough for them to burst into flame. If a non-Goron is going to explore this place, preparation is required. Following Eldin Canyon will lead one to Goron City, home of the Gorons. Along the way is the Southern Mine, where members of the Goron Group Mining Company are excavating ore.

◤ ELDIN CANYON

This jagged, rocky path coils its way around Death Mountain. Magma seeps out of the rock here and there, forming pools and rivers and making it difficult to navigate. There are iron bridges and signs along the road that have likely been placed there by the Gorons.

SCREENSHOT

▷ *Eldin Canyon Overview Rough Designs*

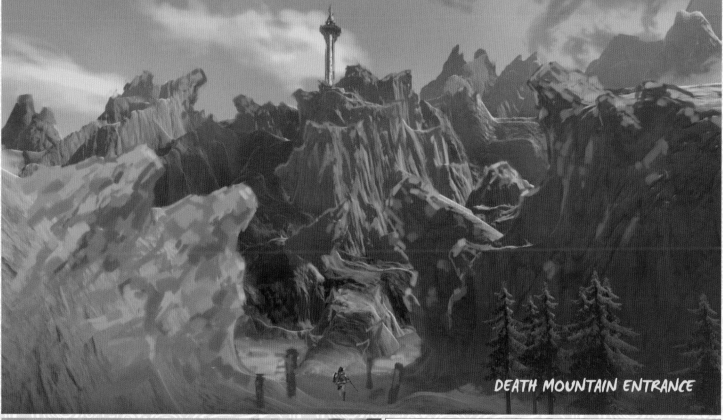

DEATH MOUNTAIN ENTRANCE

ROCKS SHAPED LIKE DRAGONS HAVE A TEXTURE THAT LOOKS LIKE SCALES. THEY ARE RESISTANT TO MAGMA.

ROCK SILHOUETTES

IMMERSED RUINS

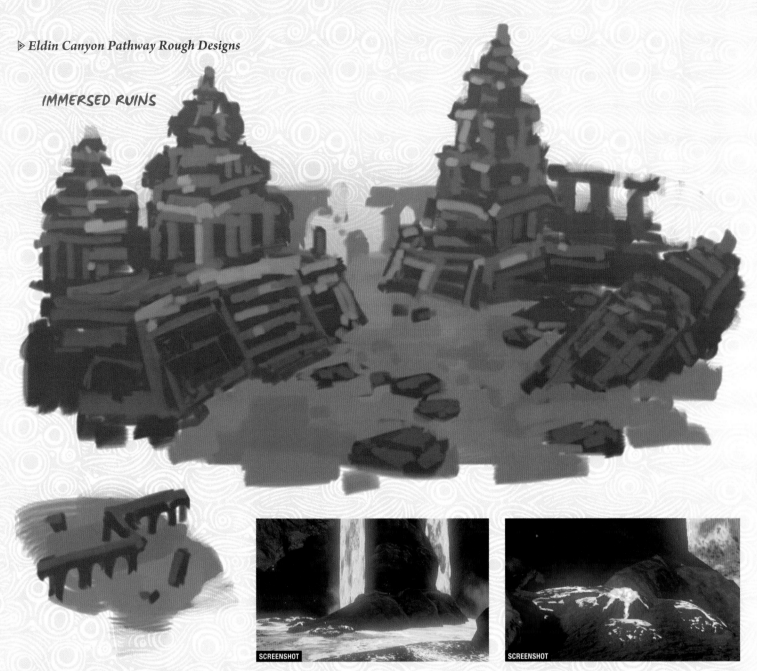

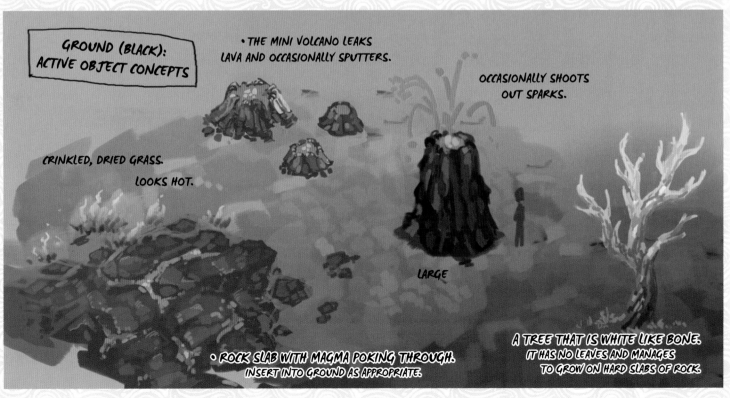

GROUND (BLACK):
ACTIVE OBJECT CONCEPTS

• THE MINI VOLCANO LEAKS
LAVA AND OCCASIONALLY SPUTTERS.

OCCASIONALLY SHOOTS
OUT SPARKS.

CRINKLED, DRIED GRASS.

LOOKS HOT.

LARGE

• ROCK SLAB WITH MAGMA POKING THROUGH.
INSERT INTO GROUND AS APPROPRIATE.

A TREE THAT IS WHITE LIKE BONE.
IT HAS NO LEAVES AND MANAGES
TO GROW ON HARD SLABS OF ROCK.

MAGMA POURING

VALLEY

SMOKE

FEELS LIKE GORON LAND.

WOULD ALSO BE
SCATTERED ON FIELDS NEARBY.

GUARDS AT GATE

RAILING

METAL PLATFORMS

▷ *Rock Roast Rough Designs*

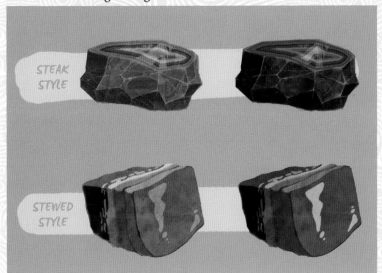

STEAK
STYLE

STEWED
STYLE

▷ *Rock Roast*

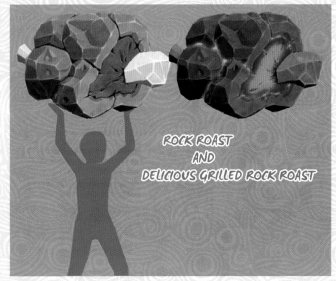

ROCK ROAST
AND
DELICIOUS GRILLED ROCK ROAST

GORON CITY

The home of the Gorons is located at the fifth stop on the road up Death Mountain. The land is intensely hot, so Hylians rarely visit. The Gorons' furniture is made of nonflammable metal and stone. Since the Gorons are not the most skilled with their hands, the resulting craftsmanship lacks some finesse but ultimately gets the job done. It is possible for Link to use a mine cart to get around up here.

▷ Goron City Overview Rough Design

GORON CITY

People live in the multitiered area constructed around a caldera. A rail runs through the village, and it is possible to use it to get around via a cart (striking down with a hammer will take it to the village center and return it to its original location).

The faces of four Goron heroes are carved into the rock behind the village.

GORON CITY

▷ Mine Cart Rough Design

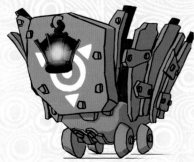

▲ They don't have the technology to make the metal beams curve smoothly, so they make curves by directly connecting multiple straight rails and changing the angles.

The cart will clang around a bit even while moving around small curves.

Metal pillars and plates are fixed together with thick wire.

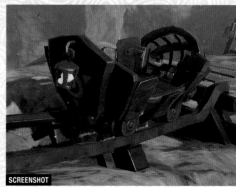

SCREENSHOT

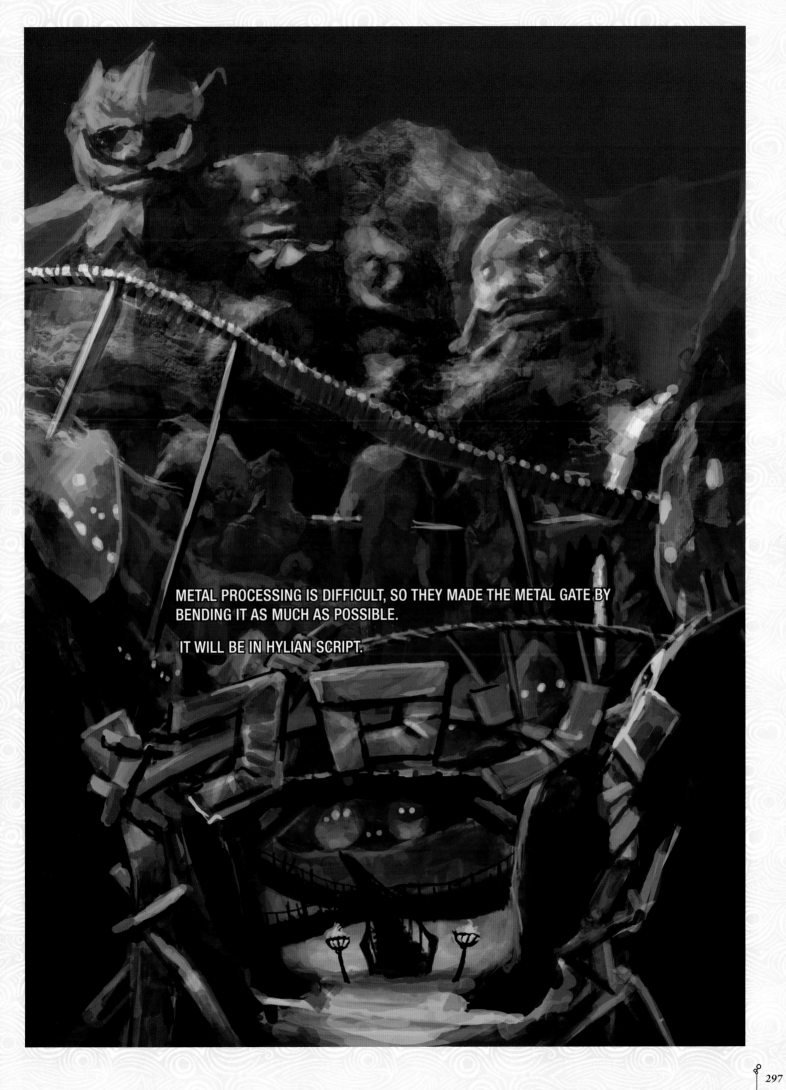

METAL PROCESSING IS DIFFICULT, SO THEY MADE THE METAL GATE BY BENDING IT AS MUCH AS POSSIBLE.

IT WILL BE IN HYLIAN SCRIPT.

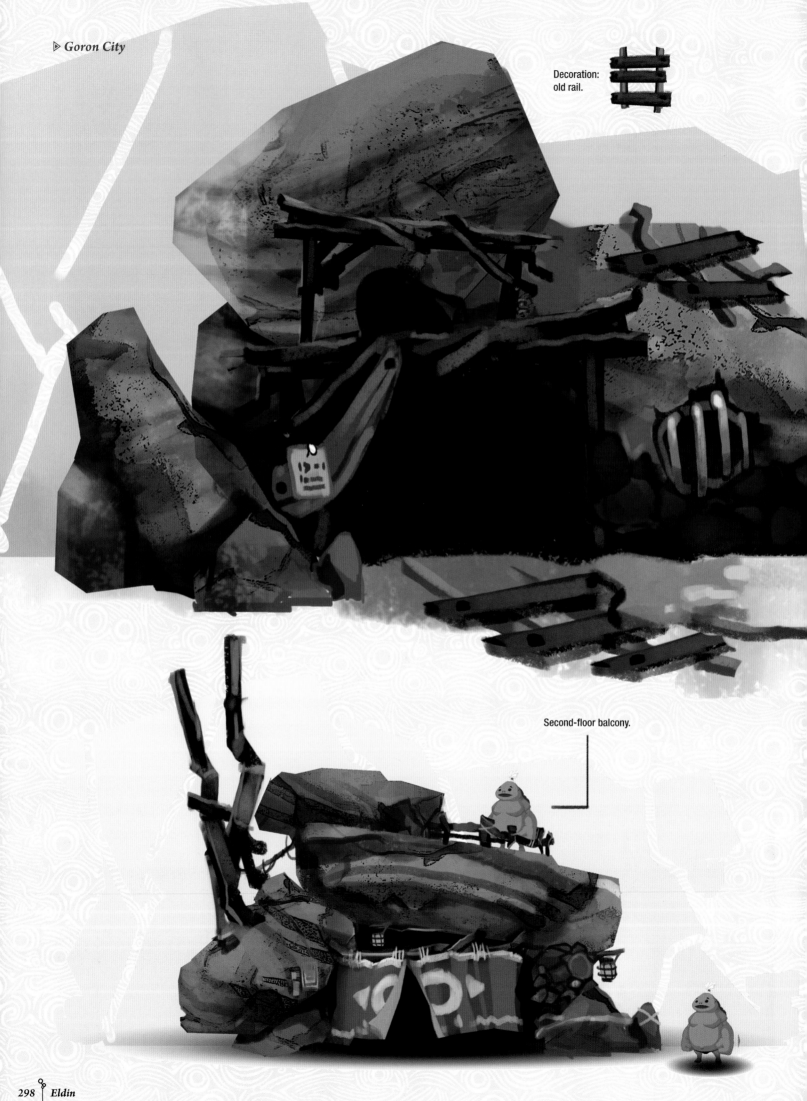

▷ *Goron City*

Decoration: old rail.

Second-floor balcony.

▷ Goron House Interior Rough Designs

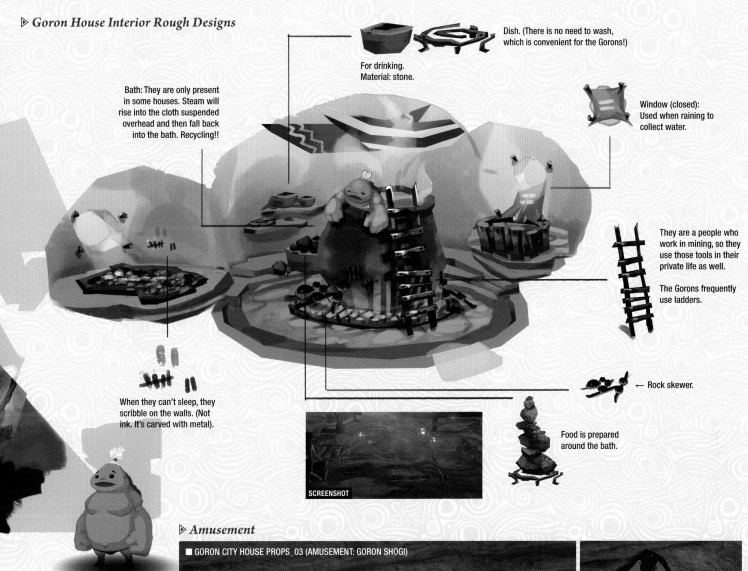

For drinking.
Material: stone.

Dish. (There is no need to wash, which is convenient for the Gorons!)

Bath: They are only present in some houses. Steam will rise into the cloth suspended overhead and then fall back into the bath. Recycling!!

Window (closed): Used when raining to collect water.

They are a people who work in mining, so they use those tools in their private life as well.

The Gorons frequently use ladders.

When they can't sleep, they scribble on the walls. (Not ink. It's carved with metal).

← Rock skewer.

Food is prepared around the bath.

SCREENSHOT

▷ Amusement

■ GORON CITY HOUSE PROPS_03 (AMUSEMENT: GORON SHOGI)

▷ Furniture

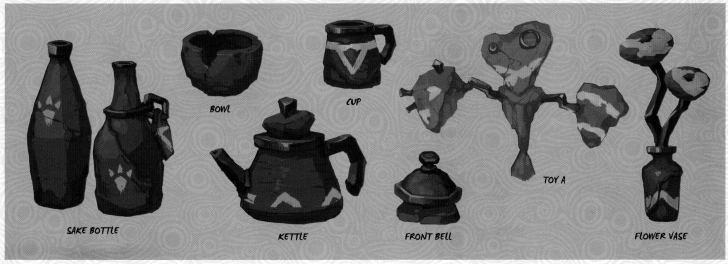

SAKE BOTTLE

BOWL

CUP

KETTLE

FRONT BELL

TOY A

FLOWER VASE

▷ *Boss's House Exterior*

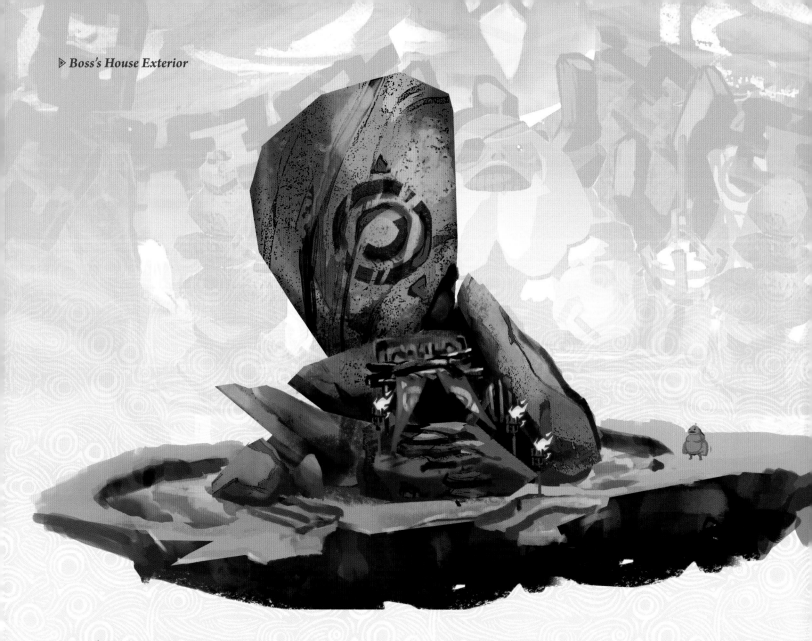

▷ *Boss's House Interior*

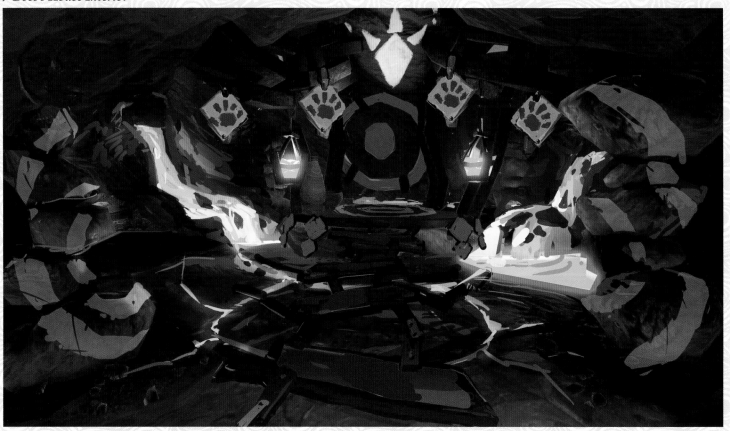

▷ Inn Rough Design

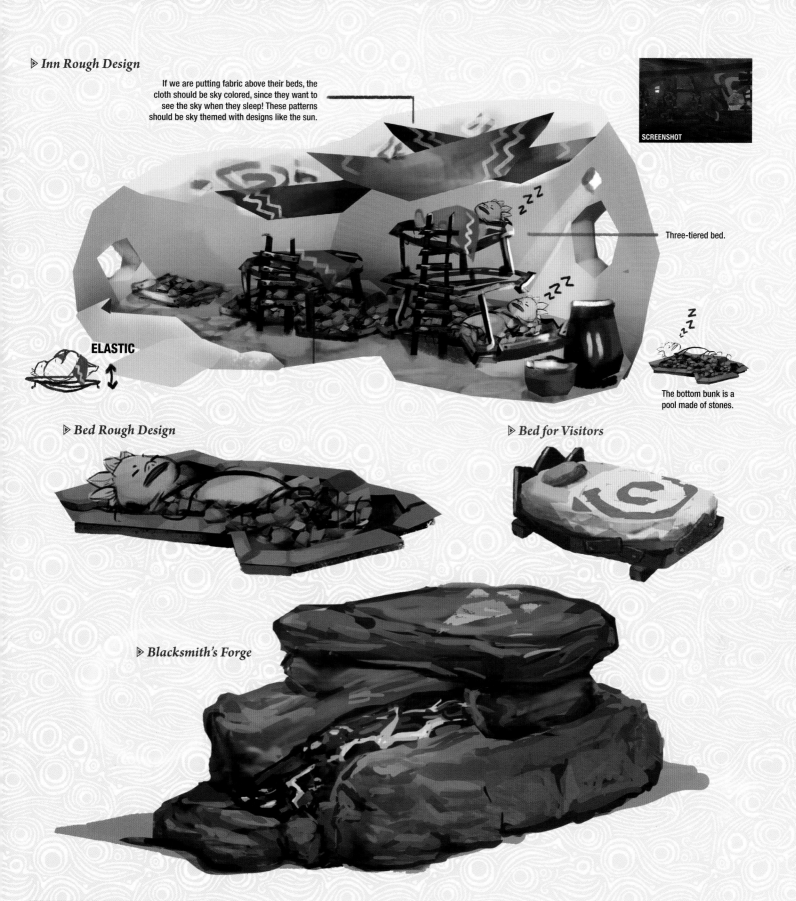

If we are putting fabric above their beds, the cloth should be sky colored, since they want to see the sky when they sleep! These patterns should be sky themed with designs like the sun.

Three-tiered bed.

ELASTIC

The bottom bunk is a pool made of stones.

▷ Bed Rough Design

▷ Bed for Visitors

▷ Blacksmith's Forge

DEVELOPERS' NOTES

Death Mountain (page 302) is an extreme environment to most, but the Gorons make their home here. Rather than making it simply ominous, I designed the area hoping that players would enjoy the contrasting silhouettes of the sharp, twisted rocks that seem like giant stone tools erupting out of the earth toward the center of the mountain, and the rounded curves of the goopy, dripping magma. I think Death Mountain's pairing of power and fluidity makes it a good fit for the Gorons.

LANDSCAPE ART: YOHEI IZUMI

Goron City is home to the Goron miners, who absolutely love metal and stone. I designed the house of the head of the town, Boss Bludo, to be symbolic of the Gorons. It incorporates a giant boulder, signifying that he is a man among men and that he is comfortable even in the scorching heat of magma. However, I would not have been able to express the unique charm of the Gorons solely through the austerity of mining, so by adding contrasting elements that show that they like cute things (toys, etc.), I was able to demonstrate their slightly timid, softer side as well.

LEAD ARTIST, STRUCTURAL: MANABU TAKEHARA

DEATH MOUNTAIN

The highest peak in all of Hyrule is an active volcano. It is even hotter than Eldin Canyon. The most precious ore in the area is found around the summit, so you would usually find Gorons mining there, but when Vah Rudania began to rampage they could no longer approach it.

▷ Eldin Bridge Rough Design

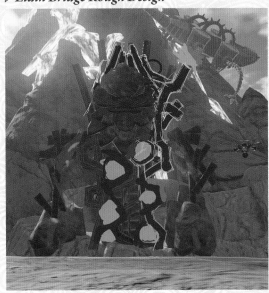

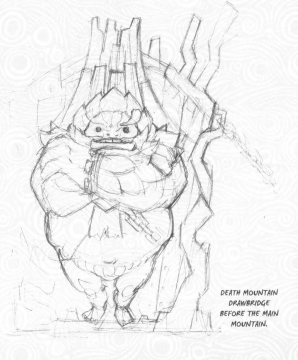

DEATH MOUNTAIN DRAWBRIDGE BEFORE THE MAIN MOUNTAIN.

BASE

TOP

▷ Eldin Bridge

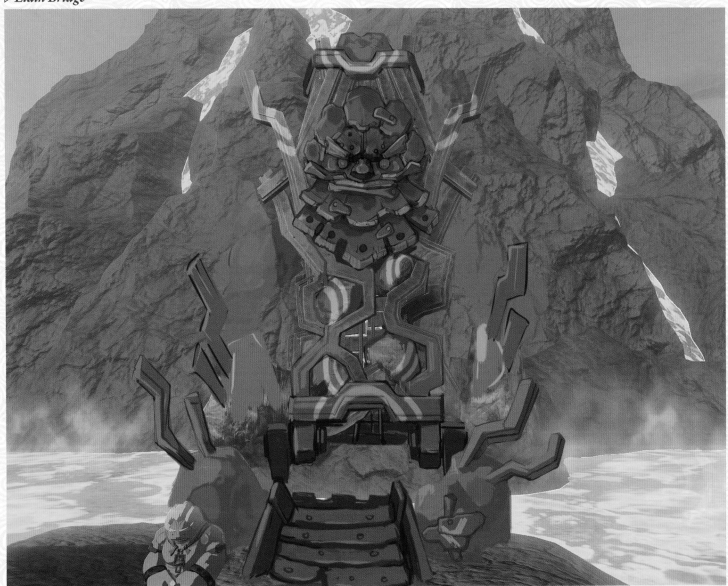

▷ Cannon Rough Designs

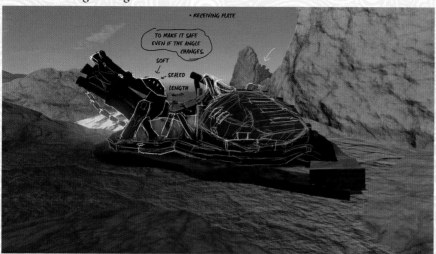

▷ Death Mountain Overview Rough Design

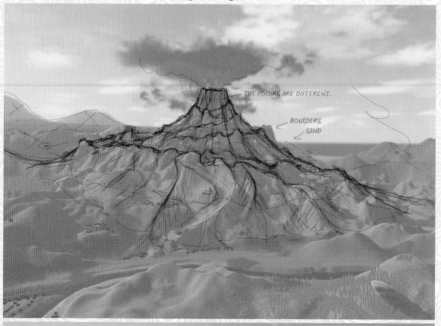

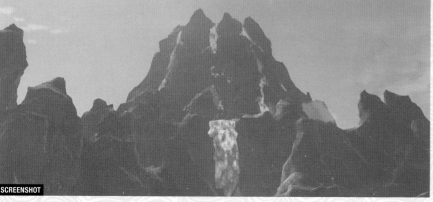

SCREENSHOT

▷ *Gut Check Rock*

This completely vertical rock stands to the north of Death Mountain. The three Goron Blood Brothers train here to become stronger. By demonstrating his strength by climbing the cliff, Link is recognized as the fourth brother.

▷ *Goron Hot Springs*

These hot springs are found at Death Mountain Marker #7. The heat of the active volcano warms these pools to just the right temperature. However, it is apparently a bit tepid for the Gorons. The springs will relieve the stress and fatigue of a hard day's work as you soak in their waters.

▷ *Abandoned North Mine*

Cannons were once used in this mine to excavate ore via blasting. Presently, Vah Rudania's rampaging, the increased flow of lava, and an influx of monsters have made it impossible to enter. It is the location of the boss's favorite cannon, which can be used to fire bombs.

HEBRA
WILD, SNOW-COVERED MOUNTAINS

The Hebra province is located in northwest Hyrule. It is geographically isolated from the neighboring Central Hyrule by the enormous Tanagar Canyon, which cuts between the two areas from northeast to southwest and creates their shared border.

The Tabantha Frontier in the southern tip of the region is a wild land of little grass, few trees, and exposed rock, while to the north are the Hebra Mountains—a frigid range with high elevation and low temperatures.

Rito Village is located in Hebra, but that is the only large settlement in a region of few inhabitants and fewer travelers.

RITO VILLAGE

The Rito's home village hangs from the sides of a giant stone pillar that stretches up from the center of Lake Totori. Airy abodes and shops constructed from lumber are affixed to the side of the column and connected by a spiraling staircase. The upward construction of their village is unique to the flight-capable Rito, and there are many other aspects of Rito Village that are inconvenient to the other races of Hyrule, so they get few visitors.

▷ *Rito Village Overview*

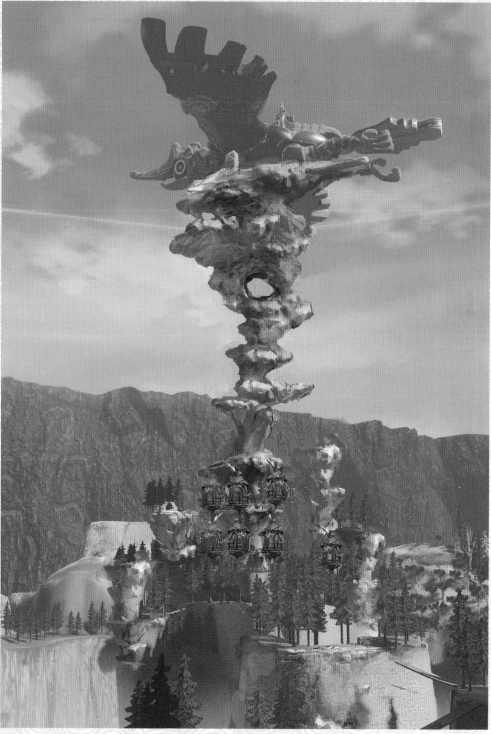

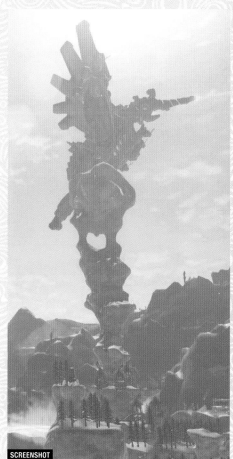

`SCREENSHOT`
The Divine Beast Vah Medoh perches atop a distinctive rock formation like a bird on a branch. The hole in the center of the rock spire was changed from a circle to a heart during production and is part of a shrine challenge.

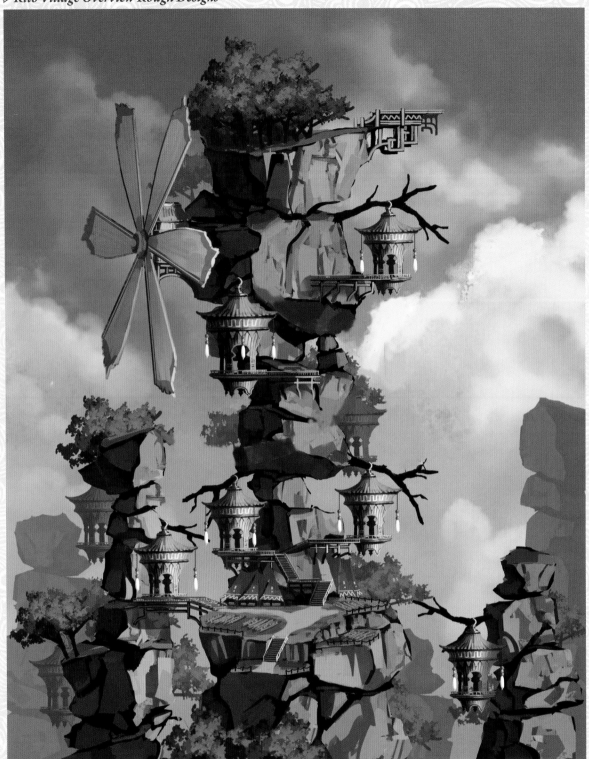

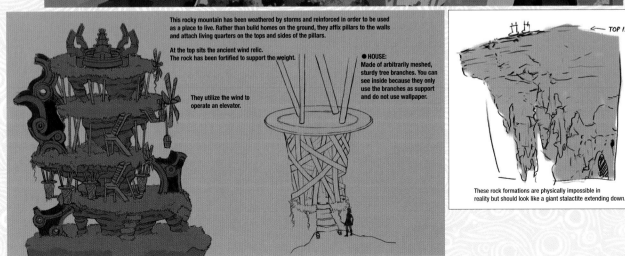

This rocky mountain has been weathered by storms and reinforced in order to be used as a place to live. Rather than build homes on the ground, they affix pillars to the walls and attach living quarters on the tops and sides of the pillars.

At the top sits the ancient wind relic.
The rock has been fortified to support the weight.

They utilize the wind to operate an elevator.

●HOUSE:
Made of arbitrarily meshed, sturdy tree branches. You can see inside because they only use the branches as support and do not use wallpaper.

← TOP IS FLAT.

These rock formations are physically impossible in reality but should look like a giant stalactite extending down.

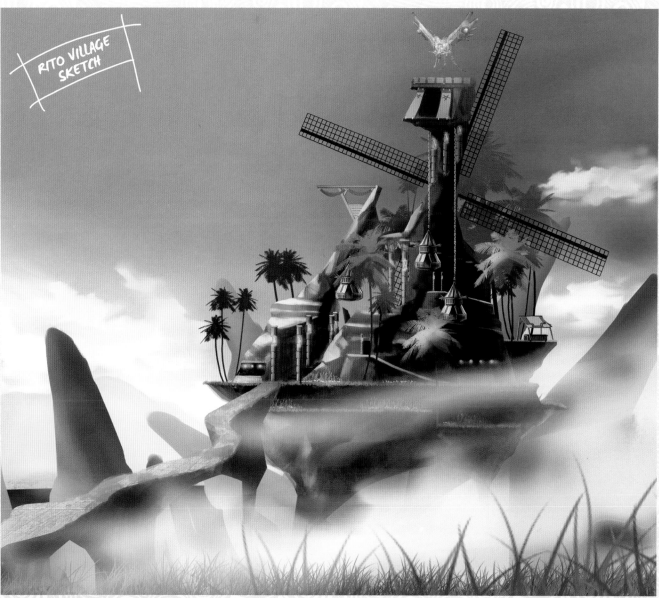

RITO VILLAGE SKETCH

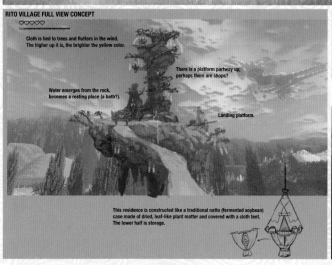

RITO VILLAGE FULL VIEW CONCEPT

Cloth is tied to trees and flutters in the wind. The higher up it is, the brighter the yellow color.

There is a platform partway up; perhaps there are shops?

Water emerges from the rock, becomes a resting place (a bath?).

Landing platform.

This residence is constructed like a traditional natto (fermented soybean) case made of dried, leaf-like plant matter and covered with a cloth tent. The lower half is storage.

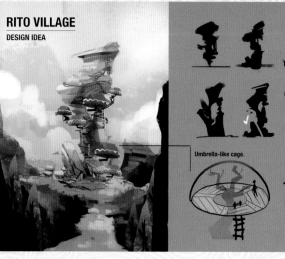

RITO VILLAGE
DESIGN IDEA

Umbrella-like cage.

DEVELOPER'S NOTE

I designed Rito Village around the concept that this village would extend upward vertically rather than expand outward, because the Rito have the ability to fly. The houses are built off the ground since the Rito are free from the effects of gravity. At the beginning of development, there were no platforms in the village, but we included them because, from a game-design perspective, the initial design wasn't practical.

The Rito live in houses reminiscent of birdcages since the Rito are based on birds. While it may be a bit on the nose, it clearly communicates who they are as a people. I feel like a design like theirs could not exist outside the *Zelda* series.

As their design progressed and we were finalizing the look of the village, I had the traditional Andean song "El Cóndor Pasa" repeating endlessly in my head. Needless to say, that is why there is so much colorful cloth used in the village's design. Another big reason is that it was a good way to express wind along with the windmills.

LEAD ARTIST, STRUCTURAL: MANABU TAKEHARA

▷ Residence Rough Designs

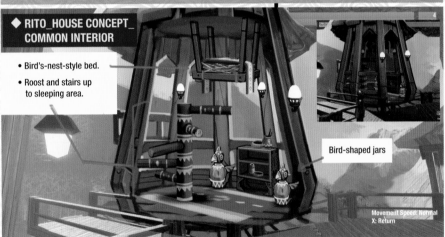

LOOKS LIKE IT HAS STAIRS.

◆ RITO_HOUSE CONCEPT_ COMMON INTERIOR

- Bird's-nest-style bed.
- Roost and stairs up to sleeping area.

Bird-shaped jars

Movement Speed: Normal
X: Return

The houses in Rito Village were based on birdcages, forgoing walls to feel open. There are also platforms like Revali's Landing on different levels that the Rito can reach via the stairs and use to take off and land. They are unique to Rito Village.

▷ Residence

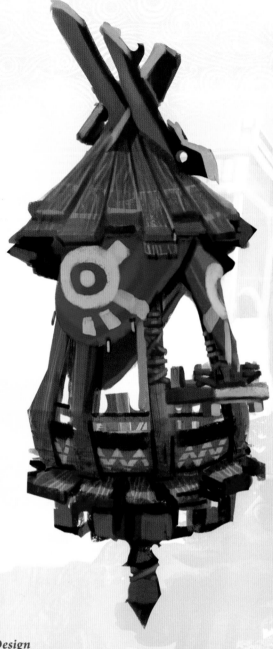

▷ Gate (ENTRANCE)

SHORT

LONG

▷ Weapon Shop Rough Design

This is concept art for a weapon shop where Link could purchase the bows used by Rito warriors. It was decided that weapons would not be purchasable items in the game, so this idea was never used.

◆ RITO_HOUSE CONCEPT_ WEAPON SHOP

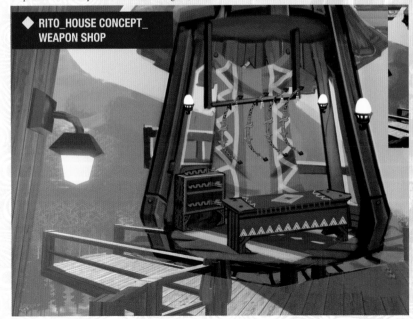

▷ Gate (STAIRS)

The lower the level, the fewer feathers there are.

The string color changes as well.

▷ *Kaneli's House*

■ **RITO CHIEF HOUSE**

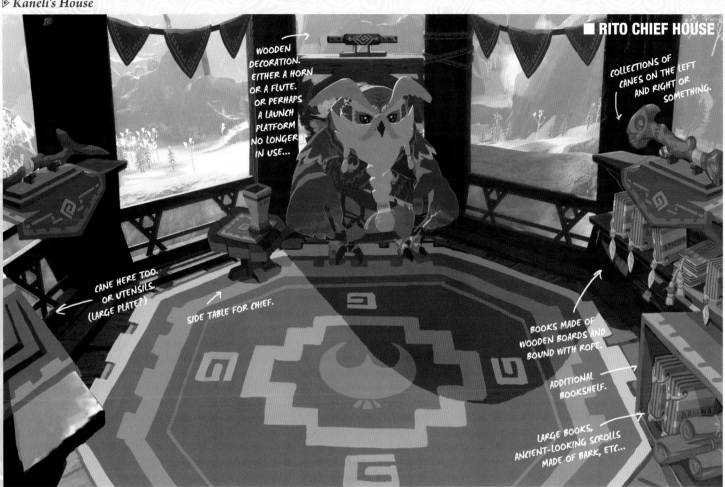

WOODEN DECORATION. EITHER A HORN OR A FLUTE. OR PERHAPS A LAUNCH PLATFORM NO LONGER IN USE...

COLLECTIONS OF CANES ON THE LEFT AND RIGHT OR SOMETHING.

CANE HERE TOO. OR UTENSILS. (LARGE PLATE?)

SIDE TABLE FOR CHIEF.

BOOKS MADE OF WOODEN BOARDS AND BOUND WITH ROPE.

ADDITIONAL BOOKSHELF.

LARGE BOOKS, ANCIENT-LOOKING SCROLLS MADE OF BARK, ETC...

▷ *Furniture & Props*

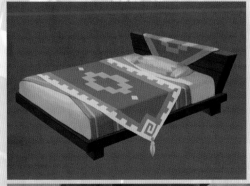

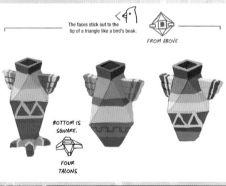

The faces stick out to the tip of a triangle like a bird's beak.

FROM ABOVE

BOTTOM IS SQUARE.

FOUR TALONS

ALTERNATIVE CONCEPT

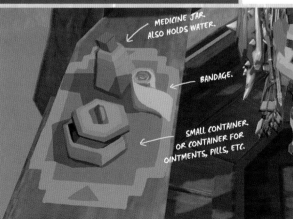

MEDICINE JAR ALSO HOLDS WATER.

BANDAGE.

SMALL CONTAINER OR CONTAINER FOR OINTMENTS, PILLS, ETC.

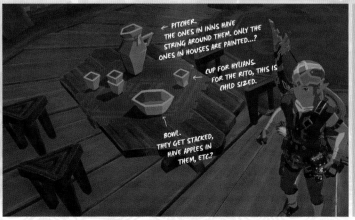

← PITCHER. THE ONES IN INNS HAVE STRING AROUND THEM. ONLY THE ONES IN HOUSES ARE PAINTED...?

← CUP FOR HYLIANS. FOR THE RITO, THIS IS CHILD SIZED.

BOWL. THEY GET STACKED, HAVE APPLES IN THEM, ETC.?

TABANTHA FRONTIER

The Tabantha Frontier can be found in the southern portion of Hebra. Its southernmost tip is defined by the gaping Tanagar Canyon, while to the north are medium-sized lakes and forests. The proprietors of the stable in this area use the resources available to them by chopping down trees for firewood.

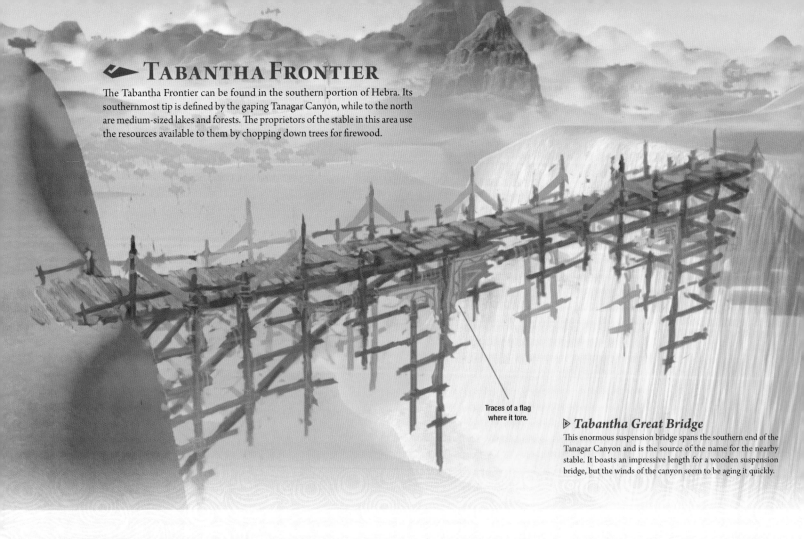

Traces of a flag where it tore.

▷ Tabantha Great Bridge

This enormous suspension bridge spans the southern end of the Tanagar Canyon and is the source of the name for the nearby stable. It boasts an impressive length for a wooden suspension bridge, but the winds of the canyon seem to be aging it quickly.

▷ Ancient Columns Rough Designs

The Ancient Columns stand above the southernmost cliff in the Tabantha Frontier. There are several stone columns engraved with reliefs, but adventurers, beware: this area is patrolled by monsters. Toward the rear is an ancient shrine that Princess Zelda investigated over a hundred years ago.

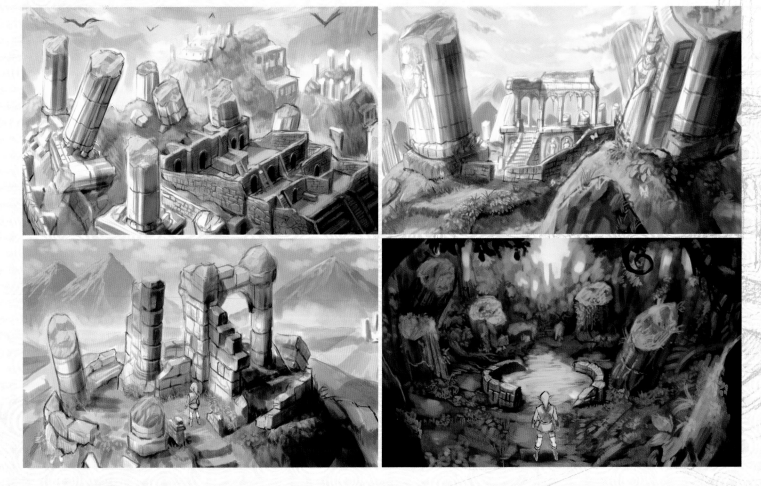

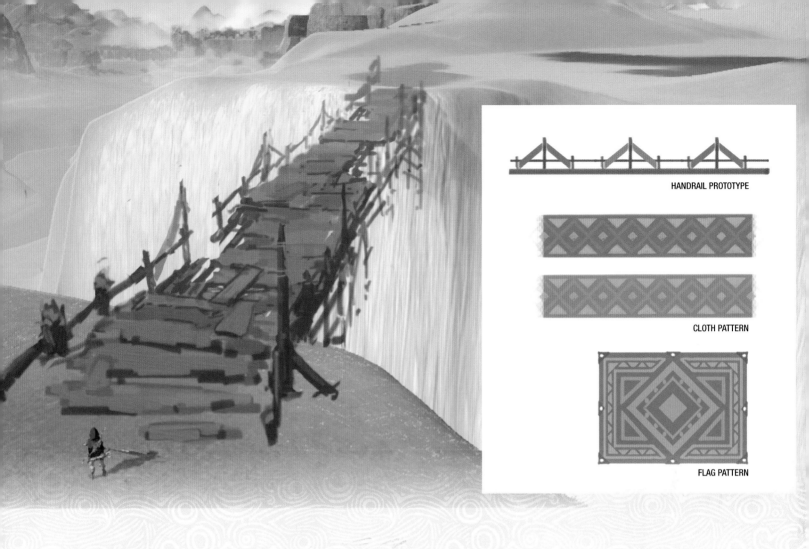

HANDRAIL PROTOTYPE

CLOTH PATTERN

FLAG PATTERN

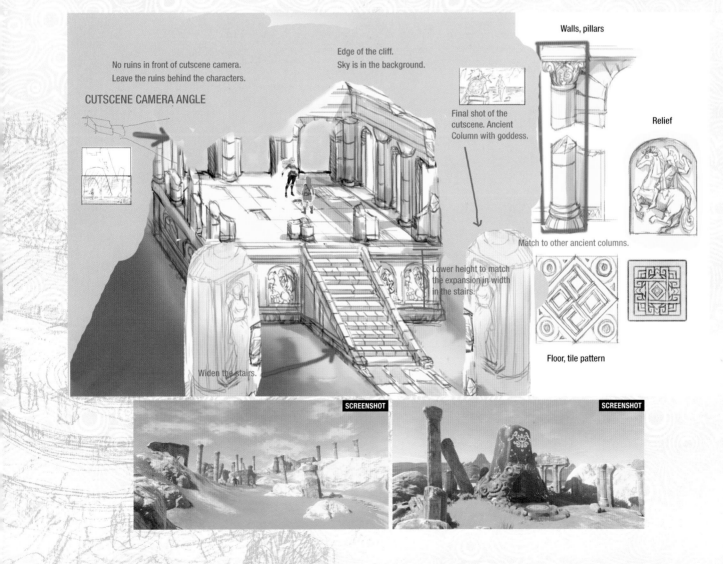

No ruins in front of cutscene camera.
Leave the ruins behind the characters.

Edge of the cliff.
Sky is in the background.

Final shot of the
cutscene. Ancient
Column with goddess.

CUTSCENE CAMERA ANGLE

Walls, pillars

Relief

Match to other ancient columns.

Lower height to match
the expansion in width
in the stairs.

Widen the stairs.

Floor, tile pattern

SCREENSHOT

SCREENSHOT

THE FORGOTTEN TEMPLE

At the northern end of Tanagar Canyon there is a massive temple built directly into the walls of the canyon itself. There are a great deal of Guardians inside defending the temple, and at its back is an ancient shrine that is watched over by a giant Goddess Statue. It is rumored that a special outfit meant for a hero who overcomes all of the trials set forth in each of the ancient shrines of Hyrule rests inside this temple.

▷ *Temple Exterior Rough Designs*

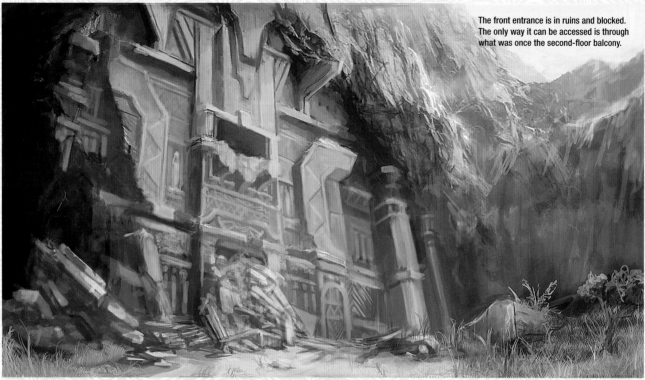

The front entrance is in ruins and blocked. The only way it can be accessed is through what was once the second-floor balcony.

◆ THE FORGOTTEN TEMPLE CONCEPT

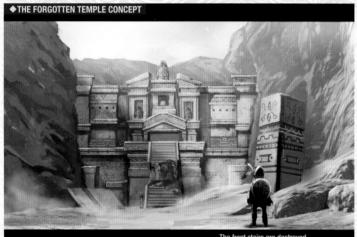

The front stairs are destroyed.

THE FORGOTTEN TEMPLE
DESIGN CONCEPT

The entire area has become unstable due to the shifts in the earth's crust. (Due to the Calamity?)

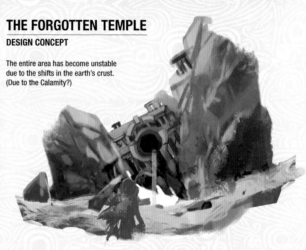

SCREENSHOT

SCREENSHOT

SCREENSHOT

DEVELOPERS' NOTES

The damaged portion of Hebra Peak is a scar from the battle against Calamity Ganon ten thousand years ago. Limiting the changes in the landscape and the presence of people gives the area a sense of isolation and solitude.

LANDSCAPE ART: YOHEI IZUMI

The Forgotten Temple was constructed in order to keep a record of the heroes throughout history who aided the royal family of Hyrule in the countless ancient battles against Ganon, who unleashed the Calamity on a recovering world.

The original concept for the temple was that it had been abandoned for so long that it had faded from people's memories. At the beginning of development, the canyon was so deeply tied to the royal family that it was called the "Valley of the Royal Family." As with everywhere throughout Hyrule, the Guardians here are possessed by Ganon, but rather than having invaded the temple from Hyrule Castle during the Great Calamity, they were placed here long ago to protect the facility.

Since it is a building that represents Hyrule's ancient past, the design incorporates construction elements from *Skyward Sword* in a similar way to the Springs of Wisdom, Courage, and Power, as well as Lanayru Road.

LEAD ARTIST, STRUCTURAL: MANABU TAKEHARA

▷ Temple Interior Rough Designs

■ THE FORGOTTEN TEMPLE CONCEPT

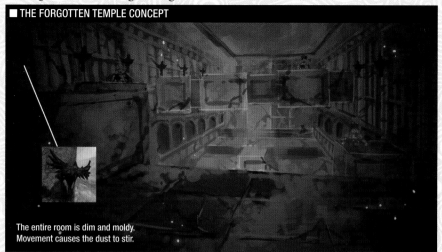

The entire room is dim and moldy. Movement causes the dust to stir.

OTHER LOCATIONS

Hebra

▷ Hebra Mountains

The Hebra Mountains are the defining feature of the Hebra region and include Mount Hebra as well as Corvash Peak, Talonto Peak, and others. They are world famous for shield surfing, but many visitors fall victim to the unceasing blizzards and dangerous mountain paths. Deep in the mountains are creatures unique to this region, and there are several spots where secret hot springs bubble to the surface.

▷ Tabantha Tundra

Hyrule's largest snowfield stretches out across the eastern side of the Hebra Mountains. As in the high peaks to the west, blizzards are a near constant here and produce low-visibility conditions for travelers. It is very rare that there is a clear day where visibility is good. Heading north increases the likelihood of encountering a Lynel or other fearsome monster, so take caution when using shortcuts or exploring.

▷ Flight Range

At the foot of the Hebra Mountains lies the training ground for Rito warriors. It was constructed at Revali's request inside a deep, donut-shaped canyon. Powerful updrafts from the canyon floor are always blowing and are strong enough that even a Hylian with a paraglider can fly with ease here. Rito warriors use these updrafts to practice their marksmanship with a bow while flying. The greatest warrior of the current generation, Teba, uses the Flight Range to train his son, Tulin.

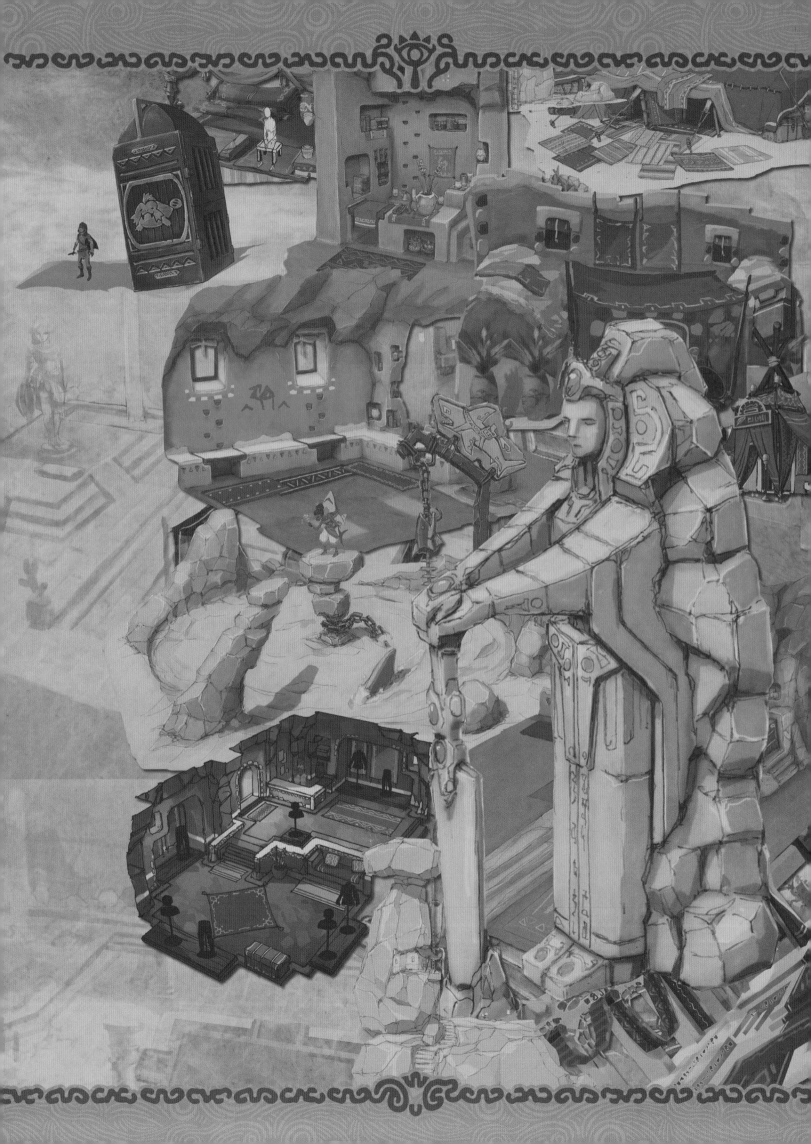

GERUDO
WHERE THE EXPANSIVE DESERT & RUGGED MOUNTAINS MEET

Gerudo is located in the southwest of Hyrule and has both a massive desert and rocky mountains. The difference between the Gerudo Desert's scorching-hot days and its frigid nights is extreme, but hearty Molduga monsters, sand seals, and Voltfruit-bearing cacti thrive in spite of the tremendous temperature swings. There are oases in the desert as well, and the Gerudo have built their city in the center of the desert around the largest one. Isolated by Gerudo Canyon and the Gerudo Desert, the culture of the Gerudo developed separately from the rest of Hyrule and is unique for that reason.

GERUDO HIGHLANDS

The mountains of the Gerudo Highlands surround the Gerudo Desert. They are nearly as tall as the Hebra Mountains and, due to their elevation, have white, snowcapped peaks. The area is home to unique Gerudo ruins and ancient shrines. It is common to see the preserved remnants of the ancient Gerudo.

▷ *Highlands Overview*

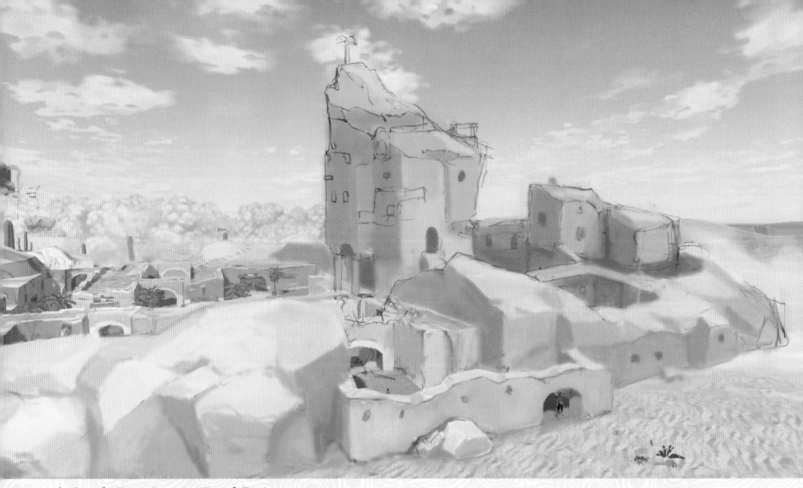

▷ *Gerudo Town Overview Rough Designs*

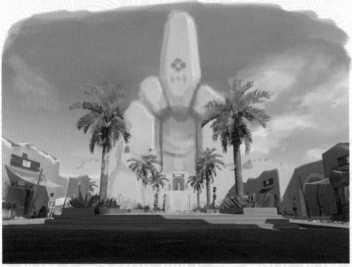

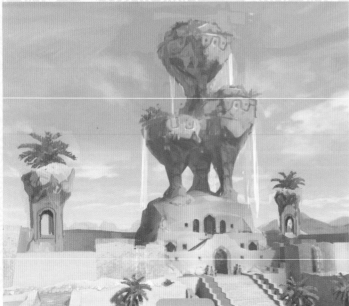

GERUDO TOWN

In the center of the desert lies Gerudo Town, the largest trading town in all of Hyrule. Only *vai* (women) are permitted to enter, and the majority of the residents are Gerudo women. There are many facilities unique to this town, including a bar and a classroom devoted to teaching relationship classes. There is also a training ground in the royal palace where Gerudo soldiers train.

SCREENSHOT

SCREENSHOT

DEVELOPER'S NOTE

Gerudo Town is unique in that it is both the center of an independent nation and a city that prohibits men from entering.

The royal palace is both symbolically and literally a landmark. In terms of game design, having this visual landmark and enclosing the town within walls was necessary to differentiate it from the surrounding desert. Water was a key design element. Controlling the source of the water in the desert is symbolic of authority. We thought about the relationship between the city's layout and its water, which led to deciding to place the water source, which was likely discovered by the ancestors of the Gerudo, behind the throne and have it flow into the city as a symbol of the ruler's authority. However, I didn't think that this alone was enough to represent the Gerudo, so I designed facilities and interiors based on bridal training in Japan, which includes relationship and cooking classes. This expresses how these women think about the opposite sex in a somewhat naive manner, since they have had minimal contact up until now.

The people have a close relationship with the sand seals, their transportation in the desert, and Riju, their chief, has a lot of sand-seal toys in her room. By displaying her love of sand seals through these items, I was able to show her emotional youth through their childish designs.

LEAD ARTIST, STRUCTURAL: MANABU TAKEHARA

▷ City Waterways Rough Design

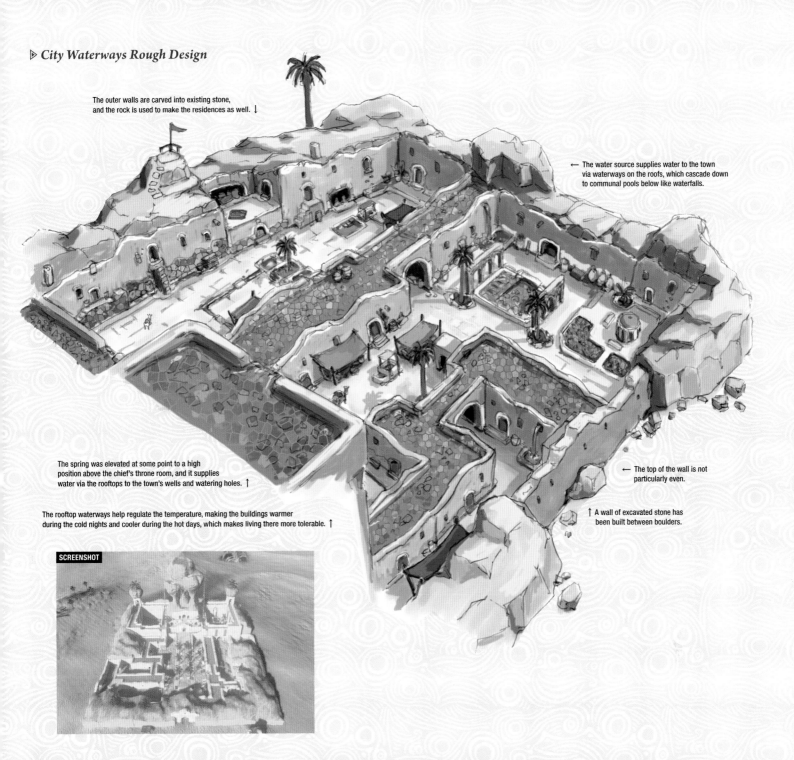

The outer walls are carved into existing stone, and the rock is used to make the residences as well. ↓

← The water source supplies water to the town via waterways on the roofs, which cascade down to communal pools below like waterfalls.

The spring was elevated at some point to a high position above the chief's throne room, and it supplies water via the rooftops to the town's wells and watering holes. ↑

← The top of the wall is not particularly even.

The rooftop waterways help regulate the temperature, making the buildings warmer during the cold nights and cooler during the hot days, which makes living there more tolerable. ↑

↑ A wall of excavated stone has been built between boulders.

SCREENSHOT

▷ Waterways Rough Design

▷ Waterways

▷ **Starlight Memories Interior Rough Design**

SCREENSHOT

▷ **Home Interior**

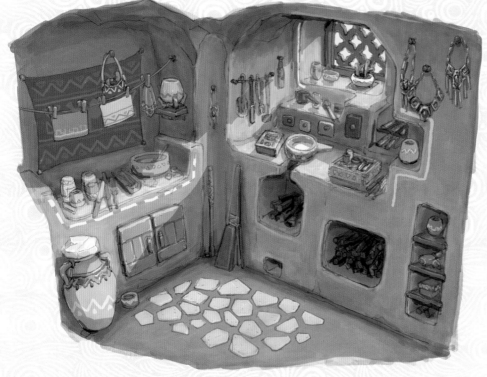

▷ **The Noble Canteen Exterior**

▷ **Stall**

▷ **Relationship Classroom Exterior**

▷ *Sand-Seal Rental Shop Rough Design*

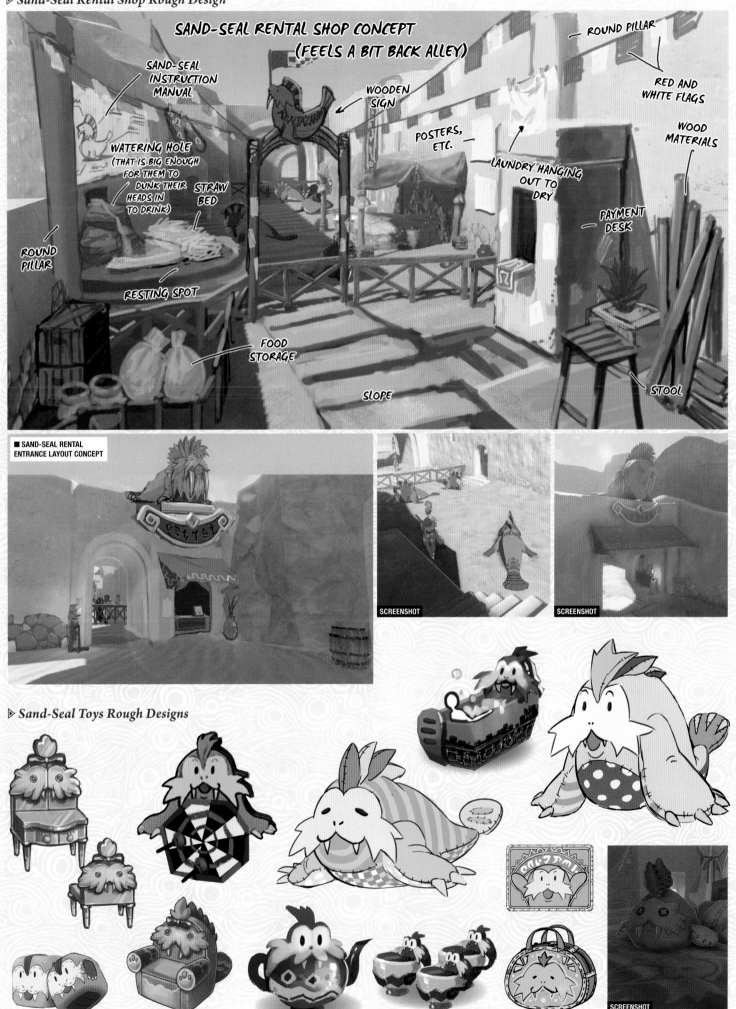

SAND-SEAL RENTAL SHOP CONCEPT
(FEELS A BIT BACK ALLEY)

SAND-SEAL INSTRUCTION MANUAL

WATERING HOLE (THAT IS BIG ENOUGH FOR THEM TO DUNK THEIR HEADS IN TO DRINK)

STRAW BED

WOODEN SIGN

ROUND PILLAR

RED AND WHITE FLAGS

POSTERS, ETC.

WOOD MATERIALS

LAUNDRY HANGING OUT TO DRY

PAYMENT DESK

ROUND PILLAR

RESTING SPOT

FOOD STORAGE

SLOPE

STOOL

■ SAND-SEAL RENTAL ENTRANCE LAYOUT CONCEPT

SCREENSHOT

SCREENSHOT

▷ *Sand-Seal Toys Rough Designs*

SCREENSHOT

▷ Riju's Throne & Decorations

▷ Royal Palace's Throne Room

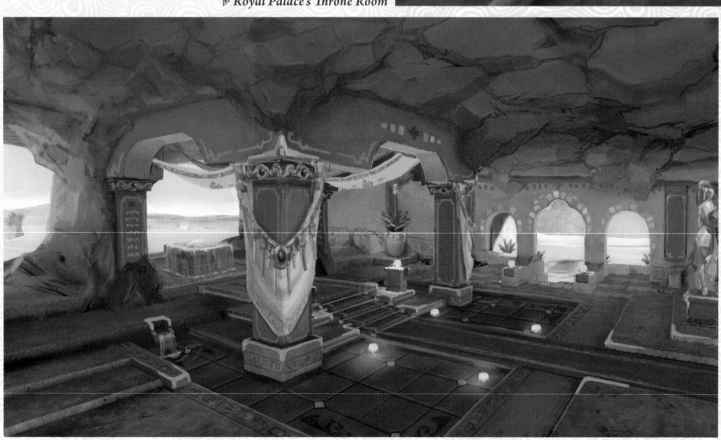

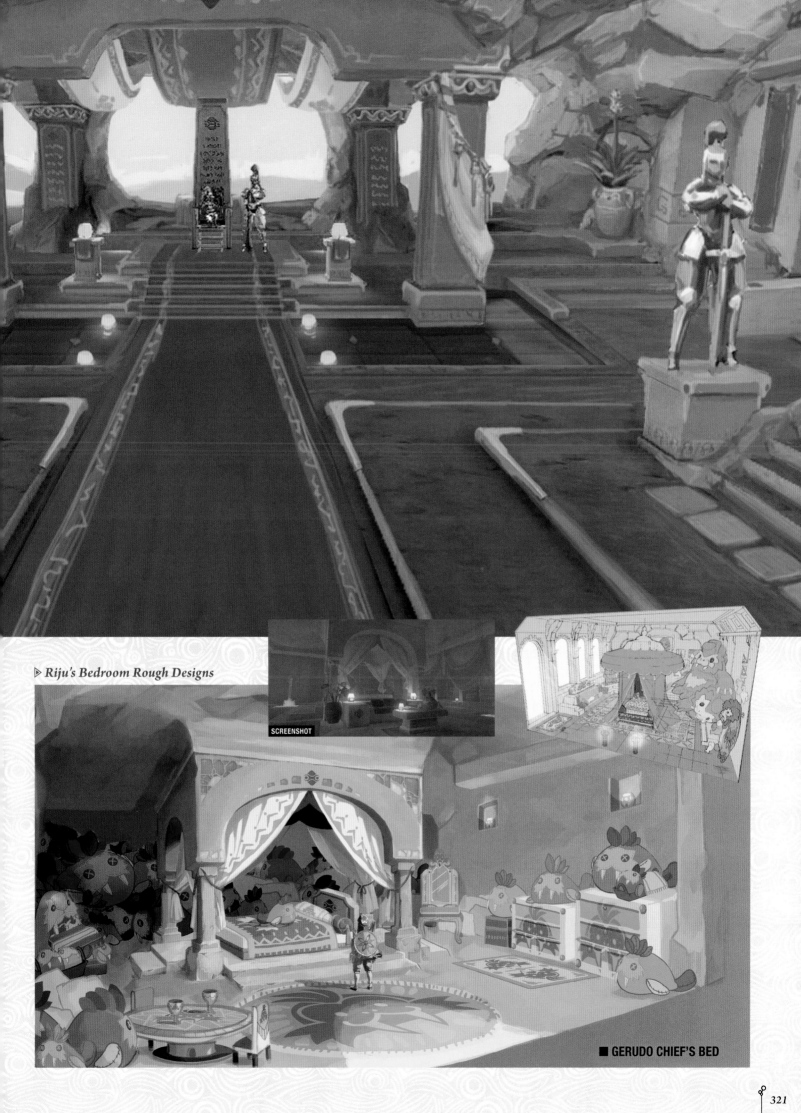

▷ *Riju's Bedroom Rough Designs*

SCREENSHOT

■ GERUDO CHIEF'S BED

GERUDO DESERT

This southwestern desert is known for dangerous sandstorms that even the Gerudo, experts when it comes to these phenomena, avoid. There are other facilities outside of Gerudo Town, including an observation post for watching the Divine Beast Vah Naboris and the Kara Kara Bazaar.

▷ *Observation Post*

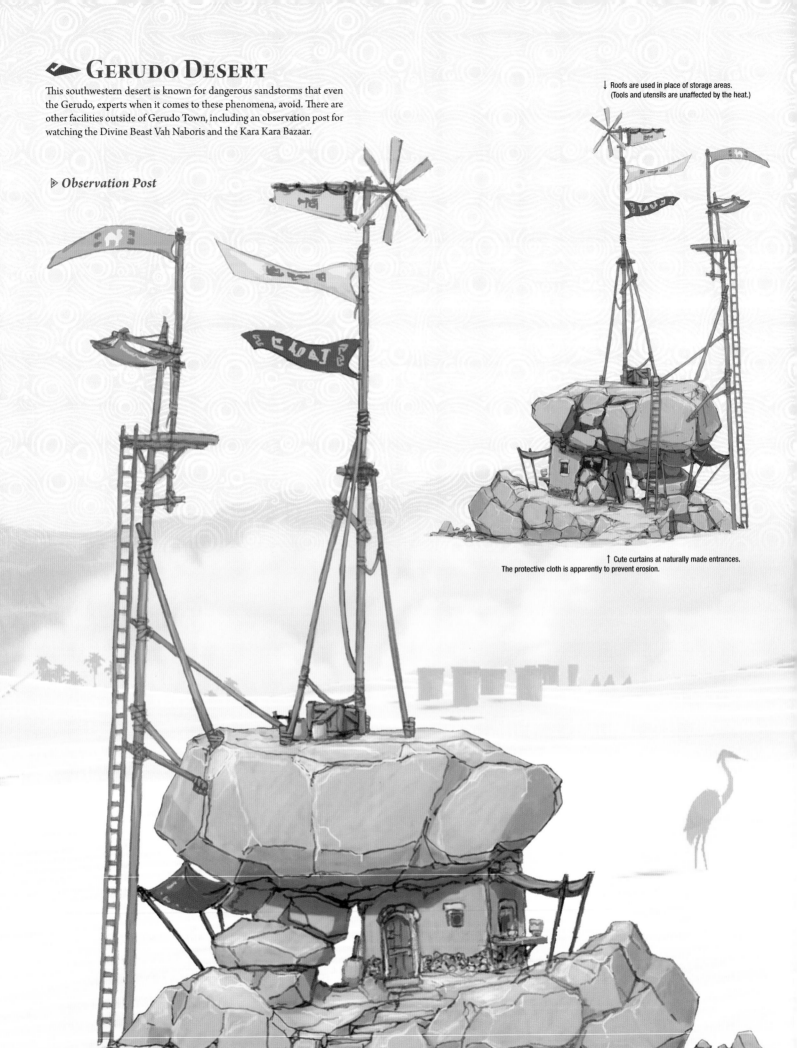

↓ Roofs are used in place of storage areas. (Tools and utensils are unaffected by the heat.)

↑ Cute curtains at naturally made entrances. The protective cloth is apparently to prevent erosion.

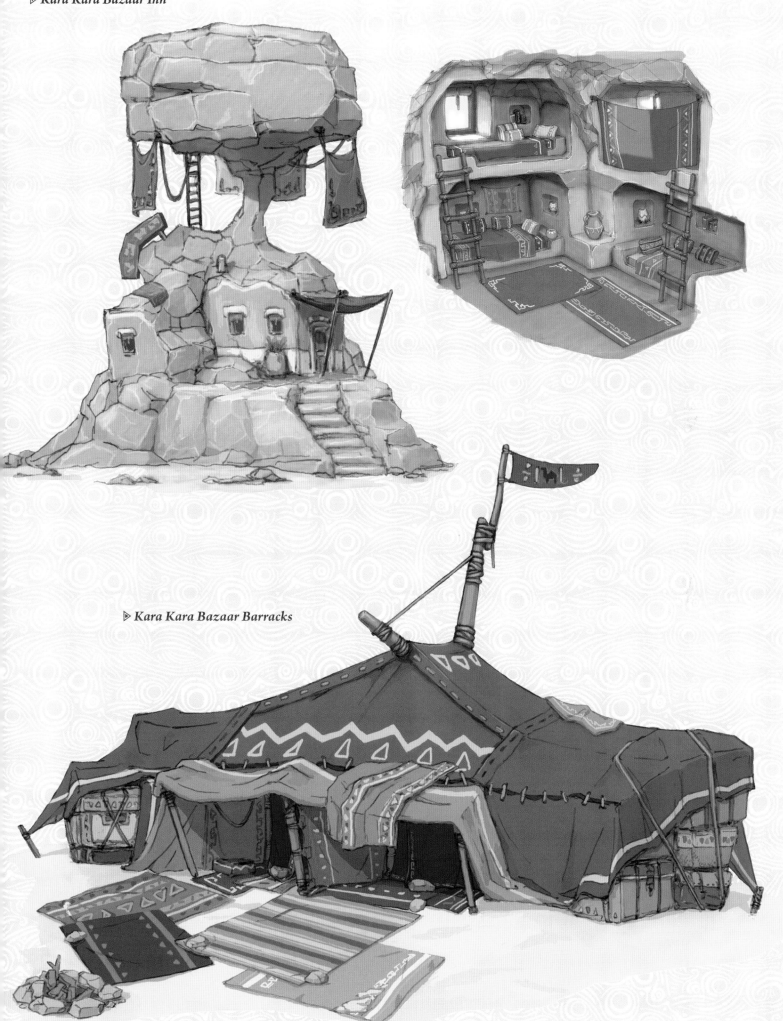

▷ *Kara Kara Bazaar Inn*

▷ *Kara Kara Bazaar Barracks*

▷ *East Gerudo Ruins*

▷ *Swordswoman Statue*

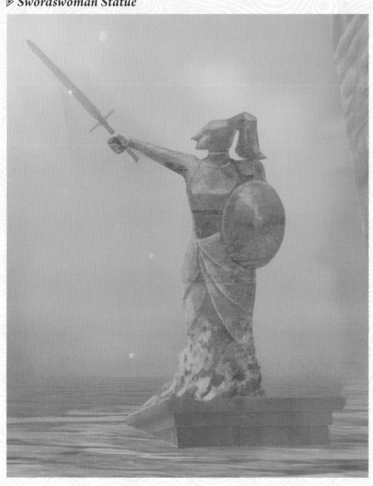

▷ *East Gerudo Ruins
Heroine Statue*

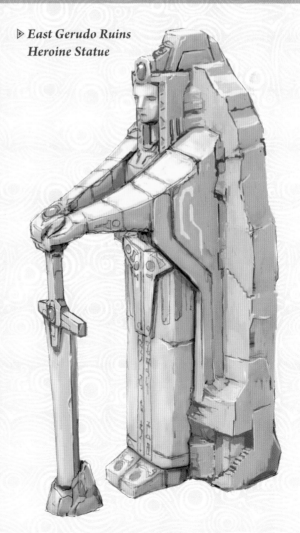

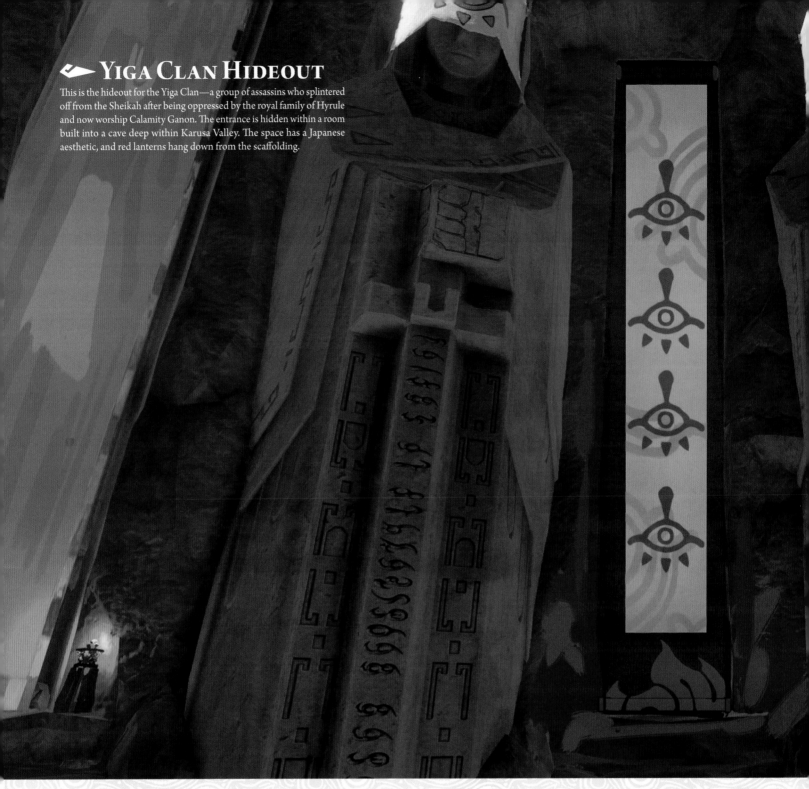

YIGA CLAN HIDEOUT

This is the hideout for the Yiga Clan—a group of assassins who splintered off from the Sheikah after being oppressed by the royal family of Hyrule and now worship Calamity Ganon. The entrance is hidden within a room built into a cave deep within Karusa Valley. The space has a Japanese aesthetic, and red lanterns hang down from the scaffolding.

▷ *Yiga Clan Hideout Hall*

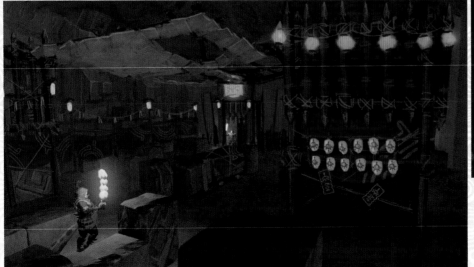

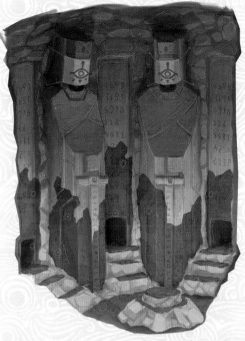

DEVELOPER'S NOTE

The Yiga Clan are descendants of the same people as the Sheikah who live in Kakariko Village. Those shared roots are why the design of the Yiga Clan Hideout contains the same Japanese motifs as Kakariko Village.

Their leader, Master Kohga, is kind of silly and has a goofy, likable personality. I also gave him elements from Japan's Bon Odori dance and temple festivals. The Yiga routinely gather around Master Kohga and hold nightly events with Mighty Bananas as prizes.

However, they are still assassins trying to dispatch the hero and who worship Calamity Ganon. I combined a number of elements into their design, including the fact that they exist in the shadows and have no hometown or village, only the Yiga Clan Hideout, which is actually an old Gerudo archaeological site that they snuck into and made their own.

LEAD ARTIST, STRUCTURAL:
MANABU TAKEHARA

▷ *Master Kohga's Room*

☜ GERUDO CANYON

This canyon is the only route connecting Greater Hyrule with the Gerudo Desert. Platforms built into the cliff sides were once used for excavation surveys, and there are man-powered elevators for moving goods. This is where the Divine Beast Vah Naboris was discovered a century ago.

▷ *Canyon Overview Rough Design*

▷ *Platform Rough Design*

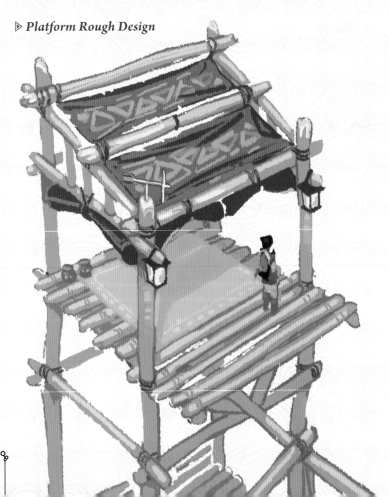

▷ *Elevator Rough Designs*

Top as seen from above.

SCREENSHOT

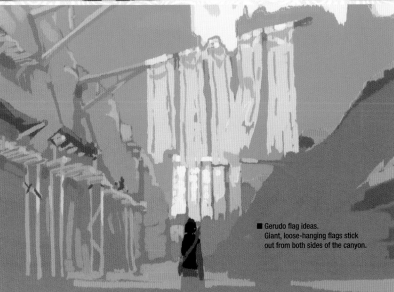

■ Gerudo flag ideas.
Giant, loose-hanging flags stick
out from both sides of the canyon.

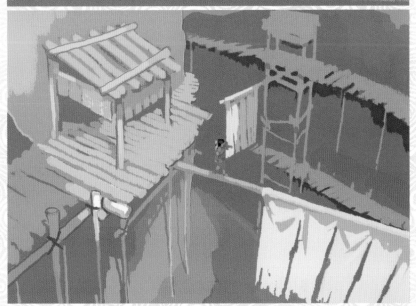

SCREENSHOT

SCREENSHOT

OTHER LOCATIONS
Gerudo

▷ Gerudo Summit

The summit of the Gerudo Highlands is covered in snow and has a massive stone sword plunged into it. There is a legend that this sword was once wielded by a forgotten eighth heroine, but that is dismissed as a myth—a folktale offshoot of the legend of the Seven Heroines passed down in the Gerudo region.

▷ The Sand-Seal Rally

The Sand-Seal Rally is a traditional competition where riders on shields pulled by sand seals wind their way through arches to reach the finish line. If Link beats Tali's race record, he will receive a trophy, and a new ancient shrine will reveal itself, but it won't be easy—Tali is the Sand-Seal Rally's world champion!

▷ Arbiter's Grounds

The Arbiter's Grounds is little more than a collection of stone pillars in the northwest of Gerudo Desert. The design of the pillars is different from all the other ruins of Hyrule, which indicates that it is uniquely Gerudo. The ruins are currently buried in the sand, and little is known of them. A Molduga inhabits the area.

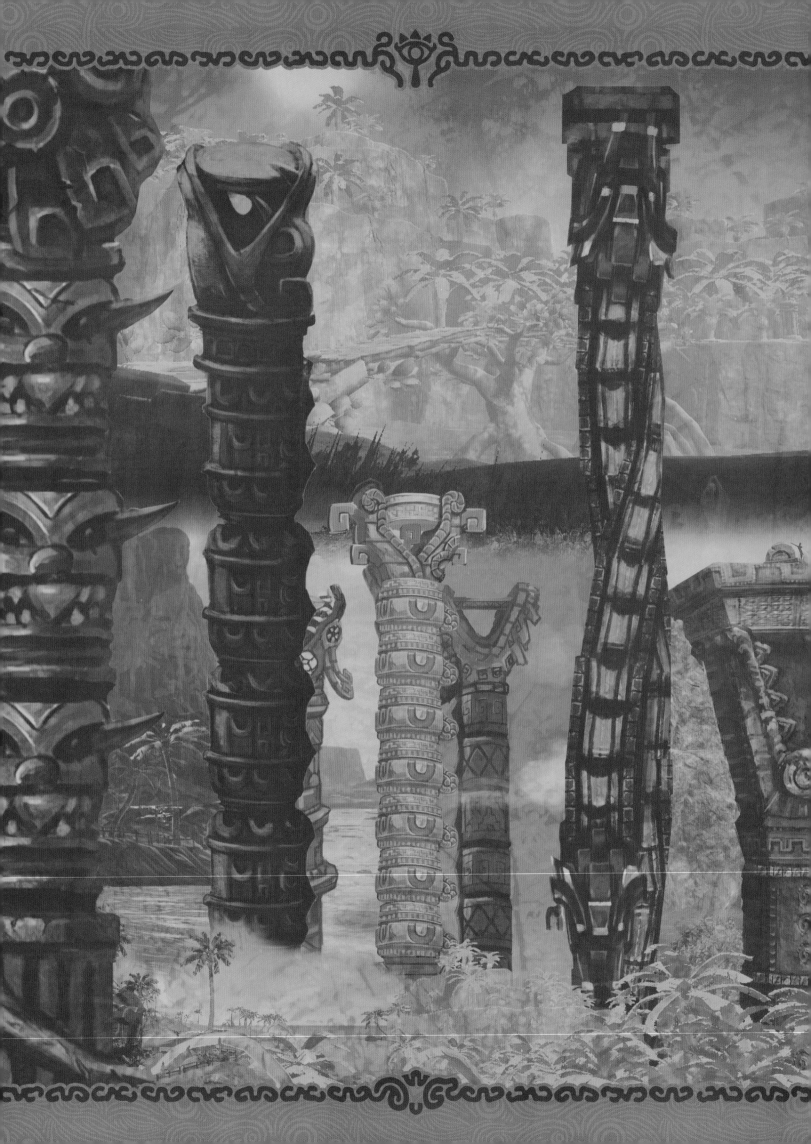

FARON
A Tropical Paradise with a Quaint Fishing Village

Faron stretches a great distance from east to west and occupies the southeastern corner of Hyrule. Its southern border is the sandy beach that extends along the coast of the Faron Sea, while the inland, northern portion is a large, thick jungle full of massive trees. The area is subtropical, so rainstorms are common.

Lurelin Village is a tiny fishing community on the coast and the only permanent settlement in the entire region, though there is a stable in the Fural Plain near the Faron Grasslands. There is an obstacle course for horses near the stable where riders compete and showcase their riding prowess.

LURELIN VILLAGE

This small fishing village along the coast is inhabited by fishermen who make a living off the Faron and Necluda seas. There is a market that sells fish, crab, and other goods, as well as a facility in town where Link can gamble rupees on a treasure chest game, which is what a number of the local fishermen do when they can't go to sea on rainy days.

▷ Village Overview Rough Designs

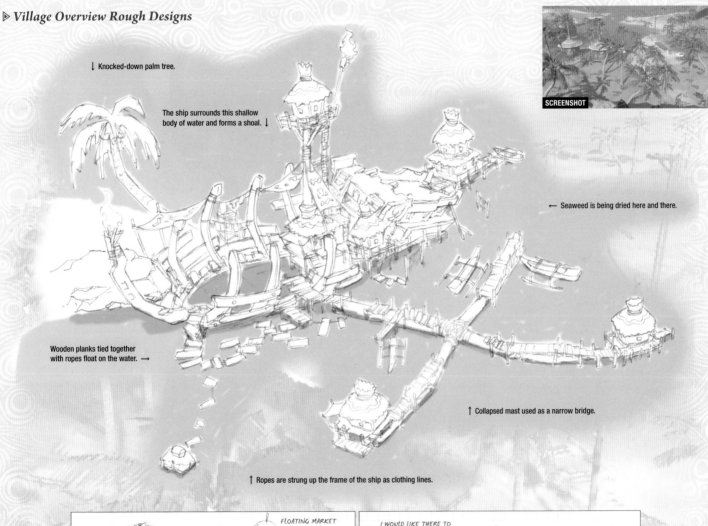

↓ Knocked-down palm tree.

The ship surrounds this shallow body of water and forms a shoal. ↓

← Seaweed is being dried here and there.

Wooden planks tied together with ropes float on the water. →

↑ Collapsed mast used as a narrow bridge.

↑ Ropes are strung up the frame of the ship as clothing lines.

SCREENSHOT

FLOATING MARKET

I WOULD LIKE THERE TO BE SOME PEOPLE WHO OCCASIONALLY PICK UP ANCIENT RELICS AND USE THEM.

LIGHT

▷ *Merchant Boat*

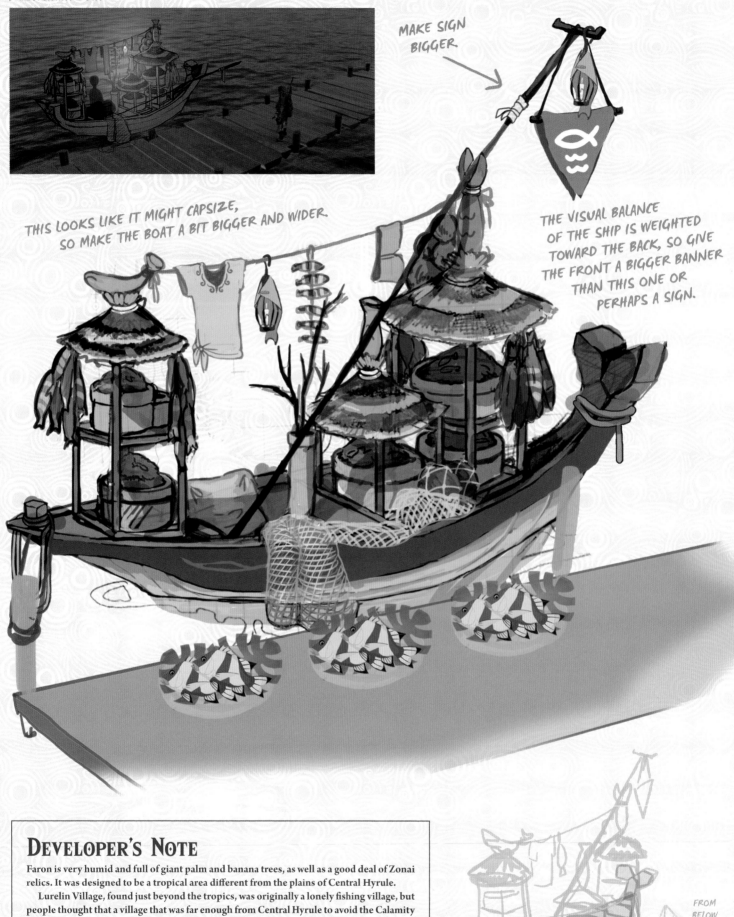

MAKE SIGN BIGGER

THIS LOOKS LIKE IT MIGHT CAPSIZE, SO MAKE THE BOAT A BIT BIGGER AND WIDER.

THE VISUAL BALANCE OF THE SHIP IS WEIGHTED TOWARD THE BACK, SO GIVE THE FRONT A BIGGER BANNER THAN THIS ONE OR PERHAPS A SIGN.

FROM BELOW

DEVELOPER'S NOTE

Faron is very humid and full of giant palm and banana trees, as well as a good deal of Zonai relics. It was designed to be a tropical area different from the plains of Central Hyrule.

Lurelin Village, found just beyond the tropics, was originally a lonely fishing village, but people thought that a village that was far enough from Central Hyrule to avoid the Calamity wouldn't be empty and that southern seas mean resorts. Because of that, the design changed to include a number of parasols and brightly colored fabrics.

By the way, there is a treasure chest game in this town, but the shop is full of books, which seems unusual for a place of that nature. As a result of gaining a wealth of knowledge from those books, the proprietor seems to have a unique philosophy.

LEAD ARTIST, STRUCTURAL: MANABU TAKEHARA

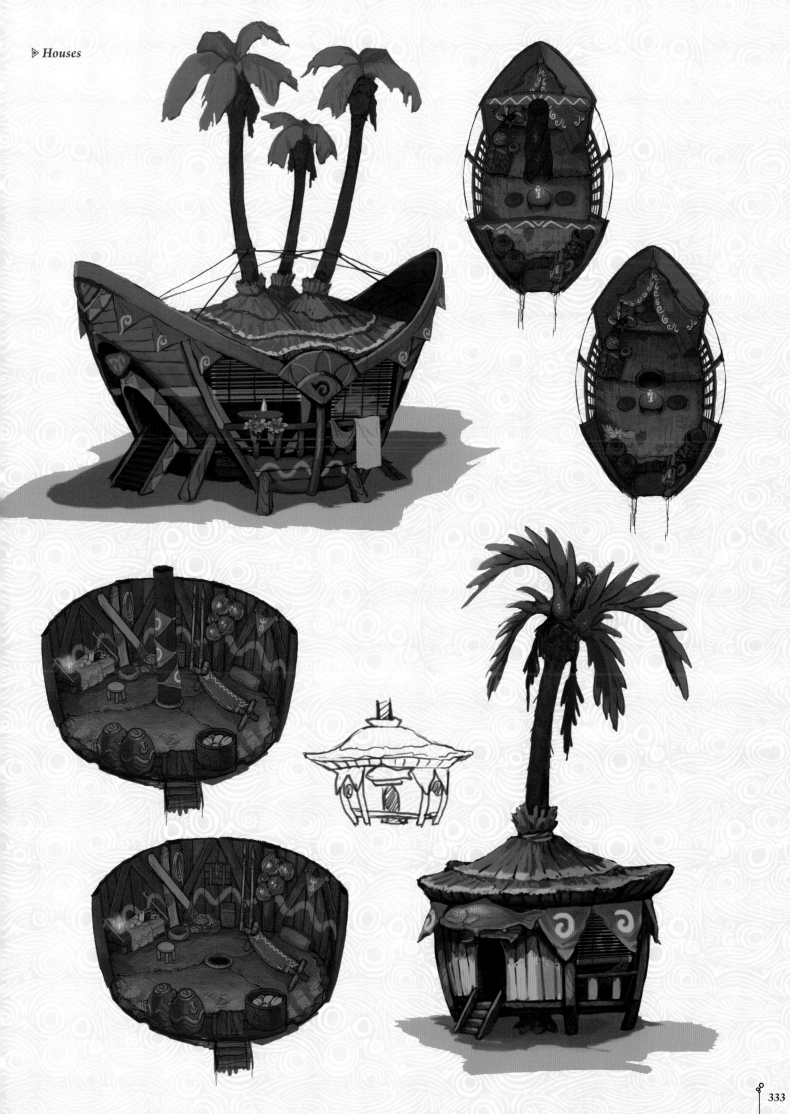

FOREST AREA

The area north of the coastline of the Faron Sea is a jungle where tall trees grow thick and mysterious stone statues are found. The massive Lake Floria takes up much of the eastern portion of the forested area and is spanned by the Floria Bridge.

▷ *Sarjon Bridge*

SCREENSHOT

▷ *Floria Bridge*

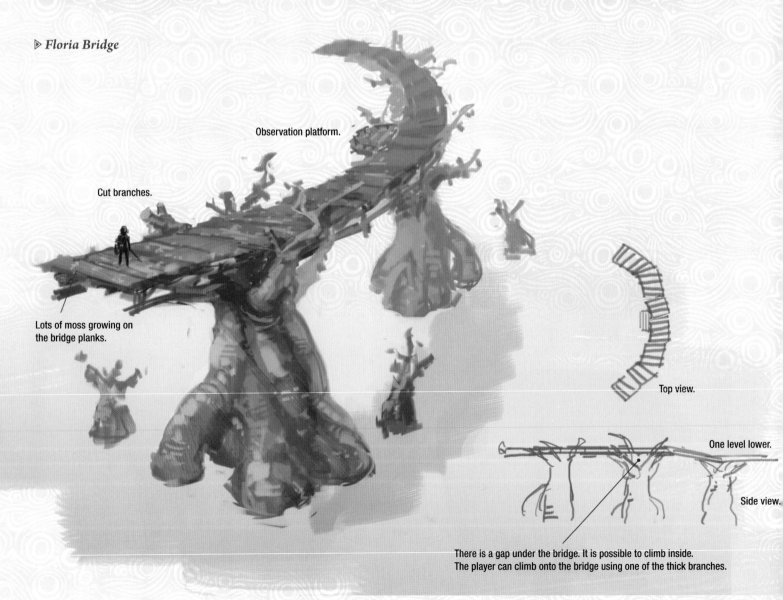

Observation platform.

Cut branches.

Lots of moss growing on the bridge planks.

Top view.

One level lower.

Side view.

There is a gap under the bridge. It is possible to climb inside.
The player can climb onto the bridge using one of the thick branches.

▷ Offering Spot

LIKE A FLAPPING PIGEON.

SAME AS STONE PLATFORM 01.

▷ Statue Rough Designs

HORN BROKE.

LINK

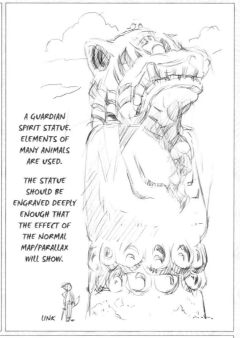

A GUARDIAN SPIRIT STATUE. ELEMENTS OF MANY ANIMALS ARE USED.

THE STATUE SHOULD BE ENGRAVED DEEPLY ENOUGH THAT THE EFFECT OF THE NORMAL MAP/PARALLAX WILL SHOW.

LINK

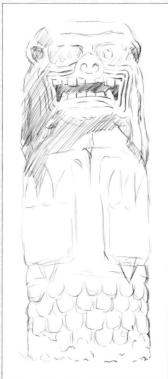

THESE ARE CARVED FROM SINGLE PILLARS OF STACKED STONE, SO NOTHING STICKS OUT BEYOND THE DIAMETER OF THE PILLAR.

SCREENSHOT

OTHER LOCATIONS
Faron

▷ Komo Shoreline

This quiet beach runs along the coast of the Faron Sea and has a naturally formed stone tunnel and tidal pools which make for breathtaking scenery. However, there are Guardians and Lizalfos about, so one must be on guard while exploring the area.

▷ Ubota Point

This plateau provides a spectacular view of the entire forest. You can gaze down into Lake Floria and marvel at the massive waterfall that feeds into it. Mighty Banana trees also grow here in clusters. Ubota Point is well worth the stop to rest and recover before once again venturing out on an arduous journey.

▷ Lover's Pond

Lover's Pond is a heart-shaped pool close to the summit of Tuft Mountain. It is said that one can find their true love by venturing there, so it has many visitors. There is a similar pond on Ebon Mountain in Necluda shaped like a broken heart.

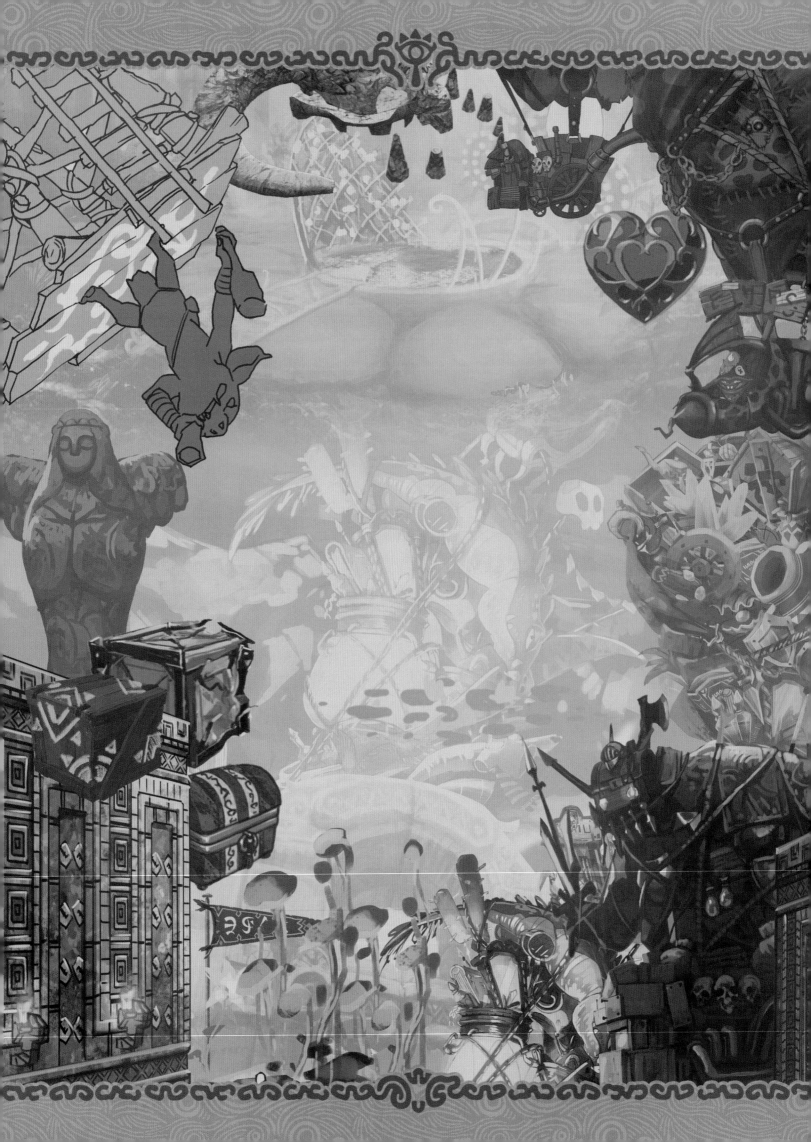

NOTABLE LOCALES
POINTS OF INTEREST
FOUND THROUGHOUT HYRULE

This section covers facilities (both stationary and mobile) and significant sites that are scattered throughout Hyrule but are not unique to any of the eight regions. These include monster dens, labyrinths, and the locations of people who provide critical items and support to Link on his adventure. This section also covers a variety of objects that Link can discover while exploring Hyrule.

STABLES

The stables exist to support adventurers and tourists traveling across Hyrule. They will board and care for wild horses that Link has tamed and registered and are great places to learn information about the surrounding area. Stables also function as inns where a traveler can rest from long days on the road.

▷ *Stable Rough Design*

■ INN IDEA 3B SIMPLE VERSION:
- INN MANAGED BY AN OWNER WHO HAS A LOVE OF HORSES.

SCREENSHOT

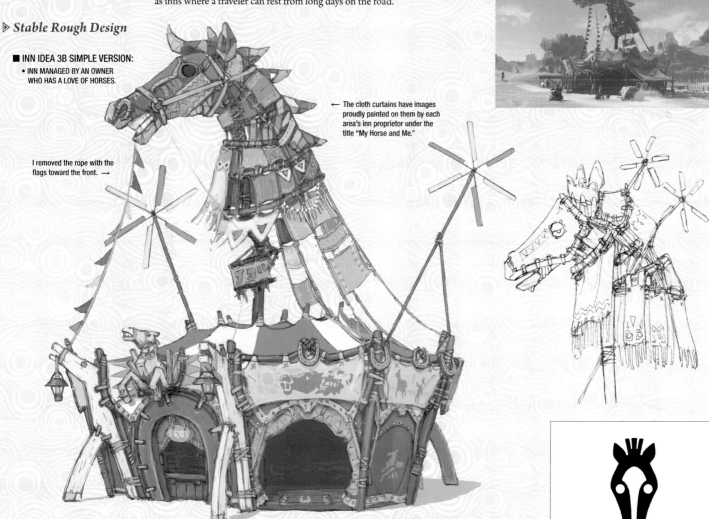

← The cloth curtains have images proudly painted on them by each area's inn proprietor under the title "My Horse and Me."

I removed the rope with the flags toward the front. →

DEVELOPER'S NOTE

I wanted to design a building that would stand out so that the stables would be visible from far away, even while running across the plains. I personally felt that they served a similar purpose to the Postman character who has appeared throughout the series, so I decided to make them completely over the top, placing a giant replica of a horse's head on top of the building. When the staff involved said that they liked it and told me that it was easy to understand, I went ahead with the design.

SENIOR LEAD ARTIST, LANDSCAPE: MAKOTO YONEZU

EPONA CO.

An established, all-encompassing horse goods maker with over one hundred and fifty years of experience.

Our company name comes from the cultural developments between man and horse born from the beloved partner of a legendary hero, which serves as our motto.

We handle everything from saddles and bridles to fine items like brushes and riding wear.

GREAT FAIRY FOUNTAINS

These pools of water are where the Great Fairies live, and Link can visit them if he wants them to enhance his armor. When Link first visits the Great Fairy Fountains, they will look like giant, sealed flower buds—dormant due to the Great Fairies having lost their power. They will bloom into beautiful flowers once Link has paid tribute in the form of rupees, and the restored Great Fairies will emerge. They are found in four places: near Kakariko Village in Necluda, near Kaepora Pass in Akkala, on Piper Ridge in Hebra, and inside a giant fossil in Gerudo.

■ ARMOR ENHANCEMENT FAIRY SPRING: FAIRY SIZE COMPARISON (This fairy is not the final version.)

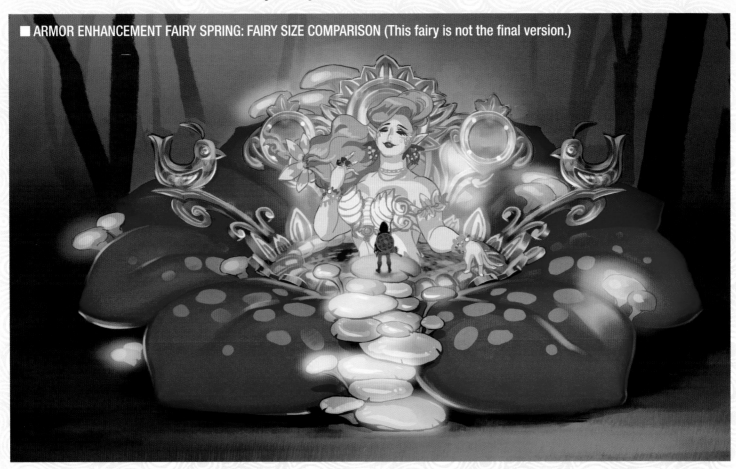

Having wrinkles here may make it seem thicker.

▷ *Bud Rough Design*

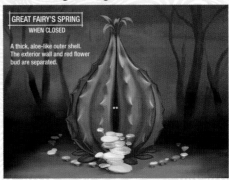

GREAT FAIRY'S SPRING
WHEN CLOSED

A thick, aloe-like outer shell. The exterior wall and red flower bud are separated.

SCREENSHOT

▷ *Fountain Rough Designs*

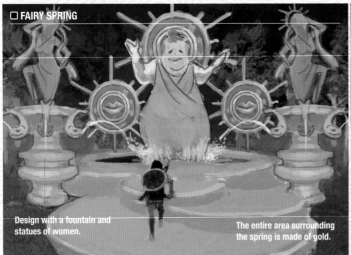

□ FAIRY SPRING

Design with a fountain and statues of women.

The entire area surrounding the spring is made of gold.

SPRING DESIGN CONCEPT 3: OVER-THE-TOP COMBINATION OF IDEAS 1 AND 2.

SPRING DESIGN 5: A CIRCUS ATMOSPHERE. THE DECORATIONS ARE BASED ON FORGING HAMMERS.

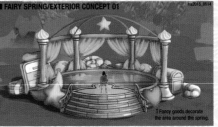

■ FAIRY SPRING/EXTERIOR CONCEPT 01

† Fancy goods decorate the area around the spring.

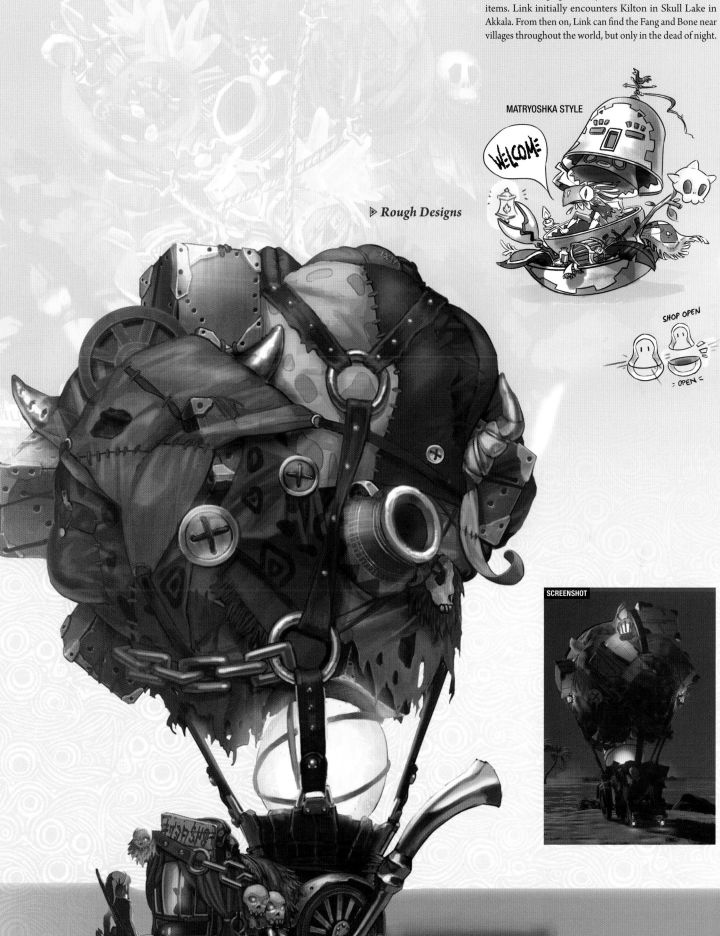

FANG AND BONE

This mobile shop operated by Kilton stocks monster-related items. Link initially encounters Kilton in Skull Lake in Akkala. From then on, Link can find the Fang and Bone near villages throughout the world, but only in the dead of night.

MATRYOSHKA STYLE

WELCOME

▷ *Rough Designs*

SHOP OPEN

OPEN

SCREENSHOT

Monster Strongholds

Groups of monsters like Bokoblins or Moblins construct strongholds to better defend against enemies and have a safe place to sleep. They build them using materials found around ruins or stolen from people in the area. Monsters will use large trees to construct their forts or occupy large, skull-shaped rocks—Lizalfos will even build theirs on water. The construction and materials vary based on the region in which the strongholds are created.

ENEMY BASE CONCEPT — BONE DECORATIONS ARE HUNG ON WOOD.

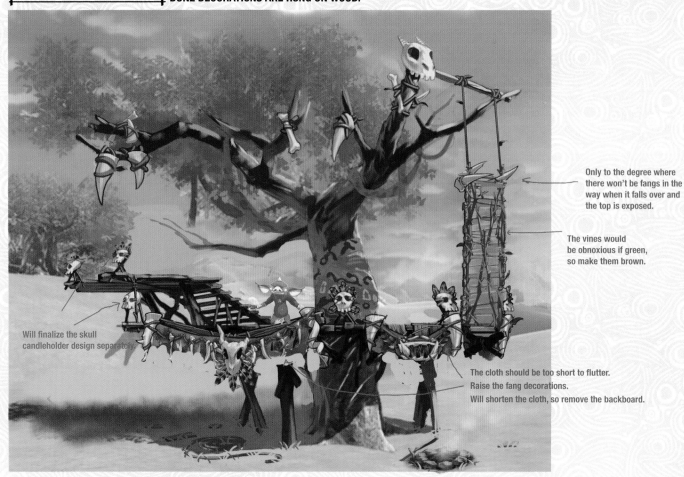

Only to the degree where there won't be fangs in the way when it falls over and the top is exposed.

The vines would be obnoxious if green, so make them brown.

Will finalize the skull candleholder design separately.

The cloth should be too short to flutter.
Raise the fang decorations.
Will shorten the cloth, so remove the backboard.

ENEMY BASE CONCEPT

DIFFERENT ANGLE.

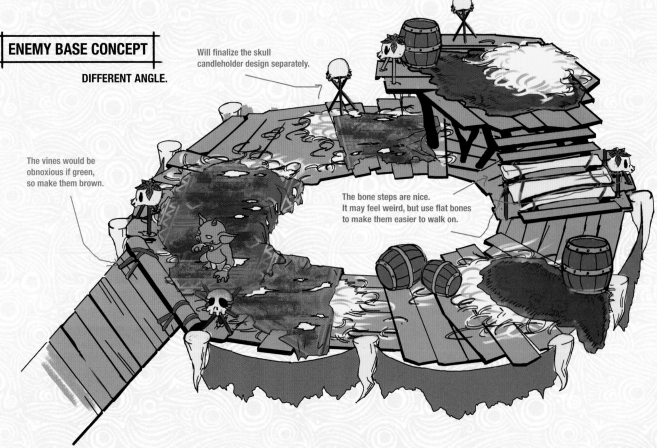

Will finalize the skull candleholder design separately.

The vines would be obnoxious if green, so make them brown.

The bone steps are nice. It may feel weird, but use flat bones to make them easier to walk on.

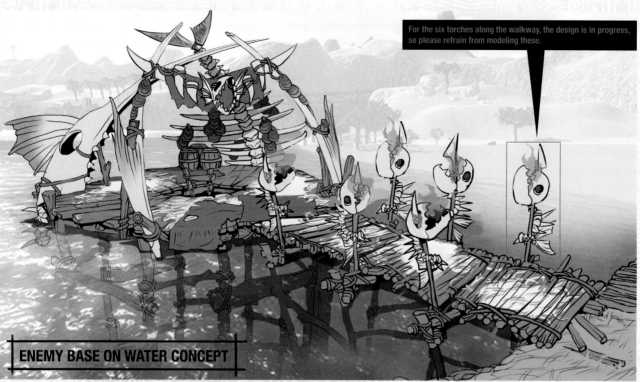

For the six torches along the walkway, the design is in progress, so please refrain from modeling these.

ENEMY BASE ON WATER CONCEPT

OVERLAID WOOD — Put the wooden platform here.

It may be too unstable if they are just laid on top of each other, so cut out a bit and fit them together so that they form a joint.

BOTTOM

TOP
↑ They are using a board stolen from people, so it has nails in it and is properly constructed.

← Affixed to overlaid wood with rope at the four corners.

PLATFORM — Rope

PILLAR
The wood is whittled so that they fit together. It might be nice for the bark to be whittled down and look a bit rough.

RUINED HOUSE

These Hylian homes were destroyed in the Great Calamity and have fallen into such disrepair that only portions of the walls and foundations remain. There are occasionally still fragments of furniture within.

HYLIAN BUILDING RUINS
- Romanesque style (thick walls, small windows).
- Has pillars but the structure looks like it is supported by walls, and those still remain.
- Should feel like a residence for priests and their congregation, or those related to Hylian royalty.
- Decorated like a slightly less dramatic Temple of Time.

Broken at its base, this wall is leaning on the structure.

Metal door (can use against enemies).

▷ *Rough Designs*

WOODEN HOUSE:
- Warped.
- Framework. Sunshine filters through foliage.
- Detached.
- Foundation made of stone.
- Broken utensils, tattered fabric, etc. Lots of signs of daily life.

Completely broken and only a pile of rubble is left.

I also want there to be a narrow tree every once in a while . . .

Exterior and interior were made by applying a thin veneer to the wood.

Destroyed roof.

Pot that can be placed over lit firewood and used for cooking.

LOMEI LABYRINTHS

These giant mazes were built long, long ago. They appear to have some similarities to the Zonai Ruins in Faron, but whether or not there is a connection between them is unknown. Regardless, both were constructed in areas that are inaccessible to the average person.

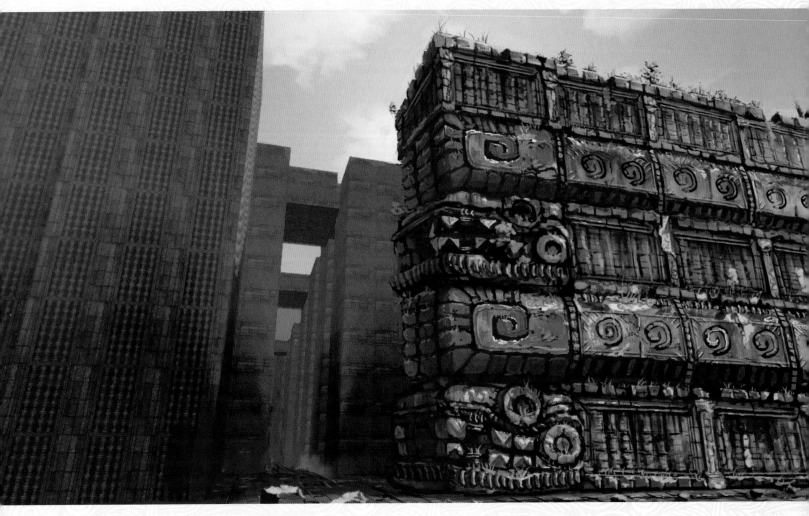

▷ *Rough Designs*

GIANT MAZE WALL

Candlestick details proposal.

Top

side front back

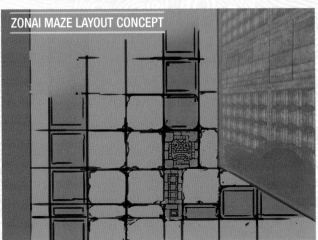

ZONAI MAZE LAYOUT CONCEPT

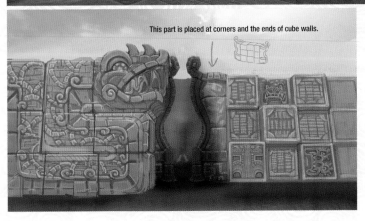

This part is placed at corners and the ends of cube walls.

DEVELOPER'S NOTE

As we were in the process of creating the cities and people of every region of Hyrule, we thought that if we showed fragments of a civilization that collapsed long ago, it would make the world feel more real. That's why we added Zonai relics throughout Hyrule.

The ruins are primarily animal themed, but with the history of the Triforce from an ancient perspective in mind. The designs are symbolic—using dragons (courage), owls (wisdom), and boars (power). And, yes, their name is a pun. "Zonai" is a take on *nazo*, a word meaning "mystery" in Japanese. [*laughs*]

SENIOR LEAD ARTIST, LANDSCAPE: MAKOTO YONEZU

ZONAI TOWER

These towers can be found looming above the surrounding terrain throughout the world. They are many times taller than any given individual, and their purpose is an utter mystery.

▷ Rough Designs

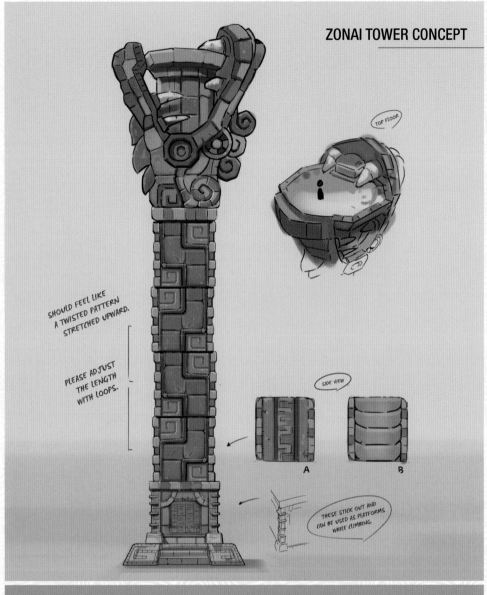

ZONAI TOWER CONCEPT

TOP FLOOR

SHOULD FEEL LIKE A TWISTED PATTERN STRETCHED UPWARD.

PLEASE ADJUST THE LENGTH WITH LOOPS.

SIDE VIEW

A

B

THESE STICK OUT AND CAN BE USED AS PLATFORMS WHILE CLIMBING.

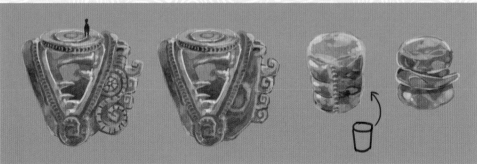

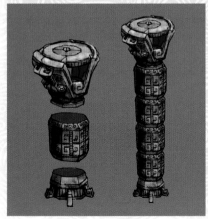

SCREENSHOT

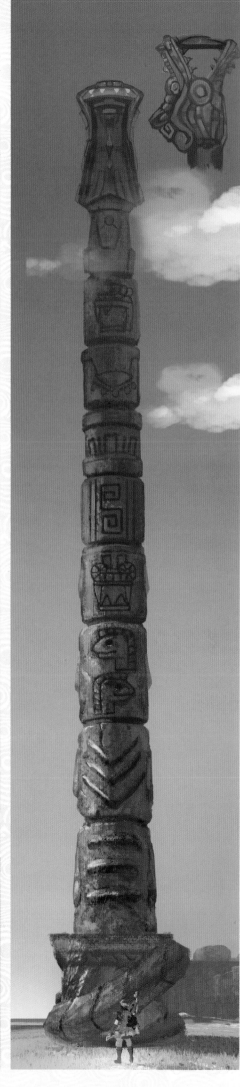

GODDESS STATUES

These are stone statues of the goddess Hylia, who is worshiped throughout Hyrule. They can be found in each of the major villages, but there are also versions large and small in every part of the realm.

SCREENSHOT

▷ *Heart Container & Stamina Vessel*

▷ *Rough Designs*

LEVIATHAN BONES

Three of these massive fossils can be found in different locations in Hyrule and are many times larger than a person. The skeletons resemble giant whales which, according to legend, existed in ancient times.

TREASURE CHESTS

WOODEN BOXES

▷ Normal

▷ Volcano

▷ Coast

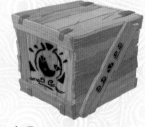

▷ Snowy Mountain

▷ Jungle

▷ Desert

FLAGS

KINGDOM OF HYRULE MILITARY FLAG

A INCREASED THE AMOUNT OF YELLOW.

THIS! → **B** THE FABRIC WAS ORIGINALLY LUSTROUS, SO I MADE IT INTO A JACQUARD WEAVING-LIKE STYLE.

C ONLY BLUE AND YELLOW.

D NO PATTERN.

GOAL POST CONCEPT FOR MINIGAME

Shorter than Hylian flag.

PLEASE MATCH THE COLORING AND FEEL OF THE BASE TO THE BRIDGE OF HYLIA.

PATTERN OF RELIEF.

OTHER LOCATIONS

Notable Locales

▷ Bottomless Swamp

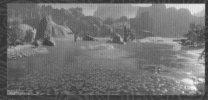

This pond is filled with muddy water. Unlike other pools, it is impossible to swim here. If Link enters the swamp, he will gradually sink and potentially drown.

▷ Garbage Dump

Piles of trash can be found near places like monster strongholds, but they pale in comparison to the largest of the garbage dumps, which is near the Ishto Soh Shrine. It must be heaven to the many flies that call it home.

▷ Lodges

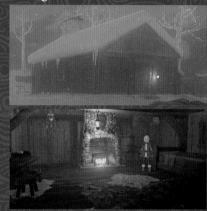

These small huts contain a bed and a desk, and can serve as a place to rest. They are frequently found in severely cold and snowy climates where there aren't any nearby villages. Many are inhabited by Hylians who prefer to isolate themselves from the rest of the world, but some are used as rest stops for travelers. They often contain diaries and other things that have been left behind, making it possible to gain some insight into their residents.

▷ Stone Statues

The world is filled with stone statues shaped like Hylians, which often take the form of the goddess or travelers' guardian deities. Their purpose or the intention with which they were placed is unclear, but some serve a critical role as keys to ancient shrines.

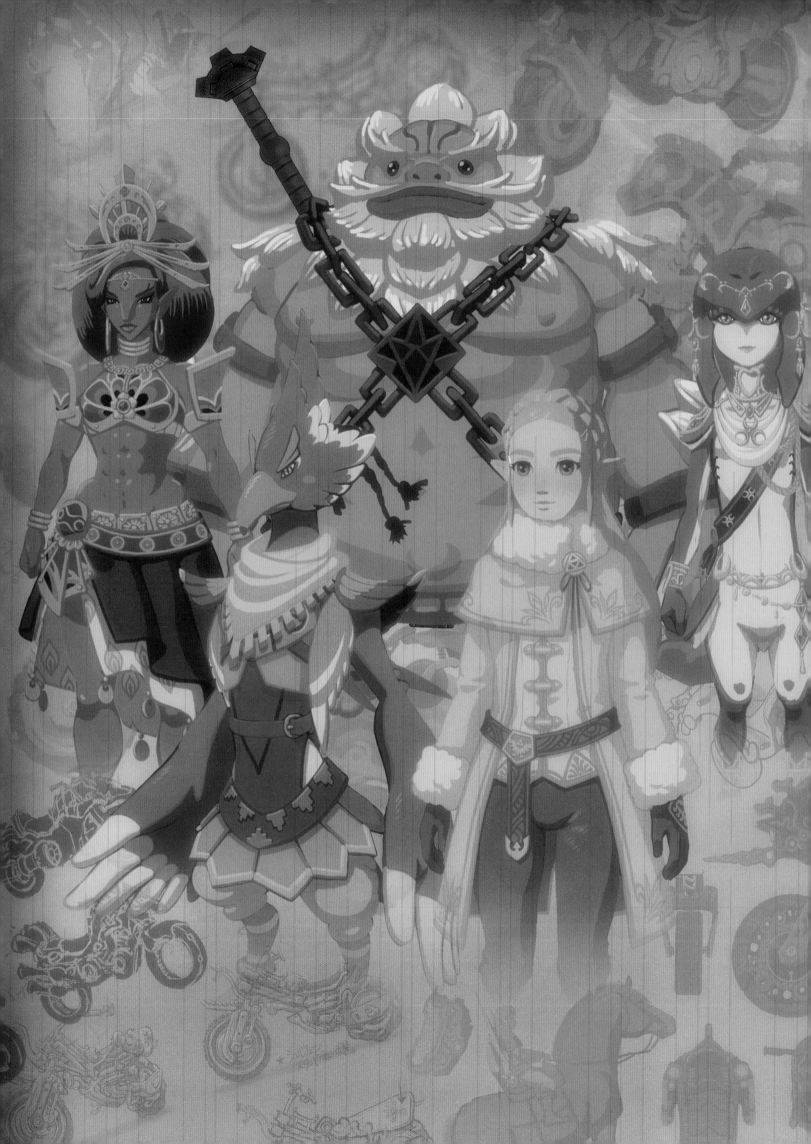

THE CHAMPIONS' BALLAD
A TALE OF THE UNKNOWN PAST

In this section, we will explore the elements seen in DLC Pack 2, "The Champions' Ballad," released in December 2017. The story depicts the events prior to the Great Calamity a century ago and delves deeper into what happened than the few memories that Link can recall. "The Champions' Ballad" shows how Mipha, Daruk, Revali, and Urbosa were chosen to be Champions, the predicaments they overcame, and their relationships with Princess Zelda.

🖌 PRINCESS ZELDA (DLC PACK 2)

This is the outfit Princess Zelda wears when she visits cold regions. The design uses white predominantly for the base, but the royal blue used for the ribbon on her chest and the lining of her coat indicates her royal lineage.

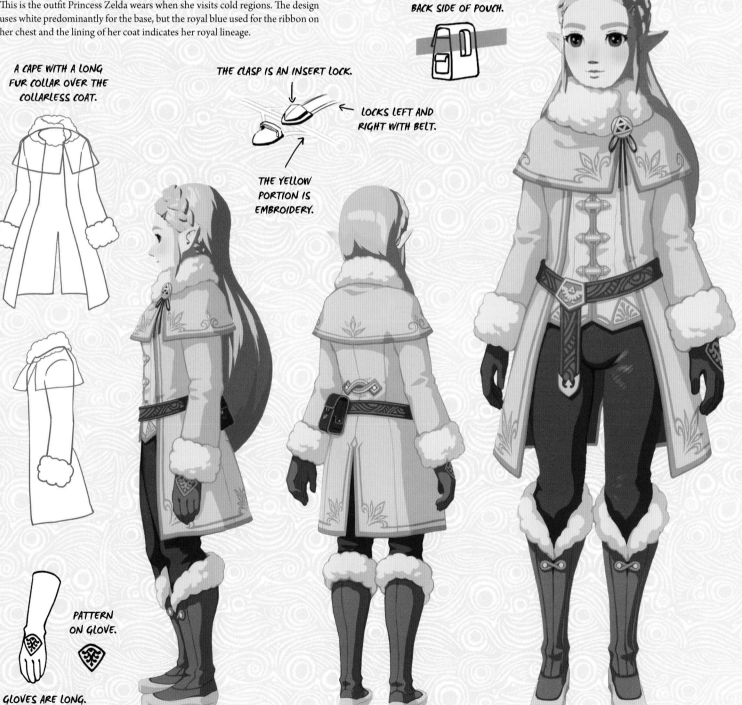

A CAPE WITH A LONG FUR COLLAR OVER THE COLLARLESS COAT.

BACK SIDE OF POUCH.

THE CLASP IS AN INSERT LOCK.

LOCKS LEFT AND RIGHT WITH BELT.

THE YELLOW PORTION IS EMBROIDERY.

PATTERN ON GLOVE.

GLOVES ARE LONG.

MIPHA (DLC PACK 2)

This is how Mipha appeared before donning a Champion's blue sash. In addition to her tiara, fitting for a Zora princess, she wears an ultramarine blue sash—a different color than King Dorephan's or Sidon's.

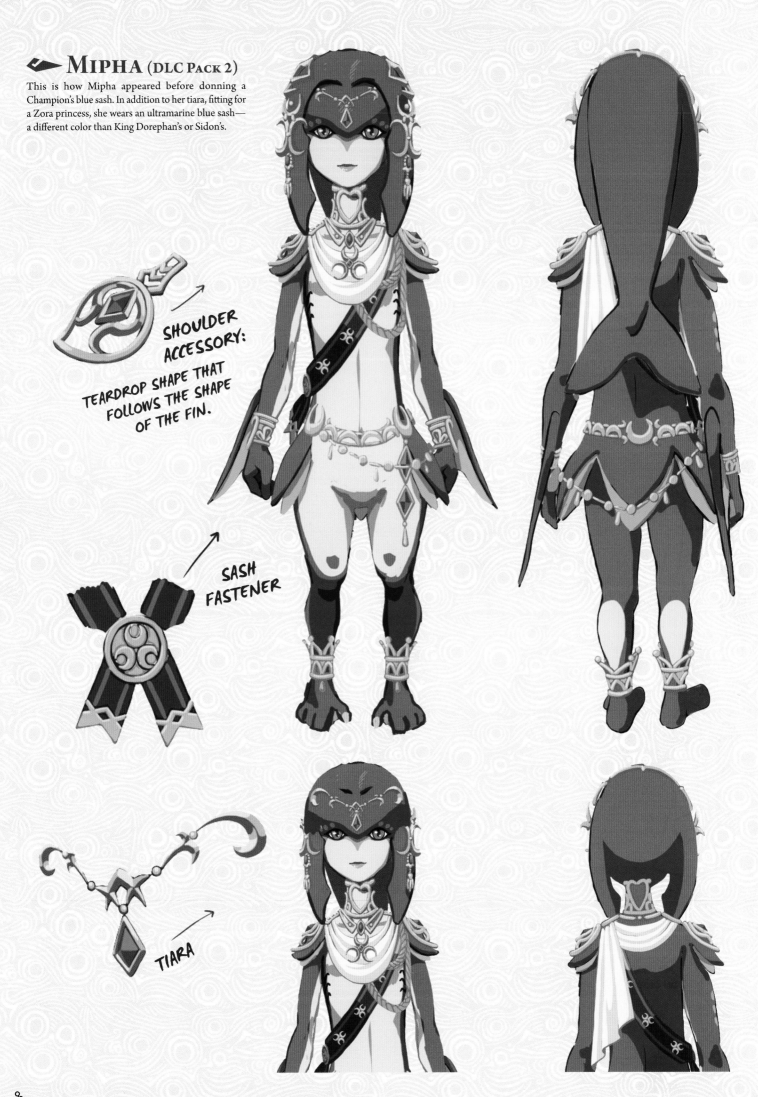

SHOULDER ACCESSORY:
TEARDROP SHAPE THAT FOLLOWS THE SHAPE OF THE FIN.

SASH FASTENER

TIARA

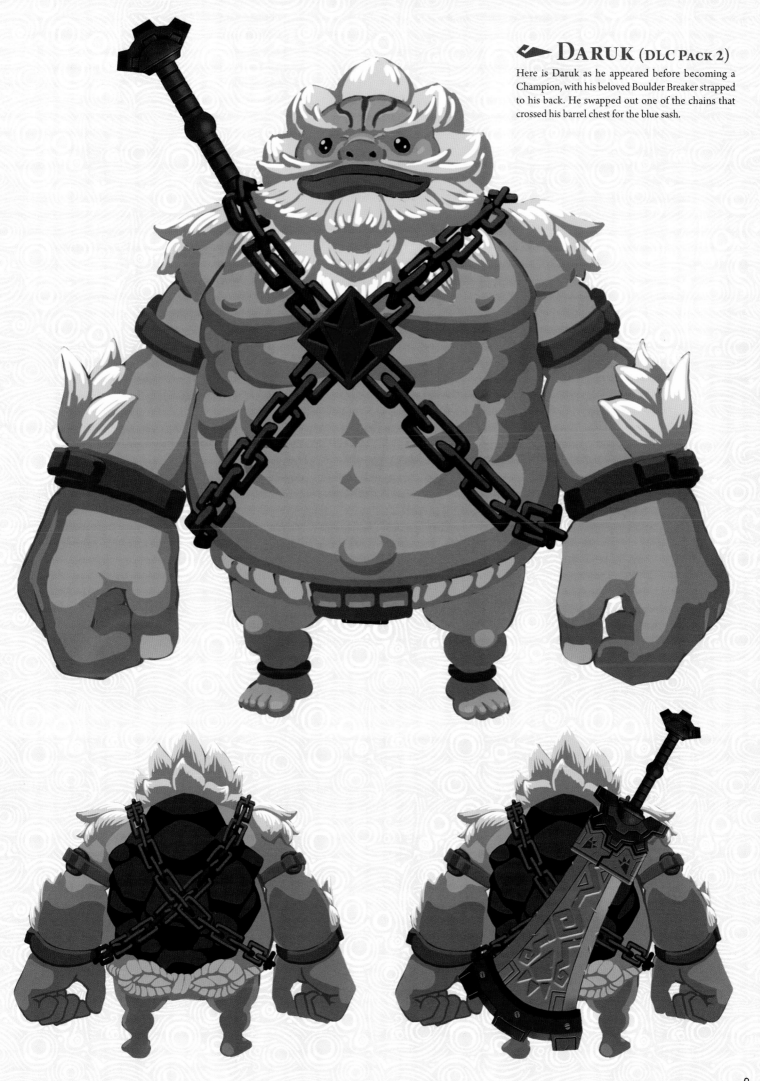

DARUK (DLC PACK 2)

Here is Daruk as he appeared before becoming a Champion, with his beloved Boulder Breaker strapped to his back. He swapped out one of the chains that crossed his barrel chest for the blue sash.

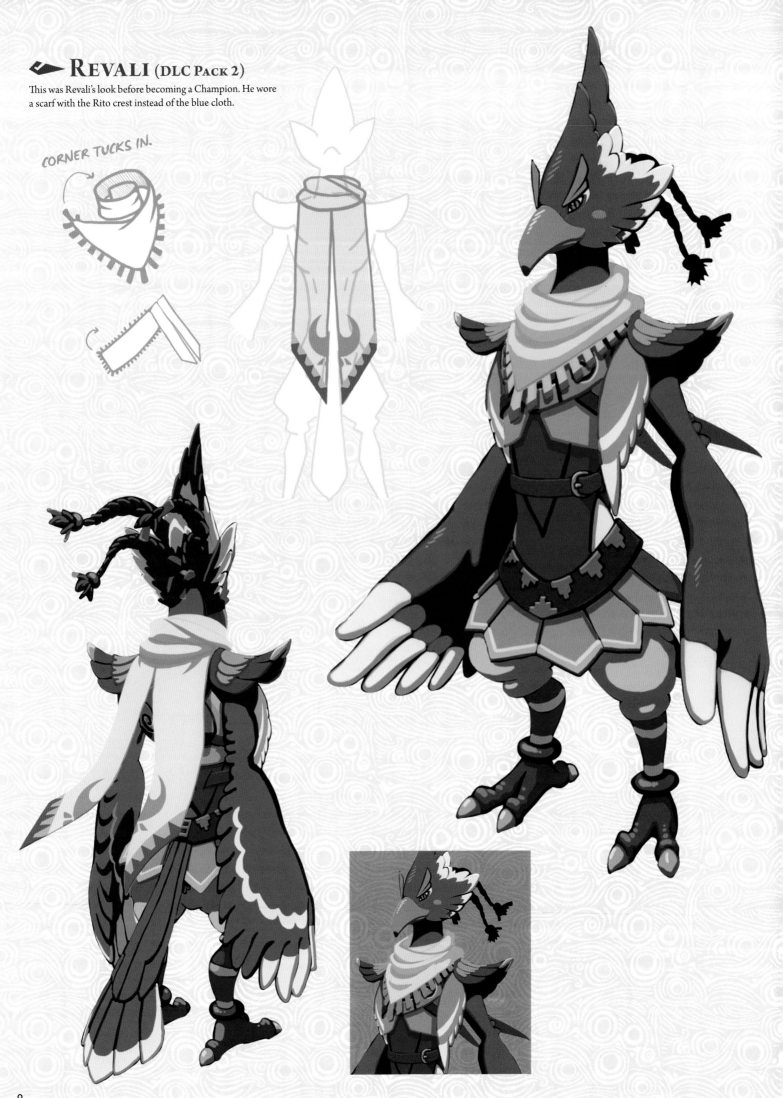

REVALI (DLC PACK 2)

This was Revali's look before becoming a Champion. He wore a scarf with the Rito crest instead of the blue cloth.

CORNER TUCKS IN.

URBOSA (DLC Pack 2)

This is how Urbosa looked when she was chief of the Gerudo. As with the current chief, Riju, Urbosa wore a black skirt which was embroidered with the crest of the Gerudo and a crown demonstrating her status as chief.

CENTER OF THE CROWN.

SAME DESIGN AS THE ONE ON RIJU'S FOREHEAD. NO GEM.

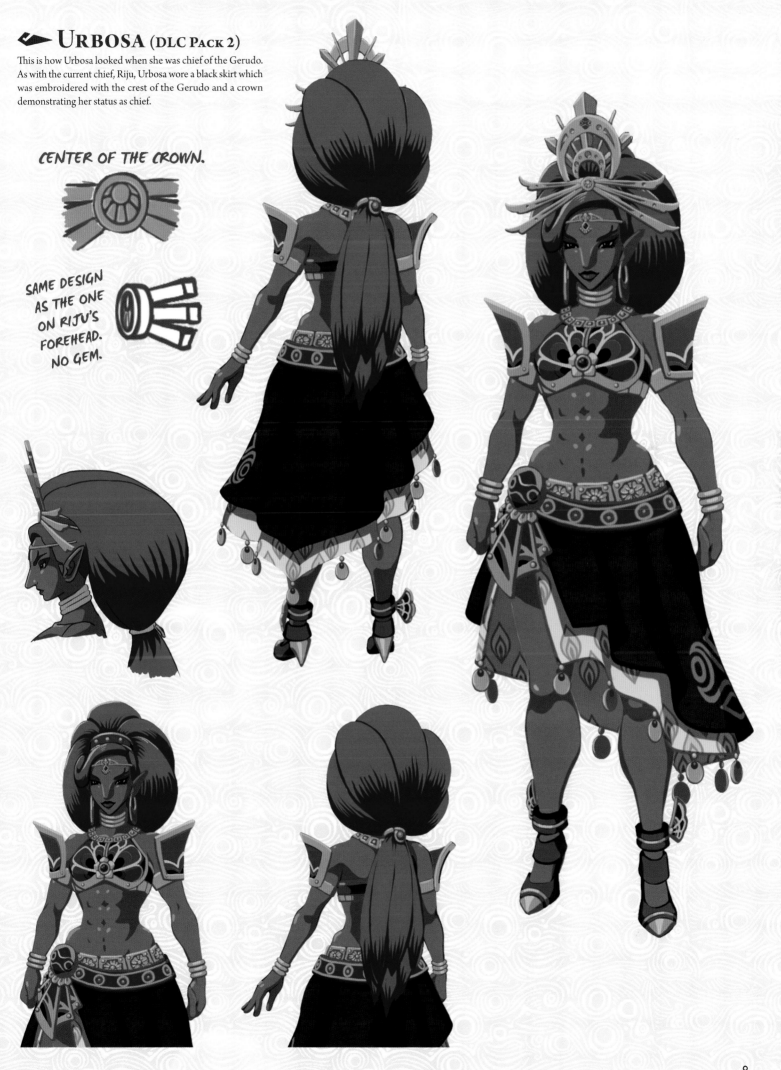

MASTER CYCLE ZERO (DLC PACK 2)

This two-wheeled vehicle is made of ancient materials. Similar to a horse, it can carry a rider quickly across the land.

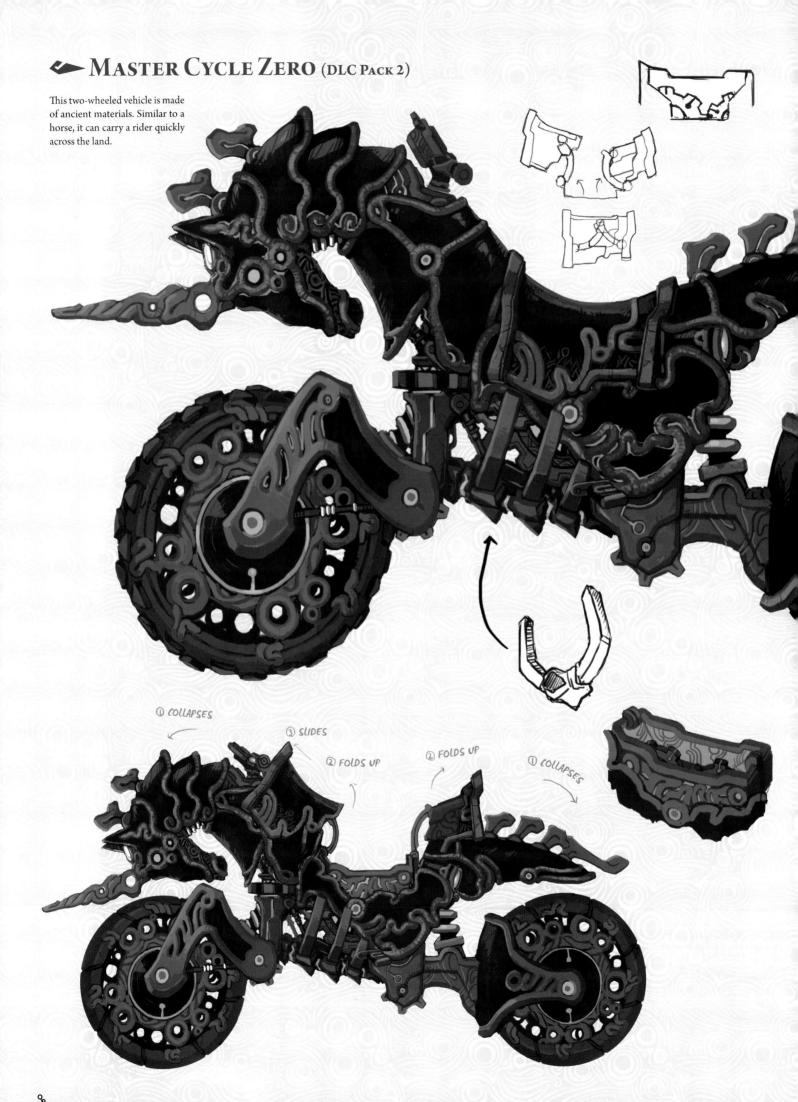

① COLLAPSES

② FOLDS UP

③ SLIDES

② FOLDS UP

① COLLAPSES

FROM LEFT FROM RIGHT

HANDLEBARS

FRONT

A

B

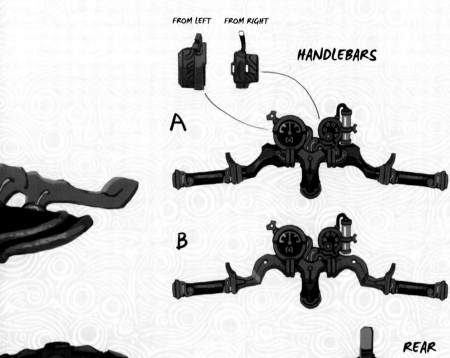

REAR

▷ **Rough Designs**

↑ FROM ABOVE

Three legs fold up when running. ↑

HORSE

NEIGH

WHEN IT STOPS ROLLING...

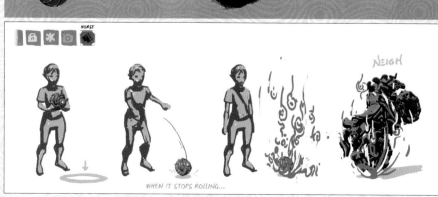

↑ Supply hatch opens and a plate of light appears.

SIDON (DLC PACK 2)

This is Sidon as he appeared just over one hundred years ago when he was still a child. Compared to the Zora children in the present (page 112), he has a uniquely long head fin. His body is small, so he wears few accessories, but he was already wearing a whistle on his chest at this point.

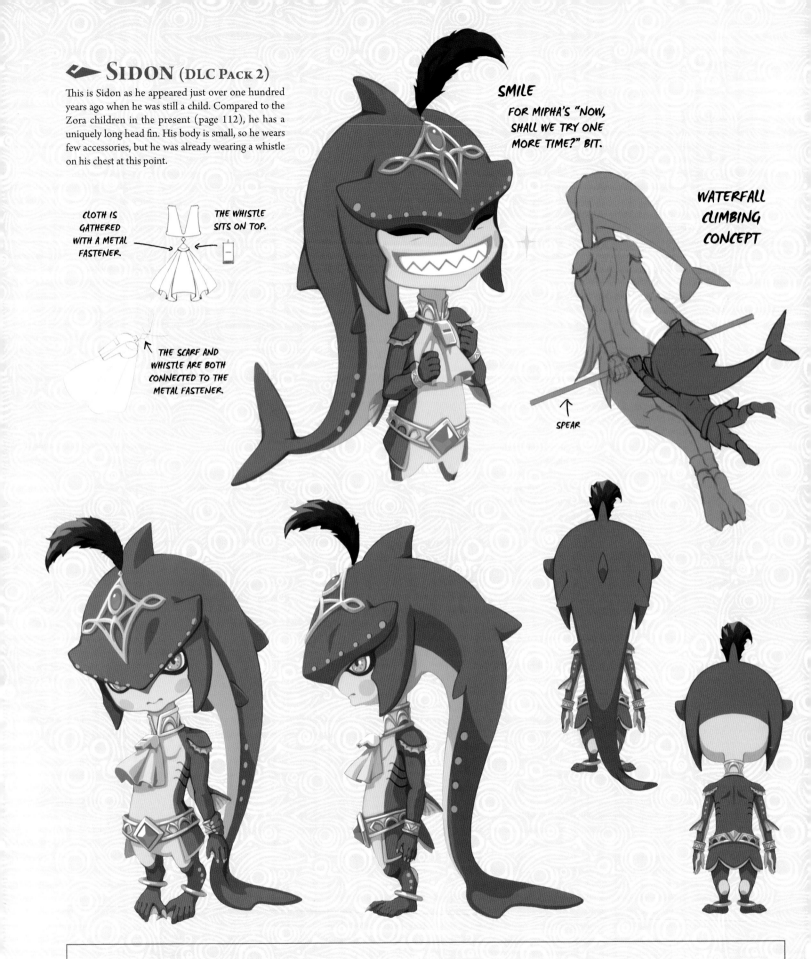

CLOTH IS GATHERED WITH A METAL FASTENER

THE WHISTLE SITS ON TOP.

THE SCARF AND WHISTLE ARE BOTH CONNECTED TO THE METAL FASTENER

SMILE
FOR MIPHA'S "NOW, SHALL WE TRY ONE MORE TIME?" BIT.

WATERFALL CLIMBING CONCEPT

SPEAR

DEVELOPER'S NOTE

There were many stories that we wanted to tell but were unable to implement in the main game, and these were especially charming. DLC Pack 1 was focused heavily on action game play, so with DLC Pack 2, I thought that players might enjoy the world of this game more if we included, of all the unspoken and untold tales, the stories of the Champions. Most of the cutscenes take place in the Hyrule of one hundred years ago and cover the events that took place before the Great Calamity. We were able to expand the world of this game through these new stories, showing Princess Zelda's cold-weather outfit for the first time, the four Champions before they donned their blue sashes, and even the Zora prince Sidon when he was a cute little kid, long before he had the impressive physique he has now.

DIRECTOR: HIDEMARO FUJIBAYASHI

ATTENDANT (DLC PACK 2)

This woman was in service to Princess Zelda and the royal family a century ago. She would accompany Zelda when she sought an audience with the leaders of other nations.

ONE-HIT OBLITERATOR (DLC PACK 2)

This one-handed weapon is part of a new trial exclusive to "The Champions' Ballad." Its prongs are shaped to resemble the four Divine Beasts.

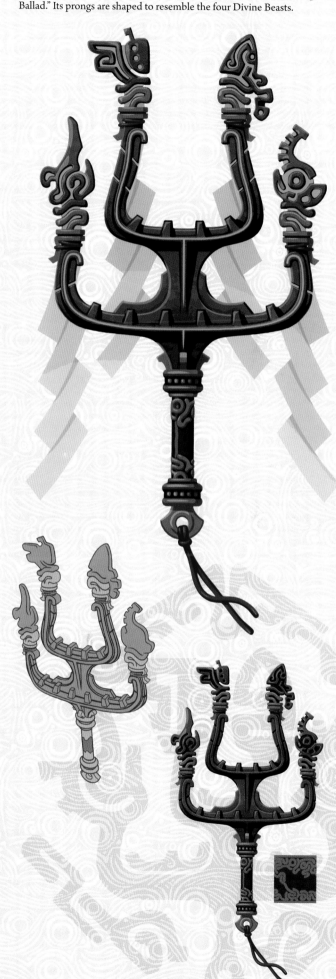

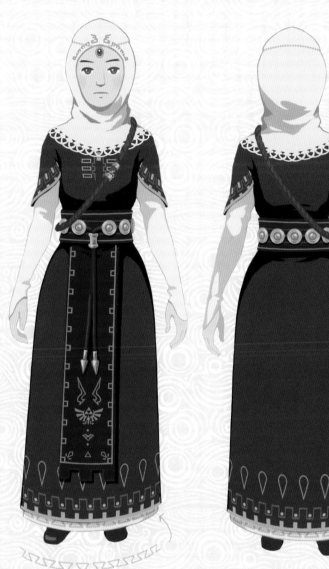

▷ Rough Designs

CONTINUOUS DIAMOND-SHAPED PAPER TAPE.

HISTORY

As players make their way through The Legend of Zelda: Breath of the Wild *they can gain insight into Hyrule's past by recovering Link's memories, engaging in dialogue with the colorful characters that inhabit Hyrule, reading old texts, or exploring ancient ruins.*

This section breaks down the history of Hyrule in chronological order as seen from the perspective of the present as it exists in the game. Along with information that the player can gain during their adventure, some of the facts presented here derive from designs created during development and from perspectives not found anywhere else.

This chapter is a historical guide meant to enrich understanding of the current state of Hyrule.

HISTORY WRITTEN ON THE GEOGRAPHY OF HYRULE

Present-day Hyrule is divided into eight provinces, and at its heart sits Hyrule Castle, once the center of the kingdom of Hyrule. Calamity Ganon's revival doomed the kingdom, and the remnants of destroyed historical landmarks and flooded villages dot the map. Five giant columns that stored the Guardians that Calamity Ganon used against Hyrule protrude from the ground around Hyrule Castle and are represented here as well.

This map lists the names of primary locations in Hyrule and includes brief explanations of each in order to enable easy reference for the current and historical events described in the rest of this section.

You can see from this map that Central Hyrule is a river basin surrounded by high mountains, reaching Necluda requires passing through the gap between the Dueling Peaks, Death Mountain is located in Eldin, and Gerudo Canyon lies at the entrance to the Gerudo Desert. Hebra and Central Hyrule are divided by a large canyon, hinting at the reason for the name of the Tabantha Frontier, in spite of the road that now spans the chasm.

Central Hyrule was burned in the Great Calamity of one hundred years ago, but it is clear from the map that one of the reasons the onslaught of Guardians that rushed out of Hyrule Castle did not reach the peoples of the other provinces is the natural protection of the terrain—whether that be mountains, water, or gorges.

The Sheikah Towers provide information on the surrounding area to the Sheikah Slate, but it is said they were originally constructed long ago as a method for detecting Calamity Ganon's inevitable revival. As such, rather than a predetermined number in each region, it seems they were built in positions close to Central Hyrule within those regions.

The four Divine Beasts aim for Ganon in Hyrule Castle from their standby positions. You can also see that the final battle that occurred one hundred years ago unfolded across Hyrule Field, the center of all of Hyrule.

The Eight Provinces

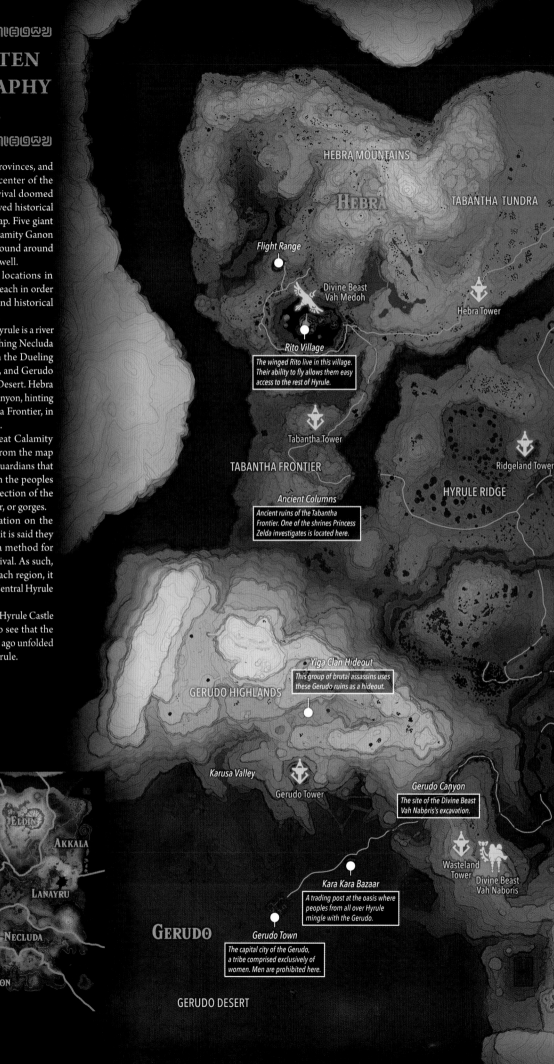

Flight Range

Divine Beast Vah Medoh

Rito Village
The winged Rito live in this village. Their ability to fly allows them easy access to the rest of Hyrule.

HEBRA MOUNTAINS

HEBRA

TABANTHA TUNDRA

Hebra Tower

Tabantha Tower

TABANTHA FRONTIER

Ridgeland Tower

HYRULE RIDGE

Ancient Columns
Ancient ruins of the Tabantha Frontier. One of the shrines Princess Zelda investigates is located here.

Yiga Clan Hideout
This group of brutal assassins uses these Gerudo ruins as a hideout.

GERUDO HIGHLANDS

Karusa Valley

Gerudo Tower

Gerudo Canyon
The site of the Divine Beast Vah Naboris's excavation.

Wasteland Tower

Divine Beast Vah Naboris

Kara Kara Bazaar
A trading post at the oasis where peoples from all over Hyrule mingle with the Gerudo.

GERUDO

Gerudo Town
The capital city of the Gerudo, a tribe comprised exclusively of women. Men are prohibited here.

GERUDO DESERT

HEBRA • ELDIN • AKKALA • CENTRAL HYRULE • LANAYRU • NECLUDA • GERUDO • FARON

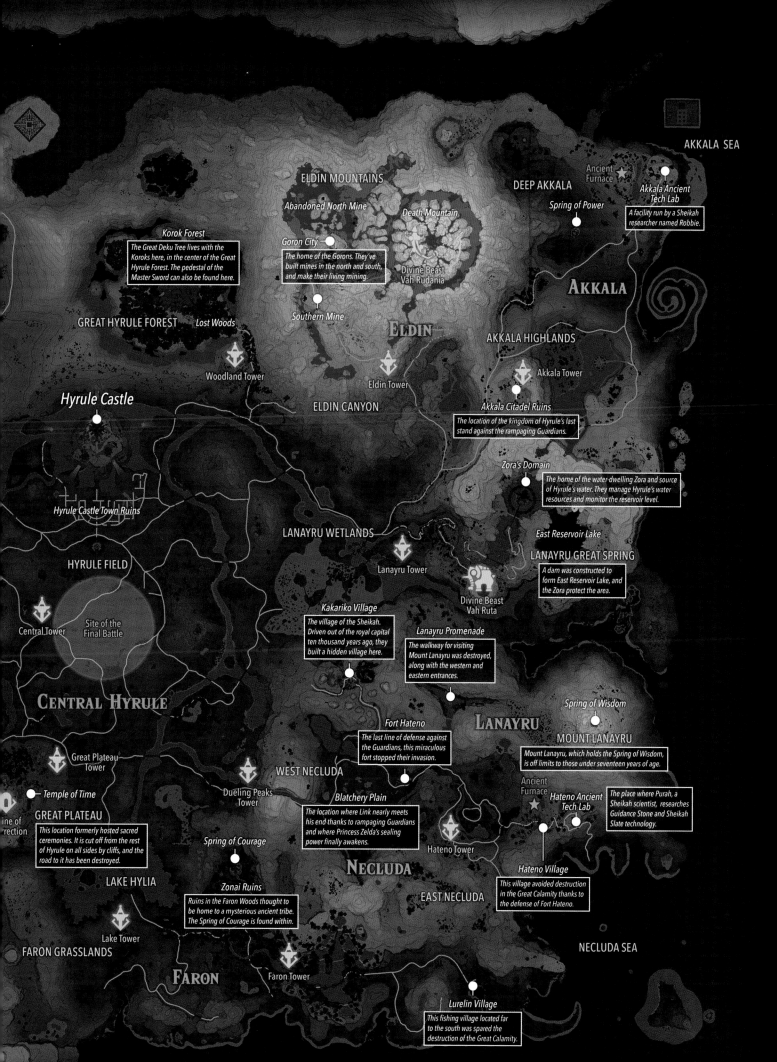

AKKALA SEA

ELDIN MOUNTAINS

DEEP AKKALA

Ancient Furnace

Akkala Ancient Tech Lab

Abandoned North Mine

Death Mountain

Spring of Power

A facility run by a Sheikah researcher named Robbie.

Korok Forest

Goron City

AKKALA

The Great Deku Tree lives with the Koroks here, in the center of the Great Hyrule Forest. The pedestal of the Master Sword can also be found here.

The home of the Gorons. They've built mines in the north and south, and make their living mining.

Divine Beast Vah Rudania

GREAT HYRULE FOREST

Lost Woods

Southern Mine

ELDIN

AKKALA HIGHLANDS

Woodland Tower

Eldin Tower

Akkala Tower

Hyrule Castle

ELDIN CANYON

Akkala Citadel Ruins

The location of the kingdom of Hyrule's last stand against the rampaging Guardians.

Hyrule Castle Town Ruins

Zora's Domain

The home of the water-dwelling Zora and source of Hyrule's water. They manage Hyrule's water resources and monitor the reservoir level.

LANAYRU WETLANDS

East Reservoir Lake

HYRULE FIELD

Lanayru Tower

LANAYRU GREAT SPRING

A dam was constructed to form East Reservoir Lake, and the Zora protect the area.

Central Tower

Site of the Final Battle

Kakariko Village

The village of the Sheikah. Driven out of the royal capital ten thousand years ago, they built a hidden village here.

Divine Beast Vah Ruta

Lanayru Promenade

The walkway for visiting Mount Lanayru was destroyed, along with the western and eastern entrances.

CENTRAL HYRULE

Fort Hateno

Spring of Wisdom

The last line of defense against the Guardians, this miraculous fort stopped their invasion.

LANAYRU

MOUNT LANAYRU

Great Plateau Tower

WEST NECLUDA

Mount Lanayru, which holds the Spring of Wisdom, is off limits to those under seventeen years of age.

Temple of Time

Dueling Peaks Tower

Ancient Furnace

Hateno Ancient Tech Lab

ine of rection

GREAT PLATEAU

Blatchery Plain

The place where Purah, a Sheikah scientist, researches Guidance Stone and Sheikah Slate technology.

This location formerly hosted sacred ceremonies. It is cut off from the rest of Hyrule on all sides by cliffs, and the road to it has been destroyed.

The location where Link nearly meets his end thanks to rampaging Guardians and where Princess Zelda's sealing power finally awakens.

Spring of Courage

Hateno Tower

Hateno Village

LAKE HYLIA

Zonai Ruins

NECLUDA

EAST NECLUDA

This village avoided destruction in the Great Calamity thanks to the defense of Fort Hateno.

Ruins in the Faron Woods thought to be home to a mysterious ancient tribe. The Spring of Courage is found within.

Lake Tower

FARON GRASSLANDS

NECLUDA SEA

FARON

Faron Tower

Lurelin Village

This fishing village located far to the south was spared the destruction of the Great Calamity.

FARON SEA

THE HISTORY OF HYRULE
∼ CHRONOLOGY & EVENTS ∼

THE DISTANT PAST	*ERA OF MYTH*	The kingdom of Hyrule flourishes under the Hyrulean royal family.
		Ganondorf, king of the Gerudo, transforms into Dark Beast Ganon and threatens Hyrule. The princess of Hyrule and the chosen hero combine their power to seal Ganon.
		In a seemingly endless cycle of darkness and light, Ganon continues to be revived and then sealed away.
MORE THAN 10,000 YEARS AGO	*ERA OF PROSPERITY*	Civilization is highly advanced thanks to the technology of the Sheikah.
10,000 YEARS AGO		The revived Ganon is sealed away by the princess of the royal family and the hero chosen by the Master Sword, with the help of the Guardians and Divine Beasts built by the Sheikah.
		The king of Hyrule orders the abolishment of technology and begins to subdue the Sheikah. Under his orders, the Divine Beasts are buried deep within the ground in different spots throughout Hyrule.
		The Sheikah divide into peaceful and militant factions. The militant faction eventually forms the Yiga Clan.
		A long era of peace ensues.
JUST BEFORE THE EVENTS OF 100 YEARS AGO	*SIGNS OF THE CALAMITY REVIVING*	A princess is born, and she is named Zelda. This is in line with the tradition that each princess born to the royal family shall be so named.
		A fortune teller predicts the revival of Calamity Ganon.
		King Rhoam begins searching for ancient relics in response to the prophecy. The Divine Beasts are discovered.
		When Princess Zelda is six, the queen of Hyrule passes away suddenly.
		When Princess Zelda is seven, the king commands that she begin training to awaken her sealing power.
		Link, a child of a line of knights, extracts the Master Sword.
		Princess Zelda speaks with the royal adviser Impa, who is responsible for relic research. Impa introduces Zelda to Purah and Robbie, and she joins them in their research.
		The Sheikah Slate is discovered. Its functionality is partially restored. They succeed in activating the Divine Beasts.
		Princess Zelda selects four highly skilled individuals from across Hyrule and entrusts them with operating the Divine Beasts.
		She summons the four and Link to Hyrule Castle, where King Rhoam appoints them Champions in an official ceremony.
		The four Champions overcome trials to prove themselves worthy of piloting the Divine Beasts.

The kingdom of Hyrule has a long, long history. So long, in fact, that the events that occurred leading up to its founding and in its early years have faded into myth. Hyrule's recurring periods of prosperity and decline have made it impossible to tell which legends are historical fact and which are mere fairy tale. However, it is an indisputable truth that Calamity Ganon attacked Hyrule and was sealed ten thousand years ago, and that it revived one hundred years ago in an event called the Great Calamity.

Still, ten thousand years is an extraordinarily long time, and all that remains of that event is the legend itself. Any official documents regarding Calamity Ganon's latest revival and the periods surrounding it were burned away in the Great Calamity, so no detailed accounts remain. As such, what is listed here is a sketch of Hyrule's history, limited to what little information can be found today.

JUST BEFORE THE EVENTS OF 100 YEARS AGO		Link, under the royal command of King Rhoam, becomes knight attendant to Princess Zelda.
		The four Champions begin operational training to pilot the Divine Beasts.
		The Yiga Clan, moving in the shadows, attempt to assassinate Princess Zelda. She is attacked but escapes unharmed.
		The number of monsters increases, and they become more active. Powerful species begin to appear. Attacks against citizens of Hyrule are on the rise.
100 YEARS AGO	***THE DAY OF THE GREAT CALAMITY***	Princess Zelda turns seventeen years old. She ventures to the Spring of Wisdom on Mount Lanayru for a purification ceremony, attempting to awaken her sealing power.
		Calamity Ganon revives. The Guardians and the four Divine Beasts are taken over, and Hyrule Castle Town is destroyed.
		King Rhoam commands the knights. He perishes fighting the Guardians and monsters while helping the people to safety.
		The Champions rush to the Divine Beasts and are slain by the manifestations of Ganon that appear inside them. Their souls are imprisoned in the Divine Beasts.
		The Hyrulean soldiers make their last stand against the Guardians at Akkala Citadel, but ultimately fall. The kingdom of Hyrule is no more.
		Link is defeated at Blatchery Plain. Princess Zelda's sealing power awakens.
		Civilians mount a successful defense at Fort Hateno.
		Link is placed in the Shrine of Resurrection, where he will sleep for one hundred years. The Master Sword is put to rest under the Great Deku Tree to await the day the hero returns.
		Princess Zelda confronts Calamity Ganon within Hyrule Castle.
		Princess Zelda is able to seal Ganon's power, causing the Divine Beasts to withdraw and the Guardians to cease their assault.
	AFTER THE GREAT CALAMITY	The regions' stable owners form a network of stables that double as inns. Hateno Village begins a self-sufficient lifestyle.
THE PRESENT	***THE HERO AWAKENS***	Princess Zelda's sealing power weakens, and the once-quiet Calamity Ganon becomes more active, responding to signs that Link will soon return.
		The Divine Beasts renew their rampage in response to Ganon's increased activity and Link's imminent return.
		Link awakens within the Shrine of Resurrection.

The History of Hyrule & the Historical Chronology of Each Race

	THE HISTORY OF HYRULE	THE HISTORY OF THE SHEIKAH	THE HISTORY OF THE ZORA
THE DISTANT PAST	Ganondorf becomes Ganon and invades Hyrule. Ganon is sealed. In a seemingly endless cycle of darkness and light, Ganon continues to be revived and then sealed away.	Shadows acting on behalf of the Hyrule royal family, the Sheikah operate in the dark corners of history. The legends of Ganon and the Hyrulean royal family are passed down orally.	Princess Ruto is born into the Zora royal family. She awakens as a Sage and fights alongside the princess of Hyrule and the hero of legend. The king, unskilled at the art of war, dons armor handmade by the queen with one of her own scales woven into it and repels a Lizalfos assault, starting a Zora tradition.
MORE THAN 10,000 YEARS AGO	Civilization is highly advanced thanks to the technology of the Sheikah.		The Zora settle in Lanayru.
10,000 YEARS AGO	Calamity Ganon attacks the kingdom of Hyrule. The combined might of the four Divine Beasts, the chosen hero, and the princess who possesses the sealing power allows for the sealing of Calamity Ganon. The royal family of Hyrule feels threatened by the Sheikah's advanced technology and drives them away.	Using their advanced technology, they develop the four Divine Beasts and the Guardians. They overwhelm Calamity Ganon. The Sheikah divide into peaceful and militant factions. The peaceful Sheikah found and settle in the hidden Kakariko Village. The militant faction flee to the Gerudo Province and later become the Yiga Clan.	The Zora and the people of Hyrule join together to construct the East Reservoir Lake. They complete the project in one year. The Zora have managed its water levels ever since.
JUST BEFORE THE EVENTS OF 100 YEARS AGO	Princess Zelda is born. A fortune teller predicts the revival of Calamity Ganon. King Rhoam begins searching for ancient relics. The four Divine Beasts are uncovered. When Princess Zelda is six, the queen of Hyrule passes away suddenly. Princess Zelda begins her training. Link extracts the Master Sword. Four highly skilled individuals from across Hyrule are selected and entrusted with operating the Divine Beasts.	Purah and Robbie, young but talented, join the excavation and research effort. One of the Sheikah becomes the court poet. He leaves behind songs for the hero. Impa takes charge of relic research. She works in Hyrule Castle as an official adviser. Princess Zelda joins Purah and Robbie's relic survey. The Sheikah Slate is discovered.	King Dorephan assumes the throne. Princess Mipha is born. King Rhoam's court visits Zora's Domain to show respect. Mipha meets Link, who is about four years old. The Divine Beast Vah Ruta is excavated in Zora's Domain. Mipha is reunited with Link after a long time apart. Princess Zelda requests that Mipha serve as a Divine Beast pilot. Dorephan and the other elders oppose this plan. Mipha and Link defeat the Lynel on Ploymus Mountain.

The following pages contain the history of each Hyrulean race living in present-day Hyrule. Unfortunately, the specific time many of these events took place is often unclear, and knowledge of the periods of time separating these events has been lost.

Moreover, the amount of documentation that has survived throughout the ages varies by race. While records pertaining to the Sheikah and Zora are plentiful, there are practically no records regarding the Gorons or Rito that predate the Great Calamity.

Though they don't have a column of their own, you will find a sidebar about the Koroks, the rarely seen forest spirits, on page 365.

 THE HISTORY OF THE GORONS

 THE HISTORY OF THE RITO

 THE HISTORY OF THE GERUDO

The History of the Gorons	The History of the Rito	The History of the Gerudo	
They Gorons live separately from other Hyruleans and are ruled by a chief.		A boy is born to the all-female Gerudo tribe, as happens every one hundred years. He is named Ganondorf. Ganondorf plans to take control of Hyrule. He transforms into Dark Beast Ganon and is sealed. Ganon, having long lost his reason, becomes Calamity Ganon, a pure incarnation of hatred and malice for the royal family of Hyrule and the chosen hero.	***THE DISTANT PAST***
			MORE THAN 10,000 YEARS AGO ***10,000 YEARS AGO***
A Divine Beast is excavated at Death Mountain. It is later determined to be Vah Rudania. Daruk and Link meet on Death Mountain. Princess Zelda requests that Daruk serve as a Divine Beast pilot. Daruk accepts immediately.	As a prize for winning countless archery competitions and breaking all previous Rito archery records, Revali requests the construction of the Flight Range. Princess Zelda requests that Revali serve as a Divine Beast pilot. Revali delays in responding.	The queen of Hyrule, an old friend of Urbosa's, visits Gerudo Town. She introduces Urbosa to the newborn Princess Zelda. Urbosa attends the queen of Hyrule's funeral. Urbosa accompanies Princess Zelda on her visits to the sacred springs. Princess Zelda requests that Urbosa serve as a Divine Beast pilot. Although she is chief of the Gerudo and the prospect concerns her people, Urbosa accepts.	***JUST BEFORE THE EVENTS OF 100 YEARS AGO***

 THE HISTORY
OF HYRULE

 THE HISTORY
OF THE SHEIKAH

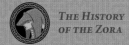 THE HISTORY
OF THE ZORA

	THE HISTORY OF HYRULE	THE HISTORY OF THE SHEIKAH	THE HISTORY OF THE ZORA
JUST BEFORE THE EVENTS OF 100 YEARS AGO	A ceremony is held at Hyrule Castle. The chosen hero and the Divine Beast pilots are appointed Champions. Link, under the imperial command of King Rhoam, becomes knight attendant to Princess Zelda.	The Yiga Clan, moving in the shadows, attempt to assassinate Princess Zelda. She is attacked but escapes unharmed.	King Dorephan consents to Mipha becoming a Divine Beast pilot. After completing the necessary trials, Mipha is deemed worthy to pilot the Divine Beast Vah Ruta. Mipha practices operating the Divine Beast Vah Ruta in the area around Zora's Domain.
100 YEARS AGO: THE DAY OF THE GREAT CALAMITY	Calamity Ganon revives. The Guardians and the four Divine Beasts are taken over, and Hyrule Castle Town is destroyed. King Rhoam is killed. A battle takes place on Blatchery Plain. Link collapses, and Princess Zelda's sealing power awakens. Princess Zelda suppresses Ganon's power, attempting to hold him off until the hero awakens.	Impa, Purah, and Robbie take the Guidance Stone and various ancient parts and escape to Kakariko Village. Sheikah soldiers are dispatched to search for the missing Princess Zelda. Princess Zelda is reunited with Impa in Kakariko Village. Purah and Robbie head for the Shrine of Resurrection and place Link within it for treatment. Many of the Sheikah flee to Kakariko Village and become caught up in the crisis that is the Great Calamity.	Waterblight Ganon takes over the Divine Beast Vah Ruta and slays Mipha. The Guardians' assault stops, and disaster is averted.
AFTER THE GREAT CALAMITY		Impa and the rest of Kakariko Village await the awakening of the hero. Purah and Robbie separate, heading for Necluda and Akkala, respectively. They continue their research on the ancient relics. Robbie succeeds in developing the Ancient Oven.	The Champion Festival is established. A stray Guardian invades Zora's Domain. King Dorephan lifts the Guardian and throws it into a ravine, smashing it. Prince Sidon defeats the giant Octorok in the Necluda Sea.
THE PRESENT	Link awakens within the Shrine of Resurrection. Link defeats Calamity Ganon.	A Sheikah tower is activated.	The Divine Beast Vah Ruta rampages, discharging water into the East Reservoir Lake, which threatens the dam there.

THE BOND BETWEEN THE ZORA & HYRULE

Lanayru Great Spring, located near Zora's Domain, is a critical source of water for Hyrule. The Zora manage the water levels of the Great Spring with a giant reservoir and dam. King Dorephan describes the building of the dam as a key moment in history for the Zora, and the dam gives context to the more than ten-thousand-year relationship between Hyrule and the Zora. The text carved into the stone monument labeled "A Reservoir of Hope" reads as follows:

Once every ten years, the Lanayru region experiences unusually heavy rainfall. The Zora River flooded every time. The tides damaged not only our domain but our people, washing away poor souls and causing great suffering and disarray. The Zora king of that time, after seeking aid from the king of Hyrule, rode out to see what could be done. By joining the architectural genius of the Zora and Hyrule's technological prowess, East Reservoir Lake was swiftly built. Thanks to this fruitful partnership, Hyrule was no longer plagued by these devastating floods. In gratitude, the Zora king promised the king of Hyrule to manage the reservoir level to protect all of Hyrule from floods. Each Zora king since has kept that oath, spanning ten thousand years. That is why the reservoir signifies our bond with Hyrule.

A Monument

Rutala Dam
A giant dam constructed to create the East Reservoir Lake. Its beautiful stonework design is a specialty of the Zora.

THE HISTORY
OF THE GORONS

THE HISTORY
OF THE RITO

THE HISTORY
OF THE GERUDO

THE HISTORY OF THE GORONS	THE HISTORY OF THE RITO	THE HISTORY OF THE GERUDO	
After completing the necessary trials, Daruk is deemed worthy to pilot the Divine Beast Vah Rudania.	Revali accepts Princess Zelda's request to be a Divine Beast pilot after she goes to Rito Village a second time to meet with him.	After completing the necessary trials, Urbosa is deemed worthy to pilot the Divine Beast Vah Naboris.	**JUST BEFORE THE EVENTS OF 100 YEARS AGO**
Daruk practices operating the Divine Beast Vah Rudania in the area around Goron City.	After completing the necessary trials, Revali is deemed worthy to pilot the Divine Beast Vah Medoh.	Urbosa practices operating the Divine Beast Vah Naboris in the area around Gerudo Town.	
	Revali practices operating the Divine Beast Vah Medoh in the area around Rito Village.		
Fireblight Ganon takes over the Divine Beast Vah Rudania and slays Daruk.	Windblight Ganon takes over the Divine Beast Vah Medoh and slays Revali.	Thunderblight Ganon takes over the Divine Beast Vah Naboris and slays Urbosa.	**100 YEARS AGO: THE DAY OF THE GREAT CALAMITY**
The Guardians' assault stops, and disaster is averted.	The Guardians' assault stops, and disaster is averted.	The Guardians' assault stops, and disaster is averted.	
The Goron leader Bludo establishes the Goron Group Mining Company.	Kass inherits the songs left for the hero by his teacher, the court poet.		**AFTER THE GREAT CALAMITY**
Yunobo is born.	Teba is born.	The chief's daughter, Riju, is born.	
		Riju's mother dies. Riju is appointed chief at a young age.	
The Divine Beast Vah Rudania rampages, keeping the Gorons from mining Death Mountain Summit.	The Divine Beast Vah Medoh rampages, flying low over Rito Village and firing on any Rito flying near it.	The Divine Beast Vah Naboris rampages, wandering across the Gerudo Desert, disrupting travel and threatening the residents there. Anyone who gets too close runs the risk of being struck by lightning.	**THE PRESENT**
Death Mountain's volcanic activity increases. Tourism to Goron City declines due to the deadly magma bombs spewing from the volcano's caldera.			

THE HISTORY OF THE KOROKS

While many different races reside in Hyrule, there's something undeniably special about the forest spirits known as Koroks. They reside in the Korok Forest in the center of the Great Hyrule Forest, which grows around its protector, the Great Deku Tree. They are invisible to ordinary folk, which is why they don't appear in the annals of history.

The Master Sword rests in its pedestal in Korok Forest, and the Great Deku Tree has watched over it for the one hundred years since Princess Zelda placed it there.

The Koroks live in harmony with the Great Deku Tree and aid in protecting the Master Sword. They transformed the entrance to the Great Hyrule Forest into the Lost Woods to drive away intruders. They're a brave race who give everything they have to aid the hero in their own way.

Great Deku Tree

Lost Woods
Rumors of the legendary Master Sword swirl among certain treasure hunters and at least one traveling gossip, but the Lost Woods prevent any intrusion by outsiders, so the existence of the sword's resting place remains a mystery.

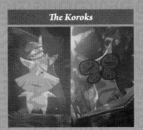
The Koroks

Pedestal of the Master Sword
The Great Deku Tree is one of the spirits that watch over Hyrule. He keeps a watchful eye over the Master Sword until it is needed once again.

The kingdom of Hyrule was once a land of lasting peace
A culture of such strength and wit, that suffering did cease.
But Ganon lurked beneath the surface, strengthening its jaws
So the ancient people of Hyrule set out to help the cause.
Their efforts bore fruit in an automated force,
To help avert Calamity by sealing it at its source.
Four giant behemoths for which power never ceased,
Each of these titans was called a "Divine Beast."
And free-willed machines that hunted down their prey
These Guardians were built to last so they could join the fray.
To guide the beasts in battle, warriors were needed,
So four Champions were pledged to see Ganon defeated.
Divine Beasts, Champions, princess, and knight,
Their plan to rout Ganon was looking airtight.
And when Calamity Ganon reared its head, Hyrule rose against it
The optimism of Hyrule all the more incensed it.
Ganon raged in its assault, boiling with hate,
It gnashed its teeth and thrashed about, but it was all too late.
The Guardians kept the heroes safe through every hour . . .
The Divine Beasts unleashed attacks that weakened Ganon's power.
The hero with the sealing sword struck the final blow,
And the holy power of the princess sealed Ganon so.
—Ancient Song, Second Verse

Life in Hyrule
Woodcutters, farmers, horses carrying goods, and a lively town are illustrated here.

The kingdom of Hyrule has flourished since ancient times, but its history is inextricably intertwined with a being who brings ruination and is sealed away, only to revive and bring calamity again and again—a being known as Ganon.

But Ganon is not the only constant in the cyclical history of Hyrule. In every age where Ganon rises up to cause chaos, there are born two defenders fated to protect the kingdom: a warrior with the soul of the hero and a sacred princess who is the goddess reborn. Together, the two are able to repel Ganon, allowing the kingdom of Hyrule to flourish.

Eventually, the kingdom became so culturally and technologically advanced that even the monsters that roamed Hyrule no longer posed a threat to its people, but Ganon inevitably revived and threatened to destroy everything they had built. No matter how advanced the kingdom had become, Ganon could only be sealed away by the hero and the sacred princess.

The Sheikah, in service to Hyrule's royal family, sought to aid the chosen hero and the princess in their fated task by developing mechanical soldiers known as Guardians and four gigantic weapons called Divine Beasts that were piloted by Champions. The Guardians protected the hero and the princess, while the Divine Beasts' attacks suppressed Ganon's power. The hero then struck the final blow with the Master Sword, and the princess, inheritor of a sacred power, sealed Ganon away, thus ushering in a new age of peace.

Their battle against Ganon has been passed down through the generations in the form of a legend. The song above and the tapestry to the right are surviving versions of the story of the battle against Calamity Ganon from ten thousand years ago.

10,000 YEARS AGO
∼ LORE ∼

THE KEYS TO THE SEAL

Even with the power of the Sheikah's advanced technology, the sacred princess and the hero chosen by the Master Sword are key to sealing Calamity Ganon away. This has been the fated cycle of Hyrule since the era of myth.

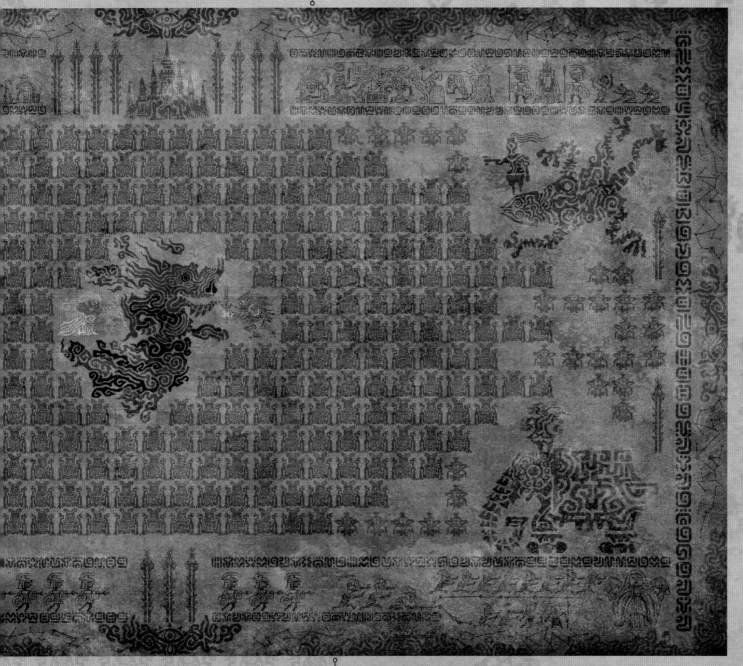

The Sheikah and the Sheikah Slate

The Sheikah possessed advanced technology, some of which has survived through the ages. The Sheikah Slate, which would be recovered as a relic ten thousand years later, can be seen in this illustration, along with a stone that seems to be a power source. To the right of them is a figure who appears to be the king of Hyrule flanked by soldiers, and behind them, astonished figures.

SEALING SUPPORT

Calamity Ganon is visible in the center of the tapestry surrounded by many Guardians and Sheikah monks. The four Divine Beasts—Vah Ruta, Vah Rudania, Vah Medoh, and Vah Naboris—can be seen in the corners, as can the four skilled Champions chosen to operate them. It is said that the fifteen Sheikah Towers were to act like radar to detect signs of Calamity Ganon's reappearance as quickly as possible.

Sheikah Towers

The four Champions of the Divine Beasts. Their names and races are unknown.

The Driving Out and Division of the Sheikah

The lower portion of the tapestry illustrates what happened following the sealing of Ganon ten thousand years ago. On the far left are citizens of Hyrule behind the king of Hyrule, who is ordering his soldiers to pursue the fleeing Sheikah. To the right, the Sheikah divide into those who retreated into their devotion to the goddess Hylia and those who became militant. Since the Sheikah symbol is visible in the center of the border design, it is likely that the story is told from their perspective.

THE DIVINE BEASTS NAMED FROM LEGEND

The origins of only two of the names of the Divine Beasts are certain. The Divine Beast Vah Ruta was named for Princess Ruto, born into the royal family of the Zora long ago, and the name Vah Naboris is said to derive from the Gerudo Nabooru. Legend has it that both awakened as Sages and fought alongside the princess of Hyrule and the chosen hero against a wicked being.

Divine Beast Vah Ruta

Divine Beast Vah Naboris

THE SHEIKAH DIVIDED

Ten thousand years ago, the kingdom of Hyrule reached an advanced level of civilization thanks in no small part to the technological prowess of the Sheikah. The Sheikah have worked from the shadows to support Hyrule's royal family since the era of myth, and their contributions have been significant. Their technology was key in helping the chosen hero and the princess seal Ganon away ten thousand years in the past and usher in an age of peace, but the king of Hyrule at the time began to fear and doubt the Sheikah. He became possessed by thoughts of imagined Sheikah betrayal. He issued an order to abolish technology and began to oppress the Sheikah. The Sheikah's laboratories were closed, research was prohibited, and data was destroyed. Their best researchers were expelled from the kingdom and monitored. Any Sheikah who dared oppose this order was met with severe punishment, including imprisonment.

This oppression led to dramatic changes within the Sheikah tribe and ultimately to a division into two main factions. The moderate group chose to live peacefully,

accepting the restrictions placed on them out of respect for their long-standing ties to the royal family. They built a hidden village, now known as Kakariko Village, and lived there in secret.

Those who violently rejected the king's decree formed a militant group that specialized in assassination, the Sheikah's original dark purpose. In time, they came to follow Calamity Ganon. They retreated to the remote Gerudo Province, outside of the kingdom of Hyrule's reach, and later formed the Yiga Clan. Their goal became eliminating Calamity Ganon's enemies, specifically the princess and the chosen hero.

Within that first group, there were also those who chose to remain peaceful and loyal to the royal family while laboring in secret to keep the flames of research burning.

As the Sheikah's paths went separate ways, so did their homes. The Sheikah drifted apart, scattering to all corners of Hyrule.

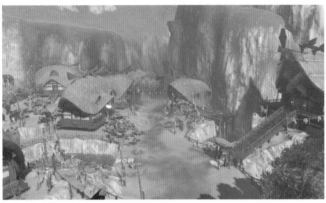

Kakariko Village
Surrounded by tall mountains, this hidden village was built to avoid attention. A road that leads to the Great Plateau, formerly the place of sacred ceremonies, runs through the village to a Great Fairy fountain located to the north.

Yiga Clan
These agile assassins have the ability to appear and disappear at will. Their weapons are designed specifically for quick and silent kills.

NOTES

SHEIKAH TECHNOLOGY

At the time that the Sheikah helped the hero and the princess seal away Calamity Ganon, their technological capabilities outstripped those of their Hylian counterparts by a significant amount. Up until that point the royal family's sacred power made them the authority in Hyrule, but because of the cycle of prosperity and decline of the kingdom of Hyrule, their technology was not able to keep up with the Sheikah's, creating a massive technological imbalance. In particular, the ability to create and control gigantic mechanical structures and wield an amount of power massive enough to subdue Calamity Ganon was said to be on par with the powers of the goddesses, and because of that, the people of Hyrule began to fear the Sheikah.

The Sheikah clan have served the royal family from the shadows and helped them maintain a prosperous Hyrule. Over their long history, they have occasionally stained their hands with dark activities like assassinations and executions. It is possible that their history is a cycle of bloodshed.

THE GODDESS HYLIA & THE SHEIKAH

In the age of myth, the Sheikah were sent by the goddess Hylia to protect her reincarnated mortal form. The reincarnated goddess was said to have been an ancestor of the royal family of Hyrule, which is why the Sheikah have guarded the royal family from danger through the ages and been tasked with passing down legends and knowledge. Their original

purpose was so deeply ingrained that the Sheikah continued the mission entrusted to them so long ago even after their expulsion from the capital, with some becoming monks.

Both the Hylians and the Sheikah worship the goddess Hylia. Carved statues of her both large and small can be found across the land and are loved by many.

Goddess Statue (Temple of Time)

Goddess Statue (Kakariko Village)
Goddess Statues have been touched by the faithful so much over the years that they have taken on a rounded shape. The apron seen here is an expression of the Sheikah's unique culture.

THE YIGA CLAN HIDEOUT & CURRENT ACTIVITIES

It has been said that the militant branch of the Sheikah that fled to the Gerudo Province are followers of Calamity Ganon, but there are no outward signs of their allegiance in their present hideout, and without records from the last ten thousand years, the details about this clan are unclear. It appears that they began calling themselves the Yiga Clan just over a hundred years ago, when the first signs of Calamity Ganon's revival began to appear. Their crest is an inverted Sheikah symbol, and they take their orders from their master, Kohga.

The members of the Yiga Clan seem to hold more allegiance to their master than to Ganon himself but share the common goal of eliminating the chosen hero and the inheritor of the blood of the goddess. To maximize their chances of finding the hero and the princess, they have spread themselves throughout Hyrule. Disguised as travelers and moving in the shadows they will use specialized techniques on the hero should they ever happen upon him. Not content in this goal alone, they are also rumored to have snuck into Gerudo Town and stolen an heirloom important to the Gerudo.

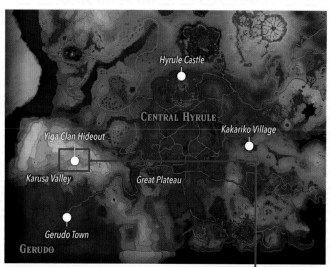

Hideout Entrance
The Yiga Clan use Gerudo ruins as a hideout and have placed noisemakers around the valley to alert them to intruders. Past the canyon and through the entrance to the ruins is a grand hall covered in decorative scrolls that conceal the hidden passage to the hideout.

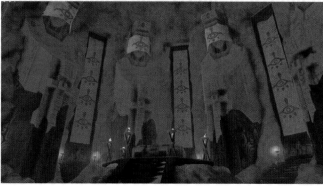

The Gerudo Desert lies in the far southwest of Hyrule, where the royal family's power does not reach. The Yiga Clan's hideout is nestled deep within the plateaus of Karusa Valley in the northern part of the Gerudo Desert that even the Gerudo, who are accustomed to desert living, cannot easily access. However, the nimble Yiga Clan seem to have no trouble navigating the difficult canyon terrain, coming and going with ease.

YIGA CLAN SPIES

The Yiga Clan installed spies in Kakariko Village in order to try to learn the whereabouts of the hero. One of the spies fell in love and started a family with a woman there. The Yiga Clan does not tolerate defection and assassinated his wife. He is forced to continue spying for the Yiga Clan under the threat that they may harm his children.

Hideout Interior
Since the hideout is carved into the cliff of the canyon and no sunlight can get in, the inside is dim, lit only by the red lanterns hung throughout. Patterns like those found on the walls of ancient shrines can be seen within, and the layout is similar to Kakariko Village, showing their shared heritage with the Sheikah.

Mighty Bananas
There is a large quantity of Mighty Bananas, the Yiga's favorite food, stored in the hideout. The Yiga Clan members stationed in the hideout spend their time either on guard or eating bananas.

▷ Master Kohga

The current master of the Yiga Clan has inherited the name Kohga. It is said that only the leader of the Yiga Clan can master a secret technique that gives him the same power possessed by ancient energy sources, and we can infer that it comes from ancient technology passed down in secret.

ANCIENT SHEIKAH MONKS

Within the Sheikah tribe of the ancient past, there were over one hundred monks in service to the goddess Hylia. After doing their part to seal away Calamity Ganon, they offered themselves to ensure the well-being of Hyrule in the future. They built shrines throughout Hyrule containing trials that would become training grounds for the chosen hero as he prepared for the inevitable revival of Calamity Ganon. They continue to wait for the hero, practicing austerity to the point of death and mummification. Once their duty is fulfilled, they award the hero their Spirit Orb, turn to dust, and quietly fade away.

Myahm Agana

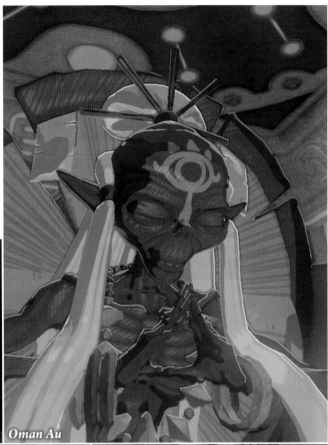

Oman Au

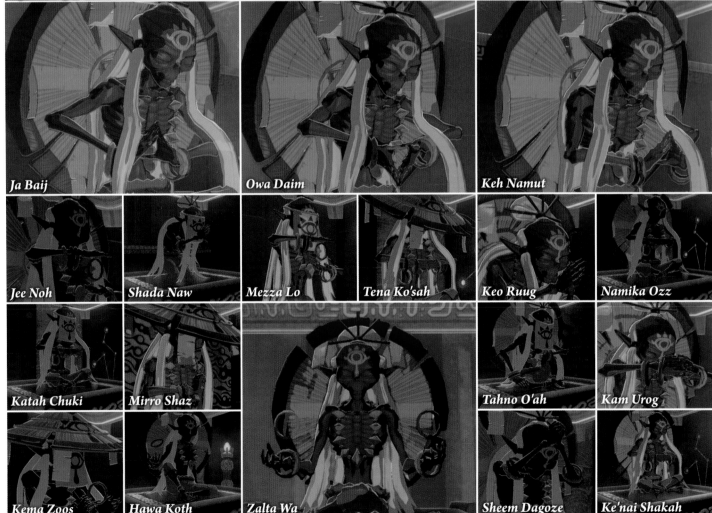

Ja Baij

Owa Daim

Keh Namut

Jee Noh

Shada Naw

Mezza Lo

Tena Ko'sah

Keo Ruug

Namika Ozz

Katah Chuki

Mirro Shaz

Tahno O'ah

Kam Urog

Kema Zoos

Hawa Koth

Zalta Wa

Sheem Dagoze

Ke'nai Shakah

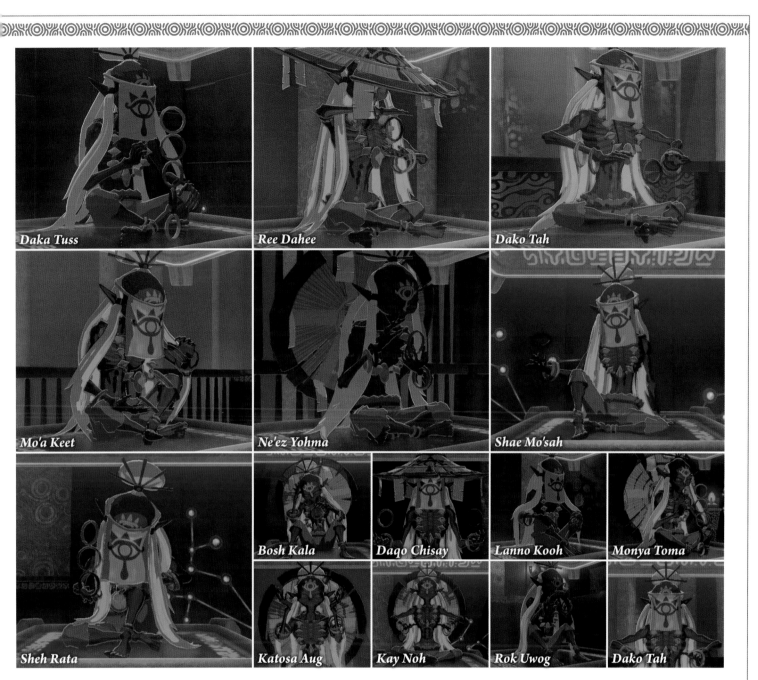

Daka Tuss

Ree Dahee

Dako Tah

Mo'a Keet

Ne'ez Yohma

Shae Mo'sah

Sheh Rata

Bosh Kala

Daqo Chisay

Lanno Kooh

Monya Toma

Katosa Aug

Kay Noh

Rok Uwog

Dako Tah

THE HIDDEN MEANING OF THE MONKS' POSES

Ancient shrines appear all across Hyrule and don't seem to follow any particular pattern. However, the four monks in the shrines of the Great Plateau, Oman Au, Keh Namut, Owa Daim, and Ja Baij, each make equilateral triangles with their hands, with three pointing up and one pointing down, forming the shape of the Triforce.

Additionally, monks who issue tests of strength have fists positioned like those of martial artists. Ta'loh Naeg, whose shrine is just outside Kakariko Village, is the highest ranking of the martial monks. "Ta'loh Naeg's Teaching" provides the hero with instruction for foundational combat techniques.

Shee Vaneer

Shee Venath

Shee Vaneer and Shee Venath occupy the shrines on the Dueling Peaks and impose the paired trials "Twin Memories." Their body positions are also paired.

Here are examples of monks with the martial arts pose. Soh Kofi provides "A Minor Test of Strength." Ta'loh Naeg, being the highest ranking martial monk, emanates authority and wears clothing of distinction.

Soh Kofi

Ta'loh Naeg

After the sealing away of Calamity Ganon and the subsequent turmoil, the kingdom of Hyrule enjoyed many years of peace.

Ten thousand years passed. Memory of the battle faded into legend, and Calamity Ganon became a boogeyman of fairy tales. Only a few records and songs passed down by court poets remained to recount the tale.

Although the kingdom of Hyrule no longer possessed the technology of the past and could no longer be considered an advanced civilization, it flourished as the central hub that bound together all the lands of Hyrule. Young people from villages all over Hyrule aspired to one day come to Hyrule Castle, accomplish great deeds, and go home heroes.

One day, a beautiful princess was born to the king of Hyrule, Rhoam Bosphoramus Hyrule, and his queen. They named her Zelda, as was the tradition for the royal family of Hyrule.

The people of Hyrule celebrated her birth and hoped for even greater prosperity, though that hope proved fleeting. Soon after Princess Zelda was born, a fortune teller predicted that disaster would befall Hyrule, saying, "The signs of a resurrection of Calamity Ganon are clear." After all these years, it seemed Calamity Ganon would return.

However, there was hope in the fortune teller's prophecy. "The power to oppose it lies dormant beneath the ground." The king heeded the prophecy and began excavating large areas of land. Soon after, the Guardians and the legendary four Divine Beasts were discovered.

The prophecy put a great deal of pressure on Princess Zelda. The princesses of the royal family each possessed a sacred sealing power, and hers would be needed in the battle to come. The queen herself possessed those sacred powers and was to tutor Zelda in its awakening and use, but when Princess Zelda was six, the queen died suddenly before she was able to pass on her knowledge. It was up to Zelda alone to awaken her powers and seal the Calamity when the day came.

The ancient Sheikah relics, Princess Zelda's sealing power, the Divine Beasts piloted by Champions, and the hero wielding the Master Sword were all that would stand between Hyrule and Calamity. Seeking these, Hyrule entered a period of deep unease, waiting for the prophesied return of Calamity Ganon.

Hyrule Castle Town a Century Ago

Hyrule Castle and the thriving town connected to it were the center of Hyrule and the peak of commerce and scholarship. With the fountain in Central Plaza at its heart, the town rippled outward, its blue-roofed buildings forming neat rows.

Now, the grandeur of Hyrule Castle Town can only be conjured in one's imagination or the memories of the few folks who still remember that time. The texts prior to one hundred years ago were largely destroyed during the Great Calamity, and only a few notes, oral traditions, and songs remain.

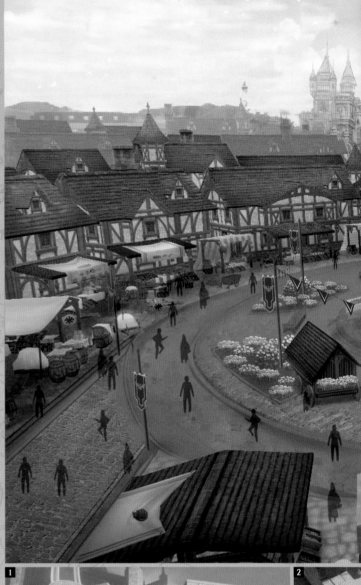

About 100 Years Ago
~ Preparing for Calamity ~

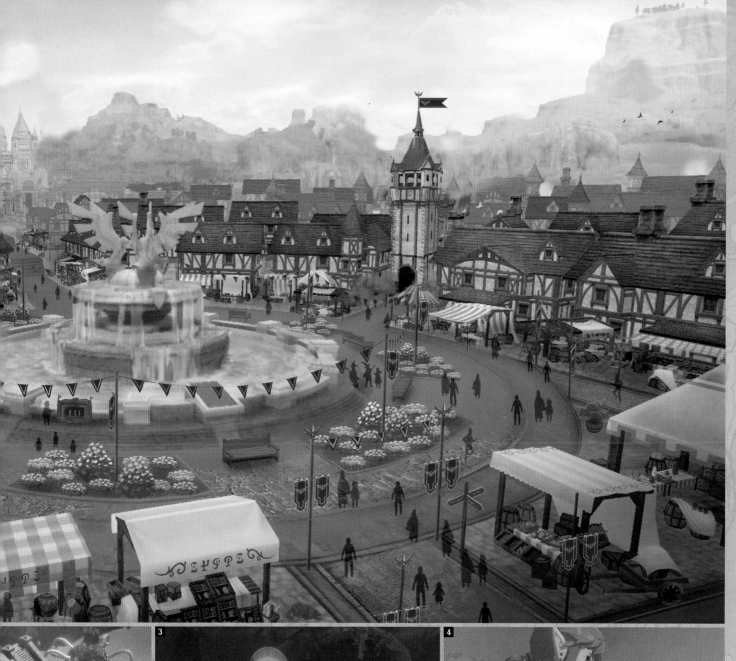

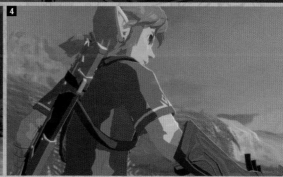

1 The king of Hyrule, Rhoam Bosphoramus Hyrule. **2** Princess Zelda assesses the results of the experiments with the Guardians at Hyrule Castle. **3** Princess Zelda cleanses herself in the waters of a sacred spring as part of her training to unlock her sealing power, but to no avail. **4** Link, the hero chosen by the Master Sword. The future of Hyrule rests, in large part, on his shoulders. **5** Princess Zelda reunites with the Champions, who are from all parts of Hyrule.

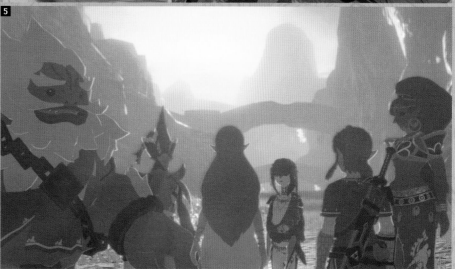

EXCAVATIONS & SURVEYS OF ANCIENT RELICS

After the events of ten thousand years ago and up until one hundred years ago, Calamity Ganon was spoken of only in legends and fairy tales. That changed when a Hylian fortune teller foretold its revival. King Rhoam took the prophecy seriously and began preparing defenses against Ganon's return.

The fortune teller predicted that finding ancient relics that had been crucial in the battle to seal Calamity Ganon ten thousand years ago would be a critical countermeasure in the fight to come. King Rhoam entreated the aid of the group that created these mechanisms, the Sheikah, who established a research institute under direct control of Hyrule Castle and began the excavation and surveying of ancient relics. As a result of those efforts, four enormous relics were discovered: the Divine Beasts. Their names were inscribed within them and matched the names of legend. Simultaneously, autonomous weapons known as Guardians were being

excavated, one after another. These findings proved that the seal on Calamity Ganon was not a legend or a fairy tale but a terrifying truth, and the dire nature of the situation began to sink in.

Not one to sit back idly, Princess Zelda would end up taking great interest in the research of ancient technology and found that she had an aptitude for it. She was part of a significant breakthrough in the study of these ancient relics when she and Purah discovered the object known as the Sheikah Slate. With it, they were able to activate the Divine Beasts. In line with the ten-thousand-year-old legend, the royal family of Hyrule appointed four warriors to pilot the Divine Beasts against Calamity Ganon and dubbed them Champions. Though their understanding of the relics was accelerating, there was still much they did not know about them.

Remnants of Relic Excavation
The royal adviser Impa and Princess Zelda often visited excavation sites. The platforms in Gerudo Canyon seen in the photo above still remain.

Guardian Testing
An image of an experiment done by Sheikah researchers for activating and controlling an excavated Guardian, conducted in the courtyard on the western side of Hyrule Castle.

NOTES

THE FORTUNE TELLER

The fortune teller was a trusted adviser of King Rhoam and predicted the revival of Calamity Ganon and the existence of the ancient relics.

The reason we know that the fortune teller must have been a trusted aid or a high-ranking official is because the king believed the prophecy and acted on it. Alternatively, it's possible that the fortune teller may have been the queen of Hyrule. Women of the royal family have the sacred power to seal but have also been known to have premonitions. Though these theories are speculation, it is difficult to imagine the king believing the words of a common prophet and bringing all of the resources of the nation to act upon those words.

It is impossible to know the fortune teller's identity, since no documentation remains that reveals that information. He or she either perished with the kingdom, was ousted because his or her powers were feared, or went into hiding. However, it is because of this fortune teller's prediction that it was possible to prepare for Calamity Ganon's revival at all. The fortune teller is a person of great importance in the history of Hyrule, even if his or her name remains unknown. He or she is a savior from the shadows.

RECONCILIATION

In the face of this unorthodox crisis, King Rhoam made the decision to ally and work with the Sheikah once again. The battles between their people had faded into legend, and there were no longer those who felt that the Sheikah posed a threat. Even then, peace between them was a significant event and was only possible due to the peaceful group of Sheikah whose descendants remained in Kakariko Village and to King Rhoam's political prowess.

ENORMOUS RELICS

Four giant weapons in the form of beasts were excavated: the Divine Beast of water, Vah Ruta (an elephant), the Divine Beast of fire, Vah Rudania (a lizard), the Divine Beast of wind, Vah Medoh (a bird), and the Divine Beast of lightning, Vah Naboris (a camel).

The symbol of the Sheikah and ancient text inside one of the Divine Beasts.

ANCIENT RESEARCH INSTITUTE

In order to create effective measures against Calamity Ganon, a research center was established under the direct control of the king. It was a given that the royal family would cover the costs of all research, but Hyrule Castle itself had a wealth of ancient energy that was more valuable than money and critical for activating the relics. That energy and the discovery of the Sheikah Slate proved to be keys for researching the Guidance Stones. Purah and Robbie were the brilliant young Sheikah that led the research, and Princess Zelda joined them in time.

The study of the relics was critical to Hyrule's survival, but it also utilized an unknown energy that was potentially dangerous. There was concern that Purah was being reckless in her aggressive research methods so her sister, Impa, became the overseer for ancient research as a royal adviser and was responsible for keeping Purah in check.

EXCAVATION OF THE FOUR DIVINE BEASTS & THE GUARDIANS

Under the orders of the king at the time, the banned Sheikah technology was buried, starting with the Divine Beasts. Thankfully, the Sheikah kept secret records of where the Divine Beasts were buried, two of which survived the ages. The Divine Beast Vah Ruta could be found in Zora's Domain, and the Divine Beast Vah Naboris was located in Gerudo Canyon.

Relic surveys of those areas led to the discovery of the Guardians, which were brought back to the research center. Robbie, who was heading up the research of the Guardians, began conducting trial runs on the relics. After much effort, they were able to get them operational. That provided a measure of hope that they could be used to defend against Calamity Ganon.

A surviving record stated that in ancient times the Guardians were stored in five columns beneath Hyrule Castle. However, an exhaustive search of the castle yielded no trace of the columns.

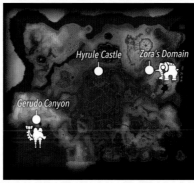

Excavation Sites
The locations of two of the Divine Beasts were known, but the other two were found far from Hyrule Castle. Stories say that one was found on Death Mountain and the other near Rito Village. That means it is likely that the king's expedition surveys covered the entire expanse of Hyrule.

RESEARCHING THE GUIDANCE STONES & THE SHEIKAH SLATE

Inside the four Divine Beasts are terminals known as Guidance Stones. At the time they were rediscovered, nothing could be done with the terminals, and the Divine Beasts remained dormant. Priority was given to finding the device needed to activate them. Princess Zelda and the Sheikah Purah discovered a small rectangular object called the Sheikah Slate. Pressing it against the Guidance Stones in the Divine Beasts activated them. Once the Divine Beasts were active, each was entrusted to one of four newly appointed Champions.

The Sheikah Slate not only was able to activate the Guidance Stones but had the ability to take and store pictures as well, showcasing the impressive technological prowess of the ancient Sheikah. Impa entrusted the study of the slate to Princess Zelda.

The Sheikah Slate advanced their understanding of the mysterious ancient shrines found throughout Hyrule. Legend said that the shrines were training facilities for the hero, and it was apparent that the Sheikah Slate was the key

to operating them, but they could not figure out how to activate them themselves. They did not fully understand the fundamental structure of the relics, and it would be another hundred years before the method for accessing the shrines would become clear.

Guidance Stone	Ancient Shrine

Sheikah Slate
This mysterious relic is a handheld device with a screen that lights up and displays information. It is made from an unknown material thought to be the same as the material the shrines are made from.

THE MYSTERY OF THE SHEIKAH SLATE

The Sheikah Slate is a one-of-a-kind relic that pushed research forward significantly. At the time it was discovered, there were few mechanisms that accepted the Sheikah Slate and could be activated. In addition, such mechanisms were limited to the one used for research purposes and the one in the Shrine of Resurrection, if we exclude those in the Divine Beasts. There are no records of where the Sheikah Slate was discovered, but since the mechanism accepting the Sheikah Slate in the Shrine of Resurrection has only a pedestal, that presents a strong argument that it was discovered there.

No record of the device's actual name was found in any of the excavated materials. Since the relic was created by the Sheikah, Purah suggested the name Sheikah Slate. Its true name is unknown.

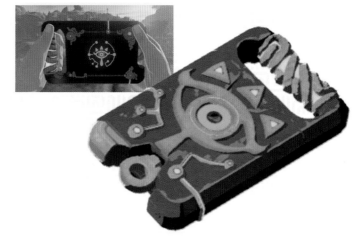

THE CHAMPIONS

The research into ancient relics was progressing as the revival of Calamity Ganon began to feel imminent. Once the Divine Beasts were activated, in line with ancient tradition, four exceptional individuals were chosen from across Hyrule to pilot them. Princess Zelda herself traveled to their homes to request their aid.

Together with the hero chosen by the Master Sword, Link, they were dubbed Champions by King Rhoam and led by Princess Zelda. The team that would seal Calamity Ganon was complete. Link, with the sword that seals the darkness, would be the linchpin, locking Ganon in battle with the Champions piloting the Divine Beasts supporting him. Then, it would be up to Princess Zelda to seal Calamity Ganon away.

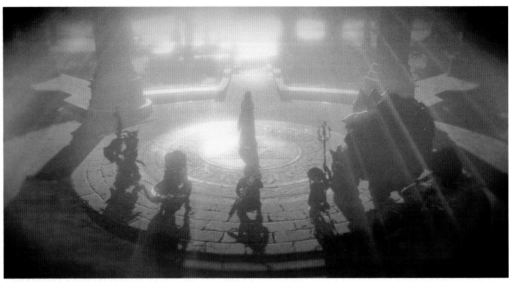

Princess Zelda and the Champions
The five appointed Champions wore the same blue as Princess Zelda and gained a kind of celebrity among the people. Even though they were from different Hyrulean races and came from vastly different walks of life, they forged a deep bond as they prepared to face that fated day.

THE HERO CHOSEN BY THE MASTER SWORD

Born into a line of knights, Link was skilled with a blade and bow and was also an accomplished rider. Gripping the Master Sword this knight was to become the key to sealing Calamity Ganon.

It is said that the legendary Master Sword can only be wielded by a hero chosen by the sword itself, and its whereabouts had long been a mystery. The details of how Link obtained the sword a hundred years ago have been lost to the mists of time, but since he was in possession of it for a number of years prior to becoming a Champion, he was likely around twelve or thirteen years old when it happened.

Extracting the Master Sword from the pedestal where it rests requires unparalleled character and physical strength. The toll taken from the attempt will kill anyone unworthy of wielding the blade. Because of this, it is clear that Link always possessed extraordinary physicality and a strong heart worthy of a hero. There are also stories of Link besting all of Hyrule's seasoned knights when he was only a child.

According to tales told by the long-lived Zora, Link visited Zora's Domain when he was younger and formed a bond with them, defeating a Lynel and teaching various skills to Zora children. This story sheds light on both his physical abilities and his strength of character.

After the Champions for the Divine Beasts were chosen, there was an incident at Hyrule Castle. A Guardian went berserk during a test run. Link deftly defeated it, earning himself a great deal of recognition. Impressed, King Rhoam made him Princess Zelda's appointed knight. With no regard for his own personal safety, he loyally fulfilled his duty to guard Princess Zelda with his life.

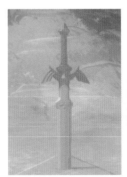
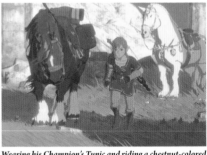

Wearing his Champion's Tunic and riding a chestnut-colored horse, Link faithfully guarded Princess Zelda.

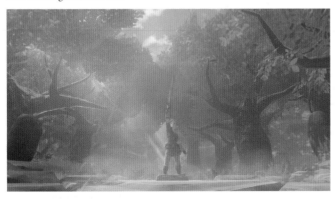

LINK'S FAMILY

There are no records of Link's origin, but he is not nobility. It is thought that his hometown may have been Hateno Village. Being a country knight who rose through the ranks to become a Champion and Princess Zelda's personal bodyguard seems to have raised a few eyebrows and caused a few tongues to cluck.

MIPHA, THE ZORA PRINCESS

Mipha was the daughter of Dorephan, king of Zora's Domain. She was skilled with a spear and possessed the power to heal. She piloted the Divine Beast of water, Vah Ruta, and even though she had a mild and quiet personality, she was the first of the Champions to master the controls of her Divine Beast.

Mipha and Link
They had known each other since Link was a child. Hylians and Zora age very differently, so the young Link seemed to become an adult very quickly to Mipha. He held a special place in her heart.

Mipha and Vah Ruta
When the Divine Beast Vah Ruta was discovered in Zora's Domain, those present said that there was a sparkle of excitement in Mipha's usually calm eyes. She was extremely proud to be chosen as a Champion and cared about Vah Ruta, talking to the Divine Beast as though they were partners.

DARUK, THE STALWART GORON

Daruk was the Goron Champion, chosen to pilot the Divine Beast of fire, Vah Rudania. He had a large, stout build, like a boulder, and the special power to create a defensive sphere around himself. A respected Goron elder, Daruk's personality was as large as his stature, though he showed a softer, protective side around Princess Zelda.

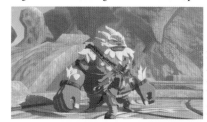

Daruk and Link
They were aquainted before Daruk was chosen to be a Champion. Daruk was fond of Link because they had both strength and gluttony in common and jovially gave him the nickname "little guy."

Daruk and Vah Rudania
Vah Rudania is able to cling to the outside of Death Mountain. Daruk struggled to master the Divine Beast but, with Link's support, became a proficient pilot.

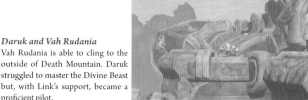

REVALI, THE RITO WARRIOR

Even among the skilled warriors of the Rito, Revali stood alone as the pride of his people, racking up victory after victory in archery tournaments. While he was never quite satisfied with operating a Divine Beast, he finally relented, agreeing to pilot the Divine Beast of Wind, Vah Medoh.

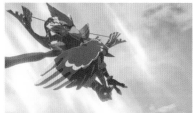

Revali and Link
Revali was so confident in his skills that he was certain that he should be the key to defeating Calamity Ganon. He was dissatisfied with his role supporting Link with the Divine Beast, and he was often in poor spirits because of it.

Revali and Vah Medoh
Vah Medoh soars through the skies. Greenery covers its back, and it resembles a flying garden with an elegant shape. None but the flying Rito, such as the Champion Revali, can approach it.

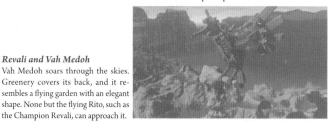

URBOSA, THE CHIEF OF THE GERUDO

Urbosa was the chief of the Gerudo and had the special power to control lightning. It is appropriate that she was the pilot of the Divine Beast of lightning, Vah Naboris. Legend states that Calamity Ganon was once a Gerudo, which seemed to motivate Urbosa in regard to this mission.

Urbosa and Zelda
Urbosa was close with Princess Zelda's mother and had known the princess since she was a child. The Gerudo chief was one of the few people that Princess Zelda, with all of her burdens, could open up to.

Urbosa and Vah Naboris
Vah Naboris strides across the desert. The inner workings of its interior are particularly complicated, and it is potentially the most difficult of the Divine Beasts to operate. Even still, Urbosa was able to manage.

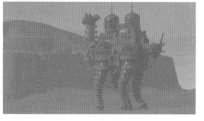

THE CHAMPION PILOTS

The four chosen Divine Beast pilots were invited to the castle where they, along with Link, were appointed as Champions, with Zelda as their leader. Afterward, the four Champions of the Divine Beasts had to undergo trials to measure their compatibility with the Divine Beasts and were assigned one based on the results. They began to practice piloting their assigned beast, attempting to master its controls. Mipha trained with Vah Ruta near Zora's Domain, Daruk trained with Vah Rudania around Goron City, Revali piloted Vah Medoh near Rito Village, and Urbosa operated Vah Naboris in the desert near Gerudo Town.

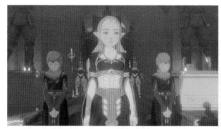

Princess Zelda Visits Urbosa
Princess Zelda traveled all over Hyrule to request the aid of potential pilots. Urbosa accepted her proposition without hesitation, but at least one of the Champions was less than enthusiastic and took convincing. Regardless, the four Champions all eventually agreed to aid the princess.

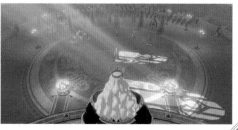

The Inauguration Ceremony
The ceremony to inaugurate the Champions was held in Hyrule Castle's Sanctum. The five gathered warriors, with Princess Zelda as their leader, were all appointed Champions.

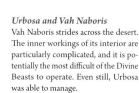

ZELDA'S RESEARCH & TRAINING

With the reality of Calamity Ganon's imminent revival looming, Princess Zelda's responsibility weighed heavily on her.

Women born into Hyrule's royal family were said to be sacred princesses, inheritors of the blood of the goddess Hylia and the power that comes with it. Many princesses were naturally adept at awakening and utilizing this power. Princess Zelda's mother was said to have felt the power overflowing inside her. However, the queen passed away suddenly when Princess Zelda was six years old. The young Princess Zelda's sealing power was expected to awaken, but her mother wasn't able to pass on any of her knowledge of that power.

The following year, at the age of seven, Princess Zelda was encouraged to begin training to draw the dormant power out, but, try as she might, she was never able to awaken her latent ability. The Champions supported her as she made pilgrimage after pilgrimage to the sacred springs to pray. She tried many different avenues, but ten years passed without any results.

Concurrently, Princess Zelda became a proper member of the relic research team. Along with Impa, the head of relic research, as well as the researchers Purah and Robbie, she tirelessly worked to unlock the secrets of the ancient relics. She visited the lands where the Champions were practicing in their Divine Beasts in person, both to train and to make adjustments to the beasts herself. She worked hard on a number of different projects to make sure that they would be prepared for Calamity Ganon with as many countermeasures as possible. She searched for every conceivable way to save Hyrule through understanding the ancient relics in addition to her strict training. King Rhoam, her father, did not see the value in her research and prohibited her involvement with the relics, ordering her instead to increase her training.

Ultimately, Calamity Ganon revived before Princess Zelda could awaken her sealing power, but an event soon after drew out the full extent of her power.

Training at the Springs
Princess Zelda offered her prayers at the spring. She had to submerge herself in cold water, which exhausted her strength and sometimes resulted in high fevers.

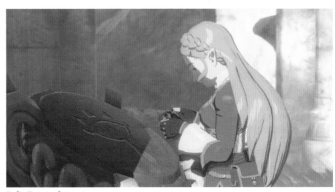

Relic Research
Princess Zelda, who was put in charge of the Sheikah Slate by Impa, redoubled her efforts, traveling the realm trying to understand the relics.

NOTES

THE SACRED PRINCESS

Legend has it that a young princess named Zelda fought alongside the chosen hero utilizing sacred power. Beyond her sealing power, Princess Zelda was said to have prophetic dreams from a young age, which led some to believe that she could hear the voice of the goddess.

DIARY & RESEARCH NOTES

Princess Zelda kept a diary in her room and research notes in a study dedicated to her research. Additionally, a note next to a recipe in a cookbook in Hyrule Castle's library stated that Princess Zelda loved fruitcake.

Fruitcake

Diary *Research*

IMITATING ANCIENT CEREMONIES

Daruk, who could not bear to see Princess Zelda unable to awaken her sealing power, proposed imitating an ancient ceremony in honor of Link being appointed Zelda's personal knight, thinking it might help. The blessing contains many legends regarding the Master Sword.

ANCIENT CEREMONIAL BLESSING
Hero of Hyrule, chosen by the sword that seals the darkness, you have shown unflinching bravery and skill in the face of darkness and adversity, and have proven yourself worthy of the blessings of the Goddess Hylia. Whether skyward bound, adrift in time, or steeped in the glowing embers of twilight, the sacred blade is forever bound to the soul of the hero. We pray for your protection and we hope that the two of you will grow stronger together, as one.

Forged in the long-distant past, the sword that seals the darkness, guardian of Hyrule, ancient steel, forever bound to the hero, in the name of Goddess Hylia, I bless you and your chosen hero. Over the seas of time and distance, when we need the golden power of the goddess, our hope rests in you to be forever by the hero's side. Again, we pray that the two of you will grow stronger and be together as one.

THE YIGA CLAN ATTACKS

During one of Princess Zelda's many training and research trips, the Yiga Clan sprang from the shadows, weapons drawn. In spite of Princess Zelda's resolve to avoid him, Link was determined to fulfill his duty to guard her with his life. He leaped into action, deftly defeating the would-be assassins and showing his true fighting spirit. Rather than making Zelda fearful of pursuing training and research further, it became the pivotal moment that drew her closer to Link.

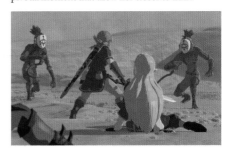

TRAINING TO UNLOCK THE SEALING POWER

Princess Zelda began training to unlock her sealing power at the age of seven—one year and three months after the unexpected passing of her mother, the queen. Unfortunately, the technique for unlocking the sealing power is not written down in any book; it is something that either comes naturally or develops through mentorship with one who has already awakened their power. With Princess Zelda's mother gone, she was responsible for unlocking the sealing power herself, whether she possessed the natural talent or not.

During her training pilgrimages Princess Zelda would wear a white gown in honor of the goddess Hylia, purify herself in the three springs tied to the three Golden Goddesses of creation, and offer her prayers. The last of the springs that Zelda visited was the Spring of Wisdom, located on Mount Lanayru. Lanayru's decree is specific: "No one is allowed, under the age of seventeen. For only the wise are permitted a place upon the mountain." On her seventeenth birthday, ten years after her training began, Princess Zelda ventured up the mountain hoping that this final training journey would be the key to unlocking her power. To her dismay, it was not to be.

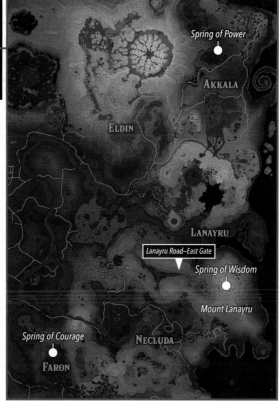

Spring of Power
Of the three springs, this is the easiest to access. It's just off the beaten path.

Spring of Wisdom
Located at the freezing peak of Mount Lanayru, this spring requires a difficult journey through a treacherous mountain pass to access.

Spring of Courage
Found in Faron's dense tropical forest, this spring is part of the mysterious and ancient Zonai Ruins.

Locations of the Three Springs
All three springs can be found to the east of Central Hyrule and require journeying on roads deep into nature.

RESEARCH RESULTS

Outwardly, it may have seemed that Princess Zelda plunged herself into relic research as a means of escaping the dire reality of Calamity Ganon's impending revival. However, she was both logical and overflowing with curiosity, which gave her a scholarly temperament. Zelda had vast knowledge of the flora and fauna of Hyrule and conducted component analysis tests on a number of things, including a study of the effects of ingesting a hot-footed frog on soldiers and the artificial cultivation of the endangered flower known as the silent princess. Princess Zelda had a great passion for research of all kinds. On research surveys of relics, she was able to restore ancient technology to a working state, putting her technological prowess on par with that of Sheikah researchers of the time.

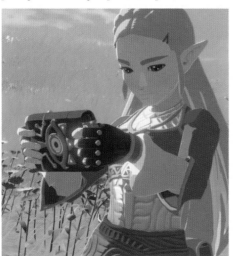

Hot-Footed Frog
The unique nutritional properties of the hot-footed frog were found to improve soldiers' physical abilities for a short time. Princess Zelda was determined to put this knowledge to use in actual combat.

Silent Princess
The endangered silent princess was unable to thrive in captivity. Perhaps it reminded Zelda of herself . . .

CONFLICT BETWEEN FATHER & DAUGHTER

All of the self-doubt that Princess Zelda felt about being unable to unlock her power was intensified by her proximity to Link, who seemed to be so naturally gifted. Link's silence also seemed to exacerbate Zelda's insecurities. However, once she saw Link for who he truly was, her opinion changed. In a moment of personal growth, Zelda realized that everyone, even Link, has struggles that go unseen by the world.

King Rhoam was also troubled by a deep personal conflict. Since his daughter was unable to awaken her sealing power, he felt that it was his duty, as king, to be strict toward her. The people were relying on her but were losing faith, calling her the heir to a throne of nothing but failure. However, if the Ganon prophecy were not looming over their heads, he would have told her to take her time with her training. The king's journal, found in Hyrule Castle, reveals a father who cares deeply for his daughter.

The last entry in the journal was made shortly after Zelda headed for the Spring of Wisdom. King Rhoam knew that it was likely Zelda's final chance to unlock her power before the prophecy was fulfilled, and resolved that, if this should fail too, he would speak kindly to her the next time they met and encourage her to research her beloved relics. Unfortunately, the two would never see each other again.

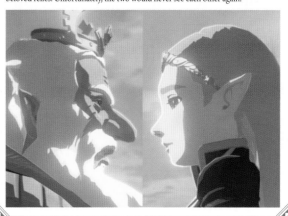

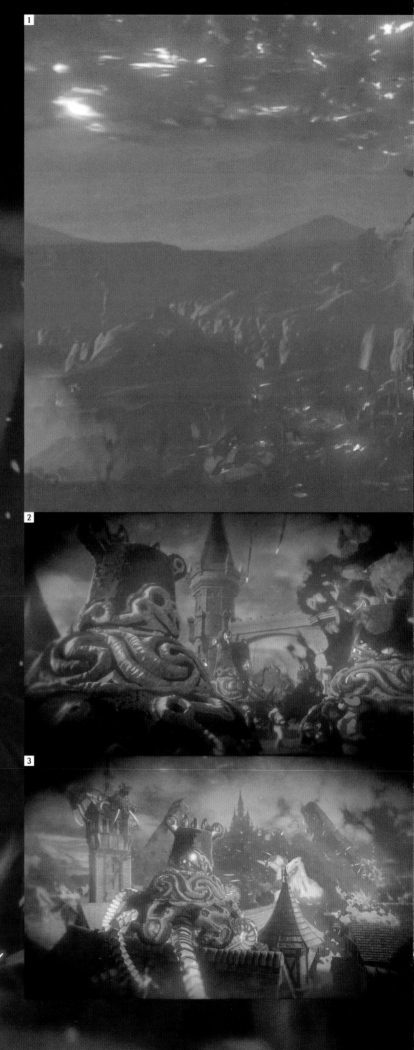

Calamity Ganon emerged suddenly from deep beneath Hyrule Castle. Even though its return was prophesied, it was hard to accept after ten thousand years of peace.

It's possible that sometime in the ancient past, Calamity Ganon was once a Gerudo or one of the other Hyrulean races, but now it could only be described as hatred and malice incarnate, defying all understanding. The only thing that was clear was that it meant to annihilate Hyrule.

Having suffered defeat at the hands of the mechanical Guardians once before, it took control of them before they could be brought to bear and used them as an army.

It possessed the four Divine Beasts as well, and with Princess Zelda's sealing power still dormant, even Link, though he fought valiantly, fell before the sheer number of enemies they faced.

The casualties were countless. Hyrule Castle burned, and the king of Hyrule perished, leaving Hyrule without a functioning power structure. Though the soldiers had lost their leader, they fought to the last.

The kingdom of Hyrule was destroyed.

THE GREAT CALAMITY
~ DOWNFALL ~

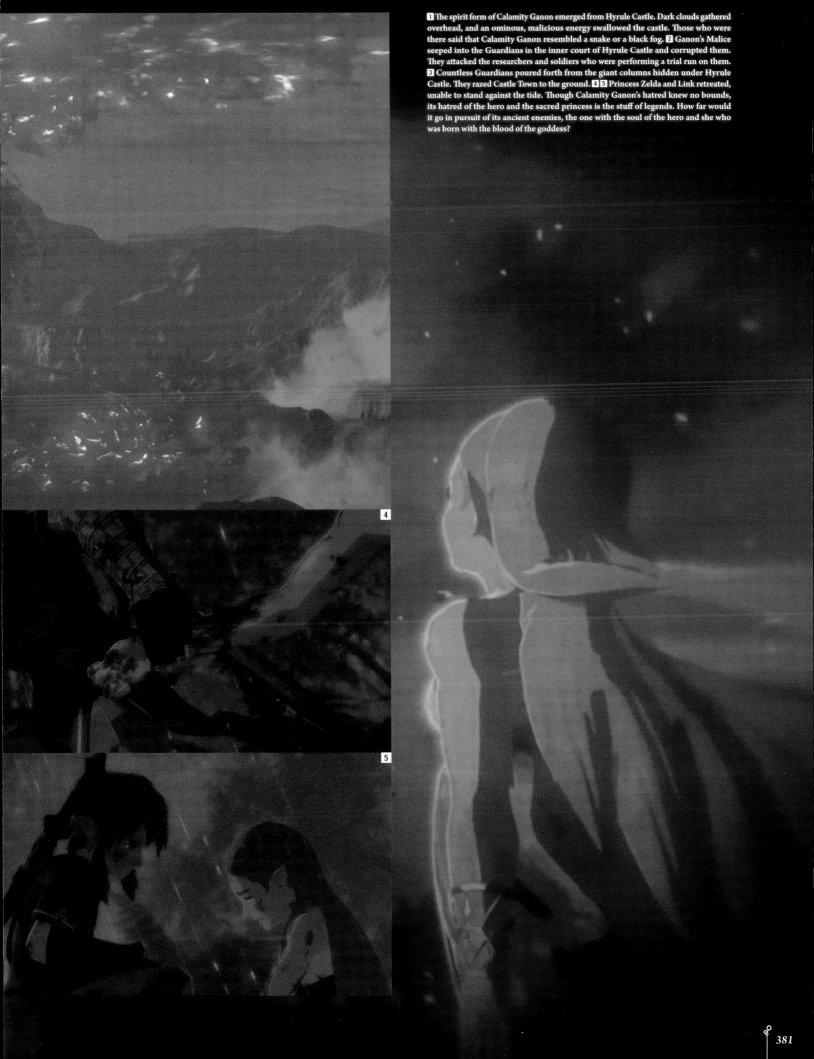

1 The spirit form of Calamity Ganon emerged from Hyrule Castle. Dark clouds gathered overhead, and an ominous, malicious energy swallowed the castle. Those who were there said that Calamity Ganon resembled a snake or a black fog. **2** Ganon's Malice seeped into the Guardians in the inner court of Hyrule Castle and corrupted them. They attacked the researchers and soldiers who were performing a trial run on them. **3** Countless Guardians poured forth from the giant columns hidden under Hyrule Castle. They razed Castle Town to the ground. **4 5** Princess Zelda and Link retreated, unable to stand against the tide. Though Calamity Ganon's hatred knew no bounds, its hatred of the hero and the sacred princess is the stuff of legends. How far would it go in pursuit of its ancient enemies, the one with the soul of the hero and she who was born with the blood of the goddess?

CALAMITY GANON'S REVIVAL

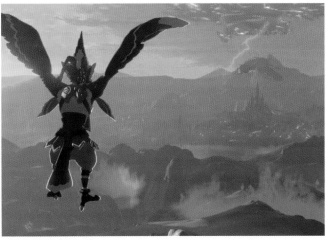

The Moment of Revival
On the way back from the Spring of Wisdom, the Champions were surprised when the ground began shaking. Revali flew high enough to see Calamity Ganon's Malice spreading like a fog.

Calamity Ganon appeared from deep under Hyrule Castle as though it would rend the sky asunder. Dark clouds gathered, and the area became a whirlpool of Malice.

Calamity Ganon's Malice spread like tendrils through the castle, permeating the Guardians and turning them into pawns to attack Hyrule. The Divine Beasts, key to subduing Calamity Ganon's great power long enough for Link and the princess to seal it away, were possessed by phantom versions of Ganon. Though the great Champions fought valiantly, none were able to stand against the dark manifestations of Ganon, and the Divine Beasts were also turned against the people they were meant to protect.

The Guardians flooded out of Hyrule Castle like locusts, turning Castle Town into a sea of flames. Most people were killed in the initial onslaught, King Rhoam among them, and the wave of Guardians flowed out into greater Hyrule. The towns of Central Hyrule bore the brunt of the assault and were annihilated. The proud kingdom, which had withstood calamity big and small for millennia, was destroyed by Calamity Ganon and its army of ancient automata.

Just when it looked as though nothing could stop Ganon, Zelda's power awakened, and she alone turned it back, sealing it within Hyrule Castle. The Guardians' assault was stopped, and the survivors of the Great Calamity were left to pick up the pieces.

THE GIANT COLUMNS CONTAINING THE GUARDIANS

Calamity Ganon's revival coincided with the appearance of the five giant columns of legend surrounding Hyrule Castle. These columns were built by the ancient Sheikah to house the Guardians in anticipation of Calamity Ganon's next revival, sensing the moment it stirred, springing to life, and sending an army of Guardians to contain it. However, Ganon was too cunning to be defeated the same way twice. It took control of the Guardians and made them its vanguard. Without their protectors, the castle, Castle Town, and the towns and villages of Hyrule were powerless and fell one by one.

The brave soldiers of Hyrule were overwhelmed by the sheer number of Guardians spewing forth from the columns, and by the time Link and Zelda made their way back from Mount Lanayru to Hyrule Castle Town, it was already gone. The few remaining soldiers fled to the Akkala region, and Link and the princess retreated toward Necluda with Guardians pursuing them. The soldiers, Link, and the princess would be forced into desperate battles.

Hyrule Castle Town, villages, ranches, garrisons, and other settlements were mowed down by the merciless Guardians. The region shows no sign of recovery, and the ruins have become home to monsters over the last one hundred years. Central Hyrule wears their remains as scars of the Great Calamity.

The Giant Columns
The columns were storage facilities for the Guardians and were buried deep underground in key locations surrounding Hyrule Castle. When they were functioning properly, they emitted the soft blue glow of ancient energy, but those under the control of Calamity Ganon's Malice glowed an ominous pink.

The Castle and Castle Town Destroyed
Only the skeletal remains of the domiciles, walls, and roads of Castle Town remain. It is known that there were survivors, which seems to suggest that the town was not annihilated instantly. One of the known survivors was the court poet. The quick-witted member of the Sheikah tribe was able to escape to Kakariko Village.

Calamity Ganon's Malice enters one of the Guardians being tested by the Sheikah in the castle courtyard. The moment Ganon's influence penetrates the automaton, it becomes an enemy soldier.

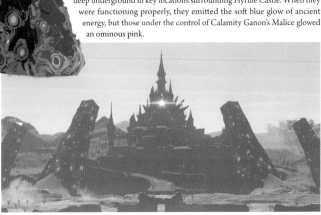
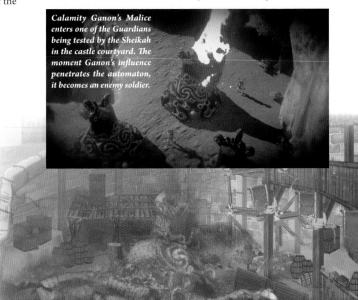

THE CHAMPIONS' DOWNFALL

When Calamity Ganon revived, the Champions were accompanying Princess Zelda from her final training pilgrimage at the Spring of Wisdom on Mount Lanayru. Together, they felt the ground shake and saw Hyrule Castle engulfed in darkness.

With Princess Zelda's sealing power still dormant, Daruk came up with a desperate plan to stop Calamity Ganon. Link would confront Ganon head on while the four Champions would lend their support. With that, Link headed to Hyrule Castle and the other Champions to their Divine Beasts.

However, Malice had already assumed control of the beasts, and phantom versions of Ganon awaited the Champions. Each one of them perished, and their spirits were trapped within the Divine Beasts for the next one hundred years.

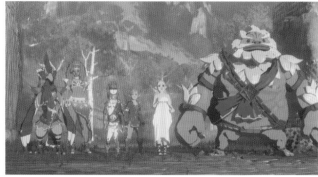

Princess Zelda and the others see Calamity Ganon from the eastern gate of Lanayru Road.

The Divine Beasts Corrupted
Four precisely aimed globs of concentrated Malice were launched at the Divine Beasts, corrupting them and turning into phantom versions of Calamity Ganon. With the Divine Beasts under their control, they attacked Hyrule.

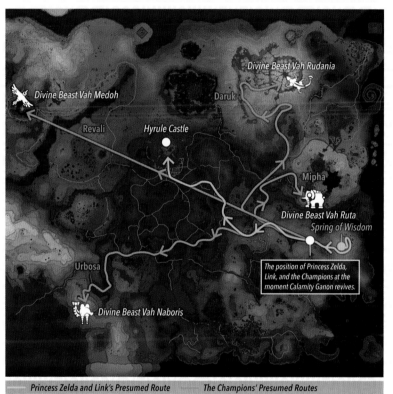

The normally well-maintained paths through the Divine Beasts, now clogged with Malice.

Princess Zelda and Link's Presumed Route	The Champions' Presumed Routes

Due to the distance between the east gate of Lanayru Road, Hyrule Castle, and the standby positions of the Divine Beasts, it is impossible to know what state Hyrule was in when the Champions reached their designated positions.

THE SPIRITS OF THE FOUR CHAMPIONS

Once Calamity Ganon took control of the Divine Beasts, it created phantom versions of itself. The Phantom Ganons were a combination of Calamity Ganon's Malice and ancient weaponry and wielded the elemental power of the Divine Beast that they'd taken over, whether that be fire, wind, water, or lightning.

When the Champions arrived at their respective Divine Beasts, they fought the Phantom Ganons in an attempt to reclaim them and support Link. None survived. Not even the stout Daruk was able to withstand the awesome might of Fireblight Ganon, and Urbosa, though she controlled lightning itself, fell to Thunderblight Ganon.

Not only did the Phantom Ganons defeat the Champions; they imprisoned their spirits within the Divine Beasts. Since no one but a Champion is able to enter a Divine Beast, and all the Champions were presumed dead, the fate of the spirits of the Champions was grim. Mipha spent each day in hopeless sorrow, and the other Champions could only hope that somehow, Link would come to take back the Divine Beasts. It is said that strong-willed spirits are occasionally able to lend their power to that of the chosen hero. If Link were alive, perhaps they would still have a chance to assist him in taking down Calamity Ganon.

Mipha, her spirit freed, looks toward Zora's Domain wistfully and remembers her people, her father, and the life she left behind.

When Daruk's spirit is freed, he is able to see his hometown once more and is content knowing that the Gorons are still going strong.

THE TWO FORTRESSES & THE FINAL BATTLES

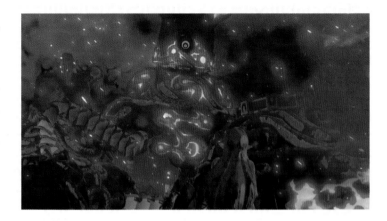

It is possible to infer what happened during the Great Calamity from the path of destruction caused by the Guardians, the ruins, the wreckage of destroyed Guardians, and the verbal history passed down by those who survived the Calamity.

After the Guardians were corrupted, they flowed outward from Hyrule Castle. First, they destroyed Castle Town and then spread out in all directions, annihilating the towns, garrisons, and outposts of Hyrule Field. From there, they pushed on into greater Hyrule. Most settlements were destroyed, leaving only ruins behind, but two fortresses stood their ground and mounted impassioned defenses: Akkala Citadel, the final battleground of the kingdom of Hyrule, and Fort Hateno, the destination that the desperate Link and Zelda were attempting to retreat to. The remains of these two fortresses tell of fierce battles.

RETREATING TO THE FORTRESSES

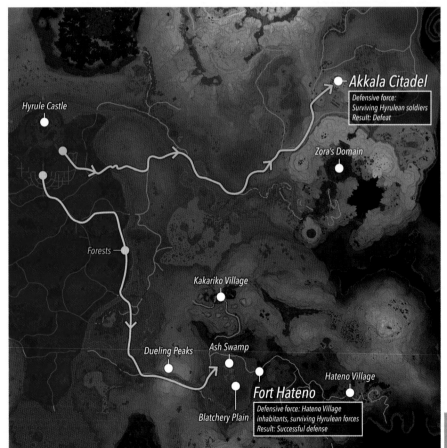

Akkala Citadel
Defensive force: Surviving Hyrulean soldiers
Result: Defeat

Hyrule Castle

Zora's Domain

Forests

Kakariko Village

Dueling Peaks — Ash Swamp

Hateno Village

Fort Hateno
Defensive force: Hateno Village inhabitants, surviving Hyrulean forces
Result: Successful defense

Blatchery Plain

■ Destroyed The Guardians' Advance
 Link and Zelda's Escape Route
 The Surviving Soldiers' Escape Route

With Hyrule Castle compromised, the soldiers of the kingdom of Hyrule fell back to Akkala Citadel, a mighty fortress thought to be impregnable. Though they fought valiantly, the soldiers were unable to withstand the Guardians' assault. Akkala Citadel was the last stand of the proud kingdom of Hyrule and the location where it was extinguished.

While the soldiers fled to Akkala, Link and Zelda made their way toward Necluda and Fort Hateno, from which they could head north and deliver Princess Zelda to the safety of Kakariko Village. Using the dense forests as cover, they escaped along the river, guiding the remaining survivors as they went. Though they were exhausted from the retreat and skirmishes with the Guardians along the way, the survivors and forces from nearby Hateno Village summoned the strength to make one last stand at the frontier stronghold, Fort Hateno. They successfully held off the advance of the Guardians, sparing Hateno Village just beyond the fort from the devastation of the Great Calamity. Fort Hateno continues to be spoken of with reverence as the miraculous fortress that withstood the unstoppable assault of the Guardians, protecting Hateno Village and its people.

Though the role that the Champion Link played was not known to many, the great number of Guardians that Calamity Ganon sent in pursuit of the chosen hero shows just how much of a threat Calamity Ganon felt him to be.

Link, fulfilling his duty to protect Princess Zelda, leads her through the forest in an attempt to get her to Kakariko Village. The skilled knight defeats many Guardians along the way but, injured and fatigued, finally succumbs and collapses on Blatchery Plain, half a day away from Kakariko Village.

Here is Blatchery Plain as seen from Fort Hateno. The remains of the Guardians litter the area, reminders of the fierce battle. Many of the decaying husks of the Guardians surrounding Ash Swamp were destroyed when Link collapsed and Princess Zelda's power awakened.

THE MIRACULOUS FORT HATENO

According to local legend, Fort Hateno was defended by a makeshift militia from Hateno Village and the surrounding area, along with the Hyrulean soldiers stationed nearby. Unlike the sturdily constructed Akkala Citadel, Fort Hateno was a simple structure far from Central Hyrule, and it has been speculated that is why it escaped significant damage.

In reality, Link destroyed a significant number of Guardians en route, and with Princess Zelda's power awakening and disabling all of the Guardians around her, the forces heading to Fort Hateno were greatly weakened. That gave those at the fort the edge they needed to avoid a protracted battle with the Guardians and set the stage for the miracle of Fort Hateno.

The present-day Fort Hateno is a simple barricade reinforced by wood where the original was destroyed by the Guardian attack. It hasn't been restored because the people were forced to prioritize rebuilding their lives following the attack, and, more practically, because those skilled in stonemasonry were wiped out, along with the knowledge of how to repair stone buildings. Even if that weren't the case, the people of this region lack the funds to make comprehensive repairs to the fort.

▷ Fort Hateno's Line of Defense

Fort Hateno sits at a chokepoint in a valley along the road from Central Hyrule to Necluda, and its appearance suggests it was more of a checkpoint than a fortress. There are no permanent living quarters for soldiers, so it's likely that they came from elsewhere to work their shifts, and it can be inferred that Fort Hateno's purpose was to observe the coming and going of people between Central Hyrule and Necluda.

Since it was never intended to face a full-scale assault, it didn't have the space to deploy soldiers like Akkala Citadel did. It's said that on the day of the Great Calamity, all they could do was shoot arrows from the wall in an attempt to slow the approaching Guardians.

The road from Central Hyrule passes between the Dueling Peaks, creating a bottleneck that slowed the Guardians down, but Blatchery Plain, right in front of Fort Hateno, is a wide-open space that made defense difficult for the protectors of Necluda. There was also a limit to how many people could stand on the wall at the same time, so their defensive capabilities were minimal. With Hateno Village being so close, reinforcements were readily available, but because the fort was not meant for a prolonged battle, there wasn't anyone there capable of coming up with a long-term strategy for extended warfare.

It is obvious from the remains of the Guardians that were in the process of climbing the wall of Fort Hateno when they were destroyed that the fort was mere moments from being overrun. It is reasonable to call the successful defense of this frontier outpost a true miracle.

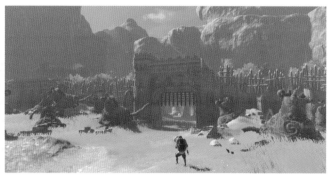

The Guardians assaulted Fort Hateno from Blatchery Plain. The remains of Guardians climbing the fortress walls can still be seen.

Here are the wooden platforms made for soldiers on the side of the fort facing Hateno Village. The portions of the wall destroyed in the assault have been reinforced with simple wooden lattice barricades. It has not been repaired since that day, so it's still possible to conjure up images of what happened during the battle.

ROBBIE'S ATONEMENT

Perhaps forty or fifty years after the day of the Great Calamity, Robbie, the lead Guardian researcher, created the first weapon that was effective against the mechanical monsters: the ancient arrow. It is said that while testing his new weapon, he annihilated a few stray Guardians still patrolling near Fort Hateno. Some say that this was his way of atoning for his deepest regret: not providing Link with weapons effective against the Guardians on the day of the Great Calamity. He thought that if the hero had those weapons he might have stood a chance.

If this story is true, then some of the Guardians surrounding Fort Hateno were destroyed by Robbie and not in the assault. That could mean that the people fought against slightly fewer Guardians on the day of the massive defensive battle than is currently thought.

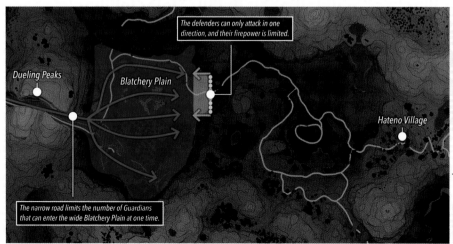

The defenders can only attack in one direction, and their firepower is limited.

Dueling Peaks

Blatchery Plain

Hateno Village

The narrow road limits the number of Guardians that can enter the wide Blatchery Plain at one time.

The height of the walls shows that they were built to ward off other Hyruleans, not Guardians. The top levels were destroyed in the fighting as the Guardians scaled the wall.

→ Guardians' Assault
■ Fort Hateno's Defensive Range
■ Guardians Held at Bay

AKKALA CITADEL: THE KINGDOM OF HYRULE'S LAST STAND

Akkala Citadel, which watches over the Akkala region, was said to be an impenetrable fortress. With the king gone, the kingdom's soldiers were in disarray and fell back to this famed fortress in order to put up an effective resistance.

The soldiers were overrun, and, one hundred years later, few know about this citadel. However, looking at the topography and the citadel's ruins, details of the battle become clear.

▷ Akkala Citadel's Tactical Functions

Akkala Citadel sits in the middle of two roads that enter Akkala, one on each side, and is perched high atop a peak in between them. A sheer cliff face forms a natural border all the way from the northwest side to the northeast side. A stone staircase to the citadel runs clockwise up the peak from the former Akkala Bridge in the southeast. The south side of the citadel faces the main road into Akkala, so a high stone wall was constructed for defense.

It is unclear how many soldiers defended Akkala Citadel, but due to the scale of the fortress, it's likely that many skilled soldiers were needed. The Akkala parade ground is to the south of the citadel, and it is possible to see the living quarters at the top of the citadel, so it's clear that there were soldiers present continuously, even in peacetime.

Reaching Akkala Citadel requires crossing the Akkala Span and Akkala Bridge. Due to its elevation, transporting provisions to the citadel would have been extremely difficult. In other words, during times of siege it was not possible to reinforce the position. It would have had to be built to be self-sufficient and must have had enough provisions to last several months or perhaps several years.

Akkala Citadel's primary function was to repel invaders from across the sea and keep them from marching on Central Hyrule. The batteries were set up to annihilate an enemy coming from the sea, with battery 3 being the first point of attack and batteries 1 and 2 cleaning up the forces that made it through. However, the battle that ultimately took place against the Guardians had Akkala facing an enemy assaulting them from Central Hyrule.

There were two routes that led from Central Hyrule to Deep Akkala: the route that crossed from west to east on the south side of Akkala Citadel and the western road that descended a long road into the valley. The western road was directly exposed to an attack from the fortress, which made it unsuitable for an invasion. Even if the invader managed to make it through the barrage headed its way from the citadel, from behind it would have been exposed to counterattack from the fortress. Thus, it would have made more sense for an enemy to try to attack via the southern road, but they would have had to face the three well-positioned batteries if they made the attempt. It was thought that the powerful batteries would provide an onslaught that a foe could not hope to survive. Batteries 1 and 2 had different fields of fire due to the difference in their elevation, increasing their firepower and attack range. Battery 3's range covered the east side of Akkala Citadel and eliminated the enemies that survived attacks from batteries 1 and 2.

Due to these factors, Akkala Citadel could have defended itself from any traditional foe attacking from either direction and was a more than sufficient defensive position for the large tactical role it played in the defense of Hyrule.

However, the Guardians' assault was outside the realm of what those that designed Akkala Citadel could have imagined. Faced with an unanticipated amount of firepower and numbers from an unanticipated route, the impenetrable fortress finally fell.

Cannons
The cannons were the last line of defense the soldiers of Hyrule had against the Guardians. They still stand where they were last used. Exposure to wind and rain has rusted them, and spider webs now adorn the barrels. They will not see action again.

There are still traces of how people lived inside the long-undisturbed citadel.

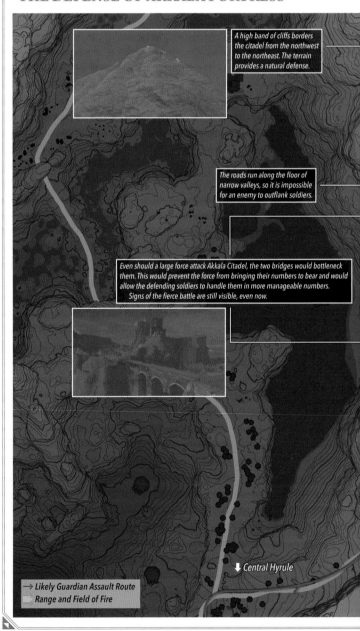

THE DEFENSE OF AKKALA FORTRESS

A high band of cliffs borders the citadel from the northwest to the northeast. The terrain provides a natural defense.

The roads run along the floor of narrow valleys, so it is impossible for an enemy to outflank soldiers.

Even should a large force attack Akkala Citadel, the two bridges would bottleneck them. This would prevent the force from bringing their numbers to bear and would allow the defending soldiers to handle them in more manageable numbers. Signs of the fierce battle are still visible, even now.

↓ Central Hyrule

→ Likely Guardian Assault Route
☐ Range and Field of Fire

The Citadel and the Tower

The Akkala Tower is presently visible emerging through the center of the Akkala Citadel ruins. The citadel boasted top-tier construction, but the existence of the Sheikah Tower was not discovered during its creation. The tower was likely buried deep within the ground. One can only speculate how events would have changed had they discovered the tower at that time.

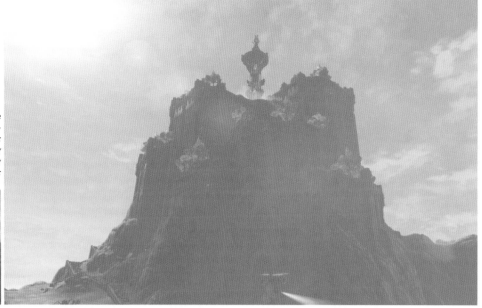

There are no cannons in either Hyrule Castle or the military training camp. Aside from the Sheikah's technological terrors, the cannons were likely the most powerful weapon in Hyrule. The fact that Akkala Citadel possessed them indicates that a significant level of fighting was anticipated. While it isn't known how powerful the cannons were, it is obvious from Akkala's tactical significance that they played a large role in Hyrule's defense.

Deep Akkala ⬆

Akkala Bridge Ruins

Battery 1

Akkala Citadel

Battery 2

Battery 3

Akkala Span

The open area to the south of Akkala Citadel features two overlapping fields of fire, making it seemingly impossible for an invader to approach the citadel. However, the citadel was powerless before the might of the Guardians.

Battery 3 was the first line of defense against enemy forces attacking from the south, and if an enemy slipped through from the west, it would wipe them out in their retreat. However, it is likely that due to the direction of the Guardians' assault, this battery did not play a role in the battle.

Sokkala Bridge ➡

Battery 1

Located at the top of the citadel, battery 1 was likely the heart of Akkala Citadel's military strength. Nothing stood a chance if targeted by an accurate shot from a battery that high up.

Battery 2

Battery 2 is below battery 1 and provided crossfire for it. It is closer to the ground and was used to completely destroy the remnants of the enemy.

Battery 3

This battery stands alone atop a lingulate plateau and is capable of covering the road near Sokkala Bridge.

PRINCESS ZELDA'S AWAKENING & LINK'S SLUMBER

With the Divine Beasts corrupted and the spirits of the Champions trapped inside, Link grabbed Zelda's hand and retreated with her through the forests. Right outside Fort Hateno, Link's legendary strength finally gave out and he collapsed. Princess Zelda begged him to run and save himself, but he refused, rising to his feet to face his destiny. Seeing his state, Princess Zelda placed herself between Link and the Guardians, protecting him with her body and sticking her hand out as though willing the Guardians to stop their advance. Just then, the mark of the Triforce appeared on the back of her hand, and the princess was surrounded by a powerful light. Princess Zelda's sealing power had awakened. The light drove Calamity Ganon's Malice from the Guardians, and one by one, they ceased functioning.

Although Zelda had taken care of the immediate threat, Link was near death. It was then that Princess Zelda heard a voice from within the Master Sword: "He can still be saved."

Trusting the voice, Princess Zelda had the Sheikah take Link to the Shrine of Resurrection. In order to restore his battered body, the hero was placed into a long, deep slumber.

Princess Zelda took the Master Sword, which Link had used to fend off many Guardians, to its pedestal in the forest. The legendary blade had been damaged in the fighting, and it too needed time to recover. Princess Zelda believed that Link would return to reclaim it in the future and entrusted the sword to the protection of the spirit of the forest, the Great Deku Tree.

Then, alone, she headed to Hyrule Castle to confront Calamity Ganon. With her sealing power awakened, she was able to suppress its power. The kingdom of Hyrule had been destroyed, but Princess Zelda succeeded in stopping the invasion.

NOTES

THE TRIFORCE

The Triforce crest is made up of three equilateral triangles. Since the actual relic plays a large part in the creation myth of Hyrule, its symbol is often used in heraldry and artisinal decorations.

The Triforce itself is said to contain the power of the goddesses, but that cannot be confirmed since the only verifiable power tied to the Triforce in this era was the light that appeared from Princess Zelda's right hand. Unfortunately, nothing more is known regarding the Triforce.

A relief chiseled into the surface of the floor of Hyrule Castle Town's central square is pictured here. Symbols similar to the ones seen here are carved around the Spring of Power, Spring of Wisdom, and Spring of Courage, due to their connections to the goddesses.

THE VOICE WITHIN THE MASTER SWORD

A voice from within the Master Sword called out to Princess Zelda after Link collapsed. Zelda was able to hear it because her power had awoken. The sword offered guidance and helped the princess save Link from the brink of death. Though Zelda knew Link would likely lose his memories in the healing process, the sword persuaded her to send the hero to the Shrine of Resurrection.

It has been said that the voice in the sword sounds like a woman, which echoes the myth passed on through the ages of a sword spirit who once fought alongside the hero.

The Master Sword glows with an inner light and tells Princess Zelda what she must do next.

SHRINE OF RESURRECTION

Of the shrines found on the Great Plateau, the Shrine of Resurrection is unique. It houses a treatment facility rather than a trial. A massive device where a person can be placed lies within. Once the patient is in position, the device fills with a mysterious healing liquid, starting the process of resurrection. The critically injured Link was carried here by the Sheikah.

The treatment table is shaped like a dish and filled with liquid. The mark of the Sheikah can be seen on the headrest.

PRINCESS ZELDA'S JOURNEY

Impa had ordered a large-scale search for Princess Zelda, and when her sealing power awakened on Blatchery Plain, there were several Sheikah headed for her location. Princess Zelda entrusted the critically injured Link to the Sheikah and gave them the Sheikah Slate as well, to operate the Shrine of Resurrection. She then headed to Kakariko Village to pass on a message to Impa. From there, she made her way to Korok Forest to place the Master Sword in its pedestal to recover. Princess Zelda's decisive actions after her power awakened gave Hyrule the best chance of surviving Calamity Ganon.

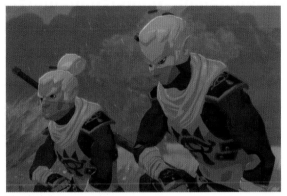

The Sheikah Arrive on the Scene
The agile Sheikah arrived just moments after Link collapsed. After hearing Princess Zelda's tale in Kakariko Village, Purah and Robbie hurried to the Shrine of Resurrection to look after Link.

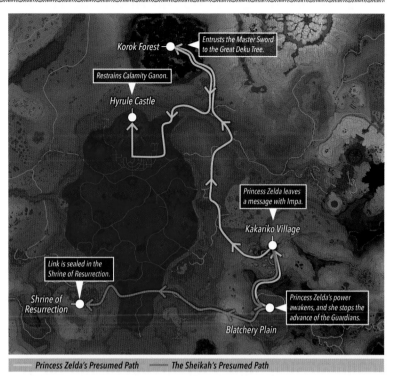

Korok Forest — Entrusts the Master Sword to the Great Deku Tree.

Restrains Calamity Ganon.

Hyrule Castle

Princess Zelda leaves a message with Impa.

Kakariko Village

Link is sealed in the Shrine of Resurrection.

Shrine of Resurrection

Princess Zelda's power awakens, and she stops the advance of the Guardians.

Blatchery Plain

——— *Princess Zelda's Presumed Path* ——— *The Sheikah's Presumed Path*

THE MASTER SWORD RESTS

The Great Deku Tree has watched over Hyrule for a very long time. Princess Zelda trusted that the Master Sword would recover while under his watchful gaze. It is clear that Princess Zelda was prepared to sacrifice herself in order to suppress Calamity Ganon, but a few well-chosen words by the wise Great Deku Tree made her reconsider her options.

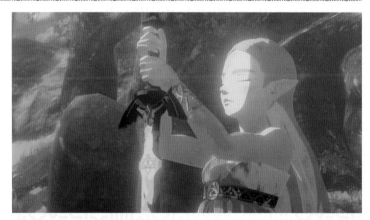

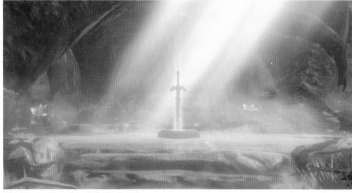

The Master Sword and the Pedestal
The voice inside the Master Sword provided invaluable advice following Zelda's awakening, but this is where the two had to part. Zelda spoke to the sword, saying that although the Slumber of Restoration would most certainly deprive Link of his memories, he would arrive before the legendary blade again one day.

THE PRESENT
~ RESURRECTION OF THE HERO ~

An ancient hero, a Calamity appears,
Now resurrected after 10,000 years.
Her appointed knight gives his life,
Shields her figure, and pays the price.
The princess's love for her fallen knight
awakens her power
And within the castle the Calamity is
forced to cower.
But the knight survives! In the Shrine of
Resurrection he sleeps,
Until from his healing dream he leaps!
For fierce and deadly trials await.
To regain his strength. Fulfill his fate.
To become a hero once again!
To wrest the princess from evil's den.
The hero, the princess—hand in hand—
Must bring the light back to this land.
—"Song of the Hero" by the Court Poet

"Wake up, Link."

A disembodied voice calls out to Link, beckoning him to open his eyes. Real or imagined, it appears that it is time for the hero to awaken. A pedestal housing a glowing object catches his eye. Link retrieves the mysterious object. Though he has never seen it before, it seems familiar. The voice tells Link that the object is a Sheikah Slate and that it will guide him after his long slumber.

Sheikah Slate in hand, Link makes his way to the exit of this dim, cave-like facility. The natural light flooding in is blinding, and Link must squint as he walks into it. The verdant expanse of Hyrule spreads out before him. Though his eyes are still adjusting, Link can see a grand but ominous castle in the distance.

The damp, fresh air embraces him as he breathes it in as though for the first time. The voice returns, speaks of a beast, and tells him to hurry. While the meaning is not entirely clear, it seems that fate has something grand in store for him.

This is how the new journey begins for the chosen hero of Hyrule, the Champion Link. It is also how the story of his true battle with Calamity Ganon begins.

As the song left behind by the court poet foretold, he will have to overcome many trials, take the hand of the sacred princess, and restore light to the land.

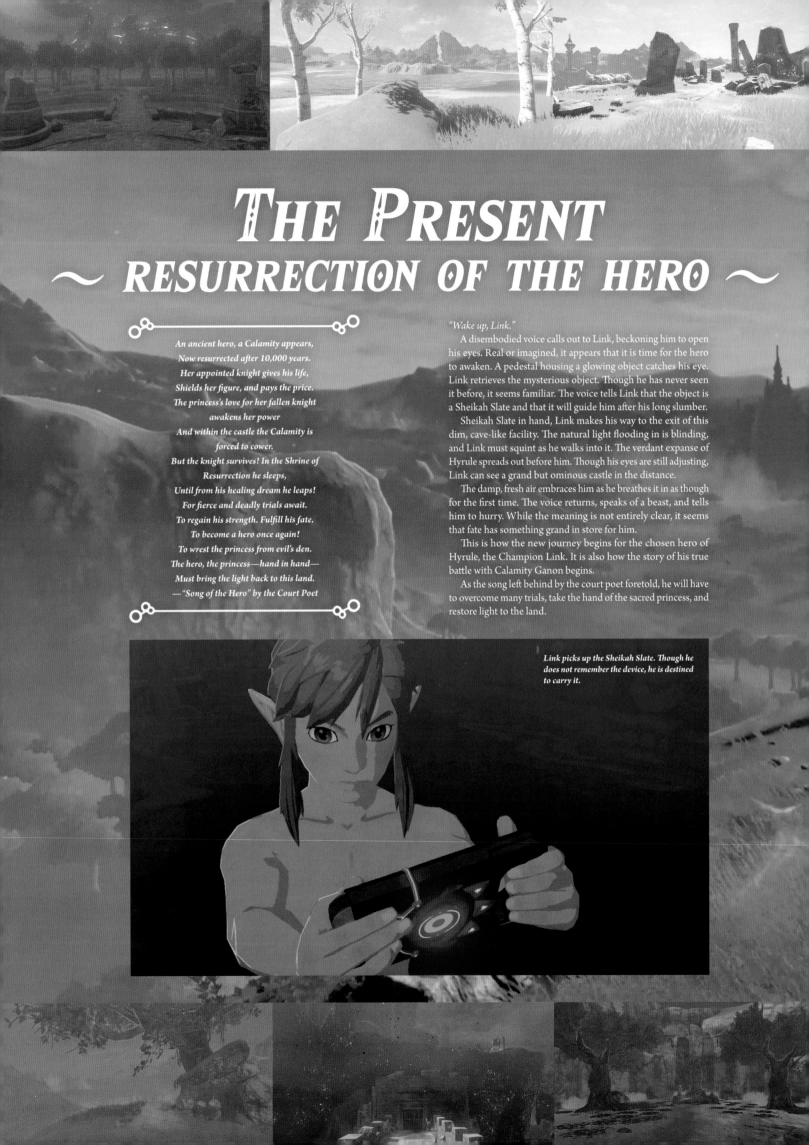

Link picks up the Sheikah Slate. Though he does not remember the device, he is destined to carry it.

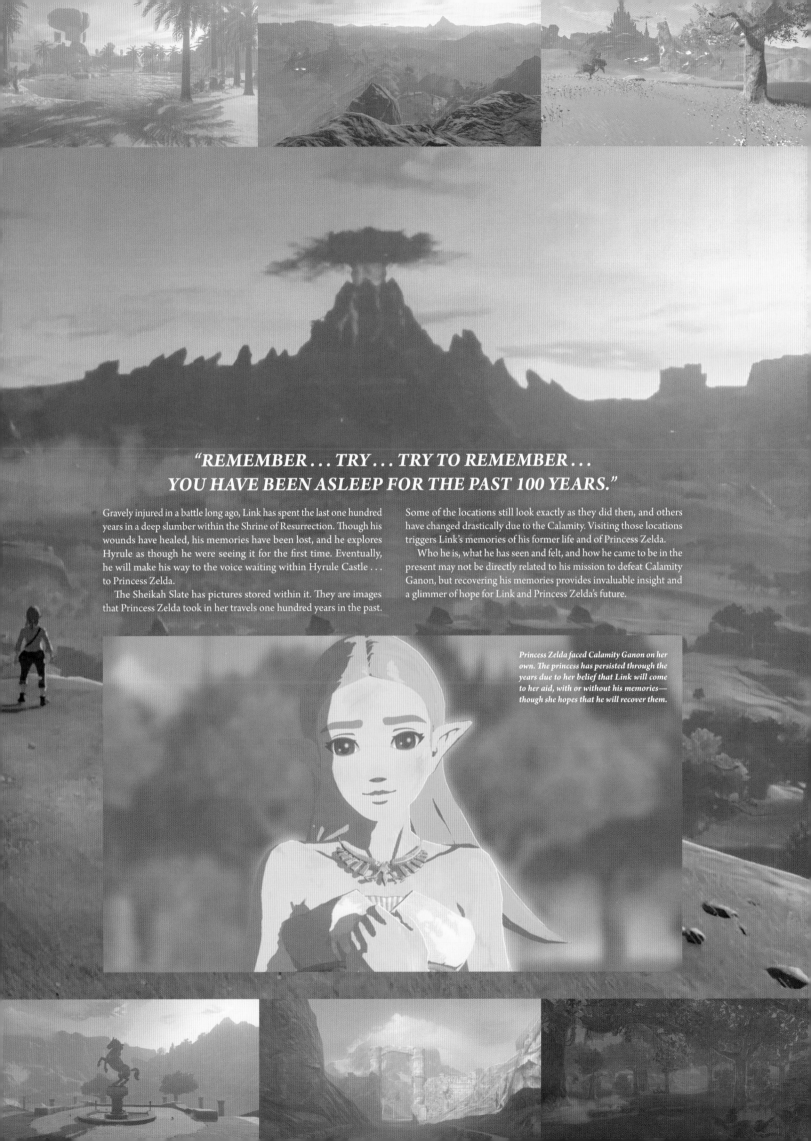

"REMEMBER . . . TRY . . . TRY TO REMEMBER . . .
YOU HAVE BEEN ASLEEP FOR THE PAST 100 YEARS."

Gravely injured in a battle long ago, Link has spent the last one hundred years in a deep slumber within the Shrine of Resurrection. Though his wounds have healed, his memories have been lost, and he explores Hyrule as though he were seeing it for the first time. Eventually, he will make his way to the voice waiting within Hyrule Castle . . . to Princess Zelda.

The Sheikah Slate has pictures stored within it. They are images that Princess Zelda took in her travels one hundred years in the past.

Some of the locations still look exactly as they did then, and others have changed drastically due to the Calamity. Visiting those locations triggers Link's memories of his former life and of Princess Zelda.

Who he is, what he has seen and felt, and how he came to be in the present may not be directly related to his mission to defeat Calamity Ganon, but recovering his memories provides invaluable insight and a glimmer of hope for Link and Princess Zelda's future.

Princess Zelda faced Calamity Ganon on her own. The princess has persisted through the years due to her belief that Link will come to her aid, with or without his memories—though she hopes that he will recover them.

HYLIAN SETTLEMENTS BEFORE & AFTER THE CALAMITY

Calamity Ganon's revival and the subsequent assault by the Guardians leveled all the Hylian settlements in their path. There are currently just a few Hylian settlements left, but looking at the ruins of villages and buildings from one hundred years ago indicates that Hylians used to be widely distributed throughout Hyrule. This section explores how the Great Calamity affected the lives of the Hylian people.

Central Hyrule
Other than Hyrule Castle Town, there were not many large, prosperous towns in Central Hyrule, but from the number of ruins in the area, it is apparent that it was far more populated than it is now.

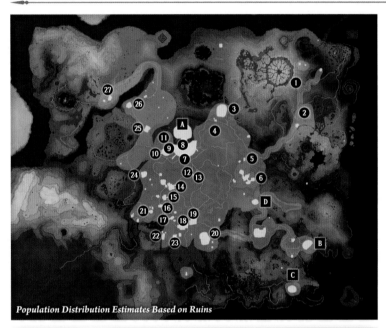

Population Distribution Estimates Based on Ruins

▷ Former Hylian Population

The Hylian population distribution seen in the map to the left is an estimation based on present-day ruins.

Central Hyrule bustled with activity from Hyrule Castle **A** and Hyrule Castle Town, and the population spread out southward into Hyrule Field with garrisons, villages, and trading posts. The southern portion of Central Hyrule boasted two outposts and Gatepost Town **17**–**19** and is thought to have been used as a waypoint for those on pilgrimages to the Great Plateau or travelers headed for Lanayru or Gerudo Desert. Kakariko Village **D**, home of the Sheikah, must have been full of people coming and going, since many Sheikah were researching ancient relics in Central Hyrule.

Ruins of settlements like Shadow Hamlet **1** can be seen at the base of Death Mountain. It can be speculated that many people traveled the roads leading from Akkala Citadel **2** to the base of Death Mountain on their way to small villages or on pilgrimages to the Spring of Power.

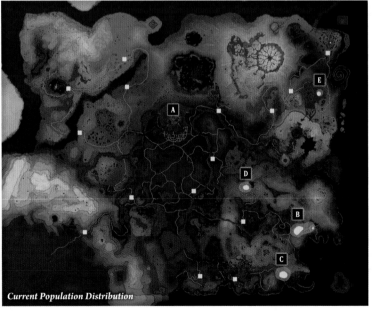

Current Population Distribution

▷ Current Hylian Population

All of the settlements in Central Hyrule, including Hyrule Castle **A**, were destroyed by the Guardians. Very few Hylian population centers escaped destruction, but those that did include Hateno Village **B**, due to the miraculous defense of Fort Hateno, Lurelin Village **C**, and Kakariko Village **D**, whose inhabitants were well versed in martial warfare and whose terrain is inhospitable to Guardians. These villages see a few travelers come and go, but by and large are unable to keep consistent contact with the other surviving villages.

With the number of habitable villages greatly diminished and spread out, a network of stables was established to support the travels of merchants and treasure hunters. Additionally, the newly constructed Tarrey Town **E** in northeast Akkala is one of the few signs of recovery found in Hyrule.

▷ Location Names

1 Shadow Hamlet Ruins	**8** Central Square	**15** Exchange Ruins	**22** Temple of Time	**A** Hyrule Castle
2 Akkala Citadel Ruins	**9** Water Reservoir	**16** Kolomo Garrison Ruins	**23** Eastern Abbey	**B** Hateno Village
3 Military Training Camp	**10** Quarry Ruins	**17** Gatepost Town Ruins	**24** Sage Temple Ruins	**C** Lurelin Village
4 Rauru Settlement Ruins	**11** Castle Town Prison	**18** Outpost Ruins	**25** Royal Ancient Lab Ruins	**D** Kakariko Village
5 Moor Garrison Ruins	**12** Mabe Village Ruins	**19** East Post Ruins	**26** Maritta Exchange Ruins	**E** Tarrey Town
6 Goponga Village Ruins	**13** Ranch Ruins	**20** Deya Village Ruins	**27** Tabantha Village Ruins	
7 Hyrule Castle Town Ruins	**14** Hyrule Garrison Ruins	**21** Coliseum Ruins		

THE DESTROYED SETTLEMENTS

After the Great Calamity, Central Hyrule was left a charred plain. Texts and critical documents stored in the settlements were lost in the blaze, and, since few Hylians survived the Great Calamity, many details of Hyrule from before a century ago are a mystery. The devastation was widespread, and it is difficult to analyze the ruins in a comprehensive fashion due to their great number. This section attempts to piece together the state of Hyrule as it existed one hundred years ago.

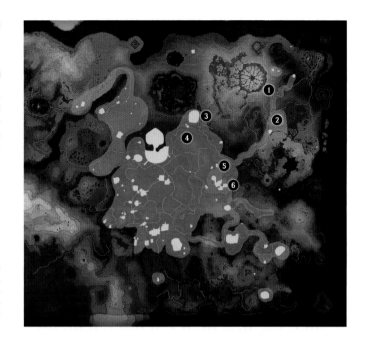

Unknown Remnants
Many fragmentary ruins dot Blatchery Plain and Tumlea Heights, but the structures were so thoroughly demolished that it is unclear what they were originally.

❶ *Shadow Hamlet Ruins*

This small hamlet once existed at the eastern base of Death Mountain. Only a few charred remains of homes are left standing. It is likely that they had no means to resist the Guardians and were annihilated before they had a full understanding of what had happened in Central Hyrule.

❷ *Akkala Citadel Ruins*

This citadel in Akkala was equipped with cannons and said to be impregnable. Its solid exterior is still in one piece, but the facility located at the pinnacle of the building is a pile of rubble infected by Calamity Ganon's Malice.

❸ *Military Training Camp*

Once the training ground of Hyrule's soldiers, the camp has become a fortress for monsters. They have erected new scaffolding around the remains of the facility, making it a stronghold for the very things soldiers were meant to fight.

❹ *Rauru Settlement Ruins*

Just to the south of the training camp are the remains of Rauru Settlement. Several buildings can be seen just off the road. It was too close to Hyrule Castle to escape destruction. Some of the buildings lean at an angle, indicating there may have been a landslide. Restoring this settlement would be difficult.

❺ *Moor Garrison Ruins*

The Moor Garrison was located in the Lanayru Wetlands and has largely maintained its shape. Bokoblins have taken up residence in what was once a spacious one-story building and a sturdy two-story building, both surrounded by what looks like the remains of an external wall.

❻ *Goponga Village Ruins*

This village was built on Goponga Island in the Lanayru Wetlands. Judging by the number of structures, this island was likely heavily populated. A system of bridges once connected the islands to the mainland. Now, the village is only inhabited by the imp-like Wizzrobes.

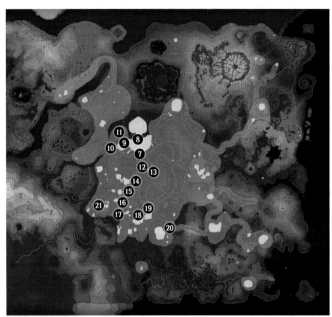

It's clear from looking at the ruins that Hyrule Castle and its accompanying town occupied a large amount of space. The remains of a reservoir and a rock quarry that accommodated the people in the area are nearby. Hyrule Field is now a wide-open plain but used to be dotted with settlements, including Mabe Village, the ranch, garrisons, exchanges, and stables that tied the entire area together as one prosperous region. The coliseum located in the southwest corner of Central Hyrule must have hosted massive events, and, based on its size, entertained large crowds. The stables helped connect Central Hyrule to the rest of Hyrule and would have made commerce and pilgrimages to places like the Great Plateau a straightforward endeavor.

7 Hyrule Castle Town Ruins

Once a beautiful city, Hyrule Castle Town was at ground zero of the Guardians' assault and reduced to Malice-infected rubble. The skeleton of the town can still be seen and gives a good idea as to the shape it once took. Many Guardians still patrol the area.

8 Central Square

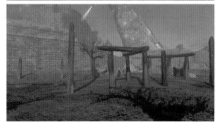

Central Square was the centerpiece of Hyrule Castle Town and suffered heavy damage. Once a place of rest, it's now a reminder of the suffering that took place here. The Guardians that overran the castle and Castle Town likely started their attack in Central Square and spread out radially.

9 Water Reservoir

The Water Reservoir is located just to the west of Hyrule Castle Town and is connected to it by a road. It was likely used for citizens' daily water needs. All that remains is a small, burned-out shack sitting next to its still waters.

10 Quarry Ruins

The quarry west of Hyrule Castle Town provided all the stone used in the construction of the structures nearby. There are no ruins, so the artisans must have lived in town. It seems as though all the stoneworkers were lost in the Great Calamity, since that skill set appears not to have survived.

11 Castle Town Prison

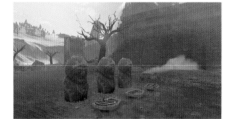

There was a prison to the west of Hyrule Castle. The stone structure of the building was damaged and the rest was burned away. It is likely that the prisoners within did not have time to react to the impending attack.

12 Mabe Village Ruins

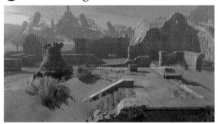

This village was located on the Mabe Prairie in Central Hyrule. Due to its proximity to Hyrule Castle Town, it was likely the next population center to be attacked. Watching this town disappear in a flash of light from across Hyrule Field must have made it seem like a fleeting dream.

⑬ *Ranch Ruins*

There are the remains of a ranch next to Mabe Village. The entrance, silo, and racetrack can still be seen, and it's likely that horses were trained here. Now, instead of horses, Guardians and Bokoblins move about the track.

⑭ *Hyrule Garrison Ruins*

This garrison was located in the middle of Central Hyrule. It appears the soldiers lived in its stone buildings, and the visible traces of farm work indicate the garrison was self-sufficient. They may have grown food for the horses there. It also had a fountain. It's likely this garrison was a permanent residence.

⑮ *Exchange Ruins*

Just to the southwest of the garrison was an exchange that facilitated the trading of goods. This would have been the first settlement to be beset after Hyrule Garrison fell. Now, only portions of the exchange remain.

⑯ *Kolomo Garrison Ruins*

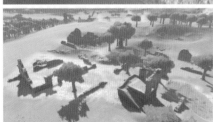

The Kolomo Garrison ruins can be found on a rocky outcropping jutting into Lake Kolomo. The structures are smaller in scale than Hyrule Garrison's. There is a remnant of an observation tower here that was perhaps once used to keep watch over Hyrule Field.

⑰ *Gatepost Town Ruins*

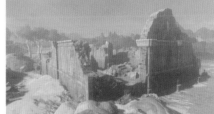

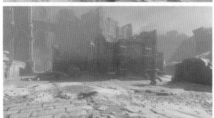

This outpost is located at the entrance to the Great Plateau. Pilgrims headed to the Temple of Time likely spent the night here. The surviving structures have been worn down by the passage of time, but, due to its convenient proximity to the road, some travelers still use it to take brief rests.

⑱ *Outpost Ruins*

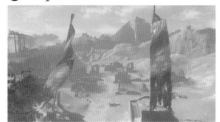

This seems to have been one of the most bustling outposts across Hyrule Field. There are enough structures left that it allows the viewer to imagine what it might have been at its liveliest. The husks of many Guardians can be found here, which seems to indicate that it was subjected to persistent attacks.

⑲ *East Post Ruins*

The East Post ruins are located in the southeast portion of Central Hyrule and currently occupied by Moblins. The domiciles sitting close to the road still resemble what they would have looked like a century ago, but the farther one gets from the road, the more reclaimed by nature the structures become.

⑳ *Deya Village Ruins*

This large village is located in the highlands, but, unfortunately, that did not hinder the Guardians' assault. It has since been swallowed up by Deya Lake and now resembles marshland. Lizalfos have taken up residence and attack those who pass too close.

㉑ *Coliseum Ruins*

The Coliseum was by far the largest entertainment facility in Central Hyrule. The once lively arena sustained significant damage and is currently infested with Malice. It is no longer a welcoming place for people, unless you would like to fight a Lynel for an audience of monsters!

The Great Plateau is the birthplace of the kingdom of Hyrule and home to the Temple of Time and Eastern Abbey. Outposts built around the plateau developed into bustling hubs as the area became a key stop for travelers. Tabantha Village was the only Hylian village in Hebra to the northwest of Central Hyrule and was considered the frontier. There are not many visitors that now tread the Hebra and Central Hyrule border. The Sage Temple ruins found there seem to have been entirely forgotten.

The Great Plateau

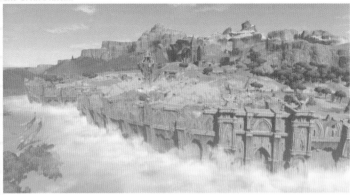

The Great Plateau was home to a number of sites that would hold traditional ceremonies. It was considered sacred, so a stout wall was built around it, as grand as the area's status. In its center is the Temple of Time, with a shrine dedicated to the Goddess Hylia within. There are also remnants of other temples and an abbey with lodgings for monks and pilgrims.

22 Temple of Time

Not even the walls surrounding the Great Plateau could keep the Guardians from invading Hyrule's sacred land. The roads leading to the Temple of Time have been demolished, but traces of the three buildings that formed the front of the temple can still be seen and give an idea of how immense it was.

23 Eastern Abbey

The remains of an abbey sit on the eastern portion of the Great Plateau. As with the Temple of Time, the Guardians leveled the site. There are wrecked Guardians from a century ago, and some that are still active.

24 Sage Temple Ruins

The remnants of the Sage Temple can be found west of Hyrule Field. Overrun by the Guardians one hundred years ago, it has since been submerged by the Regencia River. It is now a favorite territory of some water-loving Lizalfos.

25 Royal Ancient Lab Ruins

It is thought that these ruins represent the ancient relic research facility that was under the direct control of Hyrule Castle, but only the outer walls remain. There is no trace of the building's interior, let alone any research materials. The thoroughness of its destruction feels intentional.

26 Maritta Exchange Ruins

The Maritta Exchange was the locus of trade between Central Hyrule and the frontier area of Tabantha. Monsters have constructed a tower out of the tree in the middle of the exchange and infest the area.

27 Tabantha Village Ruins

Tabantha Village was the lone Hylian settlement in the snowy Tabantha region. Since only a few hearty souls reside in the area, it will not likely be rebuilt. Monsters now live in the wreckage and make the area dangerous for travelers.

CIVILIAN EVACUATION & CURRENT COMMUNITIES

A great many people perished during the Great Calamity, but there were a lucky few who recognized the danger they were in and were able to flee to Necluda.

Mabe Village and the ranch nearby were close to Hyrule Castle, so it is unlikely that there were any survivors, but if any did escape, they would likely have traversed Hyrule Field, crossed the Horwell Bridge, and forded the shallows of Squabble River as they fled toward the Dueling Peaks. It's possible that the civilians at the exchange and stables were guided toward Fort Hateno by soldiers stationed at Hyrule Garrison or Kolomo Garrison. Deya Village, which was surrounded by high, rugged terrain, was set upon by the Guardians before they realized that there was danger approaching from Hyrule Castle.

No one knows how many people safely escaped to Necluda, but judging by the size of Hateno Village in the present, there were few survivors.

Meanwhile, Goponga Village was along the evacuation route taken by the kingdom of Hyrule's remaining forces headed for Akkala Citadel and was likely caught up in the fighting. When the citadel fell, the rest of Akkala was devastated. It would be one hundred years before a new village would finally be built in the region.

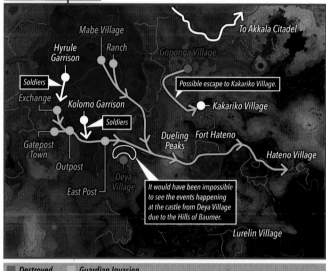

▷ *Civilian Evacuation*
The civilians living in Hyrule Field fled toward the Hylian village in Necluda. Those who made it as far as Fort Hateno were spared the Calamity, and those who could fight probably joined the defensive effort there.

It would have been impossible to see the events happening at the castle from Deya Village due to the Hills of Baumer.

- ■ Destroyed
- ■ Guardian Invasion
- — Civilian Evacuation
- — Hyrulean Soldiers' Evacuation

Destroyed Villages
Goponga Village was located near the epicenter of the assault, and its residents would likely have noticed the Great Calamity immediately. The remaining Hyrule Castle soldiers could have evacuated to Kakariko Village by cutting south past Goponga Village.

▷ *Hateno Village*

The Hylians who escaped the Calamity banded together and built a simple life here.

▷ *Lurelin Village*

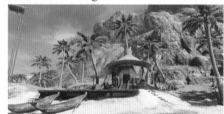

This fishing village in the southern portion of Necluda has a unique culture and way of life. Far from Central Hyrule and surrounded by harsh terrain, they were spared the devastation of the Great Calamity.

▷ *Tarrey Town*

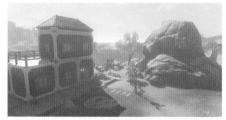

Akkala was left in ruins a century ago, but Hudson of Bolson Construction has a vision for a new community and has recently founded Tarrey Town here.

PLACES OF WORSHIP DESTROYED BY THE CALAMITY

Even Hyrule's most sacred places were not spared Ganon's attack. Places of worship and the routes pilgrims took to get there were wiped off the map.

Despite the Great Plateau being a relatively isolated piece of land, there used to be a road that connected it to Gatepost Town and the rest of Central Hyrule. It was crowded with pilgrims journeying to the Temple of Time. The road is now in ruins, and the gate is impassable.

The Shrine of Resurrection, where the gravely wounded Link rests, is also found on the Great Plateau, in addition to the ruins of an abbey and the Temple of Time. It is possible that the gate leading to the Great Plateau may have been blocked to hinder any further Guardian incursion.

The famous Mount Lanayru is the location of the Spring of Wisdom. Although admittance is prohibited for those under the age of seventeen, the Lanayru Promenade could be entered by people of all ages. It had a fountain and a waterfall that visitors could wander behind. The views must have been stunning. Unfortunately, this beautiful place was lost in the Great Calamity. The stone road collapsed, and its pieces lie submerged below the water.

The people living in the kingdom named for the ancient goddess were no longer able to make their way to their places of worship. The Great Calamity ultimately stole the people's faith.

The Lanayru Promenade lies in ruins. Pilgrims passed through the West Gate, across the Promenade, and out the East Gate to reach Mount Lanayru, but the arduous journey to the spring has become even more difficult.

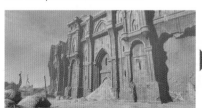

This large gate once connected the Great Plateau to Central Hyrule. It was destroyed in the Great Calamity and remains impassable.

This is how the road looks from the Great Plateau side. It is flooded and littered with Guardians.

THE GREAT CALAMITY & THE TRIBES OF HYRULE

The Great Calamity affected everyone in Hyrule, not just the Hylians; thankfully the Guardian invasion halted just before it started to damage the lands occupied by other races. At that same moment, the Divine Beasts also ceased their destructive rampages. This was due to Princess Zelda's courageous sealing of Calamity Ganon, but only the Sheikah and Koroks were aware of her role in suppressing it.

Believing that the threat had passed, those who had escaped direct damage did not prepare for a time when Ganon might awaken once again. So, after one hundred years had passed and the seal began to weaken, they were unprepared for the rampaging Divine Beasts that Zelda had so long kept at bay. Link would awaken soon after, but, until he did, the tribes were left without any defenses against the chaos.

The Koroks Await the Hero
In addition to guarding the Master Sword, the Koroks have set up a bed and two shops inside the Great Deku Tree for the hero in what they call the Great Deku Tree's Navel.

THE GREAT CALAMITY & THE SHEIKAH

On the day of the Great Calamity, the surviving Sheikah from the castle and Hyrule Castle Town fled to their hometown of Kakariko Village. The village avoided damage from the Guardians' assault, and Impa, former adviser to Hyrule Castle, now lives there as the village chief. The Sheikah are a relatively long-lived people, but Impa, Purah, and Robbie are the only Sheikah alive that experienced the Great Calamity.

Impa, Purah, and Robbie decided to live in different areas of Hyrule so that, should something terrible befall Kakariko Village, at least one of them would be left to deliver Princess Zelda's message to Link. Purah and Robbie took the Guidance Stone from Hyrule Castle as well as various parts and moved them to areas with abundant ancient energy. They set up tech labs and resumed the research that had been interrupted by the Calamity. While they have not remained in close contact, they continue their experiments with the help of their pupils.

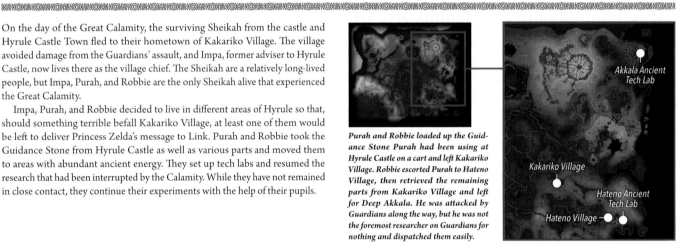

Purah and Robbie loaded up the Guidance Stone Purah had been using at Hyrule Castle and left Kakariko Village. Robbie escorted Purah to Hateno Village, then retrieved the remaining parts from Kakariko Village and left for Deep Akkala. He was attacked by Guardians along the way, but he was not the foremost researcher on Guardians for nothing and dispatched them easily.

▷ Kakariko Village

Impa, elder of the village, passes on the story of the Great Calamity, and so even the young villagers know of Link and the Sheikah Slate. Impa's intended heir, her granddaughter Paya, has made it her daily routine to polish the orb in Impa's house that is intended to help the chosen hero.

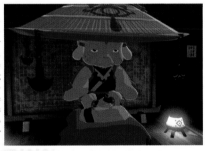

Impa
A former adviser to the crown, she is one of the few people who know the truth about Princess Zelda and what happened a century ago. She has been entrusted with passing along Princess Zelda's message to Link, and the Yiga Clan would like nothing more than to make sure she's not around to do so. She is thought to be around one hundred and twenty years of age.

The Final Picture
Princess Zelda entrusted Impa with the task of helping Link restore his memories with the help of pictures in the Sheikah Slate's album. Impa was told to give this picture to him last. It's a shot of Blatchery Plain and the site of Princess Zelda's awakening. This memory reveals the shocking truth of the last moments they spent together.

▷ Hateno Ancient Tech Lab

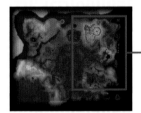

Purah
Despite her looks, she is Impa's older sister and somewhere around one hundred and twenty-four years old. She has used the Guidance Stone to research ways to improve the functionality of the Sheikah Slate's runes. She has also researched an antiaging experiment which, while successful, left her looking like a child. Symin is her student.

▷ Akkala Ancient Tech Lab

Robbie
He developed the Ancient Oven from the parts of a Guidance Stone. It is able to create ancient weapons that are more effective against Guardians than standard weapons. He is around one hundred and twenty years old and married to Jerrin, his research assistant. They have a son together.

THE GREAT CALAMITY & THE ZORA

The Zora and the kingdom of Hyrule have maintained friendly relations for millennia, but the events of the Great Calamity left a crack in that bond.

Other than the stray Guardian that made its way to Zora's Domain and was handily dispatched by King Dorephan, the Zora were spared the damage caused by the Great Calamity. However, Princess Mipha, Champion and pilot of a Divine Beast, was lost in the battle, causing many Zora to lose faith in the Hylians.

One hundred years after the Calamity, the Divine Beast Vah Ruta, which had once been a protector of the Zora people, went berserk. It planted itself within East Reservoir Lake and began spouting large volumes of water through its trunk, which poured down onto the realm like a monsoon. The Zora feared that the reservoir might overflow and the dam might break, taking Zora's Domain with it and flooding the rest of Hyrule.

They hurriedly made plans to stop the rampaging beast, but, though they discovered that Shock Arrows were effective against it, due to their water-dwelling nature, it was difficult for the Zora to wield them. There were some calls to ask the Hylians for aid, but Zora leadership vetoed the idea. That is when Prince Sidon took it upon himself to leave Zora's Domain to search for Hylian assistance.

East Reservoir Lake
East Reservoir Lake was a joint construction effort between the Zora and the people of Hyrule more than ten thousand years ago. The Zora are responsible for managing it and have reservoir monitors whose duty is to report to the Zora king should water levels approach their limit.

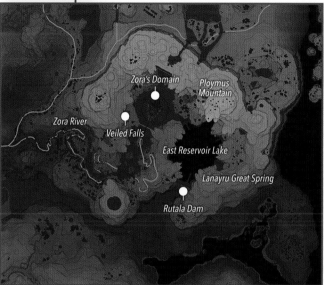

Zora's Domain
Ploymus Mountain
Zora River
Veiled Falls
East Reservoir Lake
Lanayru Great Spring
Rutala Dam

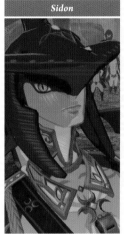

Sidon

Prince Sidon was a child one hundred years ago, but has grown into a wonderful prince and is the pride of his people.

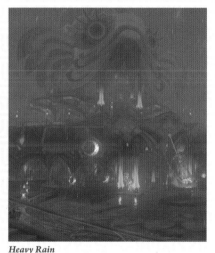

Heavy Rain
The Divine Beast Vah Ruta's rampage causes rain to fall unyieldingly, creating problems across a significant area that includes Zora's Domain.

The Divine Beast Vah Ruta
Vah Ruta has fallen into Calamity Ganon's hands and gone berserk. East Reservoir Lake is large, but Vah Ruta's unceasing showers have filled it to the very brim.

THE CHAMPION FESTIVAL & MIPHA'S FEELINGS

According to Zora history, during the Era of Myth there was a Zora princess named Ruto who awakened as a sage and saved the world alongside the chosen hero. The Divine Beast of water is named "Ruta" in her honor. It was a proud moment for the Zora when Princess Mipha was picked as a Champion to fight alongside the chosen hero and carry on the legacy of the ancient princess.

When Princess Mipha was born, the smith Dento presented her with a gift: a mighty spear called the Lightscale Trident. Under the tutelage of the royal family's order of knights, Mipha honed her skills with the spear. Though an accomplished fighter, Mipha became one of the many casualties of the Great Calamity. All of Zora's Domain fell into misery, and, as a way to send her soul to rest, they were about to release the Lightscale Trident to the river's currents. It was then that the trident began to glow and a voice as clear as day spoke: "The Lightscale Trident and I are one . . . Abandon your grief and know joy once again. Do not cry . . . just remember."

From that day forward the Zora have venerated the Lightscale Trident and created the Champion Festival to honor their brave princess on the anniversary of the day of her death. The lyrics of the Champion Festival's ceremonial song are memorized by the people: "A gift from the sky . . . a scale of light . . . splits the feet . . . of a Veiled Falls sight . . . Your trial awaits . . . It's glowing bright."

Mipha had known Link since they were both young, and she was very fond of him. The women of the Zora royal family have a tradition of weaving armor using one of their own scales to protect their future husbands. The armor that Mipha crafted while she was alive fits Link perfectly.

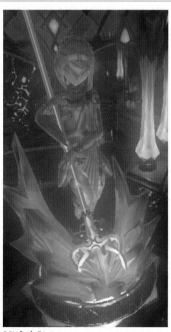

Mipha's Statue
Mipha's memorial statue is located at the center of Zora's Domain. She holds the Lightscale Trident.

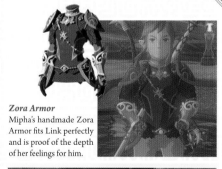

Zora Armor
Mipha's handmade Zora Armor fits Link perfectly and is proof of the depth of her feelings for him.

King Dorephan
The king understood his daughter's feelings better than anyone and held no ill will toward the Hylians following the Great Calamity. He is glad that Link survived to set foot in Zora's Domain once more. A part of him still holds out hope that Mipha is alive somewhere in the belly of the Divine Beast.

THE GREAT CALAMITY & THE GORONS

Goron City, home of the Gorons, is located on Death Mountain and was thankfully spared any direct damage during the Great Calamity. Several decades later, a visionary Goron named Bludo founded the Goron Group Mining Company, which turned the mining of ore into a thriving business venture for the race. Bludo lives in Goron City to this day as the Goron leader. Even though Death Mountain is too hot for other races to visit without fire-resistant outfits or elixirs, Goron City sees many tourists due to its now booming economy.

Bludo did not experience the Great Calamity, but Daruk, the Goron chosen to be one of the Champions, is still spoken of to this day. Daruk's descendant Yunobo has inherited "Daruk's Protection," the special defensive ability to create a protective red sphere around himself. With the Divine Beast Vah Rudania rampaging and sending flaming rocks hurtling at the citizens below and hurting both the mining and tourist businesses, Yunobo's special ability has come in handy. Bludo loads Yunobo into a cannon and shoots him like a cannonball at Vah Rudania, driving it away. Unfortunately, it always comes back.

The Rampaging Vah Rudania
The corrupted Divine Beast Vah Rudania scans the area as it clings to the side of Death Mountain. If it detects anyone approaching, it rains down Magma Bombs, which makes mining near the summit of Death Mountain impossible. Bludo keeps Vah Rudania at bay by firing Yunobo at it like a cannonball, but that only makes it retreat into the caldera for a short period of time.

GORON STONE MEMORIAL

A century ago, the stalwart Daruk was selected as a Champion and fell defending Hyrule. Ancient heroes are carved into the large mountainside near Goron City and, for his sacrifice, Daruk was immortalized in stone next to the other Goron heroes.

Bludo

Yunobo

THE GREAT CALAMITY & THE RITO

Rito Village is located in the mountainous land of Hebra. Because it is separated from Central Hyrule by a deep canyon, the Rito see very few visitors, but that did not stop Princess Zelda from venturing there to request that the Rito warrior Revali become a Champion and pilot a Divine Beast. He begrudgingly accepted the honor.

The Rito are not particularly long lived, so none living now have firsthand knowledge of the Great Calamity, but the wise Rito chieftain Kaneli is a bit of a historian and knows as much as any Rito about the event. He knows that only a Champion (or perhaps a descendant of the Champions) can enter the Divine Beast Vah Medoh and stop its rampage from within.

Vah Medoh has been circling the skies above Rito Village and shooting down anyone who might approach it. The villagers can no longer move freely through the sky and must walk to get in or out of the village. Not heeding Chieftain Kaneli's warnings that only a Champion can stop the beast, the headstrong warrior Teba and blacksmith Harth attempted to confront Vah Medoh. Harth was seriously injured in the attempt. Still not deterred, Teba is recklessly planning to oppose Vah Medoh on his own.

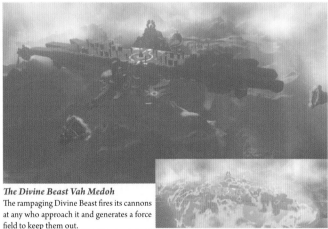

The Divine Beast Vah Medoh
The rampaging Divine Beast fires its cannons at any who approach it and generates a force field to keep them out.

THE FLIGHT RANGE & REVALI'S LANDING

The launch point where the Rito take off for the Flight Range is to the north of the village and named Revali's Landing in honor of the Rito Champion. The Flight Range was originally constructed at Revali's request. Using its updrafts, it is possible to practice archery and flying. Revali wanted to nurture the next generation of warriors, and later opened the Flight Range as a practice space for children.

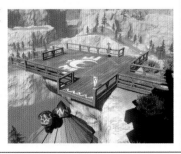

Chieftain Kaneli

Teba

Harth

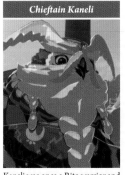

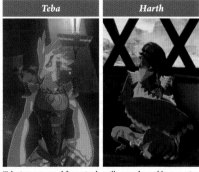

Kaneli was once a Rito warrior and Teba's mentor.

Teba is a respected figure in the village and a reckless warrior. Harth is an excellent blacksmith. They are childhood friends.

One hundred years ago, Chief Urbosa was asked to be a Champion, and she readily accepted. That was no surprise, given the Gerudo's long-standing good relations with the kingdom of Hyrule and Urbosa's personal friendship with both Princess Zelda's mother and Zelda herself.

The Gerudo live in the desert region southwest of Central Hyrule, and, since the Guardians' assault did not reach their lands, life in Gerudo Town and the Kara Kara Bazaar has continued relatively unaffected.

Lady Riju is the current chief of the Gerudo. She inherited the position at a very young age when her mother, the previous chief, passed on suddenly. Shortly after, the Divine Beast Vah Naboris began its rampage, creating dangerous sand and lightning storms, which caused turmoil throughout the region. Determined to be a great chief like her mother but fearing that she was not up to the task, Riju set out to investigate Vah Naboris on her own. After her initial reconnaissance, her sand seal Patricia was spooked and headed directly into the sandstorm and lightning. Her bodyguard Buliara found her after the incident. Unfortunately, during all the chaos, the Yiga Clan took the opportunity to steal a precious Gerudo heirloom called the Thunder Helm. From the moment she became chief, Riju's reign has been beset by difficulties, which has caused a rift between her and the Gerudo soldiers. She is working to restore their faith in her.

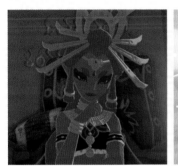

Chief Riju
Though she acts as though she is in control, Lady Riju knows that she is viewed with unease by the Gerudo people due to her youth and inexperience. She has many heavy responsibilities as chief and the pressure is mounting, but only royalty can use the Thunder Helm. She will need to regain her confidence if she hopes to wield it after it is retrieved from the Yiga Clan.

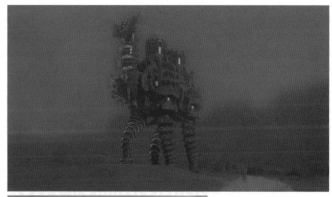

The Divine Beast Vah Naboris
Vah Naboris whips up terrible sandstorms which can be seen from across the desert as it strides through the land. Those who draw too near risk being struck by lightning.

THE GERUDO LANGUAGE

The Gerudo share a language with the Hylians but also have their own unique language, which has its own alphabet.

Sav'otta	=	Good morning
Sav'aaq	=	Good day
Sav'saaba	=	Good evening
Vasaaq	=	Welcome
Sarqso	=	Thank you
Sav'orq	=	Goodbye

Voe	=	Man
Vai	=	Woman
Vehvi	=	Daughter
Vaba	=	Grandmother
Vure	=	Bird

CALAMITY GANON'S TIES TO THE GERUDO

The Gerudo are a proud nation of women. They give birth exclusively to females and only allow women into their capital, Gerudo Town. It is a long-held belief that men only bring disaster. However, long ago it is said that a boy was born to the Gerudo tribe every one hundred years and, per tradition, became King of the Gerudo.

It is written that Calamity Ganon once adopted the form of a Gerudo and, since he was the rare male born to the Gerudo, was made king. But that wasn't enough for the man known as Ganondorf. He plotted to seize control of all of Hyrule and become the Great King of Evil. The only person standing in the way of his machinations was a young man with the soul of the hero who wielded the Master Sword. His plans shattered, Ganondorf lost control, and his powers consumed him, transforming him into the Dark Beast Ganon. After being defeated by the hero, he was sealed away by Princess Zelda and the other sages. His hatred of the hero and the princess is legendary. He revived again and again, only to be sealed many times over. Eventually, the Demon King Ganon became hatred and malice incarnate, holding a deep grudge against Hyrule itself.

According to Gerudo records there has not been another male Gerudo leader since the king who became the Calamity.

Though Ganondorf was a member of the Gerudo, one of the sages who sealed him away was also a Gerudo. Her name was Nabooru. The Divine Beast Vah Naboris is named in her honor, and her legend is still passed down with reverence. The Champion Urbosa and Chief Riju both greatly admire her.

It is said that, long ago, the ancient Gerudo had rounded ears. The prevailing theory is that the shape of their ears changed gradually after so many generations of partnering with Hylian *voes*, but a competing narrative is more supernatural in nature. There is a story that the shame that the Gerudo felt over giving birth to the source of Calamity Ganon so long ago opened them up to listening for messages from the goddesses. So, they came to have the same long, pointed ears as the Hylians, which some believe allow them to receive special messages from the divine.

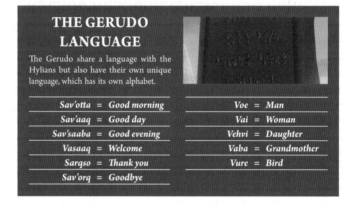

Gerudo Ears
The Gerudo's ears are pointed like the Hylians'.

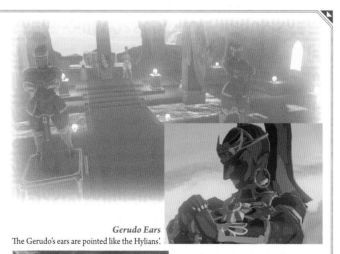

The Champion Urbosa's Hope
Looking out at the revived Calamity Ganon after being freed from the Divine Beast, Urbosa ruminates on the history of the Gerudo and speaks of the legendary Nabooru, namesake of the Divine Beast Vah Naboris. The bitter essence of defeat still sits upon her tongue, and she thinks that the moment she is able to strike back will be delicious indeed.

THE HERO AWAKENS

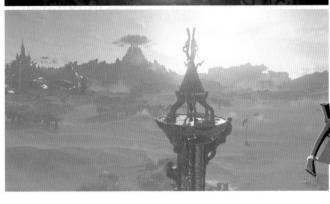

One hundred years have passed since the day of the Great Calamity. Princess Zelda has managed to hold Calamity Ganon at bay all that time, but her power is weakening. Recently, the Divine Beasts reactivated and started wreaking havoc. Zelda's efforts have allowed enough time for the hero chosen by the Master Sword to heal. Link awakens after his long slumber. Taking the Sheikah Slate in hand, he sets forth from the Shrine of Resurrection.

Link emerges into the sunlight of the Great Plateau with no memory of his past. Guided by a mysterious voice, he is directed to a Guidance Stone set into a large boulder. He is instructed to place the Sheikah Slate into an indentation on the pedestal. Upon tentatively doing so, Link activates the first of the Sheikah Towers, the Great Plateau Tower. The tower explodes upward from the ground with Link along for the ride. Tremors shake Hyrule as all of the Sheikah Towers across the kingdom rumble to life. At the same time, the ancient shrines begin glowing with a strange light. From his vantage point atop the tall tower, Link has a good view of Hyrule Castle enshrouded in Malice.

A mysterious old man meets Link back on the ground and points him toward the four shrines on the Great Plateau. Completing the trials within them restores different functions to the Sheikah Slate. After Link conquers all four shrines, the old man reveals his true identity: King Rhoam Bosphoramus Hyrule, the late king of Hyrule. King Rhoam speaks of the calamity that took place a century ago, and how his daughter Zelda is fighting on her own inside Hyrule Castle. He gives Link a paraglider so that he can drift down from the high plateau and begin his journey to save Princess Zelda and all of Hyrule.

Paraglider
This device allows Link to ride the wind, gliding from great heights to the ground below. It has a wooden frame that folds into a compact package but expands substantially for use. The cloth itself carries the unique crest of the Rito on it, which can also be found on Revali's Landing in Rito Village.

NOTES

SLUMBER OF RESTORATION

Link was taken to the Shrine of Resurrection by the Sheikah and placed into the Slumber of Restoration by the skilled hands of Purah and Robbie. The wounds Link had sustained were grave enough that it took one hundred years to fully heal them.

Although he is fully healed when he awakes, his body still carries the scars of his battles. Not trusting his eyes, Robbie confirms the hero's identity by taking account of the number and position of the scars on Link's body. Had his injuries been lighter, or if the Shrine of Resurrection had been more advanced, it is possible that he would have awakened sooner.

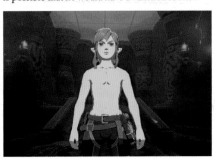

THE SHEIKAH SLATE

The Sheikah Slate was made specifically for the chosen hero. Placing it into the operating panel of a Guidance Stone allows it to run its authentication function. Link wears it on his hip so that he has easy access to it, but that also means that it's visible to others as well. Those who know their history know its significance and that the one wielding it must have something to do with the Champions.

The sight of the Sheikah Slate on Link's hip indicates to some that he is either the Hylian Champion or a descendant of the hero.

THE GREAT PLATEAU

The Great Plateau is not particularly large, but it boasts the Temple of Time, an abbey, lush forests, clear lakes, snowcapped peaks, and sheer cliff walls. It's a breathtaking area. The four shrines on the Great Plateau restore four powers to the Sheikah Slate, and their trials teach Link how to utilize them.

That the storied birthplace of the kingdom of Hyrule would serve as the land of Link's rebirth and the start of his trials is fitting.

THE GREAT PLATEAU TOWER

The researchers of one hundred years ago were able to reactivate the Guardians and the Divine Beasts, but the secret to restoring functionality to the shrines eluded them. It wasn't until Link activated the Great Plateau Tower that they sprang to life, remotely set in motion by placing the Sheikah Slate into the tower's pedestal.

Princess Zelda figured out the control mechanism just before the Great Calamity, and it was her voice that guided Link through the instructions to activate the tower. Zelda had maintained a temporary seal on Ganon for a century to allow Link to recover, and when he finally awoke she called out to him from her place in Hyrule Castle. She had also arranged for King Rhoam and Impa to aid Link when he woke up. Princess Zelda had a number of plans in place to help the hero as he prepared to face Calamity Ganon.

Unintended Uncovering
The very top of the Great Plateau Tower was uncovered during the groundshaking revival of Calamity Ganon. These towers are buried deep within the earth, and they appeared with great force when they emerged.

SHEIKAH SLATE RUNES

The Sheikah Slate has a number of useful features that the chosen hero can use on his adventure. Link finds four runes that expand the functionality of the Sheikah Slate in four shrines on the Great Plateau. Those runes are Remote Bomb, Magnesis, Cryonis, and Stasis. In addition, it can activate shrines and towers, take pictures, display a map, utilize an advanced sensor to find shrines and other things, and warp Link to particular locations. The Sheikah Slate's full potential is finally realized in the hero's hands.

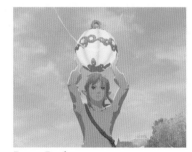

Remote Bomb
These bombs are made with advanced ancient technology. They can be detonated remotely using the Sheikah Slate. There are both round and cube-shaped bombs. Each can be useful depending on the situation.

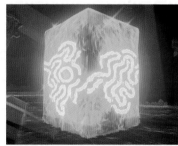

Cryonis
This rune creates pillars of ice in water. The ice pillars can be used as steppingstones or obstacles and will not melt, but the Sheikah Slate can only produce one size.

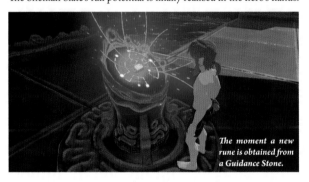

The moment a new rune is obtained from a Guidance Stone.

THE OLD MAN

The mysterious old man who makes his home on the Great Plateau is the spirit of King Rhoam in disguise. He acts as a guide for the amnesiac Link. Though he is no longer among the living, he inhabits the Great Plateau as though he is, while passing on critical knowledge to Link about how to survive in the wild.

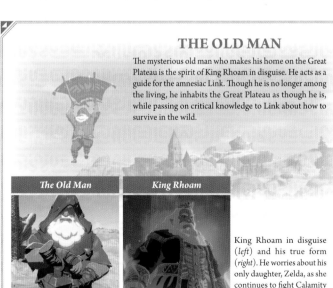

The Old Man

King Rhoam

King Rhoam in disguise (*left*) and his true form (*right*). He worries about his only daughter, Zelda, as she continues to fight Calamity Ganon inside Hyrule Castle on her own.

Meeting the Old Man
An old man is tending a bonfire on the way up to the Shrine of Resurrection, as though waiting for Link to emerge. He is the first person that Link comes upon in this era.

The Woodcutter's House
This is the lodge where the old man resides. The diary that he leaves behind details how he cooks for himself and goes about his days.

Daily Routine
He cuts down trees with his axe, hunts with a bow, and cooks using a pot. He demonstrates to Link how to be self-sustaining.

ANCIENT TECHNOLOGY

Though they are ancient relics in this era, the weapons, equipment, and facilities created by the Sheikah were cutting edge ten thousand years ago. They were so advanced, in fact, that they were key in helping the hero and the princess seal Calamity Ganon. Unraveling their secrets has been the top priority of Sheikah researchers for the last one hundred years.

The energy source used by the relics is now simply called "ancient energy." It's a highly viscous blue liquid that can be found in a few places around Hyrule and in abundance under Hyrule Castle. Using this energy, the ancient Sheikah were able to create devices like the Guidance Stones that could communicate information, as well as weapons and shrines.

Ancient energy gives off a pale blue glow that can be seen in operational Sheikah technology. It is likely that runes like the Remote Bomb somehow utilize this energy.

An Ancient Furnace
One Ancient Furnace is located near Robbie's Akkala Ancient Tech Lab. According to Robbie, the Ancient Furnace is a singular place that gathers massive amounts of energy, which manifests in a blue flame. Bringing the energy from the Ancient Furnace to the research lab requires transporting the flame with a torch.

Guidance Stones
Placing the Sheikah Slate into the terminal of a Guidance Stone allows stored data to be transferred. Guidance Stones in Sheikah Towers give the Sheikah Slate information, while Guidance Stones in shrines expand functionality in the form of runes.

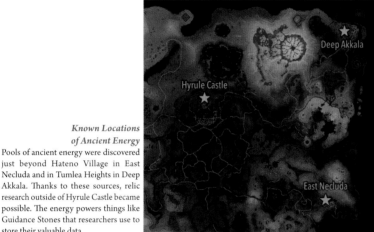

Known Locations of Ancient Energy
Pools of ancient energy were discovered just beyond Hateno Village in East Necluda and in Tumlea Heights in Deep Akkala. Thanks to these sources, relic research outside of Hyrule Castle became possible. The energy powers things like Guidance Stones that researchers use to store their valuable data.

Glowing Relics
Relics that are functioning normally glow either pale blue or orange. However, those corrupted by Calamity Ganon glow pink, which perhaps indicates that Malice has flooded their systems in place of ancient energy.

REMOTE ACTIVATION OF THE SHEIKAH TOWERS

When Link inserted the Sheikah Slate into the Great Plateau Tower's pedestal, all fifteen Sheikah Towers across the land shot up out of the earth, and the ancient shrines began to glow.

It is possible that the Great Plateau Tower sent a signal to a central control unit within Hyrule Castle, which in turn transmitted a signal to all of the towers and shrines throughout the land, activating them all at once.

This assumption may help elucidate our understanding of the way the relics operate but would also mean that if the central unit had been activated one hundred years ago, it might have been possible to activate the shrines at that time.

Hyrule Castle

Transmission

The central control unit activates

Transmission

Transmission

Sheikah Towers

The Great Plateau Tower

Ancient Shrines

The Sheikah Towers Activate

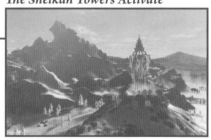

The people of Hyrule were unaware that these ancient towers were buried beneath the earth, so it came as quite the surprise when they emerged suddenly.

The Ancient Shrines Activate

Placing the Sheikah Slate on the terminal of an ancient shrine while it is in standby mode will release the lock on its door.

Activation

Due to Calamity Ganon's explosive reappearance, the Great Plateau's Guidance Stone was unearthed and Link was able to access it.

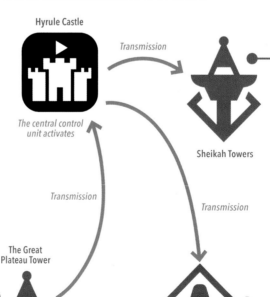

ACTIVATING THE TOWERS

Even though the towers are remotely energized when Link places the Sheikah Slate in the pedestal of the Great Plateau Tower, they are in standby mode. Like the shrines, they glow orange before they are manually activated by Link. Once he places the Sheikah Slate into a tower's pedestal, an antenna will extend out of the top and transmit data of the surrounding area directly to Link's Sheikah Slate. Having fulfilled their purpose, the towers glow blue with ancient energy, just as the shrines do once Link has obtained the Spirit Orb from within.

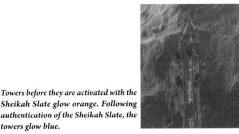

Towers before they are activated with the Sheikah Slate glow orange. Following authentication of the Sheikah Slate, the towers glow blue.

DIVINE BEAST CONTROLS

The Divine Beasts, excavated one hundred years ago, are activated by feeding them ancient energy and using the Sheikah Slate.

Within the Divine Beasts are a number of Guidance Stones with map information specific to the beast, the terminals, and the main control unit. Activating all of the terminals and then the main control unit will grant full control of the Divine Beast. They are able to generate a tremendous amount of energy to fire at Calamity Ganon.

Terminals

Main Control Unit (Standby)

THE SITUATION A CENTURY AGO & TODAY

In spite of the extensive amount of resources the researchers expended studying the ancient relics a century ago, they were unable to activate the shrines, and the giant columns and towers went undiscovered. It's theorized that the shrines and towers were inactive because the main control unit was in standby mode. An inactive shrine would not be able to respond to the Sheikah Slate. Researchers at the time would have been unaware of that, and it would have kept them from solving the puzzle of some of the relics. Below is a chart detailing what was understood one hundred years ago versus what we know now.

The Great Plateau Tower Guidance Stone
The ancient shrines, Guardians, and Divine Beasts were all excavated a century ago, but some relics buried deep underground went undiscovered. It is very fortunate that a portion of the Great Plateau Tower was exposed or they may have remained that way.

	Intended Function	One Hundred Years Ago	The Present
The Giant Columns	The columns were used to store the Guardians and would emerge from the ground upon Calamity Ganon's revival, unleashing a mechanized army against it.	They knew that there were storage units for the Guardians under Hyrule Castle but were unable to find them.	Upon Calamity Ganon's revival, they emerge from the ground. Infiltrated by Ganon's Malice, they glow a sick pink and their purpose is corrupted.
The Four Divine Beasts	Activating all of the terminals within a beast would allow access to the main control unit. Once the beast was fully operational, a Champion could use it to fire a powerful energy beam directly at Calamity Ganon.	The four Divine Beasts of legend were excavated and activated. Four Champions were chosen to pilot them. They trained for the day Calamity Ganon revived. Unfortunately, the beasts were corrupted by Calamity Ganon's Malice, and the Champions' spirits were imprisoned by manifestations of Ganon.	The Champions' spirits remain trapped within the Divine Beasts. Once Princess Zelda's sealing power weakens, the corrupted beasts begin rampaging in the regions they once protected. Activating the main control unit allows Link to reclaim control of the beasts.
The Guardians	When Calamity Ganon revived, they would pour forth from the giant columns in massive numbers to attack it.	Some Guardians were excavated and activated. However, when Calamity Ganon revived, they were corrupted.	Since being taken over a century ago, they have become Calamity Ganon's soldiers.
Ancient Energy	Ancient energy resembles a glowing, highly viscous fluid. It is the mysterious source of energy for ancient Sheikah technology.	There was a wealth of ancient energy pooled under Hyrule Castle, and they used it to further their studies of the relics.	Pools of ancient energy have been discovered in East Necluda and Deep Akkala. Research is conducted using the ancient furnaces to energize ancient relics.
The Guidance Stones	These ancient devices were used to store data. They are often used in combination with terminals and control units in a number of ancient relics.	In addition to the Guidance Stones found in the Divine Beasts, there were others within Hyrule Castle. Used in conjunction with ancient energy and the Sheikah Slate, they advanced understanding of ancient technology.	The Guidance Stone in Hyrule Castle was moved to East Necluda and research resumed. Parts of another were transformed into the Ancient Oven inside the Akkala Ancient Tech Lab. Link uses both to expand the function of his Sheikah Slate and to create ancient technology.
The Sheikah Slate	This ancient device was created to be used by the chosen hero. With it, he would be able to interface with terminals, upload or download information, and access shrines and towers. It is able to utilize Sheikah runes, has map and sensor functions, and can even take pictures.	After the slate's discovery, the researchers were able to get some of its basic functions to work. Seeing that it was for activating the shrines, Zelda focused on its study. After it was sealed with Link in the Shrine of Resurrection, Purah found ancient texts detailing its other features, but the means to add them remained unclear.	After he awakens, Link takes possession of the slate. After activating the Great Plateau Tower, he uses it to awaken other Guidance Stones. Link expands the functionality of the Sheikah Slate after completing the challenges of four shrines on the Great Plateau and can further upgrade the device at the Hateno Ancient Tech Lab.
The Sheikah Towers	The towers were built to detect signs of Calamity Ganon's revival. There are fifteen in total. They emerge from the ground when fed ancient energy. The Sheikah Slate can obtain information on the area surrounding the tower from the Guidance Stone at its top.	Knowledge of the towers had been lost to time, and they were not discovered in the excavation. A portion of the Great Plateau Tower was exposed when Calamity Ganon revived and the earth shook.	Link activates the Great Plateau Tower, and the other Sheikah Towers scattered around Hyrule emerge from the ground in response.
Ancient Shrines	The shrines were constructed by ancient Sheikah monks. The Sheikah Slate can be used to unlock their entrances and, once a trial has been completed, a monk will award a Spirit Orb to the hero. Shrines glow orange in their standby state and can be detected by the slate's sensor. They glow blue when their trial has been overcome.	They were viewed as mysterious relics of a bygone era that dotted the land. Researchers understood that they were facilities for the chosen hero, but they were unable to open them. Unfortunately, the method of activating them went undiscovered.	When Link activates the Great Plateau Tower, the shrines across Hyrule enter their default standby state. It becomes possible to enter them upon authorization of the Sheikah Slate. The songs sought by the bard Kass serve as hints to finding hidden shrines.
The Shrine of Resurrection	This medical facility contains an apparatus large enough to fit a person and is designed to heal wounds. Underneath is a large trial area used to train Champions of the Divine Beasts.	This unique shrine discovered on the Great Plateau was found to be a medical treatment facility. Link was brought here when he was on the verge of death.	Link's injuries healed over the last century. Following his awakening, he discovers that the shrine also houses a facility to train Champions to operate the Divine Beasts.

CALAMITY GANON'S INFLUENCE ON MONSTERS

One hundred years ago, as Calamity Ganon's revival grew nearer, the number of monsters found throughout Hyrule increased. Monster attacks, which had been rare, grew in frequency. After Ganon's revival, monster activity became even more fierce. For example, Bokoblins, which are a common monster found throughout Hyrule, became bolder and began to appear frequently on the roads to attack travelers. They began hunting wild game in excess and dominating the land, threatening people's livelihoods.

Calamity Ganon's powerful evil had a variety of effects on monsters, resurrecting previously killed monsters during the Blood Moon and causing fearsome silver monsters to appear.

Though monsters are terrifying, their claws, wings, and other parts can be useful and have long been prized by the people of Hyrule as raw materials. Of course, the more powerful the monster, the more difficult it is to procure those parts and the higher the price their parts can fetch. The use and trading of monster parts did not start in the present but became more frequent as monsters became more plentiful. It has enabled new trades, and quite a few people have benefited in a variety of ways.

Monster Parts
Examples of monster parts are talons, fangs, and tails. They can be used as ingredients for elixirs.

Elixirs
Elixirs are made by boiling monster parts with animals. The ingredients dictate the kind of effect the elixir has.

Dyes
Certain monster parts, like Chuchu jelly, can be combined with plants, minerals, and other materials to create dyes.

Monster Variations
The same type of monster can vary in form and traits, having evolved to thrive in the environment in which they live. At night, the bones of long-dead Bokoblins will animate with evil intent, making it dangerous to go alone.

SILVER MONSTERS

Calamity Ganon's presence has increased the number of violent monsters throughout Hyrule but has also caused the appearance of the so-called "silver" monsters. They have white bodies with purple markings, which is an outward indication that they are more powerful than other monsters of their type. They start to appear as Link slays more and more monsters. The monsters, or perhaps Calamity Ganon itself, fear the increasingly powerful hero and become more ferocious in response. The purple patterning on their bodies is said to be a sign of Ganon's influence.

THE BLOOD MOON

Even though Calamity Ganon is actively being suppressed by Princess Zelda, its power still bleeds out into Hyrule and occasionally causes a phenomenon known as "Night of the Red Moon" or, simply, the Blood Moon. Ganon's Malice stains the sky a deep red, and the monsters that Link has slain return. Any effort Link puts into reclaiming a territory from the monsters is an exercise in futility. Their forces will inevitably return. In order to ensure that the people of Hyrule are safe, the source of evil, Calamity Ganon, must be defeated.

Ganon's Malice grants these monsters new life under the red glow of the Blood Moon.

Silver Bokoblin	Silver Lynel

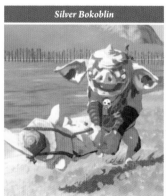 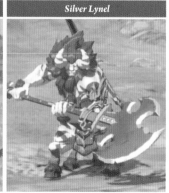

MONSTER ENCAMPMENTS

Bokoblins, Moblins, and Lizalfos form loosely organized groups and set up bases for their activities. Smaller hordes of monsters erect wooden barricades for defense, set up scaffolding, and place lookouts in key locations to watch for intruders. Larger groups will build multistory structures or use skull-shaped caves as strongholds.

Many ruins of the kingdom of Hyrule have been overrun by monsters who have adapted them for their own use. It would be fair to say that Hyrule has become a much easier place for monsters to thrive following the revival of Calamity Ganon.

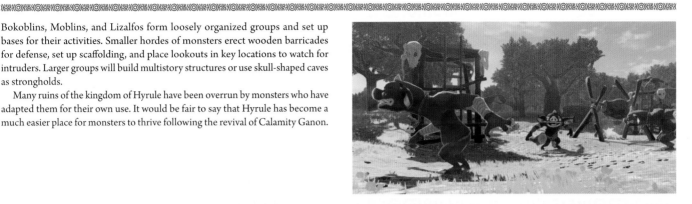

▷ *Bokoblins*

These creatures are the most common monsters found in Hyrule. Unlike other monsters, they can ride horses and mostly attack in groups.

Since they are able to hunt beasts and use fire, it appears they have some degree of intelligence but are careless. An extreme example of this are the Bokoblins that live on the Great Plateau. They have very few encounters with enemies and don't have the foresight or understanding that they may one day have to defend themselves. They live under cliffs where they are easily targeted or in dead-end canyons with no means of retreat.

While this intimidating encampment may appear like a well-realized stronghold, it is surrounded on three sides by cliffs. The Bokoblins wouldn't stand a chance if attacked from an elevated position. Also, if an enemy attacked from the front and gained the advantage, they have nowhere to run. The skull-shaped rock may seem like a solid defensive measure, but it also blocks their retreat. In this location, they are trapped by the cliffs and the skull rock.

Bokoblins prevent enemy incursions with barricades made of wooden planks and set up towers so that they can keep an eye on areas where enemies may approach. In this location they've done a decent job of fortifying their position, but the lookout is lower than the barricade, which creates a blind spot and makes it easier for an enemy to advance unnoticed.

▷ *Moblins*

Moblins stalk all parts of Hyrule. They are a much stronger monster than Bokoblins and are extremely tough. The power and ferocity behind their attacks makes them very dangerous.

Moblins can often be found around Sheikah Towers or ruins. Their territories can cover broad swaths of land. For example, in the area surrounding the Sheikah Towers in Necluda, they patrol the entirety of the road leading to the base of the tower and drive away intruders. This is also the case with the Moblins that control the areas around the Ancient Columns and Tumlea Heights. Perhaps because they are so strong, groups of Moblins do not rely on things like barricades for defense.

Moblins have no need for barricades. Their bodies are large enough on their own to serve as a barricade. They are also tall, so they have no need for lookout towers.

This Moblin keeps watch around Hateno Tower as it patrols the road leading to the tower. They prevent intruders by guarding the access point from Central Hyrule.

▷ *Lizalfos*

These agile, lizard-like monsters are a common sight in every part of Hyrule.

They have evolved unique traits based on the habitats in which they live. Lizalfos occasionally construct platforms over water to use as bases. They are protecting themselves with a natural moat. The bases are simple, constructed with fish bones. What they lack in defense, they make up for in position. These bases are often far enough from land to negate any ranged attacks.

The Lizalfos that live in snowy mountains or the desert use natural camouflage to hide from potential prey until it is within striking distance or to avoid a fight altogether.

Lizalfos are significantly more intelligent than Bokoblins and perhaps slightly more than Moblins. Their defenses are smartly and effectively designed.

A base made of fish bones. Lizalfos are extremely skilled swimmers and will swarm on an enemy in the water in mere moments. Since there are essentially no blind spots in the open water, it is difficult for anyone to approach them without being detected.

HYRULE CASTLE

Hyrule Castle was long the seat of the kingdom of Hyrule's royal family, but its awe-inspiring splendor is now in ruins. The moment Calamity Ganon revived, the castle was shrouded in Malice. The beautiful contours of its exterior managed to escape destruction, and traces of its former glory still linger.

Hyrule Castle was built to withstand assaults from monsters and other aggressors. It is a natural stronghold, surrounded by a moat and sheer cliff walls to the north. Though it was built to repel most assaults, it could not stand against the Great Calamity.

The former center of the kingdom of Hyrule's authority is now the source of unthinkable evil. If Link is to save Hyrule, he must make his way inside.

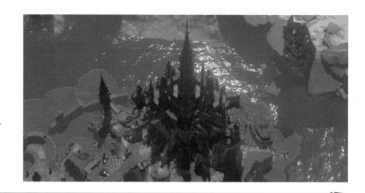

▷ Castle Layout

The Observation Room: It is possible to see Castle Town from the vantage point here, and it is likely that this room was used by royalty during ceremonies and festivals to address the citizenry.

The Docks: This rocky cave has been improved upon with smart stonemasonry to create a dock for boats entering from the moat outside. It could be used to transport goods or as a means of escape in an emergency.

The Courtyard: This is where the excavated Guardians were once tested. Link has a memory of Princess Zelda looking out over the researchers' progress here. Since it is located outside of the castle, most of it has crumbled away.

The King's Study: This room is located behind a secret door in the library. It contains a desk and a reading stand for reading large tomes. The king's journal sits on the desk.

Princess Zelda's Study: Research materials and beakers are scattered haphazardly, now buried under rubble. Miraculously, a silent princess, likely an object of study, has survived.

The Library: The texts appear to be organized alphabetically. The library is spacious enough for comfortable browsing, and there are so many books that it requires two stories.

Princess Zelda's Room: The furniture is luxurious and befitting a princess, but without being ostentatious. The room has a calm atmosphere. There is a small desk in one corner where her diary remains open on top.

The Dining Hall: Many tables are set up in this wide, long room, which was able to seat many people. Chandeliers hang from the arched ceiling.

▷ The Sanctum

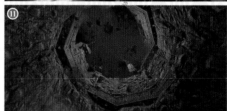

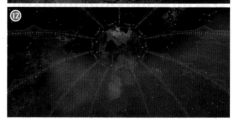

Tentacles of Malice cover the floor of the Champions' Hall, which is above the audience chamber of the Sanctum. That is because Calamity Ganon's true body is sealed within a cocoon hanging from the ceiling of the room below. When Ganon bursts out of the cocoon, it crashes through the floor and into a hollow chamber. The Sheikah once conducted astral observations here. The dome has the night sky and vistas of Hyrule painted on it.

▷ Castle Exterior

A narrow path winds around from the front gate of the castle to the Sanctum. This layout was likely designed to reduce the number of enemies that could attack at once, prevent direct access to the Sanctum, and expose the aggressors to the castle's defenses as they climbed.

Though this plan was sound for defending against normal assailants, the Great Calamity was beyond anyone's imagination and rendered the castle's defensive layout ineffective.

When Calamity Ganon was sealed in Hyrule Castle, it was contained in a cocoon in the Sanctum. Link would eventually fight Ganon in the room below the Sanctum.

⬤ = Calamity Ganon

🏠 = Entrance to the inside

The Bell Tower

Sanctum

First Gatehouse

Second Gatehouse

❸ *Princess Zelda's Study*

❹ *Princess Zelda's Room*

❷

❾ *Champions' Hall*

❿

⓫

⓬ *Astral Observatory*

Bell

❶ *Observation Room*

❽ *Dining Hall*

▷ Castle Interior (Lower Levels)

At right is a diagram that shows a top-down view of the lower levels of the castle. Although it is depicted as a circle, it is actually a spiral that increases in elevation as you wind your way through the structure. The natural cave that forms the docks and the tunnels that meander under the castle are also represented here. There are traces of excavation visible in the library, which reveals the wall of the Astral Observatory.

Library Excavation Site

Mine Cart Tunnel

❺ *Docks*

Lockup

❻ *King's Study*

East Passage

❸ *Princess Zelda's Study*

❹ *Princess Zelda's Room*

❼ *Library*

Soldiers' Chamber

❽ *Dining Hall*

West Passage

Guards' Chamber

❶ *Observation Room*

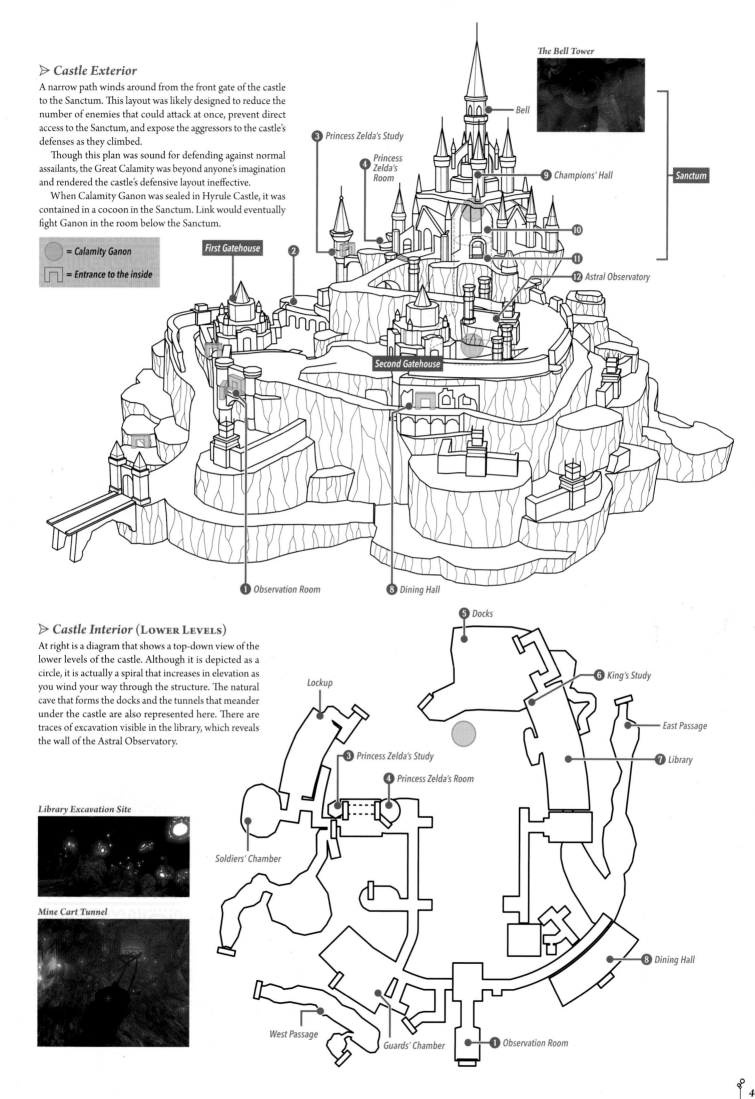

THE FINAL BATTLE

Hyrule Castle has sat untouched for one hundred years from the day of the Great Calamity, with Calamity Ganon sealed inside by Princess Zelda. Many Guardians still wander the area around the castle, making it nearly impossible to approach.

Despite the dangers, Link follows Zelda's voice and enters the Malice-covered castle. He could have challenged Ganon on his own, but taking back the Divine Beasts and freeing the souls of the Champions imprisoned within allows his former allies to aid him by taking aim at Ganon with the combined power of the four beasts.

The dark, monstrous clouds that coil around Hyrule Castle are made of Malice. Ganon's physical form is cocooned within the castle, building strength in preparation for the day it will fully revive.

When Link enters the castle's Sanctum where the festering cocoon hangs, it erupts, and an incomplete form of Ganon emerges. With the support of his friends piloting the Divine Beasts and the might of the Master Sword in his capable hand, Link deftly defeats Calamity Ganon.

However, Ganon's obsession with destroying Hyrule prevents it from yielding. Defeat only unleashes its pure rage. Calamity Ganon transforms into the Dark Beast Ganon—hatred and malice incarnate. It breaks free of the castle and makes its way into the wide-open spaces of Hyrule Field.

With Princess Zelda's sealing power waning, this is their only opportunity to seal it. One way or the other, this will be the final battle.

Princess Zelda presents Link with the Bow of Light, and, after Link weakens the beast, she uses her power to seal it away, finally ending Hyrule's century-long nightmare.

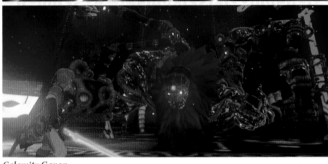

Calamity Ganon
Princess Zelda's power weakens enough to allow Calamity Ganon's physical form to emerge from its cocoon in a hauntingly incomplete state.

PRINCESS ZELDA FREED

Princess Zelda has been fighting to suppress Calamity Ganon by herself for one hundred years, and her struggle is almost unimaginable. She was devoured by Ganon and used her sealing power from within its body. Her desperate fight stopped the Calamity and halted the Guardians' assault, saving the portions of Hyrule not already affected by the invasion.

During Link's confrontation with the Dark Beast Ganon, she bestows the Bow of Light to Link. It would be fair to say that the sacred power that Zelda possesses is tremendous.

Princess Zelda uses her sacred power from within Dark Beast Ganon to show Link where to aim his Light Arrows.

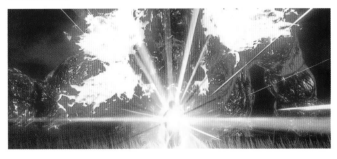

This is the moment that Princess Zelda is freed from her nightmarish situation. She looks as though she has been frozen in time for a century.

THE DIVINE BEAST BOMBARDMENT

Fulfilling their one-hundred-years-delayed purpose, the Divine Beasts fire upon Calamity Ganon as it faces off with Link, mirroring what is shown on the ancient tapestry. Their attacks are far more powerful than those of the Guardians and manage to do significant damage to Calamity Ganon. The ancient technology is just as effective in the present as it was when it was created.

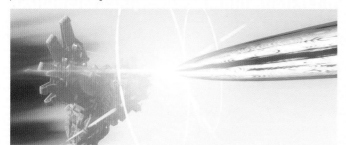

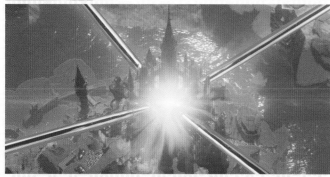

THE SITE OF THE FINAL BATTLE

Link battles Dark Beast Ganon in the wide-open space of Windvane Meadow in Hyrule Field. Princess Zelda erects a barrier of light around them, preventing Ganon from leaving the area.

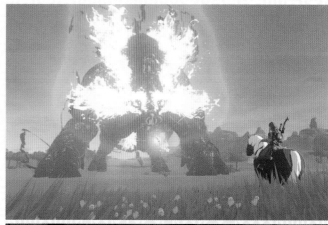

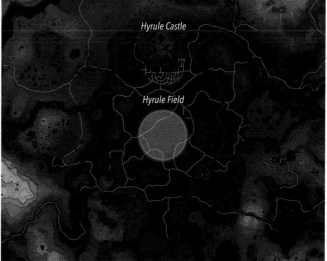

Though it may appear to be a small portion of the vast realm of Hyrule, Hyrule Field is still more than large enough for Link to comfortably ride a horse around the massive Dark Beast Ganon.

RESTORING HYRULE TO ITS FORMER GLORY

After dispelling Ganon's threat, the ruined lands of Hyrule begin to slowly recover from the Great Calamity.

Princess Zelda does not take any time to relax. She busies herself rebuilding Hyrule. From maintaining the Divine Beasts to offering Mipha's father some closure about his brave Champion daughter, there is much to do.

The chosen hero's destiny is fulfilled, but, true to his charge of being Princess Zelda's knight attendant, he continues to support and protect her.

Though her sacred power has dwindled over the years, she has great hope that if everyone works together, they can restore Hyrule to its former glory and perhaps even beyond.

Silent princesses, the near-extinct flower that Princess Zelda had been studying, now bloom across the land.

RUINS FROM TIMES UNKNOWN
~ MYSTERIES OF HYRULE ~

▷ Ancient Hylian Culture

The Ancient Columns located in the Tabantha Frontier region were ruins long before the Great Calamity. Some speculate that these structures were built around the same time period as the three sacred springs due to similarities in their use of materials.

Places that feature similar stone architecture are classified as ancient Hylian cultural relics and are highlighted on the map in yellow.

Ancient Columns
This structure's stone arches are unique.

Forgotten Temple
This temple has sat unused and undisturbed for far longer than the hundred years since the Great Calamity.

▷ Remote Ruins

Relics of bygone eras of the Gerudo are common throughout the southwest desert of Hyrule, and the Palmorae Ruins near Lurelin Village are also located far away from the beaten path of Central Hyrule. The Palmorae Ruins are from an unknown era and built by an unknown people.

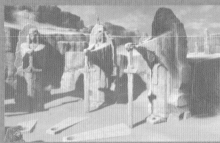

Gerudo Ruins
The Gerudo possess their own culture separate from the one commonly associated with the kingdom of Hyrule, though they have existed concurrently and interacted often. Their ruins are unique in both construction and aesthetics.

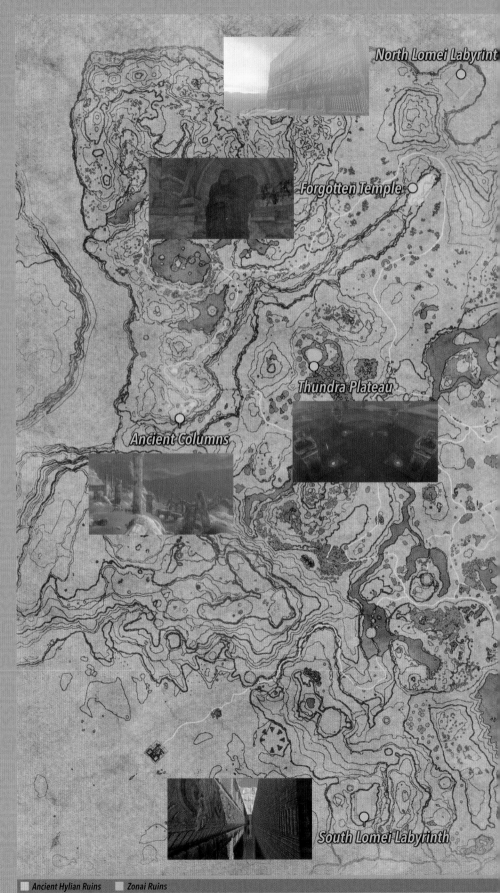

North Lomei Labyrint

Forgotten Temple

Thundra Plateau

Ancient Columns

South Lomei Labyrinth

☐ Ancient Hylian Ruins ☐ Zonai Ruins

The Great Calamity created a significant number of ruins, but there are other ruins that predate that fateful day. Nothing is known of these mysterious artifacts from former eras other than what little can be gathered from what remains.

The map shows the locations of ruins thought to be created by the ancient Hylians (yellow) and other ancient peoples (green). There are other ruins throughout Hyrule, including relics from the ancient Gerudo, that are not accentuated with a color on the map but still hint at the rich and enigmatic history of Hyrule.

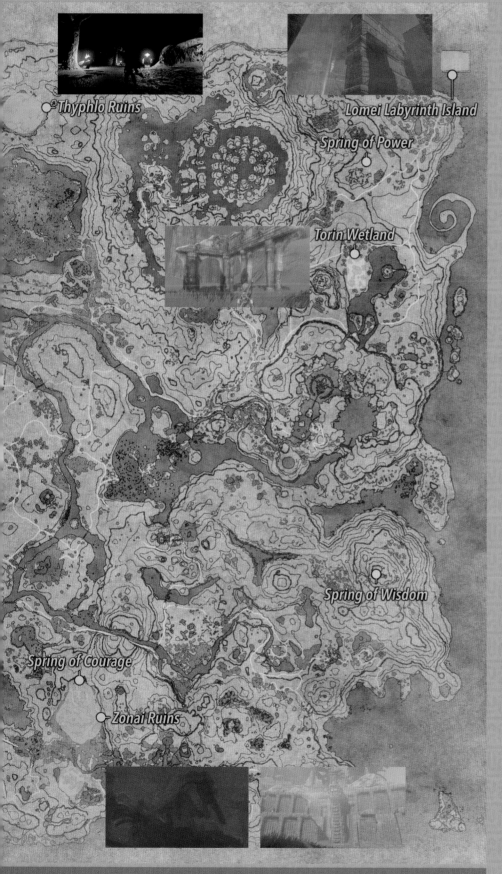

Thyphlo Ruins

Lomei Labyrinth Island

Spring of Power

Torin Wetland

Spring of Wisdom

Spring of Courage

Zonai Ruins

▷ *The Mysterious Zonai*

The history of the Zonai people has been lost to time. There are rumors that they were a savage tribe based in Faron, where the most substantial of their ruins are located. However, Zonai ruins or ruins with very similar characteristics can be found in all parts of Hyrule (highlighted in green). In addition to the massive palace in Faron, the Zonai ruins throughout Hyrule seem to have elements connecting them to the ancient shrines. The Zonai themselves are spoken of in hushed whispers as strong magic wielders who vanished suddenly thousands of years ago. The disappearance of the Zonai is one of Hyrule's greatest mysteries.

Zonai Ruins
The home of the Zonai. They are thought to have worshiped a water dragon, since the area has many rock carvings dedicated to such a being. The stone structure surrounding the Spring of Courage bears the face of a large dragon, and this place must have been a sanctuary for the Zonai as well.

Zonai Pillars throughout the Land
The purpose of these towers is unknown. Some think that they may have been used for magical purposes, but that cannot be confirmed. They remain one of the things that lend Hyrule's past an air of mystery.

This spiral pattern seems to be the unique mark of the Zonai, and it can be seen throughout the land.

BACK TO OUR ROOTS:
BUILDING THE WORLD OF *BREATH OF THE WILD*

The Legend of Zelda: Breath of the Wild was released on March 3, 2017, and has since won the Grand Award[1] at the Japan Game Awards and been critically praised all around the world. As the final downloadable content has been released and production on the game has officially ended, we were curious about how the development team feels about the reception the game has received globally and their thoughts about the process of creating the game. These interviews reveal the stories behind development that can be told now that the process is finished.

October 2017
Nintendo Co., Ltd., Headquarters
Kyoto, Japan

Assembled by Akinori Sao & Kazuya Sakai
Photography by Shoji Nakamichi

[1]An award given to an excellent piece of computer software, sponsored by the Computer Entertainment

HIDEMARO FUJIBAYASHI, DIRECTOR

The Legend of Zelda
Breath of the Wild

FUN FOR ALL AGES

Thanks to our players, *Breath of the Wild* received the Grand Award at the Japan Game Awards for 2017. The whole team is thrilled to have received such a prestigious accolade, and it afforded us the tremendously valuable opportunity to read the impressions of everyone who voted for *Breath of the Wild*. Something that immediately struck us was the broad age range of people who voted for our game. There were votes from players aged six to seventy-four. What was perhaps even more surprising was that people of different ages had similar impressions. They found joy in all the things that they could discover and the stops along the way as they journeyed through Hyrule. It made us extremely happy to know that the things we put in the game that we thought people might find fun were actually enjoyable to players of all ages and generations.

Development of this title officially started right after the development of *Skyward Sword* ended, but, with *Breath of the Wild*, development didn't end when we finished the main game. We were still developing the downloadable content, so the whole process ended up taking a long time. Of all the titles in the series, this is the one with the most energy put into it. Surprisingly, at no point during development did I feel bitter or like the process was too hard. Every day we would think of new, fun ideas, and it was a series of joyful moments as we got to realize those ideas in the game. The more ideas we had, the more massive the scale of the game, but, as robust as this game is, there were still a number of ideas we couldn't implement or which left

only traces. In some cases, that left things a mystery. For example, why is the Yiga Clan's crest an upside-down version of the Sheikah eye symbol, and, while we know that the king of Hyrule is dead, how did he die? We had also created rich backstories for the Champion characters like Daruk and Mipha during the development of the main game but weren't able to touch on them much. So, when we started development of the downloadable content, we decided to focus one of them on the five Champions, including Link. I was in charge of the structure of the story for "The Champions' Ballad," and had a lot of fun folding those characters' stories into the main narrative.

During the development of the second DLC, we did another round of recordings with the voice actors. I happened to be at the session, and, during a break, I had the chance to talk with the actors who played Daruk and Princess Zelda. Some time had passed since releasing the main game, and they both had been playing it. I asked the actor who played Daruk[1] what he thought, and he said he enjoyed the variety of ways a given situation could be solved and that the approach and solution could vary from person to person. That was something we had worked very hard on, so it made me happy to hear that. Something else I found interesting was that the voice actor for Princess Zelda[2] said she could feel the weight of one hundred years when she played. She was playing as Link from *Breath of the Wild*'s present but had already performed as Princess Zelda from one hundred years prior to that. She was experiencing the game differently from the average player,

who would find out about the past from the perspective of the present. She was playing in the game's present from the perspective of someone who was informed about the past. We had paid particular attention to the flow of time, so it was fascinating to be able to ask the only person in the world who played the game from that particular perspective what it was like.

I would also like to touch on this book, *Creating a Champion*, as well, specifically on the "History" section. For example, if you look up "Akkala Citadel: The Kingdom of Hyrule's Last Stand" (pages 386–387), it talks about the position of the cannons and the direction they face, as well as why the citadel was strong against attacks from behind. It explains why the citadel, protected by a group of trained professionals, fell, and why Fort Hateno, guarded by amateurs, was able to withstand assault. There were backstories for particular settings during development but they were very complex, so we couldn't explain them in the game. This book allows us the opportunity to tell those stories, which makes the development team and me very happy. Again, there are many mysteries in this enormous world that aren't touched on in the game, and creating this book gave us the opportunity to clarify a number of things in a satisfying way. By knowing the backstory and what went on behind the scenes, players will be able to enjoy the game on a deeper level and be inspired to revisit some of these locations. This book includes stories from the entire development team, so it will make a great companion for anyone playing the game again. It warrants a thorough read-through!

One last thing: There are many ways to have fun in this game. We've seen people freezing logs with Stasis, building up potential energy, and then having Link ride them great distances or straight upward. Nintendo Switch is able to upload videos to the internet, and the development team has had a great time watching people discover the different things you can do in this world. However, for people who might think that players have already discovered everything, we want you to know that there are still tricks that haven't been discovered yet. So, for players who think they've done it all, I encourage you to revisit the game and try a few more things; you might just discover something new.

We've reached the end, but I would like to express my gratitude to everyone who has played *Breath of the Wild*. Thank you!

HIDEMARO FUJIBAYASHI ▷ Born in Kyoto Prefecture in 1972. Began working on the series with *Oracle of Seasons* and *Oracle of Ages* while he was at Capcom. After joining Nintendo, he became subdirector on *Phantom Hourglass*, gained director experience on *Skyward Sword*, and was the director on *Breath of the Wild*, overseeing all of development.

[1] Kouji Takeda.
[2] Yu Shimamura.

Satoru Takizawa, Art Director

THE PLEASURE OF PEEKING BEHIND THE SCENES

I imagine there are a lot of people who have wondered why the visuals for *The Legend of Zelda* change with each new entry in the series. We look for the best way to express the unique spirit of that particular game and create a world that will be exciting for players to jump into and explore. Often, the results come from trial and error. With *Breath of the Wild* we spent a lot of time thinking about how to visually represent this massive open world. The theme for this game was "revising expectations," which left me at a loss as to how to express that visually [*laughs*]. At the same time, I felt that it was an ideal opportunity to establish a style that would become the definitive version of *The Legend of Zelda*'s art. After a lot of worrying and going back and forth, we created a painterly art style that combined the realism of the game world with its playability. For example, if you cut down a tree in the game, it immediately creates firewood. That was an intentional contraction of reality that cuts out portions of the game that the player might find boring or makes short waits more fun with comedy. We wanted to create a world that could accommodate the fantastical elements of Hyrule without sacrificing a more realistic art style, and we went about that by crafting a hybrid of the two that would allow the players to suspend their disbelief when certain things happen. That allowed us to include a broad range of ideas from the designers and enabled us to have some crazy stuff happen. For example, the player is able to toss a bunch of ingredients into a pot and have a dessert pop out. We found that

injecting humor into the visual shorthand helps players forgive the break from reality.

Still, before this game came out, I had a mixture of confidence and fear as to whether people around the world would end up accepting this art style. From the very beginning of development, this design seemed to have a mysterious appeal, something indefinable. Games offer few opportunities for people to try them before buying. If people aren't captivated by the visuals after seeing images or videos, we may not be able to get them to give the game a shot. So, when we revealed the first trailer at E3[1] in 2014, I'll be honest, I was very nervous, but we got a very positive response and that's when it felt like it would be safe to continue with this direction and do so with confidence.

During production, there were a number of things that I focused on expressing visually because we couldn't express them in other ways. Smell is one of them. A gaming console can't simulate a sense of smell, but I talked with the terrain and effect designers about how to create a world that gave you the impression of a smell. For example, in the real world, there is a very specific smell right before it rains. I wanted to create the illusion of that smell with the visuals in this game. At the same time, I focused on creating a world where imitation sounds could be communicated. I wanted the onomatopoetic sounds of humidity, mugginess, or dryness to be felt and conveyed without sound effects. It was very motivating. If we could simulate senses like smell and touch through visual information, the world would truly feel alive, and that was one of our big goals. We focused a lot on the air itself. The tropical rainforest is very humid, with particulates in the air. The sunlight is strong in the desert. The amount of dust in the air changes depending on what the wind is doing. The game adjusts light and air quality to more clearly express the differences in weather across regions. I wanted players to immediately get a sense of the adventure they are about to embark upon as they arrive in new lands. I wanted them to get to Gerudo Town and truly feel that they had just traveled all the way to the edge of the desert while covered in dust [laughs].

I was in the US to give a presentation at GDC[2] on launch day, and, the morning after the talk, when I woke up in the hotel, one of the development team members had sent me a message. It said, "The reviews are incredible. Go look!" I rushed to check them. A number of the media's reviews were out, and, at that point, nearly all of them were perfect scores. I was so excited I got goose bumps. I was happy about the game's reception, of course, but I was thrilled about all the positive comments about the visuals that so many designers had spent so long developing. It was like being in a dream, waking up in a foreign country to something like that.

Creating a Champion contains a lot of material that would not normally be made available outside the company, and, because of the expansive nature of this game, we ended up with a lot more material than ever before. It was a lot of work just to choose and organize it all [laughs]. For developers, what's most important is the form something takes in the final game, and these production materials weren't made with the intention of showing them to the customers. They are, at most, something akin to blueprints used to create what appears in the game. I imagine there are some members of the staff who are embarrassed about their rough materials being made public. Still, I am glad that our fans will be able to look at this material and see how the game was made. I believe there is significance in making so much development material available, especially if a child sees this book and thinks that they'd like to do this too someday. The truth is, that's what happened to me. When I was in elementary school, I read an art book that contained a collection of design materials, got really excited, and decided I wanted to do work where I could create things. That's why I ended up joining Nintendo and making games. If this book could have that sort of significance for someone else, I'd be thrilled.

SATORU TAKIZAWA ▷ Born in Nagano Prefecture in 1972. Joined the series on *Ocarina of Time*. Since then, he has been involved in the production of many *Zelda* games as a designer. After gaining experience as an art director on *Twilight Princess*, he was appointed the art director on *Breath of the Wild* as well. He oversees all work related to art design.

[1] Abbreviation for the world's largest game show, the Electronic Entertainment Expo, held annually in the United States.
[2] Abbreviation for Game Developers Conference. Every year, game developers from around the world give presentations about practical content for other game developers.

TAKUMI WADA, ILLUSTRATOR

WISHING THE ADVENTURE COULD CONTINUE

I start working on artwork after a game has already been in development for a little while. For *Breath of the Wild*, the first artwork I did was the marketing illustration that would accompany the teaser trailer at E3 in 2014. Before that, there had been an internal presentation within the company explaining what this *Zelda* would be, and that was the first time I saw the opening movie. Link awakens from a one-hundred-year slumber, emerges from the Shrine of Resurrection, and heads out into Hyrule. I vividly remember how fired up that video made me. It made me want to play the game. My job was to convey that feeling to fans of the series, as well as people who weren't interested in *Zelda*. *Breath of the Wild* became the job for which I produced the most images and worked on for the longest amount of time. Before this game, it was pretty typical for my job to end after the game was released, but this game had downloadable content, so I continued making illustrations well after the initial release date. I'm not particularly emotional, so when my work on a title ends, I usually move straight on to the next one, but this time I didn't want my work to end. I wanted to keep drawing. That's how deeply I was immersed in *Breath of the Wild*, and how close I felt to it.

After it went on sale, I enjoyed checking reviews and people's impressions online. I wasn't directly involved in the development of the game, but I would be grinning in front of my screen reading all of the reactions from fans the world over. This turned into a source of motivation to continue

drawing new images even after the game was released. There were also a lot of comments about my illustrations in many of those reactions. I was grateful for every comment about how those illustrations made people feel, but also for the commenters who touched on the intentions behind the illustrations. It made me proud to be doing a job where people could look at my art, imagine the vast world that lay behind that art, and get excited about it. Of course, there are always some things you wish you could change. For example, I encountered one of my illustrations of the current Link who had been flipped horizontally. When I asked why he had been flipped, I was told it was because they wanted the right-handed Link to be left handed. I completely understand how big a deal it is that Link has continued to be left handed for so long, but the truth is, I joined the *Zelda* team for *Skyward Sword*, so I've been drawing right-handed Links this whole time. It is very important to me that everyone loves right-handed Link as much as any other Link . . . [*laughs*].

I drew a lot of illustrations for magazine covers for this game, which was a fun experience. I wanted to create images that would pique the customer's curiosity as they tried to figure out what the illustration meant, and hopefully get them excited about the release. One of those images was for an American magazine and featured the Master Sword in the very center, grasped by both Link and Princess Zelda (pages 24–25). It's normal to draw a magazine cover with an image that connects the front to the back, but, with this cover, I wanted to connect the front to the back in a way

that would capture the reader's attention. So I settled on a concept that not only connected the front and back of the magazine but also connected two people who, although separated by one hundred years, were linked by the Master Sword. The two of them are holding the Master Sword in mirrored poses—Link as he appears in *Breath of the Wild* and Princess Zelda as she appeared a century prior to that. It appears as though the two are holding the sword at the same time, but, in reality, there is one hundred years of time in between them. There was not a lot of information available to the public at the time, and I was really happy to see that there was some very interesting examination of the image among the customers who saw the magazine.

The image I drew for this book (pages 8–9) will likely end up being the final image I draw for *Breath of the Wild*.[1] Since it was likely my final image, I decided to base it on the final battle. I ended up drawing the Champions in a group, heading to battle, but I was initially planning to draw the image based on the final scene of the game, where Link is holding the Bow of Light and the other Champions who died one hundred years prior are there lit by the green flame effect that indicates that they are spirits. But part of the way through I thought, "Can't you draw something that will be more exciting to look at and make people happy?" That's how I ended up with the current composition. I drew this imagining what could have happened one hundred years ago, but nothing would make me happier than for everyone to have fun dreaming up all sorts of scenarios.

Like everyone else, I love *Breath of the Wild*. Even after having drawn this final illustration, I still don't want this job to end. I want to keep drawing. I would be ecstatic if people opened *Creating a Champion*, saw the images I created, and remembered the world of this game and what it felt like to adventure there. Every adventure through Hyrule is unique to the adventurer. I hope my art spurs your imagination to new adventures that are unique to you.

TAKUMI WADA ▶ Born in Fukushima Prefecture in 1983. Works primarily as an illustrator making promotional images for game software. He was the head illustrator on *Skyward Sword*, which was his first title of the series. He is versatile as an artist and gave *Breath of the Wild* a fresh, new look.

[1] Wada-san created an illustration to celebrate the one-year anniversary of the release of the game after giving this interview. It can be found on pages 38-39.

EIJI AONUMA, PRODUCER

THE NEXT ZELDA HAS ALREADY BEGUN

First, I'd like to thank everyone who has played the game. And, to the development team, I imagine you're tired, but happy. I'm also happy. It's been a long time since I've had so much fun making a game, and I think that *Breath of the Wild* could only have been created by this team.

Watching everyone working on developing the game, I remembered what it was like making *Ocarina of Time* all those years ago. When *Zelda* first went 3D with *Ocarina of Time*, there were no rules on how to make 3D games in the way there are now, and it was my first time making a *Zelda* game, so, in a real sense, I had no idea how to properly create a 3D *Zelda* game. At that time, we had a blank slate. We would think of something, try it, and if it didn't work, do it over. *Breath of the Wild* was similar. It was a type of game that didn't have defined guidelines for development and which none of us had experienced before. It felt like *Ocarina of Time* all over again. I think that's why the *Zelda* team received our first Grand Award from the Japan Game Awards since *Ocarina of Time*, and I am very happy we were able to reach such heights once again.

I said from the very beginning of this project that I wanted to revise expectations of what makes a *Zelda* game. With *Skyward Sword*, the player descended from the sky to specific points on the Surface map, and we received a lot of comments from players saying that they wanted to explore the space between the different areas. That gave us an opportunity. We had always aimed to create worlds in the *Zelda* games that

you could play in endlessly, yet, at some point, we became constrained by expectations. So I told the staff, "This time, let's build the game without shying away from anything. Let's stop thinking about what *Zelda* has been up until now." I knew it was going to be difficult even as I said it. I wanted to play in this big, expansive world, but I was completely at a loss when it came to what sort of play that might be, and being able to go anywhere would mean that players could get lost.

Still, the team was up for the challenge that request presented, no matter how reckless it may have been. What they came up with was far more amazing than anything I had imagined. I was still on the fence when we hit the point of no return during development, but, in general, I was able to focus on evaluating the game that this incredibly passionate team was making. So I was able to have fun with it and, in a sense, be their first customer.

I am grateful that we were able to spend so long developing this game, though I am certain we frustrated our players in doing so. I can say this now that we've reached this point, but we could have completed development on the game and released it earlier. However, we felt like the world could be better and there was more that we wanted to do. There was no stopping it. It got to the point where I wasn't sure just how far we were going to have to take it in order to finish the game [*laughs*]. It was a really fun time, and while it took a while to make, none of it was wasted. Even with all the trial and error, development never stopped moving forward.

There was something else that reminded me of working on *Ocarina of Time*—the number of actions that

Link is capable of. When we were developing that game, we were trying to create ways to give players the feeling that they were touching and interacting with the world like they would in everyday life through Link's actions. Since then, as we've developed new games in the series, we've put a lot of emphasis on varying Link's actions toward that goal. This time, though, the team realized that having too many actions would make the controls too complicated, so we placed a limit on the number of actions we could add to the game. Instead of adding more actions, we increased the number of events the player could interact with in the world. That way, they could have all sorts of unexpected, fun experiences by combining simple actions. Up until now, we had thought of the world and Link's controls as separate vectors, but this time, we were able to successfully bring them together. The game play in *Breath of the Wild* allows for players to explore and choose how they experience the world. That was something we'd always wanted to do, and this method allowed us to better convey a sense of reality. Of course, a big part of that is the evolution of technology, like the physics simulations we included in the game, but I think that's why, even as we were taking the action back to its roots like we did on *Ocarina of Time*, we were able to make something new while still holding true to the feel of *The Legend of Zelda*.

Another expectation in *Zelda* that we needed to revisit was how the game would lead the player from one goal to the next, giving the player a new objective as soon as the one before it was completed. In *Ocarina of Time* that kind of linear guidance was a given, but with this title we were able to overcome that barrier. The first time I really felt

the freedom of this game was with the horses. I could ride them endlessly across that massive world, never getting bored, just having fun riding them without a particular goal. The horses are really smart. Rather than having an invisible barrier blocking the player's path, the horses would stop of their own volition, knowing that they shouldn't go certain places [laughs]. This sense of communicating with a living horse was completely different from the horses in *Ocarina of Time* or *Twilight Princess* and I felt its effect very strongly.

The feeling that the world kept getting bigger whenever I got on a horse was actually quite similar to the sensation I had the first time I rode a motorcycle. That made me want to ride around Hyrule on a motorcycle [laughs]. I asked the staff if we could try doing just that, but they told me it would break the game, and I was immediately denied. So I gave up initially, but later, we were talking about how there wasn't a reward for players who played all the way through the last DLC, "The Champions' Ballad." I figured it was my last chance, so I tried again, telling the team, "Since the player has played all the way to the end of the game, and this is the final reward, it is okay if it breaks the game a little bit. Let's add a motorcycle." At first, everyone was pretty unenthusiastic about the idea, but I pressed on, saying something about making it in the image of a Divine Beast that Link can ride, to which they responded that it would be confusing if there was another Divine Beast since the others are necessary to defeat Calamity Ganon. Somehow, I got them to add the Master Cycle Zero to the second DLC.

Of course, it had to be an off-road bike to be able to drive across this world.

I was happy that the staff eventually really got into the idea despite their initial reluctance. The programmers actually went out and bought a motocross bike to ride and only started designing once they understood what an off-road bike felt like. Still, since it's a fictional world, I thought we shouldn't pursue a purely realistic portrayal. I would often talk to them about ideas like wanting the bike to make a *vroom* sound when opening up the throttle. I mean, I had this very specific idea of a special-effects-heavy movie hero in my head, *tokusatsu*-style [laughs].

The final thing I'd like to convey to all of our players is that video games, not just *Zelda*, can go much, much farther! We got a lot of responses from adult players who said they felt the same way playing this game as they did when they used to be hooked on video games when they were younger. We made this game with the intention of returning to our roots, so the response from players about feeling the same as they had when they were young is promising. Since Nintendo Switch is portable, I hope that they will be able to engage deeply with the game in a fresh, new way too.

In books like the recently released *The Legend of Zelda: Encyclopedia*, we revealed where each *Zelda* game fell on a timeline and how their stories related, but we didn't do that for *Breath of the Wild*. There is a reason for that. With this game, we saw just how many players were playing in their own way and had those reactions I just mentioned. We realized that people were enjoying imagining the story that emerged from the fragmental imagery we were providing. If we defined a restricted timeline, then there would be a definitive story, and it would

eliminate the room for imagination, which wouldn't be as fun. We want players to be able to continue having fun imagining this world even after they are finished with the game, so, this time, we decided that we would avoid making clarifications. I hope that everyone can find their own answer, in their own way.

Creating a Champion is the third book to commemorate the thirtieth anniversary of the *Zelda* series, but the thirtieth year is just a milestone along the way. Development of the next *Zelda* has already begun. I think it's safe to say that there is another *Zelda* because of the kind of world we were able to create for *Breath of the Wild*. *The Legend of Zelda* has now been around for over thirty years, and I hope that you will continue to support the series in the years to come!

EIJI AONUMA ▶ Born in Nagano Prefecture in 1963. The series producer for *The Legend of Zelda*. After working on *Marvelous: Another Treasure Island* for the Super Famicom, he joined the development team for *Ocarina of Time*. Since then, he has been involved in every *Legend of Zelda* title and helms the series.